The Drawings of Goya

The Drawings of
Goya

The Complete Albums

Pierre Gassier

Thames and Hudson · London

Translated from the French
Les Dessins de Goya: Les Albums
by Robert Allen and James Emmons

First published in Great Britain in 1973 by
Thames and Hudson Ltd, London

© 1973 by Office du Livre, Fribourg, Switzerland

Printed in Switzerland

ISBN 0 500 09091 2

Preface

In recent years the number of studies devoted to Goya has steadily increased, so much so that it has become difficult, if not impossible, to keep abreast of the findings and speculations of modern scholarship and criticism. Writers of many nationalities, starting from many different points of view, continue to offer their interpretations of his immense, complex and fascinating *œuvre*.

In this accumulation of books, articles, essays and notes, some items stand out for their comprehensive scope, others for the acuteness with which they deal with certain aspects of his work and extend our knowledge of them.

Among the latter was the tentative catalogue of Goya drawings published by Pierre Gassier in 1947 in a book designed to make them better known to the public. The introductory text was written by André Malraux. Gassier himself has acknowledged that the guiding principle of his work was implicit in the writings of August Mayer and F. J. Sánchez Cantón. He developed it methodically in this catalogue which, for the first time, presented Goya's drawings in the order of the albums or series which he intended them to constitute. This book thus represented the first attempt to reconstruct these albums.

In 1970, in the large Goya volume which he published in collaboration with Juliet Wilson, Gassier extended his earlier study and added a good many drawings hitherto unknown. Now, having reached the third stage of his researches, he has marshalled in one volume all the available album drawings, together with everything at present known about them, reproducing the drawings as faithfully as possible.

This in itself is a scholarly achievement of great importance, but one particular aspect of it deserves to be emphasized, as adding very considerably to its interest and value; here for the first time we can see and study the drawings in the original order in which they stood in the artist's albums—that is, in the actual sequence in which he planned and executed them. This accurate, overall view of them brings us into closer contact with the artist and marks a significant forward step in Goya scholarship.

Goya rarely depended on traditional designs or symbols. But he often expressed himself in sequences of works which, taken as a whole, afford revealing insights into his mind and his views on a particular subject.

Much had to be done in the way of study and research before this simple but essential notion could be arrived at. Now, after the publication of the great catalogues of Gudiol and Gassier-Wilson, which in their text and illustrations provide an overall view of Goya's work, this principle is accepted by all.

Goya, then, expressed himself in sequences of works which may either develop an event or an idea, or may come as successive expressions or visions forming a commentary on an idea or an emotion, or on related ideas and emotions. It is impossible to appreciate fully Goya's reactions as a man unless one takes into account this highly personal manner of expressing himself.

In presenting Goya's drawings arranged in albums, Pierre Gassier enables us in some cases to catch the vibrations of the artist's sensibility and to share his thoughts and feelings; in others, to guess at the connection between different subjects, even though we cannot read the riddle. In still other cases, we find that there is no connection between one drawing and the next, that Goya has changed themes; that all at once the artist has approached his drawing with different ideas in mind. But whether we are faced by a clearly connected sequence or a break in the train of thought or feelings, all the evidence available for judgment and understanding is provided by this book, which represents the fulfilment of an undertaking begun in 1947.

Many years will pass before any significant improvement can be made in the reconstruction of these Goya albums, which supply the key to an understanding of some of his deeper reactions. They are an expression of private feelings which the artist never imagined might one day be revealed to the world, as they are now in this book.

Xavier de Salas

Contents

Abbreviations and Signs

Designation of the Drawings

Albums A, B, C, D, E, F, G, and H. For the sake of convenience, these letters have been retained to designate Goya's eight albums of drawings. This alphabetical listing of the albums does not imply any chronological order. In the catalogue entries, each drawing is designated:

(1) by the capital letter of the album to which it belongs, followed by Goya's autograph number or, when an autograph number is lacking, by a classification letter in lower case;

(2) by its serial number in the catalogue, given in square brackets.

Examples: Drawing D.13 [101]; Drawing A.j [10]

The drawings sold in Paris on April 3, 1877 and now lost figure in an appendix after the captions of the corresponding album. They are designated by the number given in the sale catalogue.

Inscriptions

Titles	When Goya's autograph caption figures on the drawing, it is printed in italics, with as close a translation as possible following in brackets. In all other cases a conventional title is given to the drawing, in keeping with its subject and the relevant bibliography.
/	Change of line in an inscription.
//	Change of position in an inscription, beginning at the top of a drawing and continuing at the bottom.
No. add.	Number added subsequently in a hand other than that of the artist, that can figure either in the upper right corner or upper centre of the sheet (upper r. corner; upper centre).
s.	signed by Goya.

The year or period assigned to the drawing is indicated in the following way:

1804 certain date
1804? probable date
c.1804 about 1804
1804-08 executed between 1804 and 1808

References to exact dates are given in Arabic numerals, day, month and year, in that order: e.g. 12.11.1886 = 12 November 1886.

→ *Cap.* = *Los Caprichos* (for drawings which have some connection with a plate in the *Caprichos*).

Dimensions

The dimensions of the drawings are those of the sheet of paper (unless qualified by the mention vis. = visible). Dimensions are always given in millimetres. When the edges of the drawing are not squared or are in any way irregular, the dimension given is always the largest.

Vis.	visible dimensions (e.g. where the drawing is partly covered by a mount or frame).

Technique

I	Brush and Indian ink wash
S	Brush and sepia wash
Bc	Black chalk
Lp	Lead pencil
P	Pen

These designations apply only to the technique of the drawing itself. A mixed technique is indicated by a plus sign +, the different media being given in decreasing order of importance:

Example: S + I = drawing executed mainly in sepia wash, with highlights in Indian ink wash.

The designations between brackets: (I) – (S) – (Bc) – (Lp) – (P) refer to the technique used for autograph numbers and captions.

Marks of Collections

These are given only when they are of historical interest. Reference to the Lugt catalogue is given when possible.

Paper

chain lines	Traces left in the paper by the metal rods crossing the wires in the mould. These traces are always perpendicular to the wire-marks.
26 mm	Space between the chain lines.
Watermark	For each album the fragments of a watermark are indicated by the letter designating the album, followed by a Roman numeral. The watermarks and each fragment of them are described in the introduction to the corresponding album.

History

Ps.	public sale
APs.	anonymous public sale
H.D.	Hôtel Drouot, Paris
→	means "acquired by…" or "sold to…", with the date if known.
(26 fr.)	means that the drawing was bought for 26 francs, in the currency of the period.

Whereabouts

When the whereabouts of a drawing is known, its designation (at the end of each entry) includes:

(1) the name of the city;

(2) the name of the museum or collection, unless the owner has asked to remain anonymous, together with the catalogue or inventory number.

Bibliographical References:

GW	Pierre Gassier and Juliet Wilson. Goya: his life and work, London, 1971, published in the USA as: The life and complete work of Francisco Goya, New York, 1971.

General Introduction

The reconstruction of Goya's drawing albums, enabling us to turn over the sheets in the order in which they were executed, brings us into closer touch with the artist and the man, indeed with the deeper, more revolutionary side of his work. It further reveals a phenomenon that may well be unique in the history of art: that of a great painter at the peak of his official career, laden with honours and commissions, undertaking at the age of fifty, humbly and almost clumsily, another body of work in a spirit and style totally different from anything that he had done before. The first album, the so-called Sanlúcar album (1796), is the prelude so to speak to an immense graphic *œuvre* numbering over five hundred drawings and nearly three hundred etchings and lithographs which exerted a decisive influence on European art in the 19th century. The slow rediscovery of these drawings stands out in itself as one of the most fruitful gains resulting from the present-day reappraisal of aesthetic values.

If Goya, like Velázquez, whom he acknowledged as one of his masters, had devoted himself exclusively to painting, the corpus of his drawings would not amount to very much: a few dozen sketches and studies, hardly distinguishable in fact from those of his contemporaries. Drawing as a preliminary to painting or, as Ortega y Gasset has put it, as the "conscience of the picture", was of no interest to Goya. He drew directly on the canvas with his brush or, as in San Antonio de la Florida, on the coat of fresh plaster prepared for the fresco. Drawing as he learned it from his first master José Luzán in Saragossa and practised it later with his brother-in-law Francisco Bayeu was a matter of careful, cold, academic delineation. To him, that sort of drawing soon came to seem more of an obstacle than a useful preliminary to the act of painting. Or, rather, one may say that the painting he dreamed of was the antithesis of this drawing and could not be based on it. That this should have been so was a consequence of the cleavage between the academicism of his time, as represented by Mengs, and the great tradition of Velázquez which he rediscovered from 1778 on and from which he learned lessons diametrically opposed to those inculcated by Bayeu.

The negligible role of drawing in Goya's work before 1796 is thus accounted for by this steady maturing of his art, as he was led to depart more and more from the neo-classical canons to which his associates tamely kept.

It might be supposed that the change that came over him following his very serious illness of 1792-93 gave rise to these albums of drawings, prompted by fancy and "caprice". Such was not the case, however, and we know today that the first results of this change were the set of cabinet pictures presented to the Academy of San Fernando early in 1794. So it was in a series of paintings, not drawings, that he gave an outlet, publicly and officially, to that freedom of expression for which he felt so deep-seated a need and for which there was no scope in the ordinary run of commissioned works. This fact deserves special attention, because it provides the key to that new aesthetic which was to inform all his subsequent work.

At this crucial point in his career Goya did not consider drawing – such, anyhow, as he then practised it himself and saw it still practised around him – as a suitable medium for the subjects which he was at last free to choose (shipwreck, fire, madmen, bullfighting). He instinctively relied on painting, on his brushes, to express this renewal of his art, and though he handled these cabinet pictures with a sketch-like spontaneity, he considered them sufficiently finished to present them to the Academy of San Fernando. It was as if he wished official notice to be taken of this unexpected revival of his creative powers, at a time when his best friends and of course his many rivals assumed that he would never be able to work again.

9

It was only two years later, at Sanlúcar de Barrameda in 1796, that he turned to drawing as a specific means of expression, used independently of paintings or prints. Unlike the cabinet pictures of 1793, these drawings were not an outcome of that painful and trying crisis in his life, that critical period when Goya, hitherto so robust and frankly rejoicing in life, had been weakened and left irremediably deaf by his illness. On the contrary, that summer of 1796 was a happy one for him, living with the Duchess of Alba on her Sanlúcar estate, in the glowing heat and sunlight of Andalusia: there, at fifty, he re-experienced the pleasures of love with an intensity heightened by his recent brush with death. The drawings in the first album, the Sanlúcar album, are the fruit of this new lease of life, which brought with it an outburst of eroticism centring of course on the Duchess of Alba but also kindled by daily contact with other young women in the house, on what appear to have been terms of uninhibited intimacy. Goya drew what he saw or glimpsed, then what he remembered, day after day, for the pure pleasure of recording unposed figures in perfectly natural attitudes. His sole concern seems to have been to fix, in brush drawings in Indian ink, the images of a fleeting happiness. This was an unusual technique at that period. Practising it for the first time, he invented and perfected his means of expression as he went along and as his needs arose. Until he left Spain for France in 1824, he employed no other medium in his drawing albums, reserving pencil and pen for the preparatory studies for his series of etchings.

With his long experience of painting, he very soon raised his ink wash drawings to the level of fully developed compositions, brushed in spontaneously on the sheet of paper. These album drawings bear the mark, to an almost unrivalled degree, of the direct touch and impetus of an artist's hand. Caught by an exceptionally keen eye and dictated by the heart of a man passionately in love with life, these ever renewed scenes are brought before us now in the very order and rhythm intended by Goya. They are the most accurate and telling reflection not only of a vision of the world, but of an inquiring mind and a conscience always responsible to the ways of the world.

Although this ensemble, consisting originally of over five hundred drawings, seems to form a world apart in Goya's œuvre, it nevertheless marks, directly or indirectly, the starting point of the four great sets of etchings: the *Caprichos, Disasters of War, Tauromaquía* and *Disparates*. After his initial experiment with the Sanlúcar album, which arose, as we have seen, from an imperious need to record a few moments of happiness, he went on to the systematic organization of the Madrid album, with its captions and serial numbers, which exemplifies an ever recurring feature of Goya's work. Again and again he chose to express himself in a series of work (drawings, etchings and even paintings), each series having a unity of technique and, usually, of support and format. The subjects are connected by a common theme or at least are governed by a prevailing spiritual mood. After the *Caprichos* — which themselves stemmed from the Madrid album — many examples are to be found among the paintings, beginning with the six scenes of witchcraft and sorcery painted in 1797-98 for the Duchess of Osuna. The inventory of Goya's studio drawn up in 1812 lists a number of pictures grouped together in sets of the same size; for example, the six scenes relating to the bandit El Maragato, a series of twelve still lifes, and the twelve *Horrors of War*. Later came the five panel paintings in the Academy of San Fernando and finally the Black Paintings in the Quinta del Sordo. It would be tedious to give a complete list of these very homogeneous series. There are many of them, besides the four great sets of etchings (to which may be added the *Bulls of Bordeaux* lithographs), so many that with Goya they may be said to represent an almost obsessional form of creation. They gave scope for the many-sided expression of an idea or theme, which he liked to take up again and again, varying his approach to it but keeping to the same style or the same scale of tones.

One last point of importance emerges from the study of all these works: Goya created most of them for his own satisfaction and in his lifetime they were seen only by him and the close friends whom he admitted to his studio. To use a familiar term of that period, given currency by Goya himself, they were all *capriccios*. And the eight albums of drawings published here represent what is probably the deepest, most intimate aspect of this private sphere of creative activity. They are like an underground river of which contemporaries had but a glimpse of the surface, and which only now, after more than a century of painstaking research, can be seen in its entirety.

Laurent Matheron, in the book he published in 1858, was the first to call attention to the large body of Goya drawings, whose scope and importance was confirmed two years later by a fundamental study published in the *Gazette des Beaux-Arts* by Valentín Carderera, who had known Goya personally and owned nearly four hundred drawings by him. Thereafter, most biographers of the great Spanish master included a varying number of drawings in the catalogue of his œuvre. But it was August Mayer, in 1923, who drew up by far the most extensive list, running to 739 items; this has formed the basis for all the research work done in the past fifty years.

Today it is safe to say that their number verges on a thousand. Already in 1955 I assumed the existence of "nearly a thousand drawings" (Bibl. 95, p. 11). The catalogue which I published in 1970 in collaboration with Juliet Wilson reproduced 937. Making due allowance for the sheets that have disappeared or are temporarily missing, one realizes that the number of drawings left by Goya at his death must have run to well over a thousand.

Examining and tabulating this huge corpus of drawings, we find that only twenty of them are connected with paintings, while 281 are preparatory studies for prints. There remains a very considerable lot of more than 600 sheets on various subjects which, with a few exceptions, have no direct connection with the paintings or prints.

This is not the place to describe the investigations, spanning many years, which have enabled us to sort out these "miscellaneous drawings" and arrive at the coherent sequence of the eight albums presented in this volume. The decisive steps in this slow work of reconstruction may, however, be mentioned. The two pioneers were unquestionably F. J. Sánchez Cantón and August Mayer, who based their work on Carderera's article of 1860, cited above, and the penetrating study by Félix Boix, dated 1922 (Bibl. 80). To Sánchez Cantón we owe a valuable booklet entitled *Los dibujos del viaje a Sanlúcar* (The Drawings of the Sanlúcar Journey), published on the centenary of Goya's death, and the short guide to the room of Goya drawings in the Prado, unfortunately presented in a wholly arbitrary order. As for Mayer, he was the first to realize that the drawings fell into sequences ordered and numbered by Goya; as early as 1930 he called attention to the "black border" drawings (Bibl. 143) and in several fundamental articles he published and analysed several groups of drawings all belonging to the albums. But neither Sánchez Cantón nor Mayer ever published the comprehensive study of the drawings which, in view of their insight and ripe judgment, might have been expected of them: Sánchez Cantón, because he never really believed in the importance of the autograph numbers and sequences, so that his two volumes on the Prado drawings, published in 1954, take no account of them; Mayer, because of the War and the tragic consequences it had for him.

In 1935 an exceptionally fine Goya exhibition was organized by Jean Adhémar at the Bibliothèque Nationale in Paris (Bibl. 4). In addition to superlative etchings and lithographs, visitors were privileged to see for the first time outside Spain one hundred and ten of the best Prado drawings and above all, for the first and last time in Europe, the famous album of fifty drawings which then belonged to Mariano Fortuny and immediately after the exhibition was purchased by the Metropolitan Museum of Art in New York. This acquisition – the largest ever made of Goya drawings, after the sets acquired by the Prado in 1866 and 1886 – resulted in the publication in 1938 of a sumptuous facsimile of the whole album, containing a remarkable study by Harry B. Wehle and a tentative catalogue of three albums: the Madrid album (B), then known as the Large Sanlúcar album, following the terminology of Sánchez Cantón; the black border album (E) and the album of sepia wash drawings (F). Wehle, moreover, on the strength of only three drawings, was shrewd enough to infer the existence of a further series, then unknown: the unfinished album (D). So on the eve of the Second World War, which was to put an end to all further research work for some years, the existence of seven of the eight albums of Goya drawings was already established in principle, in the provisional form given below:

Small Sanlúcar album	(Sanlúcar album: A)
Large Sanlúcar album	(Madrid album: B)
Indian ink series	(unfinished album: D)
Black border series	(black border album: E)
Sepia series	(sepia album: F)
Black chalk series	(Bordeaux albums: G and H)

Only the large album C, in Indian ink and sepia, preserved almost entirely in the Prado, remained unrecognized.

But the essential groundwork for the study of the drawing albums had been done, and after the War there began a further stage of research, which was not made any easier by the upheavals of the War years, particularly in Europe. The frame of reference being fixed, the next step was to define the characteristics of each album and, by checking each known or newly discovered drawing, to make sure that each sheet was assigned to the right album, to the position corresponding to its number, on the basis of the following elements, whose different combinations characterized the eight albums: format, medium, captions, position of the number on the sheet, presence or absence of a black border.

As a result of a chance meeting at the end of the War with Albert Béguin, who had been deeply impressed by the Prado Goyas, I was called upon to make a selection among the four hundred and eighty-three Prado drawings, with a view to a publication which the atrocities of the War made more topical than ever (Bibl. 135). Rather than being guided by aesthetic criteria, which are always open to discussion, I followed in the steps of Mayer, Boix, Sánchez Cantón and Wehle, and was fortunate enough to convince Albert Skira that the drawings thus selected formed a coherent whole in an order established by Goya. This tentative catalogue included no sheets from albums D and E, since none of these were owned by the Prado and our book was limited in scope to the Prado collections. But for the first time one hundred and ninety-five drawings from six albums (out of the two hundred now identified in the Prado) were catalogued and reproduced on the basis of their technical characteristics and, whenever they had any, their autograph numbers. Despite its shortcomings, this book was entirely illustrated with large-sized plates and it gave some idea of what modern art publishing might eventually do to make the complete set of Goya's drawing albums better known.

In the twenty-five years that have elapsed since then, a growing number of publications, sales and exhibitions all over the world have deepened and extended the knowledge of this very large and highly original part of Goya's *œuvre*. It would be tedious to enumerate one by one all the stones that have gone to ensure the solidity of this great edifice of modern criticism, but I should like to mention the more substantial contributions that have been made. Professor José López-Rey, a leading authority on Spanish art, published two very important works in the space of a few years: one on the *Caprichos,* in 1953 (Bibl. 127), together with as complete a catalogue as possible of the Sanlúcar and Madrid albums (a new distinction proposed by López-Rey); the other, in 1956 (Bibl. 131), dealing with the large album of Indian ink and sepia wash drawings (album C), nearly the whole of which is in the Prado. The chief merit of these works lay in the fullness of the historical and stylistic commentaries and the accuracy of the reproductions, for at that time the author was in no position to make a thorough scrutiny of the drawings, apart from those exhibited in 1954 in London, then in the United States, with an introduction by Xavier de Salas (Bibl. 12).

During the same period, forgotten or unknown sheets continued to turn up unexpectedly in public sales. These, together with exhibitions, proved a determining factor in the better comprehension of this corpus of drawings which, by their sheer numbers and expressive power, were beginning to command attention as one of the summits of modern art. At the same time, there appeared several studies of outstanding importance for the advancement of our knowledge of Goya's work. Following the 1953 exhibition in Basle (Bibl. 11) and the sale of nine drawings of quite exceptional quality at the Galerie Charpentier in Paris in 1957 (Bibl. 61), two new specialists came forward with scholarly contributions which deserve special mention. Enrico Crispolti, a young Italian art historian, who summed up the situation of the albums in the light of the latest finds and, for the first time, emphasized the importance of paper and watermarks (Bibl. 86 and 87). Almost simultaneously the *Boston Museum Bulletin* published a substantial article by Eleanor Sayre, keeper of the department of drawings, which had just acquired one of the finest sheets sold at the Galerie Charpentier (E.15). In two appendices, she set forth the technical characteristics of the eight albums, designated by the letters A to H, and drew up a still fragmentary list of the drawings in the Black border album (album E).

Six years later, in 1964, on the occasion of the great exhibition of "Goya and His Times" at the Royal Academy in London (Bibl. 22), the *Burlington Magazine* published a special issue (Bibl. 176) containing several remarkable studies, among them one by Eleanor Sayre dealing with the Sanlúcar and Madrid albums, which she carefully catalogued on the basis of a thorough bibliographical check and a direct examination of most of the sheets available. This scholarly piece of work was unfortunately not followed up by the sequel which seemed to be implied in its title, "Eight books of drawings by Goya – I".

Finally, in the comprehensive volume on Goya's life and work which I published in 1970 in collaboration with Juliet Wilson, every known drawing from the albums was given its due place in the catalogue appended to each section of the book, and all were reproduced for the first time in the order laid down by Goya; but, to keep the book within manageable limits, they had to be reproduced on a small scale. It thus remained for the present volume to illustrate the album drawings with reproductions corresponding to their actual size and to provide them with a critical apparatus capable of satisfying both the amateur and the scholar, without, however, overburdening a book that is sizable enough as it is.

Thanks to the work done by the scholars mentioned above, we now know of four hundred and seventy-six drawings divided into eight albums or series, whose existence has now been firmly established by modern criticism. Although we devote a separate study to each of them, it seems advisable to present here an overall

picture of the albums, which will provide at the same time an outline of this book. Each album is designated by a title based on its predominant feature and, in some cases, on a tradition which it would be ill-advised to ignore. As for the identifying letters A, B, C, etc., given by Eleanor Sayre, they are retained only for the sake of convenient reference, and we would emphasize the fact that their alphabetical sequence does not necessarily imply any chronological order:

I – *Sanlúcar album* (A), 1796
II – *Madrid album* (B), 1796-97
III – *Unfinished album* (D), 1801-03
IV – *Black border album* (E), 1803-12
V – *Journal-album in Indian ink and sepia* (C), 1803-24
VI – *Sepia album, without captions* (F), 1812-23
VII-VIII – *Bordeaux albums* (G and H), 1824-28.

What, then, are the features that all the albums have in common and what is it that, within the corpus of Goya's drawings as a whole, makes them an exceptionally coherent *ensemble* for which, so far as I know, there is no equivalent in the work of any other artist? There is, first of all, what I shall call unity of support and unity of medium, each album being executed on an identical type of paper, whatever the number of sheets. Each type of paper is defined by its tint and consistence, and above all by the disposition of the chain lines in relation to the subject, the distance between the chain lines and, lastly, the presence or absence of a watermark. To avoid any mistake on this essential point, it may be well to say what is meant by these chain lines, which are not to be confused with the wire marks. They are the wider parallel lines formed in the pulp of the paper by the metal rods at the bottom of the moulds, whereas the wire marks are the finer, more serried lines running perpendicular to the chain lines. The spacing of the chain lines may vary considerably according to the quality of the paper and the manufacturer. As regards the watermarks, these were recorded in a great many cases by Enrique Lafuente Ferrari and partially utilized by Sánchez Cantón (Bibl. 173, vol. I, unnumbered pages after the bibliography). We find that they vary freely in the preparatory drawings for the prints, whereas for each album Goya carefully chose a single make of paper and always used it in the same way, in a vertical format. Of all the known album drawings, not a single sheet is used breadthwise, in contradistinction to the studies for the *Disasters of War,* the *Tauromaquía* and the *Disparates,* for example, which, like the engraved plates, are all in a horizontal format.

What is one to infer from this astonishing constancy in so impassioned and unmethodical an artist? To my mind, it means, beyond a doubt, that Goya planned each album in advance as a single work, as a coherent whole, each drawing as produced being assigned its due place in accordance with the themes and their continuous sequence. This carefully planned unity extended even to the medium employed in each album. No arbitrary changes of technique occur from one sheet to the next: all the albums, with the exception of the Bordeaux albums, consist of brush and wash drawings, the first four (A, B, D, E) in Indian ink and album F in sepia. Only album C, whose elaboration must have spanned many years, combines the two and corresponds to a transitional period between the two techniques. Only here and there do we find a few pencil strokes, used no doubt to block out the subject, or a few highlights laid in with a pen, but always in the same tone. In short, there is a striking unity here, in contrast, for example, with the extraordinary diversity of media used in the preparatory drawings for the *Caprichos,* in which pen, bistre, Indian ink, red wash, and red and black chalk are combined in the most unexpected proportions, at the prompting of the creative impulse.

Two elements play a key part in the drawing albums: the autograph numbers and the captions. (We shall deal later with the numbers subsequently added, first by Javier Goya, then by Román Garreta.) As we have seen, the first album to be numbered by Goya, to be systematically ordered, was the Madrid album (B). Like the Sanlúcar album, it was an actual sketchbook (as shown by the rounded corners which I have recorded for several sheets), and the numbers were added in the same Indian ink as the drawings, as these were executed, or possibly even before on the still blank pages. The other albums, however, (with the exception of the unfinished album D), were made up of loose sheets, which Goya probably kept in portfolios, and, as we shall see, the numbers and often the captions as well seem to have been added subsequently, after the drawings had been made. This assumption is borne out in particular by a careful examination of album C in the Prado, an account of which will be given in the relevant introduction. By proceeding in this way, Goya went on from the purely numerical order of the pages in the Madrid album (B), in which the only sequences in subject matter are those between the recto and verso of the same sheet, to a logical order obtained at times only at the cost of sweeping

changes, as can be seen most noticeably in albums C and H, where whole sets of numbers were corrected. (See, for example, the sequence of visions in a single night, C.39 to C.47; the series of Inquisition victims, C.85 to C.92; or the duelling and hunting series in album F, F.10 to F.15 and F.97 to F.106.)

As regards the captions (wholly absent from the Sanlúcar album and the first half of the Madrid album, and unusual in albums F and H), they would require a long study devoted to them alone, so true is it that their telling, incisive style reflects the artist's personality and amounts to an actual signature. Beginning with brief captions in the middle of the Madrid album (filled out later with additions written with a pen), Goya quickly realized to what extent these pithy phrases could be turned to account, either to emphasize the subject or, on the contrary, to give it a quite unexpected drollness. To appreciate the profound originality of his captions, one would have to compare them with those of the contemporary English caricaturists and with the later ones of Daumier, Gavarni or Grandville. It would then be seen that here again the Spaniard is unique. Title-captions seemed to him dull and he rarely used them. The scraps of dialogue between two figures which are so common in Daumier never appear in Goya, doubtless because of their too explicitly anecdotal character. What Goya was especially fond of is the commentary-caption, which points the irony, expresses surprise, ventures a statement but never overstates, or suddenly leaves things at that, ruefully or indignantly. Often Goya exclaims or wonders, but his true originality and incomparable force lies in his way of apostrophizing his figures, questioning, advising, comforting or even threatening them. The phrasing is apt to be abrupt but it is always very human and colloquial, and his outbursts often recall the famous *piropos,* those impulsive compliments which Spaniards come out with in passing an attractive woman in the street.

The tone of Goya's captions, however, changes considerably from one album to another. While albums B and D contain for the most part commentary-captions, it is significant that the next two albums, E and C, are richer in apostrophizing captions, exactly as in the series of the *Disasters of War,* which is roughly contemporary with these drawings. One might say then that these two categories of graphic work bear witness to the extent of Goya's commitment in the political drama of Spain between about 1808 and 1820. Later, in his retreat in Bordeaux, far from the strife and sufferings which he had seen at home, he took a more detached view of things, and his captions (album G) again become almost exclusively titles or comments, as in the albums preceding the upheaval of 1808.

This tension which Goya deliberately imparted to his drawings, as also to the series of the *Disasters of War,* raises the question of the political relevance of this important part of his *œuvre;* and in a more general way it leads us to consider how far the subjects represented in the albums may reflect visual reality. A thorough study of them makes it clear that Goya worked largely from memory, recomposing figures and attitudes from what were sometimes dim recollections, in which the scenes he had witnessed were overlaid by what he had heard or read about. So it cannot be said that this or that album, such as the one in the Prado, is actually a "journal" in the strict sense of the term, which would mean that the drawings were executed in the chronological order of the events to which they refer. The fact is that Goya's art is much more complex, and in that complexity lies its true greatness. For while he took his subjects from the life of his time, we rarely find in him that outright caricature of topical events, that love of the telling anecdote, which is so characteristic of Daumier's genius. Transcending the anecdote, Goya, for example, combines the tortures of his own day with those of the past in order to denounce more effectively the horrors of torture in all periods. In a word, what he shows us is not just the men of his time and country, but Man as he is and has always been in all times and places.

Each album and each drawing will be commented on in its due place, but before concluding these introductory remarks on the album drawings as a whole, I should like to say a word about their curious vicissitudes after Goya's death.

When Goya left Madrid for France in June 1824, he had been living in the Quinta del Sordo for about four years and there he left almost all his prints and drawings, with the exception, of course, of those executed subsequently. In 1828, shortly after Goya's death, the young painter Antonio Brugada, who had been his faithful companion in Bordeaux, inventoried the works in the Quinta del Sordo in the presence of the artist's son Javier and his grandson Mariano (Bibl. 88, p. 54). This inventory lists "two cases of prints and drawings, aquatints, caprices, etc." and "four cardboard boxes of prints and caprices"; above all, carefully listed separately, there were "three books of original, unpublished drawings" – *Tres libros de dibujos originales, inéditos.* Undoubtedly this refers to the albums of drawings. Yet the word "books" seems surprising; it suggests that, instead of consisting of loose sheets, like the prints and remaining drawings in the cases and cardboard boxes, these drawings were mounted on sheets of paper actually forming three volumes. We have the further

testimony, unfortunately rather vague, of a certain Father Tomás López, a Carthusian monk at Aula Dei, quoted by Carderera and published by the Conde de la Viñaza (Bibl. 185, p. 463): he mentions having seen in the possession of Goya's son, at an unspecified date, "three large books made up by him of many original drawings and caprices (most of them unpublished), some drawn with a pen, others with pencil, charcoal, sepia, bistre, Indian ink, etc." There is certainly a noteworthy coincidence between these two documents which, within the space of a few years, refer to three books of drawings, using the same terms: "books", "original", "unpublished". Is one to assume that they refer to the same three books? Personally, I should be inclined to make that assumption. In this case, then, the testimony of the Carthusian monk would confirm that the books were made up by Javier Goya, but obviously at some time before the 1828 inventory. In the opinion of Eleanor Sayre, the pink paper still to be found on the back of nearly all the album drawings in the Prado and in many other collections is the very paper on which Javier pasted the drawings before assembling them in three books (Bibl. 176, p. 125). It is certain that this pink paper appears on the back of the album drawings alone, to the exclusion of all the others, and that the album drawings owned by Román Garreta, Valentín Carderera and Federico de Madrazo were mounted on the same pink paper; clearly, therefore, the drawings had already been mounted on this paper before they entered these three collections. The Fortuny album, in particular, purchased by the Metropolitan Museum in 1935, was entirely mounted on this pink paper. Now Carderera, in his 1860 study of the drawings (Bibl. 84, p. 226), implies that this album, which he was soon to purchase from Mariano Goya, had been made up by Javier Goya of forty-nine drawings, in addition to a self-portrait used as a frontispiece. So there can be no doubt that it was Javier Goya who mounted them on pink paper.

But in view of the fact that the drawings done in Bordeaux, which I recently examined in the Prado, were also mounted on this pink paper, one must assume that they were brought back to Madrid and pasted into the three books before 1828, with the exception, perhaps, of a small lot (seventeen black chalk drawings) which apparently remained in Bordeaux in the hands of Leocadia Weiss and were sold after Goya's death to one Hyadès, an army inspector in Bordeaux; they subsequently found their way, together with a few more sheets, including two from the Sanlúcar album, into the collection of Jules Boilly (Bibl. 29). It may therefore be said that the three books inventoried in 1828, and seen a few years later by Father Tomás López in the possession of Javier Goya, contained nearly the whole set of album drawings, all mounted on pink paper.

The albums only began to be broken up in the 1840s, when the reduced circumstances of Javier Goya, and the even worse straits of his son Mariano, constantly obliged them both to procure ready money (Bibl. 162, *passim*). It was presumably at that time that Javier made a selection of the finest drawings contained in the three books with a view to selling them. He thus put together three sets in which the different wash techniques were represented, and in which, therefore, no account was taken either of the original albums or of his father's numbering. The first set was bound up and became known as the Fortuny album. The other two apparently remained in the form of loose sheets; I have been able to reconstruct them in part by means of a careful study of the catalogue of the one hundred and six Goya drawings sold in Paris in 1877 (Bibl. 34 and 99). For a great many of the drawings at this sale bear numbers added subsequently with a fine pen, in a hand which is undoubtedly the same as on the drawings in the Metropolitan Museum – a hand which can only be that of Javier Goya. These secondary numbers figure at the top of the sheet, either on the right, underscored with a stroke of the pen, or in the centre, invariably followed by a full stop, as on the New York drawings. Javier's purpose in disposing the numbers differently was to distinguish the three selections he had made, which consisted solely of drawings from albums B, D, E and F. While the New York album is complete, the other two are not: dispersed at the 1877 sale, they show many gaps, due in particular to the fact that the various collectors who owned these drawings often scratched off Javier's numbers. The drawings numbered in the upper right corner were the more numerous, amounting to at least sixty-nine sheets (see F.94); the others came to at least forty-seven (see F.30). But we know that the Paris sale of 1877 comprised one hundred and six drawings (one hundred and five listed in the catalogue, plus one more that was uncatalogued, thus accounting for the note figuring in the catalogue of the Calando sale in 1899 [Bibl. 42, p. 18 after lot 75] and referring specifically to an "album of 106 drawings"). These one hundred and six drawings, together with fourteen versos, which as a rule were not counted in the nineteenth century, give a total of one hundred and twenty drawings – only four more than the sum of the two figures cited above. Furthermore, in reconstructing these two albums of Javier Goya, one discovers that there is a certain cohesion between the numbers in fine pen, the order fixed by Goya and the numbers of the 1877 sale; this means that, while the overall sequence of the album drawings was thrown into confusion by Javier, several smaller groups remained intact until the 1877 sale. This sale is known to have been held on behalf of one Paul

Lebas, a merchant at 18 rue de Châteaudun, Paris. Either he himself was selling off this fabulous collection, purchased in Spain from a great collector who, as we shall see, might well have been Román Garreta himself; or else he was an intermediary acting on the owner's behalf on the Paris art market.

Apart from these three sets carefully numbered by Javier Goya, what was the fate in store for the other album drawings? In all, Goya must have made about five hundred and fifty of them, this figure representing the sum of the highest numbers known in each series. What became of the three hundred and eighty or so drawings that remained? The largest lot was purchased by Román Garreta, either from Javier or from Mariano soon after his father's death in 1854. For Laurent Matheron in 1858, in his book on Goya (Bibl. 137, note 7 and catalogue of the drawings), twice states that Mr R. G. of Madrid then owned more than three hundred Goya drawings, the copper plates of the *Disasters of War* and several fine paintings. As pointed out by Elizabeth du Gué Trapier (Bibl. 184, p. 12), this Mr R.G. was certainly Don Román Garreta, the brother-in-law of Federico de Madrazo and uncle of Raimundo de Madrazo. Moreover, a note by the latter, kindly communicated from the archives of the Hispanic Society in New York, specifies that the twelve drawings which he sold in 1913 to Archer M. Huntington came "from the same album that contained those which are in the Prado museum and which belonged to Don Román Garreta, uncle of Raimundo de Madrazo"; thus giving the exact provenance of the one hundred and eighty-eight Prado drawings (186 plus 2 versos) purchased in 1866 by the Museo de la Trinidad. As further pointed out by Elizabeth du Gué Trapier, the word "album" deliberately employed by Raimundo de Madrazo doubtless applied to one of the three books made up by Javier Goya. I would add that, in my view, Román Garreta also owned the two sets numbered by Javier and sold in Paris in 1877, for the total of three hundred and two drawings, not counting the versos (one hundred and eighty-six in the Prado, plus ten sold to Mr Huntington, plus one hundred and six sold in Paris in 1877) corresponds almost exactly to Matheron's statement: "Mr R. G. owns more than 300 Goya drawings."

Valentín Carderera, for his part, owned the Fortuny album, which he soon sold to Federico de Madrazo; nearly all the studies for the sets of prints, which were sold to the Prado in 1886 together with twelve album drawings (two from the Sanlúcar and ten from the Madrid album); and further miscellaneous sheets, among them fourteen album drawings acquired in 1867 by the Biblioteca Nacional in Madrid. His collection included nearly four hundred drawings, as already noted by H. B. Wehle (Bibl. 186, p. 5).

Finally, Federico de Madrazo also had a certain number, including thirty-seven from the Bordeaux albums. They later passed in part to Aureliano de Beruete and then, after being published by Paul Lafond in 1907 (Bibl. 113), to Gerstenberg whose collection was destroyed in 1945 in the battle of Berlin.

Today there are about seventy-three sheets missing from these eight albums. Through the catalogue of the 1877 sale, I have been able to find some trace of thirty-one of them, which may still exist, unrecognized or unreported, in private collections, or may have been destroyed for ever. I know that a few sheets have eluded me. I console myself with the thought that the intense, ever-renewed joy which these drawings have given me cannot be measured with a yardstick, and that my aim has never been to set a record but rather to make better known and better loved a body of work for which there is probably no equivalent in the whole field of art.

Sanlúcar Album (A)

Introduction

The first mention of this album occurs in the article by Valentín Carderera published in the *Gazette des Beaux-Arts* in 1860 (Bibl. 84, p. 223). It tells us that "the first drawings of Goya's youth were done in a pocket notebook on bluish Dutch paper bound vertically. The small albums were not yet known in our country." Before attempting to analyse the leaves that are still extant, we must consider this text, for it affords invaluable information which the author's personality renders trustworthy. First of all, it confirms the existence of a pocket-size notebook bound up the side (not, as some scholars have believed, bound at the top). But an extremely important detail supplied by Carderera concerns the circumstances in which the little volume originated. He says: "It was started on a journey with the famous Duchess of Alba, Doña María Teresa de Silva, when that noble lady took up residence for some time in her lordly villa at Sanlúcar de Barrameda." This evidence, at once precise and vague, has served many of Goya's biographers as a basis for a patient analysis and collation of the few documents that gradually came to light. Yet they have never succeeded in establishing an exact chronology of the years 1796 and 1797, which are so crucial for both his life and his art.

On the face of it, this departure for Andalusia was far from being a lovers' escapade. In this context I would recall the reason for the journey Goya made in 1792 as related in a letter by Don Sebastián Martínez, his friend at Cadiz: "My friend Don Francisco de Goya left the Court . . . impelled by the desire to see this town [Cadiz] and others on his route." (Bibl. 163, doc. 160). At Cadiz he fell seriously ill and so was certainly unable to take advantage of that first stay in Andalusia as he had hoped. Back in Madrid, his health was still so poor that, as we know from the minutes of the ordinary meetings of the Academy of San Fernando (Bibl. 176, note 4), he was quite unable to perform his duties as Director of Painting during the whole of 1795. What more natural, therefore, than the decision to rest for several months in a region which must have pleased him for its climate and the beauty of its monuments and where he could count on at least two very good friends – Ceán Bermúdez, settled at Seville since 1790, and Sebastián Martínez, a rich merchant and art collector of Cadiz? Another reason for making the journey may have been to supervise the setting up of the three important paintings he had just finished for the Santa Cueva at Cadiz, consecrated on March 31, 1796 (GW 708, 709 and 711).

There is, however, one point that has never been cleared up. The Duke of Alba, whose health had deteriorated, left for Andalusia early in February of that year. He died suddenly at Seville on June 9. Might there not be a connection between these events and Goya's journey? It is worth noting, in fact, that Goya was on friendly terms with the Albas at least since the previous year, when he painted the famous portraits of the duke and duchess (GW 350 and 351) and two small intimate scenes (GW 352 and 353), now lost. In a letter written on May 25 (Bibl. 157), a fortnight before the duke's death, Goya told his friend the sculptor Aralí that he would soon be leaving for Sanlúcar. Carderera says he travelled with the duchess. Though we may doubt this, there is really no reason why it should not be true. All the more so as Ezquerra del Bayo (Bibl. 91, p. 185) concedes that the great lady was at Seville with a number of servants when her husband died. A few weeks later, on July 22, Aralí in a letter to Ceán sent his "best wishes for Goya, if he has returned from Sanlúcar." How could he have stayed there after the duke's death unless the Cayetana was there too? But his visit is confirmed in a note by Conde de Maule (Bibl. 138, p. 115 and No. 1): "Goya . . . was here [at Sanlúcar] to see the Duchess of Alba."

In September another letter of Aralí's mentions Goya's bad state of health. And on October 20 the Academy of San Fernando took note of his absence without further comment. However, thanks to the publication of Moratín's *Diary* (Bibl. 147) and its review by Jeannine Baticle (Bibl. 78, p. 111-113), we know that at the end of December 1796 and the beginning of January 1797 the painter was staying at Cadiz and was unwell. He was still there at the end of January. Nothing more is known of him until April 1, when he wrote to the Academy from Madrid handing in his resignation for reasons of health. In the meantime, on February 16, the Duchess of Alba had signed and dated at Sanlúcar her will, in which Goya's son is mentioned among the other legatees.

From all these documents it would seem that Goya's most certain stay at Sanlúcar was between mid-June and late July 1796 and that he then settled for some time, in good health or bad, at Cadiz. Consequently, if we link this chronological data with the traditional statements by biographers such as Ezquerra del Bayo (Bibl. 91) and more especially those made at first hand by Carderera, we find that the Sanlúcar album should date from the summer of 1796. And indeed that season of the year is eminently propitious to siestas and to the unconventional poses, more or less undressed, rendered in those drawings (A.b, A.d, A.g, A.k, A.l, A.m and copy b).

Judging from the sixteen authentic drawings and the copies still extant, the album consisted entirely of sketches of young women caught in various postures, many of them very lightly clad or even stark naked. The unity of the subject matter is striking and gives us an inkling of what interested Goya on the journey. There is not a single monument, nor landscape, nor street scene, nor portrait of a man, nor even a couple, so common in the next album. Nothing but young women, who seem to have monopolized the painter's attention to the point where he was blind to his surroundings. The album might be given the title "Women," like the famous suite of lithographs published by Toulouse-Lautrec a hundred years later. Who were the young women whose charms are so generously displayed? On this point, too, Carderera's testimony is invaluable. For he not only says that he had several pages of the album but also describes five of them which, in his opinion, portray the Duchess of Alba.

Three sheets (six drawings) unquestionably from the Carderera collection are still extant – two in the National Library in Madrid (A.a/b and A.c/d) and one in the Prado (A.e/f). But only two of the drawings tally with scenes described by Carderera. The three others are known only from a drawing of dubious authenticity and two copies (A.q, copy a and copy c). On the other hand, it is certain that Carderera possessed, or knew of, other leaves from this album representing the Duchess of Alba. But probably the treatment was so free – cf. copy b for an idea of the sketches of this type – that he was led to speak of them in veiled terms: "Lastly, a great many leaves are filled with light sketches picturing the duchess's slender, supple figure, with the modest grace that is the one and only true distinction."

To complete Carderera's text, there is Charles Yriarte's published seven years later with Carderera's assistance (Bibl. 189, preface). Other, more intimate scenes described there tally perfectly with known drawings: "She is taking a siesta in very carefree attire" (A.h); "She is putting on her garter" (A.j). The brief annotation: "Here the carriage, the mules, the *posada* where one stops . . ." might perhaps refer to the two drawings, A.n and A.o, which were in the collection of the painter Jules Boilly until 1869 (Bibl. 29).

The sixth drawing described by Carderera was, he said, one of the last leaves of the album "filled with scenes sketched in Andalusia" and was used for Plate No. 15 of the *Caprichos* entitled *Bellos consejos* (Fine advice). It is A.p, now in a French private collection; but when Carderera wrote his article it, too, belonged to Jules Boilly.

So there is no doubt that the Duchess of Alba was the focal point of the Sanlúcar album. We know very few exact dates concerning her stay at Sanlúcar except for those supplied by the will dated February 16, 1797, and the Alba family account books, from which it may be inferred that he spent the whole of 1797 in Andalusia. But it is more than likely that during the summer of the previous year she stayed there with Goya in the country house called El Rocío or Coto de Doña Ana (Bibl. 91, Chap. XVII). A bad sonnet, unfortunately not dated, by Don Manuel Aria de Ayona, a Sevillian priest, sings the praises of the duchess, whose presence on her estate of Sanlúcar was known throughout the region. It bears a meaningful title: "To a lady, recently widowed, who has taken up residence at Sanlúcar de Barrameda." It is also a homage to her famous beauty, for the gallant cleric did not scruple to proclaim her "Spain's new Venus". In any case, the term "recently widowed" (*recién viuda*) seems to indicate a period not long after the duke's death on June 9, and therefore confirms her stay at Sanlúcar during that summer.

18

Life must have been very free and easy on that splendid estate close to the Guadalquivir and the ocean, amid bosky hills interspersed with vineyards and orange orchards. A dream setting, where the untrammelled presence not only of the beautiful duchess but also of her maidservants titillated Goya's senses. Did he really live the great love that has been so written and spoken of, and know the fullness of ardent bliss followed by the torments of jealousy? It would seem more than probable, if we are to judge from the famous unpublished plate of the *Caprichos, Sueño de la mentira y de la inconstancia* (Dream of falsehood and inconstancy). But, on examining with all due care the remaining sheets of the Sanlúcar album and the first few of the Madrid album, we realize that, for a man of fifty, who had found it so hard to take up the cudgels again after 1793, and for his art as well, that stay in Andalusia marked a true rebirth under the sign, voluptuous yet distressing, of Woman. Carderera must have grasped that too, for he speaks, in connection with these drawings, of "the women's grace and their voluptuous curves," adding: "here . . . all is light, gaiety and candour, like the springtime of the artist's life." A little further on he insists once more on "this Andalusia where one watches the charming girls of the Guadalquivir, whose tiny feet seem hardly to touch the ground."

The chronology of that period spent in Andalusia, in so far as we can establish it at present, allows us to envisage a different hypothesis. It is far from certain that Goya returned to Sanlúcar after staying at Cadiz during the winter of 1796-97. Moreover, as E. Sayre has observed (Bibl. 177, p. 21, note 14), the minutes of the Academy of San Fernando make no mention of Goya's absence during the first quarter of 1797 before the letter of resignation as Director of Painting (April 1, 1797). So it is quite possible that he returned to Madrid in February or March, still unwell but bursting with impressions, memories and projects. He had discovered a new manner of drawing and his one idea was to develop it in a complex work. That was the origin of the second album, whose early pages are still pervaded by the luminous memory of Andalusia.

I shall have more to say about the chronology of the year 1797 when I come on to the Madrid album. But before bringing this presentation of the Sanlúcar album to a close, I must still deal briefly – without going into the details of the drawings as I shall in the notes – on the style of these sketches, and their action as catalysts on Goya's *œuvre* from then on.

Before proceeding any further I must insist on the fact that, as far as I know, Goya never utilized the medium of wash before the Sanlúcar album. The catalogue of the drawings he did before 1796 includes a few studies – thirty-eight, to be precise – nearly all connected with paintings (cartoons for tapestries and religious compositions) or with prints (copies after Velasquez). The techniques employed are perfectly classical, involving red or black chalk, frequently combined with white crayon on tinted paper. This means that, until he was fifty, Goya drew in a very commonplace manner like all the good artists of his time, notably his brother-in-law Francisco Bayeu, who had been his teacher. Many painters of that day, among them the Tiepolos, whom Goya had known in Madrid, utilized wash, but always in combination with a first design in pen, and the patches of varying darkness applied with the brush served only to model the volumes. One is astonished at the awkwardness of some drawings in the Sanlúcar album. In my opinion it is due to the fact that for Goya the medium was a new departure. I cannot imagine that in his circle, whether Bayeu, Maella, Mengs, Carmona or the Tiepolos, he found examples of wash employed entirely on its own. But that revolutionary technique – the term is no exaggeration in the Spain of the end of the 18th century – was the one Goya used by preference in all the albums executed between 1796 and 1824, a total of over four hundred drawings. So it is essential for us to understand its main points. As Carderera so rightly said: "It is impossible to convey the clearness of the lines in most of these drawings, done with the very tip of the brush dipped in Indian ink . . ." (Bibl. 84, p. 223). In fact, Goya first *drew* with his brush, as we can see, for example in A.f and A.j, a fine contour line in pale ink to set up his subject and establish its main features. In a second phase he took up that first state again, applying the wash in broad patches and larger areas (cf. A.c) to fix the shadows, somewhat in the manner of the Tiepolos but without their deft grace. Finally, in a third phase, he finished his drawing with touches of almost black wash whose purpose was to stress certain details of hair or dress (cf. A.a). Only very exceptionally can we observe a few sparse touches with a pen or a light pencil. Otherwise Goya employed exclusively brush and wash. The novelty of the technique explains his occasional blunders, soon forgotten amid examples of such incredible freshness as A.g and A.h, where the great painter's genius – born anew – achieves spontaneity and immediate response, like a man who lets himself drift untrammelled on the river of life.

Paper: Strong, slightly bluish, laid; vertical chain lines at 24-26 mm intervals.
Watermark: Sheet A.m is the only one to display a barely visible trace of watermark (cut-off letters).
Maximum sheet size: height 173 mm, width 101 mm.
Drawings: On recto and verso.
Technique: Brush and Indian ink wash; a few pen and pencil strokes.
Goya's numbers: None.
Additional numbers:

 1. *numbering by Don Román Garreta* (before 1866) with fine-point pencil in the lower right-hand corner: Nos. 185 and 186 on A.i and A.g (Madrid, Prado).

 2. *more recent numbering:* with thick black crayon (after 1886): Nos. 3 on A.f; No. 2 on A.h; No. 4 on A.i (Madrid, Prado).

BIBLIOGRAPHY

Exhibitions: 2, 4, 8, 16, 19, 20, 22.
Public sales: 29.
Authors: 69, 76, 78, 80, 81, 84, 87, 91, 93, 97, 117, 127, 135, 136, 138, 144, 147, 157, 161, 163, 164, 165, 171, 176, 177, 179, 183, 189.

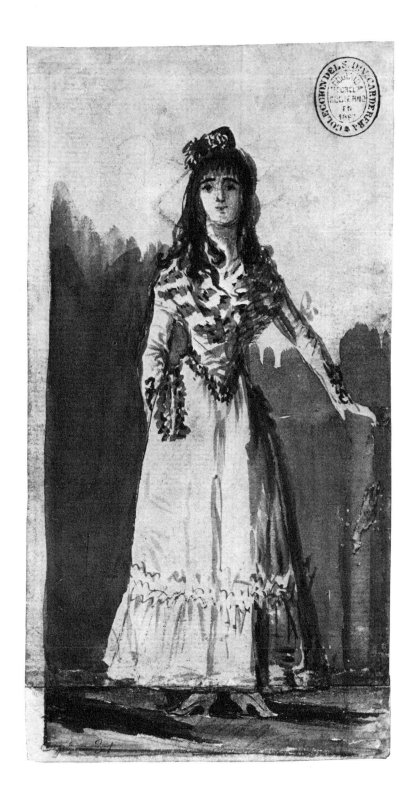

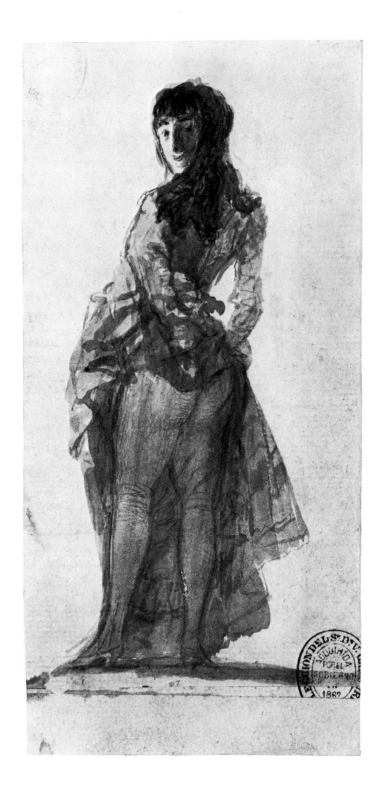

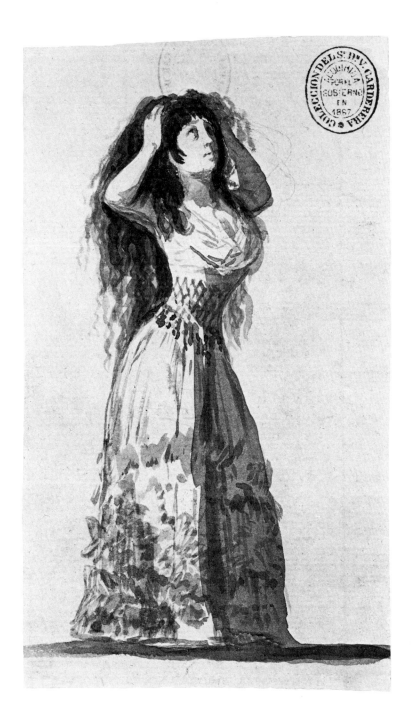

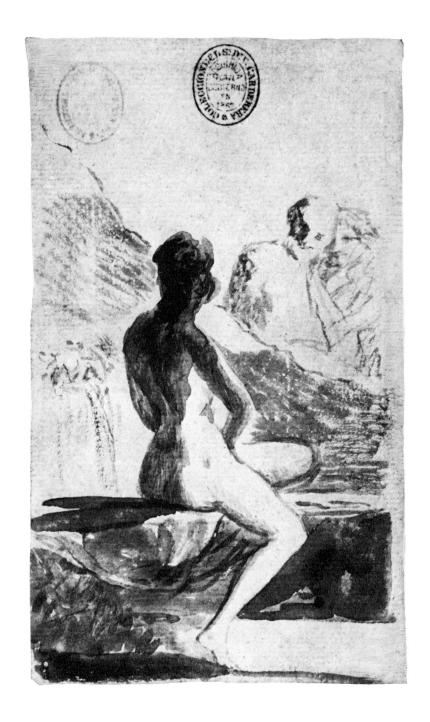

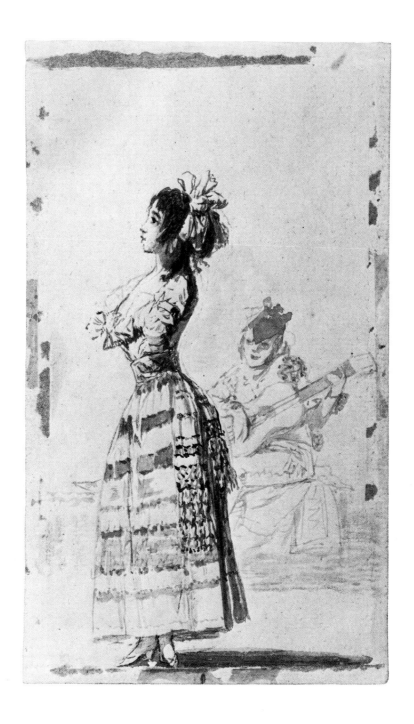

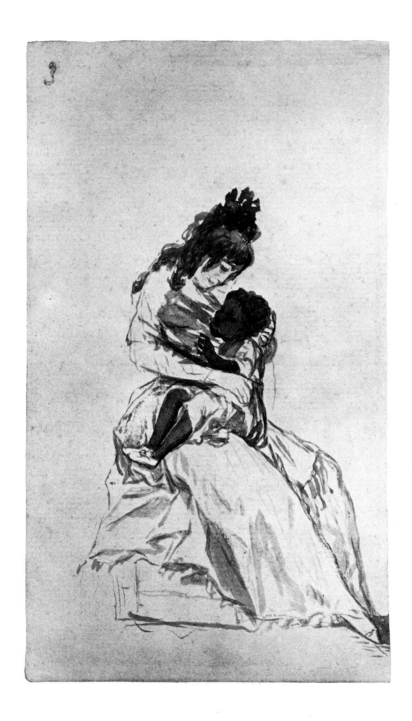

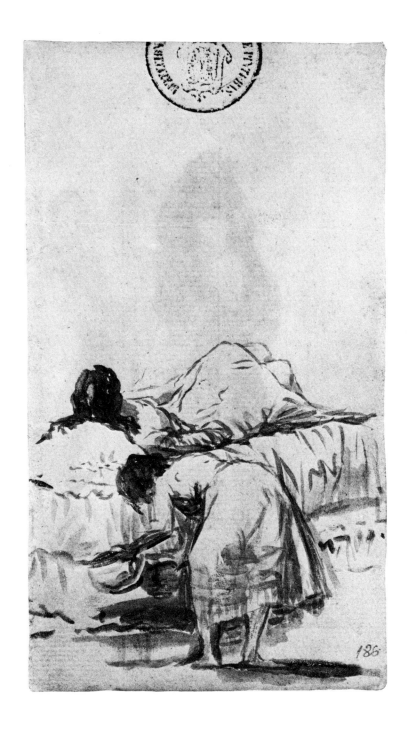

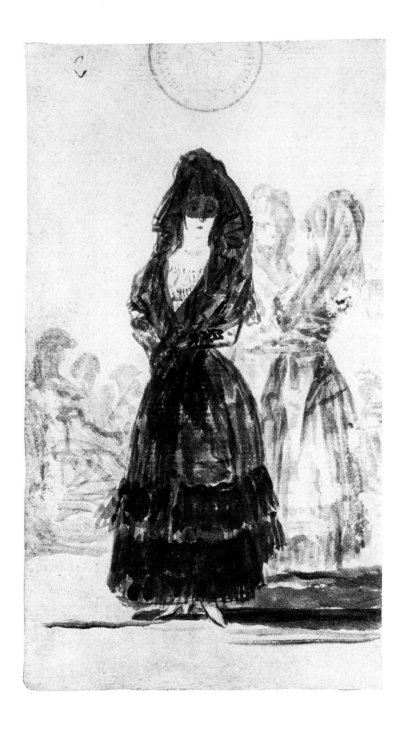

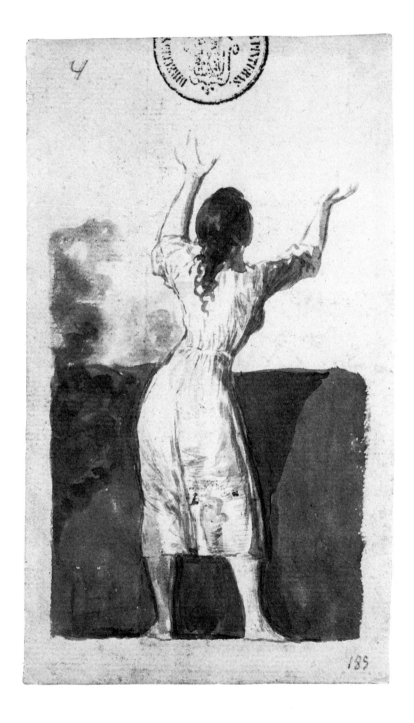

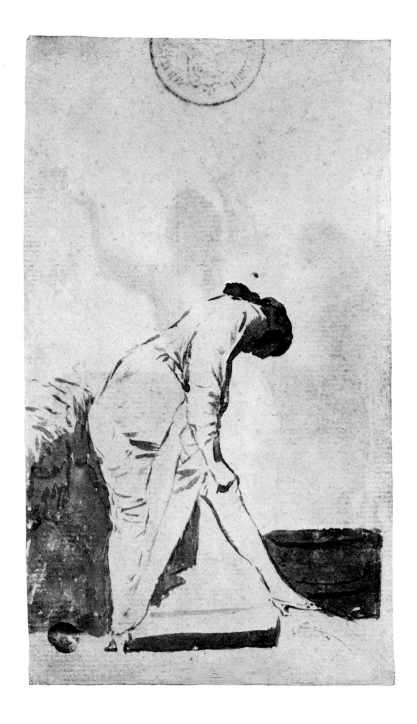

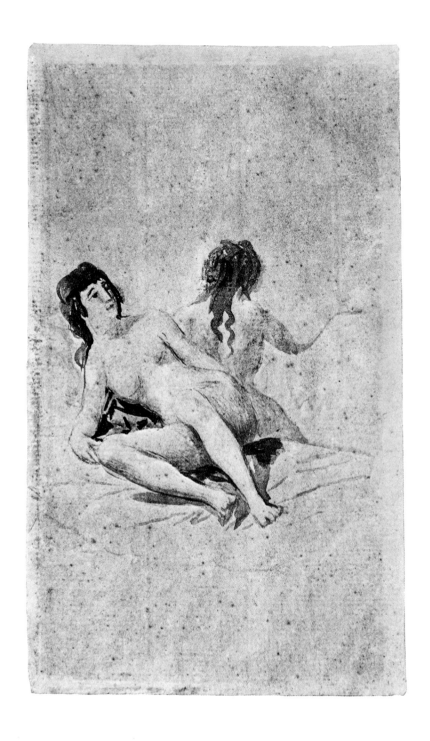

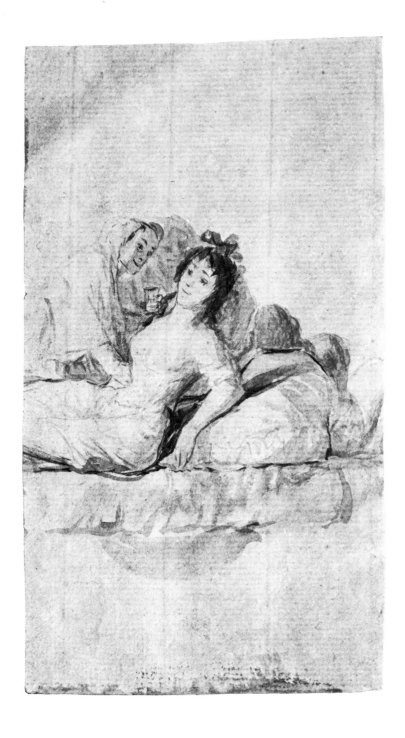

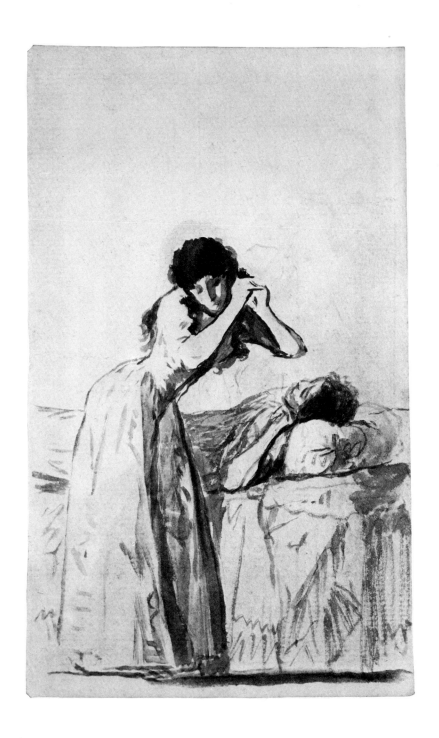

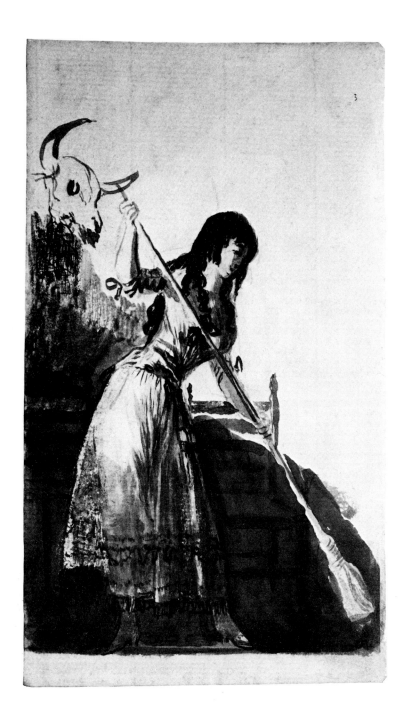

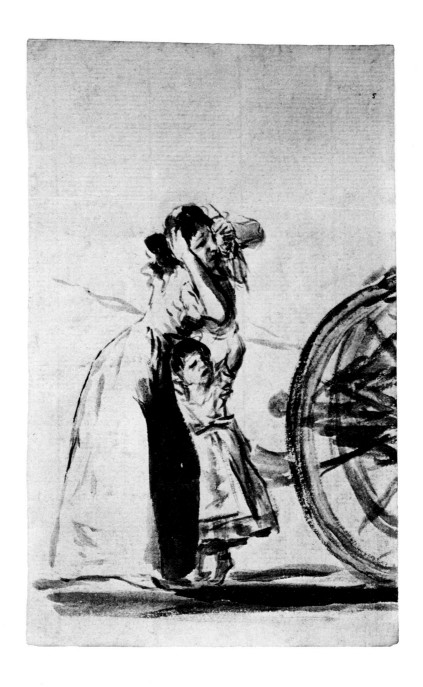

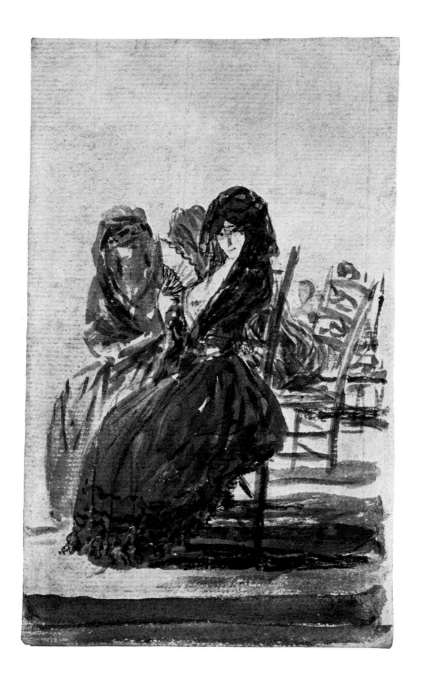

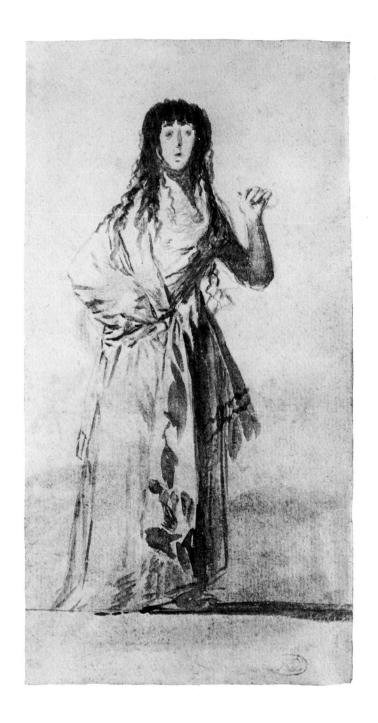

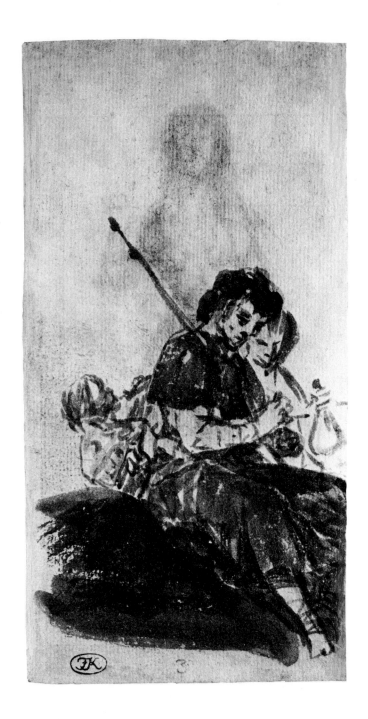

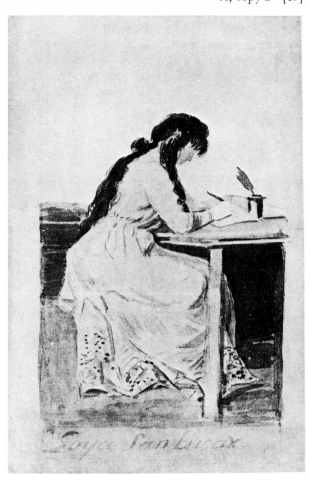

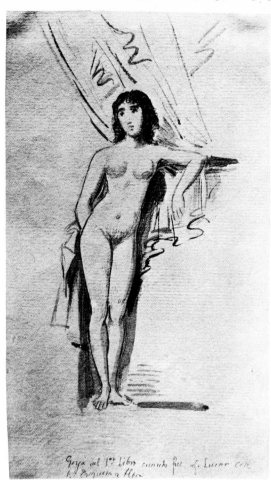

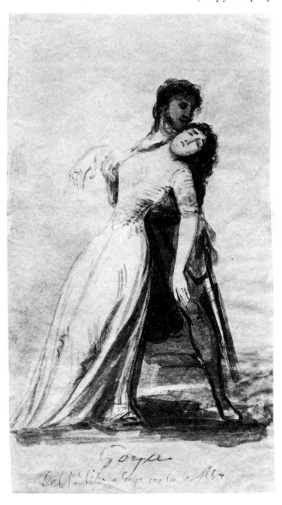

Sanlúcar Album (A)

Captions and Commentaries

A.a [1] p. 21

"Young woman in front view wearing a small hat" – 1796-97 – 190 × 97 – I – Acquisition stamp of the Carderera coll. (1867). The strip of paper on which the feet are drawn was added after 1867 (h. 17 mm) – *Paper :* vertical chain lines (26 mm) – *Hist. :* Javier Goya ; Mariano Goya ; V. Carderera → 1867 – Madrid, Biblioteca Nacional (B.1270) – GW 356

Most of the scholars who have studied this drawing, and I myself until recently, have assumed that it represents the Duchess of Alba. I have now been led to question this identification, for two reasons: first, the fact that Carderera (Bibl. 84) does not describe this sheet among the drawings in his collection ; secondly, the notable differences between this figure and the Duchess of Alba as she appears in the Hispanic Society portrait (GW 355) which can only have been executed one year later at most.

A.b [2] p. 22

"Young woman in back view lifting up her skirts" – 1796-97 – Verso of A.a – I – Acquisition stamp of the Carderera coll. (1867), cut off at the edge of the original sheet of paper – Madrid, Biblioteca Nacional – GW 357

This drawing, bold indeed for the Spain of that day, where the nude in art was taboo, is one of the feeblest in the album. The arm holding up the skirts is very sketchily indicated, and on the whole the lower part of the body seems ill adjusted to the bust and the folds of the tucked-up skirts. It is in the lower body, however, that the modelling is most carefully done. Using three tones of ink wash, light grey, medium grey and black, Goya brought out with the tip of the brush the rounded volumes of buttocks and legs, the latter marked transversally by the creases of the garters. It

has often been conjectured – and rightly so, it would seem – that the woman is wearing a mask, which gives the grinning expression to the mouth ; the face is divided in half by a strong shaft of light from the left.

A.c [3] p. 23

"The Duchess of Alba tearing her hair" – 1796-97 – 171 × 101 – I – Acquisition stamp of the Carderera coll. (1867) – *Paper :* vertical chain lines (26 mm) – *Hist. :* Javier Goya ; Mariano Goya ; V. Carderera → 1867 – Madrid, Biblioteca Nacional (B.1271) – GW 358

"Richly dressed, she gazes heavenwards, as despairingly as one of Niobe's daughters, and tears her hair" (Carderera).

Carderera's description fits this drawing perfectly ; so it may be taken as one of the five which, according to him, represent the Duchess of Alba. Here her famous *chevelure* is the most prominent feature of the drawing ; when loosed, its jet-black tresses fell below her waist, as we know from contemporary accounts (Bibl. 171, pp. 54-55).

A.d [4] p. 24

"Young woman bathing at a fountain" – 1796-97 – Verso of A.c – I – Acquisition stamp of the Carderera coll. (1867) – Madrid, Biblioteca Nacional – GW 359

This drawing belongs to the series of nudes figuring in this sketchbook and at the beginning of the Madrid album. Of more complex design, it shows a deliberate attempt, unusual in album A, to lay out the compositional elements on several planes. Lurking behind a mass of foliage or a stretch of wall, two figures gaze at

the naked woman. It has been suggested that the left-hand figure may be a statue (Bibl. 177, p. 24, note 30); but this can hardly be the case, considering the way the head is tilted to one side and the vivid gaze of the eyes fixed on the young woman. The drawing is undoubtedly based on a scene Goya had actually witnessed, and he must have had in mind the famous theme of Susanna and the Elders. This drawing may be compared with B.25, which represents the same young woman in a similar posture.

A.e [5] p. 25

"Girl dancing to a guitar" – 1796-97 – 170 × 99 – I – *Paper*: vertical chain lines (26 mm) – Traces of pink paper on the edges – Rounded corner on lower right – *Hist.*: Javier Goya; Mariano Goya; V. Carderera; M. Carderera; → Prado on 12.11.1886 – Madrid, Prado (468) – GW 361

The discovery of a rounded corner on the lower right proves that this side of the sheet is the recto, and not the verso, as hitherto supposed. Here Goya has no doubt recorded a glimpse of an Andalusian dance, which he may have seen either at Sanlúcar or at Cadiz or Seville. For he was passionately fond of flamenco dancing. In a letter to Zapater, unfortunately lost, he warmly recommended to his friend a *cantaor* whom he had much admired. Another well-known letter shows how fond he was of the *seguidilla* (Bibl. 97, p. 68).

A.f [6] p. 26

"The Duchess of Alba holding Maria da la Luz" – 1796-97 – Verso of A.e – I – No. add. 3 (heavy Lp) – Madrid, Prado (426) – GW 360

"Finally, in another [drawing], she is seen seated, holding in her arms a little negress whom she had taken under her protection" (Carderera).
One of the five drawings described by Carderera, and belonging to him. Having no children of her own, the duchess found an outlet for her maternal instincts by mothering two children who lived in her home: Luis de Berganza, son of her steward Don Tomás de Berganza, and a little negro girl María de la Luz, whose origins are unknown. They head the list of legatees in the will drawn up by the duchess at Sanlúcar on February 16, 1797 (Bibl. 91, p. 190). In 1795 Goya had painted a small picture showing the two children teasing one of the old maid-servants in the Alba household, known as la Beata (Bibl. 91, pl. p. 153). A poem by Quintana dedicated to "Una negrita protegida por la duquesa de Alba" confirms the "philosophical"

aspect of her singular affection for this child (Bibl. 91, pp. 182-184).

A.g [7] p. 27

"The siesta" – (The discovery of rounded corners on the right side of the sheet proves that this is the recto.) – 1796-97 – 172 × 97 – I – No. add. 186 (Lp) – *Paper*: horizontal chain lines – Rounded corners on the right – *Hist.*: Javier Goya; Mariano Goya; Román Garreta; → Museo de la Trinidad, 5.4.1866 – Madrid, Prado (428) – GW 363

It is impossible to say whether this is the Duchess of Alba, as believed by Ezquerra del Bayo (Bibl. 91, plate p. 193), or a young woman in her entourage lying on a bed and attended by a servant, who appears to be emptying a chamber pot. Three other drawings in this album represent two young women on a bed, possibly the same persons in different postures.

A.h [8] p. 28

"*Maja* on the *paseo*" – 1796-97 – Verso of A.g – I – No. add. 2 (heavy Lp) – *Paper*: traces of pink paper – Madrid, Prado (466) – GW 362

It is quite possible, as suggested by López-Rey (Bibl. 127, p. 16) and E. du Gué Trapier (Bibl. 183, p. 3), that this elegant *maja* is the Duchess of Alba: silhouette, dress and bearing are very close to the Hispanic Society portrait of the duchess in black (GW p. 115). True, Carderera makes no mention of it in his article published in 1860 in the *Gazette des Beaux-Arts*; but then this sheet and the next never belonged to him. A subtle charm emanates from this figure, due in particular to the veil cast over the eyes by the shadow of the mantilla, an effect Goya was fond of; it recurs in *Caprichos 5* and *15* and in two of the finest figures in San Antonio de la Florida (Bibl. 117, pl. 73 and 79).

A.i [9] p. 29

"Young woman in back view with arms uplifted" – 1796-97 – 171 × 100 – I – No. add. 185 (Lp) and 4 (heavy Lp) – *Paper*: vertical chain lines (25 mm) – *Hist.*: Javier Goya; Mariano Goya; Román Garreta; → Museo de la Trinidad, 5.4.1866 – Madrid, Prado (427) – GW 364

Another young woman in an intimate scene. Clad only in a light chemise and seen from behind, she raises her arms as if welcoming someone; or perhaps she is simply expressing her joy at the beginning of a fine day. Sturdily planted on both legs, but with the weight thrown slightly to one side, the body has a youthful

grace skilfully conveyed by a few spirited brushstrokes which bring out essentials. Note the dark area of the parapet or balcony, setting off against the white sheet the first of those rectangular backgrounds which Goya was to employ so often in the Madrid album (cf. B.28, B.31, B.33, B.34, B.36, etc.).

A.j [10] p. 30

"Young woman pulling up her stocking" – *Cap. 17* – 1796-97 – Verso of A.i – I – *Paper:* traces of pink paper – Madrid, Prado (467) – GW 365

A famous theme taken up again in *Capricho 17, Bien tirada está,* but in quite a different key. There is no chiaroscuro effect here: Goya makes the most of the white sheet and volumes are simply suggested by a few lines laid in with the tip of the brush dipped in a very light wash. Of the drawings in this album, this is certainly the one whose technique comes closest to that of the drawings after Flaxman, a series now known to have been done about 1795 (Bibl. 161, p. 36). This sheet, marked 185, was acquired like the previous one in 1866 by the Museo de la Trinidad.

A.k [11] p. 31

"Two young women naked on a bed" – 1796-97 – 172 × 101 – I – *Paper:* vertical chain lines (24-25 mm) – Traces of pink paper? – *Hist.:* Javier Goya; Mariano Goya; V. Carderera; F. de Madrazo; Rome, Clementi-Vannutelli (bought about 1875) – Formerly Rome, Clementi coll. – GW 366

This drawing and the next two form a set, to which may be added A.g, representing two young women lightly clad or, as here, in the nude, on a bed. Is it the same pair of women in each drawing? Who can they be? These questions are unanswerable. One may, however, say this: in view of these drawings and the copy of a nude published not long ago by de Salas (Bibl. 161), it might be worthwhile reconsidering the problem of the two *majas* in the Prado and – while admitting that they can hardly represent the Duchess of Alba – to connect them with that period of violent passion which Goya experienced around the age of fifty with the Cayetana. The bed on which the two *majas* lie might well be the very bed represented in the Sanlúcar drawings; and these would then be the starting point of the two celebrated canvases in the Prado.

A.l [12] p. 32

"Two old women tending a girl on a bed" – 1796-97

– Verso of A.k – I – Formerly Rome, Clementi coll. – GW 367

This scene actually includes four figures: the girl sitting up on the bed, the two old *Celestinas* bustling round her, and on the right, lying in the opposite direction, another young woman, it would seem, whose head, right shoulder and right leg alone are visible. López-Rey has put forward a possible interpretation of this scene (Bibl. 127, p. 20), but one could suggest others equally plausible. Here, even more than in the other drawings of this series of nudes, one is struck by several details approximating closely to the *majas*: the young woman's coiffure with a bow at the top; her breasts, "firm and divergent", as de Salas has put it; and the large pillows with broad flounces.

A.m [13] p. 33

"Young woman arranging her hair beside another woman lying on a bed" – 1796-97 – 172 × 101 – I – *Paper:* vertical chain lines (26 mm) – *Watermark:* fragment of letters – *Hist.:* Bordeaux, Hyades; Ps. Jules Boilly, Paris, H.D. 19-20.3.1869, No. 48 → Leurceau (450 fr. for entire album); A. Strolin – Paris, priv. coll. – GW 368

The perspective of the bed is that of drawing A.g in the Prado, but reversed from left to right. Here again are two young women, doubtless the same pair, one reclining as before, the other now dressed and doing her hair, leaning over her companion who looks up at her. As in the best drawings in the album, the play of the brush is admirably light and sure. There is nothing here of the sketch dashed off from life: the design was carefully worked out and a few traces of lines to the right of the main figure seem to indicate a change of plan in the composition.

A.n [14] p. 34

"Young woman sweeping" → *Cap. 20* – 1796-97 – Verso of A.m – Paris, priv. coll. – GW 369

The scene is apparently situated in one of those small Andalusian taverns or *posadas*. On the wall a bull's skull, relic of some local corrida, and a caged canary, still indoors as the morning house-cleaning begins. Even the two chairs, especially the one on the left, are characteristic of the Andalusian style, and have the high back with four crosspieces and the uprights topped with a knob. Chairs of the same type reappear in sheets B.18, B.27, B.28, B.31 and B.43 – which would seem to bear out Carderera's view that this latter album, though sketched in Madrid, contains in

the first half many Andalusian scenes, memories of which were still running in the artist's head on his return to the capital. It is curious to note how, in this drawing, nearly all the volumes are massed on one side of the diagonal formed by the broom; this layout often recurs in the first half of the Madrid album (B.3, B.8, B.13, B.22, B.23, B.24, B.25, B.27, B.32, B.33, B.43).

A.o [15] p. 35
"Young woman weeping behind a carriage" – 1796-97 – 172 × 101 – I – *Paper:* vertical chain lines – *Hist.:* Bordeaux, Hyades; Ps. Jules Boilly, Paris, H.D. 19-20.3.1869, No. 48 → Leurceau (450 fr. for entire album); A. Strolin – Paris, priv. coll. – GW 370

The only sad theme among the drawings in this album. It must refer to a leave-taking and perhaps we should see an allusion to this drawing in the quotation from C. Yriarte: "Here come the carriage and mules . . ." (Bibl. 189). Mayer, the first to publish this drawing (Bibl. 144), saw fit to stress the shortcomings of the versos. But in an album of unnumbered sheets how far is one justified in reading shortcomings into the versos as opposed to the rectos? The ingenious hypothesis put forward by de Salas thus seems untenable (Bibl. 161, p. 39 ff.), the more so as the three sketches recently acquired by the Prado are undoubtedly copies.

A.p [16] p. 36
"*Majas* sitting on the *paseo*" → *Cap. 15* – 1796-97 – Verso of A.o – Paris, priv. coll. – GW 371

". . . In the last leaves of the first book [Sanlúcar album], appears the charming group of a lady on the promenade beside an old woman who is trying to entice her and whom he used again in this plate No. 15 of the *Caprichos* (*Fine Advice*)" (Carderera).
It is difficult to recognize an old woman in the roughly delineated figure on the left of the young woman in the black dress of a *maja*. We need only compare these two sketchy figures with the drawing recently acquired by the Prado (GW 482) and *Capricho 15*, which represents its end-result, to measure the gulf separating them from every point of view.

A.q [17] p. 37
"The Duchess of Alba with her hand raised" – 1796-97 – 171 × 88 – I – *Paper:* horizontal chain lines – *Hist.:* F. Koenigs; van Beuningen – Rotterdam, Boymans-van Beuningen Museum (S.2) – GW 372

"Sometimes she [the Duchess of Alba] is standing, draped in a shawl, and raises her arm to give an order" (Carderera).
First published in 1953 (Bibl. 93), this drawing exactly fits the description given by Carderera, but there are shortcomings in the execution, particularly in the face. This said, the strongest argument against its authenticity lies in the quality of the paper, which is thinner and, above all, is laid vertically with horizontal chain lines, unlike every other sheet in the album. One possible explanation is that this drawing might have been done at the end – or the beginning – of the album on the end-paper which, as is generally the case, would have been a paper of different quality.

A.r [18] p. 38
"Group of shepherds (?)" – 1796-97 – Verso of A.q – I – No. add. 3 (Lp) – Mark F.K. (Koenigs) – Rotterdam, Boymans-van Beuningen Museum (S.2) – GW 373

This mediocre drawing seems to represent a group of three shepherds taking refreshment. The roughly sketched figure in the middle distance on the right holds a water-bottle in his hand, while the left-hand figure, also in the middle distance, leans back and pours the liquid down his throat without touching the bottle. The clothes are laid in with clumsy strokes of the brush, as is the dark mass of the hillock or embankment on which the shepherds are sitting.

A, copy a [19] p. 39
"The Duchess of Alba writing" – 194 × 127 – I – "Goya San Lúcar" (I) – Madrid, Fund. Lázaro (M.I-10, 619) – GW 374

"Sometimes she is writing, in stylish morning dress, her long dark hair falling over her shoulders" (Carderera).

A, copy b [20] p. 39
"Standing nude woman" – 201 × 115 – I – "Copia de [partially obliterated] Goya del 1.er libro quando fué a S. Lúcar con la duquesa de Alba" (Lp) – Copy of Goya from the 1st book when he was at S. Lúcar with the Duchess of Alba. – Madrid, Prado (485) – GW 375

A, copy c [21] p. 39
"Young woman fainting in an officer's arms" – 200 × 107 – I – "Goya/del 1.er libro de Goya con la de Alba" (Lp) – Goya/from Goya's 1st book with the de Alba. – Madrid, Prado 487 – GW 376

"Further on, the swooning duchess is supported by a general officer" (Carderera).

Madrid Album (B)

Introduction

Like the Sanlúcar album, this one was mentioned for the first time by Carderera in his essay of 1860 (Bibl. 84). He saw a close link between the two series of drawings: "In my opinion, it was this whole suite of drawings devoted to the duchess, and the last leaves of the same book filled with scenes sketched in Andalusia, that gave him the idea of continuing with this type of studies on his return. He did another collection in Madrid, drawing either from nature or from memory, which I think more likely . . .". This is certainly very close to the truth, and López-Rey (Bibl. 127, pp. 8-11) based on Carderera's text his suggestion that the title should be "Madrid album" rather than "Large Sanlúcar album", as Sánchez Cantón had called it in 1928 (Bibl. 164). On the other hand, Carderera was not absolutely sure of his stance, for he added a little further on: "It is not known whether this second suite was begun in Madrid...". This prudent aside had the same cause as the hesitation of many of Goya's biographers, namely the presence at the beginning of the Madrid album of scenes that still found their inspiration in Andalusia. We must, therefore consider two hypotheses. Either these drawings were done on the spot and consequently Goya began the album at Sanlúcar, or more likely at Cadiz during the winter of 1796-97; or else he worked entirely from memory and, back in Madrid, started on this new collection in his studio. Carderera apparently tends towards this second hypothesis, and López-Rey goes along with him. E. du Gué Trapier (Bibl. 184, p. 12), on the other hand, holds out for the first and speaks of the "Sanlúcar-Madrid album." E. Sayre (Bibl. 177, p. 22, note 21) rejects this unwieldy title while at the same time considering it more correct.

In view of the very sparse documentary evidence, one may well waver between the two hypotheses. But, in my opinion, if one prefers the first, the accent should be placed on Cadiz rather than Sanlúcar. I find it rather improbable that, when Goya was living with the duchess on her estate of El Rocío, he should suddenly have started work on this new album. In fact, this would imply a thoughtfulness and a care for composition of which there is no trace in the little sketchbook, so well suited for making rapid jottings during a period when his senses left him neither the time nor the place for technical speculations. On the other hand, Moratín's diary (Bibl. 147, pp. 174-175) tells us that Goya's stay at Cadiz was much lengthier than had been thought. Instead of lodging with his friend Sebastián Martínez, as he had done during his serious illness in 1792-93, he seems to have taken a house of his own. In fact, Moratín notes "at Goya's" with regard to each of the seven calls he paid him between December 26, 1796, and January 8, 1797. What is more, the only limit to Moratín's meetings with Goya and Martínez was the length of his own stay at Cadiz (from December 22 to January 11). Goya may well have settled there since the previous September, when his friend, the sculptor Aralí (cf. introduction to album A), wrote that he was sick; and his ill health was confirmed by Moratín on December 25. So there is reason to believe that it was at Cadiz that he started on the new album, where one finds a presumable allusion to that district (cf. note to B.62).

Unfortunately, we do not know exactly when Goya returned to Madrid. It was probably between January 24, 1797, and April 1, the date of his letter of resignation as Director of Painting at the Academy. Personally, I incline towards February or March, for I think it unlikely that, after staying with the duchess at Sanlúcar in 1796, Goya went back there again before returning to Madrid. It might be objected that the famous

portrait in black belonging to the Hispanic Society (GW p. 115) was painted in 1797. But, though the date cannot be questioned, there is no proof that it was done in Andalusia. In view of its size and of the somewhat commemorative tone of the inscriptions, it would be more logical to see it as executed in Madrid, after the painter's return there, with the help of the sketch A.h for the duchess and the drawing B.32 for the background, as noted by E. du Gué Trapier (Bibl. 183, p. 2 ff).

In conclusion, one might say that what I shall for practical reasons continue to call the Madrid album contains, in effect, a certain number of scenes still inspired by Andalusia (approximately the first half of the volume) but done either at Cadiz or, like the rest of the drawings, at Madrid. But I would insist that by selecting a far larger format and marking the leaves from the very beginning with serial numbers on both recto and verso, Goya indicated his intention of composing a "suite" of subjects all done with brush and Indian ink. The first section reveals the same source of inspiration as the sketches of the Sanlúcar album, namely Woman; but now she is surrounded by other figures and escorted by male partners. It is as if the purely descriptive impulse of the rapid sketches done at Sanlúcar was now replaced by a will to recreate the microcosm of the Andalusian *fiestas* that he had seen live before his eyes at Cadiz, with the light-hearted intrigues that sometimes ended in tragedy (e.g. B.35). At the same time the composition of the drawings underwent a radical change in the sense of a growing complexity. As the number of his figures increased, Goya thrust one or two into the foreground, distributing the others in several secondary planes; in this way he achieved an effect of depth and airiness and a play of light and shade.

Within the limits of this first section of the album, the composition of the drawings underwent a rapid change not only as regards the arrangement of the figures but also through the introduction of backgrounds that denote a first attempt to obtain an effect of chiaroscuro, which is extremely difficult on the pure white of the paper. Besides the lightly sketched, sometimes wooded, landscapes used as a background in some of the drawings (e.g. B.4, B.8, B.13, B.24 and B.32), we find the first, often awkward, attempts at backgrounds partially or entirely covered with wash. A harbinger of this is the tent (or canopy) in B.26, still a realistic setting that permits of strong contrasts of light and shade. But it is in B.28 (Group of *majas* on the *paseo*) that we find the most striking example of a rectangular wash background, against which the figures stand out in strong relief. Many other – later – drawings in this album display the same procedure, which foreshadows the areas of aquatint of the *Caprichos* (B.31, B.33, B.34, B.36 etc.).

But the most notable change – I would even call it a caesura – in the Madrid album appears when we reach sheet B.55/56. This does not mean that it did not occur earlier, perhaps in one of the two leaves (B.51/52 and B.53/54) that have disappeared. Of a sudden, new subjects crop up in this world of intrigue and flirtation: masks, witches, caricatures (B.55, B.56, B.57, B.58 etc.). Youth and grace give way to ugly or ludicrous grimaces and – a great novelty in Goya's *œuvre* – witchcraft (B.56 and B.57). In addition to their caricatural aspect, the characters present an obvious connection with Lavater's famous physiognomical studies, which were greatly admired throughout Europe at that time (cf. in this context López-Rey, Bibl. 127, pp. 57-72). If we add the rest of the collection, where the moralizing tone is often striking (B.68, B.70, B.75, B.76 etc.), we realize that it is quite a different Goya who displays his ideas before our eyes. The metamorphosis did not occur of itself. It should apparently be ascribed to the circle in which the artist moved on his return to Madrid. Profoundly altered by the physical sufferings he had experienced during the last four years and also by the bitter aftermath of his great love affair at Sanlúcar, Goya was still more inclined than before to the moral and political speculations of his *ilustrados* friends, Jovellanos, Bernardo de Iriarte, Ceán Bermúdez, the poet Meléndez Valdés, the priest Juan Antonio Melbón, the young lawyer González Arnao, and in particular Moratín, who were on the point of acceding to power at last. On his return to Madrid on February 5, 1797, Moratín started to annotate the "Report on the famous *auto-da-fé* at Logroño in 1610," a real treatise on practical witchcraft that he wanted to re-publish and was glad to comment on in the presence of his friends (Bibl. 105, p. 111). That book and others may have supplied Goya with the source material for the two drawings, B.56 and B.57, in the Madrid album. The first renders a black mass exactly as described in the "Report."

Another great novelty that also appears from B.55 on is the introduction of the captions, that became Goya's chief offensive weapon in most of the drawings in these albums. Here, too, it is interesting to observe that his first halting steps developed into a headlong rush once the artist had found a personal style of his own. A careful examination of the first attempts at caption-writing is very revealing (B.55 to B.59? inclusive). At the start all they amount to is a single word written with the brush: *Mascaras, Brujas, Caricat.*[8] – a simple note or title. But they soon became entire phrases, such as *Parten la vieja* (B.60?); and in particular the abbreviation

Fragment of B.I *Fragment of B.II* *Fragment of B.III*

Caricat.ᵛ is expanded and explained: *Caricatᵛ/es día de su santo* (B.61), *Caricatura de las Carracas* (B.62) and *Caricatura alegre* (B.63). And as his tone grows more assured we find the pithy phrases, at once descriptive and witty, of which Goya became so fond. The sheet B.65/66 affords two perfect examples of this.

When it comes to captions completed in pen (B.55, B.56, B.57, B.58 etc.) or written entirely in pen (B.78, B.79, B.83 etc.), we may presume that they were added later by the artist himself. But the hypothesis that they were written by his son cannot be rejected out of hand, and this for two reasons: first, because those inscriptions seem to have been written with the same pen used for the numbers traced later by Javier; secondly, because in B.76 it is hard to visualize Goya himself correcting his own spelling mistake: *larg(u)eza*.

Let us now turn to one of the most important problems raised by the Madrid album, namely its relationship to the *Caprichos*. But before doing so we must establish the chronological order in which the work was done. The famous suite of eighty plates was finished and printed by January 17, 1799, for on that day Goya signed a receipt for 1,500 *reales,* the price of four sets sold to the Duchess of Osuna (Bibl. 188, p. 47). On the other hand, the caption on the preparatory drawing for plate No. 43, *El sueño de la Razón...* (The dream of Reason...), fixes 1797 as the date of this first frontispiece for the suite. Consequently, we may infer that on returning to Madrid between January 24 and April 1 of that year Goya finished the drawings in the Madrid album – or executed the entire album, if we accept the other hypothesis I have suggested – and at the same time started his preliminary studies for the *Caprichos*. We must bear in mind, however, that in spite of the bad state of his health – whether real or exaggerated in order to rid himself of the duties inherent in his position as Director of Painting – he painted a great many pictures during that period. They include some important portraits (GW 668 ff), the large *Prendimiento* (Apprehension of Jesus) for Toledo Cathedral (GW 736), a set of six pictures on witchcraft for the Osunas (GW 659-664) and in particular, between August 1 and the end of November 1798, the frescoes in San Antonio de la Florida (GW 717-735). This means that Goya's creative work on the *Caprichos* must have been concentrated in the main between spring 1797 and summer 1798. But what it is important for us to realize is that at least the second half of the Madrid album and the studies for the *Caprichos* were done within a very short time in 1797 and that, far from being independent works, they were closely related.

As a matter of fact, we know beyond the shadow of a doubt that the first form of the *Caprichos* was this series of *Sueños* (Dreams), identified thanks to the pen and sepia drawings which bear that title and often a serial number (cf. GW p. 125 ff.). There are nineteen numbered *Sueños,* beginning with the frontispiece *Sueño de la Razón* . . . and ending with No. 28, plus six other possible ones (GW 460-627). Of the sixteen drawings in the Madrid album that are related to the *Caprichos,* twelve form a sort of first state of these twenty-five *Sueños,* all of which tally with engraved plates. This is proof enough that Goya's work on the suite of prints fell into two different phases. First, in 1797, starting out from the drawings in the album, he did the suite of *Sueños* with No. 1 – subsequently Plate 43 of the *Caprichos* – as frontispiece. Later, perhaps not before 1798, he produced the definitive series of eighty plates, deliberately upsetting their order, with the famous self-portrait as frontispiece.

It is also worth noting that the autograph captions to the *Sueños* are far closer to those of the drawings in the Madrid album than to the definitive titles of the relative *Caprichos;* in the latter the words *brujas, mascaras, caricaturas* never occur. As for the key-word *Sueño,* it survives in the caption to No. 43 but in none of the titles engraved on the plates. This, in my eyes, is the first sign of the "ambivalent" art mentioned by Ortega y Gasset. Initially, in both the album drawings and the *Sueño* prints, each scene could have only one meaning, whereas in the definitive form of the *Caprichos* it is open to many different interpretations, religious, political, social, erotic or a variety of others. Launching this fantastic series of prints like a rocket, Goya would seem to be saying, with a sardonic pout: "To every man his truth." But the Inquisition saw it differently, and realized at once the danger of a work which, by its visual beauty, its author's famous name, and its capacity for multiplication, risked infecting the whole realm with the dreadful poison of "enlightenment."

TECHNICAL FEATURES

Paper: Strong, slightly bluish, laid; vertical chain lines at 25-29 mm intervals.
Watermark: Three fragments of watermark occur in this album:
 B.I – more or less important fragment of fleur-de-lis;
 B.II – fragment of shield with bend;
 B.III – illegible characters cut by edge of paper.
Maximum sheet size: 237 × 150 mm.
Drawings: On recto and verso of all known sheets.
Technique: Brush and Indian ink wash.
Captions: Brush and Indian ink wash, usually at the bottom of the drawing. Some captions begin at the top of the sheet. Additions in fine-point pen are perhaps by Goya, though they could equally well be by his son Javier.
Goya's numbers: With brush and Indian ink wash at top right-hand corner on the recto and top left-hand corner on the verso. Highest number: 94. (Catalogued: 74).
Additional numbers:
 1. *numbering by Javier Goya:* with fine-point pen, traced with great care:
 Fortuny album: at top right-hand corner, followed by period;
 Album I sold in 1877: at top right-hand corner, underscored with rounded pen and followed by period;
 Album II sold in 1877: at top centre of page followed by period, as in the Fortuny album;
 2. *more recent numbering:* with thick black crayon (after 1886), on Prado sheets only (B.7, B.20, B.27, B.31 and B.64).

BIBLIOGRAPHY

Exhibitions: 2, 4, 8, 11, 13, 14, 19, 20, 22, 26, 27.
Public sales: 34, 36, 42, 45, 46, 53, 59, 60, 61.
Authors: 69, 76, 79, 84, 91, 105, 106, 126, 127, 135, 136, 147, 164, 176, 177, 179, 183, 184, 186, 188, 189.

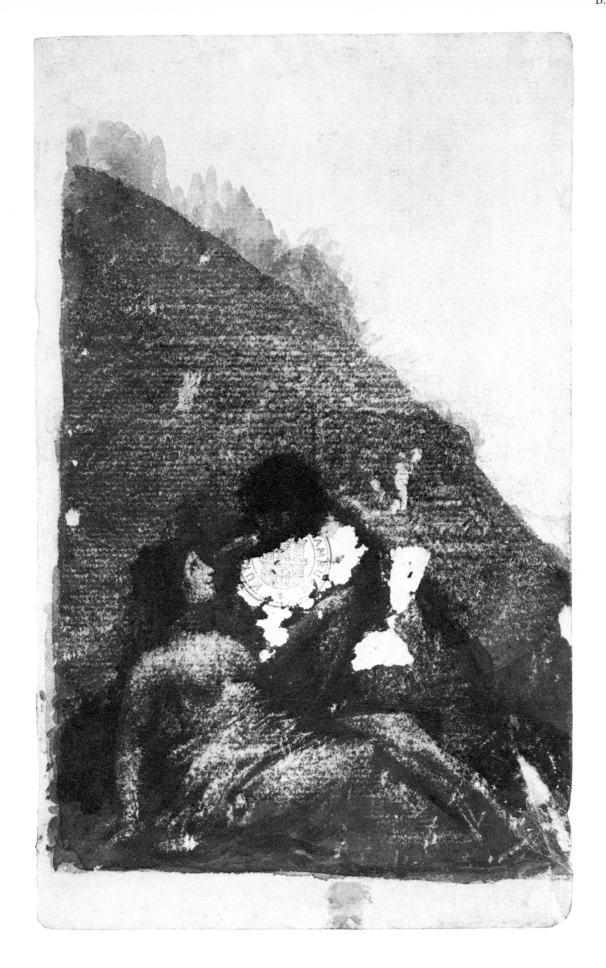

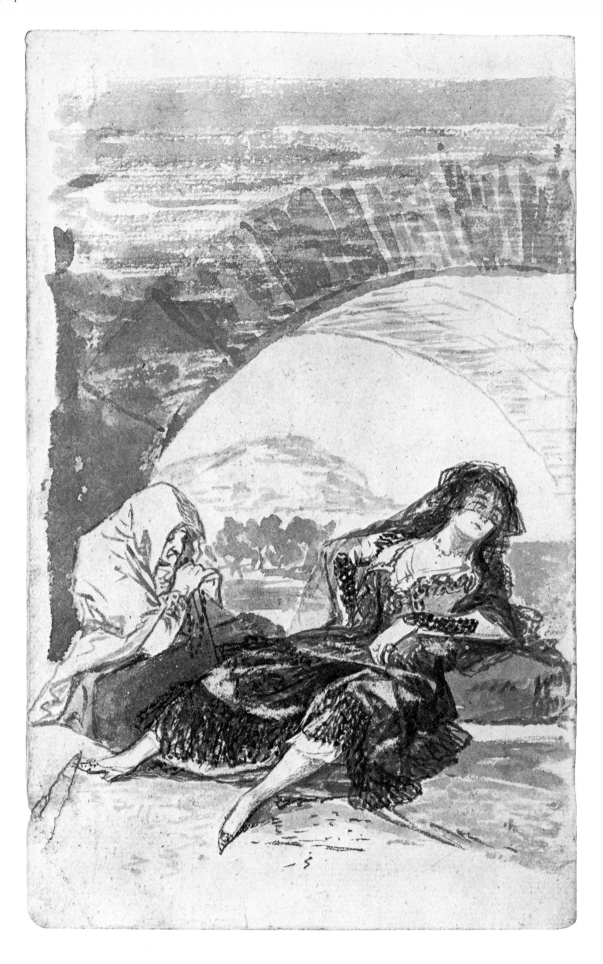

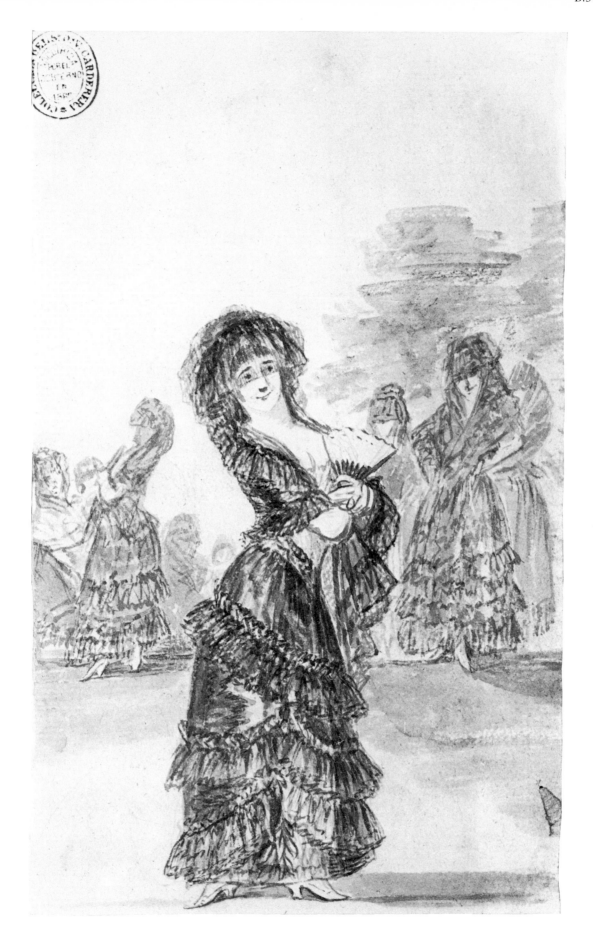

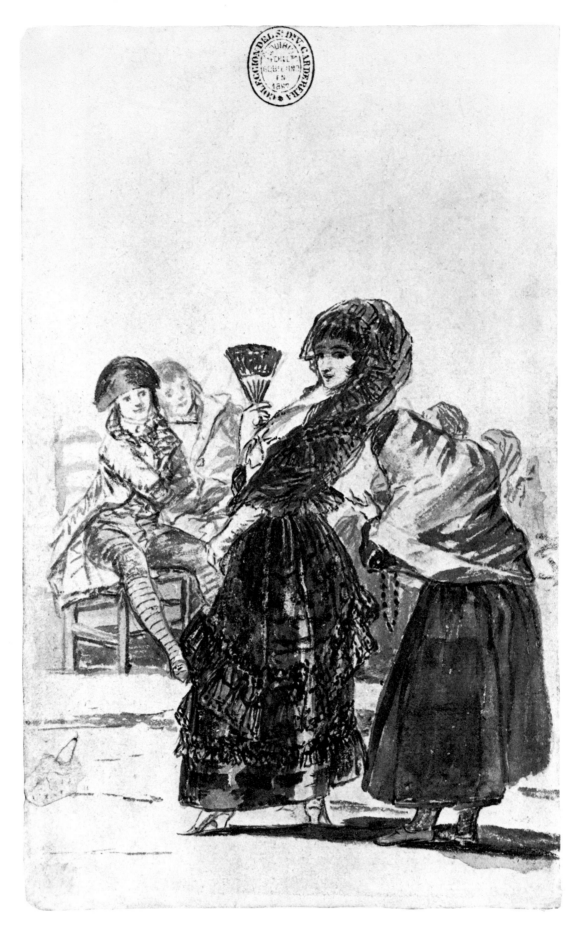

6

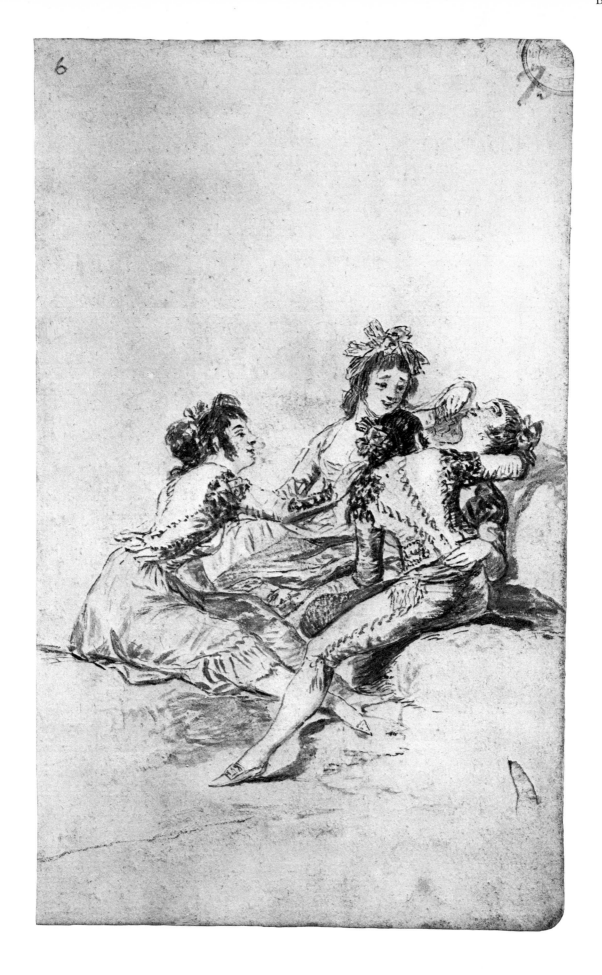

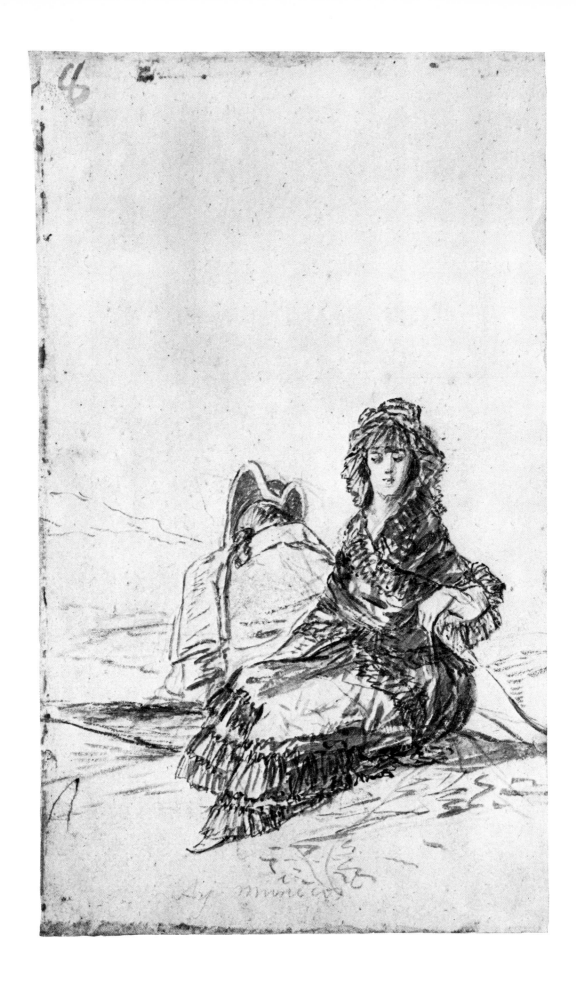

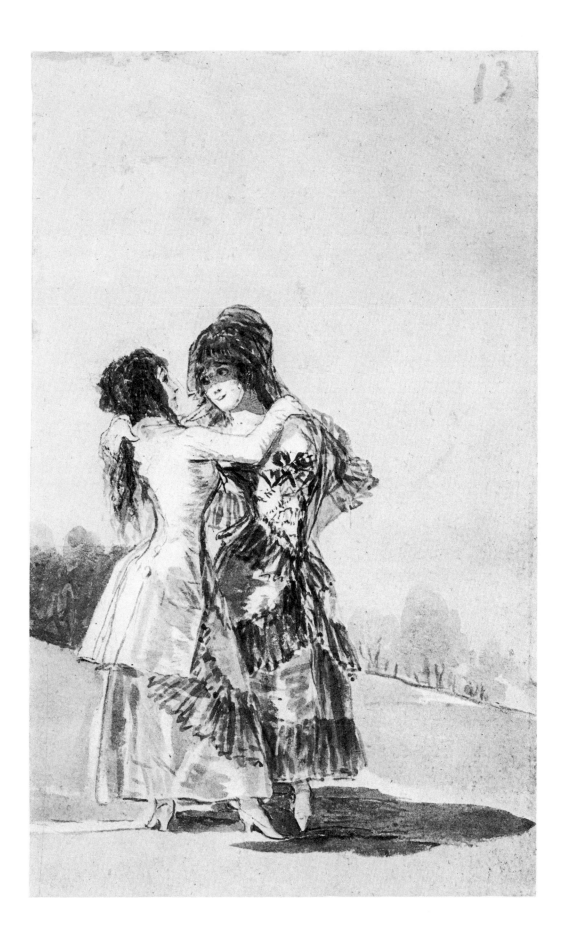

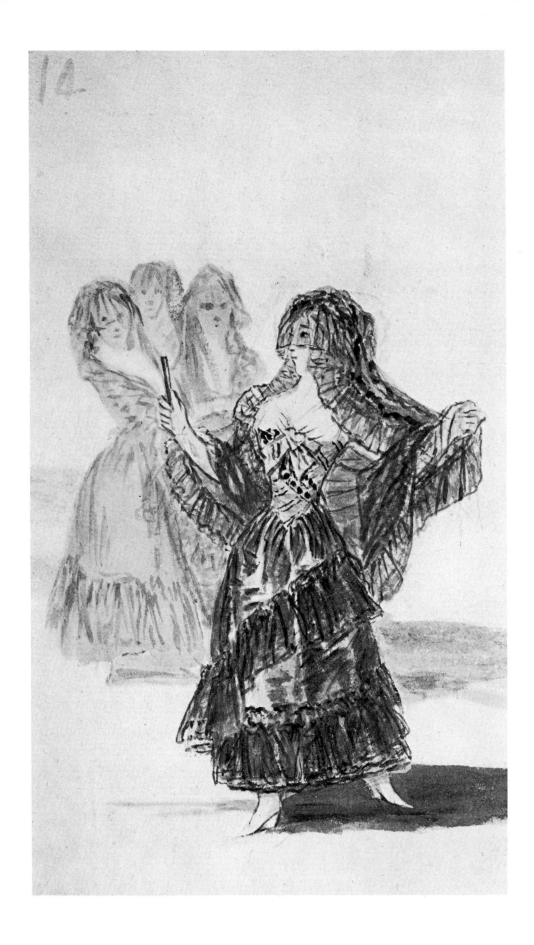

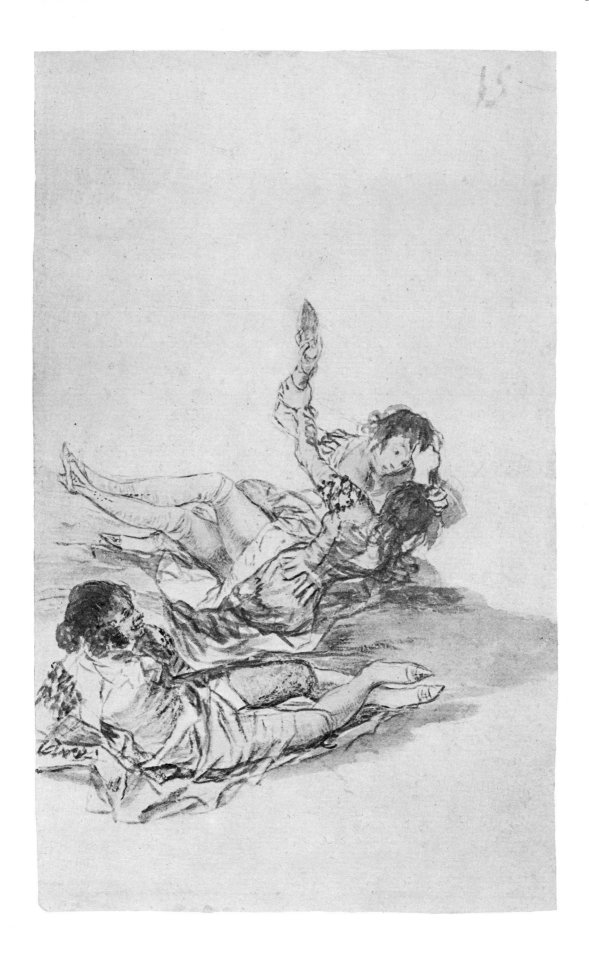

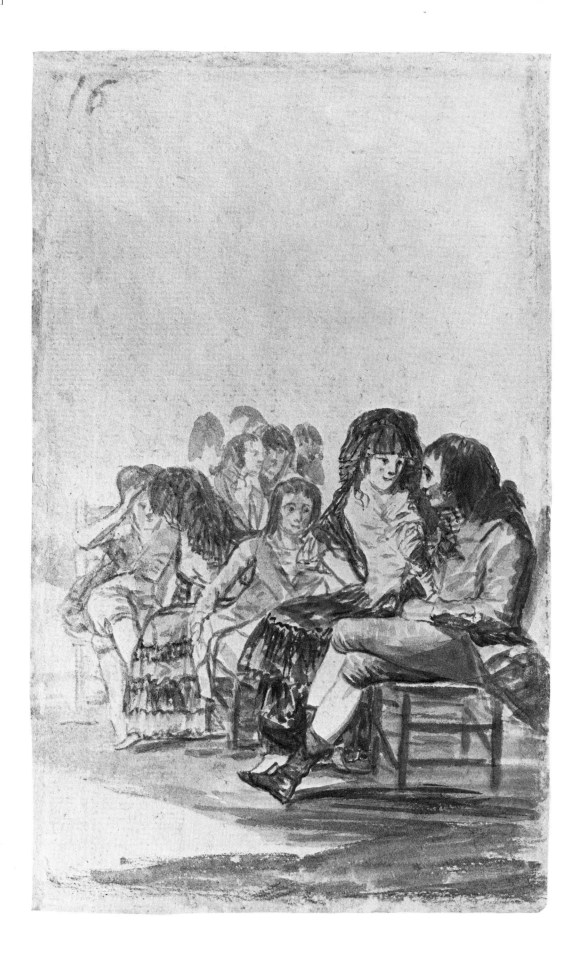

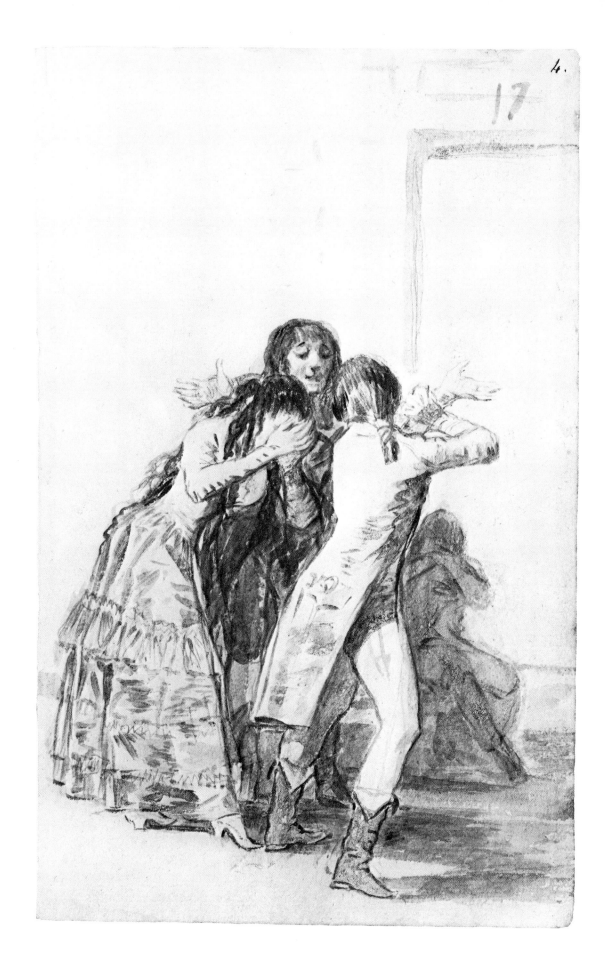

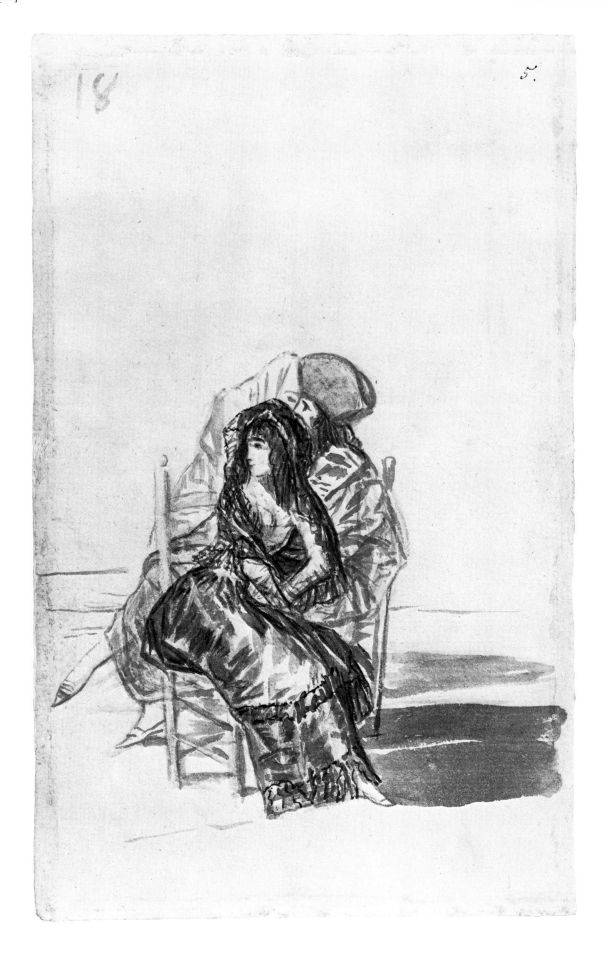

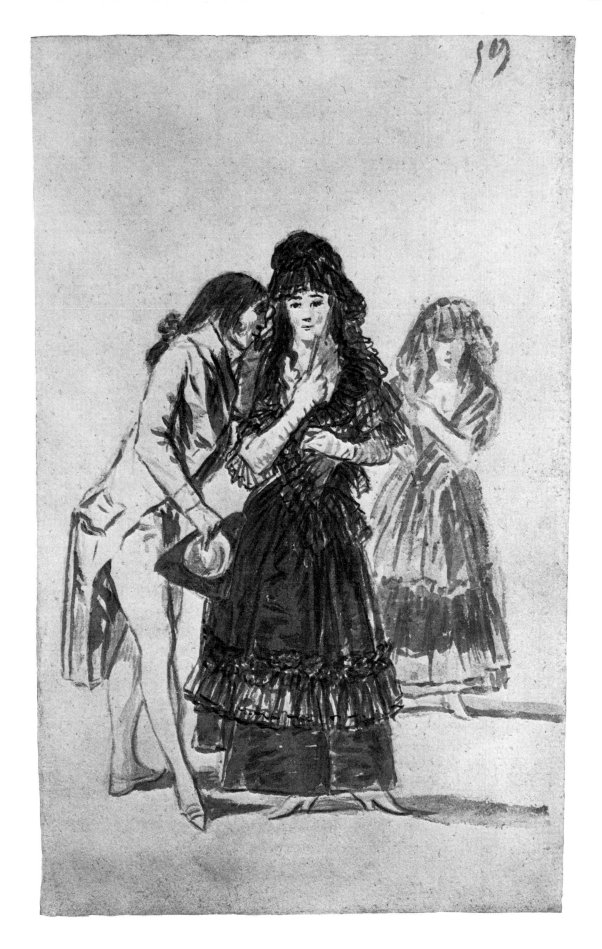

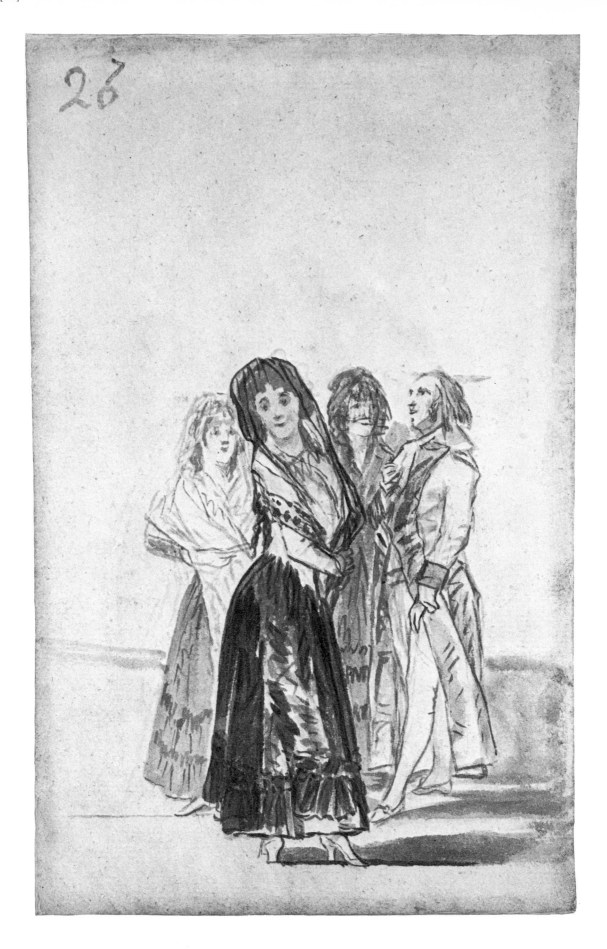

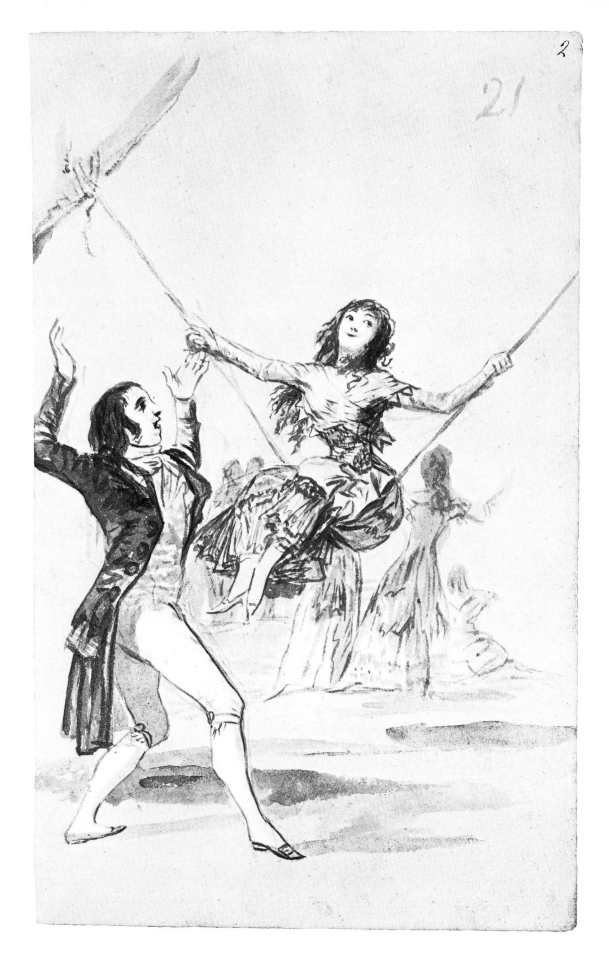

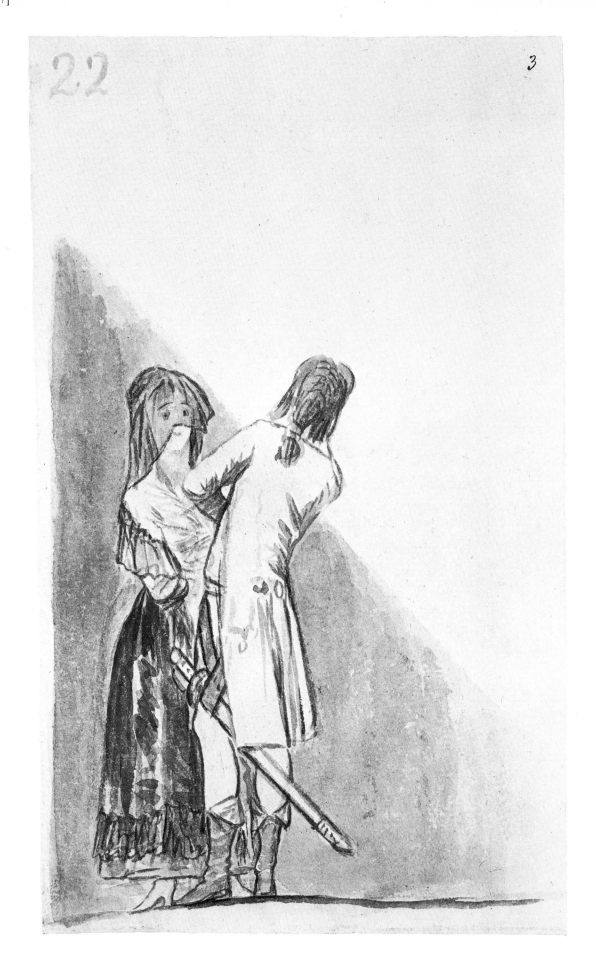

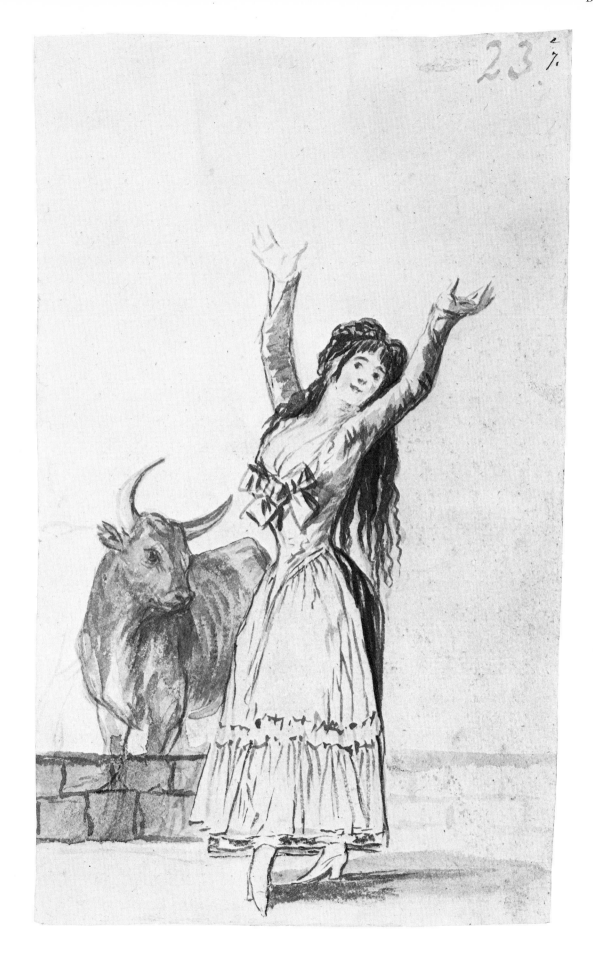

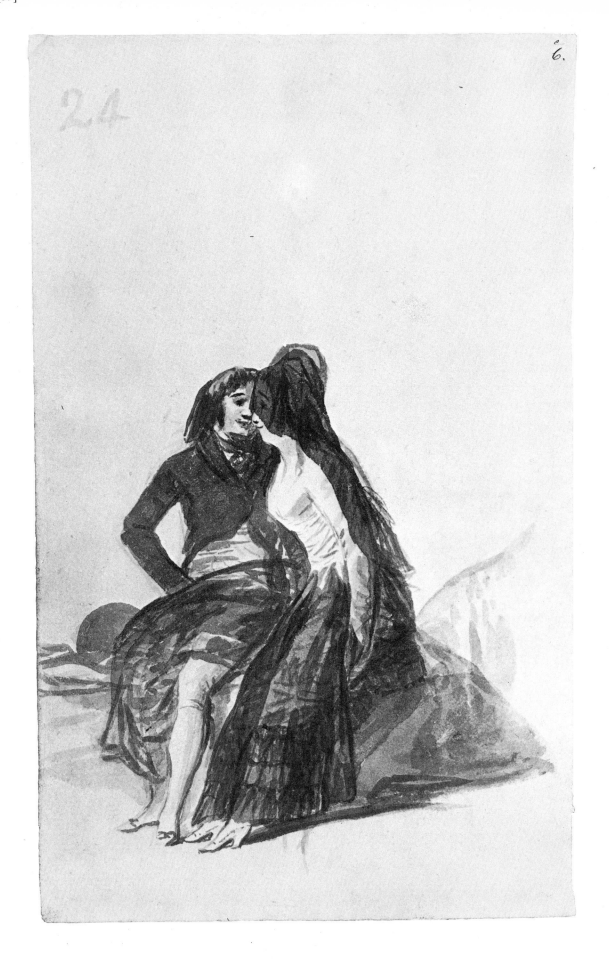

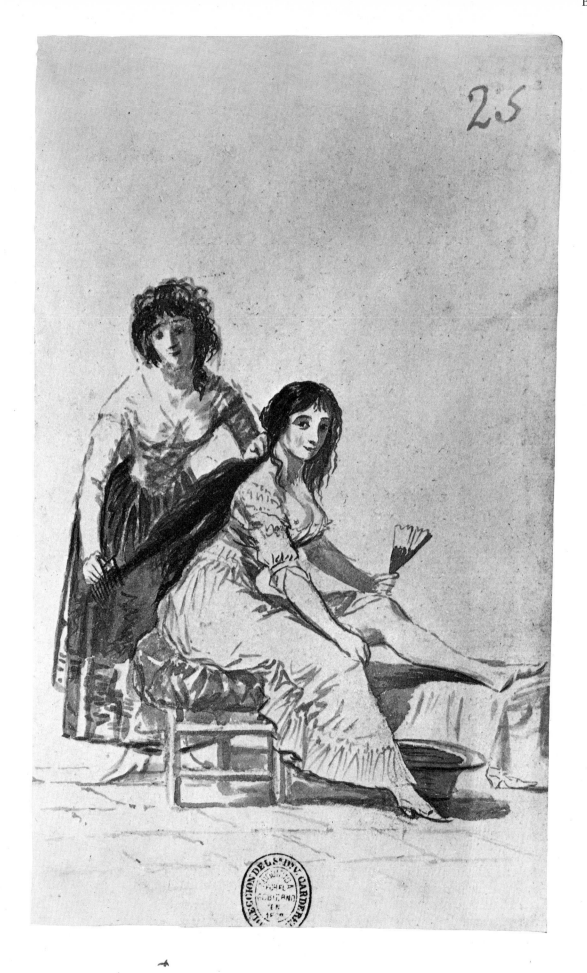

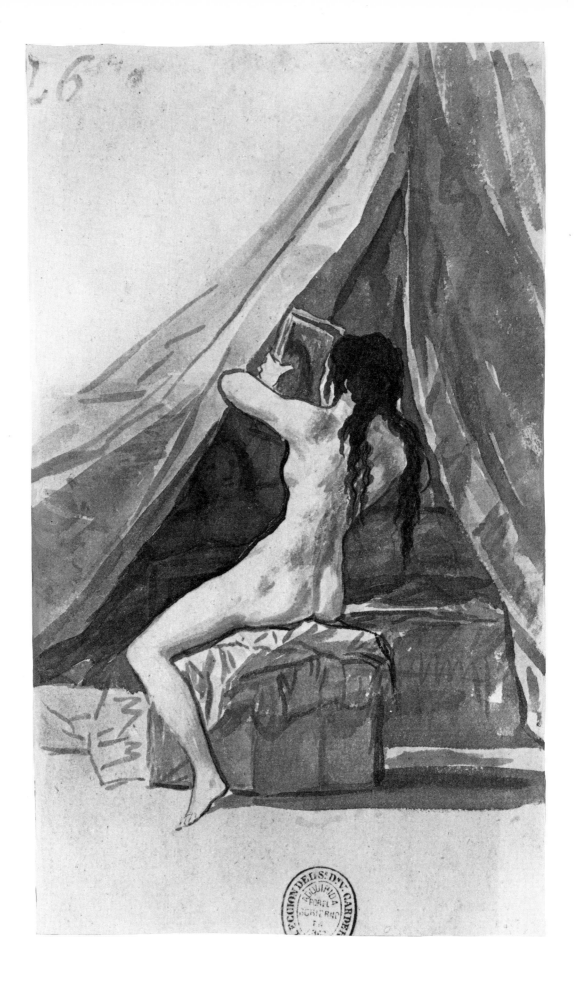

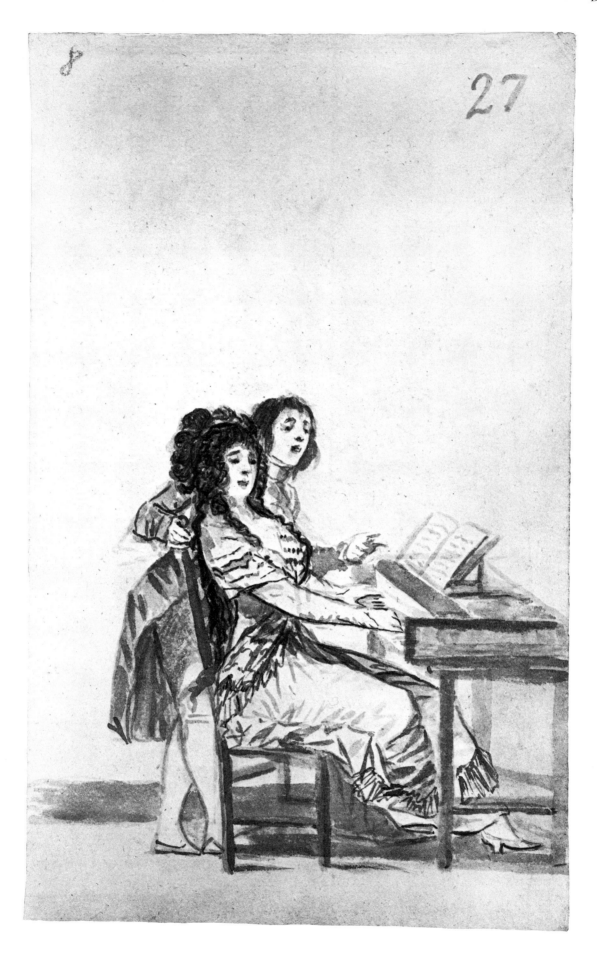

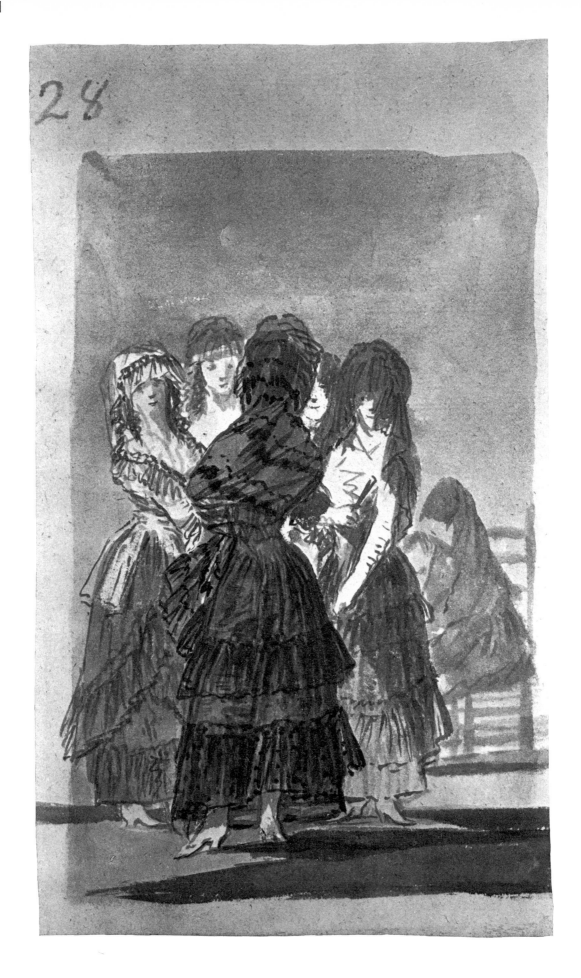

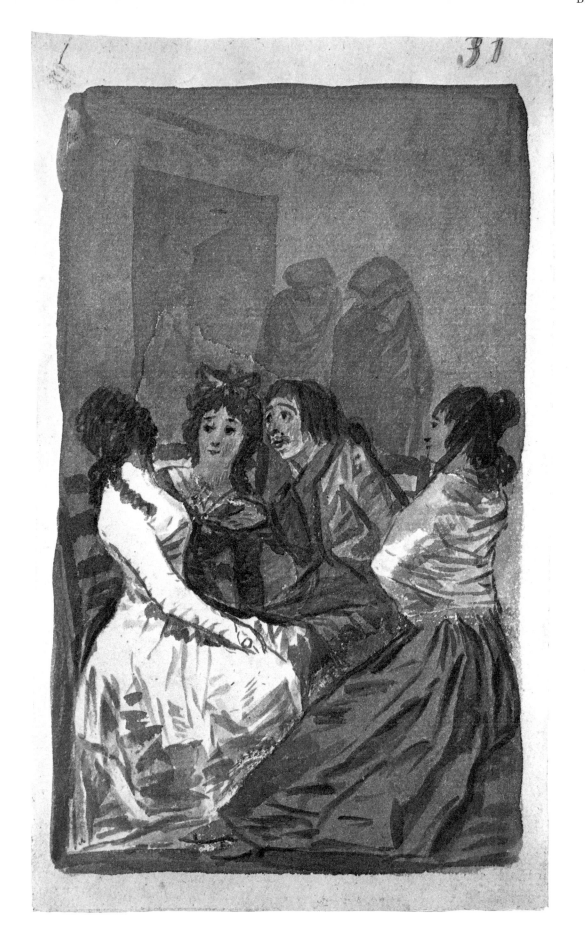

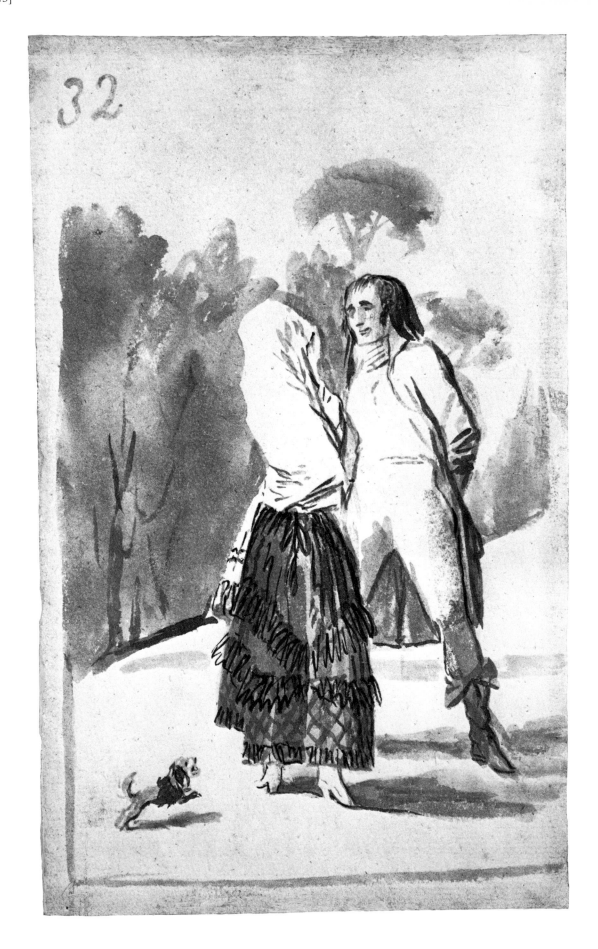

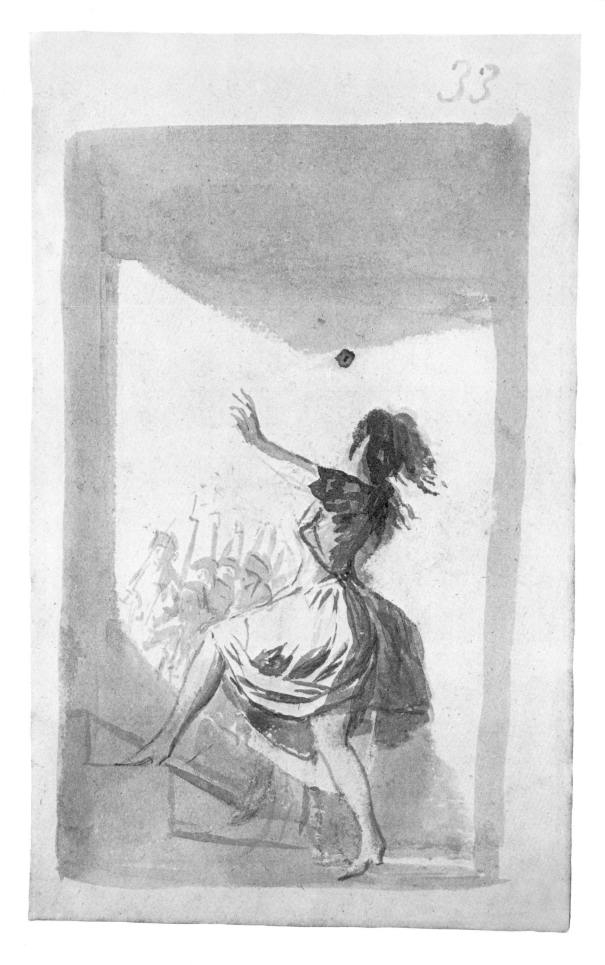

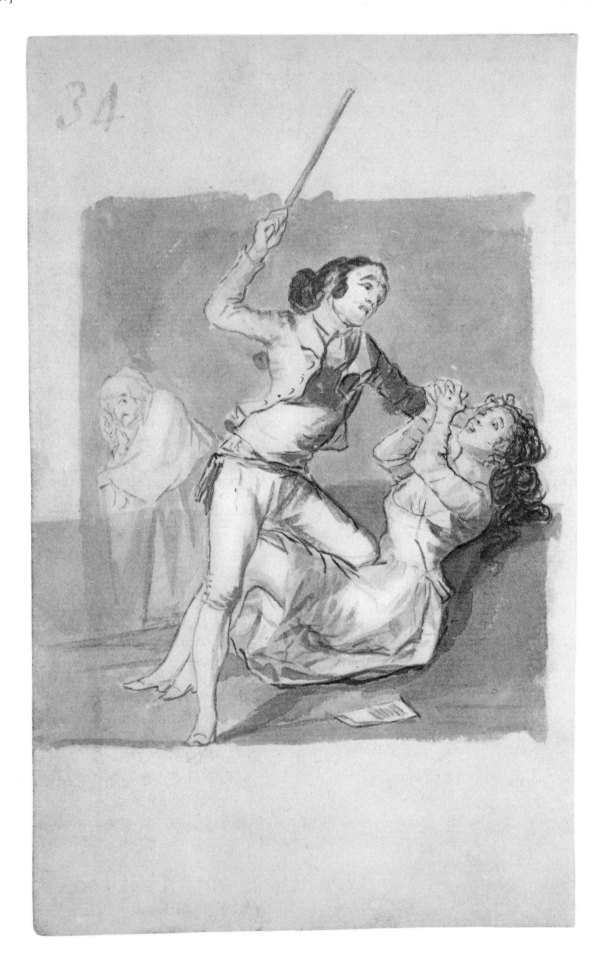

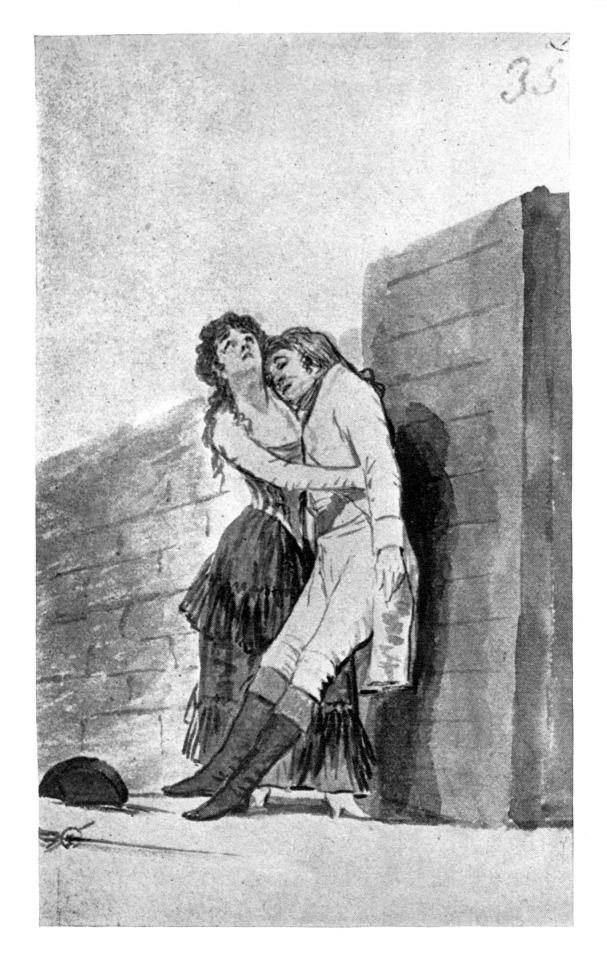

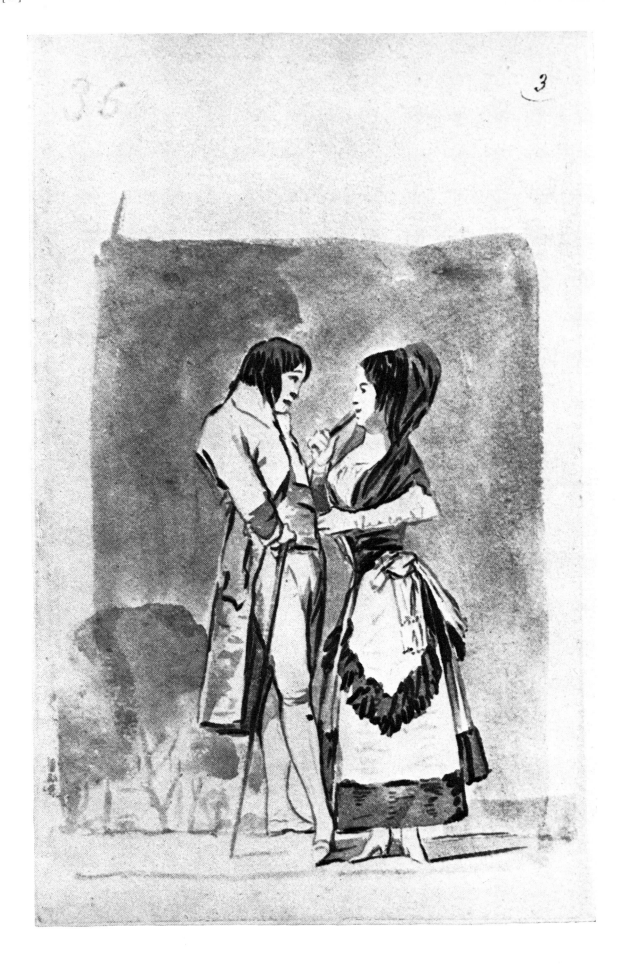

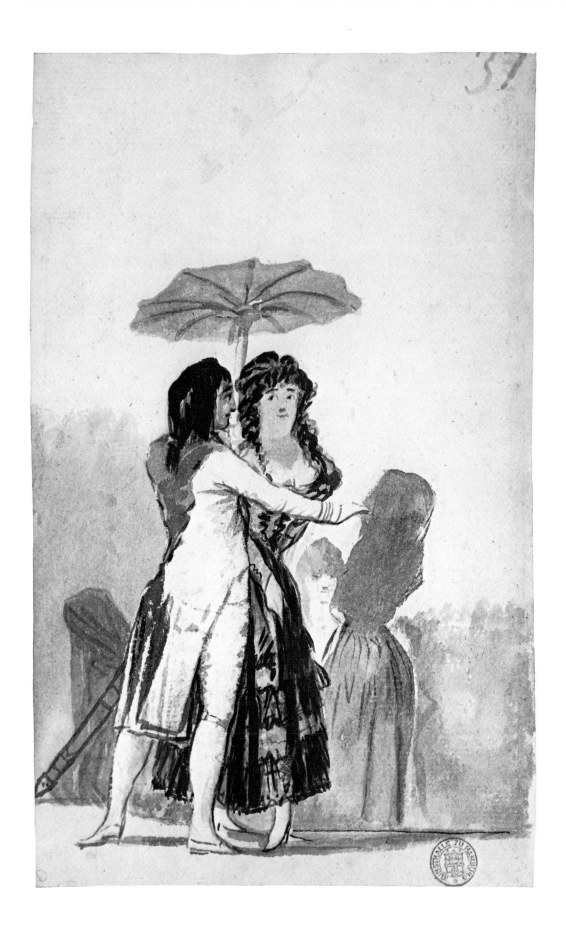

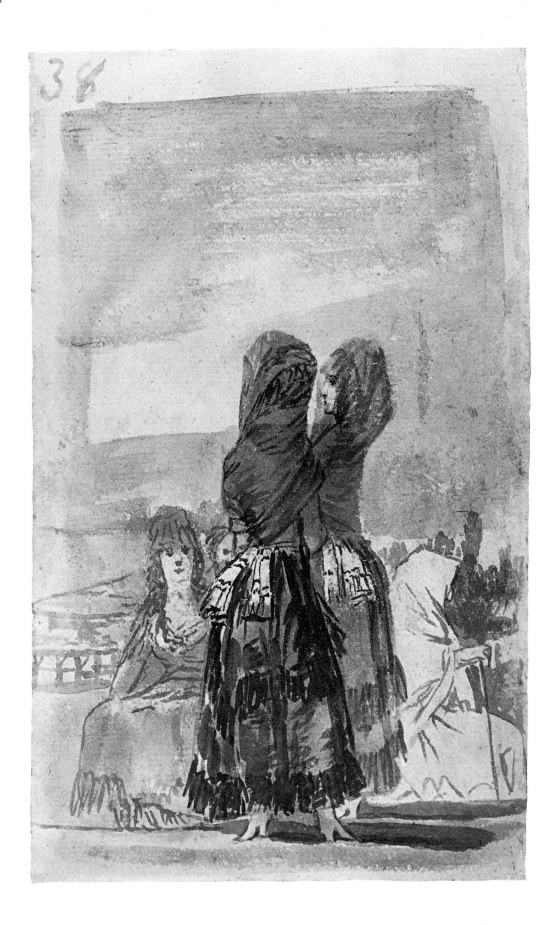

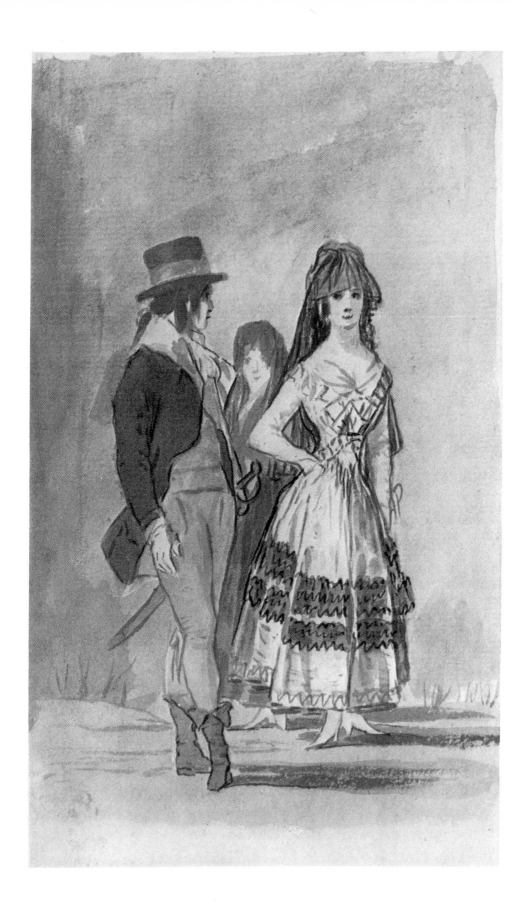

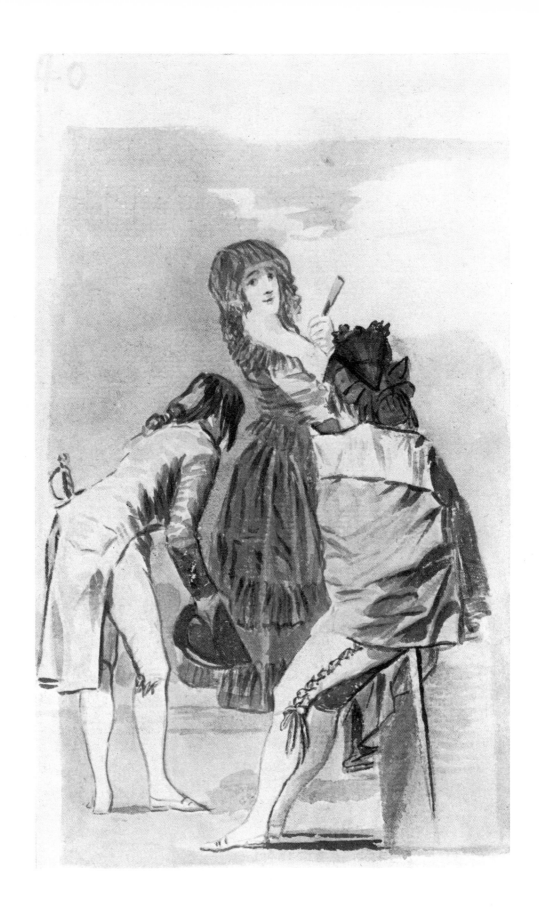

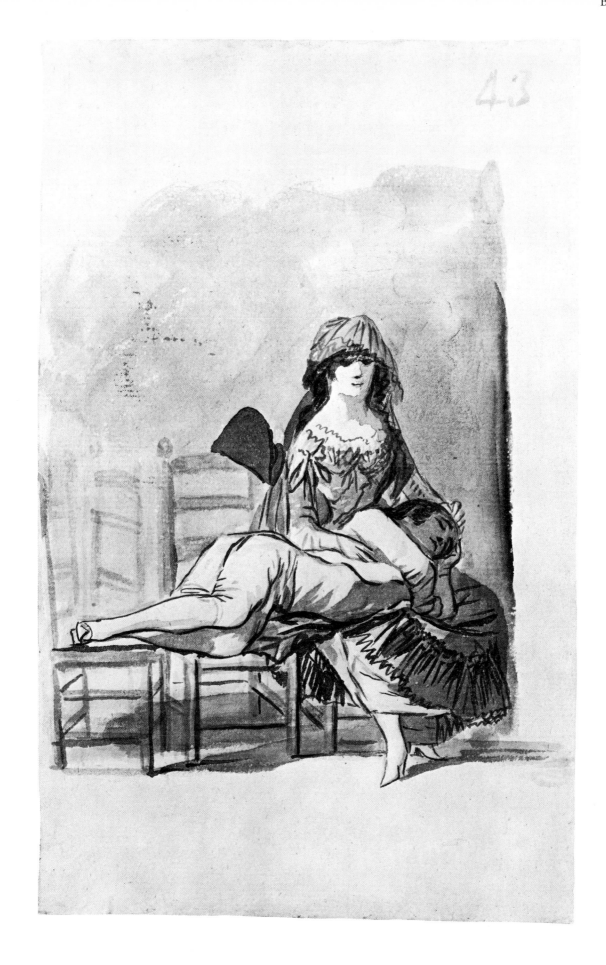

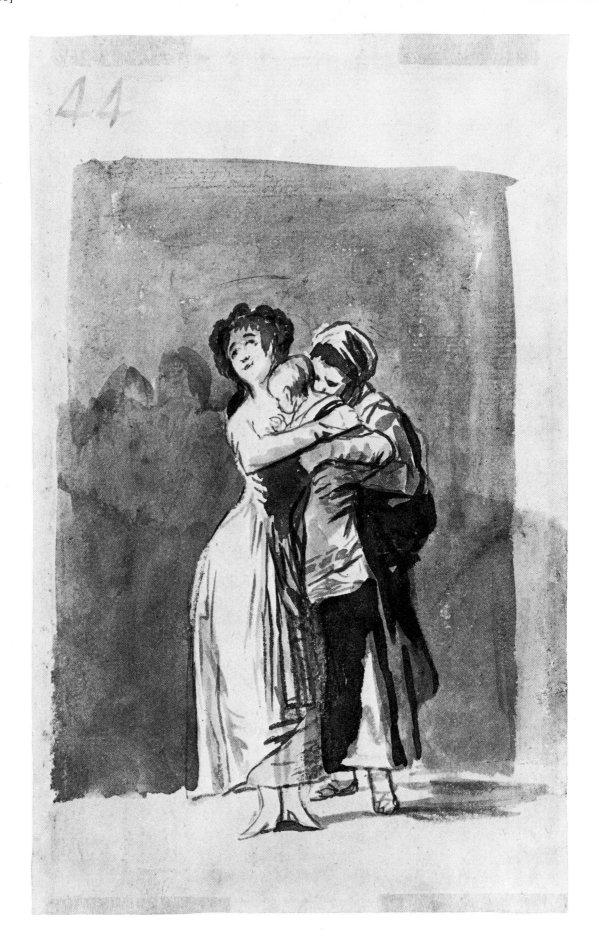

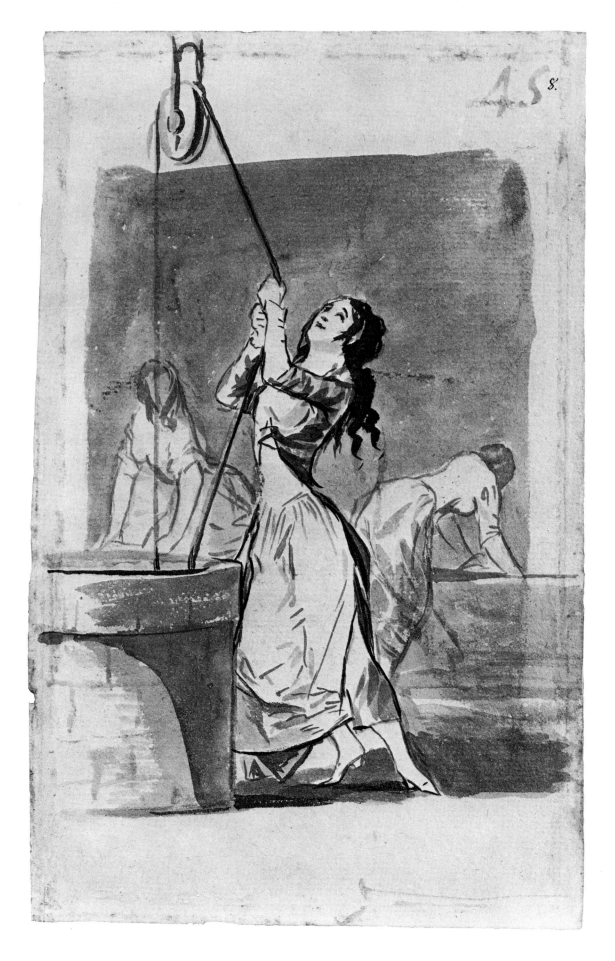

46

9.

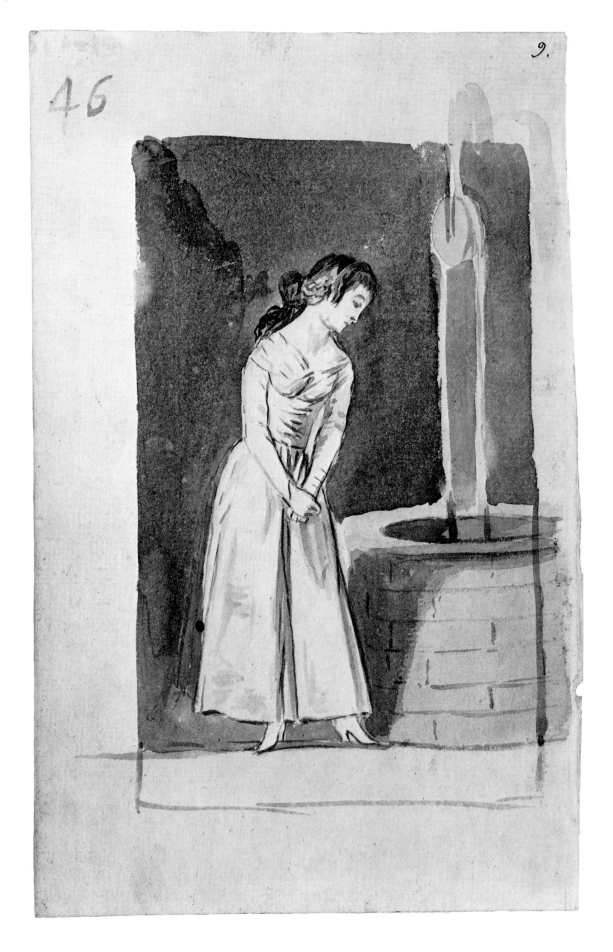

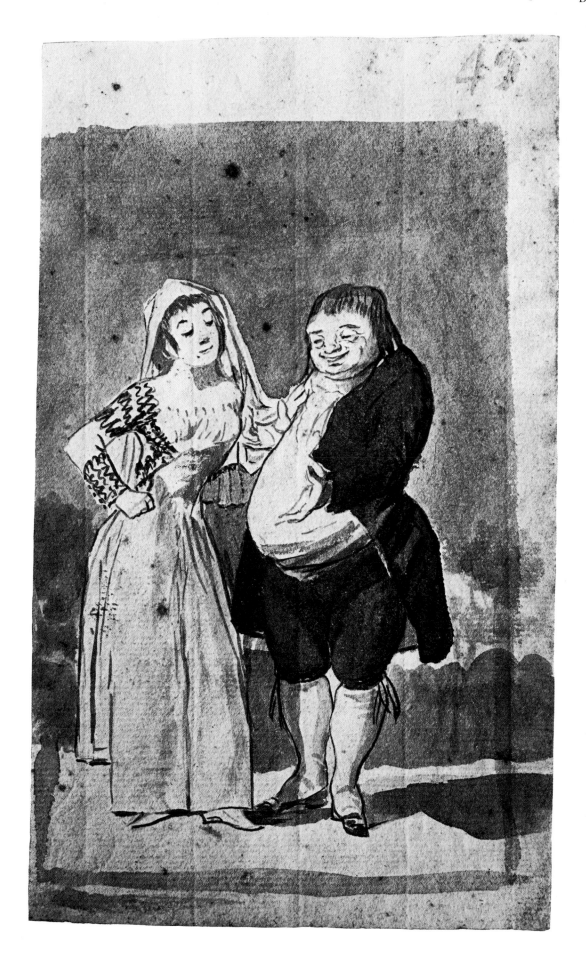

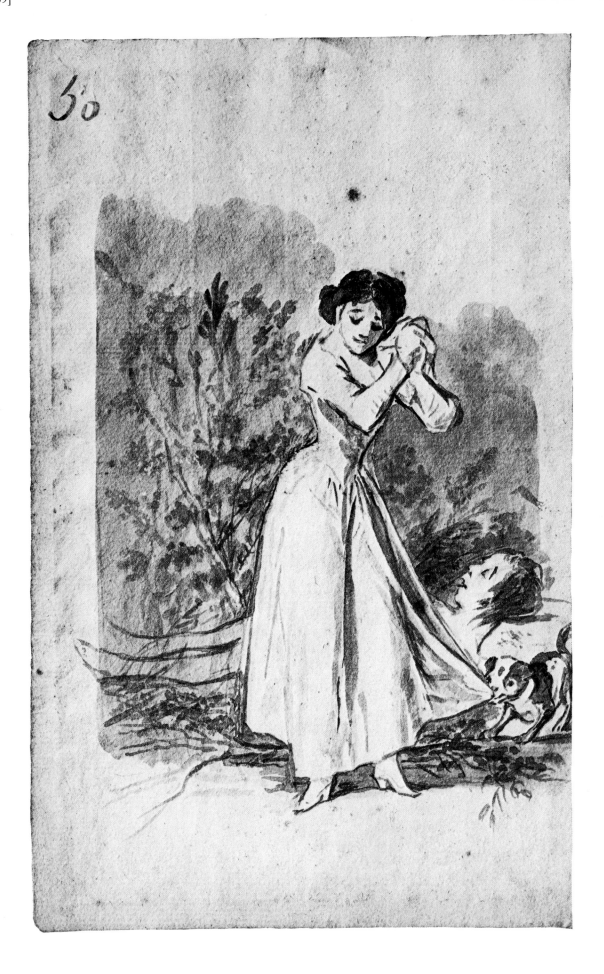

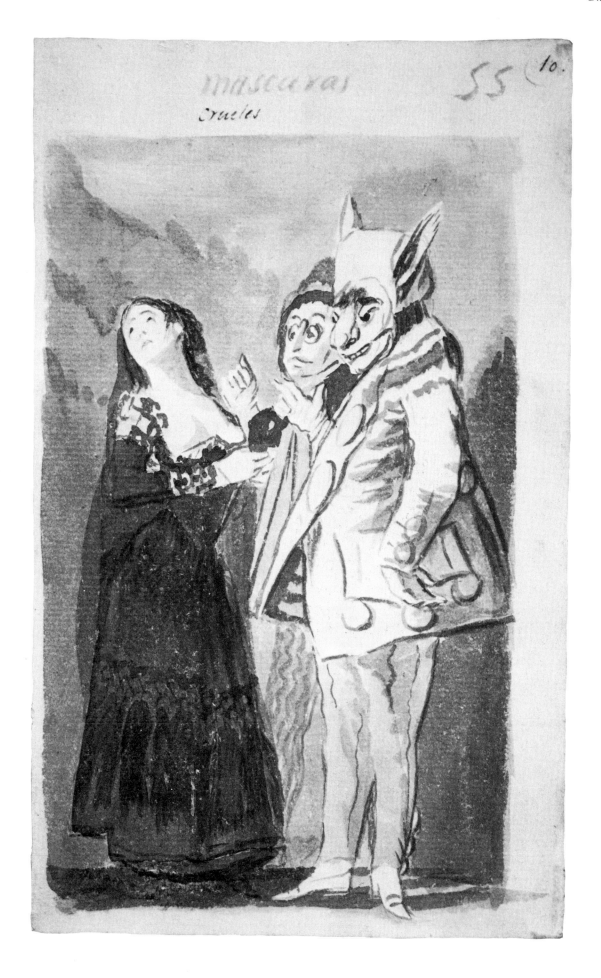

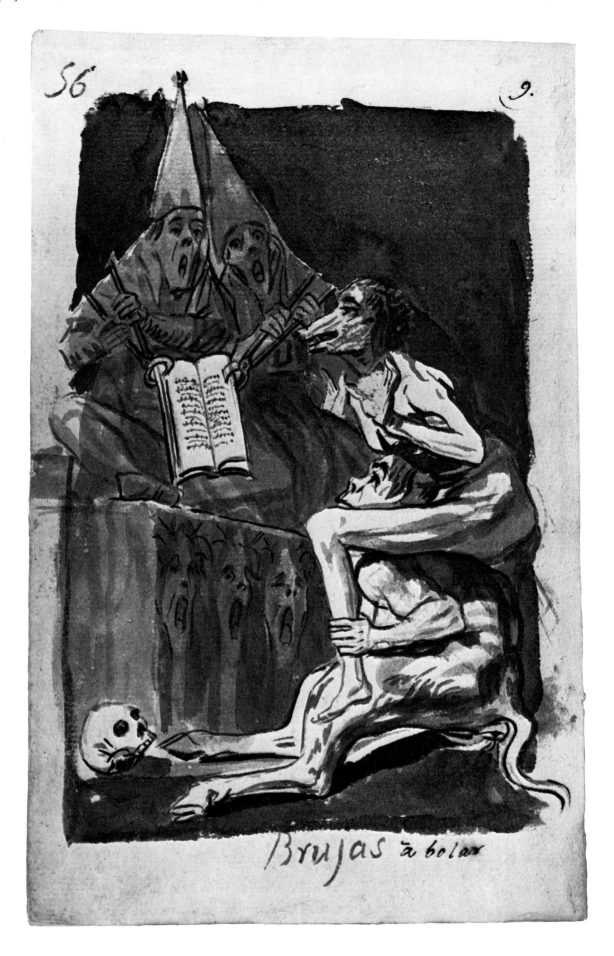

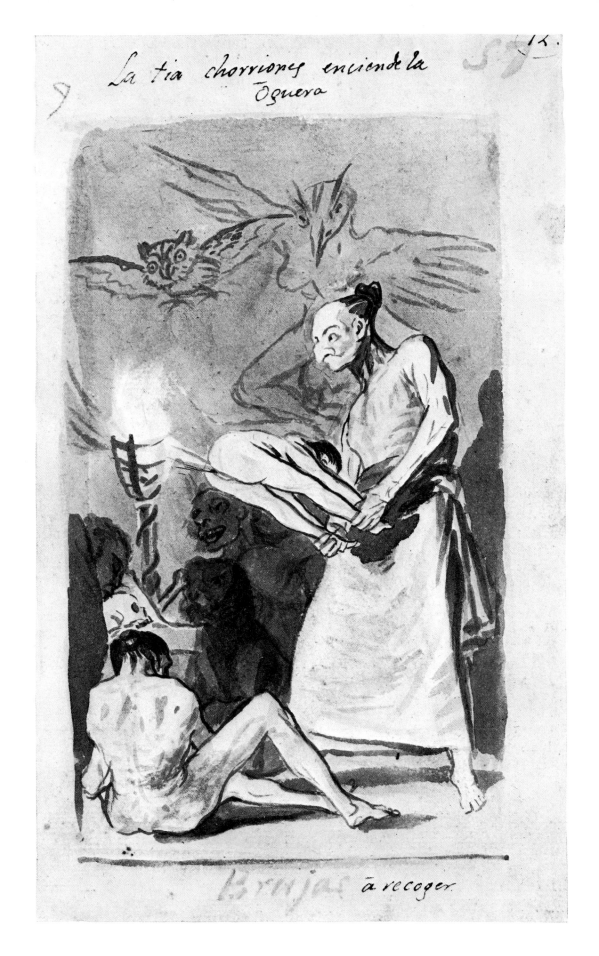

La tía chorriones enciende la
Oguera

Brujas ā recoger.

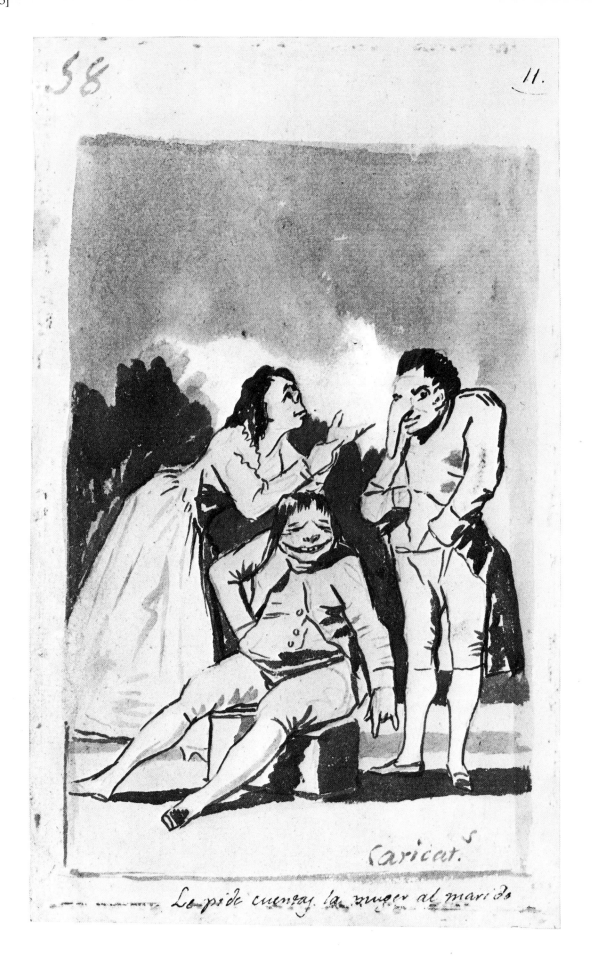

Caricat.ˢ

Le pide cuentas la muger al marido

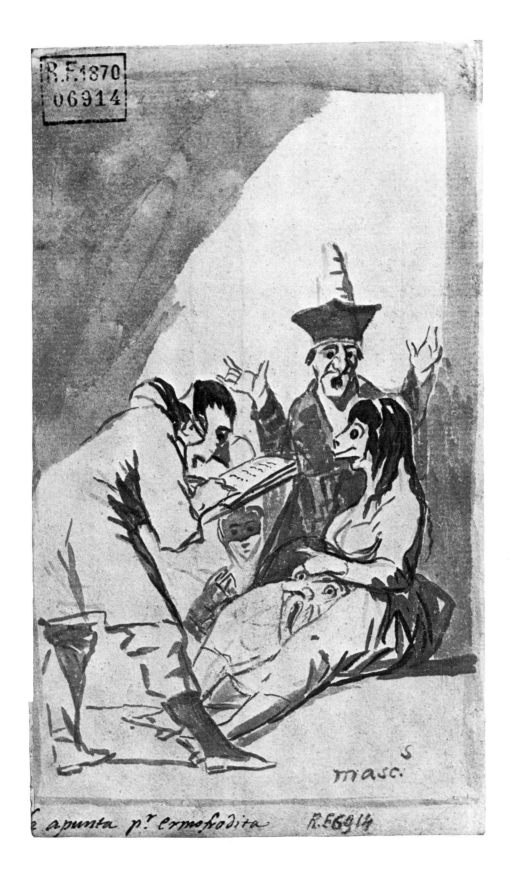

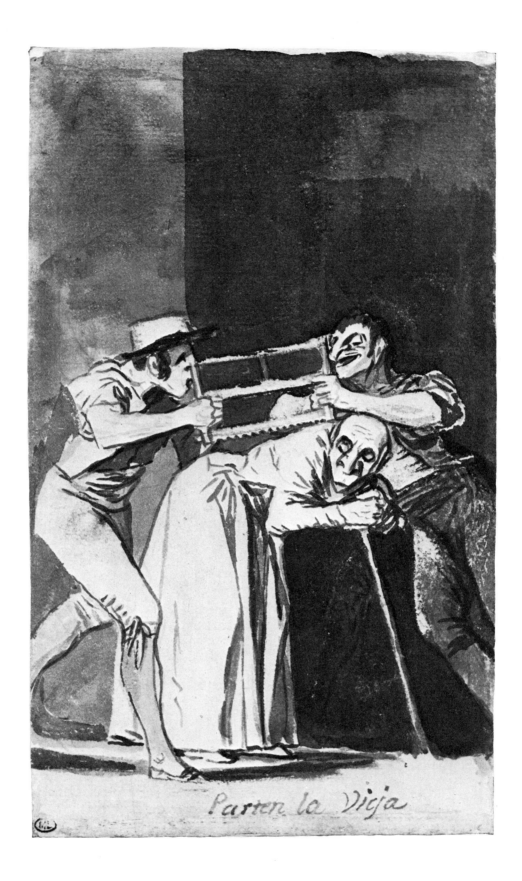

Parten la Vieja

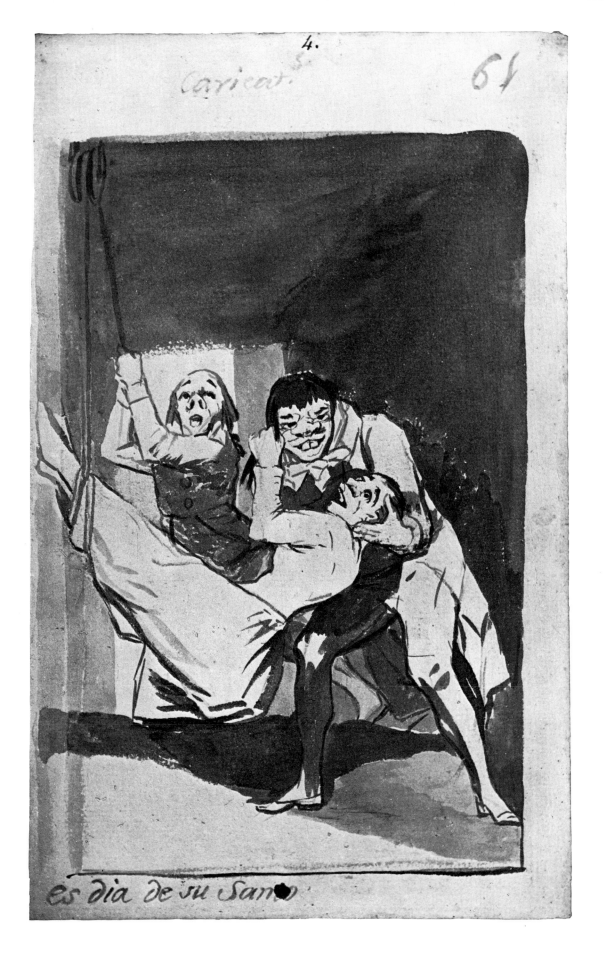

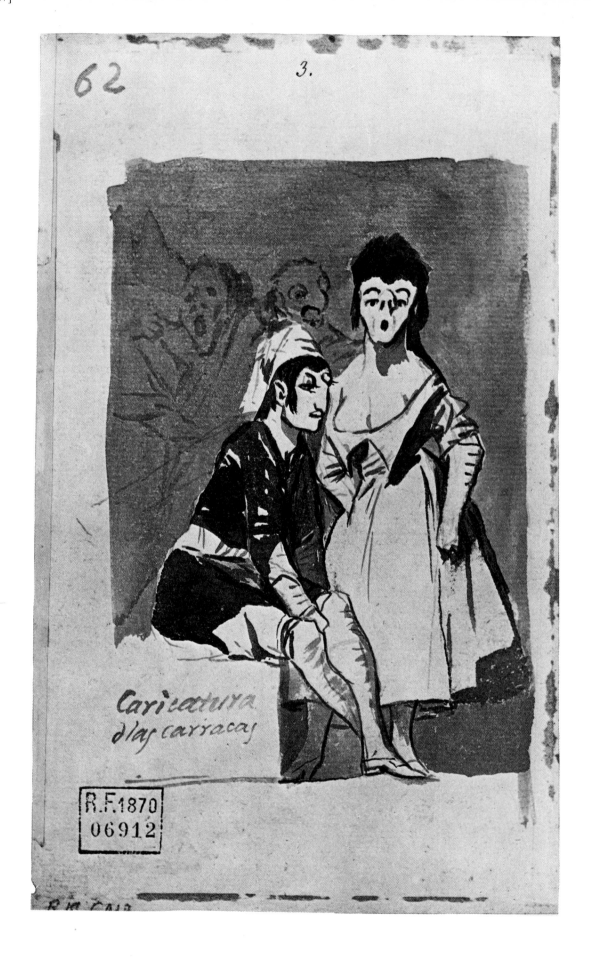

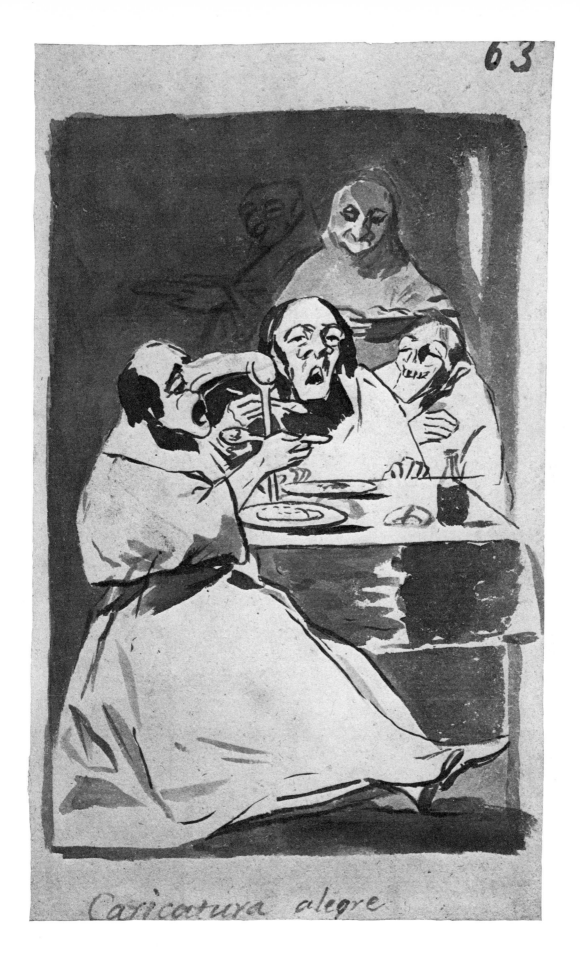

Caricatura alegre

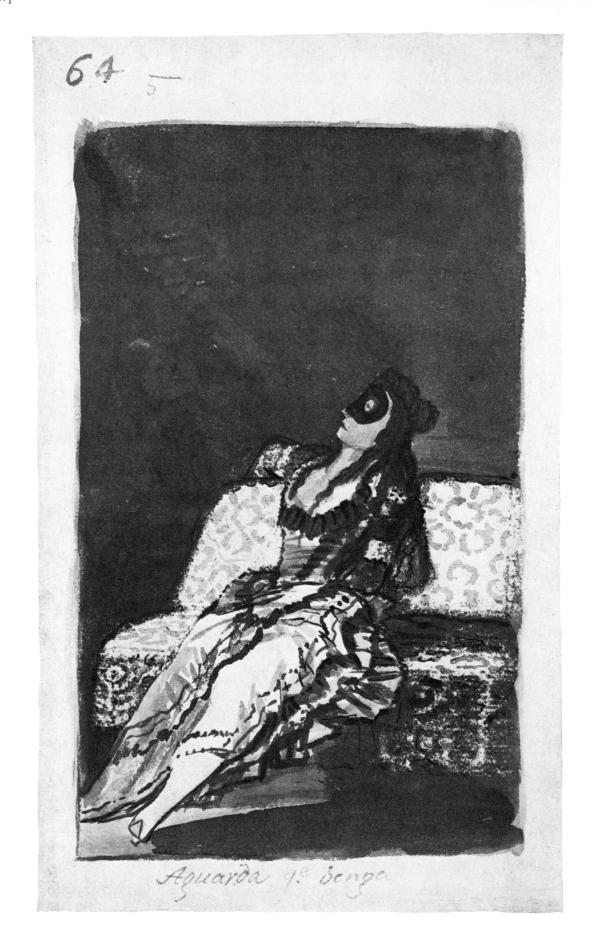

Aguarda q.ᵉ te unga

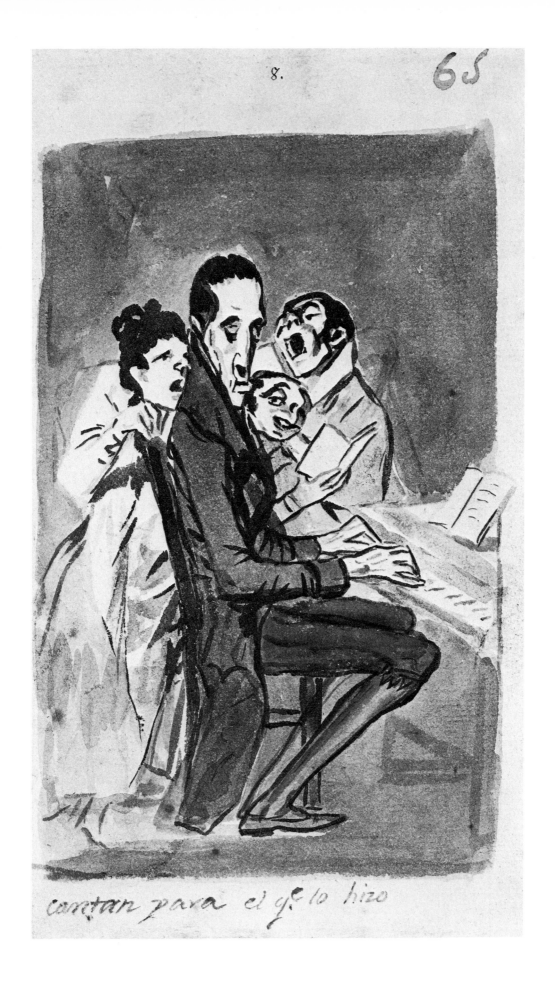

cantan para el q.º lo hizo

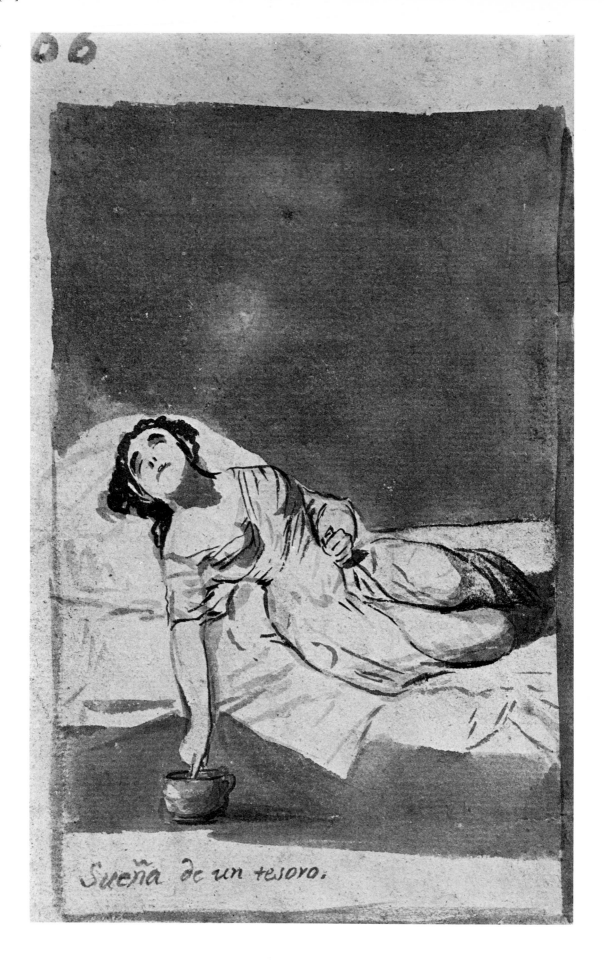

Sueña de un tesoro.

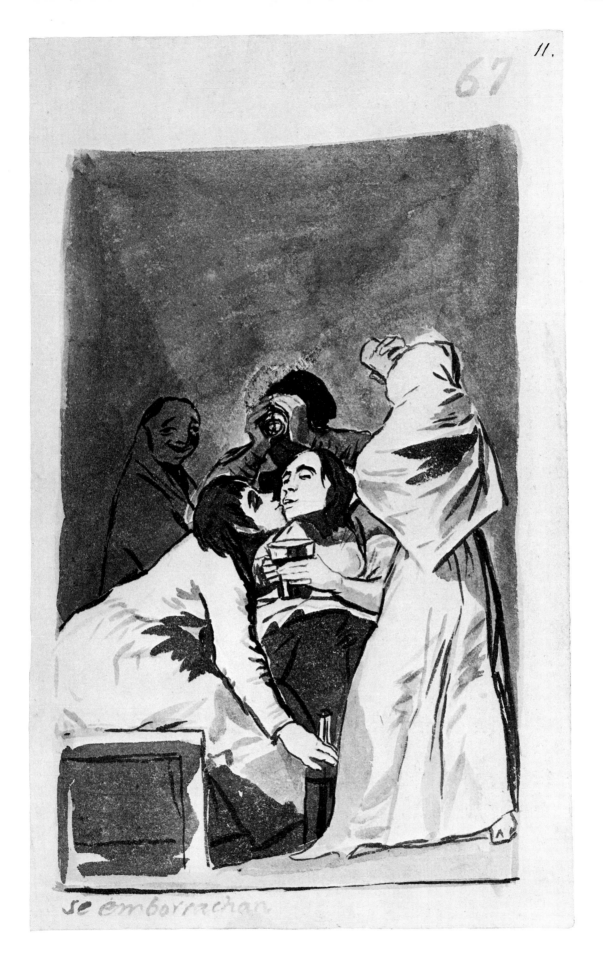

se emborrachan

Solo p.r q.e le pregunta, si esta buena su Madre —
se pone como un tigre

Confiana

2.

lo mismo

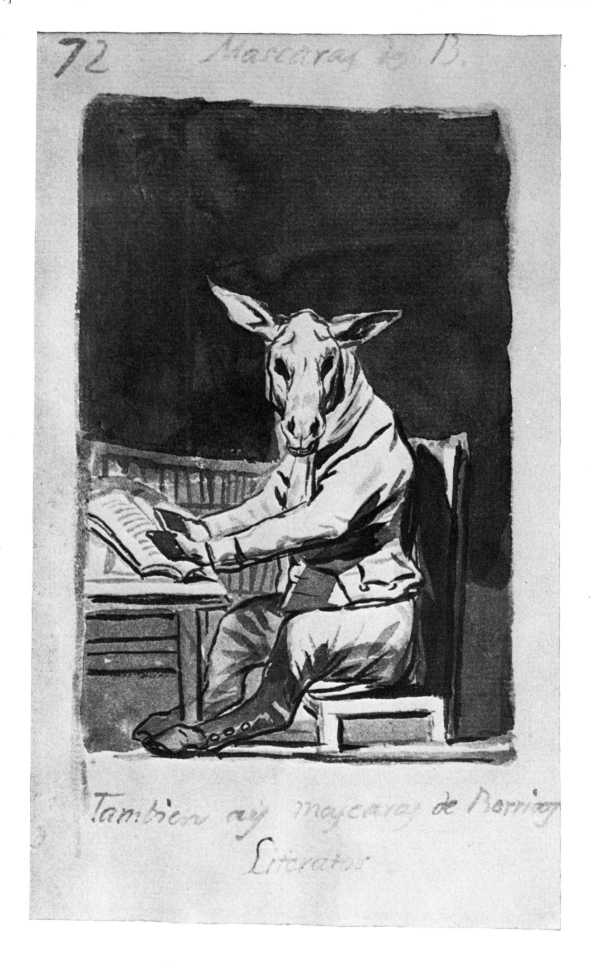

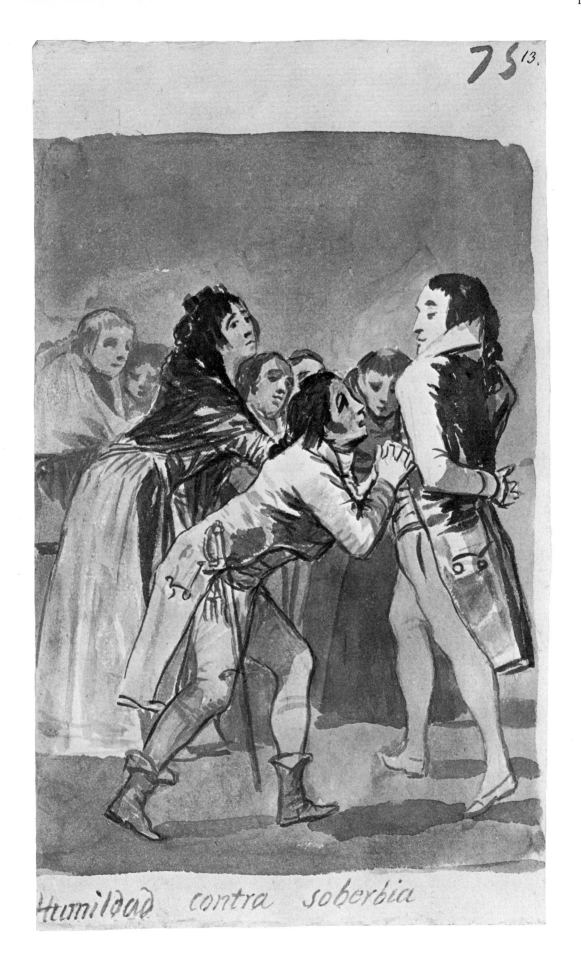

Humildad contra soberbia

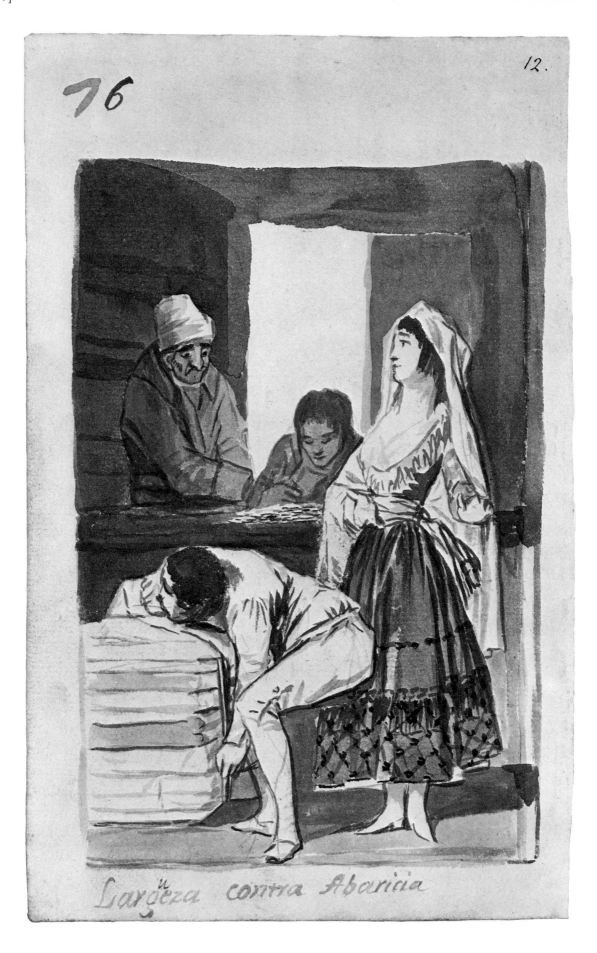

Largueza contra Abaricia

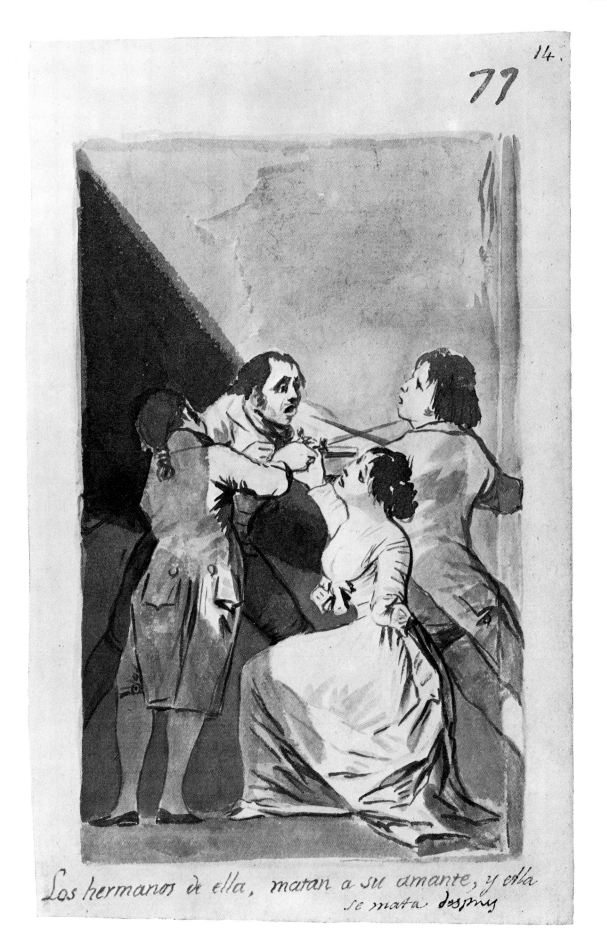

Los hermanos de ella, matan a su amante, y ella
se mata despues

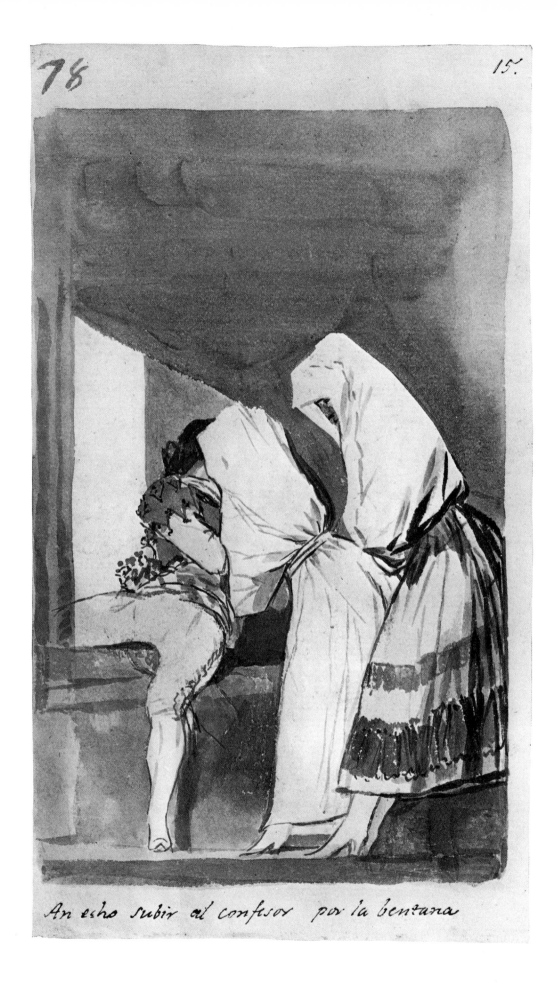

78 15.

An echo subir al confesor por la benzana

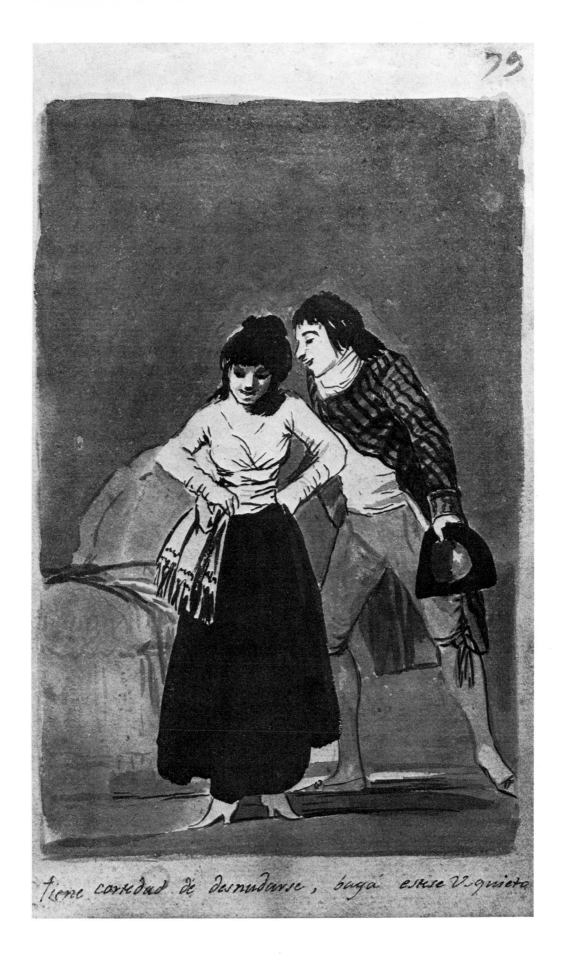

tiene cortedad de desnudarse, baga esese V. quieta

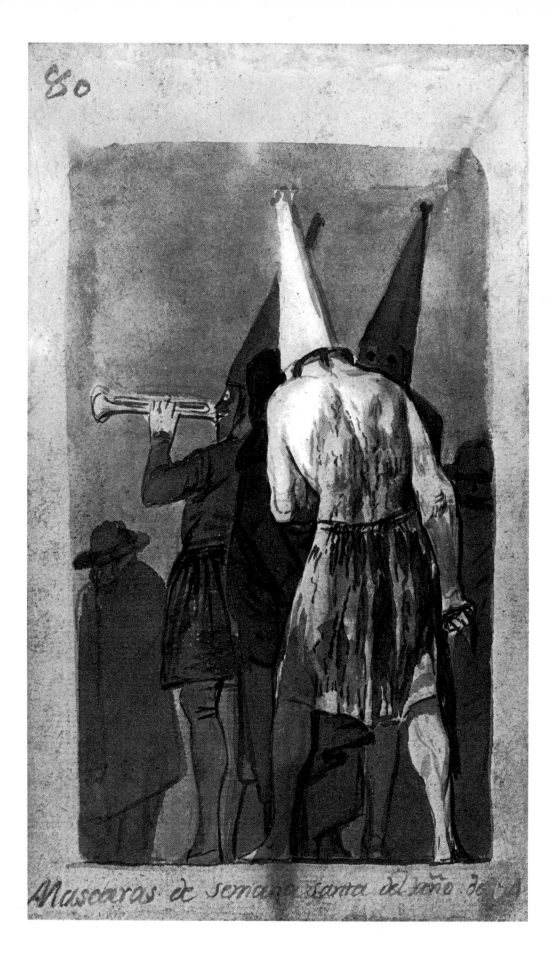

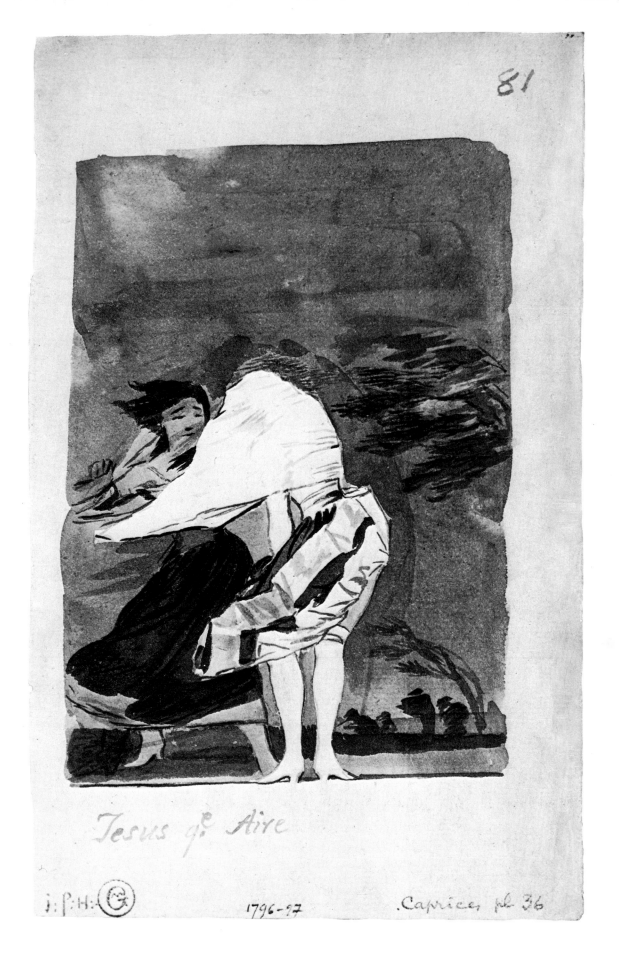

Jesus q⁰ Aire

i: P: H: ☉ 1796-97 . Caprices pl 36

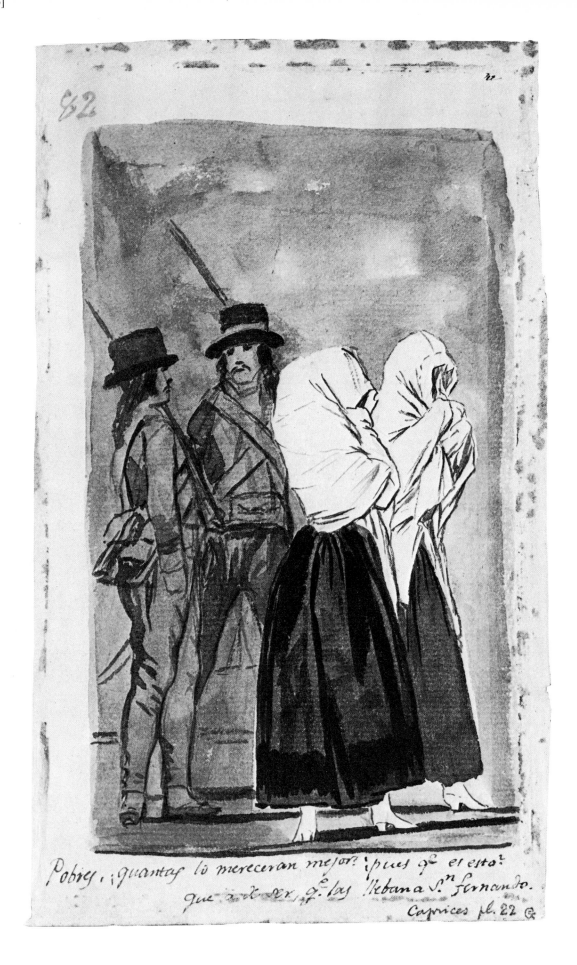

Pobres ¿quantas lo mereceran mejor? ¿pues q.e es esto?
que as de ser g.e las llevan a S.n fernando.

Caprices pl. 22

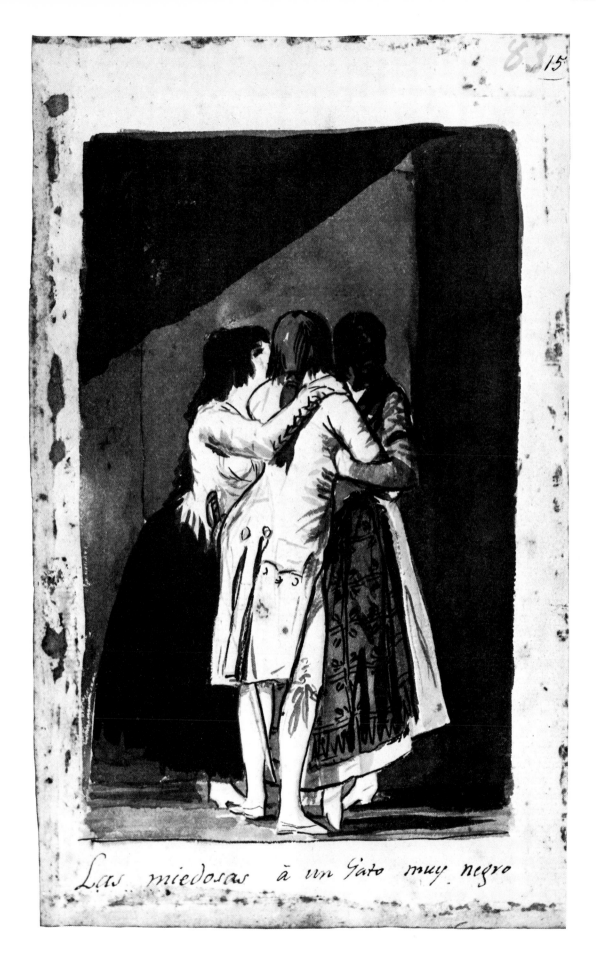

Las miedosas à un Gato muy negro

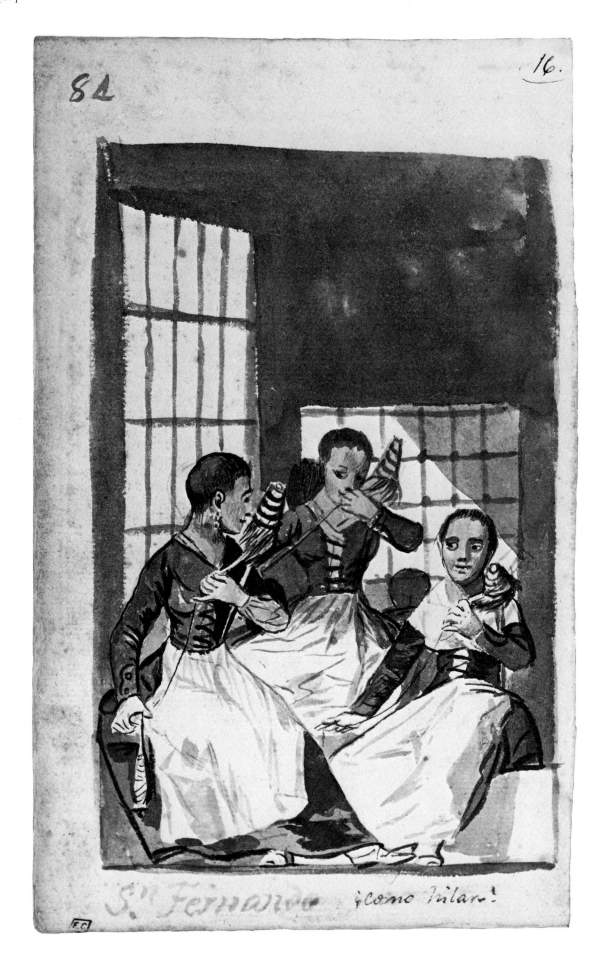

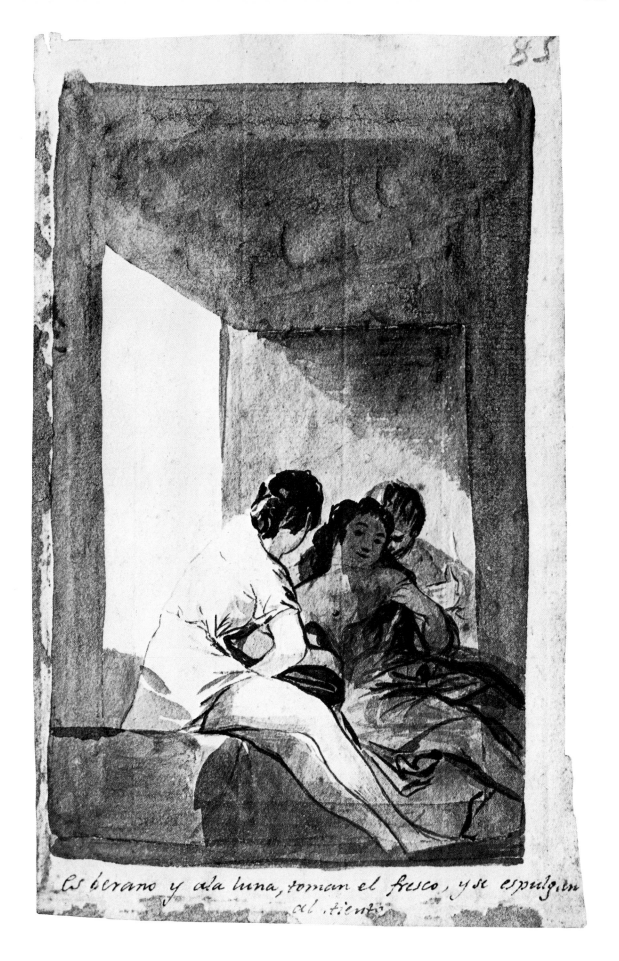

Es berano y ala luna, toman el fresco, y se espulgan al tiento

Buena gense somos los Moralistas

el Abogado.

89

Este á nadie perdona, pero no es tan dañino como
como un Medico malo

120

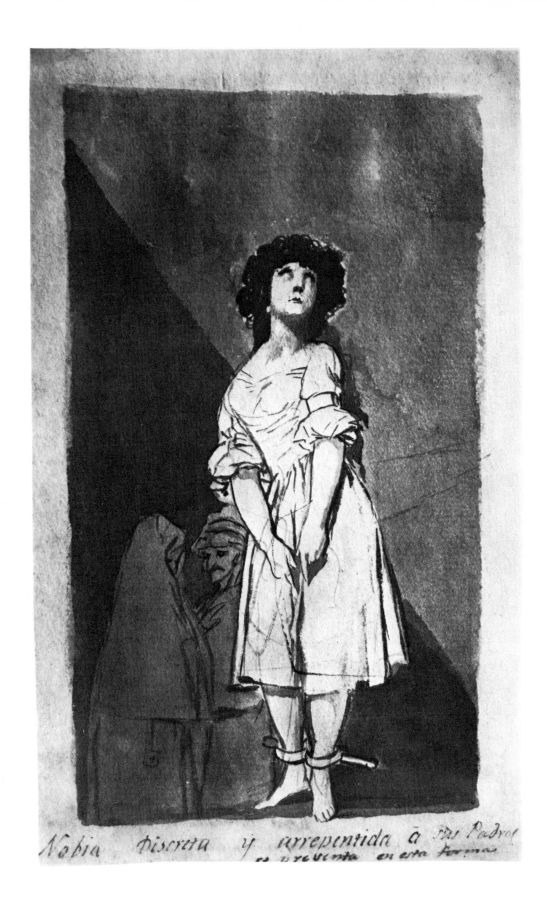

17

Conócelos el aceitero y dice ¡ola! y empieza
a palos con las mascaras

93

ellos huyendo, claman la injusticia del poco respeto
a su representacion

Madrid Album (B)

Captions and Commentaries

B.3 [22] p. 49
"Couple making love in the dark" – 1796-97 – 236 × 147 – I – No. (I) – *Paper:* vertical chain lines (27 mm) – *Watermark:* fragment of a coat of arms (B.II) – *Hist.:* Mexico City, José Atanasio Echeverria (?); GB, anon. coll. → 1891 – Hamburg, Kunsthalle (38544) – GW 377

Drawing in very poor condition. For us, this strange night scene is now the first drawing in this large album, though it seems to bear the number 3 (the reading of this number is difficult and uncertain). Sitting up on the ground, and naked to the waist, this young woman much resembles the nudes in the Sanlúcar album, particularly in drawing A.k. The dark wash of the background forms an arch, and so perhaps this scene is the sequel to the one on the verso. After waiting for him in the company of the old bawd, the *maja* receives her lover in the twilight.

B.4? [23] p. 50
"*Maja* and *Celestina* waiting under an arch" – 1796-97 – Verso of B.3 – I – No. (I) – *Paper:* rounded corners on the left. The paper is torn at the bottom and on the left; the same triangular tear occurs in the first three sheets of the album – Hamburg, Kunsthalle (38544) – GW 378

Here is the stock pair of figures from the Spanish picaresque novel: the young, handsomely dressed *maja,* and the *Celestina,* an old bawd leaning on her stick and holding her rosary in her hand, telling the beads as she gazes fondly at her protégée. As pointed out by López-Rey (Bibl. 127, p. 36), the highly provocative posture of the reclining *maja* leaves no doubt about the meaning which Goya intended the scene to convey. But the most remarkable feature of the drawing is the background landscape, with the massive arch spanning the upper half of the sheet and the distant glimpse of a clump of trees and a hill on the horizon.

B.5? [24] p. 51
"*Majas* on the paseo" → *Cap. 5 (Sueño 19)* – 1796-97 – 234 × 145 – I – Acquisition stamp of the Carderera coll. (1867) – *Paper:* vertical chain lines (25-27 mm) – Triangular tear at the bottom and on the right – *Hist.:* Javier Goya; Mariano Goya; V. Carderera → 1867 – Madrid, Biblioteca Nacional (B.1262) – GW 379

This drawing enables us to gauge the evolution which, in a brief space of time, led Goya from the drawings in the Sanlúcar album, most of them confined to a single figure occupying nearly the whole sheet, to this type of composition set out on several planes and even including a landscape sketch behind the *majas* in the background. The young woman with a fan thereby acquires added prominence, and her silhouette seems all the more strange, with the over-emphatic curve of her back over a skirt and, above all, two feet distinctly shown in front view. In *Capricho 5,* deriving from this sketch, these mistakes have been corrected, as also in the preparatory drawing (GW 460).

B.6 [25] p. 52
"Old beggar woman with a *maja*" → *Cap. 16 (Sueño ?)* – 1796-97 – Verso of B.5? – I – No. (I) – Acquisition stamp of the Carderera coll. (1867) – Rounded corners on the left – Madrid, Biblioteca Nacional – GW 380

Regarded as the recto of the sheet by López-Rey, (Bibl. 127, p. 175), this drawing, given the rounded corners on the left, must be the verso. Observing the triangular tear at the bottom and on the left, E. Sayre made the rectification (Bibl. 177, p. 30); but being unable to make out the number 6, though it is visible in the reproduction in López-Rey (Bibl. 127, Fig. 29), she wrongly proposed the number 2 for this drawing. The old woman here seems to be the stock *Celestina*

123

giving some last words of advice to her protégée before her meeting with the gallants sitting in the background. In *Capricho 16* and the preparatory drawing for it (GW 484), the meaning of the scene was changed, the old woman becoming the mother of the *maja*.

B.7 [26] p. 53

" *Maja* fainting" – 1796-97 – 235 × 144 – I + bistre – No. (I) – No. add. 6 (heavy Lp) – *Paper:* vertical chain lines (27 mm) – Rounded corners on the right – Triangular tear on lower right – *Hist.:* Javier Goya; Mariano Goya; V. Carderera; M. Carderera; → Prado (12.11.1886) – Madrid, Prado (464) – GW 381

This drawing is not just a figure sketch but illustrates a small incident: a *maja* fainting during a picnic. With the help of two other *majas*, the *majo* has carried the girl in his arms to a sort of sofa and is holding up her head. As aptly noted by López-Rey (Bibl. 127, p. 28), the feelings experienced by the figures are clearly conveyed by their gestures and attitudes. This scene may be compared with *The Fall* (GW 250), painted for the country residence of the Osunas. Here the brushwork is remarkable for its exceptional delicacy in the details of faces and clothes, reworked in bistre.

B.8 [27] p. 54

Ay muñecos (I) (There are puppets *or* Poor puppets!) – 1796-97 – " *Maja* and man with tricorn" – Verso of B.7 – I – No. (I) – Traces of pink paper on the edges – Madrid, Prado (422) – GW 382

The caption seems to be in Goya's hand, but its meaning is not clear. The second interpretation is perhaps better in keeping with the subject. Love's puppets, the two figures sitting in a hilly landscape, turn their back on each other after quarrelling: the *maja* darts a sidelong glance at her sulky lover and elegantly flutters her fan. There is an arresting contrast between the sober figure of the man and the profusion of details which Goya has lavished on the *maja*'s dress with delicate strokes of the brush.

B.13 [28] p. 55

" Two women embracing" – 1796-97 – 224 × 133 vis. – I – No. (I) – *Paper:* Vertical chain lines (27 mm) – *Hist.:* APs. Parke Bernet, 8.11.1952; F. Wildenstein – Princeton University Art Museum – GW 383

There is no reason to suppose or even to suggest that the Duchess of Alba is shown here. Does the meeting of these two young women out-of-doors correspond to an actual scene witnessed by Goya? Very possibly, considering the marked difference in clothes and coiffure, which suggests that the young woman with an overcoat has come out in something of a hurry. What feelings are conveyed here? Friendship? Tenderness? Concern? The fine eyes of the *maja* are veiled by her mantilla, and sketched in around these two enigmatic figures is a charming landscape in broad sunlight, stretching out to the sloping line of trees in the background.

B.14 [29] p. 56

" *Maja* parading in front of three others" – 1796-97 – Verso of B.13 – I – No. (I) – Princeton University Art Museum – GW 384

These parading *majas,* whether the Duchess of Alba is one of them or not, are an ever-recurring theme in the Sanlúcar and Madrid albums. It occurs first in drawing A.g in the Prado, and then in sheets B.5, B.6, B.20, B.28 and B.38 of the present album. It is noteworthy that the subject disappears completely in the second half of the album. The *maja*'s attitude here well expresses the pride with which she shows off her finery, while in the background three of her companions stare at her; the pale wash neatly conveys their sense of effacement before the elegant beauty in the foreground, drawn by Goya with a refinement of detail which throws them into the shade.

B.15 [30] p. 57

" *Majo* laughing as two girls fight" – 1796-97 – 228 × 140 – I – No. (I) – *Paper:* vertical chain lines (27-28 mm) – *Watermark:* fragment of a coat of arms (B.II) – Mounted on pink paper – *Hist.:* Javier Goya; Mariano Goya; Román Garreta; ? F. de Madrazo; R. de Madrazo y Garreta; A. M. Huntington (1913) – New York, Hispanic Society of America (A.3309) – GW 385

Directly connected with his stay in Andalusia, this scene was either drawn there or done from memory in Madrid, like all the drawings in the first part of this album. The *majo* lolling on the ground recalls several figures in the tapestry cartoons, shown in similar attitudes as they watch the main scene (see in particular *The Picnic,* GW 70, and *The Kite,* GW 81). But here Goya amused himself in recording a racier incident: a scuffle between two *majas,* one of them with her skirts tossed up displaying her thighs, while the other, like a true Andalusian, is trying to hit her with her shoe.

B.16 [31] p. 58
"*Majas* and *majos* conversing" – 1796-97 – Verso of B.15
– I – No. (I) – New York, Hispanic Society of America
(A.3310) – GW 386

After the strenuous scene on the recto, there comes
now a moment of relaxation which might well be
entitled "Conversation galante". Men and women are
sitting out-of-doors, probably on a public walk, talking
together in small groups extending from the fore-
ground into the distance, in a sequence of receding
planes which give remarkable depth to the drawing.
Thanks to the strongly marked shadows, the ground
takes on an unusual firmness, contrasting with the
empty sky which occupies the upper half of the sheet.

B.17 [32] p. 59
"Weeping woman and three men" – 1796-97 – 235 × 146
– I – No. (I) – No. add. 4 (fine P) – upper r. corner – *Paper:*
vertical chain lines (26-27 mm) – Rounded corners on the
right – Mounted on pink paper – *Hist.:* Javier Goya;
Mariano Goya; V. Carderera; F. de Madrazo; Venice,
Mariano Fortuny y Madrazo (Fortuny album) – New York,
Metropolitan Museum of Art, Harris Brisbane Dick Fund,
1935 (35.103.4) – GW 387

As one leafs through the pages of this album, one is
struck by the growing complexity of the scenes repre-
sented, a complexity evident not only in the grouping
of the figures, in their attitudes and the lighting, but
also in the sentiments they express. Here we have an
amatory imbroglio of some kind: hiding her face in
her hands, a woman has burst into tears, while two
men quarrel and gesticulate, and a third, in the back-
ground by a door, sits in the shadows, his hands over
his eyes. The figures form a perfect pyramid, thrown
into vigorous relief by the harmonious alternation of
lights and shadows combined with the rhythm of the
lines.

B.18 [33] p. 60
"*Maja* with two other figures" – 1796-97 – Verso of B.17
– I – No. (I) – No. add. 5 (fine P) upper r. corner – New
York, Metropolitan Museum of Art, Harris Brisbane Dick
Fund, 1935 (35.103.5) – GW 388

There is a certain confusion in the drawing of both the
maja in the foreground and the two figures curiously
grouped behind her. The bust and arms of the *maja* are
out of line with the face and lower body; above all one
is puzzled by the man and woman behind her – who
are they and what are they doing? López-Rey thinks
the woman is sitting on the man's lap (Bibl. 127,
pp. 29-30); in fact, however, there does not seem to be

any satisfactory interpretation. Probably the drawing
was reworked and left unfinished.

B.19 [34] p. 61
"Gallant quizzing a *maja*." → *Cap. 7 (Sueño 21)* – 1796-97
– 233 × 148 – I – No. (I) – *Paper:* vertical chain lines
(26 mm) – Traces of pink paper – *Hist.:* Javier Goya;
Mariano Goya; V. Carderera → Prado (12.11.1866)
– Madrid, Prado (424) – GW 389

Here is the initial idea for *Capricho 7*, entitled *Ni asi
la distingue* (Even so he cannot make her out). The two
main figures – the *maja* and *petimetre* dressed in the
French fashion – are almost identically repeated in the
etching; only the young woman's attitude changes;
indifferent here, she becomes more accommodating in
the *Capricho*. Here a second *maja,* drawn in a lighter
wash, observes the scene from a distance. Again one
notes the curious position of the *maja*'s feet.

B.20 [35] p. 62
"*Maja* standing before three companions" → *Cap. 27*
– 1796-97 – Verso of B.19 – I – No. (I) – No. add. 7
(heavy Lp) – Madrid, Prado (462) – GW 390

The relief given to the *maja* in the foreground is quite
striking; Goya obtains it by an interplay of more or
less diluted washes, the last strokes on the skirt being
in undiluted Indian ink. The man behind her in a long
coat might supply the key to the confused figures in
drawing B.18; for if the seated man in the latter is
wearing the same coat as here, the legs visible on the
left do not belong to a woman sitting on his lap, but
are his own, and the woman in the background,
whose cast shadow moreover is quite distinct, is lean-
ing towards him to whisper something in his ear. The
position here of the *maja*'s feet is manifestly inac-
curate.

B.21 [36] p. 63
"The swing" – 1796-97 – 237 × 146 – I – No. (I) – No. add. 2
(fine P) upper r. corner – *Paper:* vertical chain lines (28-
29 mm) – *Watermark:* fragment of a coat of arms (B.II)
– Rounded corners on the right – Mounted on pink paper
– *Hist.:* Javier Goya; Mariano Goya; V. Carderera; F. de
Madrazo; Mariano Fortuny y Madrazo (Fortuny album)
– New York, Metropolitan Museum of Art, Harris Bris-
bane Dick Fund, 1935 (35.103.2) – GW 391

This scene is obviously a reminiscence of *The Swing*
painted in 1787 for the Osunas (GW 249). Whenever
Goya reverts to a theme previously treated, he always

handles it much more freely. Here the figures, particularly the young *maja,* are more natural, less stilted. The man is no longer a *majo,* but a *petimetre* who seems to be singing out in his admiration for the girl. Again a remarkable shading off of planes is obtained by different tones of ink, from the frock-coat with its vigorous black highlights to the small, faint figures in the background.

B.22 [37] p. 64
"*Maja* and an officer" – 1796-97 – Verso of B.21 – I – No. (I) – No.add. 3 (fine P) upper r. corner – New York, Metropolitan Museum of Art, Harris Brisbane Dick Fund, 1935 (35.103.3) – GW 392

An off-centre composition organized to striking effect on one side of the diagonal running from upper left to lower right. This procedure was used for the first time in drawing A.n in the Sanlúcar album. But here it is the background wash that exactly defines the delineated area, from which emerge only the head and shoulders of the officer, who thus seems to survey the zone of light, while the carefully veiled *maja* keeps to the shadows.

B.23 [38] p. 65
"Girl and bull" – 1796-97 – 235 × 146 – I – No. (I) – No. add. 7 (fine P) upper r. corner – *Paper:* vertical chain lines (26-27 mm) – *Watermark:* fragment of a fleur-de-lis (B.I) – Mounted on pink paper – *Hist.:* Javier Goya; Mariano Goya; V. Carderera; F. de Madrazo; Mariano Fortuny y Madrazo (Fortuny album) – New York, Metropolitan Museum of Art, Harris Brisbane Dick Fund, 1935 (35.103.7) – GW 393

The mythological interpretation of this scene proposed by López-Rey (Bibl. 127, p. 31) seems to me unacceptable: it is out of keeping with the banality of the subject – a girl frightened by a bull-calf – and the prevailingly realistic character of this first half of the album. As for the girl's theatrical reaction to a danger that seems more imagined than real, we misjudge the charms of Andalusia if we attribute it to anything but the usual overwrought expression of feelings. Finally, we must not forget that the Sanlúcar region is well known for its breed of bulls.

B.24 [39] p. 66
"Pair of lovers sitting on a rock" – 1796-97 – Verso of B.23 – I – No. (I) – No. add. 6 (fine P) upper r. corner – New York, Metropolitan Museum of Art, Harris Brisbane Dick Fund, 1935 (35.103.6) – GW 394

Here again the composition is built up to one side of the diagonal, which coincides exactly with the axis of the *maja*'s upper body. The couple is isolated in the midst of a roughly sketched landscape, dominated on the horizon by what seems to be the disk of the setting sun. A second composition appears over the legs of the *petimetre,* which are covered by a long dark fabric which cannot form part of the clothes worn by the two figures represented.

B.25 [40] p. 67
"Maid combing a young woman's hair" → *Cap. 31* – 1796-97 – 237 × 145 – I – No. (I) – Acquisition stamp of the Carderera coll. (1867) – *Paper:* vertical chain lines (27 mm) – Mounted on pink paper and recut – *Hist.:* Javier Goya; Mariano Goya; V. Carderera → 1867 – Madrid, Biblioteca Nacional (B.1263) – GW 395

Another composition aligned on the diagonal of the sheet of paper. Hence the prominence assumed by the elements that project beyond the diagonal, into the empty space of the background: the highly expressive head of the *maja,* whose eye seems to catch and challenge ours, her bared breasts, her hand with a fan and her bare leg nonchalantly stretched out over a brazier. The drawing is full of delicately recorded details, all very expressive, from the receding squares of the floor tiling to the maid's slightly bowed head, and including the geometric pattern of the stool, the undulating curve of the flounce edging the skirt and the dark mass of hair separating the two women.

B.26 [41] p. 68
"Naked woman holding a mirror" or "After the bath" – 1796-97 – Verso of B.25 – I – No. (I) – Acquisition stamp of the Carderera coll. (1867) – Madrid, Biblioteca Nacional – GW 396

This drawing invites comparison with the one in the Sanlúcar album (A.d) of a young woman bathing at a fountain. It enables us to gauge the considerable evolution that has taken place within a few months, or a year at most, in Goya's handling of the wash technique and, more generally, in his actual conception of the drawing. Here the large curtains in the background, opening onto depths of mysterious shadows, envelop the naked woman's body, set off its supple curves and create around its beauty a context of desires, dreams and secret thoughts – in short, a living tissue very different from the cold display of the first drawing.

B.27 [42] p. 69
"Duet at the clavichord" – 1796-97 – 235 × 145 – I – No. (I) – No. add. 8 (heavy Lp) – *Paper :* vertical chain lines (26-27 mm) – Rounded corners on the right – *Hist. :* Javier Goya ; Mariano Goya ; V. Carderera ; M. Carderera ; → Prado (12.11.1886) – Madrid, Prado (425) – GW 397

Here we are no longer in the world of *majas* and *Celestinas,* but in an eighteenth-century drawing-room with an elegant couple performing some fashionable melody or aria. The young woman at the keyboard closely resembles the Duchess of Alba, and the duke is known to have been a passionate music-lover, especially fond of Haydn. In Goya's 1795 portrait of him, done at the same time as that of the duchess in white, he is shown turning over a Haydn score entitled *Cuatro canciones con acompanamiento de forte piano* (Four songs with pianoforte accompaniment). The connection between that portrait and this drawing is therefore unquestionable.

B.28 [43] p. 70
"Group of *majas* on the *paseo*." – 1796-97 – Verso of B.27 – I – No. (I) – Madrid, Prado (469) – GW 398

A late afternoon scene, judging by the long shadows on the ground, with a group of *majas* conversing on the *paseo*. One is struck by several new elements here : the prominence given to a figure group instead of a single *maja,* and above all the rectangular background in wash, which subsequently became a stock device in Goya's graphic work and enabled him to obtain an inexhaustible wealth of contrasting lights and shadows.

B.31 [44] p. 71
"Corner of a *tertulia*" – 1796-97 – 233 × 144 – I – No. (I) – No. add. 1 (heavy Lp) – *Paper :* vertical chain lines (26-27 mm) – Old blue slip-in mount with traces of pink paper on the verso – *Hist. :* Javier Goya ; Mariano Goya ; V. Carderera ; M. Carderera ; → Prado (12.11.1886) – Madrid, Prado (429) – GW 399

The wash now extends over the whole drawing. This scene of an interior, or rather of a public way at night, thereby takes on an unusual dramatic intensity, thanks to the play of lights and shadows, but also to the contrasting movements of the four figures in the foreground and the looming silhouettes of the two *embozados* (figures in capes) in the shadows behind them. A striking impression of depth is created between the young woman in white in the left foreground and the two men at the back, whose antithetical masses are

disposed along a diagonal. When we remember the balder style of the earlier drawings in the Sanlúcar album, we must admire all the more the pictorial vigour which Goya has achieved here.

B.32 [45] p. 72
"Encounter on the *paseo*" –1796-97 – Verso of B.31 – I – No. (I) – Madrid, Prado (465) – GW 400

After the nocturnal effect of the *tertulia* of the other side, we come here to a charming open-air scene evocative of summertime in a park or the countryside. The blurred silhouette of the leafage against a clear sky recalls the trees forming the background of the portrait of the Duchess of Alba in black, painted in 1797 at Sanlúcar, according to tradition. The warm season is suggested by the short shadows on the ground, the white mantilla of the mysterious young woman and above all by the little dog already shorn of its hair, like the one figuring in the *Young Women with a Letter* in Lille Museum (GW 962).

B.33 [46] p. 73
"Young woman running up steps to see soldiers" – 1796-97 – 237 × 147 – I – No. (I) – *Paper :* vertical chain lines (26-27 mm) – *Watermark :* fragment of a coat of arms (B.II) – *Hist. :* Javier Goya ; Mariano Goya ; V. Carderera ; F. de Madrazo ; Mariano Fortuny ; Venice, Mariano Fortuny y Madrazo ; Henriette Fortuny ; Paris, Otto Wertheimer – Zurich, Anton Schrafl – GW 401

This is one of the most touching drawings in the album. The young woman, scantily clad, hurries up a stairway, panic-stricken at seeing a man (her lover?) being led away by a party of armed soldiers. The tone of the scene is set by the arm flung out against the background of sky, the dishevelled hair, and the wash border, added afterwards to frame the luminous area in which the dramatic incident is taking place.

B.34 [47] p. 74
"Young man beating a girl with a stick" – 1796-97 – Verso of B.33 – I – No. (I) – Zurich, Anton Schrafl – GW 402

Another episode, this time a violent one, in this chronicle, as it were, of lovers' vicissitudes to which a large part of the Madrid album is devoted. A young man is about to bring down his cane on a girl who has fallen to the ground ; she begs for mercy with clasped hands, but a letter lying on the ground beside her supplies the key to this fit of jealousy, observed from the back by

an old *Celestina* whose shifty look betrays the part she has certainly played in this amatory affair. Note the black highlights which vigorously set off the two main figures and the alterations made in the frame of the wash background.

B.35 [48] p. 75
"Woman holding up her dying lover" → *Cap. 10* – 1796-97 – 236×146 – I – No. (I) – No. add. 4 (fine P) upper r. corner – *Paper :* vertical chain lines (27 mm) – *Watermark :* fragment of a coat of arms (B.II) – *Hist.:* Paris, Paul Lebas; APs. Paris, H.D. 3.4.1877, No. 69 " Les suites d'un duel " → de Beurnonville (50 fr.); Ps. de Beurnonville, Paris, H.D. 16-19.2.1885, lot No. 51, → Philippe (105 fr.) – Cambridge (Mass.), Philip Hofer – GW 403

Love and Death : this title given by Goya to *Capricho 10,* which derives from this drawing, speaks for itself. The sword and hat lying on the ground indicate that a duel has taken place, and the young woman was presumably the cause of it. The bleak, receding wall against which the dying man is propped up gives depth to the scene, starting from the vertical edge in the foreground. This type of architecture reappears in *Caprichos 9* and *12,* which are also equivocal death scenes.

B.36 [49] p. 76
"Couple conversing on the *paseo*" – 1796-97 – Verso of B.35 – I – No. (I) – No. add. 3 (fine P) upper r. corner – *Hist. :* same as previous drawing, with the title "Conversation galante" given in the catalogue of the 1877 Ps. – Cambridge (Mass.), Philip Hofer – GW 404

The *maja*, plying the traditional fan, chats with an elegant *petimetre* leaning on his long cane. Here again one observes the illogical position of the feet in both figures. The very low horizon line and the scale of the trees in the background give an almost excessive prominence to the couple, further accentuated by the rectangular wash added afterwards to the original background.

B.37 [50] p. 77
"Couple with a parasol" – 1796-97 – 221×135 – I – No. (Ch) – *Paper :* vertical chain lines (27 mm) – *Hist. :* Mexico City (?), José Atanasio Echeverria; London, F. B. Cosens; B. Quaritch (1891) → Kunsthalle – Hamburg, Kunsthalle (38545) – GW 405

A gracious outdoor scene with a young gallant wearing a sword and shading a *maja* with a parasol, while seeming to point out the way she should take. Against the rectangular background wash stand out faint silhouettes in the distance of other *majas* wrapped in their mantillas. As in the *Duet at the Clavichord* (B.27), one is struck by the buxom figure of the young woman, a detail already noticeable in the Duchess of Alba in drawing A.c of the Sanlúcar album. This was no doubt due to an obsession with a certain type of woman, ideally represented, in Goya's mind, by the Cayetana.

B.38 [51] p. 78
"Two *majas* parading on the *paseo*" – 1796-97 – Verso of B.37 – I – No. (I) – Hamburg, Kunsthalle – GW 406

Against a rectangular background in wash, patterned with a faint landscape of hills and trees, Goya sets a perfectly triangular composition centring in the foreground on two standing *majas* – slender, elegant figures of young Spanish women, their busts tightly wrapped in the mantilla over an identical shawl tied to the belt, and a full skirt with the traditional flounces. Another *maja* on the left sits in front view in the middle distance, looking at them, while on the right, in side view, is the inevitable *Celestina,* leaning on her stick, her head shrouded in a hood. This further variant of a stock scene vouches for the pleasure Goya took in recalling these charming light-o'-loves, who seem to have attracted him as much as they did his friend Moratín (Bibl. 147, passim).

B.39 [52] p. 79
"Young man with two *majas*" – 1796-97 – 216×130 vis. – I – No. (I) – *Paper :* vertical chain lines (26-27 mm) – *Watermark :* fragment of a coat of arms (B.II) – *Hist. :* ? Paris, Paul Lebas; APs. Paris, H.D. 3.4.1877, No. 67 "Jeune fille debout" (?); Basle, Galerie Les Tourettes; bought in 1959 – New York, Benjamin Sonnenberg – GW 407

Set out on three planes, the figures are drawn with many refinements of detail. Our attention, however, is focused on the *maja* in front view in a light-coloured dress: proud of her elegance and young beauty, she basks in the admiration of the young man, who has turned towards her in an attitude of delighted surprise. The man himself is being stared at by another *maja*, whose face appears at the back, in the gap between the two main figures.

B.40 [53] p. 80
"*Majo* watching a *petimetre* bowing to a *maja*" → *Cap. 27* and plate B.N. Paris (Harris 118) – (*Sueño* 18) – 1796-97

– Verso of B.39 – I – No. (I) – *Hist.:* same as previous drawing, with the title "Trois personnages" (?) given in the catalogue of the 1877 Ps – New York, Benjamin Sonnenberg – GW 408

The *maja* represented here is apparently the same as the one in drawings Nos. 5 and 6 of this album. A familiar figure on the *paseos* of Cadiz and Madrid, she brings to mind the lines of Baudelaire:

> *D'un air placide et triomphant*
> *Tu passes ton chemin, majestueuse enfant.*

But now her admirers are in the foreground. They represent the two types of men who were then in fashion in Spain: the *petimetre* dressed in the French style and the *majo* wrapped in the traditional cape. One bows politely to the young woman; the other eyes her as she passes, but without troubling to rise from his seat.

B.43 [54] p. 81

"Seated *maja* with a man lying across her lap" – 1796-97 – 233 × 144 – I – No. (I) – *Paper:* vertical chain lines (27 mm) – *Hist.:* Paris, P. Burty; Martin Birnbaum; Grenville L. Winthrop (1932); entered the Fogg in 1943 – Cambridge (Mass.), Harvard University, Fogg Art Museum (1943-551a), Bequest of Grenville L. Winthrop – GW 409

An unexpected episode in this chronicle of love intrigue: tired out, the *petimetre* has fallen asleep on the lap of his *maja,* who watches over him with motherly solicitude. But the most striking detail lies in the arrangement of the chairs on which Goya has installed his two figures: the pattern of cross-pieces and uprights introduces into the composition an unusual geometric element which forms a contrast with the two figures massed to the right of the diagonal. Rectangular background wash, setting off, in the centre, the dark patch of the empty hat dangling from the back of the chair.

B.44 [55] p. 82

"Young woman taking an infant from a nurse" – 1796-97 – Verso of B.43 – I – No. (I) – Cambridge (Mass.), Harvard University, Fogg Art Museum (1943-551b), Bequest of Grenville L. Winthrop – GW 410

The only scene of motherly love in this album, and it occurs precisely on the back of the drawing evoking similar sentiments towards a man. The baby passes from the hands of the nurse, who seems to be giving it a parting kiss, into the arms of its mother whose apparent delight is tinged with a certain affectation. The rectangular background was laid in over an original area of wash running breadthwise.

B.45 [56] p. 83

"Three washerwomen" – 1796-97 – 235 × 146 – I – No. (I) – No. add. 8 (fine P) upper r. corner – *Paper:* vertical chain lines (26-27 mm) – *Watermark:* fragment of shield (B.II) – Mounted on pink paper – *Hist.:* Javier Goya; Mariano Goya; V. Carderera; F. de Madrazo; Venice, Mariano Fortuny y Madrazo (Fortuny album) – New York, Metropolitan Museum of Art, Harris Brisbane Dick Fund, 1935 (35.103.8) – GW 411

The main figure, alone in the foreground as so often occurs in this album, apparently personifies the merry activity of a washerwoman drawing water from a well. The interpretation suggested by López-Rey, though ingenious, would seem to go beyond the artist's true intention (Bibl. 127, p. 38). As in other sheets of this series, the rectangular ground was added after the elements of the drawing, with the result that many of them (the pulley, part of the well and of the washing trough on the right) lie outside it.

B.46 [57] p. 84

"Girl at a well" – 1796-97 – Verso of B.45 – I – No. (I) – No. add. 9 (fine P) upper r. corner – New York, Metropolitan Museum of Art, Harris Brisbane Dick Fund, 1935 (35.103.9) – GW 412

The two sides of this sheet have one element in common – the well. Here, however, the young woman – apparently the same person as in the previous drawing – instead of pulling gaily on the rope to hoist up her bucket, gazes sadly down into the bottom of the well, where the two ends of the rope dangle loosely. The lonely white figure is silhouetted against a far darker ground which matches her melancholy attitude. The two scenes might well be intended as illustrations of the popular Spanish saying: *Mi gozo en un pozo* (literally, "My joy in a well") with the first representing joy and illusion, the second disillusionment.

B.49 [58] p. 85

"Young woman with potbellied man" – 1796-97 – 236 × 146 – I – No. (I) – *Paper:* vertical chain lines (26 mm) – *Watermark:* fragment of fleur-de-lis (B.I) – *Hist.:* Javier Goya; Mariano Goya; V. Carderera; F. de Madrazo; Rome, Clementi-Vannutelli (bought c.1875), formerly Rome, Clementi coll. – GW 413 .

Caricature and the grotesque – major elements of Goya's art – appear for the very first time in this drawing. Until now he had always depicted his young women in the company of attractive gallants – dandies or *majos*. The only grotesque figure was the *Celestina,* who already had her place in Spanish literature; so that this deformed man with the wry grin was something entirely new. Goya's lively wit seems to have taken a new turn that was to have an important bearing not only on his own work but on all European art in the 19th century.

B.50 [59] p. 86
"Young woman wringing her hands over a man's naked body" – 1796-97 – Verso of B.49 – I – No. (I) – GW 414

Another dramatic scene in which a young woman weeps before a corpse stretched out in a thicket. The composition with two figures placed at right angles might have been excessively rigid, were it not broken by the tangled branches drawn on the wash background and still more by the little dog pulling its mistress by the hem of her skirt. Some twenty years later Goya did another drawing very close to this one in subject matter but treated it in a totally different vein (F.94).

B.55 [60] p. 87
mascaras (I)/*crueles* (P) (Masks [Cruel ones]) – 1796-97 – 237 × 150 – I – No. (I) – No. add. 10 (fine P) upper r. corner – *Paper:* vertical chain lines (26 mm) – *Watermark:* fragment of shield (?) (B.II) – *Hist.:* Paris, Paul Lebas; APs. Paris, H.D. 3.4.1877, No. 72 "La cruelle" → de Beurnonville (22 fr.); de Beurnonville Ps., Paris, H.D. 16-19.2.1885 (lot No. 51) → Philippe (105 fr.); de Bayser – Paris, priv. coll. – GW 415

This drawing is of capital importance in Goya's *œuvre.* The human countenance disappears, giving way to a mask – a first mutation that ended in the "plausible monstrosity" of the *Caprichos.* The simple carnival scene subverts the human quality of this first half of the album by introducing a grotesque element whose ambiguity is a source of anxiety. The word "*crueles*" (cruel) was probably added later, perhaps by a different hand. In fact, the two masks do not express cruelty, but merely a brutish admiration for the young woman who has removed her mask to reveal her snowy bosom.

B.56 [61] p. 88
Brujas (I) *á bolar* (P) (Witches about to fly) → *Cap. 70* (*Sueño* 3) – 1796-97 – Verso of B.55 – I – No. (I) – No. add. 9

(fine P) upper r. corner – *Hist.:* the same as the foregoing, except for the title "Les chanteurs" in the catalogue of the 1877 sale – Paris, priv. coll. – GW 416

Another important drawing on the same sheet. Here it is the word "*brujas*" (witches) that appears for the first time under Goya's brush. His Basque origins must have made him familiar with stories of witches and warlocks, but it was his friend Moratín who led him to delve more deeply into the subject on his return from Andalusia in 1797. (See the introduction to this album.)

B.57 [62] p. 89
La tia chorriones enciende la/Óguera (P)//*Brujas* (I) *à recoger* (P) (Auntie Bellows lights the fire. Witches about to gather again) → *Cap. 69* (*Sueño* 7) – 1796-97 – 235 × 145 – I – No. (I) – No. add. 12 (fine P) upper r. corner – *Paper:* vertical chain lines (27 mm) – *Watermark:* fragment of letters lower right (B.III) – *Hist.:* Paris, Paul Lebas; APs. Paris, H.D. 3.4.1877, No. 73 "La Tante Chorriones allume le bûcher" → Paul Meurice (28 fr.); Ps. Paul Meurice, Paris, H.D. 25.5.1906, No. 97 → A. Strolin (120 fr.); APs. Paris, Gal. Charpentier, 9.4.1957, No. 4 – Paris, priv. coll. – GW 417

It is a remarkable fact that the two drawings on this sheet are the only ones of the whole album representing scenes of witchcraft, as is indicated quite clearly by the word "*brujas*" in Goya's own hand. The inference might be that he was only momentarily concerned with them under Moratín's influence, and that their subsequent development in the *Caprichos,* where scenes of this sort are so numerous, was due more to a moral than to a documentary interest.

B.58 [63] p. 90
Caricat.⁸ (I)/*Le pide cuentas la muger al marido* (P) (Caricatures, the wife asking the husband for an explanation) – 1796-97 – Verso of B.57 – I – No. (I) – No. add. 11 (fine P) upper r. corner – Traces of pink paper – *Hist.:* the same as the foregoing, except for the title "La Femme demande des comptes à son mari" in the catalogue of the 1877 sale – Paris, priv. coll. – GW 418

A grotesque scene from married life. A pug-nosed woman heaps reproach on the head of a hunchback with a nose the shape of a penis, while he tucks his hands into the breast of his coat and the waistband of his breeches. A second man with brutish features makes the horns gesture with his left hand.

B?(59) [64] p. 91

masc.[8] (I)/*La apunta p.*[r] *ermafrodita* (P) (Masquerades. He notes her down as an hermaphrodite) → *Cap. 57* (*Sueño* 11) – 1796-97 – 209 × 125 – I – *Paper:* vertical chain lines (27 mm) – *Watermark:* B.II – *Hist.:* Paris, Paul Lebas; APs. Paris, H.D. 3.4.1877, No. 65 "Il l'inscrit comme hermaphrodite" → de Raincy (10 fr. 50); G. Poelet; Ps. Poelet, Paris, H.D. 19.6.1906; Cosson; bequeathed to the Louvre in 1926 – Paris, Louvre (RF.6914) – GW 419

The three principal figures are masked but the whole point of the scene lies in the mask between the girl's thighs, which represents a double sex. The spectator in the background lifts up her hands in a gesture of disapproval; still further back is the figure of a lightly veiled woman. *Capricho 57*, though very close to this drawing in composition, is given a totally different meaning because it has a grotesque head in place of the androgynous mask.

B?(60) [65] p. 92

Parten la vieja (I) (They are cutting the old woman in two) – 1796-97 – Verso of B?(59) – I – Traces of pink paper on the edges – *Hist.:* the same as the foregoing, except for the title "Ils coupent la vieille" in the catalogue of the 1877 sale – Paris, Louvre (RF.6914) – GW 420

A grotesque scene inspired, like the foregoing one and B.55, by the carnival. As a matter of fact, what Goya has depicted here – as López-Rey proved beyond any shadow of doubt (Bibl. 127, pp. 42-43) – is Mid-Lent ridiculed by Andalusian folklore in the shape of an old woman sawn in half by two men. It is worth noting, too, that Goya was in Cadiz at the time of the Carnival. The same theme recurs in a more vigorous drawing done much later at Bordeaux and captioned *Mitad de Cuaresma* (G.14).

B.61 [66] p. 93

Caricat.[s]//*es dia de su santo* (I) (Caricatures. It's her Saint's day) – 1796-97 – 235 × 146 – I – No. (I) – No. add. 4 (fine P) upper centre – *Paper:* vertical chain lines (27 mm) – *Watermark:* fragment of shield (B.II) – *Hist.:* Paris, Paul Lebas; APs. Paris, H.D. 3.4.1877, No. 64 " Le jour de son Saint" (bought in); G. Poelet; Poelet Ps., Paris, H.D. 19.6.1906; Cosson; bequeathed to the Louvre in 1926 – Paris, Louvre (RF.6912) – GW 421

In this drawing, under the title *Caricatures* repeated on the verso of the sheet, Goya has illustrated a popular expression that might be rendered: "String him up! It's his feast day." What is new here is the brutish expression of the faces, particularly that of the man who supports the victim's head. At the outset the scene was merely a joke, but Goya's brush, by giving the actors hideous faces and using wash to make the background look like a tunnel, has turned it into a nightmare.

B.62 [67] p. 94

Caricatura/d(e) las carracas (I) (Caricature of the old crocks) – 1796-97 – Verso of B.61 – I – No. (I) – No. add. 3 (fine P) upper centre – Traces of pink paper on the edges – *Hist.:* the same as the foregoing, except for the title "Caricature de Las Carracas" in the catalogue of the 1877 sale – Paris, Louvre (RF.6912) – GW 422

It is hard to grasp the meaning of this drawing because of the word "*carraca*", often translated as "rattle" or an "old fogy"; but neither suits the two figures portrayed here. Might it not be more correct to view the title as a reference to a place named La Carraca, near Cadiz, where there are an important prison and a great naval arsenal founded in 1790?

B.63 [68] p. 95

Caricatura alegre (I) (Merry caricature) → *Cap. 13* (*Sueño* 25) – 1796-97 – 232 × 142 – I – No. (I) – *Paper:* Vertical chain lines (27 mm) – Traces of pink paper on an old blue mount – *Hist.:* Javier Goya; Mariano Goya; V. Carderera; M. Carderera; → Prado (12.11.1886) – Madrid, Prado (443) – GW 423

Another caricature in which monks figure for the first time. Two of them sit at table, eating like pigs, beneath the laughing or condescending eyes of their companions. The faces are brutishly grotesque; notably the principal figure on the left, whose huge nose is supported by a two-pronged fork set on the table. The phallic symbol is apparent, as in B.58, and, though it has been eliminated in *Capricho 13*, the caption to the print *Estan calientes* (They are heating up) and still more the commentary in the Biblioteca Nacional, Madrid (Bibl. 106, p. 223) are a direct allusion to monks' indulgence in physical excesses.

B.64 [69] p. 96

Aguarda q.[e] *benga* (I) (She is waiting for him to come) – 1796-97 – Verso of B.63 – I + S – No. (S) – No. add. 5 (thick Lp) upper r. corner – Madrid, Prado (452) – GW 424

The quality of this drawing is not outstanding but the mysterious masked woman waiting sprawled on the sofa imbues it with a turbid sensuality. The impression is heightened by the strong contrast between the

murky background and the highlights on her face, bosom, legs and the back of the couch. Note the use of sepia – the only time it occurs in this album – which Goya did not employ in washes until a great deal later. There is a possibility that the drawing was retouched at a later date.

B.65 [70] p. 97
cantan para el q.ᵉ lo hizo (I) (They are singing for the one who made it up) – 1796-97 – 236 × 147 – I – No. (I) – No. add. 8 (fine P) upper centre – *Paper:* vertical chain lines – *Watermark:* fragment of fleur-de-lis (B.I) – *Hist.:* Paris, Paul Lebas; APs. Paris, H.D. 3.4.1877, No. 63 "Il chante pour celui qui le fit" → Vazier (28 fr.) – Lille, priv. coll. – GW 425

This caricatural transposition of the charming scene depicted in B.27 reveals how vast an evolution Goya's art has undergone since he did the first drawing in this album. The cruel exaggeration culminates in the black-clad figure of the composer, whose face is just as long as the legs folded back under his chair – the sinister mediocrity of a sham talent set off by the grotesque admirers who bleat his song. Goya here has attained Daumier's level of social satire – with thirty years advance on him.

B.66 [71] p. 98
Sueña de un tesoro (I) (She is dreaming of a treasure) – 1796-97 – Verso of B.65 – I – No. (I) – *Hist.:* the same as the foregoing except for the title "Rêve d'un trésor" in the catalogue of the 1877 sale – Lille, priv. coll. – GW 426

This drawing might be compared with A.h in the Sanlúcar album in order to measure the gulf that separates the two renderings of a similar theme. Here there is also the caption to add a comic touch to a scene that is not really comic in itself. The broad areas of light and shade set off the limp figure of the sleeping girl, barely concealed by the flimsy shift sketched with the point of the brush.

B.67 [72] p. 99
se emborrachan (I) (They are getting drunk) – 1796-97 – 237 × 146 – I – No. (I) – No. add. 11 (fine P) upper r. corner – *Paper:* vertical chain lines (26-27 mm) – Mounted on pink paper – *Hist.:* Javier Goya; Mariano Goya; V. Carderera; F. de Madrazo; Venice, Mariano Fortuny y Madrazo (Fortuny album) – New York, Metropolitan Museum of Art, Harris Brisbane Dick Fund, 1935 (35.103.11) – GW 427

We saw monkish debauchery in B.63. Here we have female debauchery. In both drawings the principal figures in the foreground are brightly lit up, while those who serve or laugh at them are half hidden in the darker background. The flowing robes of both groups form bright areas whose geometric outlines make them stand out in strong relief. Note the two besotted profiles about to touch in the centre of the composition.

B.68 [73] p. 100
Tuto parola e busia//el Charlatan q.ᵉ arranca una quijada y lo/creen (I) (Every word is a lie. The charlatan who pulls out a jaw and they believe it) – *Quijada* is written in pen over the word *barilla* (tooth) → *Cap. 33* – 1796-97 – Verso of B.67 – I – No. (I) – No. add. 10 (fine P) upper r. corner – New York, Metropolitan Museum of Art, Harris Brisbane Dick Fund, 1935 (35.103.11) – GW 428

This drawing is the only known preliminary study for *Capricho 33, Al Conde Palatino*. Except that Goya simplified the background in the print, the latter reproduces very precisely the four major figures of the drawing. They stand out brightly lit against the dark background arranged in a pyramid, the apex of which is formed by the quack. The other three illustrate the three phases of the operation – before, during and after. Note the caption in bad Italian; it is a direct allusion to the foreign quacks, clearly mentioned in the commentary in the Biblioteca Nacional in Madrid (Bibl. 106, p. 228). *The Tooth-Drawer* by Giandomenico Tiepolo in the Louvre, engraved in 1765 by G. Leonardis, had already dealt with a similar subject.

B.69 [74] p. 101
solo p.ʳ q.ᵉ le pregunta, si esta buena su madre (I)//*se pone como un tigre* (P) (Just because she is asked if her mother is well she acts like a tigress) – 1796-97 – 235 × 147 – I – No. (I) – *Paper:* vertical chain lines (27 mm) – *Hist.:* Javier Goya; Mariano Goya; V. Carderera; F. de Madrazo; Venice, Mariano Fortuny y Madrazo; Henriette Fortuny; Paris, Otto Wertheimer; Basle, priv. coll.; London, H. M. Calman – Switzerland, priv. coll. – GW 429

Here we find, once again, the classic trio of the first half of the album – *maja*, dandy and *Celestina*. But they are placed in a totally different setting. The bright backgrounds and leafy landscapes have given way to a sort of artificial night that recurs frequently in the *Caprichos* (Nos. 2, 3, 4, 6, 8, etc.), in some of the *Disasters of War* (Nos. 4, 10, 21, 50, 62, etc.) and in the *Disparates* (Nos. 1, 2, 4, 5, etc.). It is a transposition to the visual plane of the "eternal silence of infinite

space", which after all is but the expression of metaphysical apprehension.

B.70 [75] p. 102
Confianza (I) (Trust) – 1796-97 – Verso of B.69 – I – No. (I) – Traces of pink paper (?) – Switzerland, priv. coll. – GW 430

Three people sit around a table: a priest, full face; a young *maja,* in profile; and a *petimetre* viewed from the back, sharply highlighted, in the foreground. The question is: What are they doing to justify the title? The young man seems to be showing the priest a sort of little notebook. The *maja* stretches out her left arm towards her companion and at the same time gives him a signal with her foot under the table. Maybe the word "trust" is meant ironically, as is so often the case in Goya's captions, and the scene we are witnessing is an unscrupulous couple playing a hoax on a man of God, whose eyes are fixed in a curious stare. Note the background, which makes almost the same tunnel effect as in B.61.

B.71 [76] p. 103
lo mismo (I) (The same) – 1796-97 – 235 × 145 – I – No. (I) – No. add. 2 (fine P) upper centre – *Paper:* vertical chain lines (26 mm) – Traces of pink paper – *Hist.:* Paris, Paul Lebas; APs. Paris, H.D. 3.4.1877, No. 66 "Conversation galante" → Paul Meurice (19 fr.); Ps. Paul Meurice, Paris, H.D. 25.5.1906, No. 94 → Arnold & Tripp (360 fr.); APs. Paris, Gal. Charpentier, 9.4.1957, No. 60; Schondlat coll. – Switzerland, priv. coll. – GW 431

A fine indoor scene with strongly contrasted effects of light and shade. The title does nothing to help us grasp its meaning. Are these the same two young people as in the previous drawing meeting in a brothel under the fawning eye of an aged procuress? As so often happens in the *Caprichos,* the moralizing or satirical intention is obscure, and that in the last analysis gives the plastic beauty of the work a touch of ambiguity which enhances its charm. What also strikes us, on progressing through this album, is the sobriety of the technical resources deployed by the artist. In place of the short nervous touches with the point of the brush, Goya tends more and more to prefer broad masses and large areas of wash.

B.72 [77] p. 104
Mascaras de B.//*Tambien ay mascaras de Borricos/Literatos* (I) (Masquerades of A[sses]. There are also Asses masquerading as men of letters) → *Cap. 39 (Sueño* ?) – 1796-97

– Verso of B.71 – I – No. (I) – *Hist.:* the same as the foregoing except for the title "Il y a aussi des mascarades d'ânes lettrés" in the catalogue of the 1877 sale –Switzerland, priv. coll. – GW 432

One of the finest drawings in this album and the only one (excepting B.93) with the theme of the learned ass, a theme that Goya developed to such telling effect in the *Caprichos,* where no fewer than six plates in succession are based on it. Edith Helman has identified its sources (Bibl. 106, p. 63). But the unique feature of this drawing is the attitude of the ass, which turns towards us and fixes us square in the eye with a stare as mournful as its great head with the flapping ears. In the six *Caprichos* (Nos. 37-42) and all the relative preliminary studies, the ass is shown in profile or three-quarter face, never absolutely frontally. That is why this was chosen by Javier Goya in person as the frontispiece for a selection of some fifty of the artist's drawings. In this context, see the introduction to this album.

B.75 [78] p. 105
Humildad contra soberbia (I) (Humility versus Pride) – 1796-97 – 235 × 146 – I – No. (I) – No. add. 13 (fine P) upper r. corner – *Paper:* vertical chain lines (26-27 mm) – Mounted on pink paper – *Hist.:* Javier Goya; Mariano Goya; V. Carderera; F. de Madrazo; Venice, Mariano Fortuny y Madrazo (Fortuny album) – New York, Metropolitan Museum of Art, Harris Brisbane Dick Fund, 1935 (35.103.13) – GW 433

Was it Goya's intention, in this drawing and the one on the verso of this sheet, to illustrate a moral antithesis? Or is it the captions, added after the drawings were executed, that stress the rather arbitrary parallelism of the two scenes? The second hypothesis would seem more in keeping with the artist's nature. And one should perhaps see this first one as referring to Bonaparte, who amazed all Europe with the speed of his victorious campaign in Italy (1796-97) – the very moment when Goya was working on this album. The humble postures of all the figures, excepting the young woman, who preserves her dignity even in an attitude of supplication, contrast with the scornful bearing of the young man, who is not named but can easily be recognized.

B.76 [79] p. 106
Larg(u)eza contra Abaricia (I, excepting the (u) added in pen) (Generosity versus Greed) – 1796-97 – Verso of B.75 – I – No. (I) – No. add. 12 (fine P) upper r. corner – New York, Metropolitan Museum of Art, Harris Brisbane Dick Fund, 1935 (35.103.12) – GW 434

Here the contrast is between two figures – the mean old tradesman with the wry grin and the smart, probably spendthrift young woman, whose insolent beauty literally lights up the sordid shop. This scene introduces an entirely new element in Goya's art – the representation of a calling, in the person of the boy wrapping up a bale of goods in the foreground. Compare it with *The Allegory of Trade* (Prado 2546, GW 692) and in particular with the study for that painting (GW 693), where there is also the figure of a merchant behind his counter and the background lighting that I have already called attention to in B.61 and 70. The allegorical painting, executed a little later than the Madrid album, adorned Godoy's mansion.

B.77 [80] p. 107

Los hermanos de ella, matan a su amante (I), *y ella/se mata despues* (P) (Her brothers kill her lover, and afterwards she kills herself) – 1796-97 – 235 × 146 – I – No. (I) – No. add. 14 (fine P) upper r. corner – *Paper:* vertical chain lines (26-27 mm) – *Watermark:* fragments of letters (B.III) – Mounted on pink paper – *Hist.:* Javier Goya; Mariano Goya; V. Carderera; F. de Madrazo; Venice, Mariano Fortuny y Madrazo (Fortuny album) – New York, Metropolitan Museum of Art, Harry Brisbane Dick Fund, 1935 (35.103.14) – GW 435

Two brothers avenge their sister's honour by the ferocious murder of her lover. This type of summary justice was censured by Goya's enlightened friends for the same reason as duelling, bull fighting and, needless to say, the *auto-da-fé*. The second part of the caption, written in pen, must have been added by Goya himself or by someone else to give the domestic tragedy a still more bloody ending.

B.78 [81] p. 108

An echo subir al confesor por la bentana (P) (They got the confessor to climb in by the window) – 1796-97 – Verso of B.77 – I – No. (I) – No. add. 15 (fine P) upper r. corner – New York, Metropolitan Museum of Art, Harris Brisbane Dick Fund, 1935 (35.103.15) – GW 436

Two young women carefully shrouded in their shawls extend a warm welcome to a *majo* climbing in through their window. The caption, later than the drawing, makes an ironical use of the word "confessor", which well matches the dress and deportment of the two "penitents". Notable here is the strong lighting of the figures in the foreground, standing out against the background wash, and the bright rectangle of the window on the left.

B.79 [82] p. 109

tiene cortedad de desnudarse, baya estese V. quieto (P) (She is bashful about taking her clothes off. Go on, keep still, will you) – 1796-97 – 232 × 141 – I – No. (I) – *Paper:* vertical chain lines (26-27 mm) – *Watermark:* fragment of fleur-de-lis (B.I) – *Hist.:* San Mateo, William Bourne; San Francisco, Mrs. William P. Roth – San Francisco, William M. Roth – GW 437

The two figures stand out boldly against the flat grey background broken only by the unmade bed on the left. The man, still hat in hand, stoops lovingly towards the young woman to help her undo the sash that holds up her skirt. She seems timid, if not embarrassed as the caption says. The latter displays a novel feature: this is the first time Goya speaks directly to his characters. This direct form of address recurs in many of the captions to the series of drawings done between 1805 and 1828.

B.80 [83] p. 110

Mascaras de semana santa del año de 94 (I) (Masquerades of Holy Week in the year 94) – 1796-97 – Verso of B.79 – I – No. (I) – Traces of pink paper (?) – San Francisco, William M. Roth – GW 438

Goya here has no compunction in launching a frontal attack on one of the religious customs most firmly anchored in Spanish tradition – the Holy Week processions of hooded penitents. He has purposely set the flagellant's bleeding back in the crude light of the foreground the better to denounce barbarous scenes of this type. They had indeed already been banned in 1777, but with no great success, as is proved by this reminder of 1794; the ban was repeated in 1799 and 1802.

B.81 [84] p. 111

Jesus q.ᵉ Aire (I) (Lord, What a Wind!) → *Cap. 36* (*Sueño* 22) – 1796-97 – 234 × 14.3 – I – No. (I) – No. add. undecipherable – On the back of the mount the inscription: "Given me by Sig.ʳ R. de Madrazo, 1895. JPH" – *Paper:* vertical chain lines (26 mm) – Coll. marks J. P. Heseltine and G. – *Hist.:* Javier Goya; Mariano Goya; F. de Madrazo (?); R. de Madrazo; given to J. P. Heseltine in 1895; Ps. Heseltine, London, May 1935, No. 115 – Paris, priv. coll. – GW 439

Here once again the two sides of the sheet are linked by figures shown in different situations, like two chapters of what might be called "The Tribulations of Two Prostitutes". Edith Helman has suggested that one of Goya's sources of inspiration was apparently Moratín senior's *El Arte de las Putas,* banned by the Inquisition in 1777 (Bibl. 106, p. 83). But it was

mostly scenes taken from real life that the artist rendered in a splendid range of blacks and whites which led straight to the print *Mala noche*.

B.82 [85] p. 112

Pobres i quantas lo mereceran mejor! (I) *¿pues q.ᵉ es esto?* (P. bistre)/*que a de ser, q.ᵉ la lleban a S.ⁿ Fernando* (P) (Poor things, how many would deserve it more! But what is this? What else but that they are being taken off to San Fernando) → *Cap. 22* – 1796-97 – Verso of B.81 – I – No. (I) – *Paper:* traces of pink paper round the edges – Paris, priv. coll. – GW 440

Two *alguaziles* are taking two prostitutes to San Fernando prison. The men are set further back against the grey ground. The poor girls, completely covered by their shawls, stand out in strong relief in the foreground. This was the first idea for the *Capricho* entitled *Pobrecitas* in which the two male figures and the background are considerably modified.

B.83 [86] p. 113

Las miedosas (I) *á un Gato muy negro* (P) (They are scared of a very black cat) – 1796-97 – 236 × 147 – I – No. (I) – No. add. 15 (fine P) upper r. corner – *Paper:* vertical chain lines – traces of pink paper on the edges – *Hist.:* Paris, Paul Lebas; APs. Paris, H.D. 3.4.1877, No. 75 " Les Peureuses " → E. Calando (43 fr.); Ps. Calando, Paris, H.D. 11-12.12.1899, No. 68 – Netherlands, priv. coll. – GW 441

In the penumbra of a street or doorway two girls press close in terror to a man armed with a sword. The caption tells us, with the help of an addition in pen, that this was because of a very black cat. Here Goya is poking good-natured fun at the absurdity of a superstition that has scared out of their wits, for a mere nothing, two girls who have certainly had far worse experiences.

B.84 [87] p. 114

S.ⁿ Fernando (I) *i como hilan!* (P) (San Fernando, How they spin!) – 1796-97 – Verso of B.83 – I – No. (I) – No. add. 16 (fine P) upper r. corner – *Paper:* l. corners rounded – Stamp E.C. (E. Calando) (Lugt 837) – Netherlands, priv. coll. – GW 442

This scene is the sequel to B.82. The two prostitutes have joined a third in San Fernando prison where, shorn and dressed in uniform, they are put to spinning wool. It is curious to note, after the ambiguous indoor scenes of B.71 and 78 and just before that of B.85, how well Goya succeeded in this drawing in conveying the unequivocal atmosphere of the Madrid jail. Day-

light streams in through the two large barred windows, bathing the three figures in an even light devoid of violent contrasts. This is still a far cry from the tragic prison interiors of drawings C.100, C.103, C.107 and F.80.

B.85 [88] p. 115

es berano y a la luna, toman el fresco, y se espulgan/al tiento (P) (It's summer and by moonlight they take the air and get rid of their fleas, by feel) – 1796-97 – 236 × 145 – I – No. (I) – *Paper:* vertical chain lines (26-27 mm) – *Watermark:* fragment of fleur-de-lis (B.I) – *Hist.:* Javier Goya; Mariano Goya; V. Carderera; F. de Madrazo; Rome, Clementi-Vannutelli (bought c.1875). Formerly Rome, Clementi coll. – GW 443

Here we are back again in the semi-darkness, so conducive to sensual excesses, of a warm summer evening. The two lightly clad young women – one of them has even shamelessly opened her bodice – are playing the ambiguous game of hunting fleas in front of a man all but hidden behind them. That is what the ironical caption says, but the trio are actually engaged in quite a different pastime. The effects of light and shade have attained a truly remarkable degree of perfection after the tentative efforts we saw in B.71 and 78. Here for the first time Goya, following in the footsteps of Rembrandt, whom he revered as one of his masters, has succeeded in rendering what he called " the magic of the atmosphere ".

B.86 [89] p. 116

Buen sacerdote ¿donde se ha celebrado? (P) (Good priest, where was it celebrated?) → *Cap. 18 (Sueño?)* – 1796-97 – Verso of B.85 – I – No. (I) – GW 444

The interpretation of this drawing supplied by López-Rey (Bibl. 127, pp. 48-49) is not convincing. The man with the brutish expression hitching up his breeches is not a priest. If the caption ironically uses the word *sacerdote* it is only to balance the word *celebrado*. So what rite has this fellow just celebrated alone under what seems to be the arch of a bridge or vault? Neither more nor less than an urgent call of nature.

B.87 [90] p. 117

Ay Pulgas? (I) (Are there fleas?) – 1796-97 – 237 × 147 – I – No. (I) – *Paper:* vertical chain lines (26-27 mm) – Mounted on pink paper – *Hist.:* Javier Goya; Mariano Goya; Román Garreta; R. de Madrazo y Garreta; A. M. Huntingdon (1913) – New York, Hispanic Society of America (A.3316) – GW 445

This indoor scene seems quite straightforward, but the tone of the caption suggests any number of double meanings. A man is sound asleep in the bed at the back of the darkened room, while in the strong light of the foreground a young woman stares into the half-opened top of her night-dress. It is speaking of her that Goya, greatly interested in the operation, asks slyly what she sees there? As in B.85, fleas are a convenient pretext. This combination of image and short, pithy caption is typical of Goya's genius as a graphic artist.

B.88 [91] p. 118

Buena Jente somos los/Moralistas (I) (What good people we moralists are) → *Cap. 11* – (*Sueño* 28) – 1796-97 – Verso of B.87 – I – No. (I) – New York, Hispanic Society of America (A.3317) – GW 446

Four smugglers have paused in a thick forest – a very rare setting for Goya – to smoke a cigarette. Remarkable are the effect of depth and the contrasts of light and shade; remarkable too the foreshortened right arm of the figure in the foreground to the left. Goya had already used the motif of this drawing in the cartoon for a tapestry entitled *El resguardo de tabacos* (The Tobacco Guard) executed in 1780 (GW 136).

B.89 [92] p. 119

el Abogado (I)/*Este a nadie perdona, pero no es tan dañino como/como* (sic) *un Medico malo* (P) (The Lawyer. This one never lets anybody off, but he doesn't do as much harm as a bad doctor) – 1796-97 – 216 × 127 – I – No. (I) – *Paper:* vertical chain lines – *Hist.:* Paris, Paul Lebas; APs. Paris, H.D. 3.4.1877, No. 76 " Ne fais grâce à personne, mais ne cause pas autant de mal qu'un mauvais médecin" → Pascal (76 fr.); Mariano Fortuny y Madrazo (?); Paris, A. Fauchier-Magnan; Ps. Fauchier-Magnan, Paris, 1935; London, Percy Moore Turner; Ps. London, Sotheby 21.6.1950, No. 23; Lord Wharton; Lord Wharton's heirs – Unknown coll. – GW 447

The link between this drawing and the previous one (B.88) is clear – smugglers, highwayman, dark wooded setting. This proves that Goya treated the classic theme of the Spanish bandits long before the War of Independence (1808-14). The title inscribed at the top of the sheet, *El Abogado,* is the nickname of a famous bandit. The caption added later in pen turns this realistic scene into a biting satire on doctors.

B.90 [93] p. 120

Nobia discreta y arrepentida (I) *à sus Padres/se presenta en esta forma* (P) (A wise and repentant fiancée presents herself to her parents in this manner) – 1796-97 – Verso of B.89 – I – No. (I) – GW 448

In its composition this drawing resembles B.87: a girl in the foreground, her feet touching the edge of the wash frame, stands out facing us in full light against a dark ground. Here the ground is divided in two by a diagonal and in the darker section we can make out the silhouettes of two old women. The betrothed, her eyes raised heavenwards, points with both hands to the fetters round her ankles. The old woman to the left is seemingly a nun detailed to keep watch over the youthful prisoner. Is she a " possessed" woman condemned by the Inquisition? Or rather a novice – they were termed *novias* according to Blanco White (Bibl. 79, p. 197) – guilty of some grave sin against religion or the community of which she is about to become a member?

B.93 [94] p. 121

Conocelos el aceitero y dice ¿Ola? y empieza/a palos con las mascaras//ellos huyendo, claman la injusticia del poco respecto a su representación (P) (The oil vendor recognizes them, and cries "Hey!" and begins to cudgel the masqueraders; they, fleeing, protest the injustice of such lack of respect for their performance) – 1796-97 – 235 × 146 – I – No. (I) – No. add. 17 (fine P) upper r. corner – *Paper:* vertical chain lines (26-27 mm) – Mounted on pink paper – *Hist.:* Javier Goya; Mariano Goya; V. Carderera; F. de Madrazo; Venice, Mariano Fortuny y Madrazo (Fortuny album) – New York, Metropolitan Museum of Art, Harris Brisbane Dick Fund, 1935 (35.103.17) – GW 449

This is the second drawing in this album that shows us asses dressed in tail-coats, symbolizing the stupidity and pretentiousness of mankind. A peasant, armed with his common sense and a thick stick, is not at all intimidated by their lordly airs and graces. A third ass, not in fancy dress, sits in the background watching the scene. Behind him we can see a wooded landscape.

B.94 [95] p. 122

Manda q.ᵉ quiten el coche, se despeina, y/arranca el pelo y patea//Porq.ᵉ el abate Pichurris, le à dicho en sus ocicos q.ᵉ/estaba descolorida (P) (She orders them to send away the coach, spoils her coiffure, tears her hair and stamps. Because Abbé Pichurris told her to her face that she was pale) – 1796-97 – Verso of B.93 – I – No. (I) – No. add. 16 (fine P) upper r. corner – New York, Metropolitan Museum of Art, Harris Brisbane Dick Fund, 1935 (35.103.16) – GW 450

Goya undoubtedly witnessed this scene, but today there is no possibility of identifying the participants.

At all events, attempts to identify the woman as the Duchess of Alba must be rejected out of hand.

Lost Drawings

B.91 – *Borricos de Mascara* – 230 × 140 – I – **B.92** – *Fatal desgracia* – Verso – I – *Hist.:* Paris, Paul Lebas; APs. Paris, H.D. 3.4.1877, No. 68 "Ils sont très satisfaits de passer pour des hommes grands" (They are very gratified to be taken for big men). On the verso "Fatale disgrâce" → E. Calando (37 fr.); Ps. E. Calando, Paris, H.D. 11-12.12.1899, No. 67 → (160 fr.)

There is no difficulty in identifying this sheet in the two sales because of the title *Fatal desgracia* on the verso, translated literally in the 1877 catalogue and quoted in Spanish in the Calando catalogue of 1899. However, their collocation in the two empty places 91 and 92 in the Madrid album is based on more complex considerations. Starting out from a note in the Calando catalogue, which gives the autograph numbers of the eighteen drawings in the collection bought at the 1877 sale, it was easy to establish which corresponded to which in the two sales and to infer that No. 67 in the Calando sale was the only one that could possibly be Goya's No. 91. One cannot help noting the very fanciful title given in 1877 to the recto of this sheet. The expert, unable to translate the autograph inscription, contented himself with a descriptive title in a style obviously quite different from Goya's. The measurements are those mentioned in the Calando catalogue.

B.a/b – "La Déclaration" – Verso: « Le Collier » – *Hist.:* Paris, Paul Lebas; APs. Paris, H.D. 3.4.1877, No. 70 → Pascal (31 fr.)

The titles given in the 1877 catalogue do not match any of Goya's. One must therefore infer that this sheet belonged to the first part of the Madrid album, before No. 55.

B.c/d – "La Toilette" – Verso: "Conversation" – *Hist.:* Paris, Paul Lebas; APs. Paris, H.D. 3.4.1877, No. 71 (bought in for 25 fr.)

See remarks on sheet a/b.

B.e/f – "S'éveille d'un long sommeil et s'effraie" (Awakens from a long sleep and takes fright) – Verso: "Feint d'être endiablée pour qu'on la conduise à la cérémonie de la Fête-Dieu" (Pretends to be possessed in order to be taken to the Corpus Christi ceremony) – *Hist.:* Paris, Paul Lebas; APs. Paris, H.D. 3.4.1877, No. 74 (bought in for 41 fr.)

Unlike those on the two previous sheets, the titles given in the 1877 catalogue are apparently translations of captions by Goya. If this is true, the two drawings should belong to the second half of the Madrid album. Considering the order ascribed by the 1877 catalogue to the drawings in that album from No. 72 (B.55/56) on, I suggest that the sheet B.e/f should fill the empty place B.73/74.

Unfinished Album (D)

Introduction

It is Harry B. Wehle who deserves credit for having identified this album, which gives rather the impression of being a poor relative in the great family of Goya's albums (Bibl. 186, p. 11). On examining the Fortuny album, which had just been purchased by the Metropolitan Museum, New York, he recognized at a glance, after the self-portrait frontispiece, the two impressive groups of eight sheets of the Madrid album (then called the Large Sanlúcar album in accordance with Sánchez Cantón's terminology), and the twenty-nine splendid sepia wash drawings from Album F. There remained four drawings in Indian ink wash. Two of them were easily recognizable by their obviously larger format and especially by the thick black ink lines drawn with a ruler to frame the subject. Mayer had already called attention to the existence of this suite, known as the "black border series" (Bibl. 143), and the discovery of two new sheets of the finest quality served to confirm his idea. But what of the last two? Since the drawings are on only one side of the sheet, they could not possibly belong to the Madrid album though, as Wehle had already observed (ibid., p. 6), the quality and size of the paper are identical in both. Moreover, the handling points clearly to a later period in Goya's *œuvre,* rather close to that of the black border series. They could not, however, be integrated with these because of the different format and the absence of an original border. At that point Wehle noticed that the Metropolitan Museum already possessed a drawing, D.20, purchased in 1919, that displayed all the features of the two sheets whose classification was proving such a tough problem. He suggested, therefore, that all three had been torn out of the same album – or "sketchbook", as he called it – dating it to about 1815 by reason of the technique, which he considered earlier than that of the sepia suite.

In 1954, I re-examined the drawings in the Louvre, which Mayer had studied all too cursorily (Bibl. 146). I noticed that three important sheets (D.2, D.18 and D.b) tallied exactly in both style and technique with Wehle's small group. The album was beginning to achieve a certain consistency, due to the striking regularity with which the various graphic elements were distributed on the surface of the page: the autograph number, top centre, traced with brush and brown ink (sepia) and the caption in black crayon beneath the subject. When I published the three drawings in the Louvre, I reported the existence of D.22, *La madre Celestina* (Old Mother Celestina), which I had seen in a private collection in Paris, of D.15, *Sueño de buena echizera* (Dream of a good witch) belonging to the Berlin Museum, at that time reordered at Baden-Baden, and of some drawings in the National Library, Madrid, which I saw as part of the same suite. This brought the number of those drawings close on a dozen, but the number 22 seemed to indicate that others might still be discovered. In 1970 I succeeded in listing and reproducing seventeen (GW 1368-1384) and since then, the publication of the 1877 sale catalogue (Bibl. 34 and 99) revealed the existence of five more, only one of which has recently reappeared on the Paris market (Bibl. 34 and 99). This is D.21, reproduced here by courtesy of Juliet Wilson. On the other hand, one of the drawings in the National Library, Madrid (GW 1381), is now classified in album C because it presents the essential features of that series.

This means that, at present, seventeen drawings of album D are known, only eleven of which still display an autograph number. Ten of the eleven vacant places may have been initially occupied by the six sheets now without numbers and the four "phantoms" of the 1877 sale. This all depends, of course, on the fact of Goya's

not having given any drawing a number higher than 22. Be that as it may, album D is a very slender volume compared with the others. In fact, the Madrid album has a No. 94; album C, a No. 133; album E, a No. 50; album F, a No. 106; album G, a No. 60; and album H, a No. 63. This would not be of any great interest were it not that in combination with other elements it allows us to envisage an extremely attractive hypothesis which would help us follow the evolution of Goya's art after the *Caprichos*.

It is easy to see that the drawings in album D were done on the same, probably Dutch, paper as those of the Madrid album. Wehle already noticed this, and since then a study of the watermarks has confirmed it. Furthermore, I would point out here that some sheets have the top right-hand corner rounded as we saw in the Madrid album (cf. D.13, where this detail is very clear). This proves that they were the leaves of an album and not loose sheets, which are always cut at right angles. Lastly, on analysing the subjects, as I have done in the notes, we find that many of the themes were treated at the time of the *Caprichos*; first of all, the airborne figures of D.2, D.3, D.4 and D.a; secondly, the witches – particularly the one in D.15, which is very close to *Caprichos* 44 and 45, and still closer to the pictures of witches painted for the Duchess of Osuna (cf. the witch on the left in GW p.122) – lastly, the repetition in two of the captions (D.15 and D.a) of the word *sueño*, which calls to mind the title Goya gave in 1797 to the first group of *Caprichos* (cf. introduction B).

The sum of these observations led me to the idea that Goya may have done this score or so of drawings on the last unused leaves of the Madrid album when he started working again on his own account a few years later. At that time he was definitively disgusted by the Court intrigues after the unmerited disgrace of most of his friends and the rather obscure circumstances of the Duchess of Alba's death in 1802. Between 1800, when he painted *The Family of Charles IV* (GW pp. 150-151) and the summer of 1803, when he ceded the copper plates of the *Caprichos* to the Calcografía Real in Madrid, Goya's situation seriously deteriorated. His closest friends were politically compromised and exiled. Urquijo, Prime Minister since 1798, had been dismissed and imprisoned in December 1800; Ceán Bermúdez went off to Seville again in 1801, at the same time as Jovellanos, the best friend of all, was banished to Majorca and imprisoned in Bellver Castle until 1808. Goya himself received no further commissions from the Court and, as he said in a letter written at Bordeaux many years later, it was under threat of being denounced to *la Santa* (the Inquisition) that he gave the king the plates of the *Caprichos* and the unsold sets of prints in exchange for an annuity of 12,000 *reales* for his son Javier. The man who had been the First Painter of the Chamber since 1799 was now ousted and virtually sent into retirement. The death of the Cayetana, carried off at forty by a mysterious ailment, was undoubtedly a serious shock: Goya must have felt that the last great joys of his life were buried with her. He was nearly sixty and already obsessed by old age and its attendant physical miseries. His professional life, too, had a bitter disappointment in store. In 1804, as a candidate to the post of Director General of the Academy of San Fernando he received only eight votes, while his lifelong rival Gregorio Ferro was elected with twenty-nine. In a word, his career as official painter, with all its commissions and obligations, was over.

It must have been during those years 1801-03 that Goya began to draw again during the long intervals of idleness between the rare orders for portraits he still received. Dipping his brush in Indian ink, he gave his fancy, his "caprice", a free rein. But he could rely on the extraordinary experience he had gained from 1797 to 1799 in the execution of the *Caprichos*. We have already seen how rapidly his use of wash developed all through the Madrid album and how, as Carderera said, "in the last leaves of this suite we can see by degrees that Goya took pleasure in heightening the effect of chiaroscuro in his compositions." But the change in handling was due most of all to the enormous mass of preparatory studies for the prints and to his complete mastery of aquatint effects. Starting out from the Madrid album, where he used Indian ink wash, he did a series of *Sueños* with pen and sepia ink, but he frequently repeated the same design in red chalk and sanguine wash. In the end, however, it was the long hours of work on each plate that gave him an unrivalled mastery in the treatment of forms immersed in light and shade.

D.2, the very first drawing of album D in its present state, displays a handling infinitely suppler than the last pages of the Madrid album. In place of the rather dry contour lines in B.87, B.88, B.93 and others, we find a quivering line that is entirely new. Comparing, for instance, the starchy white, almost undifferentiated dress of the young women in B.87, B.90 and B.94 with the garments of the two witches in this D.2, one might almost doubt that they were the work of the same hand. Here the materials are so soft and supple that we can feel the air flow around the two figures and their flight seems almost natural.

Another innovation that had a decisive impact on all Goya's future album drawings was that he now drew on only one side of the sheet. This means that he considered each drawing as a work of art in its own right,

Fragment of B.I *Fragment of B.II* *Fragment of B.III*

almost like a picture for hanging on the wall. And if he did not continue this series starting on another album of the same type, it was because he no longer accepted the compromise between album and picture. All he could do was use the separate sheets as a painter takes one canvas after another to paint a suite of subjects. It is in album D that we first find groups of several drawings linked by a common theme. In this it contrasts with the Madrid album where, as you may recall, such bonds were quite rare and never extended beyond the two sides of the same leaf. Here, to start with, we have the group of airborne figures: D.2, D.3, D.4, probably D.a and perhaps the lost D.j, which in 1877 was entitled "Down they come". There follows a coherent group of mean-looking old women: D.18, 20, 21, 22, D.d and D.e; and lastly three scenes of witchcraft: D.15, D.b and D.f. For the drawings whose autograph numbers have disappeared, either because they were effaced or because the sheet was cut down, such groupings are obviously hypothetical, and there is always a possibility that the sheets dealing with a given theme did not follow each other in numerical order. Indeed, this may have been one of the reasons why Goya gave up bound albums in favour of loose leaves which could be easily grouped after the drawings were done and numbered on the basis of their thematic affinity.

I have one more remark to make in connection with this album; it concerns Goya's method of composition. A striking feature of the drawings in the second half of the Madrid album is the growing complexity of their composition. The figures, either linked or separated by their different feelings, increase in number; this is accompanied by a parallel enrichment of the backgrounds. These latter range from a plain rectangle in ink wash (B.44, B.46, B.50, B.56, B.58, B.66 etc.) to light and dark planes clearly defined by doors or windows (B.61, B.70, B.71, B.76, B.78, B.84 etc.). I have already pointed out that the important part played by these wash backgrounds seems closely connected with the aquatint backgrounds that Goya brought to a peak of perfection in the *Caprichos*. In other words, many of the drawings in the Madrid album were conceived in terms of the series of prints Goya was engaged on at that time.

In album D, instead, he has apparently reverted to an extreme simplicity of composition. There are few figures, often indeed only one (D.11, D.13, D.15, D.18, D.21, D.22, D.c, D.e) and, except for D.7, the paper provides the plain white background. At most we can observe the shadow cast by the figure on the ground and a few sparse "attributes" scattered round it (D.3, D.22, D.b). Should we view this as a retrogression and infer that Goya has fallen back on the simplicity of some of the drawings in the Sanlúcar album and the first part of the Madrid album? In my opinion, the opposite rather is true. After the encumbered backgrounds of the last drawings of that suite and the plates for the *Caprichos*, he concentrated entirely on the characters and used the same means to render their inner complexity and the dullness of their lives on the physical and moral planes. What we find here is less a new style than a totally new vision of man crystallized in these beings, pitiable and grotesque, and profoundly marked by life.

Paper: Strong, slightly bluish, laid; vertical chain lines at 26-30 mm intervals. Identical with paper of album B.

Watermark: Identical with those of album B.

Maximum sheet size: 237 × 147 mm.

Drawings: On recto only.

Technique: Brush and Indian ink wash. Traces of black crayon and pen.

Captions: In black crayon at the bottom of the sheet.

Goya's numbers: With brush and sepia wash, at top center of sheet. Highest number: 22. (Catalogued: 17).

Additional numbers: numbers written by Javier Goya with fine-point pen, very carefully.

> *Fortuny album*: at top right-hand corner, followed by period (D.7, D.13).

> *Album I sold in 1877*: at top right-hand corner, underscored with rounded pen and followed by period.

> *Album II sold in 1877*: at top centre, next to Goya's number, followed by period as in the Fortuny album (D.3, D.11, D.15, D.18, D.21, D.22).

> Sheets D.2, D.a, D.b and D.c, on which the later numbers have disappeared, were sold in 1877.

BIBLIOGRAPHY

Exhibitions: 2, 16, 17, 19, 20, 22, 27.

Public sales: 34, 42, 43, 46, 61, 63, 66.

Authors: 76, 86, 94, 97, 99, 106, 143, 146, 176, 184, 186.

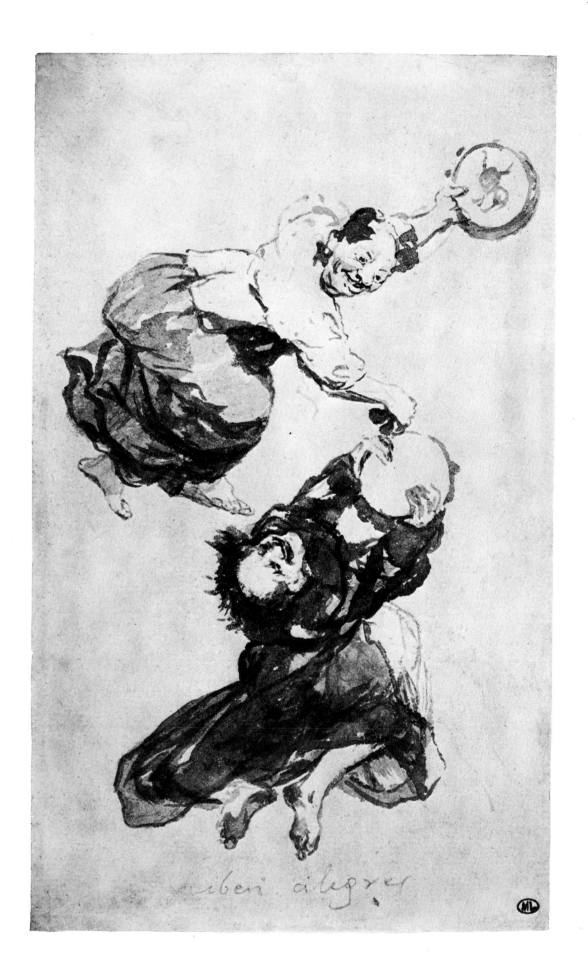

viben alegres

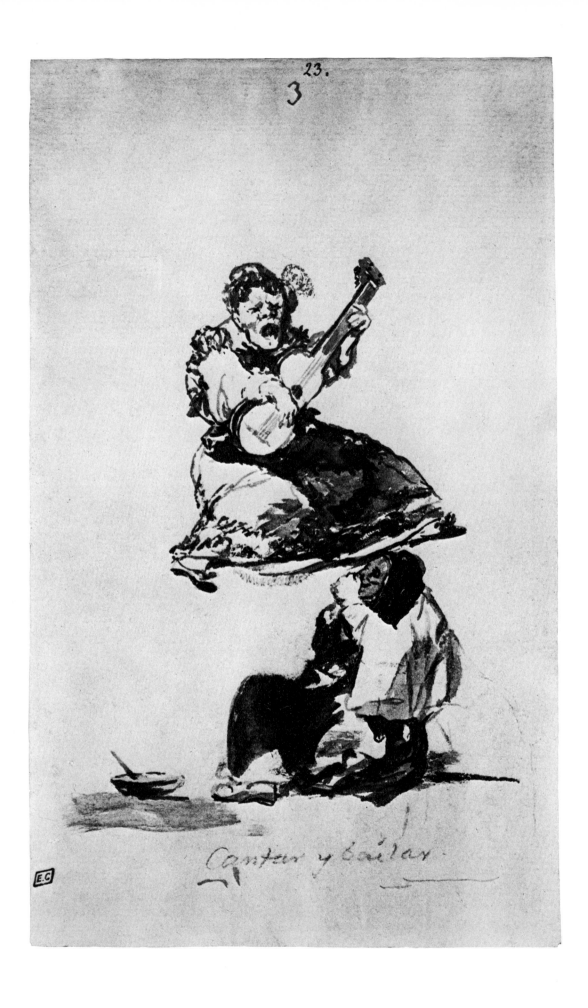

4

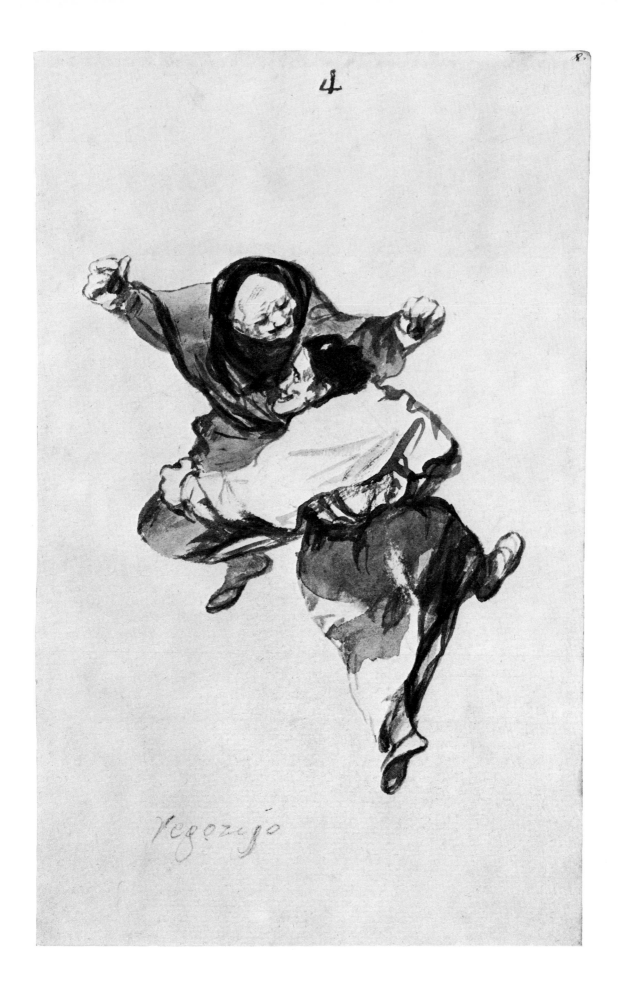

Regozijo

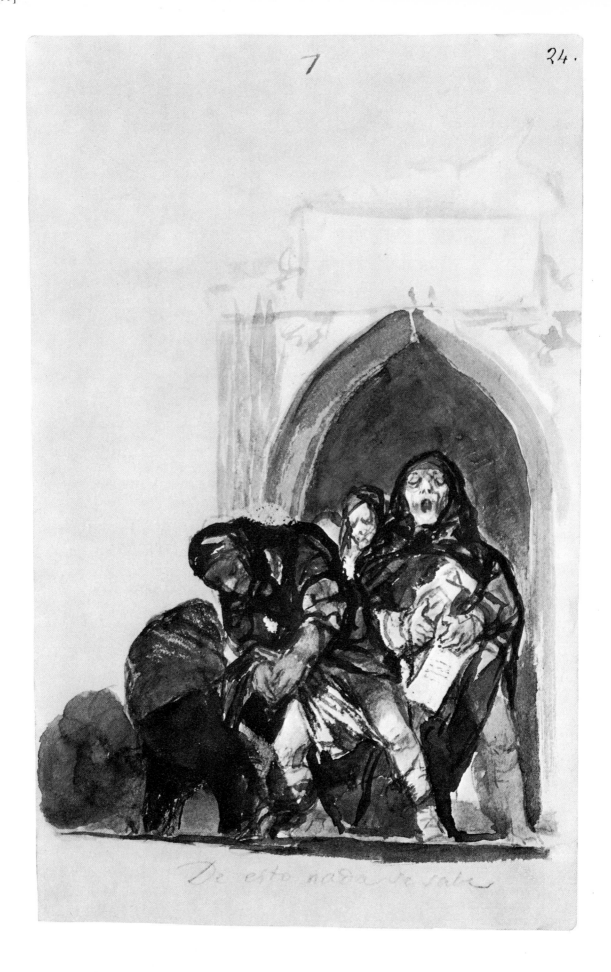

De esto nada se sabe

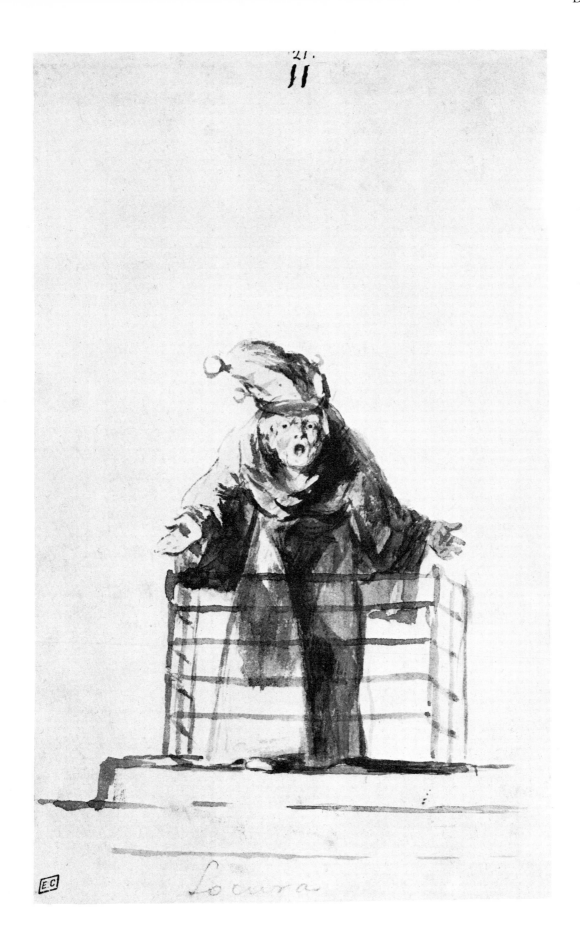

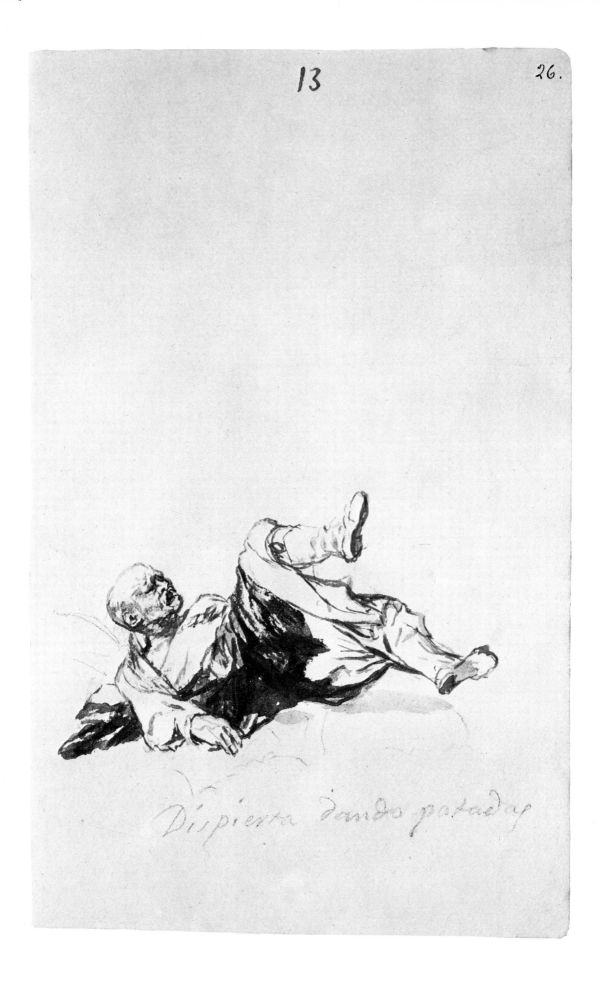

Dispierta dando patadas

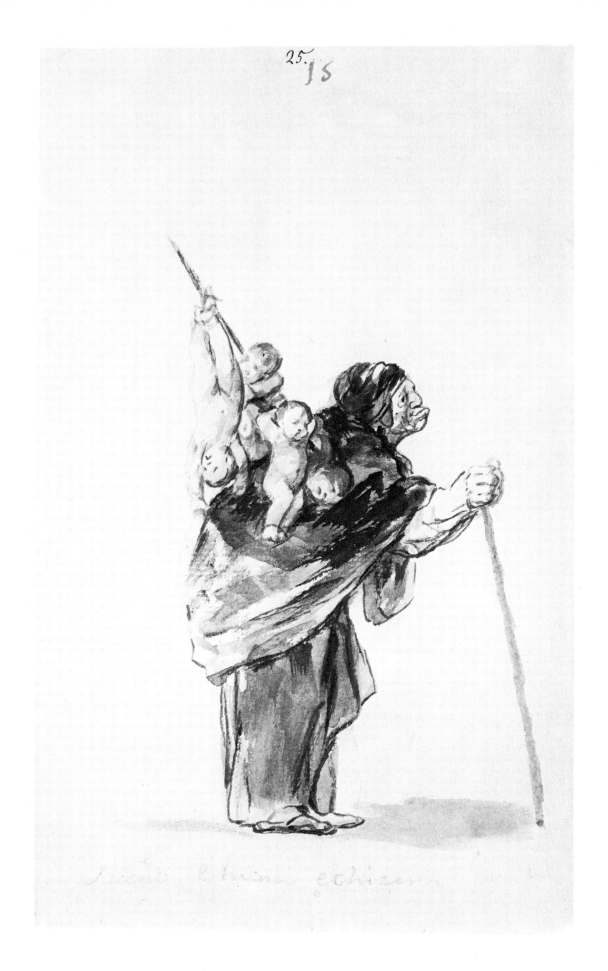

D.18 [103]

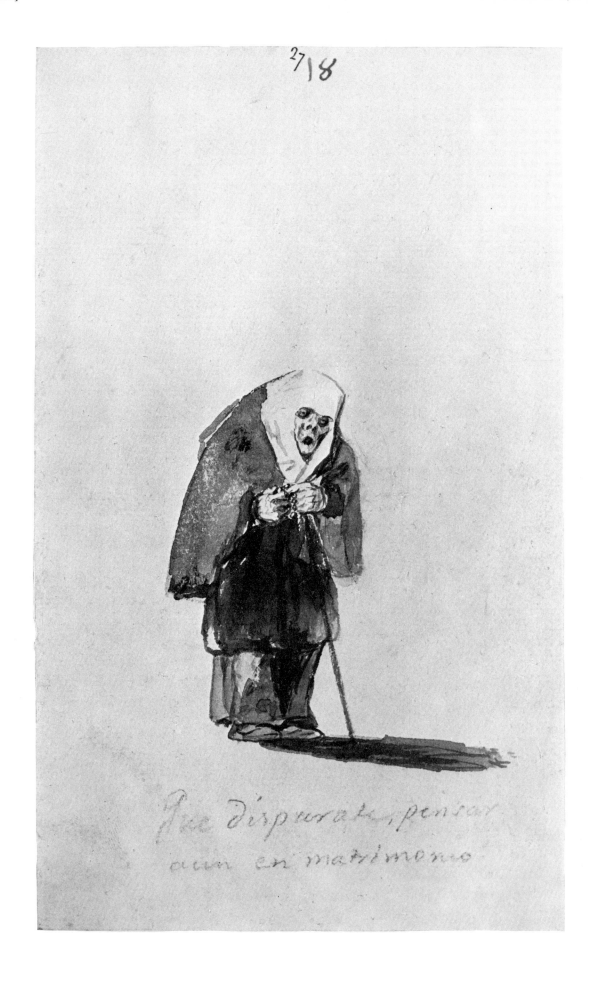

150

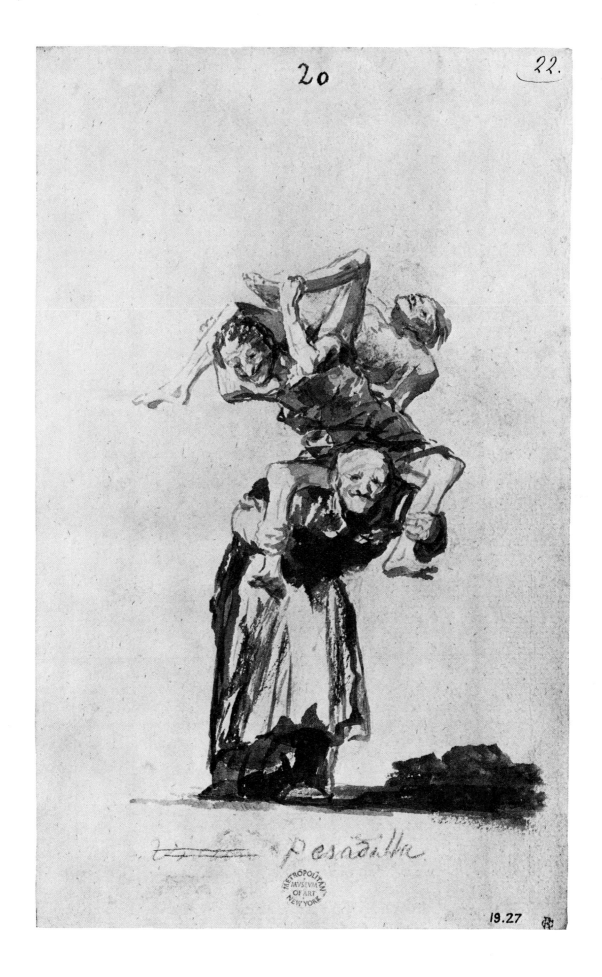

20

22.

Pesadilla

19.27

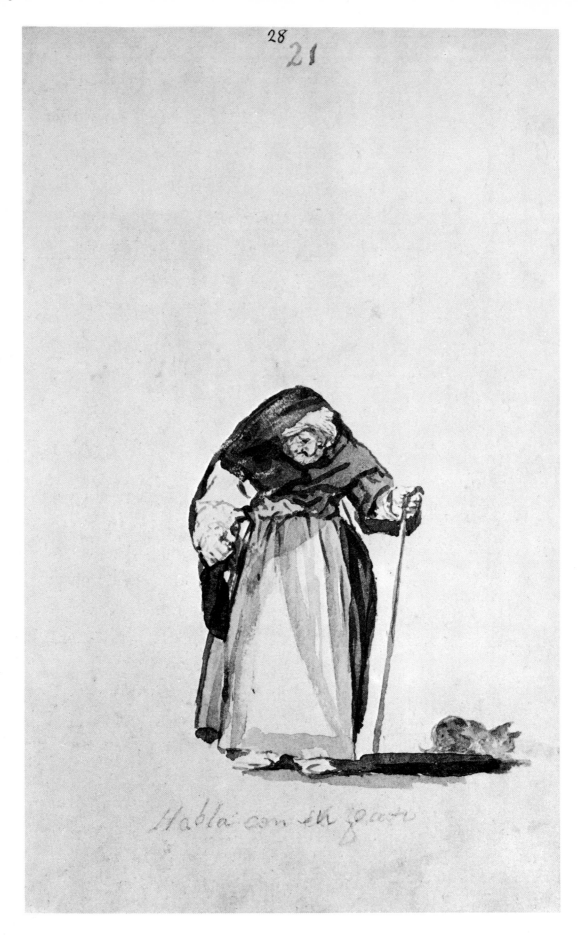

Habla con el gato

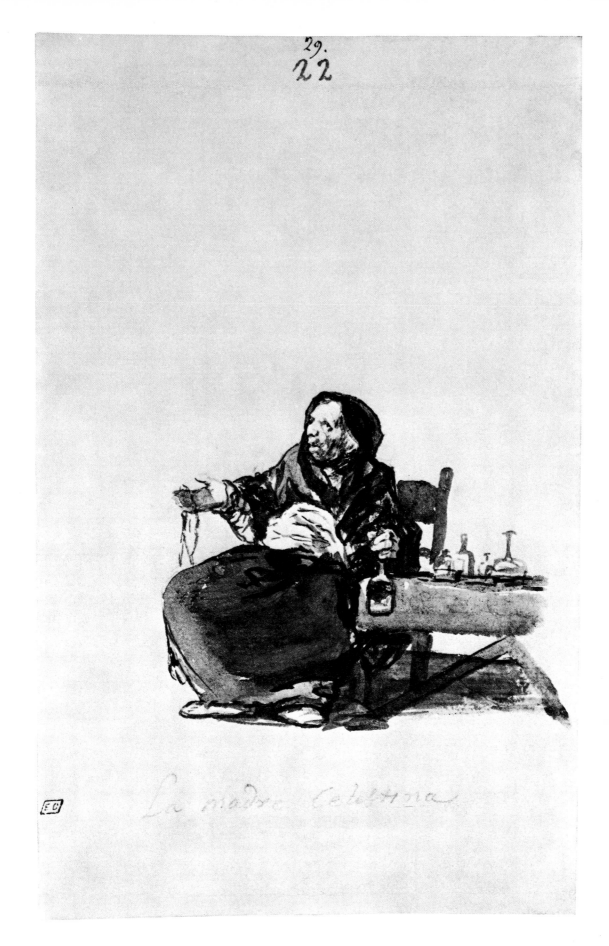

La madre Celestina

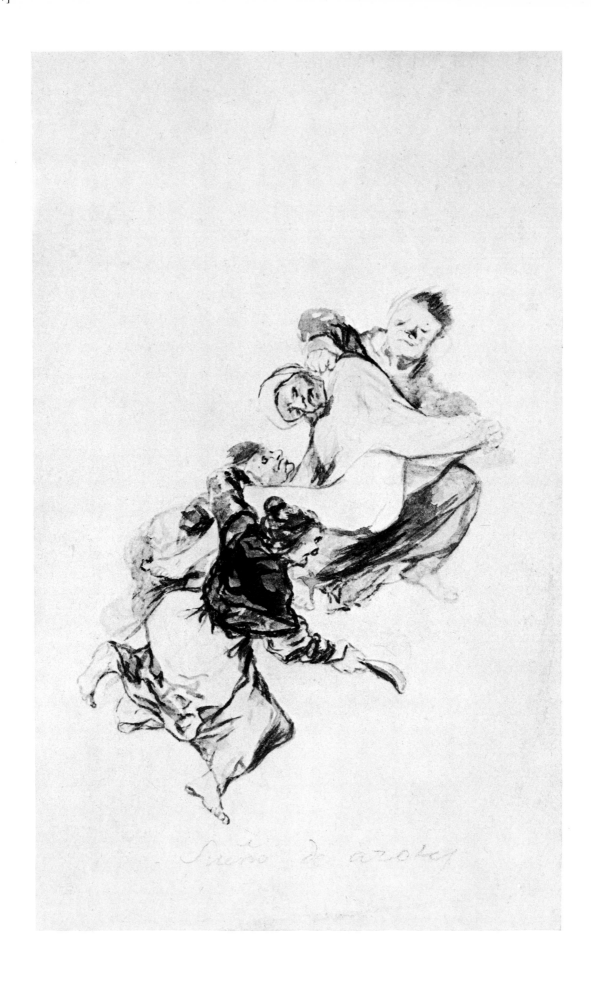

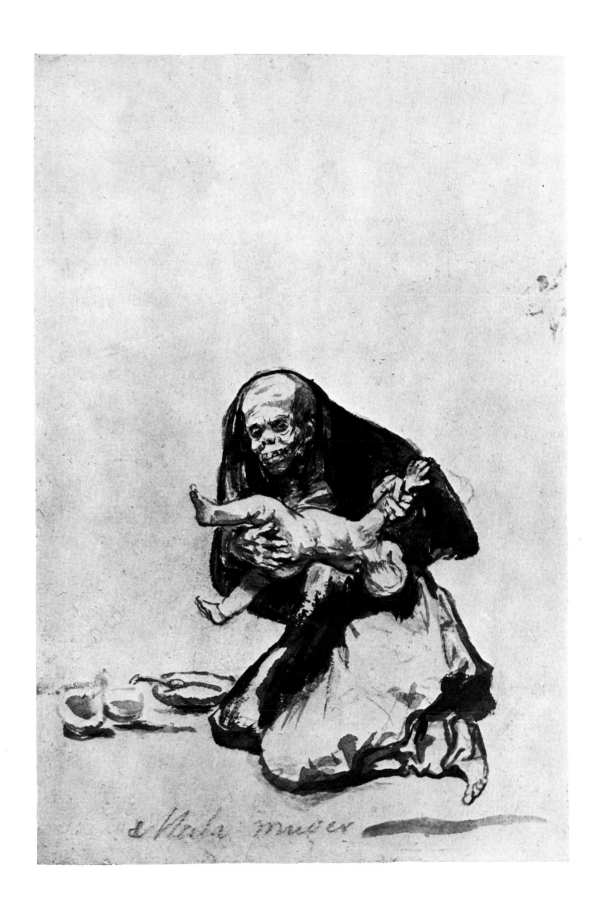

155

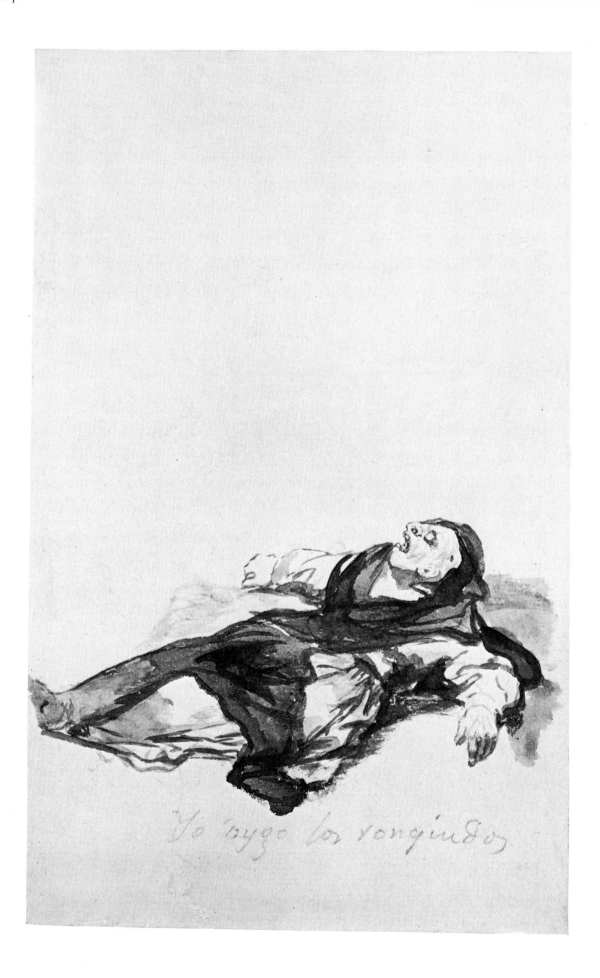

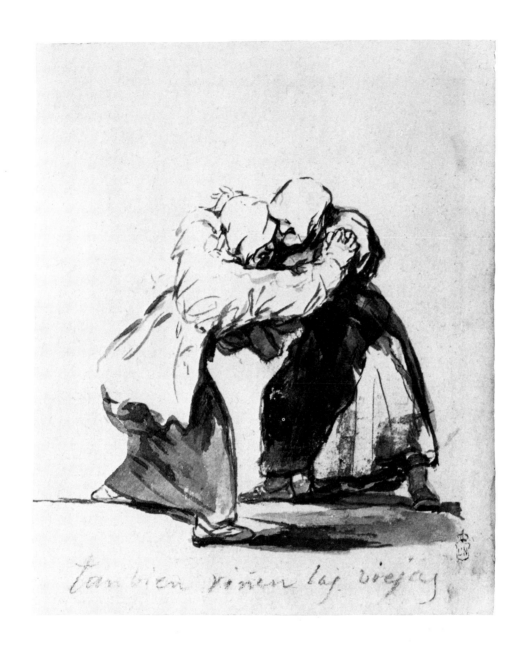

Tanbien vienen las viejas

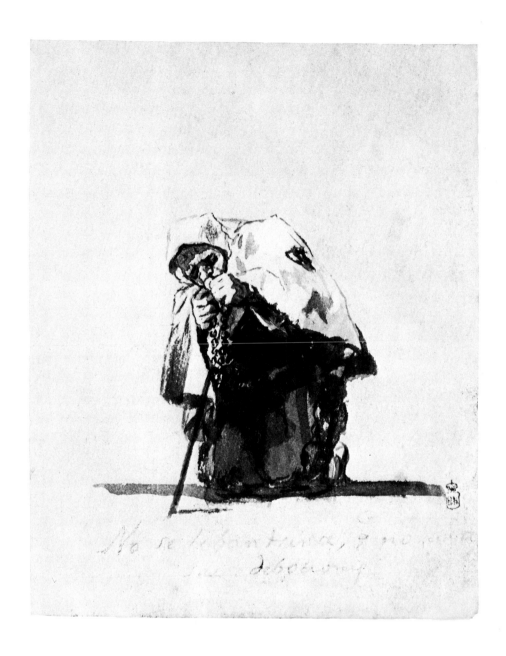

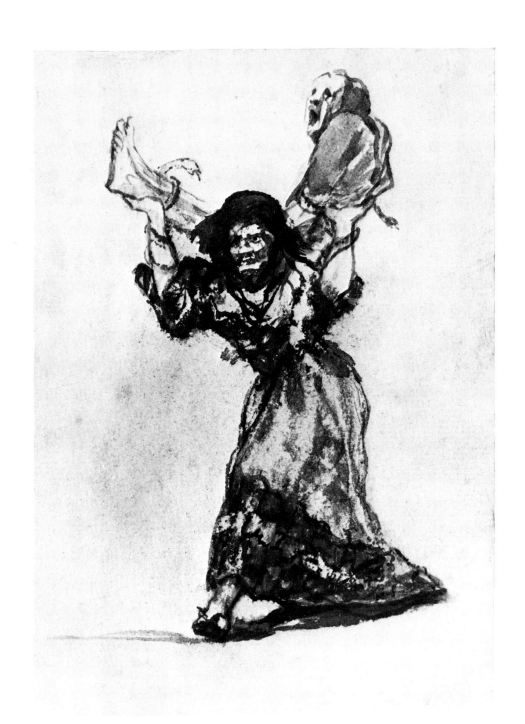

Unfinished Album (D)

Captions and Commentaries

D.2 [96] p. 143
Suben alegres (Lp) (They rise up joyfully) – 1801-03 – 233 × 139 – I – No. almost erased – *Paper :* vertical chain lines (27 mm) – *Hist. :* Paris, Paul Lebas ; APs. Paris, H.D. 3.4.1877, No. 85 "Ils montent joyeux" → E. Calando (26 fr.) ; Paris, Thomsen → 1950 – Paris, Louvre (29772) – GW 1368

Four of the drawings in this album represent flying figures. They are D.3, D.4, D.a and this one, which forms a uniform group with the first two. There is reason to believe that the fourth, whose number has been erased, was positioned close to the others. The same may be said of a drawing now lost which was sold in 1877 as No. 87 with the title "Ils descendent" (Bibl. 99, p. 116). But it is D.4 belonging to the Hispanic Society of America that is closest to this one, which shows two laughing witches playing tambourines and castanets as they fly away, their skirts ballooning in the wind. There is no trace of background. M. Thomsen, who owned the drawing at the time, told me that the number written in the artist's hand disappeared when the drawing was washed before 1950 ; today it is again visible on sufficiently contrasted photographs.

D.3 [97] p. 144
Cantar y bailar (Lp) (Song and dance) – 1801-03 – 235 × 145 – I – No. (S) – No. add. 23 (fine P) upper centre – Stamp E.C. (Lugt 837) – *Paper :* vertical chain lines – *Hist. :* Paris, Paul Lebas ; APs. Paris, H.D. 3.4.1877. No. 22 "Chanteuse et Danseuse" → E. Calando (19 fr.) ; Ps. Calando, Paris, H.D. 11-12.12.1899, lot 75 (215 fr. the lot of 3 drawings) – London, Count A. Seilern – GW 1369

In this drawing an old witch floats through the air playing the guitar, while her companion, seated laughing on the ground, holds her nose, her face upturned towards the other's amply outspread skirts. The repulsive guitar-player is dressed like a gipsy with a flower in her hair, as though this flying – and consequently unreal – figure were the image of an out-dated world and its long-lost pleasures. The earth is hinted at by a few shadows touched in with the brush. There is not the slightest trace of a background.

D.4 [98] p. 145
Regozijo (Lp) (Mirth) – 1801-03 – 237 × 147 – I + red Cr – No. (S) – *Paper :* vertical chain lines – Mounted on pink paper, upper right corner rounded – *Watermark :* fleur-de-lis (B.I) – *Hist. :* Javier Goya ; Mariano Goya ; R. Garreta ; F. de Madrazo ; R. de Madrazo y Garreta ; A. M. Huntington → 1913 – New York, Hispanic Society of America (A.3308) – GW 1370

This drawing shows still more clearly than the first two of this album how greatly Goya's technique had evolved in the interval since the Madrid album. There one could not help noting a certain stiffness and dryness in the handling of the human figures ; here it has given way to an extraordinarily flexible brush-work with heavy strokes and broad areas of wash that gives this airborne ballet the ease and lightness of a dream. The scenes of flying witches in *Caprichos 61, 62, 66* and *68* have a background and in some cases a well-defined landscape that give the impression of reality. Here, on the contrary, as in D.2 in the Louvre, all we see is the vast empty space of the white page.

D.7 [99] p. 146
De esto nada se sabe (Lp) (Nothing is known of this) – 1801-03 – 236 × 146 – I – No. (S) – No. add. 24 (fine P) upper

r. corner – *Paper:* vertical chain lines – Mounted on pink paper – r. corners rounded – *Hist.:* Javier Goya; Mariano Goya; V. Carderera; F. de Madrazo; Venice, Mariano Fortuny y Madrazo (Fortuny album) → 1935 – New York, Metropolitan Museum of Art, Harris Brisbane Dick Fund, 1935 (35.103.24) – GW 1371

The diagonal composition so common in the Madrid album recurs here, but without the shaded wash ground. Solidity is the keynote, from the pointed arch of the doorway to the chanting monks who carry out what appears to be the body of a woman. Note the effect of strain conveyed by the figure in the foreground.

D.11 [100] p. 147
Locura (Lp) (Madness) – 1801-03 – 225 × 140 – I – No. (S) – No. add. 21 (fine P) upper centre – Stamp E.C. (Lugt 837) – *Paper:* vertical chain lines – *Hist.:* Paris, Paul Lebas; APs. Paris, H.D. 3.4.1877, No. 20 "Il le guérit" (sic) → E. Calando (13 fr.); Ps. Calando, Paris, H.D. 11-12.12.1899, lot 75 (215 fr. the lot of 3 drawings); Paris, Camille Groult; Paul Brame; New York, Paul Rosenberg & Co – New York, E. V. Thaw coll. – GW 1372

This old man standing behind a sort of railing on a platform reached by a number of steps might be a fairground showman addressing the crowd, some sort of quack, or a buffoon in a fool's cap. But his face wears a fixed expression of woe that has nothing to do with caricature. His gesture and his odd costume also put one in mind of a preacher. The title says simply: "Folly" – not "Il le guérit" (He cures him), as indicated in the catalogue of the 1877 sale, due to a mistaken reading of "Lo cura" for "Locura" – another instance of Goya's fondness for ambiguity.

D.13 [101] p. 148
Dispierta dando patadas (Lp) (He wakes up kicking) – 1801-03 – 236 × 146 – I – No. (S) – No. add. 26 (fine P) upper r. corner – *Paper:* vertical chain lines (26 mm) – Mounted on pink paper – *Watermark:* fragment of shield (B.II) – rounded corners r. – *Hist.:* Javier Goya; Mariano Goya; V. Carderera; F. de Madrazo; Venice, Mariano Fortuny y Madrazo (Fortuny album) → 1935 – New York, Metropolitan Museum of Art, Harris Brisbane Dick Fund, 1935 (35.103.26) – GW 1373

Another old man lying on the ground, his face contorted with pain. The artist has caught with amazing skill the effect of foreshortening, as he struggles at the moment of awakening to free his legs from the coverlet in which they are entangled. In this simple composition, interest is focused on the single figure.

D.15 [102] p. 149
Sueño de buena echizera (Lp) (Dream of a good witch) – 1801-03 – 234 × 144 – I – No. (S) – No. add. 25 (fine P) upper centre – *Paper:* vertical chain lines – *Hist.:* Paris, Paul Lebas; APs. Paris, H.D. 3.4.1877, No. 24 "Une bonne enchanteresse" → de Raincy (30 fr.); A. Strolin → 1907 – Berlin-Dahlem, Kupferstichkabinett (4396) – GW 1374

Of all the drawings in this album this is the one that most closely resembles the themes of witchcraft treated in the *Caprichos* and in the six paintings executed during the same period for the Duchess of Osuna's study (GW 659-664). This witch is very like one in the *Aquelarre* of the Museo Lazaro, Madrid (GW 660), with a bunch of new-born babies slung from a stick. See too *Caprichos 44* and *45*. Edith Helman has proved beyond doubt (Bibl. 106, pp. 112-113) that Goya got his inspiration from the *auto-da-fé* at Logroño in 1610. Moratín had begun a commentary on it in 1797 – the very year Goya was working on the *Caprichos*.

D.18 [103] p. 150
Que disparate, pensar/aun en matrimonio (Lp) (What folly to be still thinking of marriage!) – 1801-03 – 234 × 144 – I – No. (S) – No. add. 27 (fine P) upper centre – *Paper:* vertical chain lines (27 mm) – *Watermark:* shield with bend (B.II) – *Hist.:* Paris, Paul Lebas; APs. Paris, H.D. 3.4.1877, No. 26 "Quelle sottise! penser encore au mariage" (bought in); Ps. G. Poelet, Paris, H.D. 19.6.1906; Cosson coll.; Cosson Bequest → 1926 – Paris, Louvre (6913) – GW 1375

The commonplace *Celestina* of the Madrid album, with her stick and rosary beads, has become a poor old woman, alone in the world as she is alone on the sheet of paper. Her folly is still to think of getting married. She appears a second time in this album in D.f and has her male counterpart in the old man of E.49.

D.20 [104] p. 151
Pesadilla (Lp) (Nightmare) – The original title *Vision* was crossed out with two horizontal lines – 1801-03 – 234 × 145 – I – No. (S) – No. add. 22 (fine P) upper r. corner – Stamp E.R. (E. Rodriguez) (Lugt 897) – *Paper:* vertical chain lines (27 mm) – *Watermark:* fragment of shield (B.II) – *Hist.:* ? Paris, Paul Lebas; APs. Paris, H.D. 3.4.1877, No. 78 "Le Cauchemar" → E. Féral (21 fr.); E. Rodriguez coll.; New York → 1919 – New York, Metropolitan Museum of Art, Rogers Fund (19.27) – GW 1376

This drawing, purchased by the Metropolitan Museum on the New York art market in 1919, was not part of the Fortuny album, which explains how in all probability it appeared in the 1877 sale under the undeleted title. The diabolical figures heaped one above the

other recall certain *Caprichos* (notably *65, 70* and *77*) but are closer to human experience than to anecdotal witchcraft.

D.21 [105] p. 152
Habla con su [el] gato (Lp) (She talks with her [the] cat) – 1801-03 – I – No. (S) ? – No. add. 28 (fine P), top centre – *Paper:* ? – *Hist.:* Paris, Paul Lebas; APs. Paris, H.D. 3.4.1877, No. 27 "Elle parle avec un chat" → Fiantance (or Fontaine?) (11 fr.) – France, priv. coll.

This is the first "phantom sheet" to turn up on the Paris art market since the publication of the 1877 sale catalogue (Bibl. 34 and 99). A photograph of it has been kindly supplied by Juliet Wilson, who is preparing a documented article on this drawing. My previous assumptions concerning this sheet No. 27 of the 1877 sale, based on the tables of concordance which I worked out (see the specimen given at the end of the introduction to album E), have proved to be correct. Here, by way of curiosity, are the elements which I had to go on:

No. added (fine P) top centre	Goya's No.	1877 sale No.
25	D.15	24
(26)	?	(25)
27	D.18	26
(28)	(D.21)	(27)
29	D.22	28

Now that "phantom sheet" No. 27 has taken its due place between D.18 and D.22, it may be conjectured that No. 25 "A vision" corresponds to D.16 or D.17, both missing at present, and bears the number 26 inscribed by Javier Goya at the top centre of the sheet. As regards the subject of D.21, this old woman with a wizened face, bundled up in her clothes, harmonizes perfectly with D.18, D.22, D.e and D.f in this album, which represent very similar figures.

D.22 [106] p. 153
La madre Celestina (Lp) (Old Mother Celestina) – 1801-03 – 233 × 145 – I – No. (S?) – No. add. 29 (fine P) upper centre – Stamp E.C. (Lugt 837) – *Paper:* vertical chain lines – *Hist.:* Paris, Paul Lebas; APs. Paris, H.D. 3.4.1877, No. 26 (mistake for 28) "La Mère Célestine" → E. Calando (15 fr.); Ps. Calando, Paris, H.D. 11-12.12.1899, lot 75 (215 fr. the lot of 3 drawings); Tony Mayer coll.; Ps. Tony Mayer, Paris, H.D. 3.12.1957, No. 4 – Boston, Museum of Fine Arts, William Francis Warden Fund (59.200) – GW 1377

The *Celestina* shown in the performance of her traditional functions in the Madrid album has now become a devout old wine-bibber. Seated by her bottles, she is the very image of a distant past.

D.a [107] p. 154
Sueño de azotes (Lp) (Dream of a spanking) – 1801-03 – 233 × 142 – I – *Paper:* vertical chain lines (30 mm) – *Watermark:* B.III? – *Hist.:* Paris, Paul Lebas; APs. Paris, H.D. 3.4.1877, No. 87 "Rêve de maux" → E. Féral (20 fr.); Paul Meurice; APs. Paris, Gal. Charpentier, 9.4.1957, No. 2; London, Margaret H. Drey → 1961 – Chicago, Art Institute (1961.785) – GW 1378

Again the title *Sueño* appears in this album, thus connecting it once again with the *Caprichos* and in particular with the series of preparatory drawings entitled *Sueños* on which the prints were based. (See GW 460, 464, 473, 477, etc., but above all 576, 582, 584 and 588, which likewise represent groups of witches flying through the air.) Here the scene takes a comic turn owing to the presence of the poor man, white as a sheet, who dreams he is being lustily spanked by three sturdy witches. Compare with the spanking scenes in two other drawings, B.15 and F.74.

D.b [108] p. 155
Mala muger (Lp) (Wicked woman) – 1801-03 – 215 × 144 – I – Black frame by some other hand – *Paper:* vertical chain lines (27 mm) – Mounted on heavy paper – *Watermark:* fragment of a coat of arms (B.II) – *Hist.:* Paris, Paul Lebas; APs. Paris, H.D. 3.4.1877, No. 21 "Mauvaise femme" → Fiantance (?) (14 fr.); Ps. H. Lacroix, Paris, H.D. 27-29.1.1903, No. 216; Cosson coll.; Cosson bequest → 1926 – Paris, Louvre (6910) – GW 1379

Here again is the witchcraft theme that appeared in D. 15 of this album: the witch with a taste for new-born babies which she will offer to the "Grand Master", the Fiend. But this "wicked woman" may have some connection with the two sisters who poisoned their own children in order to offer them up to the fiend, and whose confession figured in the *auto-da-fé* at Logroño (Bibl. 106, p. 113). The dish and two glasses bear out this hypothesis. But the old woman's face is that of a death's head. Another indication of the artist's concern with the "tragic sense of life".

D.c [109] p. 156
Yo oygo los ronquidos (Lp) (I can hear the snores) – 1801-03 – 233 × 145 – I – *Paper:* vertical chain lines – *Hist.:* Paris,

Paul Lebas; APs. Paris, H.D. 3.4.1877, No. 23 " J'entends les ronflements " → E. Féral (10 fr.); A. Strolin → 1907 – Berlin-Dahlem, Kupferstichkabinett (4394) – GW 1380

In theme and composition this drawing links up with D.13 in this album and, assuming that a chronological sequence may exist between certain drawings in the same series, this sheet could be assigned to the position of D.12. A certain similarity between the faces (same nose and hairlessness) and clothes bears out this apparent connection. Neither of the two drawings has any setting: both figures are isolated in the lower half of the sheet on a ground level very sketchily indicated by a few patches of shadow. This drawing is noteworthy for Goya's use of the first person singular in the caption: "I hear . . .", thus adding an unexpected comic touch to the scene represented.

D.d [110] p. 157

Tan bien riñen las viejas (Lp) (The old women also fight) – 1801-03 – 152 × 123 – I + P – *Paper:* vertical chain lines – Very much recut – Lacks acquisition stamp of the Carderera coll. – *Hist.:* Javier Goya; Mariano Goya; V. Carderera – Madrid, Biblioteca Nacional (B.1256) – GW 1382

Any strict classification is made very difficult by the present state of this drawing: it has been drastically cut down and lacks both autograph number and watermark. Two positive elements, however, justify the assumption that it belonged to this album: the pencilled caption just under the subject and the vertical chain lines characteristic of albums A, B, D and E. In style and composition, moreover, it fits in perfectly with the previous drawings: the two old women stand out against the blank sheet, and the ground level is sketched in with a single stroke to the left and a few shadows to the right. Clothes are handled broadly with free and easy strokes of the brush; one need only compare the tunic of the left-hand figure with the night-gown of the young woman in drawing B.87 of the Madrid album to see what a radical change has taken place in technique and, above all, in spirit.

D.e [111] p. 158

No se lebantara, q.ᵉ no aca [be]/sus debociones (Lp) (She won't get up till she's finished her prayers) – 1801-03 – 152 × 120 – I – *Paper:* vertical chain lines – Very much recut – Lacks the acquisition stamp of the Carderera coll. – *Hist.:* Javier Goya; Mariano Goya; V. Carderera – Madrid, Biblioteca Nacional (B.1257) – GW 1383

Here is the old *Celestina* with her traditional attributes (stick and rosary), but transformed now into a wretched and pathetic bigot. She is represented kneeling, all hunched up, wholly engrossed in her prayers. Here the world of *majas* and *petimetres* has vanished, leaving nothing but these moving glimpses of lonely old age. The composition has been stripped of non-essentials in order to set off the human figure to maximum effect against the white sheet of paper. Compare with D.18.

D.f [112] p. 159

"Unholy union" – 1801-03 – 176 × 127 – I – *Paper:* ? – *Hist.:* bought by M. Bercovici in Paris between 1924 and 1928 (sale of Comtesse de Noailles coll.?); New York, Miss Rada Bercovici; Ps. London, Sotheby, 1.12.1966 – New York, Lehman coll. – GW 1384

No information about this drawing is available. It appears to have neither caption nor autograph number. The title *Unholy union* was given to it when sold at Sotheby's, without any further details. It is placed here in album D for purely stylistic reasons. The similarity of its subject with that of D.20 is particularly striking: a witch bearing on her shoulders an old man who is bound to the fiendish crone with snakes. It might have borne a title like *Nightmare* or *Vision,* which would be well in keeping with this scene exemplifying the "sleep of reason".

Lost Drawings

D.g "A Vision" – *Hist.:* Paris, Paul Lebas; APs. Paris, H.D. 3.4.1877, No. 25 → E. Féral (10 fr. 50)

The present whereabouts of this drawing is unknown. It might be the one recorded in the archives of the Hispanic Society of America as having belonged to Philip Hofer and as bearing the caption " *Visiones*" (Visions).

D.h "Il n'en peut plus avec ses quatre-vingt-dix-huit ans" – *Hist.:* Paris, Paul Lebas; APs. Paris, H.D. 3.4.1877, No. 77 → de Beurnonville (48 fr.)

D.i "Another Nightmare" – *Hist.:* Paris, Paul Lebas; APs. Paris, H.D. 3.4.1877, No. 79 (bought back for 16 fr.)

D.j "Down they come" – *Hist.:* Paris, Paul Lebas; APs. Paris, H.D. 3.4.1877, No. 86 → E. Féral (20 fr.)

Black Border Album (E)

Introduction

It is difficult to be sure about the original size of the black border album as constituted by Goya, for out of the thirty-eight sheets that now remain eleven have no autograph number, while the highest number is 50. This is the album for which we have the largest quantity of unnumbered sheets; it is also the one for which, proportionally, we have the largest number of vacant places. Were some of these gaps occupied originally by the unnumbered drawings and the nine "phantom sheets" of the 1877 sale (E.k to E.s)? Or were there perhaps further numbers beyond 50? Unless some new discoveries are made, these questions will have to remain unanswered. Sticklers for precision and completeness at the expense of beauty may deplore the fact; personally I find it fitting that an aura of uncertainty and mystery should cling to these drawings, composed by Goya for himself and his friends in the privacy of his studio. Their intimate character is undeniable, for there is no evidence to show that in bringing these drawings together he had any intention of engraving them. On the contrary; it seems clear that the sets of drawings and the sets of prints developed on distinct though parallel lines, each set having its own techniques and its own aims. This parallelism, corresponding in Goya to two distinct concerns, has been dealt with more particularly in connection with the large album C in the Prado.

The present fragmentary state of the black border album is due to the fact that the sheets have been widely dispersed. The thirty-eight drawings catalogued here are now divided between thirteen museums and sixteen private collections, both in Europe and the United States, in contrast with the large albums like that of Madrid (B), that of the Prado (C) and F, G and H, from which several extensive lots have come down to us *en bloc,* thanks to the Fortuny album, the two early acquisitions by the Prado, the Hyadès-Boilly album and the Beruete-Gerstenberg series (cf. general introduction). Because its drawings were particularly fine and had been made into "framed" pictures by Goya himself, the black border album was broken up by Javier and largely divided between the two series that were sold in Paris in 1877. In the catalogue of this extraordinary sale (Bibl. 99), I have been able to identify as many as forty-two black border sheets; of these, sixteen still bear the additional number written by Goya's son and nine have disappeared. This means that nearly all the black border drawings now known figured in that sale and were thus widely dispersed between 1877 and the early 20th century as they passed through the sale-rooms with such collections as those of Calando, Paul Meurice, de Beurnonville, Beurdeley and Delestre. I have done my best to trace the successive owners of these drawings; their names are indicated in the technical notes, as are the public sales whose catalogues I have been able to consult. But in many cases the drawings may be lost sight of for years as they passed from collectors to their heirs or into the hands of dealers – until suddenly some of them turn up unexpectedly, like the lot sold anonymously at the Galerie Charpentier in Paris in 1957 (Bibl. 61).

The black border drawings, then, have had a very checkered "after-life", making it extremely difficult to trace all the sheets and piece together their history; and things were made no easier by the fact that investigations had to be suspended for a period of some ten years (1939 to c. 1949) during the War and its aftermath. The existence of this series was first pointed out by Mayer (Bibl. 143), who dated it to 1805. Later H. B. Wehle (Bibl. 186, p. 14) proposed a modest but courageous reconstruction of the series, on the strength of only nine numbered sheets (E.8, E.19, E.24, E.35, E.38, E.39, E.40, E.41, E.49) and four unnumbered (E.50,

E.k., E.21, E.9?). In 1953 I added E.2 from the Boymans Museum (Bibl. 93, pp. 15-17) and in 1954 E.23 from the Louvre (Bibl. 94, pp. 38-39); and I called attention to E.h, shown to me by Frits Lugt, and to the beautiful sheet E.16 which I had been privileged to see in the collection of the late César de Hauke, whose friendly advice and immense experience never failed me. Meanwhile I had an opportunity of seeing, in the collection of the Duchess of Montpensier in Madrid, three magnificent Goya drawings (already exhibited at Bordeaux in 1951, Bibl. 10, p. 55), two of which belong to this album (E.13 and E.36). As for No. 38 cited by H. B. Wehle in the 1941 reprint of his book, this was actually E.37 *Hutiles trabajos* (Useful work), whose French owner strongly urged me, from 1960 on, to publish this black border series. But the time seemed premature, there were still too many gaps to fill; above all, it seemed a pity to dissociate the black border series from the other albums, for together they form an organic whole of exceptional originality.

Two tentative catalogues were published in quick succession in 1958, following the sale at the Galerie Charpentier in Paris (Bibl. 61), first by Enrico Crispolti (Bibl. 86, p. 128), then by Eleanor Sayre (Bibl. 176, pp. 135-136). The latter was much more complete, both in the number of drawings and in the detailed descriptions of seventeen out of the twenty-four sheets catalogued. However, the space available for an article in a scholarly periodical being strictly limited, E. Sayre could only reproduce seven drawings from this superb album.

In 1970, after some forty years of patient investigation carried out by art historians of many nationalities, I was finally able to publish thirty-eight drawings from the black border album, together with the sketches on the versos of five of them. But as they appeared in a book devoted to Goya's work as a whole, there was no room for anything more than small reproductions, one-fifth of the actual size, and a critical apparatus reduced to the strict minimum. Since then, to the best of my knowledge, no new sheets have turned up to enrich this album, whose reconstruction has cost so many efforts. But the publication of the 1877 sale catalogue (Bibl. 34 and 99) has revealed the possible existence of nine drawings (E.k to E.s) which have disappeared; only the first was previously known from the catalogue of the Beurdeley sale (Bibl. 48, No. 174) and cited by H. B. Wehle (Bibl. 186, p. 14).

The drawings in the black border album were all executed with a thoroughness and a perfection of detail which show that Goya meant each composition to be a finished work of art. Several times, when he came to lay out his figures on the sheet, he hesitated and, after an initial sketch, changed his mind, turned the sheet over and adopted another layout. But it is noteworthy that the black border album is the only one with such sketches on the back of certain sheets, thus testifying to the great pains Goya took in executing this series. We reproduce here, at the end of the album, five of these trial sketches out of the six which have been noted; they figure on the verso of sheets E.30, E.36, E.48, E.a and E.g. There is much to be learned from them. From the sketch on the back of E.30, we get a clear view of the first stage in the creation of a drawing. To place his dancer in position, the artist began by laying in the main lines of the young woman's body, which went to form, as it were, the framework of the final figure, before it was "clad". The verso of E.a, which does not correspond at all to the drawing on the recto, also appears to be an initial sketch for a dancer. So he seems to have made two preparatory drawings before arriving at the final dancer of this extraordinary sheet E.30, one of the most delightful creations of Goya's brush. On the verso of E.36 is an initial arrangement of the two young women, which he abandoned in favour of the recto. As for the outline of a nun on the verso of E.g, though it is rather different and clumsy, it may possibly be an initial sketch for the very sober novice whom Goya finally drew on the recto.

This album is also distinguished from all the others by its appreciably larger sheet size. After the Madrid album and album D, whose elongated format is exactly that of the album leaves, Goya chose for the first time *his* format: gaining in height and even more in width, its squarer proportions give it a harmony not possessed by the other two. If, out of curiosity, we compare the ratio of height to width (H:W) in the different albums, we find that, between the Madrid album and the last Bordeaux drawings (i.e. between 1797 and about 1827), Goya tended instinctively towards an ever squarer format. Here are the figures: Madrid album and album D, H:W = 1:61; albums E and C, H:W = 1:42; album F, H:W = 1:41; albums G and H, H:W = 1:23. It is with the black border series (album E) that this trend begins, and the change of format is made all the more noticeable because the sheets are larger and because Goya framed each subject with these thick black lines which materialize the exact proportions.

It is true that a certain number of drawings in the Madrid album had already been partially framed, roughly outlined with the brush by way of completing the wash backgrounds that occur in the latter part of the series

(for example, B.32, B.33, B.46, B.49, B.58, etc.). This need to close off a composition with a frame reappears at the same period, and certainly not by chance, in several drawings in the series of *Sueños* which, as we have seen, are closely connected with the Madrid album (see GW 464, 473, 477, 480, 484, 488, etc.). Some later examples also occur in the sepia album (F), in particular F.30 and F.31, which are completely framed, but also F.40, F.41, F.42, F.45, F.55, F.59, F.80 and F.83. Finally, we may note that nearly all the plates of the *Tauromaquía* are also framed. But in no other piece of graphic work did Goya draw his frames with such geometric precision as in the black border album: usually single, but sometimes double, they are always carefully drawn with a ruler. How could he better convey the importance he attached to these compositions, themselves so carefully executed? How could he better indicate that he meant these drawings to be works in their own right, not studies for possible etchings? They are what I would call "pure drawings".

WATERMARK E

The transition from album D, where a new conception of drawing was worked out, to album E, where it reached perfection, is indicated by the similarity of the graphic elements prevalent in most of the albums. The autograph numbers in both are disposed in the same way, at the top centre of the sheet, and written in sepia in both. The only difference is that the numbers of the black border album seem to have been written not with a brush, as in album D, but with a blunt pen, which must also have been used to lay in the black frames. These are the only two albums to be numbered at the top centre, all the others being consistently numbered in the upper right corner. This central numbering, in the axis of the composition, is perhaps a further token of that conception of the drawing as a picture in its own right which has already been referred to. In the case of the captions, we find an almost absolute uniformity: the same small handwriting in lead pencil under each subject, with the single exception of E.28, whose caption is a quotation from Petrarch, by way of Ripa's *Iconologia*, written, no doubt as soon as the drawing was made, in Indian ink wash inside the frame and before the latter was laid in.

167

However, while the medium of the captions is the same and denotes a certain affinity in the execution of the two albums, the tone is very different. The black border series shows the highest proportion of apostrophizing captions (fourteen out of thirty-five), whereas album D does not have a single caption of this type (cf. general introduction).Without yet expressing the indignation that fills many captions in the *Disasters of War* and the latter half of album C, Goya addresses his figures, gives them advice (E.8, E.40, E.48, E.49), cautions them (E.24, E.30, E.39, E.b) or gently admonishes them (E.6, E.38, E.e). There is nothing here of the impersonal title merely designating or describing the subject. Goya's captions, on the contrary, take on a life and spontaneity that act on the image like a catalyst and bring out its latent import. Perhaps the most representative example of the part played by the text is E.21. It shows a charming scene of peasant life which might have been tritely entitled "Wayside meeting" or perhaps "Leave-taking". Only Goya could have thought of so unexpected a comment as "The donkey looks out for himself", which ironically invites us to focus our interest on the animal, when we were all ready to be touched by this rustic family group archly proposed for our conscientious consideration.

To come now to the subjects themselves. As already pointed out, there are still many gaps in this album as we have it today. Few of the numbered drawings are consecutive. So it is very difficult to tell whether or not there were any internal groups of drawings on the same theme. The only remaining sequence is that from E.19 to E.24, and among these six sheets the only possible connection that we can see is that between E.22 and E.23, which form a pair that might be entitled "Freaks" (Ribera's bearded woman and the child with withered limbs). A little further on, E.36 and E.37 have in common the figure of a sturdy young woman of the people, a type Goya seems to have particularly cared for in the years 1808-12 (see *The water-carrier,* GW p. 245, *Young women with a letter,* GW p. 243, and here E.30, E.a and E.h). But it must be admitted that these links are not very close and do not in any way compare with those that we find in the other albums. Possibly, at the very beginning of this album, there was a group of drawings representing old women, similar to those in album D; but since only three sheets remain (E.2, E.6 and E.8), separated by gaps, we cannot be sure. In fact, it seems to me that the apparent "individualism" of the drawings in the black border album is well in keeping with the character of these drawings as pictures in their own right. Here, in my opinion, Goya did not seek to create groups round a common theme or to connect the drawings and even the captions, as in the following albums. The subjects then are very different and will be dealt with one by one in the entries accompanying the drawings.

Though interrelated scenes may be lacking, one can nevertheless single out a constant feature of this black border album: the growing prominence given to the common people, above all to working people, depicted in the crude light of their everyday life. The period of the tapestry cartoons was over and, by the time Spain was involved in the great drama of the War of Independence, the "plebeianism" so well analysed by Ortega y Gasset (Bibl. 151, p. 29 ff.) had gone out of fashion. The graceful scenes of popular life painted by Goya for the Court and grandees of the previous century were superseded now by a plain, unvarnished vision of the people, quite devoid of that *majismo* on which Spanish society had been nurtured in the latter half of the eighteenth century. Nor was there anything in it of that folklore for which there was soon to be such a craze throughout Europe – nothing that depended for its appeal on "Scenes of Popular Life" or "Spanish Customs". Goya created a realism of his own, a tough and sinewy realism depicting poverty in its true colours. It made its appearance between 1805 and 1812 in the small *Maragato* paintings (GW 864 to 869) which may be dated to 1806, and in the drawings of the black border album; it was subsequently developed in many war scenes, painted or etched, and in realistic paintings like *Young women with a letter* (GW p. 240), *The water-carrier* (GW p. 245), *The knife-grinder* (GW p. 245) and *The forge* (GW p. 244). We accordingly find here such subjects as a workman on a ladder (E.19), a robust drinker (E.24), two angry men (E.32), young women (E.35, E.36, E.37, E.a and E.h), peasants (E.39 and 49) and a blind cobbler (E.d). These are the forerunners of that host of realistic figures later depicted by Daumier, Millet and Courbet.

Since this black border album figured prominently in the 1877 sale, I should like to show, by way of conclusion, the connections that exist between the catalogue of that sale, the arrangement of the drawings made by Javier Goya and the autograph numbers of Goya himself. From a comparison of these elements – which I have made for all the drawings sold in 1877 – it will be seen that some conclusions can be drawn which help to identify certain sheets in the black border album.

First of all, we find that, when Javier Goya numbered the drawings, he disregarded the original autograph numbers. His chief concern seems to have been to make up several series exemplifying the different media employed by his father; he arranged the drawings in each series according to personal criteria which I have so

168

far been unable to fathom. The most striking example is that of the two black border drawings in the Fortuny album, which Javier numbered 18 and 50, placing the first (E.24) between the drawings from the Madrid album and those in sepia from album F, and the second (E.50) at the end of the series. So Javier's numbers must be regarded with caution; they do not provide safe evidence for any deductions about missing autograph numbers.

However, if the sets of drawings sold in Paris in 1877 are listed in the order of Javier's numbers (so far as these are extant), one finds that the numbers in the sale catalogue, though not of course the same, follow exactly the same order. This means that, in compiling the catalogue of the sale, the expert and the appraiser followed Javier's numbers for each lot of drawings. This being so, we are in a position to check the uncertain identification of several drawings against the titles in the sale catalogue; and conversely, working back from the titles, we can determine what Javier's number was for a given sheet, in those cases where it has been effaced by a later collector. Here, by way of curiosity, is an excerpt from these lists, a working document which may be of interest to anyone tempted to pursue the task of unravelling this Goyesque puzzle. The numbers in brackets are unrecorded.

1877 Album – II
(Numbers added by Javier at top centre of the sheet)

No. added by Javier	Goya's No.	No. and title in 1877 catalogue	
(30)	E.2	1	"Contente de son sort"
(31)	?	2	"La dévotion le console"
(32)	?	3	"Travailler et se taire"
33	E.6	4	"Plains-toi au temps"
34	E.8	5	"Ne pas remplir autant le panier"
35	E.9	6	"Apprends à voir"
(36)	E.c	7	"Travaux de la guerre"
(37)	?	8	"Bon fils"
38	E.13	9	"Le vieux n'est pas toujours bon"
(39)	?	10	"Ceux qui fuient le travail finissent ainsi"
40	E.23	11	"Chose rare"
41	E.20	12	"Un cauchemar"
42	E.36	13	"Qui l'emportera"
(43)	E.g	14	"Le Novice"
(44)	E.f	15	"Artémise"
45	E.43	16	"Pénitence"
(46)	E.37	17	"Grand travail"

This comparative list has shed light on one important point: the original title of E.23 in the Louvre, which must have been "Cosa rara", translated in the catalogue as "Chose rare" (Something rare). Goya's caption does not appear on the sheet itself and laboratory tests carried out at the Louvre have failed to reveal any trace of it.

Paper : Heavy laid paper, Dutch mark J. Honig & Zoonen. Vertical chain lines at 27-30 mm intervals

Watermark : According to the sheets, various fragments appear of the large watermark of J. Honig & Zoonen.

Maximum sheet size : 270 × 190 mm.

Drawing : Recto only. On the verso of a few sheets is an initial sketch for an abandoned composition.

Technique : Brush and Indian ink wash, with a few pen-drawn lines. Black borders in Indian ink drawn with a broad pen and a ruler. They sometimes consist of a single line about 2 mm wide (24 drawings), sometimes of two slenderer parallel lines (10 drawings).

Captions : Written in lead pencil at the bottom of the sheet, below the black border. The only exception is E.28, whose caption is written within the black border, perhaps because it is a quotation from Petrarch and not a phrase of Goya's devising.

Goya's numbers : Written with a blunt pen in sepia ink at the top centre of the sheet, outside the black border. The highest number is 50. (Catalogued: 38).

Additional numbers : Written very carefully by Javier Goya with a fine pen, as follows:

Fortuny album : in the upper right corner, followed by a full stop.

Album I sold in 1877 : in the upper right corner, underscored with a curving stroke of the pen and followed by a full stop.

Album II sold in 1877 : at the top centre of the sheet, beside Goya's number, followed by a full stop as in the Fortuny album.

BIBLIOGRAPHY

Exhibitions : 2, 4, 7, 8, 10, 11, 13, 14, 16, 20, 22, 23, 26, 27.

Public sales : 28, 30, 34, 36, 41, 42, 43, 45, 48, 50, 52, 54, 58, 61, 64, 65, 67.

Authors : 75, 76, 86, 89, 93, 99, 111, 112, 127, 143, 144, 149, 151, 162, 171, 176, 186.

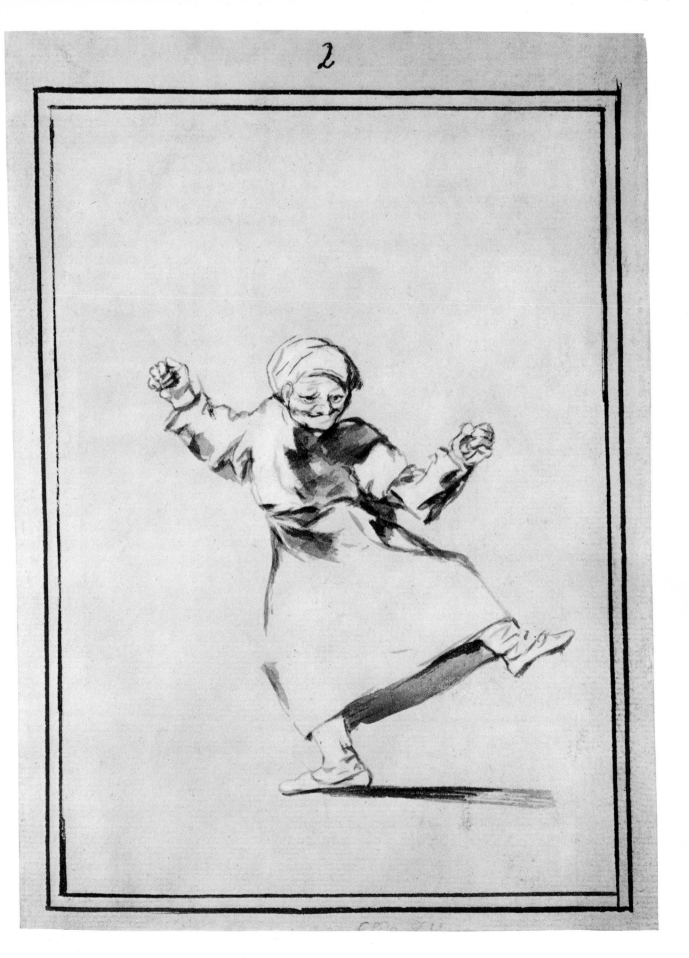

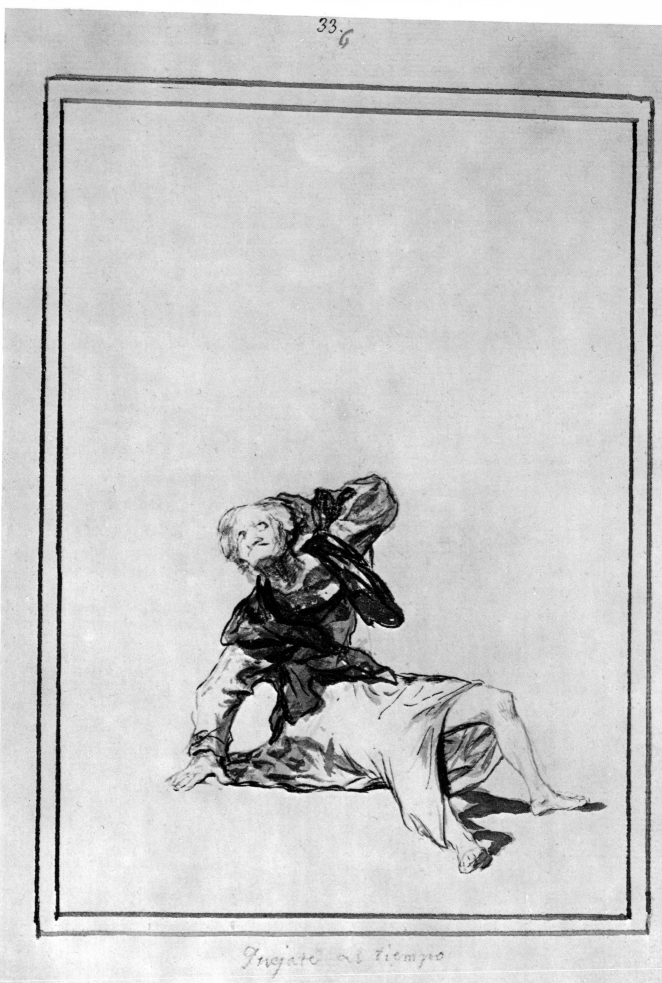

33.

Quejate al tiempo

34·8

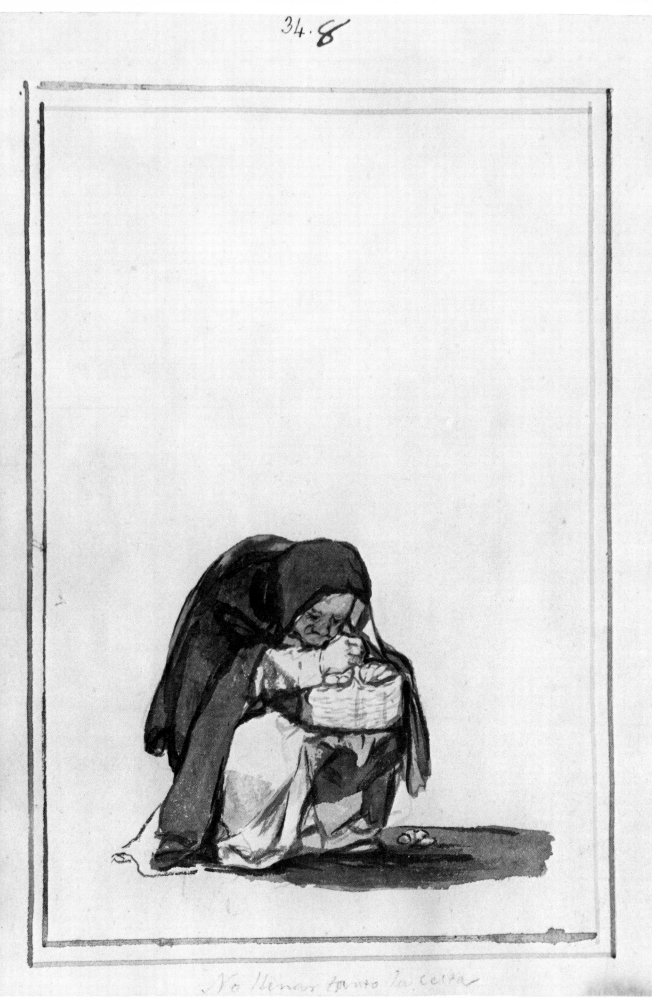

No llenas tanto la cesta

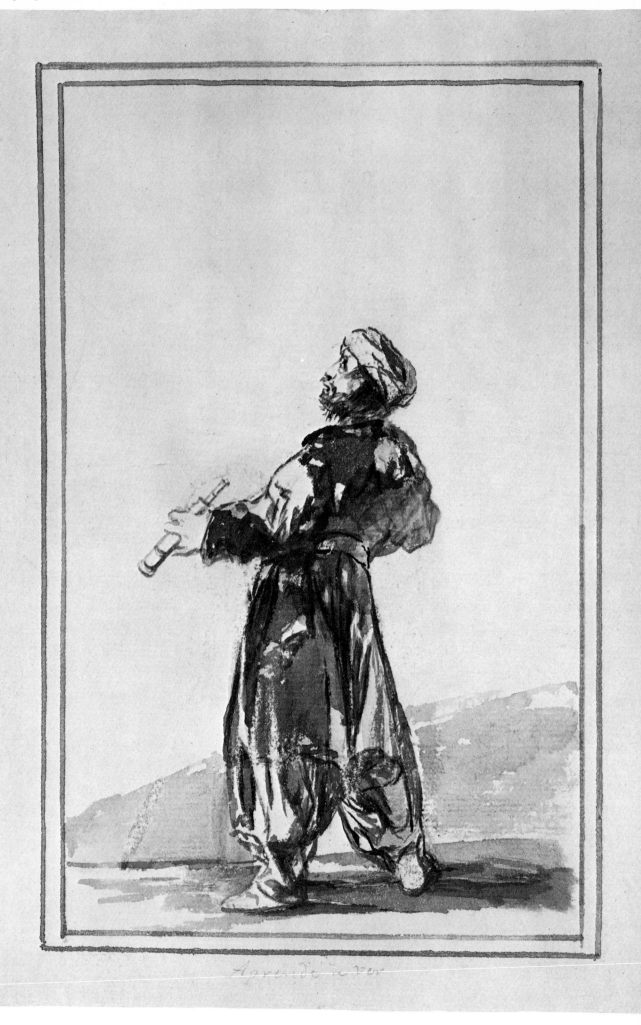

38.
13

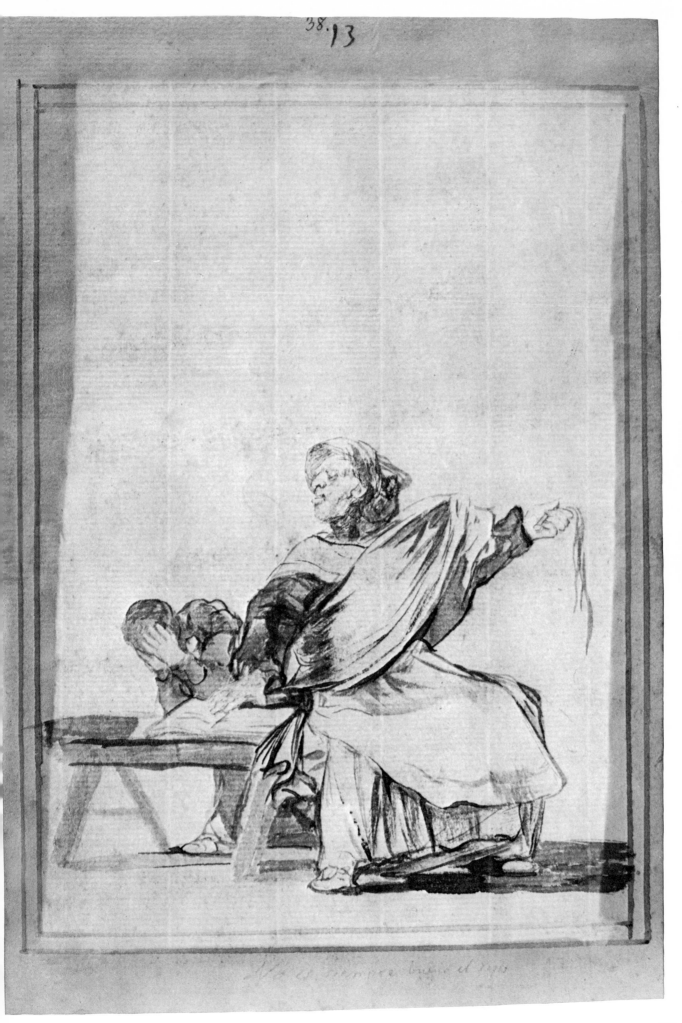

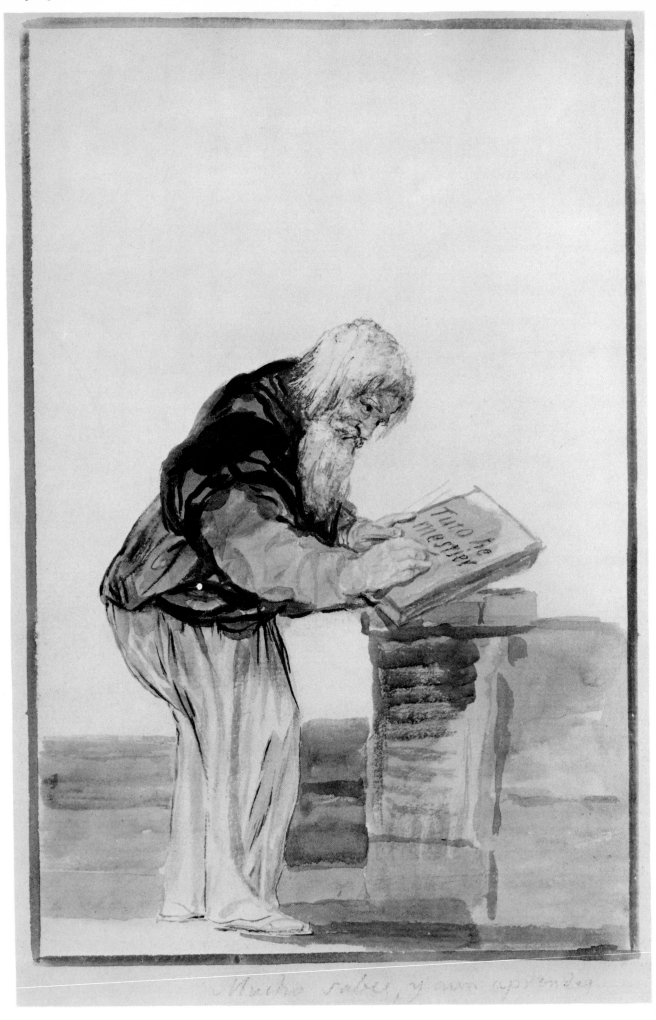

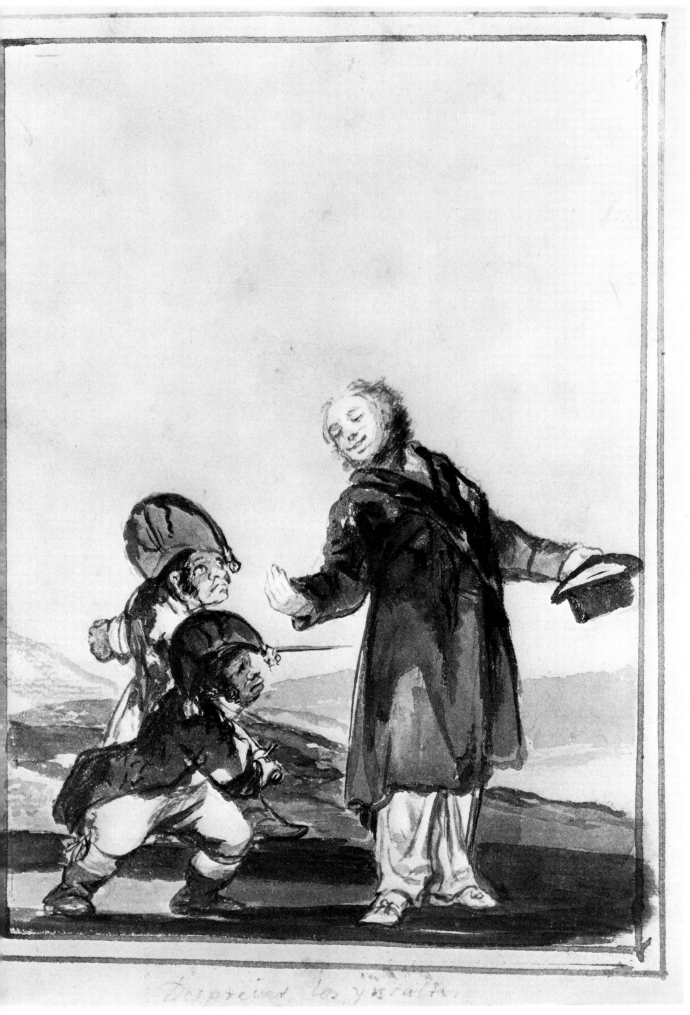

Despreciad los y os saltan

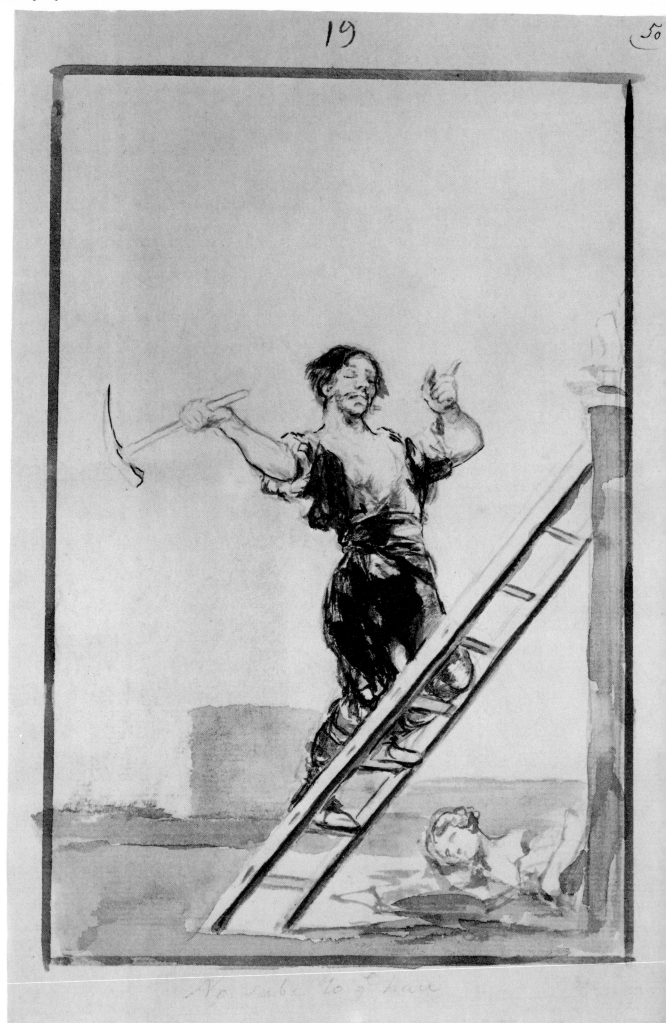

41.
20.

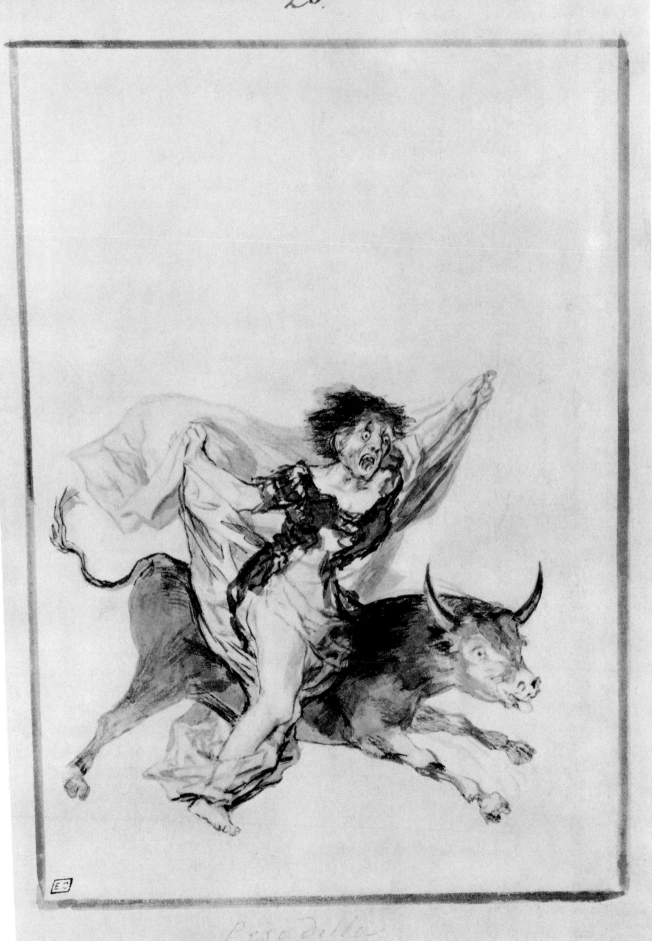

Pesadilla

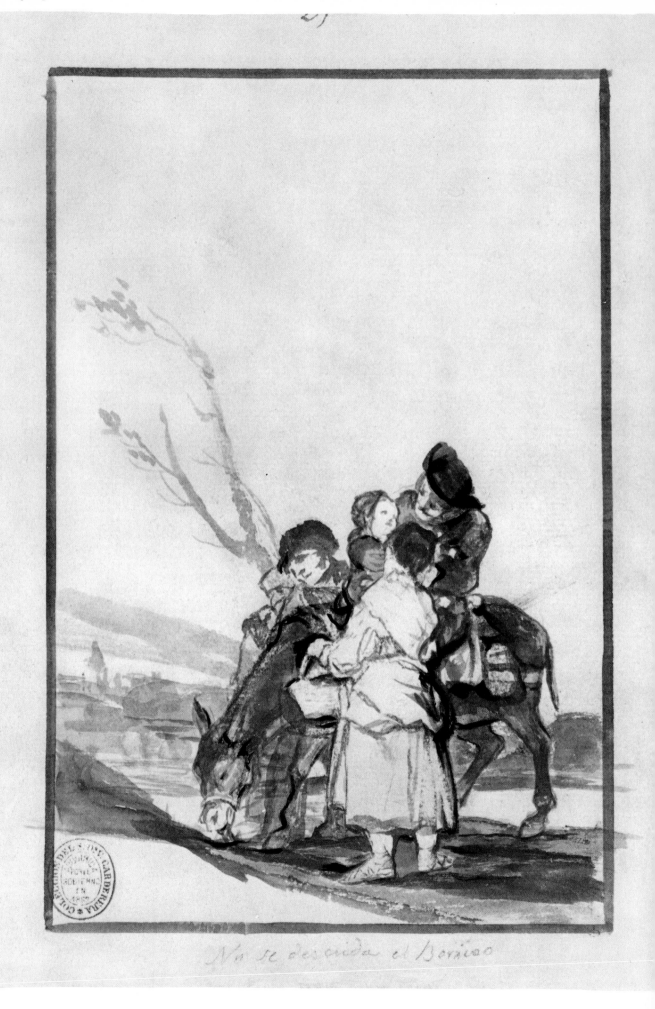

No se descuida el Borrico

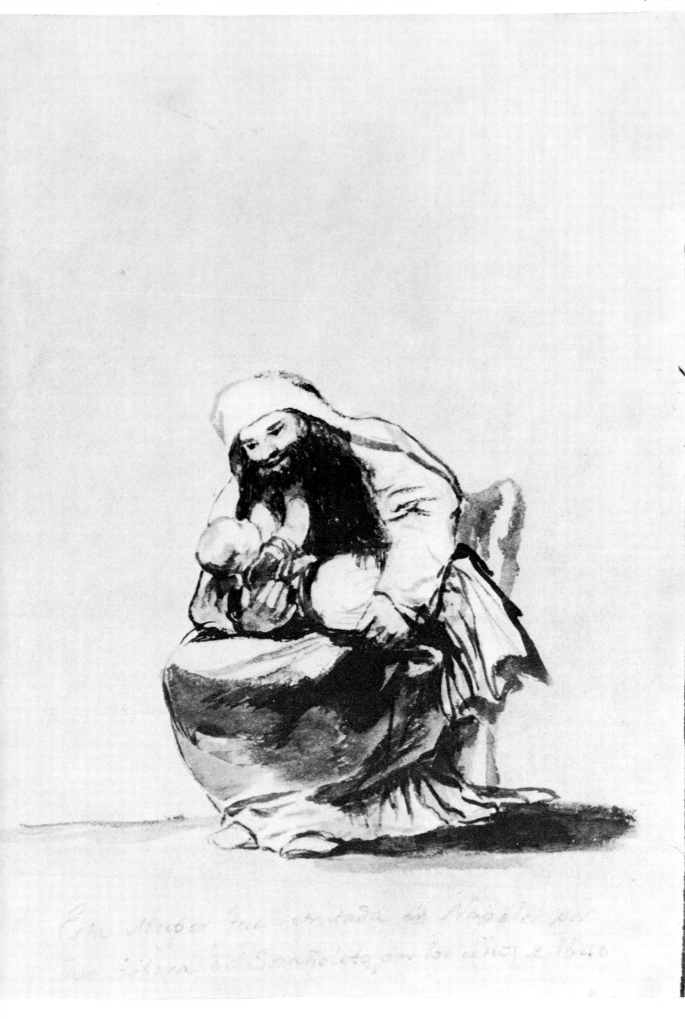

2340.

1169

24

Despues lo veras

30

Cuydado con ese paso

32

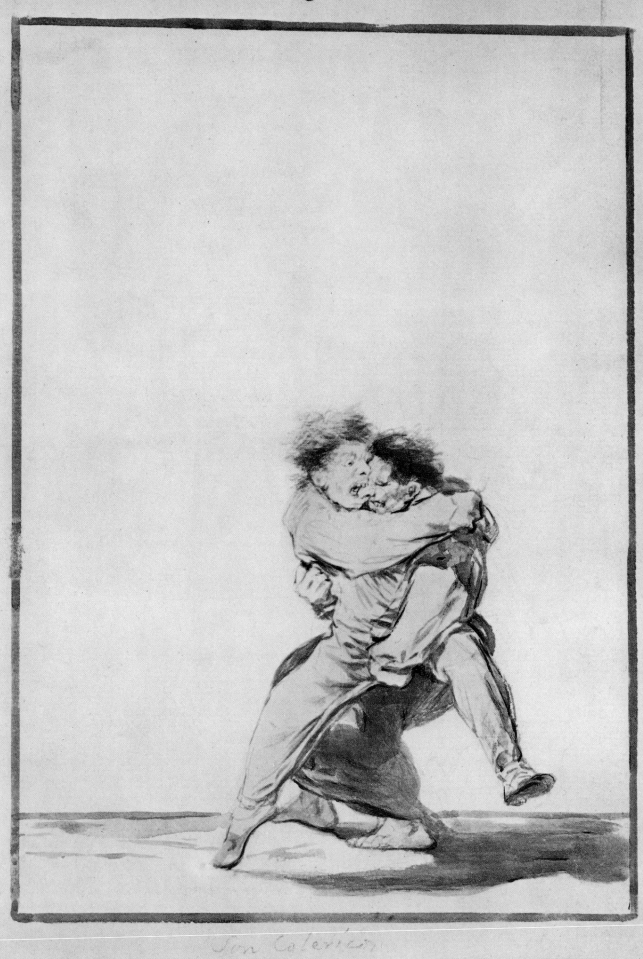

Son Coléricos

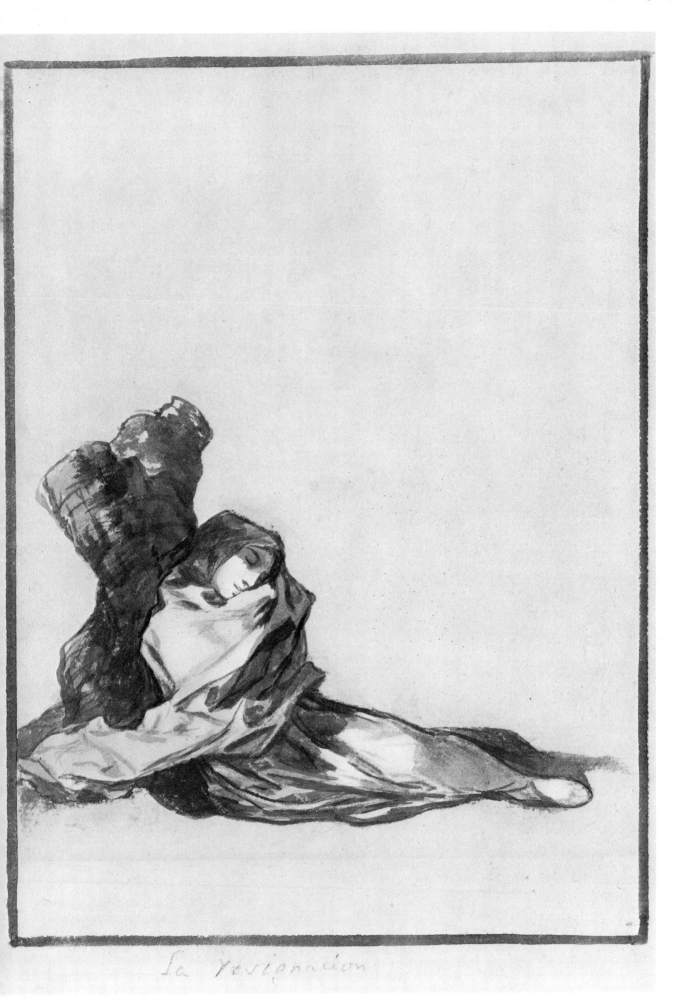

La resignacion

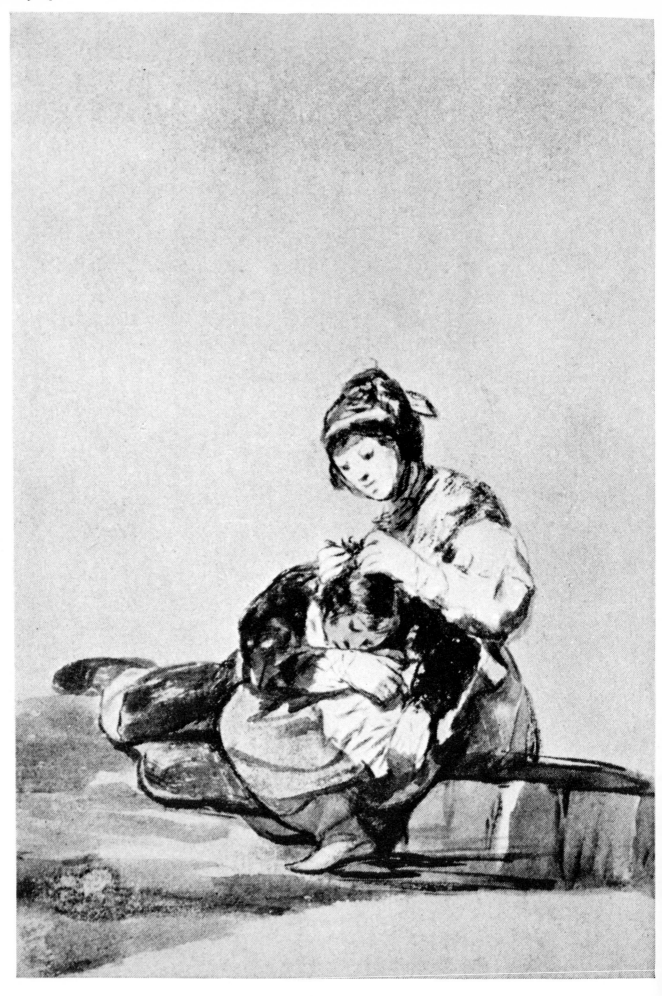

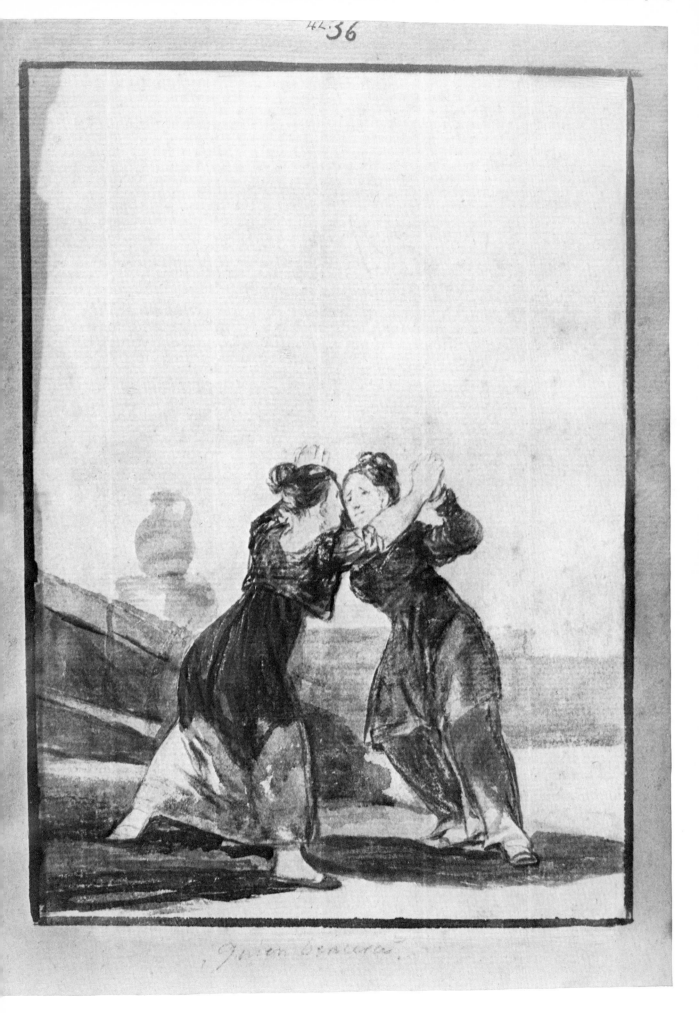

37

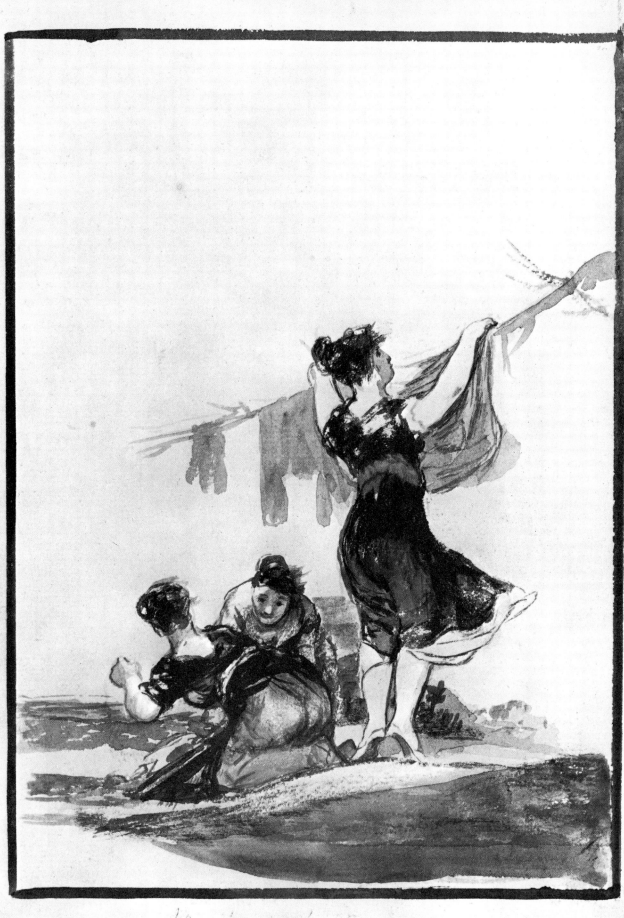

40

Dejalo todo a la probidencia

41

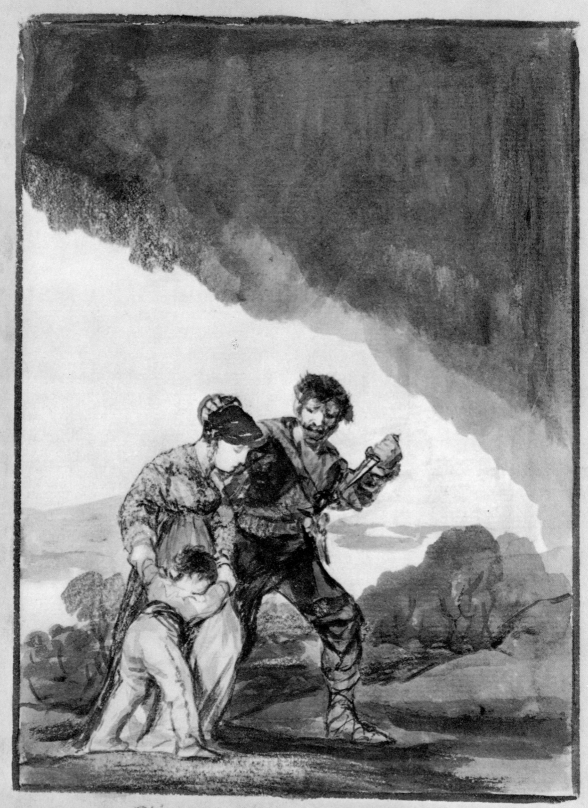

Dios nos libre de tan amargo lance

45.43

Penitencia

El trabajo siempre premia

El ciego trabajador

la culpa es tuya

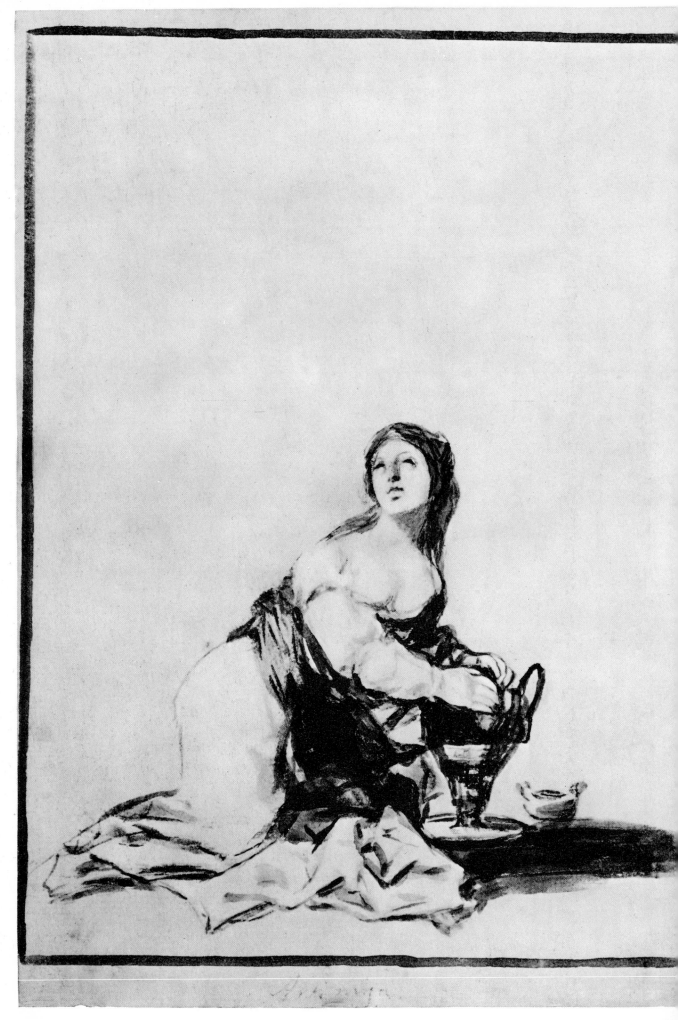

La novicia

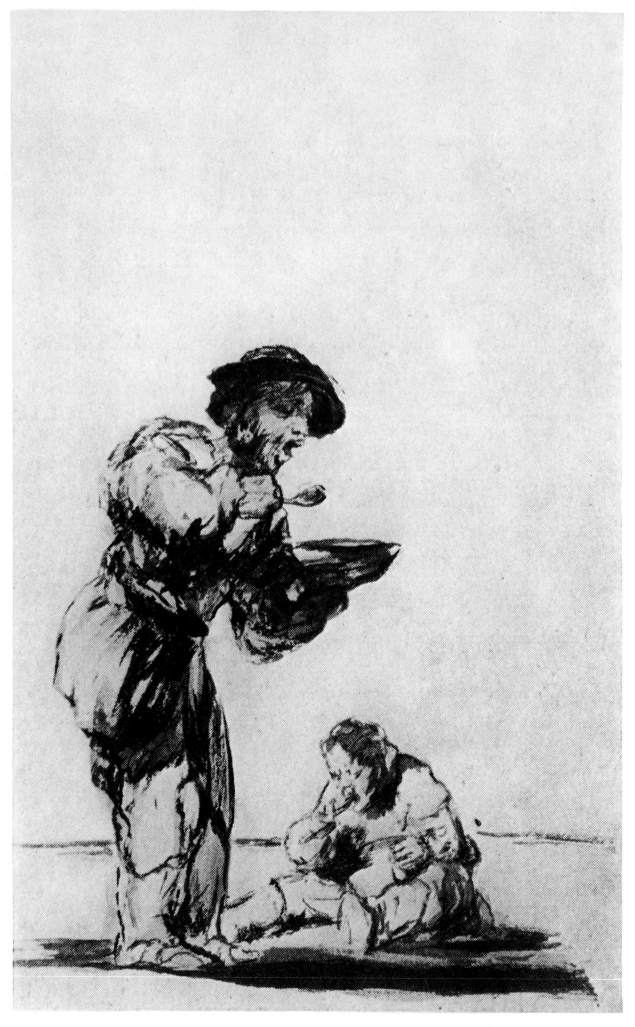

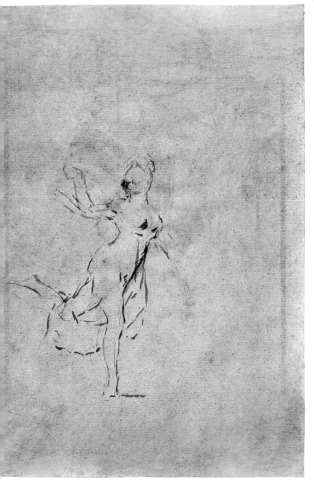

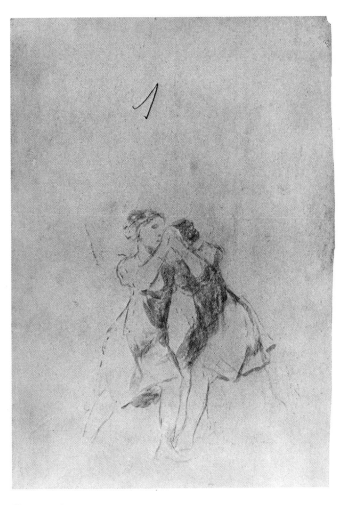

rso E.30

Verso E.36

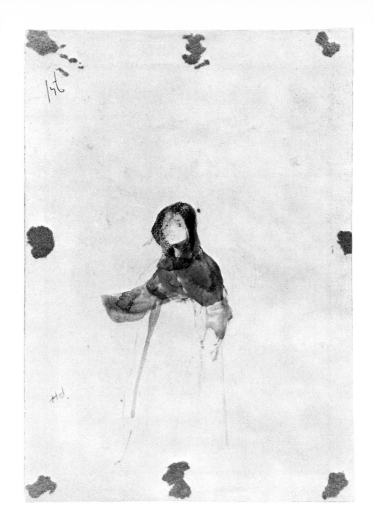

Verso E.48

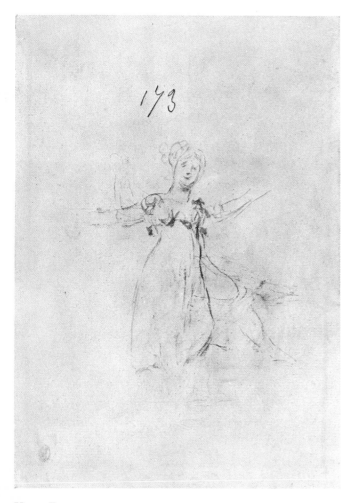

Verso E.a

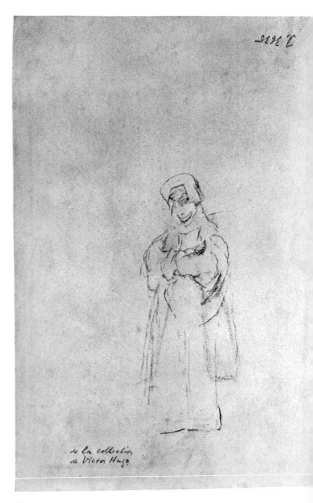

Verso E.g

Black Border Album (E)

Captions and Commentaries

E.2 [113] p. 171

... con su ... (Lp) ([Content] with her [lot]) – 1803-12 – 240 × 177 – I – No. (P.S.) – Double black border – *Paper:* vertical chain lines (28 mm) – *Watermark:* part of Honig & Zoonen (Z) – Traces of pink paper on verso – *Hist.:* Paris, Paul Lebas; APs. Paris, H.D. 3.4.1877, No. 1 "Contente de son sort" → E. Féral (7 fr. 50); A. Strolin (1912); Netherlands, F. Koenigs; D. G. van Beuningen (1940) – Rotterdam, Boymans-van Beuningen Museum (S.3) – GW 1385

First published in 1953 (Bibl. 93, pp. 15-16), this drawing now stands at the beginning of the black border album, No. 1 having disappeared. It is noteworthy that this sheet, like Nos. 6 and 8 which immediately follow it, links up perfectly with the series of witches in album D. The stylistic parallel with D.4 is particularly striking. Here, however, we no longer have flying figures but an old woman still spry enough to fling out her legs in a dance, clicking the castanets in her hands. Her posture is very close to that of the right-hand figure (man or woman?) in the central group of the *Burial of the sardine* (GW p. 2). This theme reappears in two drawings of the Bordeaux period, H.35 and H.61.

Drawing recut, so that only the upper part of the caption remains. But thanks to the French title given in the 1877 sale catalogue, undoubtedly translating the autograph text, the original caption can safely be assumed to have been *Contenta de su suerte*; indeed, the C of *Contenta* appears distinctly under the double ruled border. Whence it may be concluded that the drawing was recut after the 1877 sale.

E.6 [114] p. 172

Quejate al tiempo (Lp) (Complain to the weather) – 1803-12 – 263 × 185 – I – No. (I) – No. add. 33 (fine P) upper centre

– Double black border – *Paper:* vertical chain lines (28 mm) – Traces of pink paper on verso – *Watermark:* letters EN (part of Honig & Zoonen) – *Hist.:* Paris, Paul Lebas; APs. Paris, H.D. 3.4.1877, No. 4 "Plains-toi au temps" → E. Féral (6 fr.); M. Delestre coll.; APs. Paris, H.D. 14.5.1936 → Sacha Guitry; heirs of S. Guitry; APs. Paris, H.D. 26.5.1972 – Amsterdam, Rijksmuseum – GW 1386

This drawing and the next have always gone together. They already followed each other in one of the two original albums which were sold in 1877 (Nos. add. 33 and 34), and they figured side by side in the sale catalogue (Nos. 4 and 5); since then they have remained together in several collections, down to the purchaser at the 1972 sale. Their condition is exceptionally fresh: on the spotless sheets of paper the finest shades of the Indian ink wash have remained intact and the distinctive signs of the "black border" album are sharp and clear (double black borders, autograph captions and numbers, and numbers added later). The two sheets, moreover, show different but plainly visible fragments of the Honig & Zoonen watermark, and on the back of both are traces of the pink paper on which they were mounted by, presumably, Javier Goya. The troubles of old age (he had come a long way since the grotesque *Hasta la muerte* of *Capricho 55*) moved Goya to pity; indeed he himself had already been severely tried by them. A drawing very close to this one in subject and composition, C.82, bears the autograph caption *Edad con desgracias* (The mishaps of old age).

E.8 [115] p. 173

No llenas tanto la cesta (Lp) (Don't fill the basket so full) – 1803-12 – 260 × 175 – I – No. (S) – No. add. 34 (fine P) upper centre – Double black border – *Paper:* vertical chain lines (28 mm) – Traces of pink paper on verso – *Watermark:* Z + cartouche HONIG (Honig & Zoonen) – *Hist.:* Paris,

Paul Lebas; APs. Paris, H.D. 3.4.1877, No. 5 "Ne pas remplir autant le panier" → E. Féral (6 fr.); M. Delestre coll.; APs. Paris, H.D. 14.5.1936, No. 39 → Sacha Guitry; heirs of S. Guitry; APs. Paris, H.D. 26.5.1972 – USA, priv. coll. – GW 1387

The huddled effect of the old woman's figure as she leans over her basket is emphasized by the large black patch of shadow at her feet. As in the previous drawing and in many others from now on, Goya addresses his figures in the familiar second person singular (first example in B.79). Here it is to give a sound piece of advice to the old woman, who is filling her basket so full that she may not be able to carry it.

E.9? [116] p. 174
Aprende a ver (Lp) (He is learning to see) – 1808-12 – 265 × 185 – I – No. add. 35 (fine P) upper centre – Double black border – *Paper*: vertical chain lines (29 mm) – *Hist.*: Paris, Paul Lebas; APs. Paris, H.D. 3.4.1877, No. 6 "Apprends à voir" → E. Féral (6 fr.); A. Strolin → 1907 – Berlin-Dahlem, Kupferstichkabinett (4393) – GW 1416

Here is one of the first appearances of an Oriental figure in Goya's graphic work. This is not the classic Oriental type that figures is so many Biblical scenes in Western painting and indeed in many secular compositions of the Venetian school, particularly in those of the Tiepolos. It is undoubtedly a Mameluke, such as Goya could have seen in Madrid after the arrival of French troops in 1808. We need only compare the costume worn by this figure (baggy trousers and turban) with that of the Mamelukes in *Dos de Mayo* (*The Second of May*) (GW p. 206) which, though not executed until 1814, certainly embodies memories and notes dating to 1808. One curious detail of this drawing: the spyglass which the man holds in his left hand and which justifies Goya's ironical caption. In this connection, we should bear in mind that in the 1812 inventory of Goya's possessions figures the mention of *un telescopio* valued at 800 *reales,* revealing a curiosity for science worthy of the century of Enlightenment. Noteworthy is the way in which the whole costume has been worked with broad strokes of the brush.

E.13 [117] p. 175
No es siempre bueno el rigor (Lp) (Severity is not always good) – 1805-08 – 264 × 178 – I – No. (P.S.) – No. add. 38 (fine P) upper centre – Double black border – *Paper*: vertical chain lines (28 mm) – *Watermark*: fragment of Honig & Zoonen – *Hist.*: Paris, Paul Lebas; APs. Paris, H.D. 3.4.1877, No. 9 "Le vieux n'est pas toujours bon" (*sic*) → Fiantance (?) or Fontaine (11 fr.); Madrid, Duchess

of Montpensier; Marquis of Valdeterrazo; heirs of the Marquis of Valdeterrazo – ? USA, coll. unknown – GW 1389

This is not the first time that Goya shows his interest in the problems of bringing up children. Plates 3, 4, 25 and 37 of the *Caprichos* reflect the preoccupations of his "enlightened" friends, Jovellanos first of all. Education, in the last decade of the 18th century, was a subject of often heated discussion, which also bore fruit in practical ways; most important was the Asturian Institute at Gijón, founded in 1794 by Jovellanos. Some ten years later the methods of the famous Pestalozzi were introduced into Spain, and in 1806, after due consultation with Jovellanos, the Pestalozzi Institute was opened in Madrid under the patronage of Godoy; its emblem was designed by Goya (GW 856, 857, 873a). In 1807 he also did the frontispiece for the Spanish tranlation of a book by the famous educational reformer (Bibl. 127, p. 105). This witty condemnation of corporal punishment – banned of course by Pestalozzi and all the great pedagogues of the 18th century – thus fits perfectly into Goya's work between 1805 and 1808, when Godoy fell from power. The discrepant French title given to this drawing in the 1877 catalogue is easily explained, Goya's word *rigor* having been misread as *viejo*.

E.15? [118] p. 176
Mucho sabes, y aun aprendes (Lp) and, in the picture, *Tuto he/mestier* (I) (You know a lot and you're still learning *and* Everything is a trade) – 1803-12 – 264 × 180 – I + P – No. (P.S.) – Single black border – *Paper*: vertical chain lines (29 mm) – Mounted on pink paper – *Watermark*: fragment of Honig & Zoonen – On the verso: a slight sketch of a mythological scene in Indian ink. – *Hist.*: Paris, Paul Lebas; APs. Paris, H.D. 3.4.1877, No. 18 "Tu sais beaucoup et tu apprends encore" → E. Féral (10 fr.); Paul Meurice; APs. Paris, Gal. Charpentier 9.4.1957, No. 7 – Boston, Museum of Fine Arts, William Francis Warden Fund (58.359) – GW 1390

This old man is one of those figures imagined by Goya who are outside any specific time or place. They first appear in the frescoes in San Antonio de la Florida (1798). This man, moreover, wears a sort of blouse reminiscent of that worn by certain figures watching the miracle of St Anthony; his trousers are already characteristic of the 19th century. Hoary with age and poorly dressed, he represents the eternal youth of the mind, as does that other old man drawn by Goya at Bordeaux, G.54, who is also still learning. But here he has added the short phrase in Italian inscribed on the cover of a large volume. Is this the conclusion of a

lifetime's experience? The key to the old man's great learning? And why is it written in Italian? It is hard to say, but perhaps we should look to Italy for the illustrious example transposed here by Goya; possibly he had in mind the extreme old age of Titian (to whom he alludes in one of his last letters from Bordeaux to Javier), whose art was continually renewed to the very end. Goya must have been familiar with Titian's famous self-portrait at the age of eighty-nine in the royal collections (Prado, No. 407).

E.16 [119] p. 177

Despreciar los ynsultos (Lp) (Contemptuous of the insults) – 1808-12 – 265 × 185 – I – No. (P.S.) – No. add. 37 (fine P) upper r. corner – Double black border – *Paper:* vertical chain lines – Mounted on pink paper – *Watermark:* ZOO (fragment of Honig & Zoonen) – *Hist.:* Paris, Paul Lebas; APs. Paris, H.D. 3.4.1877, No. 83 "Il méprise les insultes" → P. Meurice (41 fr.); Ps. P. Meurice, Paris, H.D. 25.5.1906, No. 93 → M. Paulme (460 fr.); J. Groult coll.; C. de Hauke coll. (1944) – France, priv. coll. – GW 1391

This scene is a direct allusion to the War of Independence and the presence in Spain of the hated French troops. The calm, smiling disdain of the Spaniard (Goya himself, perhaps) is contrasted with the aggressive churlishness of the two dwarfs, dressed in the uniform of Napoleonic generals, who are threatening him with their swords. The telling ferocity of the caricature lies above all in the repulsive faces of the Frenchmen and their ridiculous puniness beside the stately bourgeois in his long frock-coat. The background of rolling hills is treated in sweeping streaks of wash of graduated intensity.

E.19 [120] p. 178

No sabe lo q.ᵉ hace (Lp) (He doesn't know what he's doing) – 1806-12 – 269 × 179 – I – No. (P.S.) – No. add. 50 (fine P) upper r. corner – Single black border – *Paper:* vertical chain lines (29 mm) – *Watermark:* fragment of Honig & Zoonen – *Hist.:* Paris, Paul Lebas; APs. Paris, H.D. 3.4.1877, No. 89 "Il ne sait pas ce qu'il fait" → Paul Meurice (91 fr.); Ps. P. Meurice, Paris, H.D. 25.5.1906, No. 95 → A. Strolin (95 fr.) → 1907 – Berlin-Dahlem, Kupferstichkabinett (4391) – GW 1392

F. D. Klingender saw in this drawing a symbol of the blind reaction of 1814 destroying the statue of liberty (Bibl. 111, p. 195). This political interpretation, connected with the return of Ferdinand VII, is not quite convincing. The man shown here, who seems to be half-drunk, may simply personify the ignorance of the

people, the blind vandalism that destroys a work of art without even knowing why. But the admirable thing about this drawing is the expression of force that it conveys: this sturdy boor poised on the ladder and brandishing his pick to no purpose belongs to that series of robust figures of men of the people which Goya created between 1805 and 1815. See for example the *Maragato* series (GW 864-869) and above all *The knife-grinder* and *The forge* (GW 964, 965), in which we see these men at work, their sleeves rolled up over their brawny arms. Analysis of this drawing enables us to trace the successive stages of its creation: first, with a light wash, Goya blocked out the whole composition; then, with a finer brush and a darker wash, he laid in the shadows; finally, with undiluted Indian ink, he added the lines and accents that give an extraordinary relief to the central figure. It is interesting to note that the price of 91 fr. fetched in 1877 was one of the highest of the sale.

E.20 [121] p. 179

Pesadilla (Lp) (Nightmare) – 1803-12 – 264 × 181 – I – No. (P.S.) – No. add. 41 (fine P) upper centre – Single black border – Mark E.C. (Lugt 837) – *Paper:* vertical chain lines (30 mm) – *Watermark:* J.HO (fragment of Honig & Zoonen) – *Hist.:* Paris, Paul Lebas; APs. Paris, H.D. 3.4.1877, ? No. 12 "Un cauchemar" → E. Féral (14 fr.); Ps. Calando, Paris, H.D. 11-12.12.1899, No. 73 "Pesadilla" → (175 fr.); New York, R. J. Bernhard coll. → 1959 – New York, Pierpont Morgan Libr. (1959.13) – GW 1393

Dreams and nightmares assume considerable importance in Goya's work beginning with the *Caprichos,* which were initially conceived as a series of *Sueños* (Dreams). But the most astonishing element here is the bull flying through the air, carrying a terror-stricken woman whose eyes are starting from their sockets. No doubt he got the idea from the acrobatic feats practised by certain toreros who rode one bull while fighting another; the Indian bullfighter Mariano Ceballos, immortalized by Goya in plate No. 24 of the *Tauromaquía,* was famous for such feats. Later we find further examples of flying bulls: the plate in the *Disparates* entitled *Disparate de tontos* (GW 1604) and the Bordeaux drawing G.53. Then there is the unconvincing *Capricho* in the Agen Museum (GW note 956), with a bull suspended in mid-air beside an ass and an elephant. But all these scenes have a comic touch in comparison with this "nightmare" in which the woman seems to be screaming with terror while holding out the voluminous veils that stream behind her. The wash technique here is remarkable (compare with

Capricho 61, Volaverunt) for the details worked with a fine brush, particularly in the garment, eyes and mouth of the figure.

E.21 [122] p. 180

No se descuida el borrico (Lp) (The donkey looks out for himself) – 1803-12 – 258 × 183 – I – No. (S) – Acquisition stamp of the Carderera coll. (1867) – Single black border – *Paper:* vertical chain lines (28 mm) – *Watermark:* HG (NIG or HO?), fragment of Honig & Zoonen – *Hist.:* Javier Goya; Mariano Goya; V. Carderera → 1867 – Madrid, Biblioteca Nacional (B.1254) – GW 1394

Scenes of peasant life are rare in Goya's work. To find any before this one, we have to go back to the tapestry cartoons of 1786-87, among which *Harvesting* (GW 263), *The snow-storm* (GW 265) and *Poor people by a fountain* (GW 267) form a small group rather different from the other cartoons, which for the most part were scenes of popular amusements attuned to the taste of the Court. It was not until the opening years of the 19th century that Goya began to paint and draw real men of the people (see E.19, E.24, E.39 and E.49, among others), like the ones shown here stopping near a village. The landscape around them evokes their peaceful but straitened life, exemplified by this stunted tree with half-bare branches, and we might be moved to pity at the sight of this family, were it not for Goya's sly caption, which makes the grazing donkey the central figure in the story. Amazing the power these few words have to transpose the image and carry it beyond appearances.

E.22? [123] p. 181

Esta Muger fue retratada en Napoles por|José Ribera o el Españoleto, por los años de 1640 (This woman was painted in Naples by José Ribera called Lo Spagnoletto, around the year 1640 – Inscription in another hand within the double black border – 1803-12 – 260 × 178 – I – No. (?) – *Paper:* ? – *Hist.:* Paris, Paul Lebas; APs. Paris, H.D. 3.4.1877, No. 105 "Une femme à barbe" → E. Féral (20 fr.); APs. London, Sotheby, 29.6.1960, lot 19 (withdrawn from sale?) – USA, priv. coll. – GW 1395

This drawing was considered a fake by Mayer (Bibl. 144). Though the present owner has refused to provide the information necessary for its authentication, the fact that it figured in the 1877 sale seems to vouch for its provenance. Moreover its immediate proximity to the drawing in the Louvre, E. 23, shows that Goya intended to bring together two examples of human freaks, one provided by Ribera's famous canvas representing Magdalena Ventura dei Abruzzi (Tavera

Hospital, Toledo), the other a contemporary case. Goya could easily have seen the painting, which has always belonged to the Lerma family; it was readily accessible in his time, just as it is today.

E.23 [124] p. 182

"Mother showing her deformed child to two women" – 1803-12 – 265 × 184 – I – No. add. 40 (fine P) upper centre – Single black border – *Paper:* vertical chain lines (28 mm) – Pasted on thick white paper – *Hist.:* Paris, Paul Lebas; APs. Paris, H.D. 3.4.1877, No. 11 "Chose rare" → Pascal (36 fr.); Ps. H. Lacroix, Paris, H.D. 27-29.1.1903, No. 215 → Cosson → bequest 1926 – Paris, Louvre (6911) – GW 1396

The caption of this drawing has been effaced and laboratory tests have failed to reveal any trace of it. Thanks, however, to the number 40 subsequently added and to the catalogue of the 1877 sale, it seems safe to identify it with the drawing sold under the title *Chose rare* (Something Rare); since the titles given in the catalogue for this initial series of drawings are usually close translations of Goya's captions, this title too may be accepted as such. So presumably the original autograph caption was something like *Cosa rara,* which would be in keeping with the artist's usual style (cf. drawing C.59, *Sueño raro*) and apply perfectly to the cruelty of this scene sharply focused on the deformed body of the infant, which its mother displays to two morbidly curious gossips. Note the compact mass of shadow and light formed by the figures in the centre of a landscape as empty as the sky overhead.

E.24 [125] p. 183

Despues lo beras (Lp) (You'll see later) – 1803-12 – 266 × 187 – I + P – No. (P.S.) – No. add. 18 (fine P) upper r. corner – Single black border – *Paper:* vertical chain lines (29 mm) – Mounted on pink paper – *Watermark:* ZOO (Honig & Zoonen) – *Hist.:* Javier Goya; Mariano Goya; V. Carderera; F. de Madrazo; Venice, Mariano Fortuny y Madrazo (Fortuny album) → 1935 – New York, Metropolitan Museum of Art, Harris Brisbane Dick Fund, 1935 (35.103.18) – GW 1397

The Fortuny album included only two drawings from the black border series, but both of the highest quality – further evidence that this album was made up of carefully chosen pieces. H.B. Wehle's commentary on this drawing is remarkable for its insights (Bibl. 186, p. 11); having before him several of the finest sheets in the Madrid album, he was able to point out the arresting similarity between this man drinking thirstily

from his water-bottle and the young *petimetre* in *The Swing*, B.21. Two "social species" (as Balzac was to put it a little later) are thus contrasted; one might almost say two worlds, the eighteenth-century world of care-free pleasures and the modern age with its social problems. But what is remarkable is that Goya, whose youth had been spent in that earlier world, should have perceived the ferment of new forces so much more clearly than others and expressed it so power-fully.

gories he painted in 1797-1800 for Godoy's palace in Madrid. Here, as recommended by Ripa, Philosophy is poor and barefooted, holding the open book of the moral sciences and the closed book of the secret sciences of Nature. But in keeping with his new preoccupations Goya portrays her as a sturdy peasant girl, thereby implying that philosophy is not the prov-ince of an *élite*, but accessible to all, even the humblest. Such was the astonishing boldness of an instinctive genius, with his gaze constantly fixed on the future.

E.27

Si yerras los tiros (Lp) (If you are wide of the mark) – 1803-12 – 260 × 180 – I – No. (?) – Mark E.C. (Lugt 837) – No. add. 20 (fine P) upper centre – *Paper:* ? – *Hist:* Paris, Paul Lebas; APs. Paris, H.D. 3.4.1877, No. 19 "Si tu manques ton coup" → E. Calando (15 fr.); Ps. E. Ca-lando, Paris, H.D. 11-12.12.1899, lot 72 (50 fr. for lot of two drawings) – USA or GB?, coll. unknown

It has proved impossible to obtain any precise infor-mation about this drawing which, for reasons unknown to me, has never been published.

E.28 [126] p. 184

Pobre e gnuda bai filosofia (I)/*Pet* (P) within the single black border (In poverty and barefoot goes Philosophy, Pet[rarch]) – 1803-12 – 266 × 182 – I – No. (S) – No. add. 54 (fine P) upper r. corner – The letters "Pet" are written over a capital T in pale Indian ink – *Paper:* vertical chain lines (28 mm) – Mounted on pink paper – *Hist.:* Paris, Paul Lebas; APs. Paris, H.D. 3.4.1877, No. 93 "La Philo-sophie" → Lebas (80 fr.) – France, priv. coll. – GW 1398

When this drawing came to light a few years ago, it raised serious problems of interpretation. What did this barefoot peasant girl represent, with her heaven-ward gaze, an open book in her right hand and a closed one in her left? To make matters worse the caption, inscribed in unusual fashion inside the black border and with the brush, was written in an odd mixture of Spanish and Italian, followed by the myste-rious letters "Pet". The clue to the riddle was given to me by chance by two passages in Nordström (Bibl. 149, pp. 20-21 and 110-115) quoting a text by Cesare Ripa concerning allegorical representations of Philosophy. This text from the famous *Iconologia* refers to a line from Petrarch (*Rime*, sonnet VII): *Povera e nuda bai filosofia* – obviously the source of Goya's caption. Ripa's *Iconologia* was much used by painters in the 17th and 18th centuries, and in Spain Bayeu had a copy of it in his library (Bibl. 162, p. 30); Goya had already borrowed from it several times, notably for the alle-

E.30 [127] p. 185

Cuydado con ese paso (Lp) (Be careful with that step) – 1803-12 – 263 × 182 – I – No. (P.S.) – No. add. 56 (fine P) upper r. corner – Single black border – Traces of an inscription on lower left (?) – *Paper:* vertical chain lines (28 mm) – *Watermark:* fragment of Honig & Zoonen – *Hist.:* Paris, Paul Lebas; APs. Paris, H.D. 3.4.1877, No. 95 "Gare à ce pas" → P. Meurice (59 fr.); Ps. P. Meurice, Paris, H.D. 25.5.1906, No. 92; APs. Paris, Gal. Charpen-tier, 9.4.1957, No. 6; USA, J. and H. Regenstein → 1958 – Chicago, Art Institute (1958.42) – GW 1399

One of the most graceful figures ever drawn by Goya, both in the impression of weightless ease given by the dancer caught in strenuous movement, and in the sure control of the foot on which the whole weight of the body rests, poised there for a fleeting instant. Stur-diness and lightness — a far cry from the excessively arched figures of the *majas* peopling the Sanlúcar and Madrid albums. It is easy to identify the dance executed by this girl: it is one of the most elegant in all Spain, the *jota aragonesa,* danced in canvas shoes laced high above the ankle. As a native of Aragon, Goya was familiar with the difficulty of the skipping side-step represented here; hence the caption "Be careful with that step" – the observation of a connoisseur.
Verso (GW 1400). Initial sketch for the same dancer. One notes that Goya began by laying in the main lines of his drawing, including those of the body beneath the dress which afterwards disappeared under a thick network of brushstrokes. One notes, too, that this abandoned sketch has little of the grace of the final figure, and above all that it does not correspond in the least to the typical step of the *jota*.

E.32 [128] p. 186

Son coléricos (Lp) (They are angry) – 1803-12 – 270 × 190 – I – No. (?) – Single black border – *Paper:* vertical chain lines – Inscription on the back of the photograph: "I certify that the drawing represented in this photograph belonged to the collection of my husband Mariano Fortuny and previously to that of Federico de Madrazo". Signed

Henriette Fortuny – *Hist.*: Javier Goya; Mariano Goya; V. Carderera; F. de Madrazo; Venice, Mariano Fortuny y Madrazo; Henriette Fortuny; Paris, Otto Wertheimer (?) – Switzerland, priv. coll. – GW 1401

The order laid down by Goya in this album produces some striking contrasts; thus we pass from an exquisite evocation of his native Aragon to this grotesque struggle between two men, one of whom – the one being bitten – seems to be a monk. But, however radical the difference in subject matter, the same qualities appear in both sheets; perhaps the most remarkable of them is the sheer physical thickness of these bodies, whose clothes do not merely cover them but sharply convey all the muscular strains. It should be noted that this drawing, having remained in the Madrazo-Fortuny family until the 20th century, did not figure in the 1877 sale and therefore bears no subsequent number added with a fine pen.

E.33 [129] p. 187

La resignacion (Lp) (Resignation) – 1803-12 – 255 × 180 – I – No. (?) – Single black border – *Paper*: ? – *Hist.*: ? – Boston, Museum of Fine Arts, Gift of Landon Clay (69.68) – GW 1402

Since its summary publication in 1970 (Bibl. 75, p. 87), a thorough study of this drawing has been needed, but so far the Boston Museum has released no information about it. A touching impression of tenderness emanates from this figure of a woman sitting against a tree-trunk, her bowed face alone emerging from the flowing garments in which she is wrapped.

E.35 [130] p. 188

"He doesn't wake up" – 1803-12 – 254 × 177 – I – No. (?) – *Paper*: ? – *Hist.*: Paris, Paul Lebas; APs. Paris, H.D. 3.4.1877, No. 99 "Travail pénible mais nécessaire" → Pacat d'Yenne (41 fr.) – New York, formerly Miss Ethel L. Haven coll. – GW 1403

It was H. B. Wehle who assigned this drawing to the black border series (Bibl. 186, p. 14). Exhibited in Chicago in 1941 (Bibl. 7) and reproduced in the catalogue, it has eluded all our efforts to trace it since then. Although the black border does not appear in the 1941 photograph (from which the present reproduction was made), H. B. Wehle records having seen both the autograph number 35 and the black border, and his evidence is trustworthy. From the title which he gave it and under which it is listed in the 1941

catalogue, one must assume that he translated some such autograph caption as *No se despierta*. But what the scene actually represents is a young woman picking lice from the hair of a boy lying across her lap, and this corresponds quite well to the title given to No. 99 in the 1877 sale.

E.36 [131] p. 189

¿Quien bencera? no visible (Lp) (Who will win? One cannot tell) – 1803-12 – 258 × 184 – I – No. (P.S.) – No. add. 42 (fine P) upper centre – Single black border – *Paper*: vertical chain lines (28 mm) – *Watermark*: fragment of Honig & Zoonen – *Hist.*: Paris, Paul Lebas; APs. Paris, H.D. 3.4.1877, No. 13 "Qui l'emportera?" → Fiantance (or Fontaine?) (28 fr.); Madrid, Duchess of Montpensier; Marquis of Valdeterrazo – ? Madrid, Valdeterrazo heirs – GW 1404

The setting of this scene, with the jug standing on a pillar in the background, recalls the cartoon of 1791-92, *Las mozas de cántaro* (Woman water-carriers) (GW 300). But here, instead of a quiet scene, we have a scuffle between two young women who have come to draw water at the fountain. Are they fighting or playing? Goya's caption gives no hint either way, only telling us that the girls are equally matched and that it is difficult to foresee the outcome. This scene of figures fighting with their bare hands is very close to the one with two old women in drawing D.d. The position of the contestants is the same and they lay hold of each other in identical fashion; only their age and clothes are different.

Verso: sketch for the same subject. As with the dancer of E.30, one notes here the superiority of the final solution adopted by Goya.

E.37 [132] p. 190

Hutiles trabajos (Lp) (Useful work) – 1803-12 – 263 × 186 – I – No. (P.S.) – Single black border – *Paper*: vertical chain lines (27 mm) – *Watermark*: part of a lion (Honig & Zoonen) – *Hist.*: Paris, Paul Lebas; APs. Paris, H.D. 3.4.1877, No. 17 "Grand travail" → E. Féral (32 fr.); APs. Paris, c.1930 – Priv. coll. – GW 1406

Goya had treated this theme of washerwomen in a tapestry cartoon of 1780 (GW 132), but from a rather special angle, since it shows a group of young women at rest; from their elegance and attitudes, one would never have guessed their occupation, were it not for the laundry hanging in the background between two trees, towards which one of the women is moving with a bundle of laundry on her head. This drawing, on the other hand, represents washerwomen at work:

two of them, kneeling by the water, scrub their linen while gossiping; the third stands on tiptoe to hang her laundry on a branch. These are sturdy young women of the people, their buxom figures lovingly brought out by Goya, and the diagonal composition set out along three receding planes gives the scene a strong relief, emphasized by the patch of shadow in the foreground, a sort of embankment setting off the pretty girl on the right. Compare with the washer-women figuring in the picture in the Lille Museum, *Young Women with a Letter* (GW p. 243), belonging to this same period in which Goya painted or drew many pictures of working people (cf. in particular GW 963, 964, 965).

E.38 [133] p. 191

¿Valentias? Quenta con los años (Lp) (Showing off? Remember your age) – 1803-12 – 265 × 187 – I – No. (P.S.) – Double black border – *Paper*: vertical chain lines (29 mm) – *Hist.*: Paris, Paul Lebas; APs. Paris, H.D. 3.4.1877, No. 81 "Il roule dans un escalier" → E. Féral (30 fr.); A. Strolin, 1907 – Berlin-Dahlem, Kupferstichkabinett (4395) – GW 1407

Another casualty of old age, like the old woman in E.6 of this album, but here the mishap occurs on a stair-case, whose steps cut across the drawing diagonally and introduce into the composition a geometric element that contrasts with the figure falling headlong downstairs. The upturned face expresses a stunned dismay emphasized by the pallid lighting, which also plays over the old woman's legs and upturned skirts.
Both the autograph number and the added number seem to have been scraped off at the top of the sheet, above the double black border. What appears to be a 38 can just be made out.

E.39 [134] p. 192

No haras nada con clamar (Lp) (You won't get anywhere by shouting) – 1803-12 – 265 × 181 – I – No. (P.S.) – No. add. 59 (fine P) upper r. corner – Single black border – *Paper*: vertical chain lines (30 mm) – *Watermark*: fragment of Honig & Zoonen – *Hist.*: Paris, Paul Lebas; APs. Paris, H.D. 3.4.1877, No. 98 "Tes cris ne servent à rien" → P. Meurice (68 fr.); Ps. P. Meurice, Paris, H.D. 25.5.1906, No. 96 → Strolin (140 fr.); Ps. Boerner & Graupe, Berlin, 12.5.1930, No. 80; Goldschmidt – Cambridge (Mass.), Philip Hofer – GW 1408

This drawing is one of the most remarkable of those portrayals of working people that Goya began working on around 1808-12. But what is practically unique here is that this peasant expresses revolt: having

thrown down his hoe, he flings up his arms with closed fists and implores the heavens with all his might. His tense face and tousled hair express the violence of his feelings in the face of injustice and poverty. But here again Goya's autograph caption is addressed to the pictured figure, as to a brother, advising him – and, trying, if possible, to give helpful advice. Does Goya mean to imply that this unavailing revolt of one man should give place to a thorough revision of the established social order? Such would be the logical inference from the ideas which he had already tried to express a few years before in *Capricho 42, Tu que no puedes* (You who cannot), echoing the famous report on agrarian reform published by his friend Jovellanos in 1795.

E.40 [135] p. 193

Dejalo todo a la probidencia (Lp) (Leave it all to providence) – 1803-12 – 268 × 185 – I – No. (P.S.) – Single black border – Mark A.B. (Alfred Beurdeley) – *Paper*: vertical chain lines – *Hist.*: Paris, Paul Lebas; APs. Paris, H.D. 3.4.1877, No. 104 "Elle laisse tout à la Providence" → de Beurnonville (100 fr.); Ps. de Beurnonville, Paris, H.D. 16-19.2.1885, lot No. 50 (250 fr. for lot of six drawings) → Clément; Ps. A. Beurdeley, Paris, Gal. Georges Petit, 2-4.6.1920, No. 169 → H. Brame (2200 fr.); New York, Miss Edith Wetmore; Karl Kup; Helmut Ripperger – New York, E. V. Thaw coll. – GW 1409

The emotional impact of this drawing stems chiefly from the exceptional spareness of the composition and the simplicity of the means employed by Goya. As in E.28 of this same album, which is very close to it, the young woman is isolated in the centre of the sheet against a dim landscape background delimited by a very low horizon line, thus giving the human figure an added prominence. The thick shadows running at right angles to her feet balance the dark mass of her shawl and give a strong emphasis to the foreground. But the true centre of gravity of this drawing is the pale face, faintly shaded by the veil enveloping it: it expresses keen affliction tinged with a mild resignation that justifies Goya's consoling words. What a contrast between this gentle feminine figure and the defiant peasant of the previous sheet.

E.41 [136] p. 194

Dios nos libre de tan amargo lance (Lp) (God deliver us from such a bitter fate) – 1803-12 – 267 × 187 – I – No. (P.S.) – No. add. 50 (fine P) upper r. corner – Single black border – *Paper*: vertical chain lines (28 mm) – Mounted on pink paper – *Watermark*: part of a lion (Honig & Zoonen)

– *Hist.*: Javier Goya; Mariano Goya; V. Carderera; F. de Madrazo; Venice, Mariano Fortuny y Madrazo (Fortuny album) → 1935 – New York, Metropolitan Museum of Art, Harris Brisbane Dick Fund, 1935 (35.103.50) – GW 1410

It is obviously tempting to connect this very fine drawing with the many small pictures representing scenes of banditry and murder which are usually dated to the war years 1808-14. Several of these are also set in a cave (e.g. GW 916, 917, 918, 920) and feature women. Here a woman with her child clinging to her skirts has fallen into the hands of a bandit who, lifting his dagger menacingly, pulls her by the hair into a cave whose dark mass fills the entire upper part of the drawing, a symbol of the tragic fate in store for these two luckless people, in contrast with the charming landscape which they are leaving behind them. But it is certain that such acts of banditry were common well before the war, and Goya himself had depicted them several times, notably in the famous *Maragato* series painted in 1806-07.

E.43 [137] p. 195

Penitencia (Lp) (Penitence) – 1803-12 – 260 × 185 – I – No. (S) – No. add. 45 (fine P) upper centre – Single black border – Mark E.C. (Lugt 837) – *Paper*: vertical chain lines – *Hist.*: Paris, Paul Lebas; APs. Paris, H.D. 3.4.1877, No. 16 "Pénitence" → E. Féral (10 fr.); Ps. E. Calando, Paris, H.D. 11-12.12.1899, lot 72 (50 fr. for lot of two drawings) – Paris, priv. coll. – GW 1411

Goya has deliberately adopted a very spare technique for this austere theme, which belongs to the purest tradition of Spanish asceticism. The only patches of intense black are the hood and the shadows on the front of the habit and on the ground. All the rest is the white of the blank sheet of paper on which he has drawn only the lines strictly necessary to indicate drapery, face and hands. This drawing is closely related in theme and style to E.g, *The Novice*.

E.48 [138] p. 196

Piensalo bien (Lp) (Think it over well) – 1803-12 – 265 × 185 – I – No. (P.S.) – Single black border – *Paper*: vertical chain lines – Traces of pink paper – *Watermark*: ZOO (fragment of Honig & Zoonen) – *Hist.*: Paris, C. Groult; APs. Paris, Gal. Charpentier, 21.3.1958, No. 155 → C. de Hauke – France, priv. coll. – GW 1412

In the subject of this drawing, one is struck at once by a certain strangeness with which Goya has deliberately marked many of his works. How is it that this elegant young lady with a flowered head-dress comes to be lying in the open countryside, reading a little book in which, moreover, she seems engrossed? Her relaxed pose brings to mind the portraits of reclining women done by Goya about 1805-08, the most remarkable being that of the Marquesa de Santa Cruz (GW 828 and 829), dated 1805 (see in this connection Bibl. 171, p. 76).

Verso: here the abandoned sketch has nothing to do with the drawing on the recto. This figure in fact seems to be related to that of E.40; both are wearing the same dark shawl over their head.

E.49 [139] p. 197

Lo yerras, si te bue[l]bes á casar (Lp) (You make a mistake if you marry again) – 1803-12 – 267 × 181 – I – No. (I) – No. add. 62 (fine P) upper r. corner – Single black border – *Paper*: vertical chain lines (30 mm) – *Watermark*: fragment of Honig & Zoonen – *Hist.*: Paris, Paul Lebas; APs. Paris, H.D. 3.4.1877, No. 101 "Les Erreurs, il se marie de nouveau" → Pacat d'Yenne (116 fr.); A. Strolin; Boston, Paul Sachs → 1949 – Cambridge (Mass.) Harvard University, Fogg Art Museum (1949.7), Gift of Paul J. Sachs – GW 1414

The whole point of this drawing lies in the caption, which is so unexpected in connection with this figure that one wonders whether Goya may not be dealing with a real case. For who would think of marriage at the sight of this honest old peasant leaning on his stick? True, he still bears himself well and there is a touch of heartiness in the face, but, as Goya tries to make him understand, as to the idea of getting married again . . . ! What folly! This indeed is the very exclamation that he inscribed at the bottom of drawing D.18 in the Louvre, referring to a decrepit old woman, who is also leaning on her stick. The problem of marriage is frequently touched on by Goya throughout his work, and particularly its more ridiculous aspects: the tapestry cartoon *La boda* (GW 302), *Capricho 75*, *Wedding of the Ill-Assorted Couple* (GW 978, note) in the Louvre, drawings F.18, G.13 and G.15.

E.50 [140] p. 198

Muy acordes (Lp) (Perfect harmony) – 1803-12 – 265 × 185 – I – No. (S) – No. add. 63 (fine P) upper r. corner – Single black border – Mark A.B. (Alfred Beurdeley) – *Paper*: vertical chain lines – *Hist.*: Paris, Paul Lebas; APs. Paris, H.D. 3.4.1877, No. 102 "Très-d'accord" → de Beurnonville (75 fr.); Ps. de Beurnonville, Paris, H.D. 16-19.2.1885, lot 50 → Clément (250 fr. for lot of six drawings); Ps. A. Beurdeley, Paris, Gal. Georges Petit, 2-4.6.1920, No. 172 → Rosenthal (3020 fr.) – New York, E. V. Thaw coll. – GW 1415

This would seem to be a blind couple singing in the street. They are sitting on a kind of low wall running diagonally across the sheet of paper; the guitarist's left foot projects into the foreground with a remarkable foreshortening of the leg. This skilful touch gives depth to the drawing and binds together the two figures united in song.

E.a [141] p. 199

El trabajo siempre premia (Lp) (Work is always rewarding) – 1803-12 – 240 × 170 – I + P – Single black border – Mark A.B. (Alfred Beurdeley) – *Paper:* vertical chain lines (28 mm) – *Watermark:* NIG (fragment of Honig & Zoonen) – *Hist.:* Paris, Paul Lebas; APs. Paris, H.D. 3.4.1877, No. 94 "Le travail récompense toujours" → de Beurnonville (48 fr.); Ps. de Beurnonville, Paris, H.D. 16-19.2.1885, lot 50→Clément (250 fr. for lot of six drawings); Ps. A. Beurdeley, Paris, Gal. G. Petit, 2-4.6.1920, No. 173 → Gobin (3020 fr.); USA, Grenville L. Winthrop → 1943 – Cambridge (Mass.), Harvard University, Fogg Art Museum (1943.550), Bequest of Grenville L. Winthrop – GW 1417

In connection with drawing E.37, I referred to the importance assumed in Goya's art around 1805-12 by portrayals of working people. Here is a further example, in a key of feminine gentleness and patience contrasting with the more strenuous efforts previously represented. This young housewife is sitting at home, busily knitting beside a large basket on the floor next to her chair, containing more needlework. Her delicate features and in particular her hair-style recall certain portraits of the period 1802-08, such as *Francesca Sabasa García* (GW 816) in Washington and *Lorenza Correa* (GW 836), formerly in the collection of the Comtesse de Noailles. Here again, in this young woman, one notes the abundance of forms "affected", as Baudelaire subsequently wrote of the naked *maja*, "with divergent strabismus". Possibly there is an erotic innuendo in the caption, this work having its reward not only for the woman who does it but also for those who, like Goya, take pleasure in watching her.
Verso: an abandoned sketch of a girl dancing, similar to that of E.30, with a faint sketch on the right for the same subject.

E.b [142] p. 200

Cuidado con los consejos (Lp) (Beware of the advice) – 1803-12 – 254 × 171 – I + P – Double black border – Mark A.B. (Alfred Beurdeley) – *Paper:* vertical chain lines – *Hist.:* Paris, Paul Lebas; APs. Paris, H.D. 3.4.1877, No. 82 "Gare aux conseils" → de Beurnonville (90 fr.); Ps. de Beurnonville, Paris, H.D. 16-19.2.1885, lot 50 → Clément (250 fr. for lot of six drawings); Ps. A. Beurdeley, Paris,

Gal. G. Petit, 2-4.6.1920, No. 170 → J. Homberg (3000 fr.); Ps. J. Homberg, Paris, Gal. G. Petit, 11.5.1923, No. 18 → Le Garrec (3850 fr.) – Washington, Phillips coll. – GW 1419

The caption helps us to understand what Goya meant to represent in this apparently innocent drawing. The young peasant woman sitting on a sort of bench, and still holding her basket in her right hand, ignores the words of this bold young fellow leering at her. She only turns her back upon us to mask the shameless exhibitionism of her would-be seducer. Goya later treated a similar theme in one of the *Black Paintings* in the Quinta del Sordo, *Two Young People laughing at a man* (GW 1618).

E.c [143] p. 201

Trabajos de la guerra (Lp) (Hardships of the war) – 1808-12 – 240 × 170 – I – Double black border – *Paper:* vertical chain lines – *Hist.:* Paris, Paul Lebas; APs. Paris, H.D. 3.4.1877, No. 7 "Travaux de la guerre" → E. Féral (8 fr.); P. Meurice; APs. Paris, Gal. Charpentier, 9.4.1957, No. 3; Otto Wertheimer – France, priv. coll. – GW 1420

This is the drawing most closely related to the *Disasters of War,* but with this difference, that the etchings describe the horrors of war, whereas here we have a picture of its aftermath: a poor starving cripple, leaning on a rough pair of crutches and reduced to beggary. It is the man's beggary that Goya emphasizes both in the drawing (the hat held out for alms) and in the caption, where he does not use the word *trabajos* by chance. For him the greatest crime of war is to leave in its wake so many disabled and unemployed men. Such are the "works" of war which he vigorously condemns. It is noteworthy that neither in the *Disasters* nor in the drawings of the war years did Goya ever glorify the victors; for him there are only victims and vanquished. The autograph number of this drawing seems to be masked by a frame, as is the number added later which, according to my investigations, should figure on the side. If we take into account the order of the 1877 catalogue and the drawings already satisfactorily identified, notably E.6, E.8, E.9 and E.13 (which bear respectively, in the upper centre, the added numbers 33, 34, 35 and 38), we may infer that this drawing should have an autograph number between 9 and 13 and an added number between 35 and 38.

E.d [144] p. 202

El ciego trabajador (Lp) (The industrious blind man) – 1803-12 – 238 × 171 – I – Single black border – Mark A.B.

(Alfred Beurdeley) – *Paper:* vertical chain lines (30 mm) – *Watermark:* lion + fragment of Honig & Zoonen – *Hist.:* Paris, Paul Lebas; APs. Paris, H.D. 3.4.1877, No. 90 " L'Aveugle travailleur" → de Beurnonville (40 fr.); Ps. de Beurnonville, Paris, H.D. 16-19.2.1885, lot 50 → Clément (250 fr. for lot of six drawings); Ps. A. Beurdeley, Paris, Gal. G. Petit, 2-4.6.1920, No. 171 → J. Homberg (2900 fr.); Ps. J. Homberg, Paris, Gal. G. Petit, 11.5.1923, No. 17 → Le Garrec (3800 fr.); Sagot → 1925 – Vienna, Albertina (45410) – GW 1421

Another caption in which appears a word deriving from "work", and a scene in which work triumphs over the cruellest of infirmities. To make the scene more moving, Goya shows the blind cobbler surrounded by his family. He holds his last-born child in his arms as he mends a shoe, as if this humble task and his child were his two dearest treasures. Also sitting on the floor, but set back a little, his wife is busy with the same work, and behind her appears the head of a man with a hat. A customer or an observer of the scene? It is hard to say. Probably, however, Goya inserted this figure because he felt the need to deepen the composition by the addition of a background plane.

E.e [145] p. 203

La culpa es tuya (Lp) (It's all your fault) – 1803-12 – 247 × 176 – I – Single black border – *Paper:* vertical chain lines – *Hist.:* Paris, Paul Lebas; APs. Paris, H.D. 3.4.1877, No. 91 "C'est de ta faute" → Luyatres (36 fr.); P. Meurice France, priv. coll. GW 1422

This drawing belonged to the same Paris collection as nine others sold on 9.4.1957 at the Galerie Charpentier. All of them came from the collection of Paul Meurice, friend and executor of Victor Hugo; he also owned three others. These thirteen drawings had figured in the 1877 sale, where Paul Meurice bought eight of them; the others he acquired from Féral and Luyatres (?), and then later at the Calando sale in 1899. This one is remarkable for its emphatic diagonal layout. The caption records an interjection very common in Spanish. Nevertheless, one cannot help thinking of plate No. 74 in the *Disasters of War* in which Goya represented a wolf writing on a sheet of paper a line from the Italian poet Casti translated into Spanish: *Misera humanidad, la culpa es tuya.* One also notes the man's dress: his frock-coat with broad lapels is identical with the one in several portraits of the period 1803-12, in particular *Manuel Silvela* (GW 891), *Bartolomé Sureda* (GW 813) and *Evaristo Pérez de Castro* (GW 815).

E.f [146] p. 204

Artemisia (Lp) (Artemisia) – 1803-12 – I – Single black border – *Paper:* ? – *Hist.:* Paris, Paul Lebas; APs. Paris, H.D. 3.4.1877, No. 15 "Artémise" → E. Féral (35 fr.); Cambridge (Mass.), Philip Hofer; New York, Durlacher Bros – Coll. unknown (North Africa, Robert MacDonald?) – GW 1423

All trace of this drawing has been lost, but it unquestionably figured in the 1877 sale, listed under the number 15. It seems difficult, however, to establish any logical connection between this young woman and Goya's manuscript caption at the bottom of the sheet. Does he mean to represent Queen Artemisia, widow of Mausolus, who appears in *Don Quixote*? Or is this some figure from contemporary literature? The woman's imploring attitude, the grace of her forms and the sweep of her flowing draperies make this a moving figure, related to those of several other drawings in this series: E.28, 33, 40, 48 and E.a.

E.g [147] p. 205

La novicia (Lp) (The Novice) – 1803-12 – 264 × 179 – I – Single black border – Traces of a number in upper centre of sheet – *Paper:* vertical chain lines (27 mm) – *Watermark:* NIG & Z (fragment of Honig & Zoonen) – *Hist.:* Paris, Paul Lebas; APs. Paris, H.D. 3.4.1877, No. 14 "Le Novice" → E. Féral (12 fr.); Munich, S. Meller → Frits Lugt (1928) – Paris, Fond. Custodia (Inst. Néerlandais) – GW 1424

An inscription on the back of this sheet reads "from the collection of Victor Hugo". There is, however, no certain proof that Hugo owned any drawings by Goya, even though he is known to have admired the *Caprichos* and the *Disasters of War,* and even though there is an obvious aesthetic connection between his own drawings and Goya's graphic work. This novice, bowing in humility, invites comparison with the nun of E.43 and also with a drawing in Indian ink entitled *Submission* or *Religious Submission* (GW 764), which belonged to Paul Lefort and to Etienne Arago (Bibl. 28 and 30).
Verso: unfinished sketch of a nun in front view, with her hands tucked into her sleeves. Inscription: "from the collection of Victor Hugo".

E.h [148] p. 206

"Two women embracing" – 1803-12 – 218 × 151 – I – Mark L.B. (Léon Bonnat) – Slight traces of a black border on upper left and lower right – *Paper:* vertical chain lines (28 mm) – *Watermark:* Z (fragment of Honig & Zoonen) – *Hist.:* ? Paris, Paul Lebas; APs. Paris, H.D.

3.4.1877, No. 97 "La Concorde" → E. Féral (40 fr.); Léon Bonnat coll. – Bayonne, Musée Bonnat (1415) – GW 1426

When in 1970 I published this drawing and the next (which have the same provenance), I suggested that "it must have been cut down within the black border by an over-scrupulous collector (Bonnat?) who thought the border was a later addition". Information kindly supplied by M. Paul Bazé, curator of the Musée Bonnat, now proves that this supposition was correct. Both drawings retain faint but unmistakable traces of the black borders; careful inspection of the sheet, moreover, shows that it is in fact the Honig & Zoonen paper used by Goya for this album. The young women in this scene are of the same type as those in E.36 and E.37: they are women of the people, robust yet slender, a type which has now definitely supplanted the *maja* of the tapestry cartoons, the drawings in the first two albums, and the *Caprichos*.

It seems safe to assume that this drawing and the next figured in the 1877 sale; the titles of numbers 97 and 88 in that sale seem to fit the subjects. Both were then bought by the painter Eugène Féral, an appraiser at the sale; he later sold other Goya drawings to various collectors, notably Paul Meurice and Calando.

E.i [149] p. 207
"Chained prisoner" – 1808-12 – 218 × 151 – I – Mark L.B. (Léon Bonnat) – Slight trace of a black border on lower left – *Paper*: vertical chain lines (28 mm) – *Hist.*: ? Paris, Paul Lebas; APs. Paris, H.D. 3.4.1877, No. 88 "Ne pleure pas, misérable" → E. Féral (30 fr.); Léon Bonnat coll. – Bayonne, Musée Bonnat (1416) – GW 1427

For the technical details, see the previous entry. The subject here is in sharp contrast with the companion drawing in the same museum, which expressed youth and *joie de vivre*. There is no clue to the position occupied by either of these sheets in the black border series; so we do not know if they were consecutive drawings on deliberately contrasting themes, as is the case with E.32 and 33, and also with E.39 and 40. But anyhow it is clear that in this album Goya drew inspiration from a variety of sources. This wretched prisoner bound hand and foot is probably, like E.c, an evocation of the war years. He may be compared, in particular, with the prisoner on the right in the *Interior of a Prison* in the Bowes Museum (GW 929) and more generally with the series of prints and drawings of prisoners (GW 986 to 992). The same theme appears frequently in albums C and F, e.g. C.95, C.103, C.111

and F.80. These drawings are more than realistic documents, they are a fierce indictment of man's barbaric treatment of man.

E.j [150] p. 208
"Beggars' repast" (?) – 1803-12 – 265 × 170 – I – *Paper*: ? – *Hist.*: ? Paris, Paul Lebas; APs. Paris, H.D. 3.4.1877, No. 80 "La Bouillie" → Haurois (?) (140 fr.); Ps. Heidsieck, New York, Parke-Bernet, 12-13.2.1943, No. 104 – Coll. unknown – GW 1428

It does not look as if this drawing can be identified with the one which figured in the Doria sale (Bibl. 41) under the title *Ceux qui fuient le travail finissent ainsi* (Those who avoid work end up like this) and which had also figured in the 1877 sale where it was catalogued as No. 10 (Bibl. 34 and 99, p. 112). Another title in this latter catalogue, *La Bouillie* (The Mash), seems much more appropriate to this drawing, which might well refer to the cruel famine that hit Madrid in the winter of 1811-12. Compare with plates 48 to 64 of the *Disasters of War*, which deal with the same events.

E.k
lo mismo (Lp) (The same) – 1803-12 – 260 × 180 – I – *Paper*: ? – *Hist.*: Paris, Paul Lebas; APs. Paris, H.D. 3.4.1877, No. 100 "Le Laboureur" → de Beurnonville (50 fr.); Ps. de Beurnonville, Paris, H.D. 16-19.2.1885, lot 50 → Clément (250 fr. for lot of six drawings); Ps. A. Beurdeley, Paris, Gal. Georges Petit, 2-4.6.1920, No. 174 → Hugo (3000 fr.) – Coll. unknown

Until now this drawing has been known only from the catalogue of the A. Beurdeley sale, in which it figures under the number 174, and from the tentative catalogue of Goya's drawings published by Paul Lafond (Bibl. 112, p. 157, No. 92). It has never been reproduced, and even the subject would be unknown (Goya's autograph caption gives no clue to it) were it not for the brief description of it given in the catalogue of the Beurdeley sale: "Un laboureur vu de dos guide le soc d'une charrue attelée de bœufs" (A ploughman seen from behind guides the share of a plough drawn by oxen). Here again, we note, is a subject glorifying work. Publication of the catalogue of the 1877 sale (Bibl. 34 and 99, p. 116) has revealed a much earlier reference to this drawing under the title *Le Laboureur*, given to it by the appraiser Eugène Féral, who of course could make no sense of Goya's autograph caption, whose meaning would only be clear if we had the previous drawing in the album to which it refers.

Lost Drawings

E.l
"Religion consoles him" – *Hist.:* Paris, Paul Lebas; APs. Paris, H.D. 3.4.1877, No. 2 → E. Féral (6 fr.)

E.m
"Work and keep quiet" – *Hist.:* Paris, Paul Lebas; APs. Paris, H.D. 3.4.1877, No. 3 → Siénil (12 fr.)

E.n
"Good lad" – *Hist.:* Paris, Paul Lebas; APs. Paris, H.D. 3.4.1877, No. 8 → E. Féral (9 fr.)

E.o
"Those who avoid work end up like this" – *Hist.:* Paris, Paul Lebas; APs. Paris, H.D. 3.4.1877, No. 10 → Pascal (26 fr.); Ps. Doria, Paris, Gal. Georges Petit, 8-9.5.1899, No. 433

E.p
"Don't trust that old woman" – *Hist.:* Paris, Paul Lebas; APs. Paris, H.D. 3.4.1877, No. 84 → Pascal (55 fr.)

E.q
"You are having a bad time" – *Hist.:* Paris, Paul Lebas; APs. Paris, H.D. 3.4.1877, No. 92 → Pascal (50 fr.)

E.r
"Good balance" – *Hist.:* Paris, Paul Lebas; APs. Paris, H.D. 3.4.1877, No. 96 (bought back for 41 fr.)

E.s
"Bad luck" – *Hist.:* Paris, Paul Lebas; APs. Paris, H.D. 3.4.1877, No. 103 → E. Féral (30 fr.)

Journal-Album (C)

Introduction

Of all Goya's drawing albums, this is the one that contains the largest number of sheets and it is the only one that has reached us almost intact, without being broken up and passing through successive sales. While the highest autograph number is 133, our catalogue includes 126 sheets, 120 of them belonging to the Prado Museum, which thus offers the most complete existing collection of drawings from the same album. To turn over these beautiful leaves is, for the student of Goya, an unforgettable experience, for they constitute an irreplaceable source of knowledge and at the same time touch the deepest chords of feeling. This direct contact with a work of so private a nature, with a hand whose presence is so nearly felt and seems so spontaneous in its creative action, and above all the captions in which one seems to catch the very accents of the artist's voice – all this casts a magic aura of life over this album.

It may well be wondered how, by what miracle, so extensive a cycle of drawings has happened to come down to us virtually intact. For an answer, we have to go back to the acquisition in 1866 by the Museo de la Trinidad in Madrid (officially, the Museo Nacional de Pinturas) of a large lot of 186 Goya drawings, which in 1872 were incorporated in the collections of the Prado Museum. Actually this lot comprised 188 drawings, if we include the two versos from the Sanlúcar album which formed part of it. According to the Prado records, they were purchased from one Román Huerta or la Huerta (Bibl. 173, introduction), who at the same time sold the museum three major paintings: a *Self-Portrait* (GW 1552), *Josefa Bayeu* (GW 686) and *The Exorcism* (GW 979). But there seems to be some confusion as regards the identity of Román Huerta or la Huerta. For we have, first of all, Matheron's statement concerning the copper plates of the *Disasters of War*: "These plates are in Madrid, owned by Mr. R. G., who also owns 300 original Goya drawings, in pencil, sepia, and pen and ink, as well as some of the fine pictures kept by Don Xavier Goya" (Bibl. 137, note 7). As suggested by Elizabeth du Gué Trapier (Bibl. 184, p. 12), whose view I share, this Mr R. G. was no doubt Román Garreta, brother-in-law of Federico de Madrazo. Later, and more explicitly, the Conde de la Viñaza (Bibl. 185, pp. 128-129, 248, 255, 288) refers to him as owning the copper plates of the *Disasters of War* and the three pictures mentioned above. In connection with the portrait of *Josefa Bayeu*, he specifically states that "it was purchased by the government, after consultation with the Royal Academy of San Fernando, from Don Román Garreta, who had acquired it from Goya's heirs." But, in my opinion, the document that clinches the matter, as far as the Prado drawings are concerned, is the one kindly communicated to me by the Hispanic Society of America, and already referred to by Elizabeth du Gué Trapier (ibid.). It is a note written by Raimundo de Madrazo, son of Federico de Madrazo and a nephew of Román Garreta, and given by him to Archer M. Huntington in 1913, when the latter bought some Goya drawings (cf. general introduction). The note proves that the owner of the Prado drawings, apart, of course, from the Carderera lot acquired in 1886, was actually Román Garreta and not Román Huerta or la Huerta. Was this a clerical error in the Prado records? Or was it rather, as I am inclined to think, a deliberate camouflage of the real name in order to avoid any too clear indication of the part played by the Madrazo family in this transaction? For at that time Federico de Madrazo was director of the Prado and president of the Royal Academy of San Fernando. It has not as yet been possible to clear up this somewhat delicate point.

According to Matheron, Román Garreta owned more than 300 Goya drawings, including the 186 in the Prado. He could have acquired them either from Javier Goya before his death in 1854 or, after that date, from Javier's son Mariano. It is quite possible, too, that he did not buy them all at one time. Very little is known about the sale of Goya's works after his death. We do, however, have a few clues to go on, and from these it is possible to make certain deductions. In his thorough study of the Fortuny album, H. B. Wehle, on the strength of Carderera's 1860 article (Bibl. 84), considers that the album only came into Carderera's possession after he had written his article and consequently after Javier's death; otherwise he would have known – and he did not know – whether it was Javier or someone else who assembled and numbered the drawings in the Fortuny album. The same presumably applies to the two other series numbered by Javier and sold in Paris in 1877. This precious ensemble of 170 drawings (including the versos) had no doubt been kept by Javier as a treasured heirloom, and it must have been Mariano, always short of money, who sold it after 1860 to Carderera (Fortuny album) and Garreta (albums in the 1877 sale). Now Carderera states clearly in his article that in 1860 he already owned all the drawings which were to be sold by him in 1867 to the Biblioteca Nacional in Madrid and by his nephew in 1886 to the Prado (album drawings and all the preparatory studies for the sets of prints) – a very large lot of nearly 400 drawings purchased, most probably, from Javier Goya between 1840 and 1854. (Matheron writes in this connection: "Mr V. Carderera also has many of them and some very curious ones" [Bibl. 137, catalogue of drawings].) Garreta, presumably in those same years, purchased from Javier part of what remained of the album drawings, aside from the numbered "heirloom" – that is, the 188 Prado drawings and the twelve sold in 1913 by his nephew Raimundo de Madrazo to Archer M. Huntington (200 drawings in all if we include the versos, but only 196 for the period).

In conclusion, it is safe to say that the lot of 300 drawings acquired by Román Garreta from Javier or Mariano Goya included nearly all the drawings in album C. Nearly all, because we cannot be sure that he owned the three sheets now outside the Prado (C.11, 78 and 88) and the seven that are missing, assuming that the album never numbered more than 133 drawings. As for the 120 sheets sold to the Museo de la Trinidad in 1866, they were all numbered by Garreta in lead pencil in the lower right corner, as were the other 66 drawings in the lot; I was able to check this point for the first time in 1972, thanks to the kind cooperation of the Prado authorities. But oddly enough Garreta's numbering, with a few exceptions, is exactly the reverse of Goya's. The only explanation is that Garreta must have gone through the whole set of drawings one by one, in order to eliminate a few, but without turning them over; so that he ended up with a pile of 120 sheets, the top sheet being the last, No. 133, which he numbered 1, and he proceeded to number the rest by working back through the pile to the beginning of the album. It should be noted, moreover, that this pencilled numbering had no special significance for Garreta; it was simply a means of fixing, without any risk of error, the exact number of the sheets which he intended to sell. In the past Garreta's numbering has often proved very helpful to us in determining the position of certain sheets whose autograph number was invisible. Today, after a thorough examination of these 120 sheets, at last removed from their slip-in mounts, the only doubtful case remaining is C.65?; no autograph number can be made out and its position at this point in the sequence is indicated by the additional number 60. Whenever a drawing is missing, we generally find that Garreta's numbering remains consecutive, thus showing that the missing drawing had already been eliminated either by Javier Goya or by Garreta, before the definitive lot was made up and sold to the Museo de la Trinidad in 1866.

Drawings from album C have been reproduced, in varying numbers, in many books dealing with Goya's work. But Pierre d'Acchiardi's fine edition of them in 1908 (Bibl. 69) is noteworthy for the outstanding quality of its facsimiles. Mayer in 1923, in his *Goya* (Bibl. 140), and Sánchez Cantón in 1928, in collaboration with Félix Boix (Bibl. 81), also published many of these drawings. But none of these publications took any account of the autograph numbers; which means that the very notion of an album – though these authors had some inkling of it – was ignored in their arrangement of the drawings. It was only in 1947 that a chance meeting and the example of H. B. Wehle (see general introduction) led me to bring together for the first time 117 drawings from album C, out of the 120 owned by the Prado. Reproduced in large plates (slightly larger than the actual size), they were at last presented in the order of the autograph numbers, as a homogeneous sequence which I called at the time the "Indian ink and sepia series with Goya's captions and serial numbers." I proposed to date the whole series to the period 1800-23, with the idea that they had been drawn, as occasion or inspiration offered, in a strictly chronological order. Actually this tentative catalogue, though ambitious in the large number of album drawings reproduced, had no real scholarly basis and proceeded rather from an instinctive belief in Goya's autograph numbers and the existence of distinct sequences with well-defined characteristics.

To López-Rey goes the credit for the first thorough study of this album (Bibl. 131) with a wealth of commentaries and explanations which gave proof, if proof were needed, of the author's fine scholarship and profound knowledge of Goya. He reproduced 113 drawings in a format appreciably smaller than that of the originals and often incompletely, for at that time it was impossible to examine the drawings outside their slip-in mounts. Only in the case of sheets lent to exhibitions outside Spain, notably those held in Basle in 1953 and London in 1954 (Bibl. 11 and 12), could the drawings be measured, and even then the dimensions given were only approximate. But his careful examination of the techniques employed led the author to make some very interesting suggestions concerning the progressive elaboration of the series and the dating of the drawings themselves. In short, it was significant that in 1956 so eminent an authority on Spanish art and a leading English publisher should have devoted an entire book to a single album of Goya drawings. They thus prepared the way for a general regrouping of the albums and a complete publication of them.

WATERMARKS

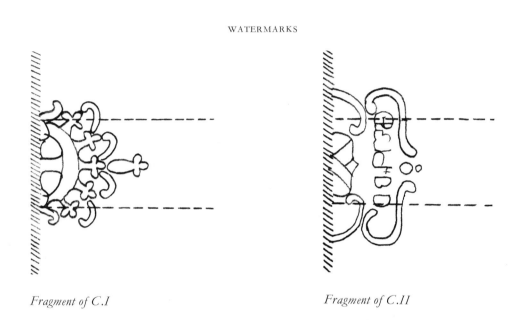

Fragment of C.I *Fragment of C.II*

My 1970 catalogue of the drawings (Bibl. 97) included 125 sheets from album C, but reproduced in postage-stamp size – sufficient for reference purposes, but of no aesthetic appeal. As regards the technical characteristics supplied for each sheet, they were necessarily succinct and in some cases incomplete, for it had not yet been possible to make a thorough examination of the Prado drawings. It is only now, in particular, that their exact dimensions can be given. Likewise, several autograph numbers have come to light for the first time on the original sheets (C.6, 55, 57, 61, 76, 93, 97, 116 and 120), enabling these drawings to be fitted conclusively into the sequence. I have also been able to ascertain that all of them were mounted on pink paper, except for C.80, 96 and 120, which are pasted on white paper. In some cases the pink paper employed by Javier Goya extends well beyond the edges of the drawing and bears part of a stamp reading "Dirección del Museo Nacional de Pinturas" (the official name of the Museo de la Trinidad founded in 1837), thus proving, incidentally, that the drawings were mounted on pink paper before 1866.

The study of the drawing paper is made difficult in the Prado by this pink paper pasted on the back of all the sheets. While the chain lines, always horizontal, generally appear very distinctly, even in photographic reproductions, the watermark does not always show through, although on many sheets it can be made out quite clearly, figuring invariably on the left edge of the drawing, about half way up. Eleanor Sayre has recorded for album C a watermark consisting of a coat of arms and a crown (Bibl. 176, p. 131). The latter, surmounted by a small cross, is quite common (see in particular C.84), but I have observed another watermark on certain sheets (C.39 and 60, among others): in a scroll 35 millimetres wide, at the foot of a coat of arms, is a name which I read

as ROMANI, presumably the manufacturer who made the same paper that Goya used to print some trial proofs of the *Disasters of War* between 1810 and 1820. Finally, one further detail may be mentioned: about ten of these Prado drawings have a tiny pin-hole in each corner, whose position was carefully determined by two faint pencil strokes drawn in at right angles.

Turning now to the subjects treated, we find that album C is distinguished from the previous albums by a new feature: the existence of several groups, varying in number, of drawings closely connected by a common theme. The most homogeneous groups would seem to be the following six:

C.39 to C.47: visions in the same night.
C.85 to C.92: the *encorozados* (victims of the Inquisition).
C.93 to C.114: prisons.
C.115 to C.118: liberty.
C.119 to C.125: against the monastic orders.
C.126 to C.131: defrocked monks and nuns.

Apart from these well-marked sequences, there are two larger groups (C.1 to C.38 and C.48 to C.84) separated by the series of "Visions in the same night". They deal with a wide variety of human cases, ranging from the direst misfortunes (C.32) to the quiet joys of life (C.9, C.10, C.11). López-Rey has tried to link up all these drawings, reading into them a pattern of interrelated ideas; but the connectedness he so ingeniously imposes on them seems to me to restrict rather than extend their scope. Although it is always possible to find a common denominator for human joys and sufferings, I think it is better to respect the specific character of these different figures and, while of course recognizing a few unmistakable parallels, to consider them as a kind of gallery representing the "Vicissitudes of life".

One may be tempted – as I was in 1947 – to deduce a chronology from some of these groups and to read into these sequences a kind of journal "written", so to speak, under the pressure of political events. The *encorozados* and the prisons would date to the period of repression that followed the return of Ferdinand VII (1814-20); the next groups would then correspond to the liberal outburst of 1820 (revolt of Riego and return to the 1812 Constitution) with, as a corollary, the anticlerical reaction and the decrees secularizing many monasteries and convents. But it seems to me now that, while this sequence of subjects was indeed chosen by Goya and indicated by his autograph numbers, it does not necessarily imply that the drawings were executed in that order, nor that the scenes represented were always scenes he had *witnessed* or even scenes of his own time, the most obvious examples being the sheets glorifying historical figures of the past like Galileo, Torrigiano and Zapata (C.94, C.100 and C.109). Needless to say, Goya was intent on denouncing the intolerance and tortures that he saw around him; he was unsparing in his attacks on the Inquisition and the political repression and obscurantism that then prevailed. But these long indictments would seem in reality to have been carefully composed on the basis of what he remembered, sometimes but dimly, what he had been told, and what he had read about. One may conclude, then, that memory and imagination were the main sources for these scenes in which Goya, transcending his own time, called up the past and appealed to the future.

Technical problems in this album are more complex than in the others, for here Goya used both Indian ink and sepia, often in the same sheet; and here captions and autograph numbers may be inscribed with brush, pen or pencil. As regards the subjects alone, one may say that album C is divided into two main families of drawings: from the beginning to C.56, all the subjects are executed in Indian ink wash (with very occasional touches of sepia); from C.57 to C.116, sepia wash predominates, although the background of the compositions from C.90 to C.116 is often laid in with Indian ink. In every drawing from that point on (C.116 to C.133) Indian ink and sepia are used in conjunction. Despite the sweeping changes made by Goya himself in the order of the drawings, as proved by the many numbers he modified, it is safe to assume that the album was executed over quite a long period of time, the earlier sheets dating perhaps to the opening years of the century and the later ones to the period 1815-20 or even 1824. The media chosen by Goya changed in the course of time. In the early part of the album and up to about 1812, he used chiefly Indian ink, the medium he had preferred since 1796 (Sanlúcar album). Then little by little he introduced some accents and details in sepia, until the time – corresponding to the early sheets of album F – when sepia became his favourite medium, though he did not yet abandon Indian ink, using it to lay in his backgrounds, which thus took on a peculiarly dramatic density in the prison scenes (C.95, 96, 100, 103, 107, etc.). But the important phenomenon was the final change-over from Indian ink to

sepia, without any subsequent return to the former, which he gave up for good. And we shall see, in connection with album F, executed entirely in sepia, that he proceeded with some hesitation before he mastered the technique of sepia wash, for it is much more difficult to handle than Indian ink. Along with this decisive change of technique which took place in the middle of album C, one notes a distinct change in Goya's style. First in the scale of the subjects represented: the figures tend to become more prominent on the sheet (for example C.57, 60, 63 and 65), until they attain monumental proportions (C.123 and 125). But above all the handling becomes freer and more spirited, and the increasingly frequent use of broad areas of wash resulted in powerful chiaroscuro effects (C.65?, 76, 85, 88, 90, 93, 95, etc.): here already we have the expressionistic style of the *Disasters of War* and the *Disparates*.

There only remains the problem of the autograph numbers and the captions. There seems to be no doubt about the parallelism between the numbers and the subjects themselves: as Goya executed each drawing in Indian ink wash, he numbered it with the same brush; then, as sepia came to prevail, the numbers too changed from Indian ink to sepia, with only a slight lag (C.54 to 66). Only in the case of the last drawings (C.119 to 133) do the numbers show the same capricious changes between Indian ink and sepia as the subjects. So we may conclude that he numbered this series at about the same time as he executed the drawings and with the same ink.

As regards the captions, a systematic examination of them raises more perplexing problems. When the subjects and numbers are executed in Indian ink wash (C.1 to 56), the captions are written first in sepia (C.1 to 25), then from C.26 on in black chalk. When the subjects and numbers go over to sepia (C.57 to 116), the captions continue to be written in black chalk up to C.75, thereafter reverting to sepia, as at the beginning, up to C.116; the end of the album (C.117 to 133) is, as we have seen, very composite. These differences in technique between captions and drawings, together with the evidence provided by a scrutiny of certain sheets, like the series of "Visions in the same night" (see entry for C.42), suggest that Goya only wrote in the captions after the drawings had been numbered and ordered. But just as we have no way of knowing how much time may have passed between a given event and the related drawings (for example, the revolt led by Rafael Riego and drawings C.115 to 118), it is equally impossible to say when exactly the captions were added. Whole sets of drawings may not have been captioned until long after they were made. Such a time-lag would also explain the unexpected turn taken by certain captions, which show a fresh consideration of the subject in view of the context formed by the adjoining drawings. In conclusion, it may be said that work on album C extended over many years (including the tragic years of the war and the repression instigated by Ferdinand VII); and that this slow working out, clearly reflected in the evolution of the style and the techniques employed, makes it the most complex of all Goya's albums.

Paper: White laid paper, mark Romani (?). Horizontal chain lines 23 mm apart.

Watermark: Two designs occur, the upper and lower fragments of the same mark:

 C.I: crown surmounted by a small cross;

 C.II: scroll and lower part of a coat of arms; in some scrolls the name ROMANI can be deciphered.

Maximum sheet size: 207 × 146 mm. (According to the catalogue card entry of the Biblioteca Nacional in Madrid, drawing C.56 measures 210 × 145 mm.)

Drawing: Recto only.

Technique: Album C is technically the most complex of all the albums. It contains brush drawings done solely in Indian ink (C.1 to C.56 inclusive) or solely in sepia ink (frequently from C.64 to C.89 inclusive), but also many drawings in which these two media are combined (chiefly from C.90 to the end). Touches and highlights in a different ink are frequent. Traces of lead pencil and pen also occur.

Captions: Same complexity as for the subjects. From C.1 to C.25: brush with sepia. From C.26 to C.75: lead pencil. From C.76 to C.116: brush or possibly blunt pen with sepia. From C.117 to the end: various media (lead pencil, Indian ink or sepia). The highest number is 133 (Catalogued: 126).

Goya's numbers: Same complexity. From C.1 to C.53: brush and Indian ink. From C.54 to C.118: brush and sepia. From C.119 to the end: brush with Indian ink or sepia. On two sheets (C.76 and 77) the numbers appear to have been written with a pen.

Additional numbers: The drawings in this album that belong to the Prado all came from the collection of Román Garreta, who numbered them in lead pencil at the lower right corner of each sheet, in an order exactly the reverse of Goya's autograph numbers.

BIBLIOGRAPHY

Exhibitions: 2, 4, 7, 8, 11, 12, 13, 16, 19, 20, 22.

Public Sales: 62.

Authors: 69, 76, 80, 81, 84, 97, 120, 121, 123, 125, 127, 129, 130, 131, 135, 137, 140, 152, 153, 165, 171, 173, 176, 184, 185.

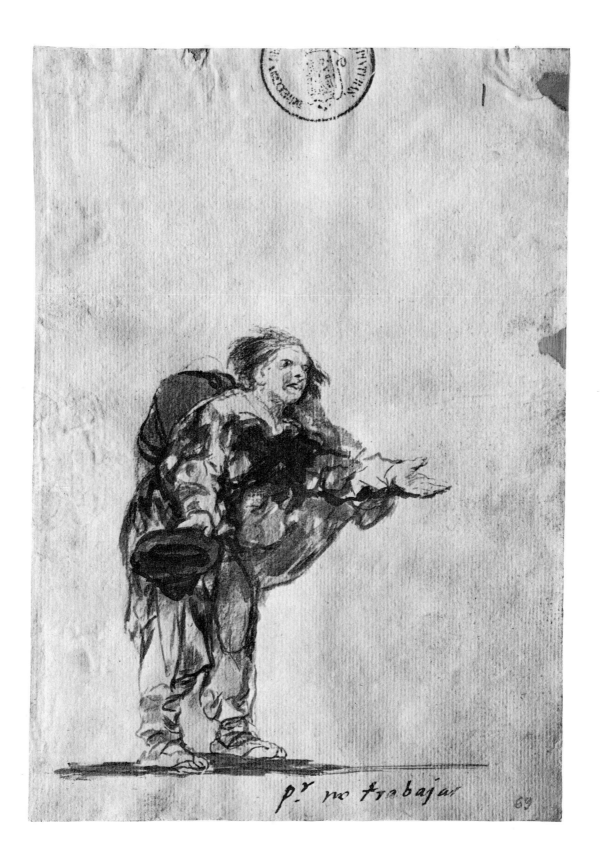

pr no trabajar

69

Salvage menos q.ᵉ otros

119

3

āq.ᵗ bendra el Faldellin y los Calzones.

118

Mas probecho saco de estar solo.

5

Este fue un Cojo q.e tenia señoria

116

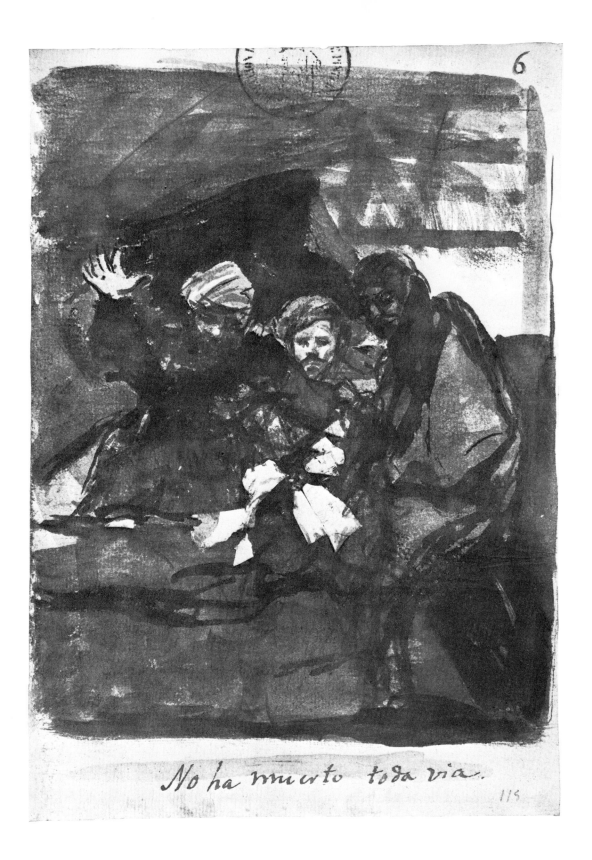

No ha muerto toda via.

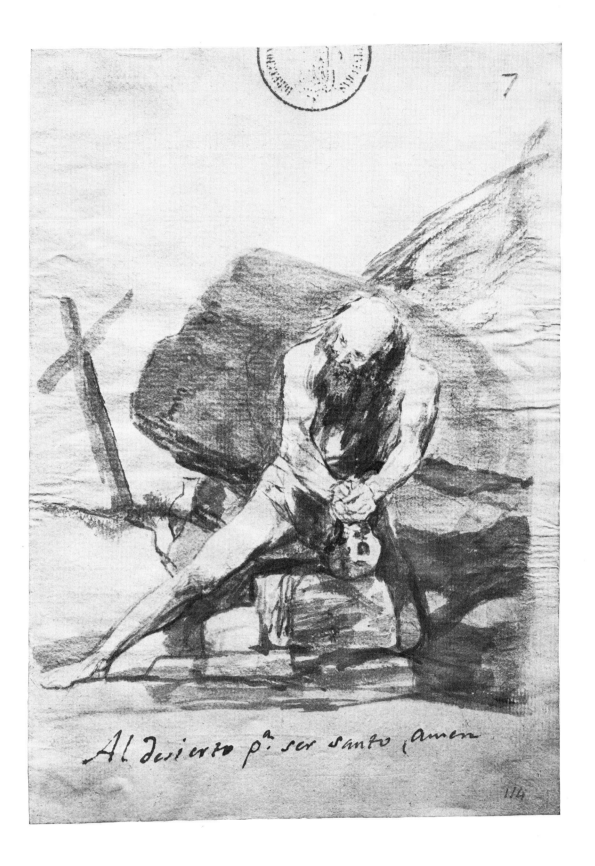

Al desierto pᵃ ser santo ¡amen

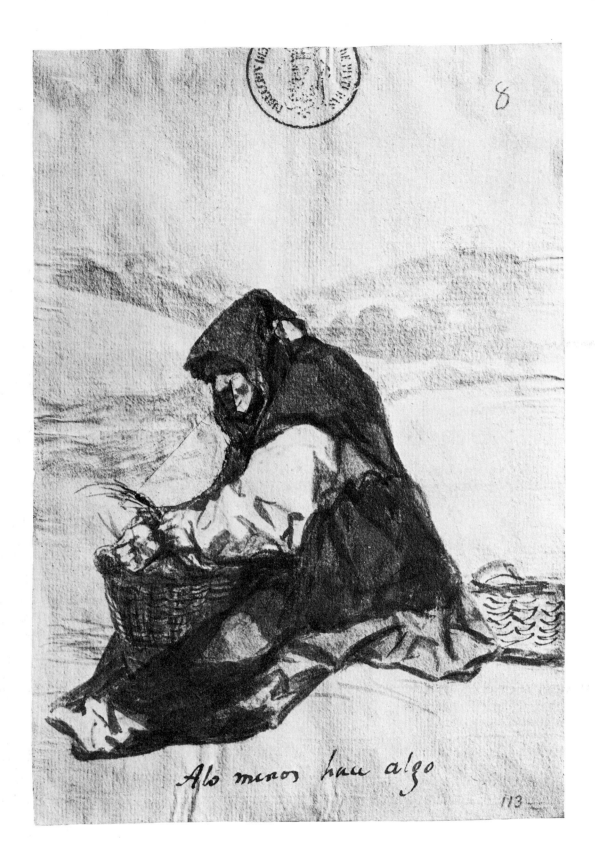

A lo menos hace algo

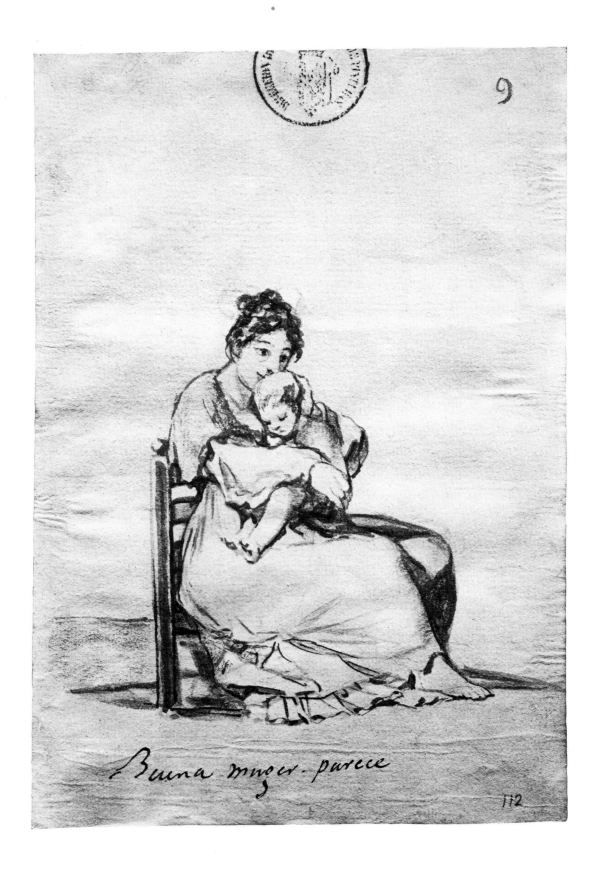

Buena muger. parece

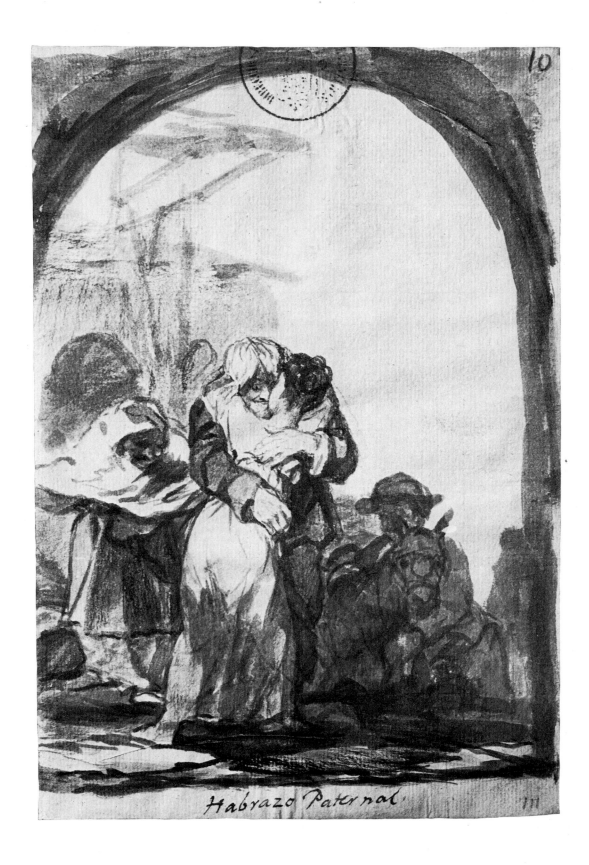

Habrazo Paternal.

Esta pobre aprobecha el tiempo

La guebera La huebera

¡q.ᵉ Necedad dar destinos en la niñez

108

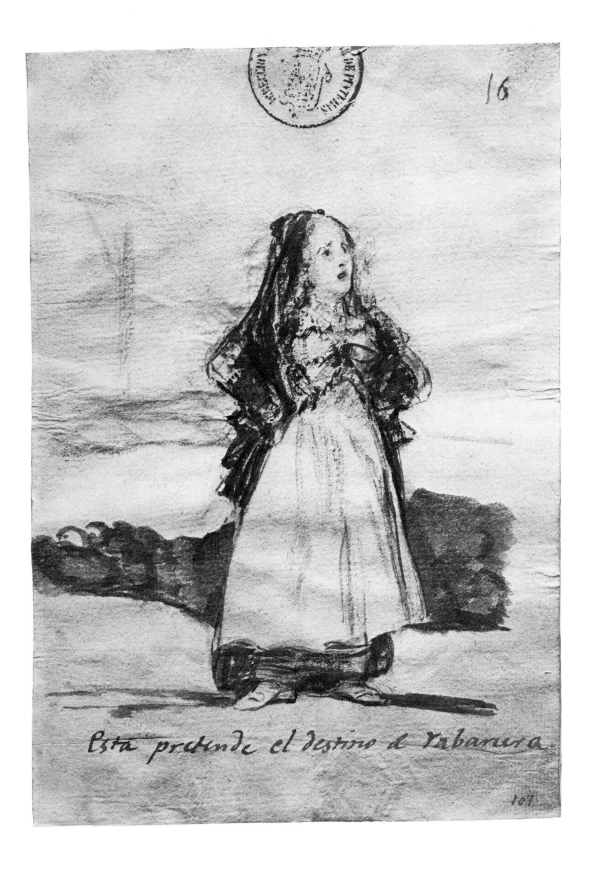

Esta pretende el destino d Rabanera

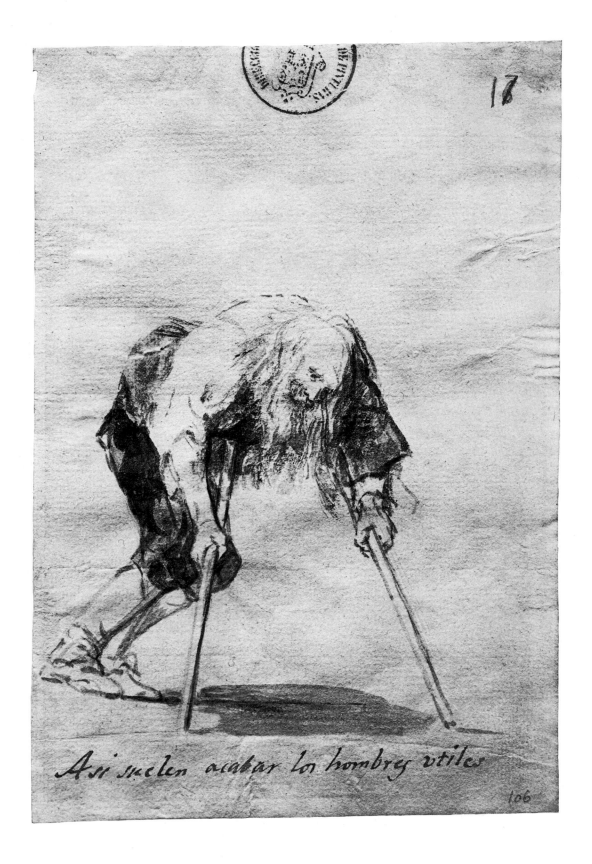

Assi suelen acabar los hombres vtiles

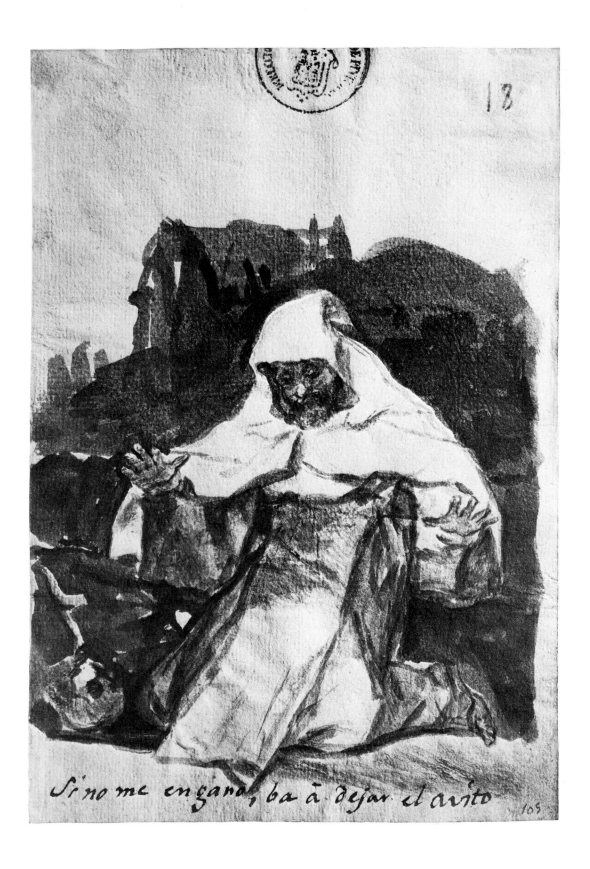

Si no me engaño, ba à dejar el avito

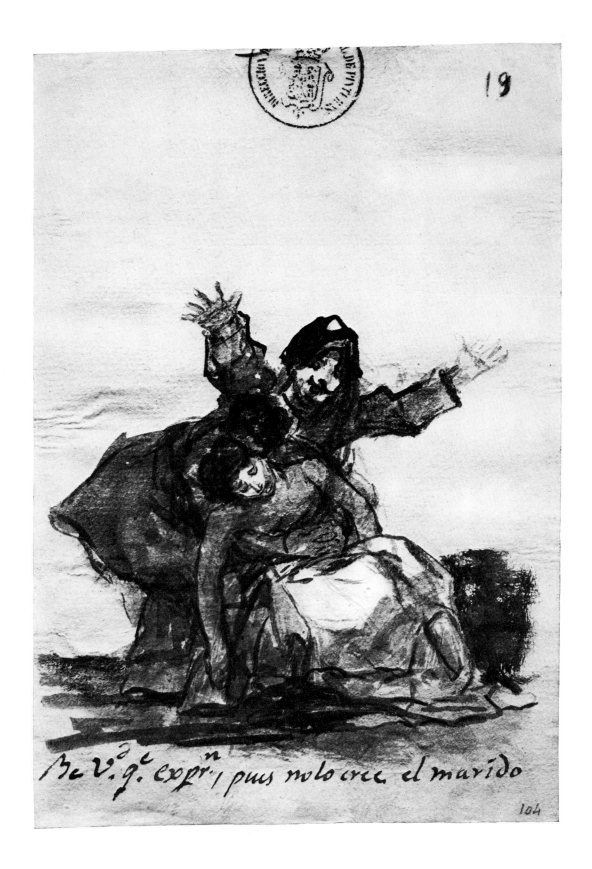

Be V.ᵃ gᵉ expⁿ, pues nolo cree el marido

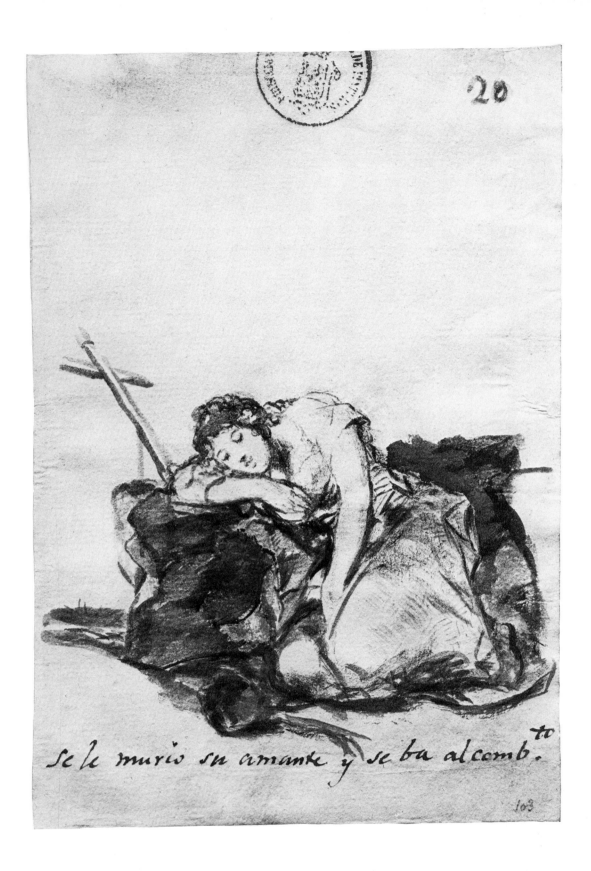

Se le murió su amante y se ba alcemb.^{to}

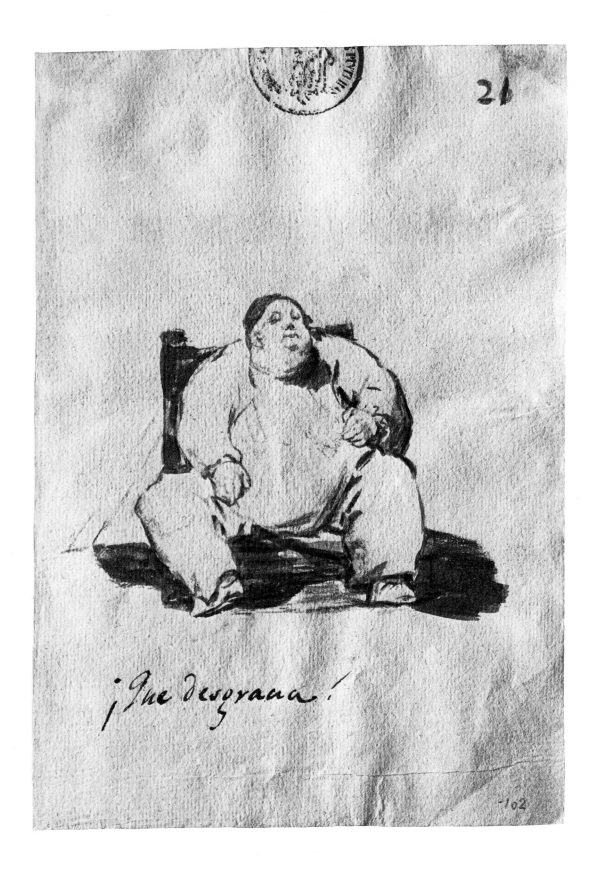

¡Que desgrana!

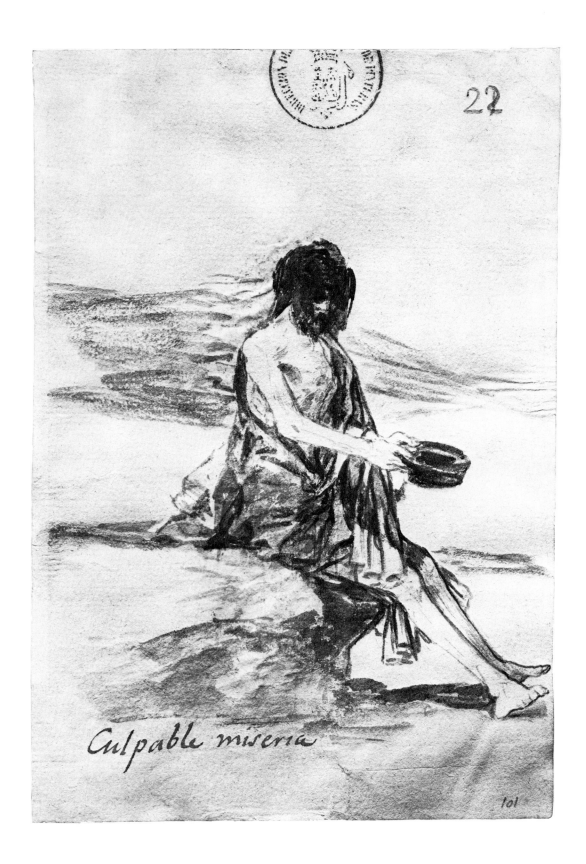

Culpable miseria

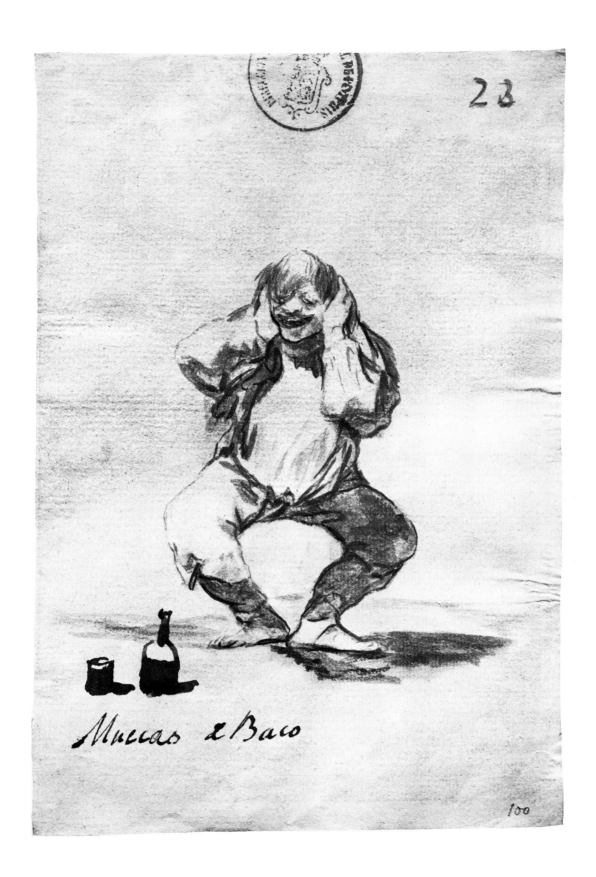

Muccas d Baco

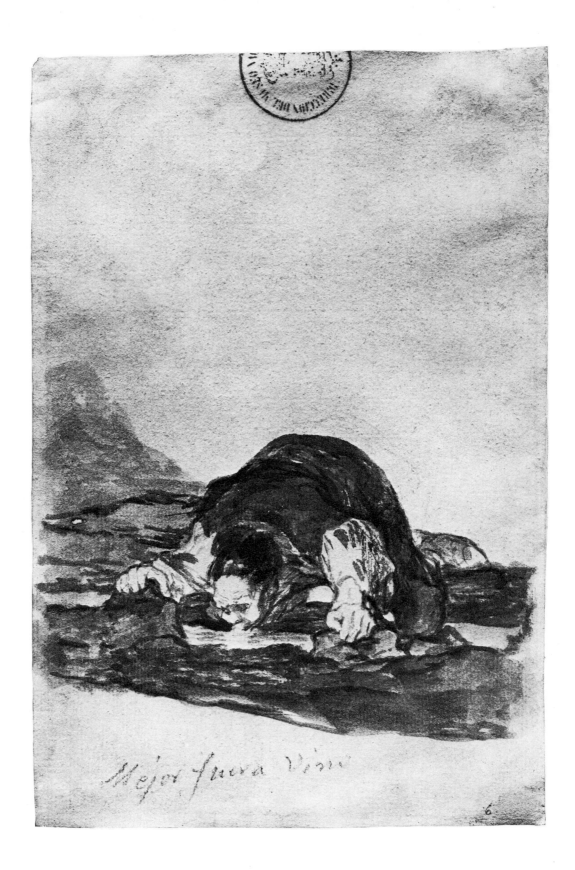

Mejor fuera visto

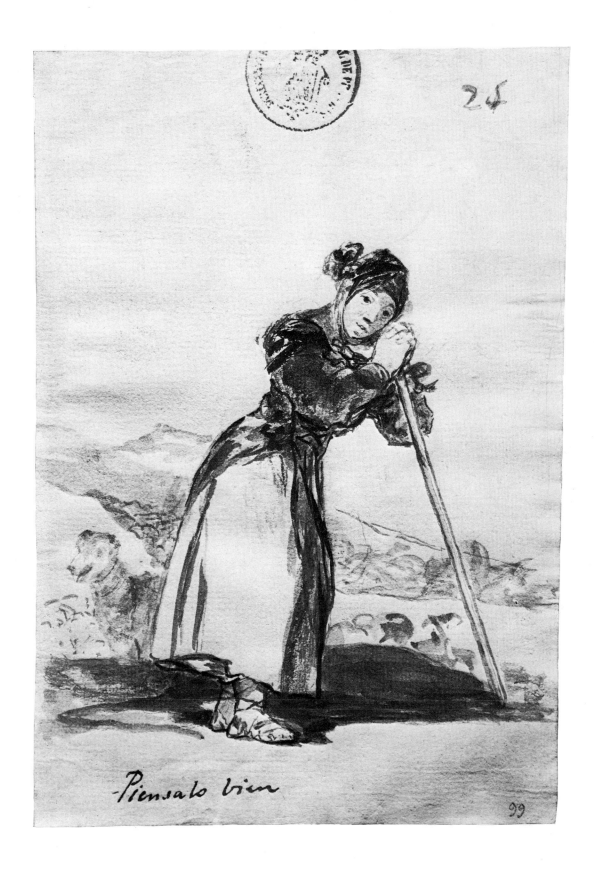

Piensalo bien

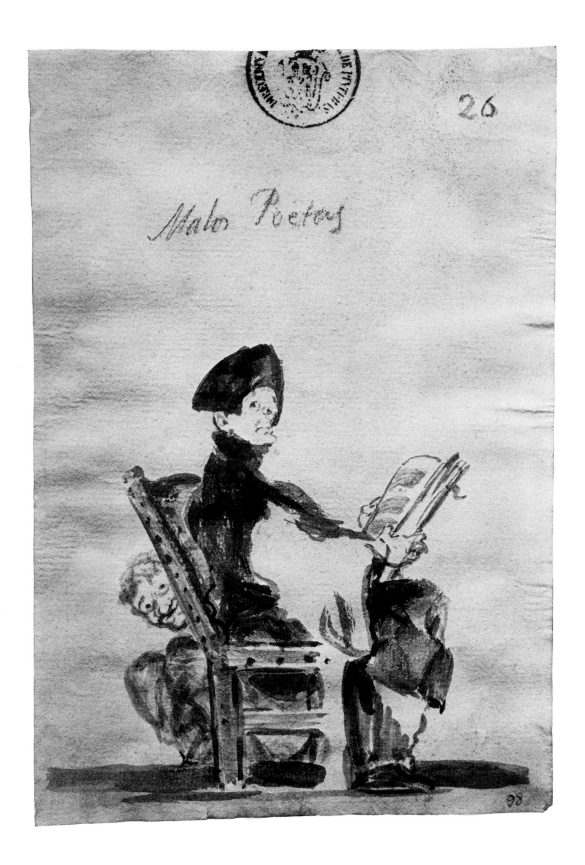

26

Malos Poetas

98

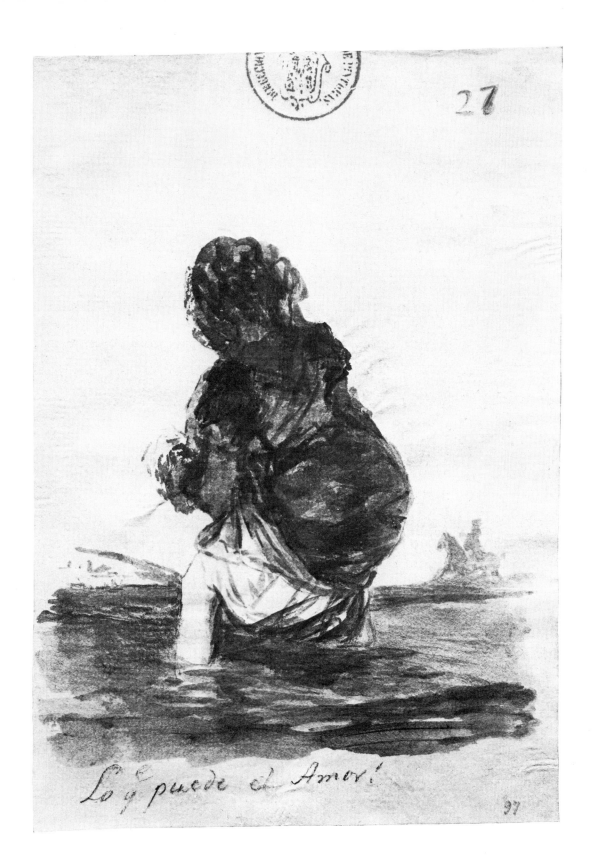

Lo q puede el Amor!

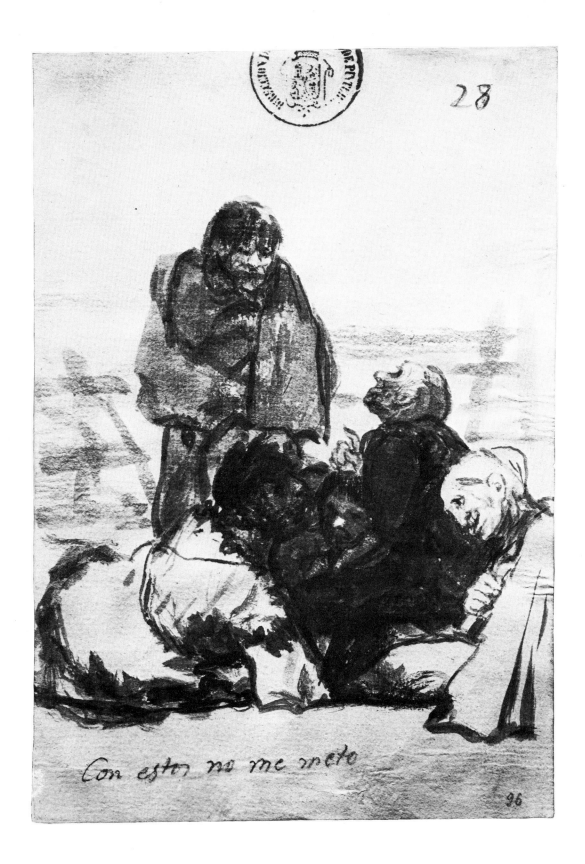

Con estos no me meto

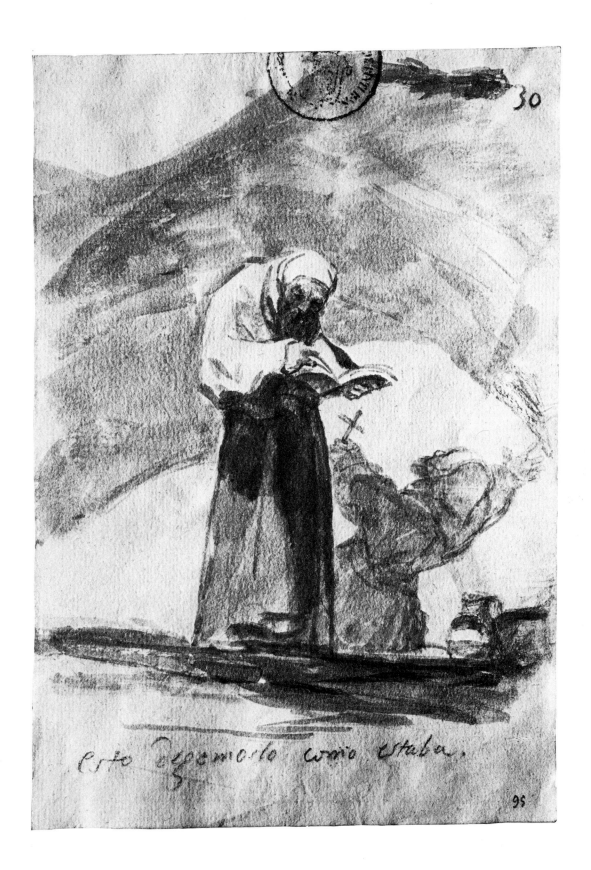

Esto lo e asto como estaba.

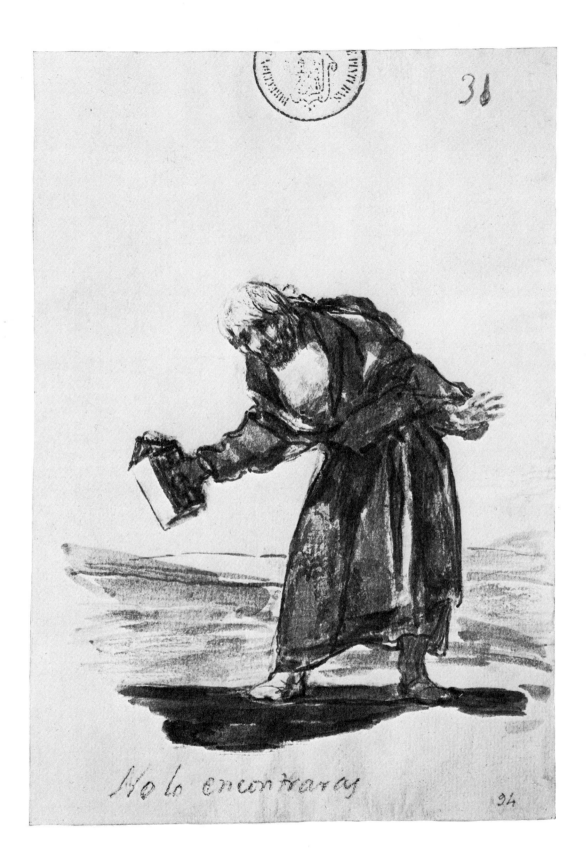

31

No lo encontraras

94

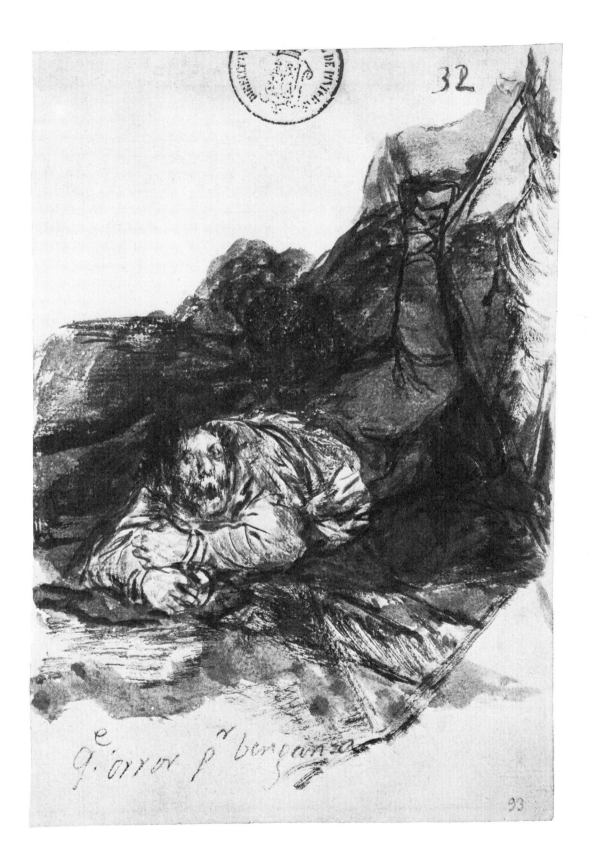

q. orror p.^a berganza

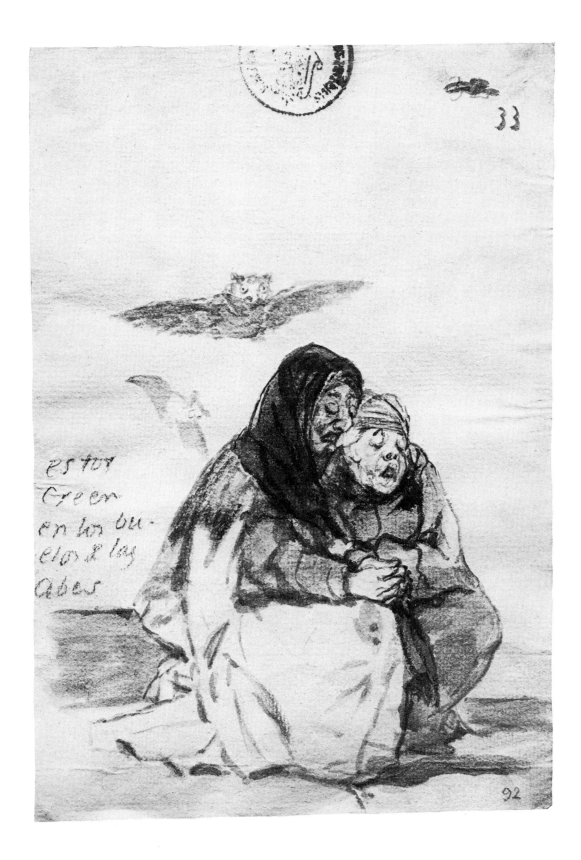

estos
creen
en los bu-
elos d las
abas

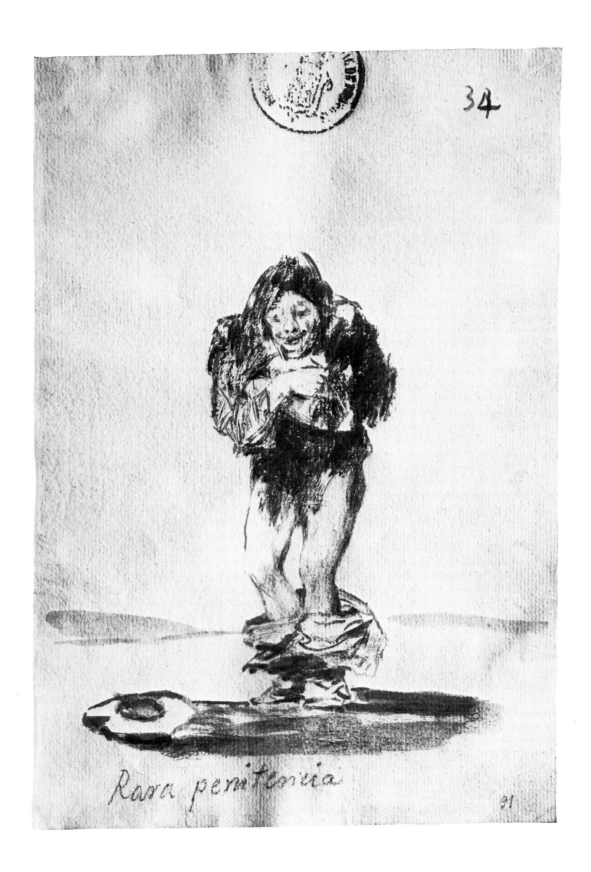

34

Rara penitencia

91

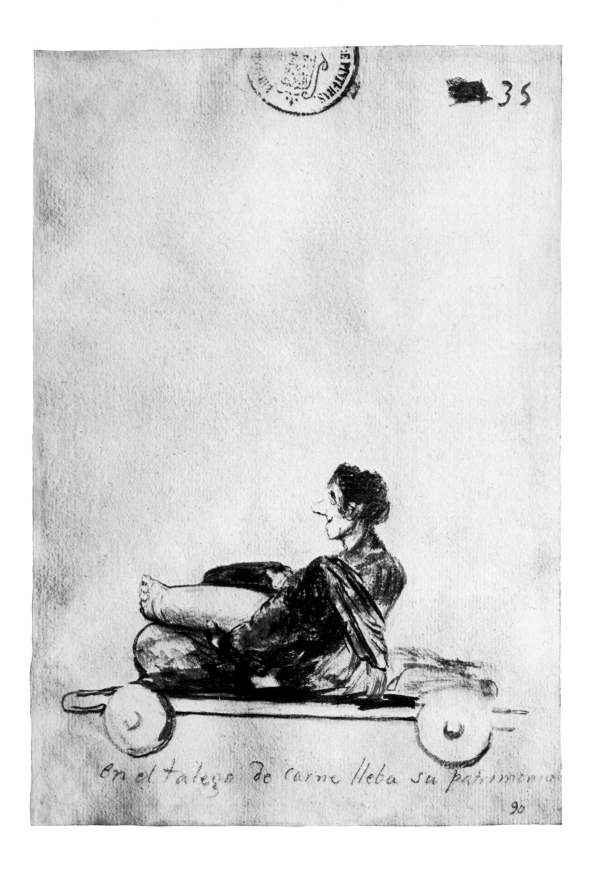

en el talego de carne lleba su patrimonio

90

36

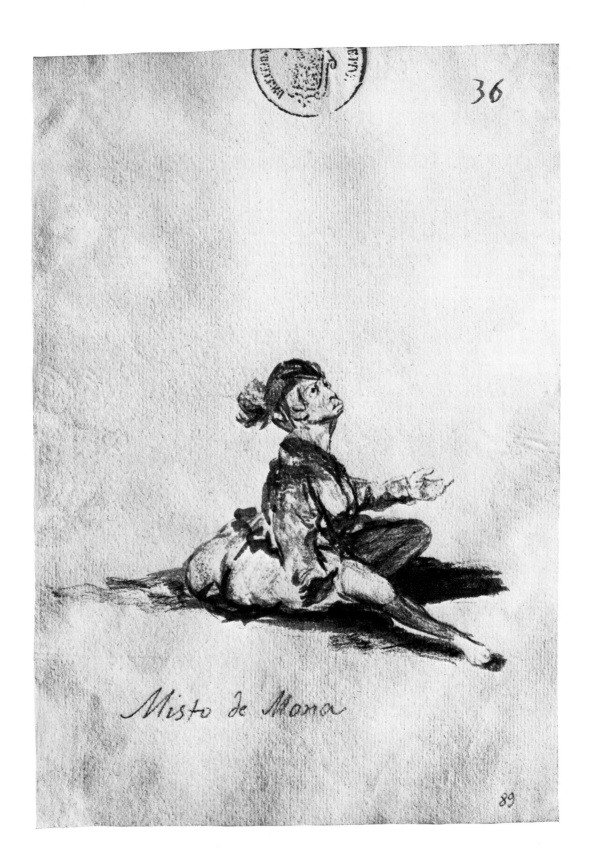

Misto de Mona

89

37

Bas mui lejos?

88

El Marison de la tia Gila

87

Vission burlesca

Otra en la misma noche

41

3ª en la
misma

84

4.2

4ª
en la misma

83

Religion en la Asia

48

77

la misma

49

76

Pobre en Asia q se enciende
la cabeza hasta q le dan algo

50

53

no se sabe

54

tampoco

71

Estropiada codiciosa

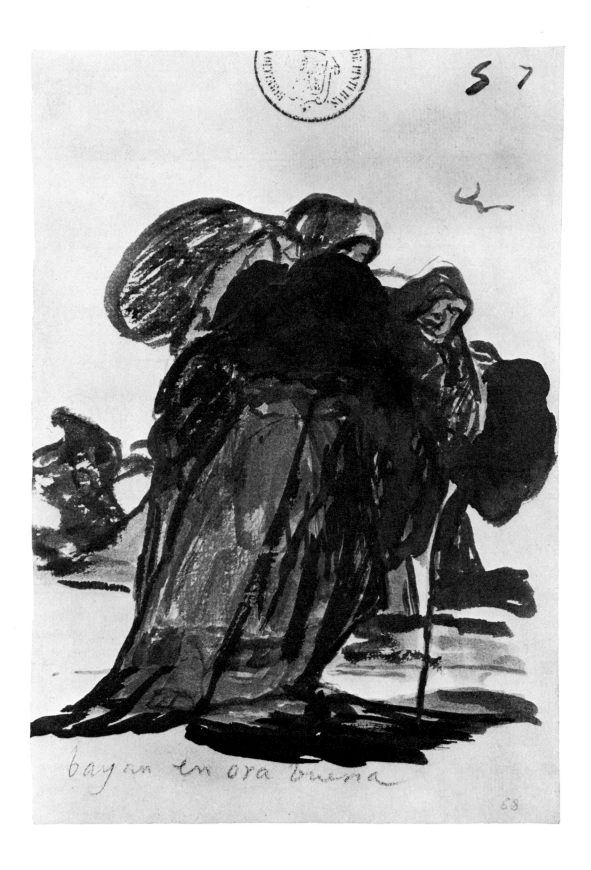

bayan en ora buena

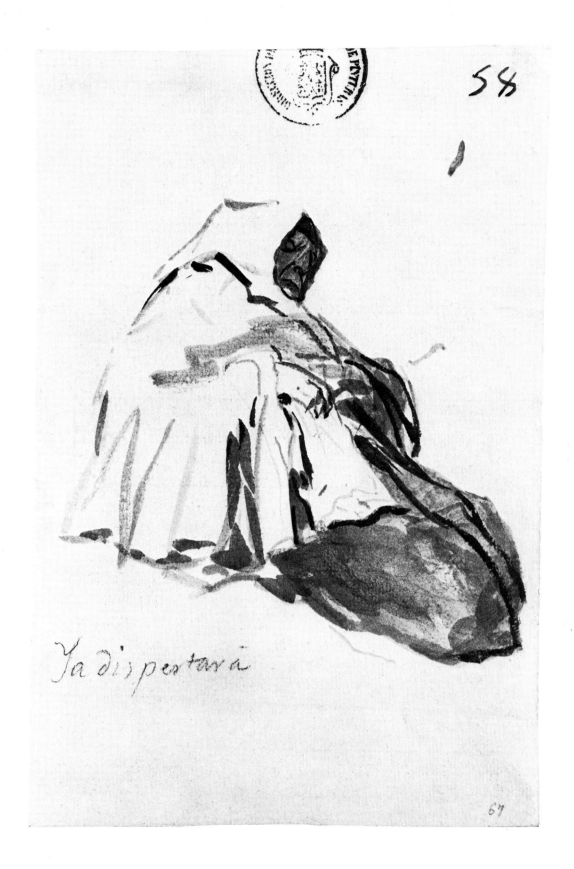

Ya dispertara

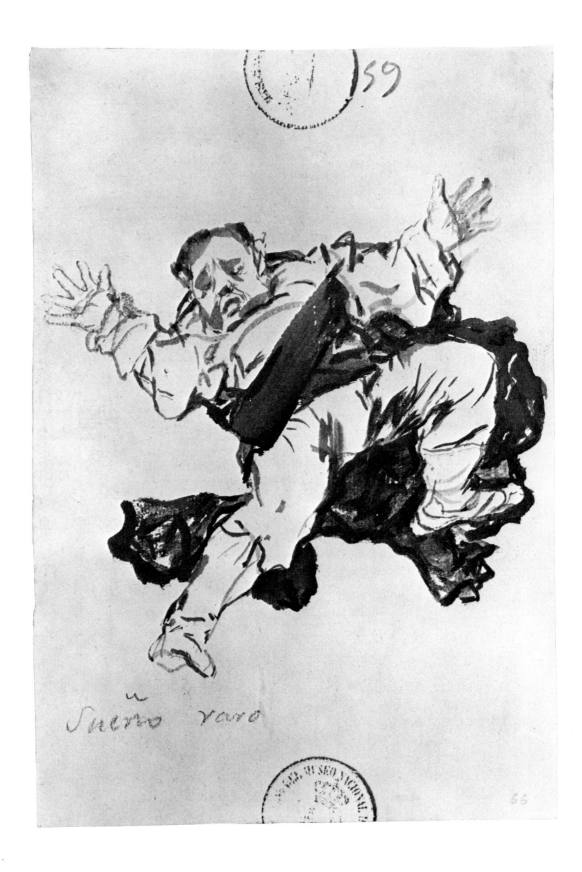

Sueño raro

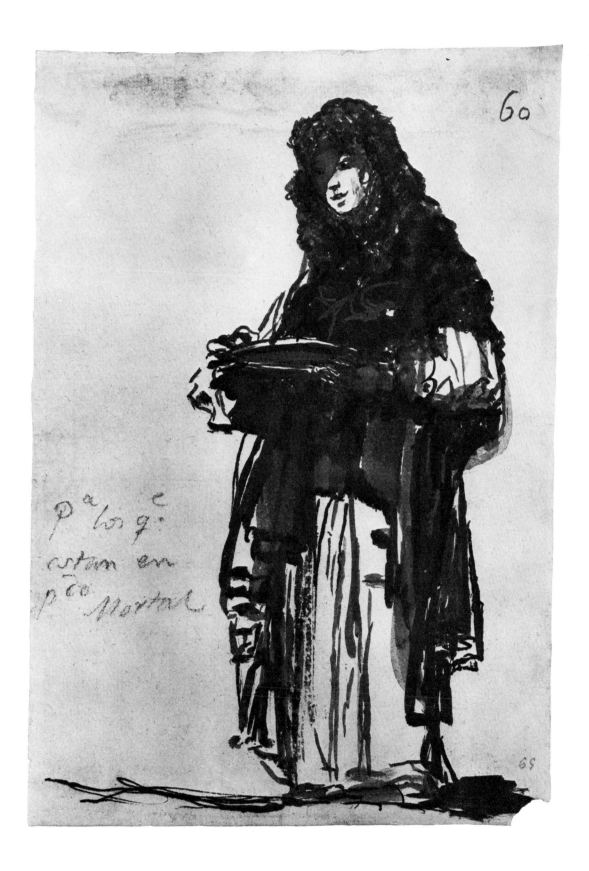

60

Pa los qe
estan en
po Mortal

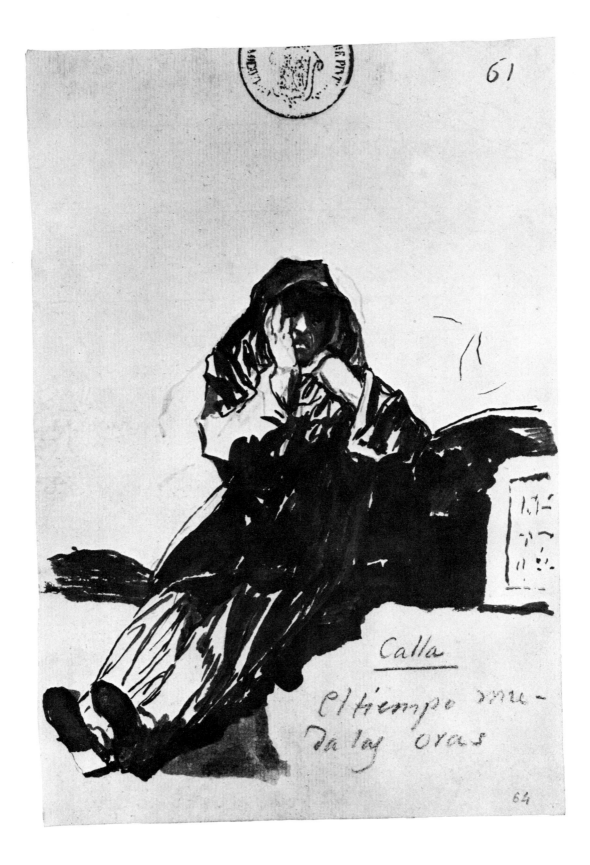

61

Calla

El tiempo mu-
da las oras

64

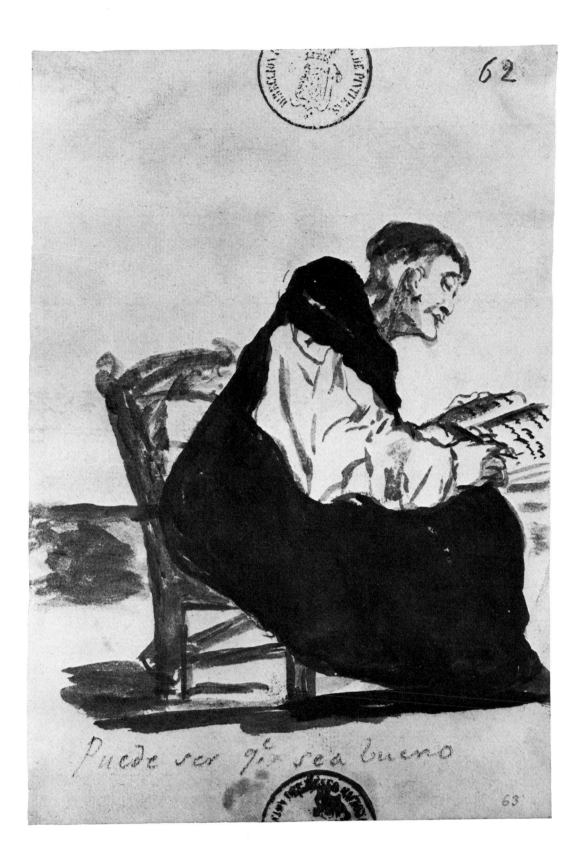

Puede ser q.ᵉ sea bueno

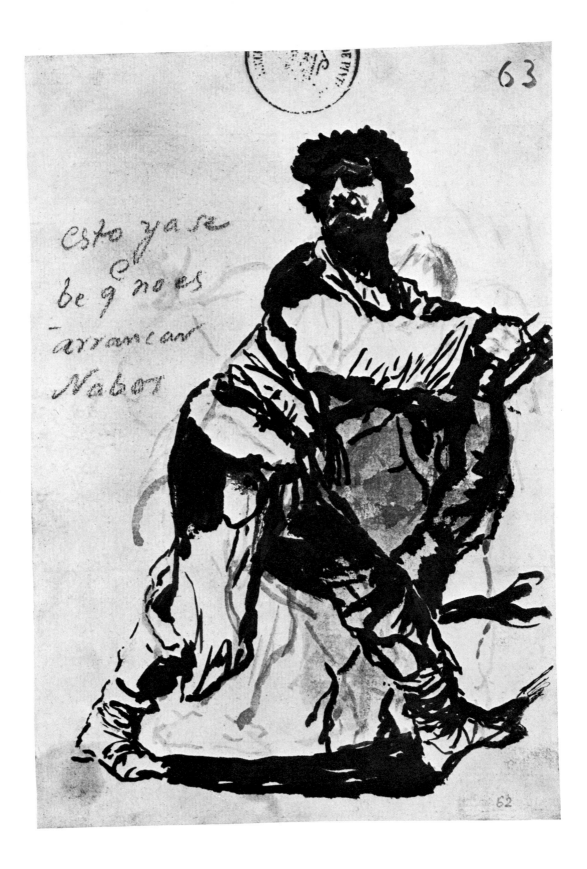

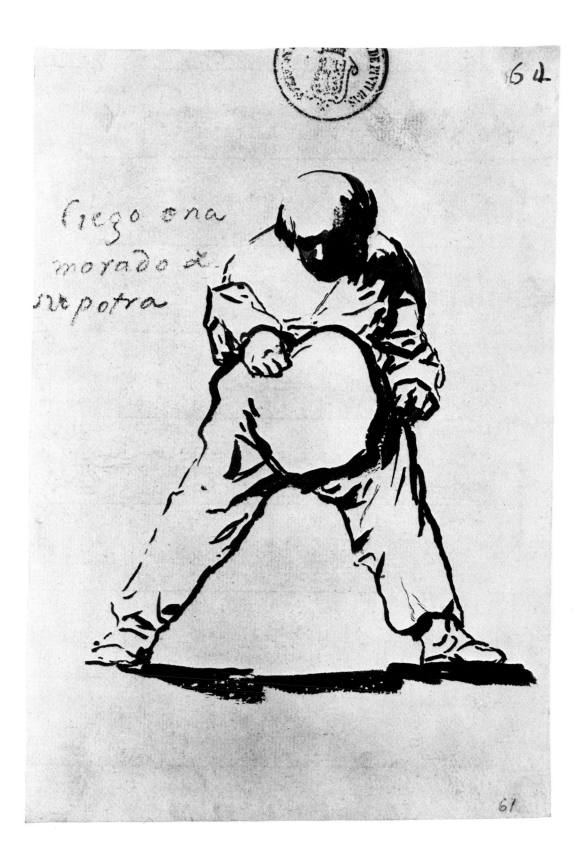

Ciego ona
morado d.
supotra

64

61

De esto hay mucho, y no se be

esto huele à
cosa de Magia

Ctas Brujas lo diran

57

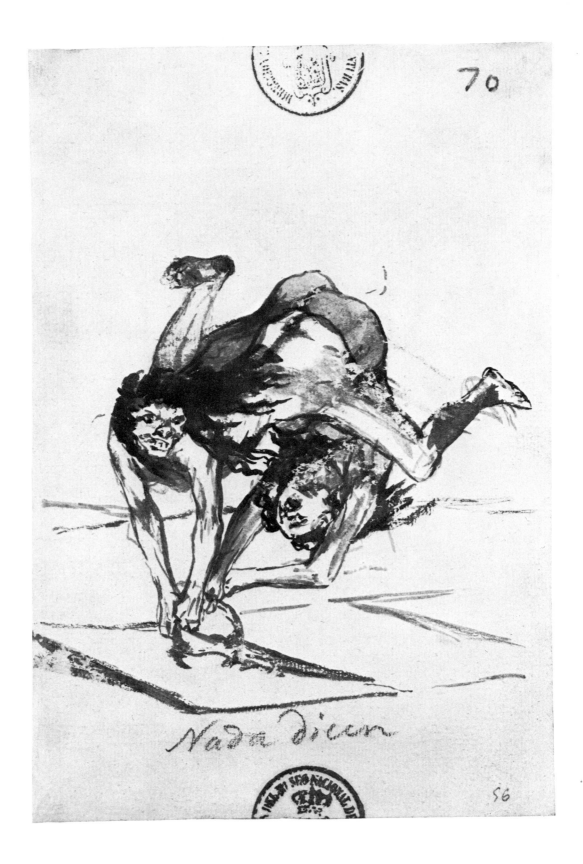

70

Nada diсеп

56

71

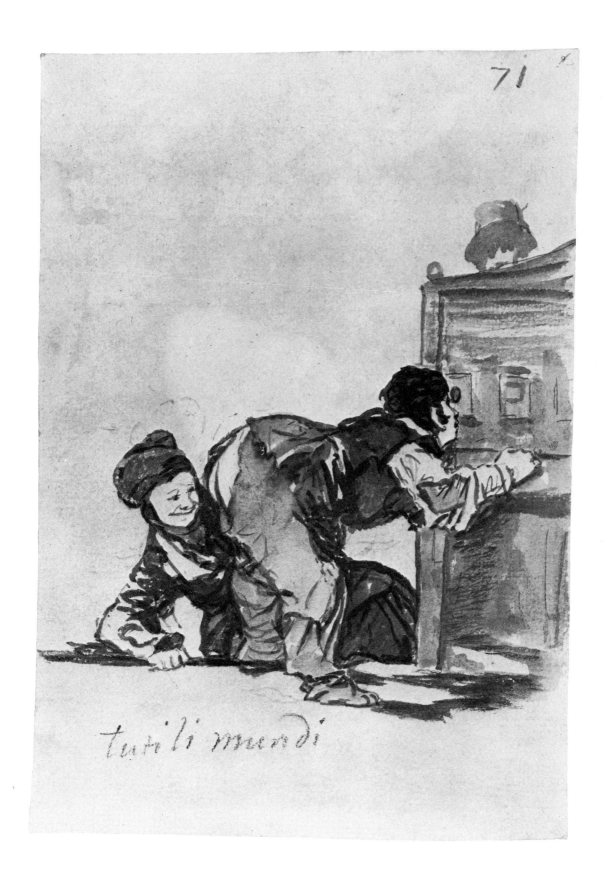

tuti li mundi

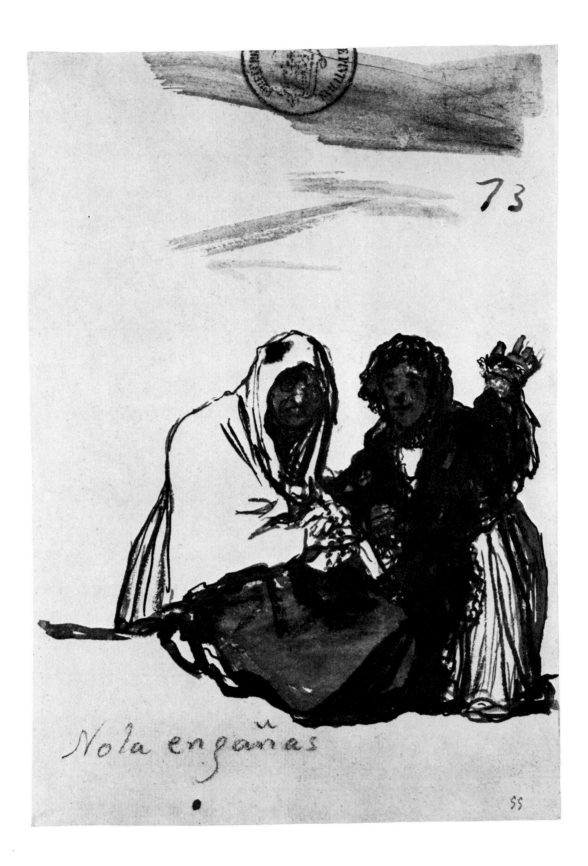

74

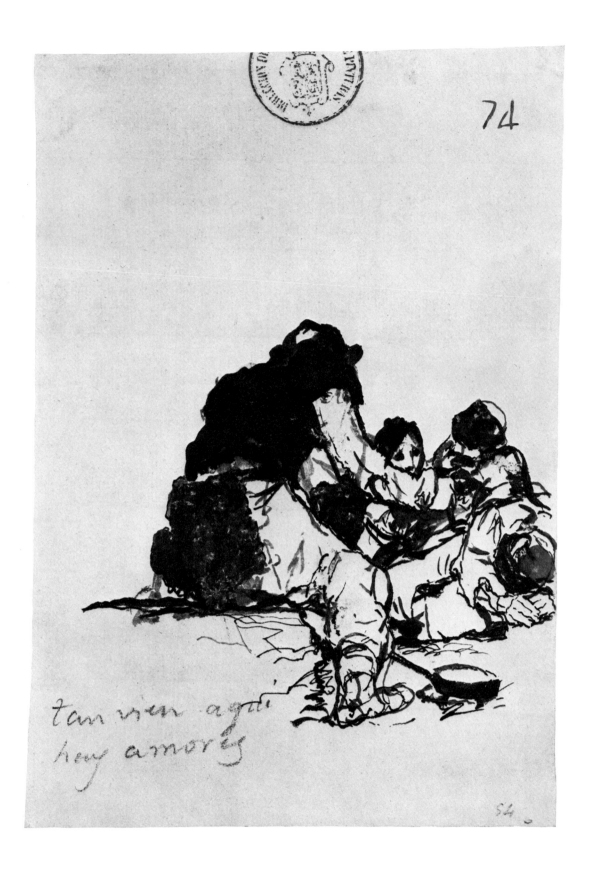

tan vien aqui
hay amorés

54

Con la musica à otra parte

Que sacrificio

Comer vien veber mejor y
dormir olgar y pasear

Lastima es q̃ no te ocupes en otra cosa

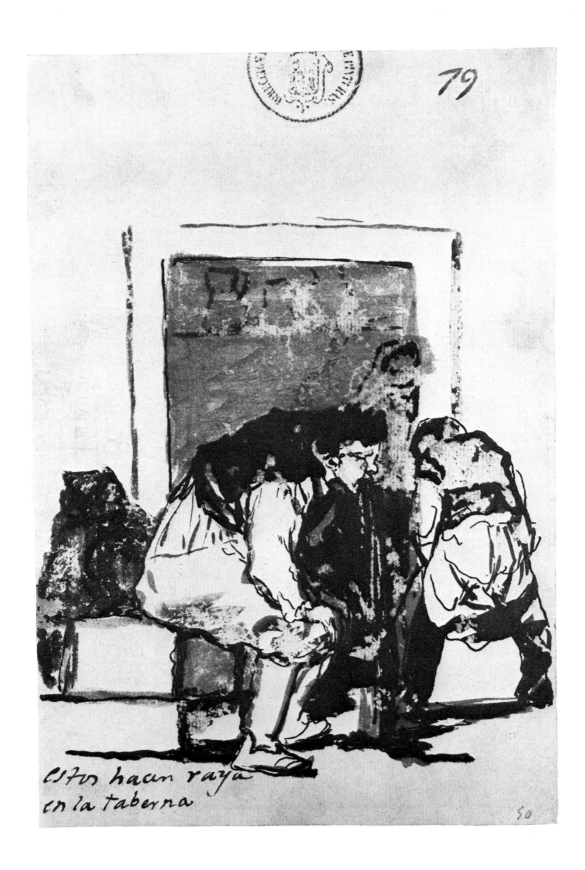

79

Estos hacen raya
en la taberna

50

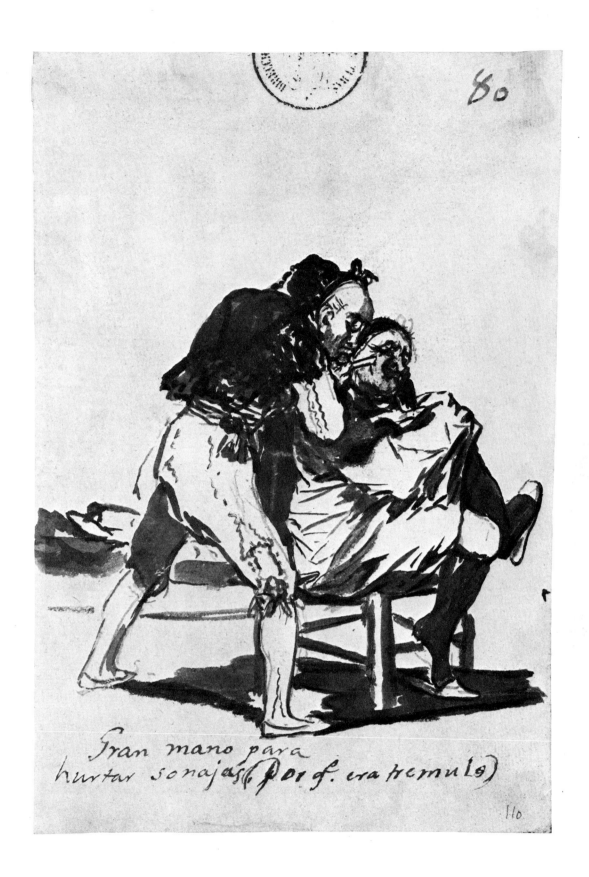

80

*Gran mano para
hurtar sonajas(.p.ot f. era tremula)*

110.

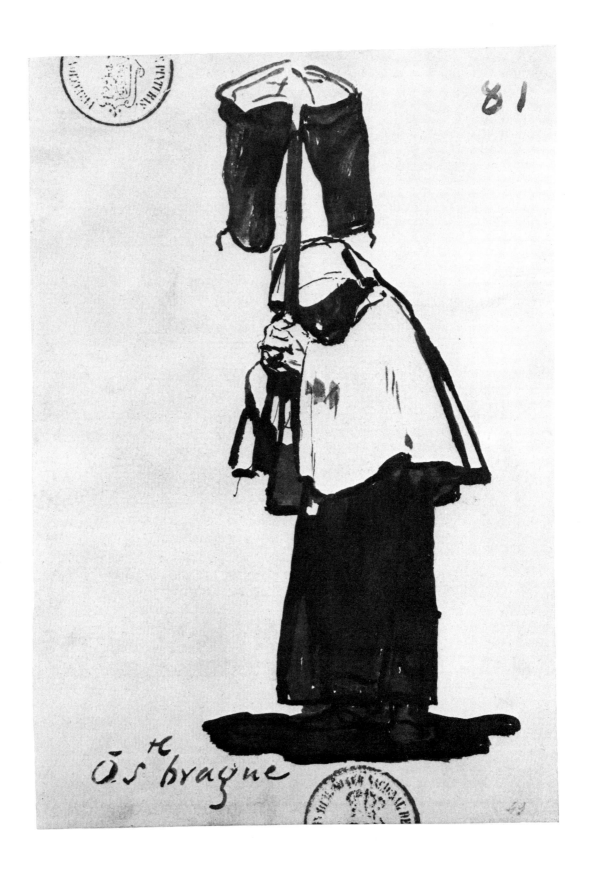

81

ō.sᵗᵉ bragne

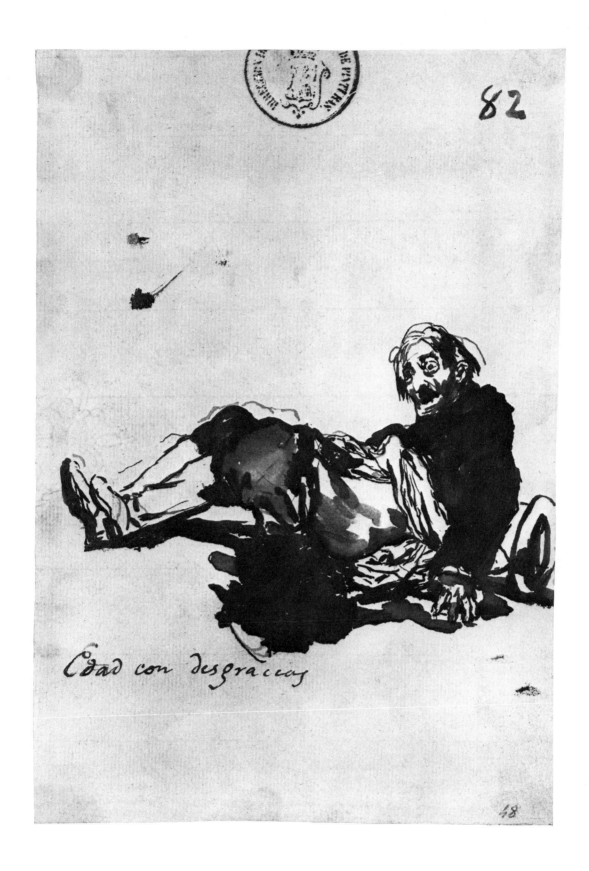

Edad con desgracias

82

48

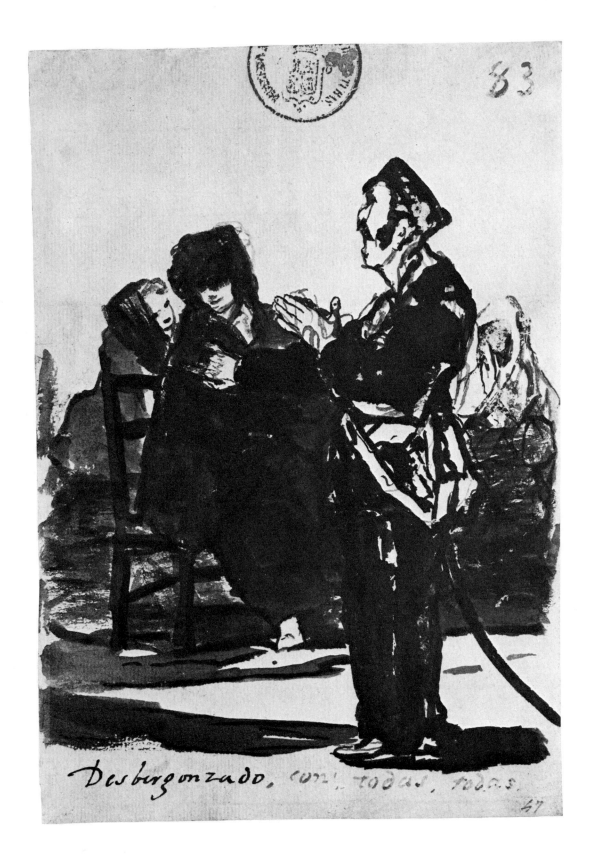

Desbergonzado, con, todas, todas.

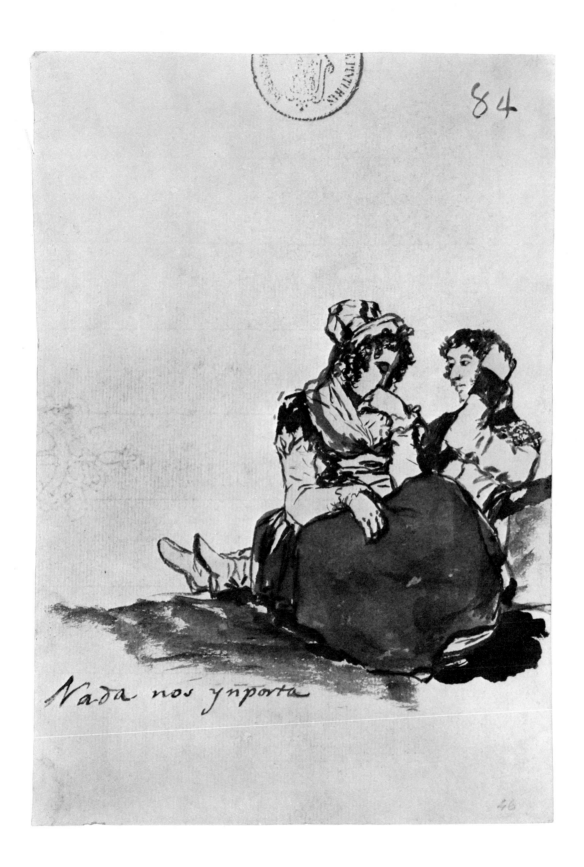

84

Nada nos ynporta

46

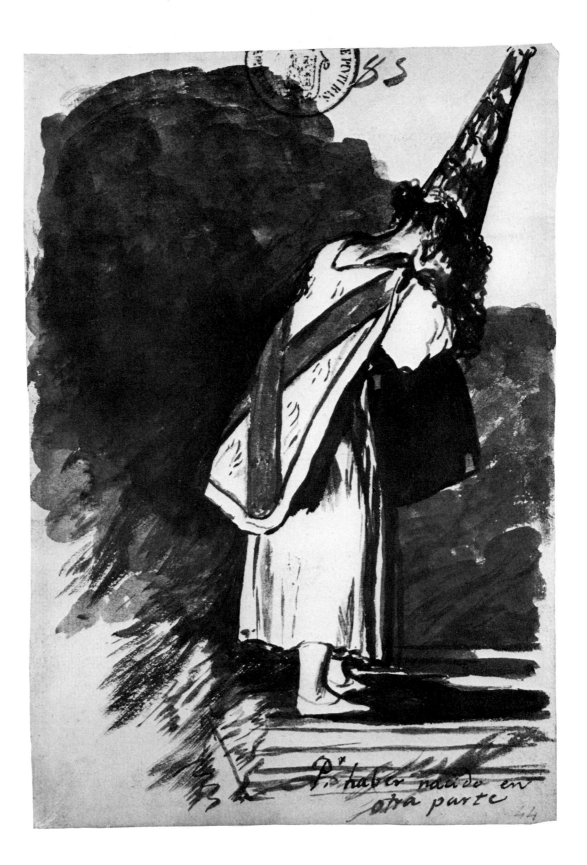

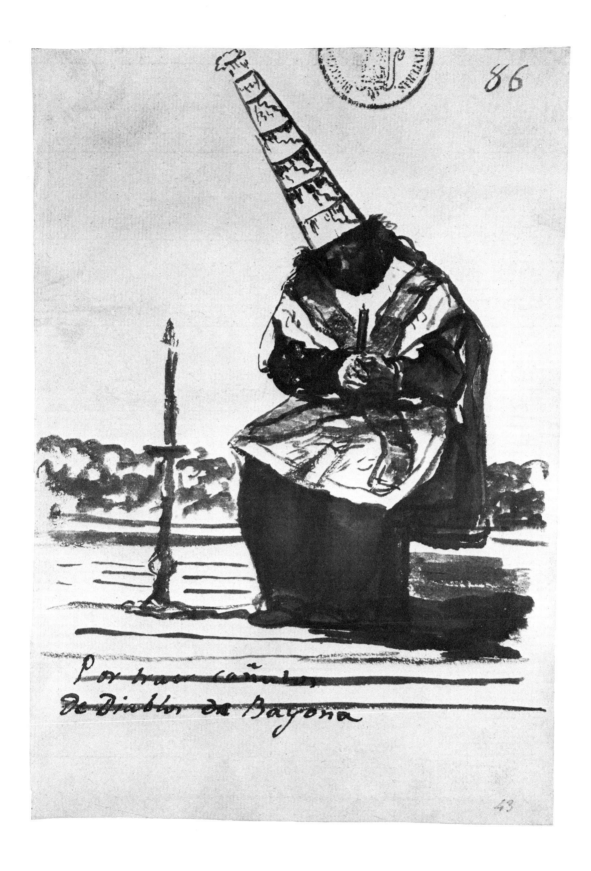

Pr mober la lengua d otro modo

yo lo Conoci à este baldado, q̃ no tenia pies
y diciendole que no tenia apierna en la calleÂ
Alcala cuando entraba lo encontraba pidiendo

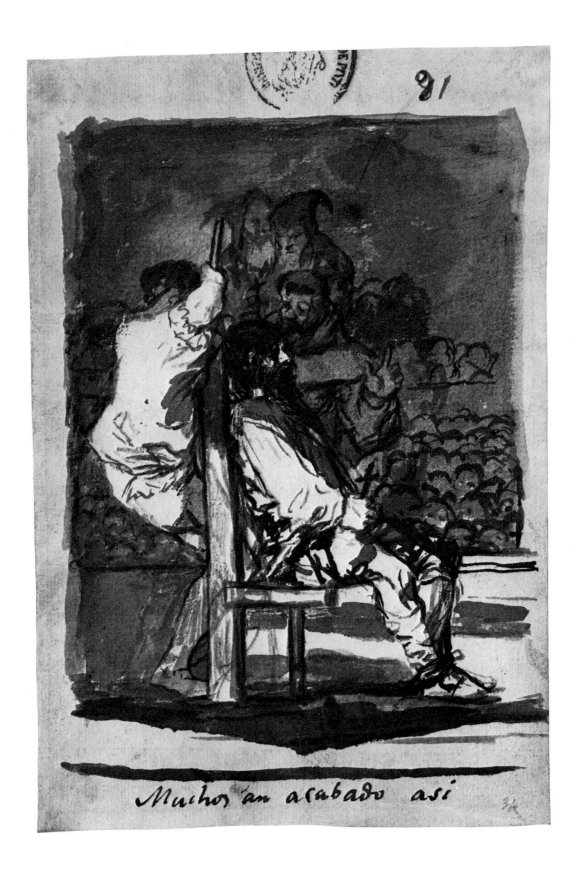

Muchos an acabado asi

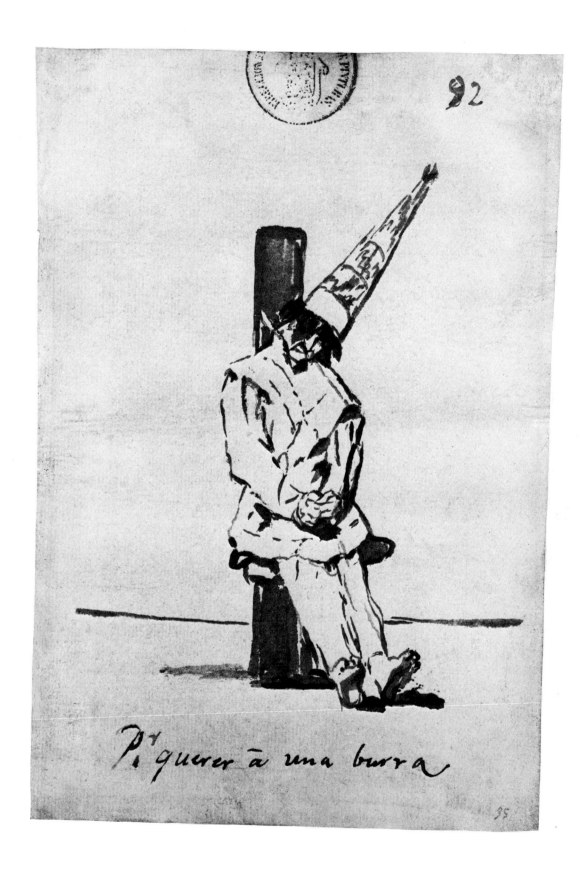

92

Pr querer à una burra

Por casarse con quien quiso

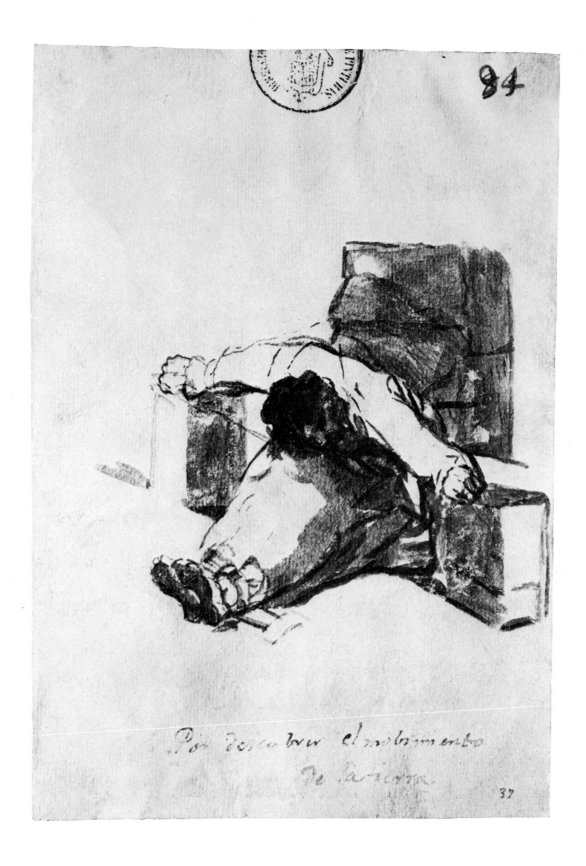

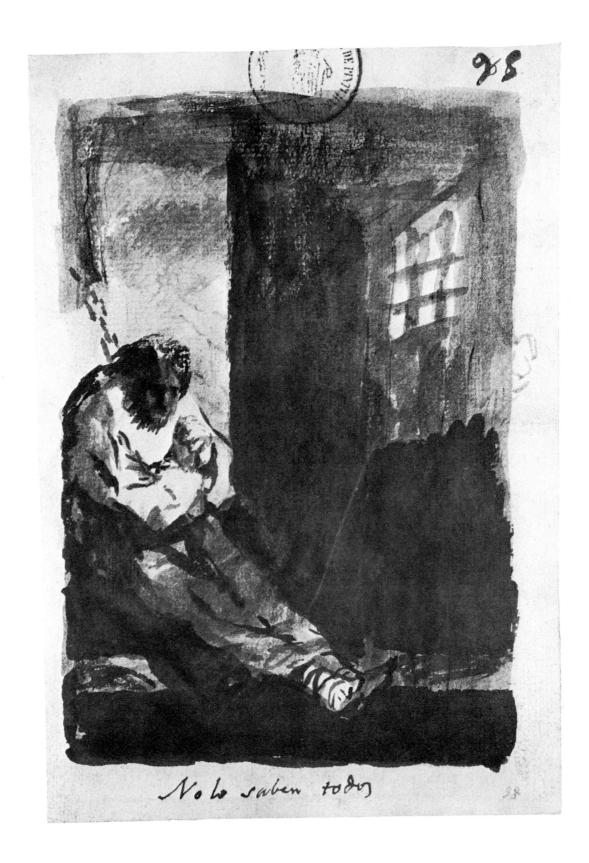

No lo saben todo

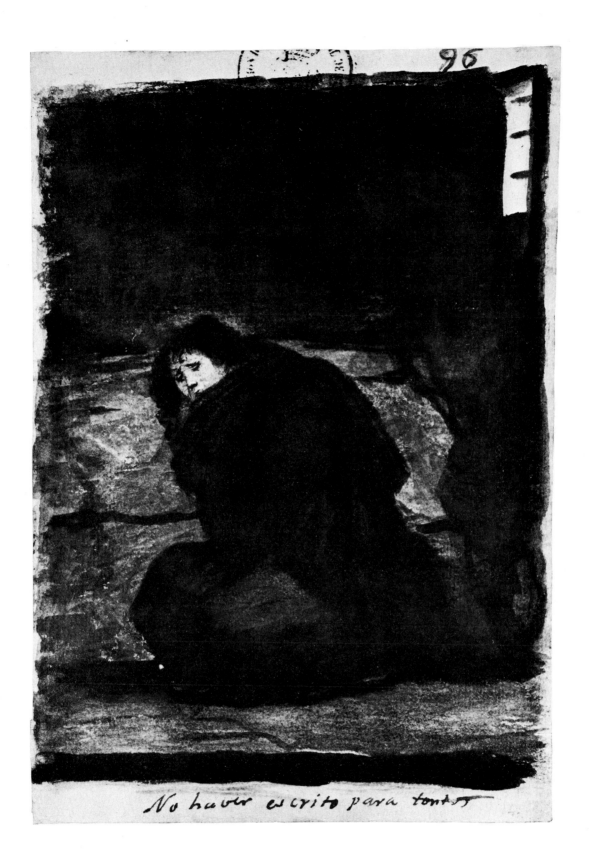

No haver escrito para tontos

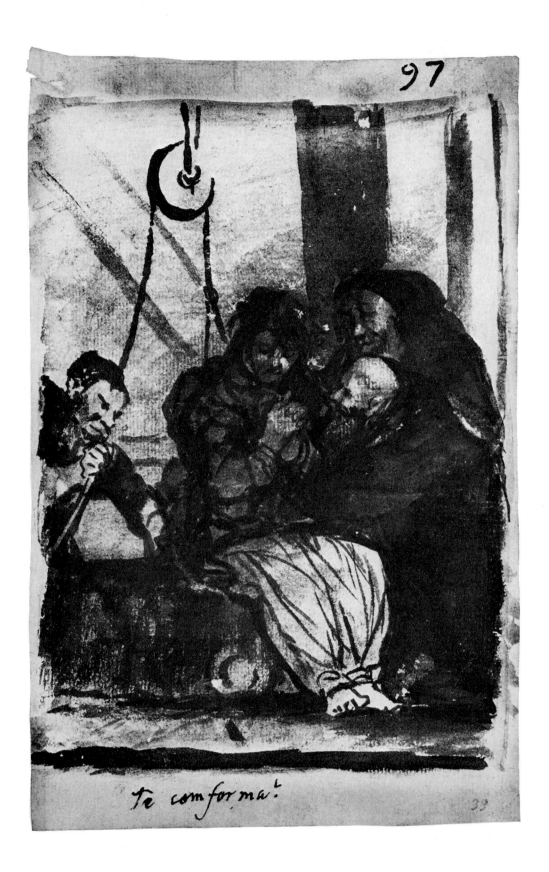

te comforma!

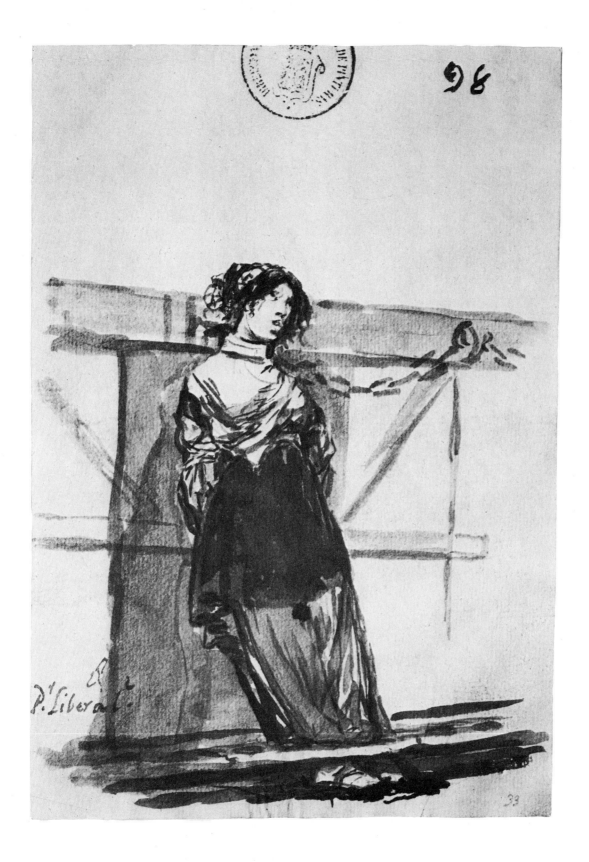

P.ᵗ Liberal.

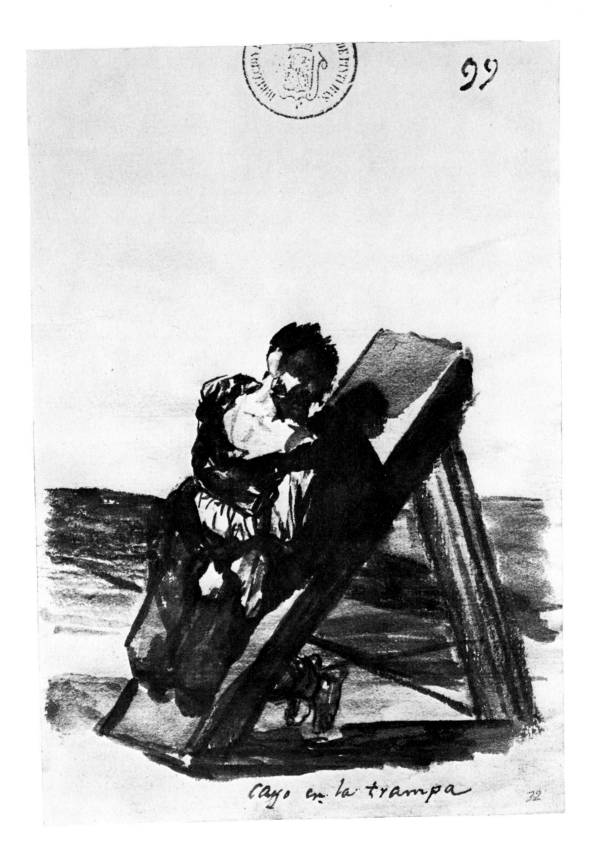

cayo en la trampa

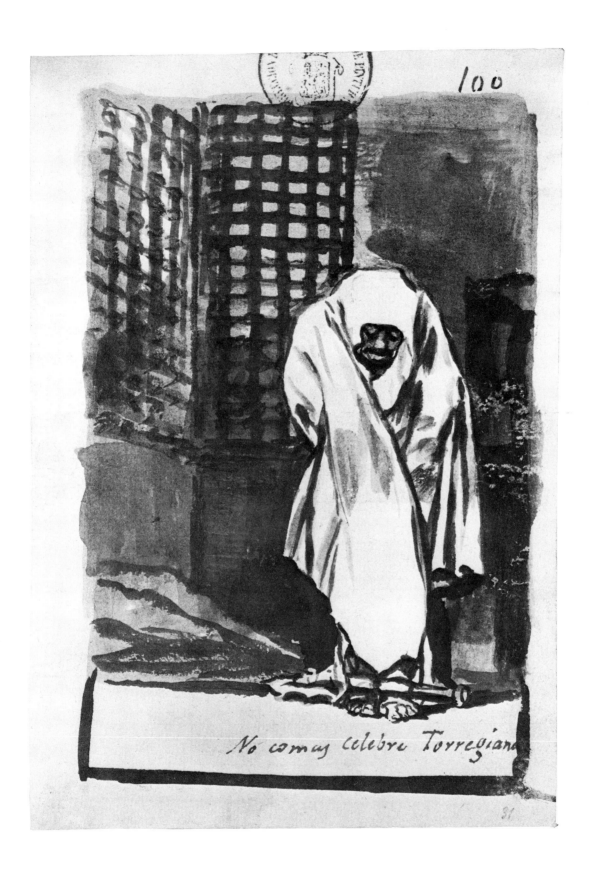

No comas celebre Torregiano

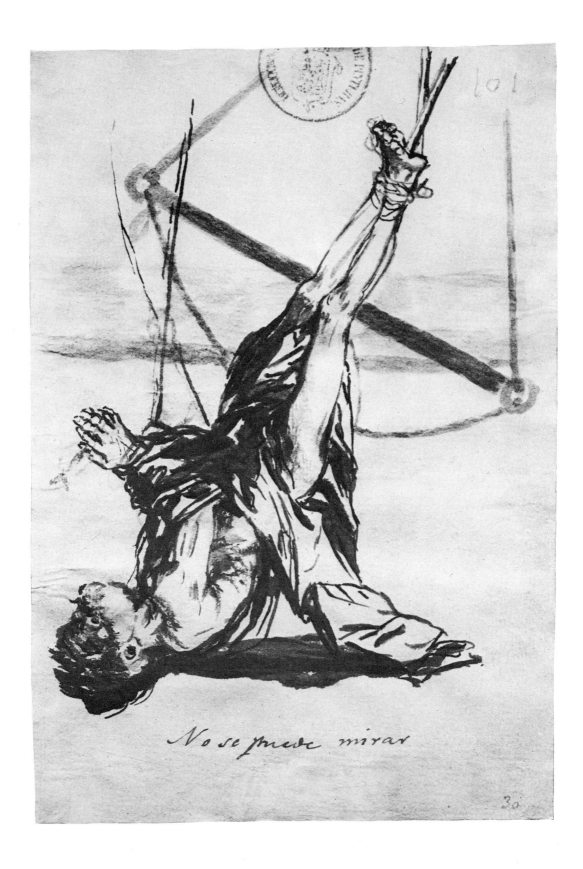

No se puede mirar

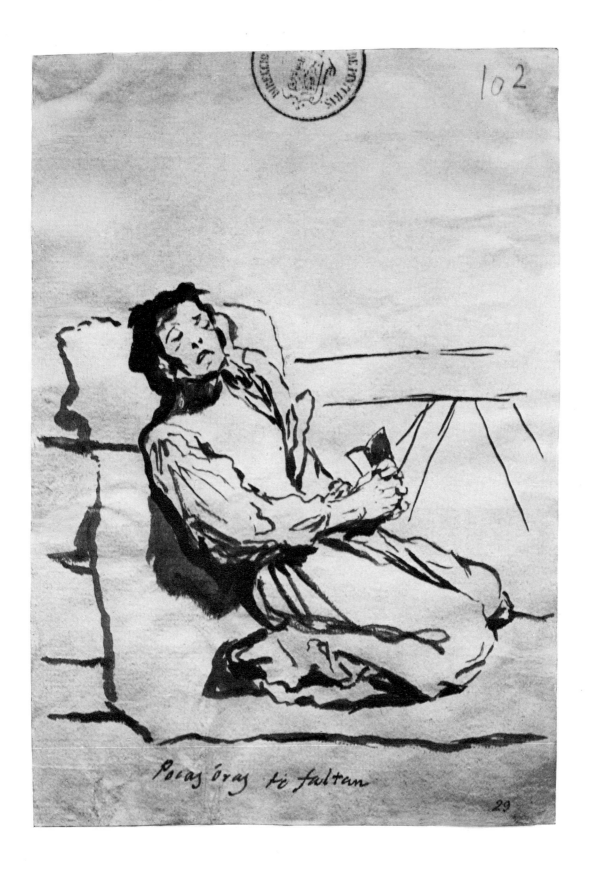

102

Pocas óras te faltan

29

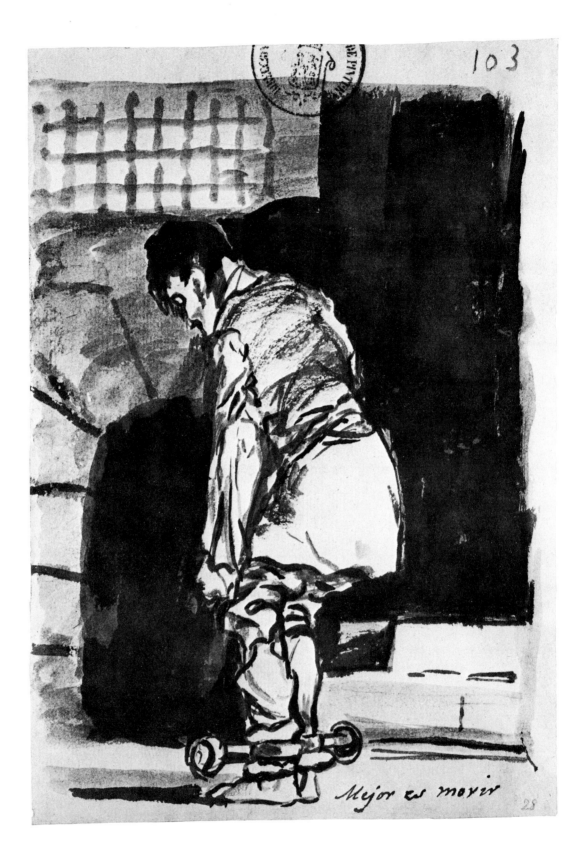

Mejor es morir

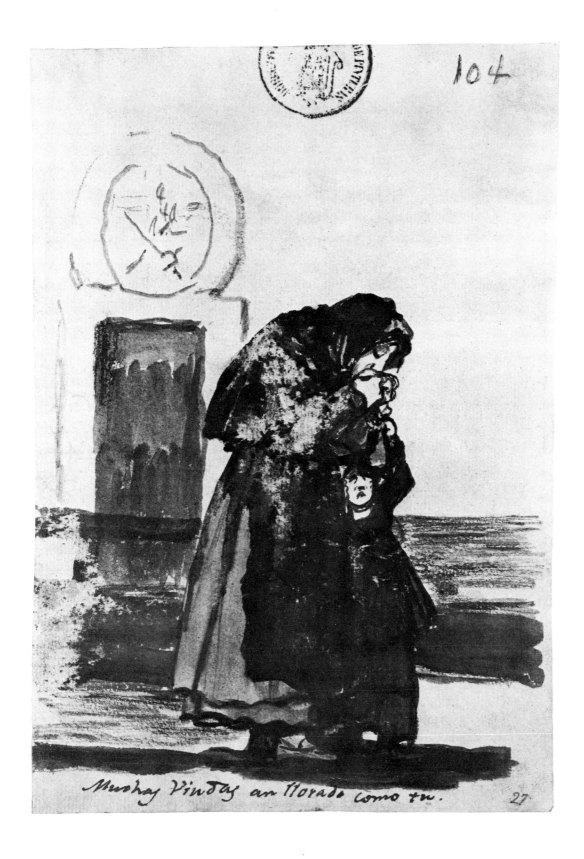

Muchas Viudas an llorado como tu.

27

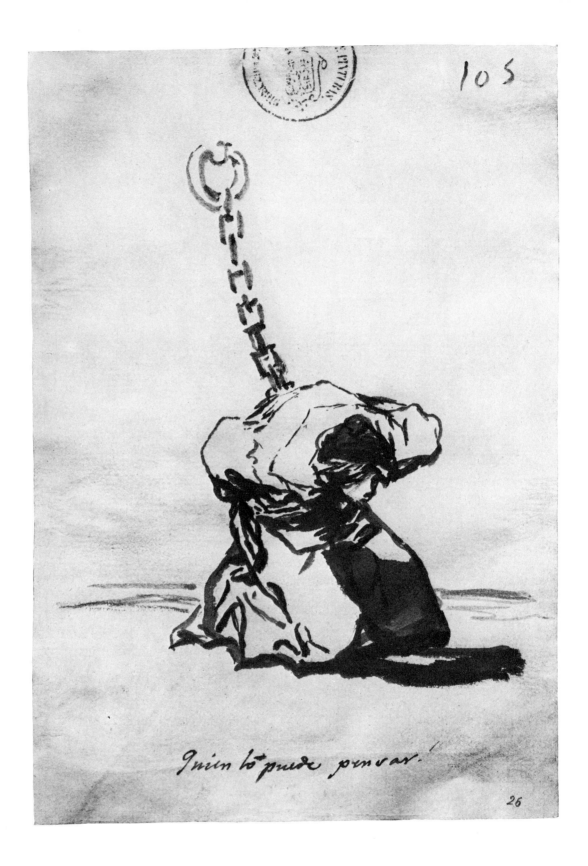

Quien lo puede pensar!

26

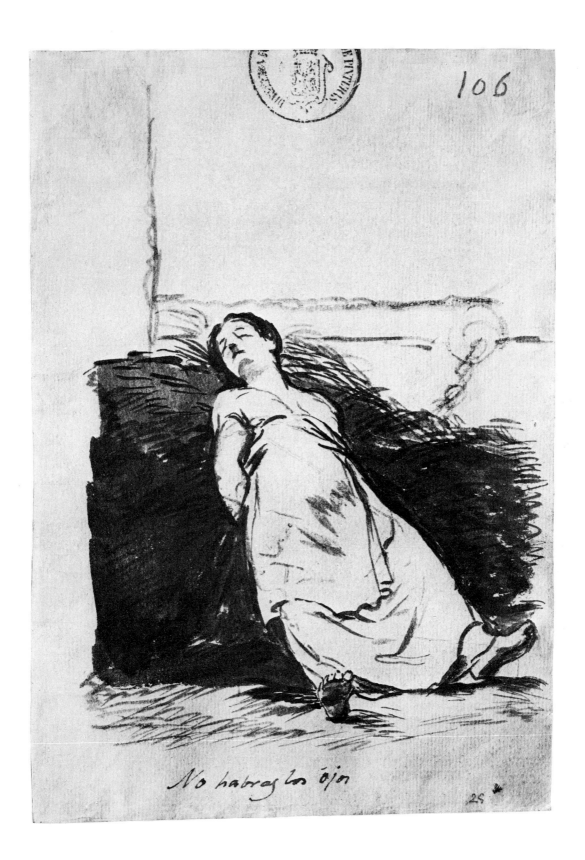

No habras los ójos

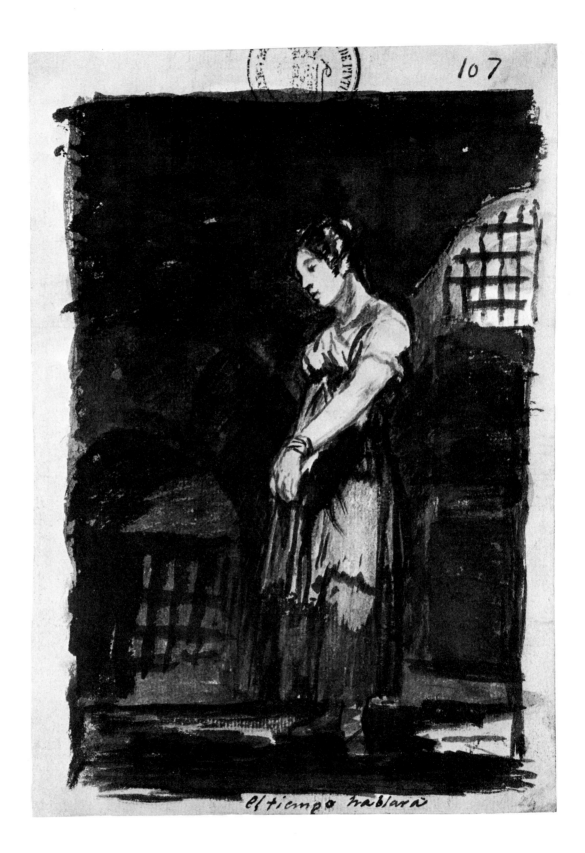

el tiempo hablará

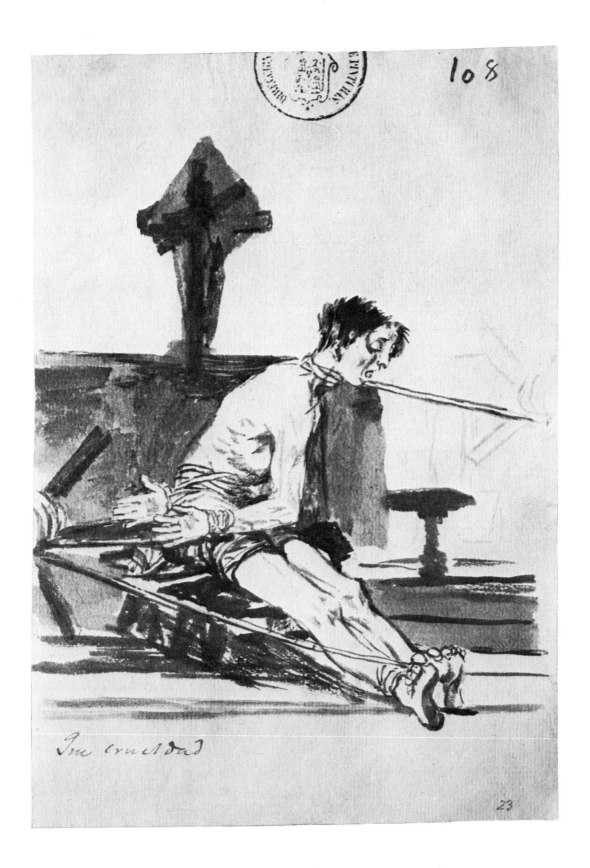

Sin crueldad

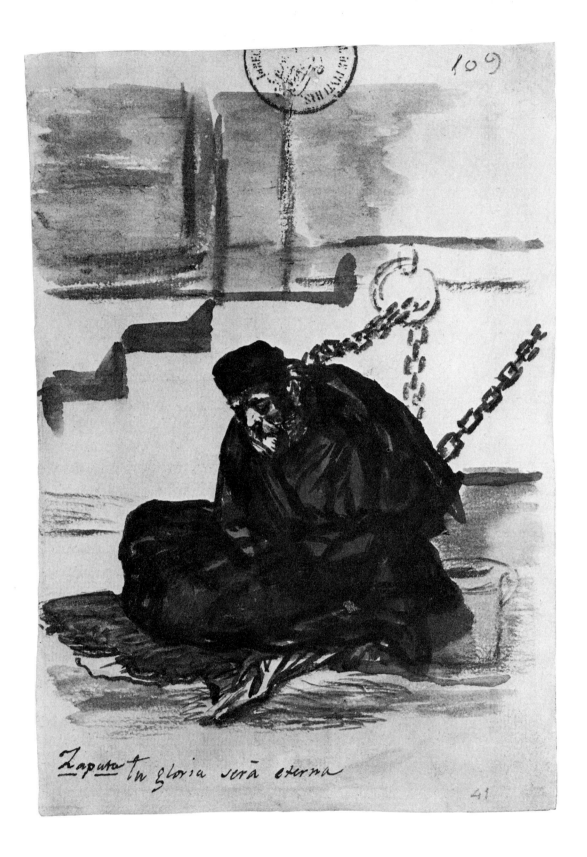

Zapata tu gloria será eterna

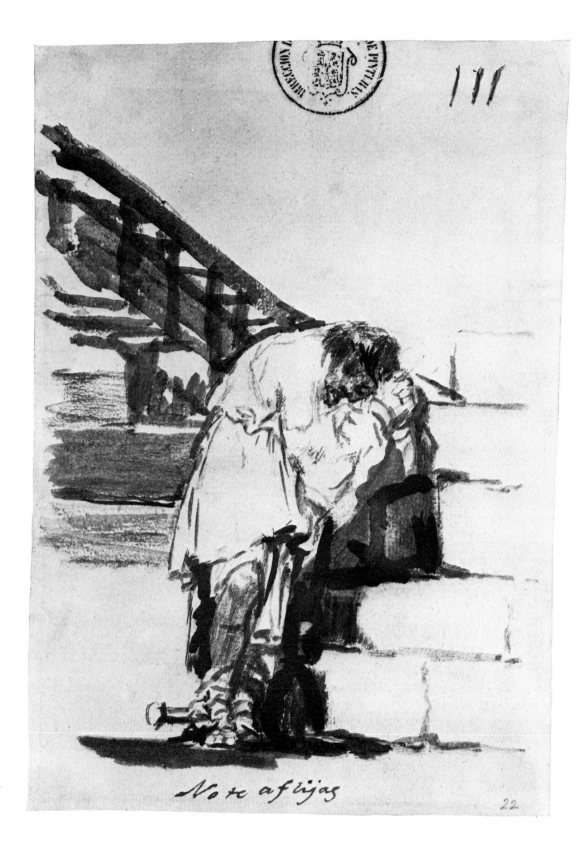

No te aflijas

22

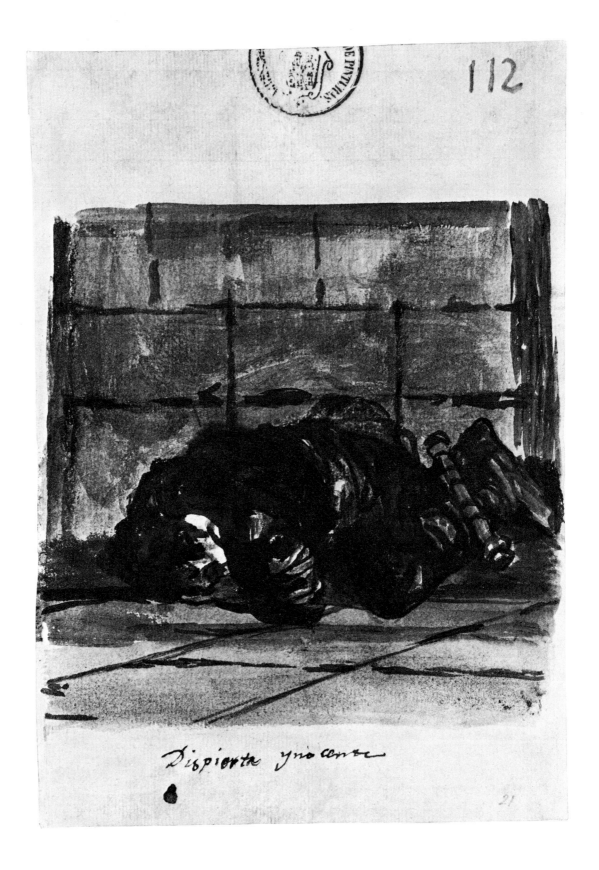

Dispierta ynocente

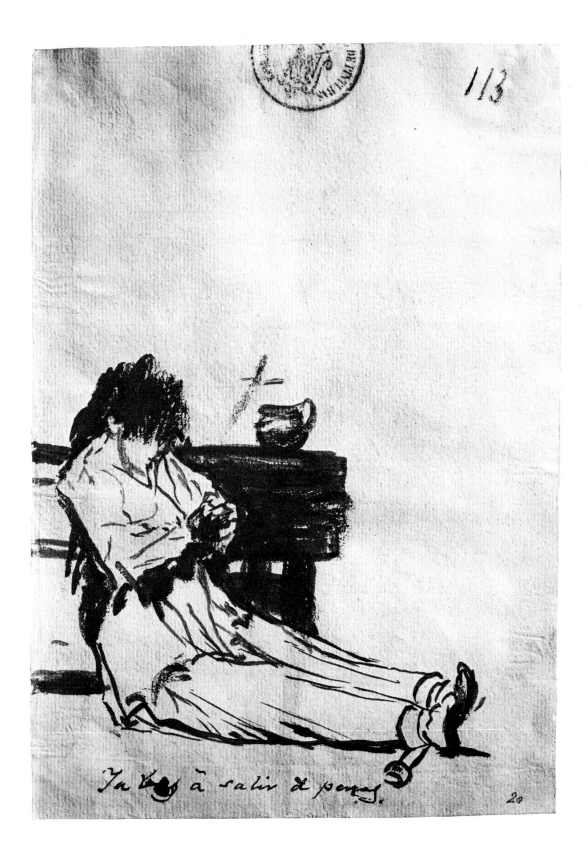

114

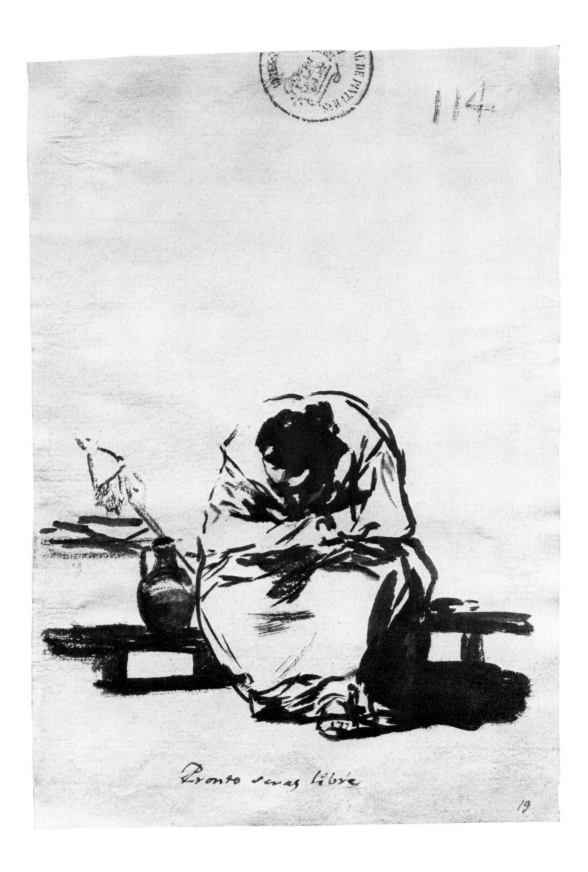

Pronto seras libre

19

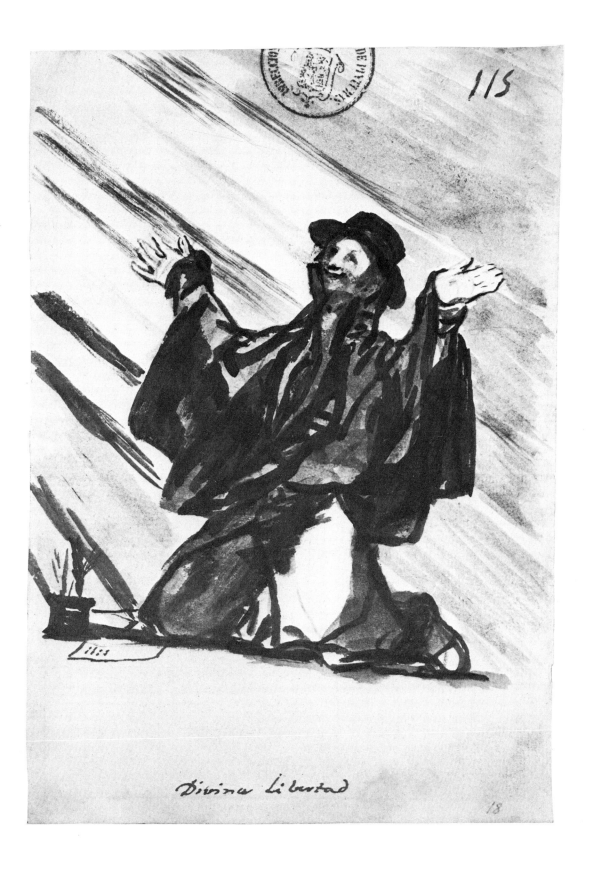

Divina libertad

Dure la alegria

LUX EX TENEBRIS.

117

Ja hace mucho tiempo q.ᵉ som.Conoci–

119

S –dos

14

¿q.ᵉ trabajo es ese?

124

¿Cuantas baras? 125

126

Sin camisa. Son felices

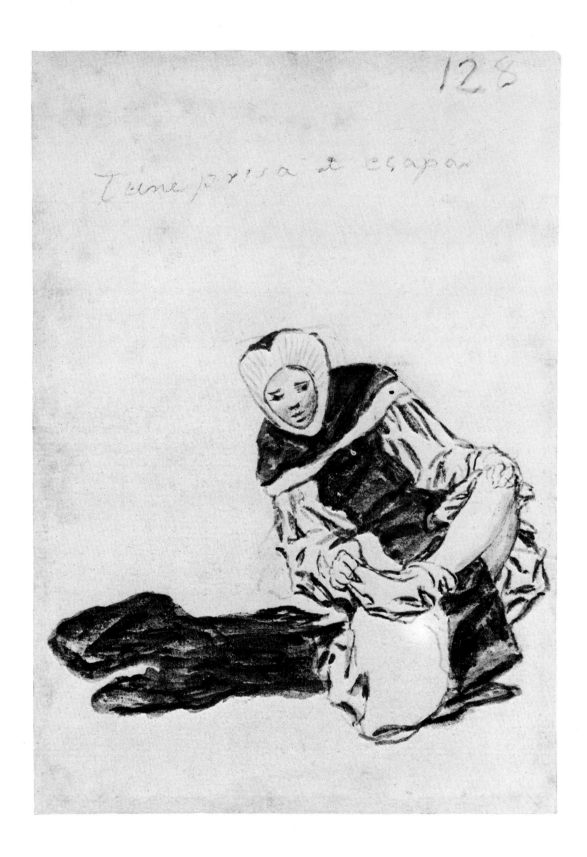

Tiene prisa d escapar

128

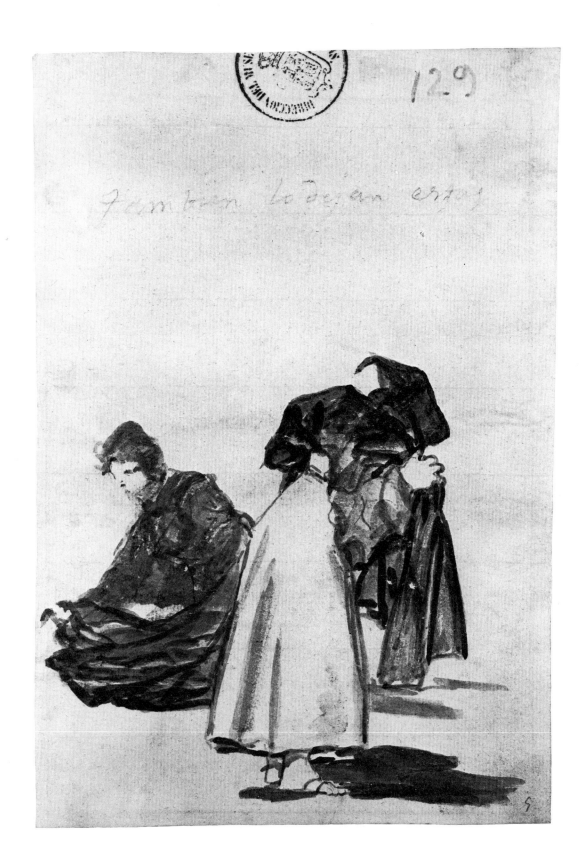

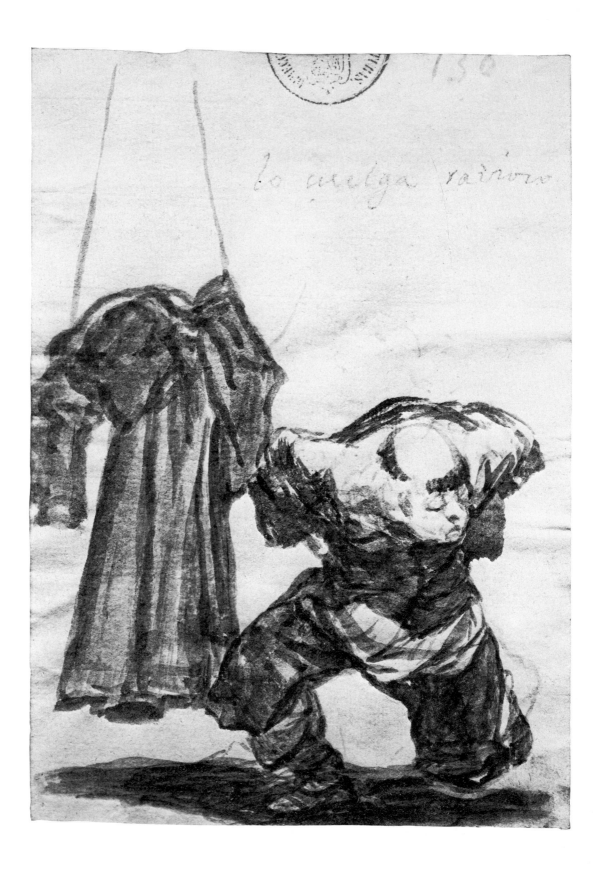

lo cuelga pairoro

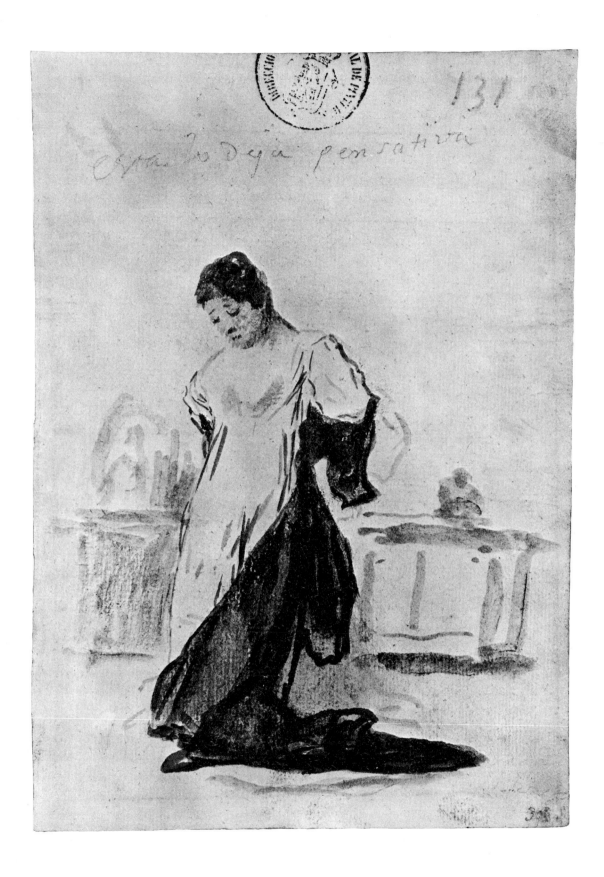

esta lo deja pensativa

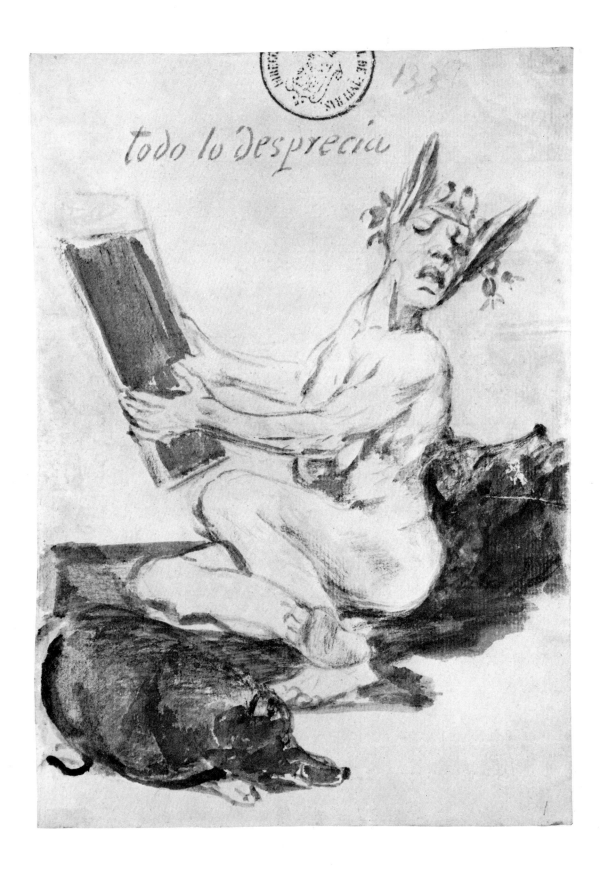

todo lo desprecia

Journal-Album (C)

Captions and Commentaries

C.1 [151] p. 229

P.ʳ no trabajar (S) (Because he has no work) – c.1803-24
– 205 × 144 – I – No. (I) – No. add. 69 (Lp) – *Paper:*
horizontal chain lines – Mounted on pink paper – *Water-
mark:* crown & cross (C.I) – *Hist.:* Javier Goya; Mariano
Goya; Román Garreta → Museo de la Trinidad (5.4.1866)
– Madrid, Prado (86) – GW 1244

Numerically, this is the most extensive of all Goya's
albums. It opens with a vision of human misery: a
man clad in shapeless rags, wild-eyed and with
unkempt hair, stretches out both arms in an appeal to
charity. The tragic image is conveyed with nervous
strokes and shaded areas in thin wash. At the same
time, the uncompromising brevity of the title censures
a state of affairs and a social system that produced the
beggary that was Spain's greatest scourge. If we are to
believe Campomanes, Cabarrús, Ward, Meléndez
Valdés and others who treated that grievous problem,
only one in every five beggars was really in need; the
other four were simply work-shy. This is the meaning
of Goya's title: idleness degrades; work alone ennobles
man and sets him free.

C.2 [152] p. 230

Salvage menos q.ᵉ otros (S) (Less savage than some) – c.1803-
24 – 205 × 143 – I + S – No. (I) – No. add. 119 (Lp)
– *Paper:* horizontal chain lines – Mounted on pink paper
– *Watermark:* crown & cross (C.I) – *Hist.:* Javier Goya;
Mariano Goya; Román Garreta → Museo de la Trinidad
5.4.1866) – Madrid, Prado (87) – GW 1245

After filling his page with a fearful, hairy savage,
Goya attached this caustic caption pregnant with
double meaning; a distant, but still perceptible, echo
of the "good savage" dear to the 18th century as
opposed to the self-styled civilized man capable of the
very worst savagery. Note the extraordinary acces-
sories with which the artist has decked out his charac-
ter. He is dressed in hairy skins with a yataghan
inserted in his belt, and carries a long bow that cuts
the composition diagonally in half.

C.3 [153] p. 231

a q.ᵉ bendra el faldellin y los calzones? (S) (What is the use of
the skirt and pantaloons?) – c.1803-24 – 205 × 142 – I
– No. (I) – No. add. 118 (Lp) – *Paper:* horizontal chain
lines – Mounted on pink paper – *Watermark:* crown &
cross (C.I) – *Hist.:* Javier Goya; Mariano Goya; Román
Garreta → Museo de la Trinidad (5.4.1866) – Madrid,
Prado (88) – GW 1246

This is one of the most delightful female figures Goya
ever drew. A young dancer stands before us in an
attitude well calculated to show off her charms. Her
head bent coyly to the side, the slightly contorted
body, the gesture of the arms that stretch the shawl
spread out behind her – all these details skilfully
combined by the artist's nimble brush give the
motionless silhouette the suggestive rhythm of the
"shawl dance". In actual fact that dance was not
always encumbered with such complicated apparel,
which explains Goya's arch question as to what pur-
pose it could serve.

C.4 [154] p. 232

Mas probecho saco de estar solo (S) (I'm better off alone)
– c.1803-24 – 205 × 143 – I – No. (I) – No. add. 117 (Lp)
– *Paper:* horizontal chain lines (22 mm) – Mounted on
pink paper – *Watermark:* C.I – *Hist.:* Javier Goya; Mariano
Goya; Román Garreta → Museo de la Trinidad (5.4.1866)
– Madrid, Prado (89) – GW 1247

As López-Rey remarked (Bibl. 131, p. 75), this is one of the very few drawings in album C in which the caption voices the character's thoughts and not the artist's. It seems most unlikely, however, that Goya saw himself in the unconventional figure of this solitary reader. What is beyond doubt is that he endowed him with the feelings he himself had assimilated through the years and the taste for reading his deafness had done much to develop. For more information on this period of semi-retirement, see the introduction to album D.

C.5 [155] p. 233

Este fue un cojo q.ᵉ tenia señoria (S) (This one was a cripple who had a title) – c.1803-24 – 205 × 143 – I – No. (I) – No. add. 116 (Lp) – *Paper:* horizontal chain lines – Traces of pink paper on the back – *Watermark:* C.I – *Hist.:* Javier Goya; Mariano Goya; Román Garreta → Museo de la Trinidad (5.4.1866) – Madrid, Prado (90) – GW 1248

Only very seldom did Goya repeat himself. Notably in the long gallery of portraits of beggars, paupers, old men and cripples, each character has his own personal features and is clearly distinguished from the other members of the numberless family of unfortunates. This one is the representative of a peculiarly Spanish class – a nobleman reduced to indigence and forced to beg for a living. His case is very different from that of the beggars portrayed in C.1, 17 and 22. The last vestiges of the rank he once enjoyed are clear to see – silk coat with lace ruffles at throat and wrists, knee-breeches and stockings, beribboned shoes and, as an ultimate derisive touch, the plumed hat extended in a gesture of humble supplication. His face has not lost its dignity despite the physical decadence vigorously rendered by the intertwined brush strokes and the touches of wash.

C.6 [156] p. 234

No ha muerto toda via (S) (He's not dead yet) – c. 1803-24 – 204 × 143 – I – No. (I) – No. add. 155 (Lp) – *Paper:* greatly damaged in the middle, where pieces clumsily cut out have been pasted on the drawing – Mounted on pink paper – *Hist.:* Javier Goya; Mariano Goya; Román Garreta → Museo de la Trinidad (5.4.1866) – Madrid, Prado (328) – GW 1294

This drawing, eliminated by López-Rey, was included for the first time in album C in my catalogue of 1970 (GW 1294). But there I gave it the wrong place because I was unable at that time to examine the entire sheet of paper and so read the numbers correctly. Both the one in the artist's own hand and the one

added later are now perfectly visible and tally with those on the adjacent sheets. Instead, the scene is totally different from the subjects treated in the first quarter of the album and is far closer to the series of condemned and tortured men starting with C.85. The turbaned figures in the middle distance recall the presence in Spain of Napoleon's Mamelukes during the War of Independence.

C.7 [157] p. 235

Al desierto p.ᵃ ser santo, amen (S) (Into the desert to be a saint, Amen) – c.1803-24 – 205 × 143 – I – No. (I) – No. add. 114 (Lp) – *Paper:* horizontal chain lines – Mounted on pink paper – *Watermark:* C.I – *Hist:* Javier Goya; Mariano Goya; Román Garreta → Museo de la Trinidad (5.4.1866) – Madrid, Prado (207) – GW 1249

Viewed on its own, this drawing might be interpreted merely as referring to the hermit's life; but the caption is quite enough to give the violently theatrical scene a totally different significance. And leafing through the album, we realize that this is only a first assault on the monastic orders and the monks' life of contemplation. It is followed by others, more or less disguised, but all starting out from the idea Goya inherited from his "enlightened" friends: namely, that monks and nuns are a dead weight on the shoulders of society. If we are to believe Casanova, Campomanes had termed them "a race of noxious parasites". Jovellanos, Cabarrús and Azara, though less violent, agreed with him. Goya's brush, by subtly combining words and image, went still further and dealt a more telling blow, as we can see in C.8, C.18, C.20, C.30 etc.

C.8 [158] p. 236

A lo menos hace algo (S) (At least he's doing something) – c.1803-24 – 205 × 143 – I + S – No. (I) – No. add. 113 (Lp) – *Paper:* horizontal chain lines – Mounted on pink paper – Pieces of paper added at three points: cheek, cowl and elbow – *Hist.:* Javier Goya; Mariano Goya; Román Garreta → Museo de la Trinidad (5.4.1866) – Madrid, Prado (279) – GW 1250

The link between this drawing and the previous one is clear to see. After the anchorite whose only thought is his own saintliness, this monk at least makes himself useful by weaving baskets. But the "conversational" tone of the caption is full of double meanings: "So many others do nothing at all" or "Did I only take the habit for this?" And to make his intention doubly clear, the artist has set the scene in a landscape of fields and hills that obviously needs men capable of overcoming sterility and routine. The figure of the Capuchin sil-

houetted against that vast empty space has the value of a symbol – as vigorous as the dark tones of the habit, as pathetic as the rugged features of the wasted peasant.

C.9 [159] p. 237

Buena mujer, parece (S) (A good woman, apparently) – c.1803-24 – 205 × 143 – I + S – No. (I) – No. add. 112 (Lp) – *Paper :* horizontal chain lines – Mounted on pink paper – *Hist.:* Javier Goya; Mariano Goya; Román Garreta → Museo de la Trinidad (5.4.1866) – Madrid Prado (13) – GW 1251

This is the perfect picture of a woman entirely satisfied with her status as a mother. A scene of simple happiness rendered with a very light wash all but devoid of shadows. The mother – a woman of low station judging by her bare feet and the clothes she wears – hugs her baby lovingly to her breast, her head bent towards his, which she caresses with one hand and touches with her lips. The drawing matches the sentiment in simplicity and candour. It is very different from the rather affected scene of B.44, where the nurse seems more motherly than the mother. The women, too, are entirely different. One is slender, elegant, aristocratic; the other robust, plainly dressed, really maternal.

C.10 [160] p. 238

Habrazo Paternal (S) (Paternal embrace) – c.1803-24 – 205 × 144 – I + S – No. (I) – No. add. 111 (Lp) – *Paper :* horizontal chain lines – Mounted on pink paper – *Hist.:* Javier Goya; Mariano Goya; Román Garreta → Museo de la Trinidad (5.4.1866) – Madrid, Prado (410) – GW 1252

Another instance of a drawing closely linked with its predecessor. There, motherly love; here, fatherly love. The scene is apparently set before a convent gateway. A father tenderly clasps his daughter, who has flung herself into his arms. On the left, a nun with a bunch of keys hanging from her girdle – no doubt the extern sister – casts down her eyes and spreads out her arms in a gesture of resignation. The girl, a picture of youth and joy in the strong light, is leaving the convent and going home; in the shadows on the right, forming a strong contrast with the nun, a man wearing a hat holds the mule ready for the journey. But what really gives the scene its pathetic effect is the great arch that frames the whole and stresses the impression of departure towards a free life in the vast, bright open space beyond. Note the combination of sepia and Indian ink, the latter concentrated on the gateway and the shadows in the foreground.

C.11 [161] p. 239

Esta pobre aprobecha el tiempo (S) (This poor woman makes the most of her time) – c.1803-24 – 205 × 140 – I – No. (I) – *Paper :* horizontal chain lines – *Hist.:* New York, Miss Ethel Haven coll. (1941) – New York, priv. coll. – GW 1388

The lack of reliable information makes it difficult to give this drawing its proper place in the albums once and for all. The only known dimensions are those indicated approximately in the catalogue of the big show in Chicago in 1941 (Bibl. 7, No. 68). They are considerably larger than the average of album C and rather closer to those of album E, where I placed the drawing provisionally in 1970 (Bibl. 97, GW 1388). But the absence of any trace of black border forced me to abandon that solution and suggest using it to fill the vacant place of C.11 until the actual size of the sheet is known. Regarding the subject, there is an obvious affinity between this young girl spinning wool as she guards her goats and the pastoral scene in the next drawing, C.12, and in C.25, which also portrays a young shepherdess. Lastly, the caption is of a peculiar type found only in this album, which always begins with the demonstrative pronoun "*este*", masculine or feminine, singular or plural, as the case may be. See in particular C.5, C.16, C.28, C.30, C.33, C.51, C.52 and so on.

C.12(11) [162] p. 240

La huebera (S) (The egg vendor) – c.1803-24 – 205 × 138 – I – No. (I) – No. add. 109 (Lp) – On the left *La guebera* covered by a blot of sepia – another inscription to the left of the erased No. 11 was covered with a stroke of the brush – *Paper :* horizontal chain lines – Mounted on pink paper – *Watermark :* C.I – *Hist.:* Javier Goya; Mariano Goya; Román Garreta → Museo de la Trinidad (5.4.1866) – Madrid, Prado (10) – GW 1253

This young peasant girl, the Spanish descendant of La Fontaine's Perrette, is walking to town at a smart pace to sell her eggs. Her outstretched arm signifies that she is quite decided not to stop until she gets there, no matter what hazards she may encounter on the way. Symbol of these hazards is a curious rock (or tree trunk?) inclined at the same angle as the girl's body but in the opposite direction, which seems to menace her with its mighty bulk. And behind it lurks a dangerous-looking man with a cudgel in his hand. To the left, in the middle distance, another man wearing a hat crouches behind a low ridge. Starting with this drawing and going up to C.50, Goya renumbered all the sheets of this album in order to make room for new subjects. Notably the one on the previous page, which

was inserted between this *Egg Vendor* and *Paternal Embrace*.

C.13(12) [163] p. 241

¡Q.ᵉ Necedad! dar los destinos en la niñez (S) (What stupidity to settle their destinies from childhood!) – c.1803-24 – 205 × 143 – I + S – No. (I) – No. add. 108 (Lp) – *Paper:* horizontal chain lines – Mounted on pink paper – *Hist.:* Javier Goya; Mariano Goya; Román Garreta → Museo de la Trinidad (5.4.1866) – Madrid, Prado (15) – GW 1254

This drawing, like E.13, censures the mistakes so common in the education of small children. Here a woman bundled up in dark, heavy clothing is forcing two children to go with her against their will. The one on the left struggles vainly; the other prefers passive resistance and has to be dragged along. Is the woman their mother, a servant or perhaps a nun? Goya seems to have avoided giving any of the figures too precise a definition in order to stress the symbolic significance of the scene. It is, in fact, a severe censure of the pressures that adults bring to bear on children from infancy, thus committing an outrage against nature. This is another instance of the grand principles dear to the eighteenth-century educationalists, notably Pestalozzi and Rousseau, whose influence was felt so deeply in Spain.

C.16(15) [164] p. 242

Esta pretende el destino de rabanera (S) (This one claims her career is selling radishes) – c.1803-24 – 205 × 143 – I – No. (I) – No. add. 107 (Lp) – *Paper:* horizontal chain lines – Mounted on pink paper – *Watermark:* unclear – *Hist.:* Javier Goya; Mariano Goya; Román Garreta → Museo de la Trinidad (5.4.1866) – Madrid, Prado (11) – GW 1255

A remarkable feature of this drawing is that, though it follows two vacant places – Nos. 14 and 15 – it is so closely linked with C.13 by the style of the caption: the word "*destino*" occurs in both. On the other hand, in Román Garreta's numbering one follows the other. The inference is that, even if Nos. 14 and 15 ever existed, they had disappeared by 1858, the year of Matheron's book on Goya, in which Garreta's collection of drawings is already mentioned. The character portrayed here is an example of coarseness and immodesty, a picture of impudence and provocation by bearing and gesture.

C.17(16) [165] p. 243

Asi suelen acabar los hombres utiles (S) (This is how useful men often end) – c.1803-24 – 205 × 142 – I – No. (I) – No. add. 106 (Lp) – *Paper:* horizontal chain lines – *Hist.:* Javier Goya; Mariano Goya; Román Garreta → Museo de la Trinidad (5.4.1866) – Madrid Prado (46) – GW 1256

This old man, the very image of human decadence, is neither a beggar nor a sluggard but merely the wreck of someone formerly active and socially useful who is now a dead weight supported on two crutches. The zigzag line formed by the legs and body, the curve of back and arms, the hoary, bent head and the eyes fixed hopelessly on the ground – every detail of the poor creature who, were it not for the two sticks, would collapse entirely, emphasizes the irreparable ravages of age and the ultimate breakdown of the human machine. Here the technique of Indian ink wash has attained a rare degree of refinement, in which the sharp contours of certain forms contrast with the supple flow of the shadows and the meagre touches of the almost dry brush point in the hair and beard.

C.18(17) [166] p. 244

Si no me engano, ba à dejar el avito (S) (If I am not mistaken, he is going to cast off his habit) – c. 1803-24 – 205 × 143 – I – No. (I) – No. add. 105 (Lp) – *Paper:* horizontal chain lines – Mounted on pink paper – *Hist.:* Javier Goya; Mariano Goya; Román Garreta → Museo de la Trinidad (5.4.1866) – Madrid, Prado (278) – GW 1257

Unlike most of the drawings in the first half of album C, this one offers a remarkable example of a dark ground against which a monk kneeling in an attitude of deep meditation is silhouetted by the bright light. The gesture of the arms and the hands with their splayed fingers is one of the most pathetic Goya ever limned. It would be a great mistake to view it as simply a convenient stereotype rendering of a "scene of religious ecstasy". The skull and crucifix on the ground to the left might tempt us to believe that we are witnessing a mystic transport of the type so frequently depicted by El Greco. But, as so often happens in these albums, the caption gives the drawing a totally different meaning; what it expresses is doubt, perhaps even disbelief, in the man's monastic vows.

C.19(18) [167] p. 245

Be V.ᵈ q.ᵉ expr.ⁿ, pues no lo cree el marido (S) (Just look at her expression, but the husband doesn't believe it) – c.1803-24 – 205 × 142 – I + S – No. (I) – No. add. 104 (Lp) – *Paper:* horizontal chain lines – Mounted on pink paper – *Hist.:* Javier Goya; Mariano Goya; Román Garreta → Museo de la Trinidad (5.4.1866) – Madrid, Prado (14) – GW 1258

The confused distribution of the wash among the three figures in this drawing makes it rather difficult to interpret the scene with any certainty. López-Rey (Bibl. 131, p. 84) read it as a young woman pretending to faint in her lover's arms, while behind them the husband arrayed "in a bulky garment" wrings his hands. In actual fact, the bulky garment on the left is not the husband's; it belongs to a woman – not a man – stooping over her companion (or mistress) and clasping her arms across her breast to keep her from falling. The fainting fit is genuine and the caption indicates that the husband simply refuses to believe his eyes. One cannot help being surprised at the almost inextricable tangle formed by the three figures. The interplay of light and shade models the young woman in the foreground, but its effect is less than mediocre on the secondary planes. It is only the husband's picturesque silhouette, standing out clearly against the bright background, that gives the drawing a dynamic quality enhanced by the touches of sepia applied over the Indian ink.

C.20(19) [168] p. 246

*Se le murio su amante y se ba al comb.*to (S) (Her lover is dead and she is going to a convent) – c.1803-24 – 205 × 142 – I + Lp – No. (I) – No. add. 103 (Lp) – *Paper:* horizontal chain lines – Mounted on pink paper – *Hist.:* Javier Goya; Mariano Goya; Román Garreta → Museo de la Trinidad (5.4.1866) – Madrid, Prado (209) – GW 1259

This young woman, asleep in an extremely relaxed posture on what looks like a rock or bank, recalls the hermit we saw in C.7 at the beginning of this album. In both there is the same cross standing oddly askew behind the figure to emphasize the religious nature of the scene. A strange vocation, Goya seems to say, in which profane love is transcended by death. However that may be, the languid pose of the sleeping woman conjures up a vision of sensuality rather than religion.

C.21(20) [169] p. 247

¡Que desgracia! (S) (What a misfortune!) – c.1803-24 – 206 × 143 – I – No. (I) – No. add. 102 (Lp) – *Paper:* horizontal chain lines – Mounted on pink paper – *Hist.:* Javier Goya; Mariano Goya; Román Garreta → Museo de la Trinidad (5.4.1866) – Madrid, Prado (91) – GW 1260

In this album Goya has dwelt on a number of physical deformities (cf. in particular C.35 and C.36) without caricature or grotesque exaggeration. This monstrously adipose figure is unable to stand erect and has to remain seated in a sort of low armchair built to measure. Viewed frontally, in a crude light that seems to magnify his rolls of fat, he inspired Goya with an immense pity that the artist rendered in his exclamatory inscription. Note the enormous black shadow cast on the ground by this character, who deserves a place in a Fellini film.

C.22(21) [170] p. 248

Culpable miseria (S) (Reprehensible poverty) – c.1803-24 – 205 × 143 – I – No. (I) – No. add. 101 (Lp) – *Paper:* horizontal chain lines – Mounted on pink paper – *Hist.:* Javier Goya; Mariano Goya; Román Garreta → Museo de la Trinidad (5.4.1866) – Madrid, Prado (43) – GW 1261

This drawing recalls the first one in this album, C.1, which showed us another of those "professional paupers" whom Goya denounced no less vigorously with the brush than his "enlightened" friends did with the pen. Yet the case he exhibits here seems far more pitiable than the other. Firstly, owing to the dreadful emaciation of the half-naked body, the arms, legs and chest are reduced to mere skin and bones. Secondly, because the face is so completely smothered by the tangled hair and beard that all semblance of human features has disappeared. The man's only clothing consists of a few rags draped over his meagre frame and a shapeless old hat held out in both hands to a non-existent passer-by. For he is completely alone in the rocky landscape, as if abandoned by man and rejected by society. The drawing, in a very pale wash with strong accents in pure Indian ink, is one of the most striking in the whole album.

C.23(22) [171] p. 249

Muecas de Baco (S) (Bacchus's grimaces) – c.1803-24 – 206 × 143 – I + S – No. (I) – No. add. 100 (Lp) – *Paper:* horizontal chain lines – Mounted on pink paper – *Hist.:* Javier Goya; Mariano Goya; Román Garreta → Museo de la Trinidad (5.4.1866) – Madrid, Prado (42) – GW 1262

It is far from certain that this grinning, dancing figure was intended from the start as an image of drunkenness. The full glass and the bottle were apparently added later, at the same time as the sepia inscription, to specify what might be termed his "attributes". If we neglect those accessories, we are left with a grimacing vision whose gestures bring it very close to the series of dreams beginning with C.40, *Vision burlesca*.

C.23? **[172]** **p. 250**
Mejor fuera vino (Lp) (Wine would be better) – c.1803-24 – 205 × 143 – I + S – No. (I) – No. add. 6 (Lp) – *Paper:* horizontal chain lines – Mounted on pink paper – *Hist.:* Javier Goya; Mariano Goya; Román Garreta → Museo de la Trinidad (5.4.1866) – Madrid, Prado (47) – GW 1267

López-Rey suggested that this drawing – the number is all but illegible – was removed from the album by Goya himself (Bibl. 131, pp. 85-86). He may have been right, but his argument is far from convincing. Firstly, the autograph number, which I was able to decipher directly on the drawing, is undoubtedly 23; but it is written in pale Indian ink, and not in pencil as López-Rey stated in corroboration of his theory. As a matter of fact, this drawing should have become C.24 since Goya altered his numerical order starting with C.12; but it was apparently overlooked and place 24 seems not to have been filled. This is proved by Garreta's later numbering, which goes directly from 100 (C.23) to 99 (C.25), skipping 24; that place, therefore, must have already been vacant when he bought the whole series from Mariano Goya. The drawing in question, C.23 uncorrected, was numbered 6 by Garreta, thus furnishing additional evidence of its displacement in the album.

C.25(24) **[173]** **p. 251**
Piensalo bien (S) (Think it over well) – c.1803-24 – 205 × 142 – I + S – No. (I) – No. add. 99 (Lp) – *Paper:* horizontal chain lines – Mounted on pink paper – *Hist.:* Javier Goya; Mariano Goya; Román Garreta → Museo de la Trinidad (5.4.1866) – Madrid, Prado (12) – GW 1263

Goya treated pastoral scenes of this kind in other drawings, for instance, C.11 and C.12 in this album. But the closest affinity can be made with one from his Bordeaux period, H.8, where an almost identical shepherdess daydreams in the same posture with her dog beside her. Here the landscape is more detailed, with hills and woods in the distance against which the dreamy young peasant girl is silhouetted leaning on her crook. She stands on a knoll stressed by a dark shadow, and behind her we can make out her dog and the rapidly sketched heads of her flock lower down in the middle distance. The caption is the same as in E.48; but there it refers to a character of a totally different type – a young town girl dressed with studied elegance. But the chief difference between the two is that one knows how to read while this pensive shepherdess is a little country girl, illiterate as most peasants were in those days.

C.26(25) **[174]** **p. 252**
Malos Poetas (Lp) (Bad poets) – c.1803-24 – 205 × 142 – I – No. (I) – No. add. 98 (Lp) – *Paper:* horizontal chain lines – Mounted on pink paper – *Hist.:* Javier Goya; Mariano Goya; Román Garreta → Museo de la Trinidad (5.4.1866) – Madrid, Prado (274) – GW 1264

This drawing is an important turning point in album C. From here to C.75 inclusive, the captions are written with black chalk instead of sepia wash. Another novelty is that the grotesque displaces the human element, as already occurred in the Madrid album and the *Caprichos,* but without becoming actual caricature. It is worth comparing this poet in his odd, outmoded costume with the ass promoted from B.72 of the Madrid album to *Capricho 39* via the drawing entitled *El Asno Literato* (The Literate Ass) in the Prado (GW 528). The same solemn pose, the same big open book held in both hands, even the same impressive chair appear in all three drawings, though they were done in quite different periods. Here, however, a second character with a leer on his face can be spied behind the "great poet's" chair. He might perhaps symbolize a certain loose poetry in contrast to the other's lofty, hollow style. In Goya's eyes the two were equally worthless.

C.27(26) **[175]** **p. 253**
Lo q.ᵉ puede el Amor! (Lp) (What Love can do!) – c.1803-24 – 205 × 142 – I – No. (I) – No. add. 97 (Lp) – *Paper:* horizontal chain lines – Mounted on pink paper – *Watermark:* C.I – *Hist.:* Javier Goya; Mariano Goya; Román Garreta → Museo de la Trinidad (5.4.1866) – Madrid, Prado (206) – GW 1265

This is one of the most romantic drawings Goya has left us. It proves that the aging master – he was 65 years old in 1811 – could still be amazed at the power of love. Incidentally, in his caption he wrote "*Amor*" with a capital A. The poetic effect produced by this scene is due essentially to the enormous disproportion between the two figures, suggesting at once the immensity of the space that separates them and the insignificance of the loved one. What is more, both figures – the woman walking into the water with her skirts tucked up above the knee and the ridiculous little horseman towards whom her every effort tends – are faceless: the anonymity of love, rendered here only by the tense lines and heavy shadows.

C.28(27) **[176]** **p. 254**
Con estos no me meto (Lp) (I won't interfere with these) – c.1803-24 – 205 × 142 – I – No. (I) – No. add. 96 (Lp

– *Paper:* horizontal chain lines – Mounted on pink paper – *Watermark:* C.I – *Hist.:* Javier Goya; Mariano Goya; Román Garreta → Museo de la Trinidad (5.4.1866) – Madrid, Prado (208) – GW 1266

Five vagrants in very lively conversation. Four sit or sprawl on the ground; the fifth stands wrapped in a sort of short cape. The different postures are caught from life and modelled by the interplay of light and shade. Attention is centred on the hideous profile of the violently lit figure (man or woman?) on the right, the rugged skull and bony finger of the next man and, still more, thanks to the pale grey wash, on the one who stands and listens, his features seemingly eaten away by want. The fences vaguely sketched in the background form an enclosure in which Goya seems to have penned these outcasts from society.

C.30(29) [177] p. 255

esto degemoslo como estaba (Lp) (Let's leave this as it was) – c.1803-24 – 205 × 142 – I + S – No. (I): the 29, to the left of the 30, was covered over with a brushstroke – No. add. 95 (Lp) – *Paper:* horizontal chain lines – *Watermark:* C.I – *Hist.:* Javier Goya; Mariano Goya; Román Garreta → Museo de la Trinidad (5.4.1866) – Madrid, Prado (277) – GW 1268

López-Rey (Bibl. 131, p. 88) was right to insist on the unreal quality of this scene both in the juxtaposition of the two monks and in the fantastic landscape that provides the setting for their ascetic way of life. This drawing, like C.7, C.8, C.18 and others in this album, is an attack on the religious orders, particularly those that are purely contemplative. Note that I have left the place of No. 29 vacant after a careful examination of C.23?, which confirmed López-Rey's opinion (Bibl. 131, p. 85) that it was actually a C.23 discarded by Goya.

C.31(30) [178] p. 256

No lo encontraras (Lp) (You won't find it) – c.1803-24 – 205 × 142 – I + S – No. (I) – No. add. 94 (Lp) – *Paper:* horizontal chain lines – Mounted on pink paper – *Watermark:* C.I – *Hist.:* Javier Goya; Mariano Goya; Román Garreta → Museo de la Trinidad (5.4.1866) – Madrid, Prado (419) – GW 1269

As an illustration of the famous story about Diogenes of Sinope, this drawing conveys the profoundly sceptical attitude Goya assumed in his sixties. He has depicted the cynical philosopher, like so many of his poor wretches, almost faceless, for the features are concealed by the pauper's matted hair and beard (cf. C.22, C.28, C.32, C.37 etc.). By the light of his lantern Diogenes searches for a man, but all he finds is his own shadow, towards which he stoops with a gesture of amazement. To stress the hopelessness of his quest, Goya stings him with the words, at once canny and discouraging: "You won't find it."

C.32(31) [179] p. 257

Q.ᵉ orror p.ʳ benganza (Lp) (What horror for the sake of revenge) – c.1803-24 – 205 × 142 – I – No. (I) – No. add. 93 (Lp) – *Paper:* horizontal chain lines – Mounted on pink paper that encroaches amply on the drawing – *Hist.:* Javier Goya; Mariano Goya; Román Garreta → Museo de la Trinidad (5.4.1866) – Madrid, Prado (329) – GW 1270

This is the first scene of torture in this album and differs entirely from those that occur from C.85 on. In fact, what we have here is probably neither war nor the Inquisition, but simply a case of brigandage of the type so common in rural districts. The victim's hands are bound, but he is not lying in a ditch as López-Rey believed (Bibl. 131, p. 88). He is tied by his feet to the tree trunk we can see on the right and has apparently been condemned to a slow death behind the rocks and thickets of this desert scene. The light that makes the upper part of his body stand out against the dark shadows of the background stresses his expression of a beast at bay. But what heightens the effect of horror most is the thin wash that Goya applied with an almost dry brush on the ground and on his character's shirt and head, splashing both with the mud in which he is soon to die.

C.33(32) [180] p. 258

Estos/creen/en los bu-/elos de las/abes (Lp) (These believe in the flight of birds) – c.1803-24 – 205 × 142 – I – No. (I) – No. add. 92 (Lp) – *Paper:* horizontal chain lines – Mounted on pink paper – *Hist.:* Javier Goya; Mariano Goya; Román Garreta → Museo de la Trinidad (5.4.1866) – Madrid, Prado (204) – GW 1271

Cruelty is followed by imbecility personified by two halfwits pressed close together, their eyes tight shut in an attitude of devotion that resembles prayer. Their faces are quite unusually ugly and stupid. But the deep significance of the scene is provided by the owl and bat that hover in the air above the two characters and by the inscription, which refers directly to them. The two poor innocents (most likely monks) believe unconditionally, against all reason, in those nocturnal creatures that fly in broad daylight. Here once again we have the symbols etched in *Capricho 43*, entitled *The Sleep of Reason . . .*, which recur whenever Goya has to render the powers of darkness, fanaticism and ignorance (cf. C.75), as opposed to the brilliant light of Reason and Truth.

C.34(33) [181] p. 259

Rara penitencia (Lp) (An odd sort of penance) – c.1803-24 – 205 × 142 – I – No. (I) – No. add. 91 (Lp) – *Paper :* horizontal chain lines – Mounted on pink paper – *Watermark :* C.I – *Hist. :* Javier Goya; Mariano Goya; Román Garreta → Museo de la Trinidad (5.4.1866) – Madrid, Prado (280) – GW 1272

Another example of indigence, this time linked with an uncommon form of penance. This exhibitionism could not fail to tickle Goya's ironic wit, as reflected in the tone of the caption. The half-naked penitent, his arms folded across his chest to keep him warm, seems as if frozen in a state of primitive bliss expressed by the broad, stupid grin that lights up his face. The upper part of the body is treated with a dry brush, giving the forms a certain roughness that contrasts with the bold strokes which predominate in the lower half of the drawing.

C.35(34) [182] p. 260

en le talego de carne lleba su patrimonio (Lp) (He carries his inheritance in his sack of flesh) – c.1803-24 – 205 × 142 – I – No. (I) – No. add. 90 (Lp) – *Paper :* horizontal chain lines – Mounted on pink paper – *Watermark :* C.I – *Hist. :* Javier Goya; Mariano Goya; Román Garreta → Museo de la Trinidad (5.4.1866) – Madrid, Prado (281) – GW 1273

Here we have a disabled beggar exhibiting a leg apparently affected with elephantiasis. Settled uncomfortably on a clumsy cart, the poor unfortunate supports his monstrous limb with one hand and with the other holds out his hat to passers-by in the hopes that the dismal spectacle may move them to compassion. Goya seems to have imprinted on the man's profile, under the outsize nose, a derisive smile at the idea of the rich profits he will reap from his infirmity. The theme of the disabled beggar recurs in a drawing in black chalk done at Bordeaux many years later, but there he is seated on a greatly improved cart that must have astonished the artist (cf. G.29).

C.36(35) [183] p. 261

Misto de Mona (Lp) (Part Monkey) – c.1803-24 – 205 × 141 – I – No. (I) – No. add. 89 (Lp) – *Paper :* horizontal chain lines – Mounted on pink paper – *Watermark :* C.I. – *Hist. :* Javier Goya; Mariano Goya; Román Garreta → Museo de la Trinidad (5.4.1866) – Madrid, Prado (282) – GW 1274

It is not certain that this "case" is also a beggar, as López-Rey suggested (Bibl. 131, p. 89). It might be merely a hybrid creature with simian features, rigged out in woman's dress and holding a rather stagy posture that expresses a silent prayer. His bare legs are exceedingly thin and apparently very hairy, making him still more like an animal.

C.37(36) [184] p. 262

Bas mui lejos? (Lp) (Are you going very far?) – c.1803-24 – 205 × 141 – I – No. (I) – No. add. 88 (Lp) – *Paper :* horizontal chain lines – Mounted on pink paper – *Hist. :* Javier Goya; Mariano Goya; Román Garreta → Museo de la Trinidad (5.4.1866) – Madrid, Prado (205) – GW 1275

The four drawings that precede this one are notations of isolated human case histories jotted down with the brush on a sheet of paper. Here instead we have a scene in the open air with several figures. Seated on a rock surrounded by a mountain landscape, a wayfarer has stopped for a short rest. His left arm leans on a stick and he grips the straps of his knapsack with both hands. His outstretched left leg reveals the leggings and boots needed for a long journey on foot. Below the knoll on which he sits, two hatted figures seem to be going their way without bothering about him. What we have here is probably one of the journeymen who roved the Spanish countryside looking for work. They were typical products of the great distress in the rural districts denounced by Jovellanos, Campomanes and many other authors of the late 18th century. The accents in pure Indian ink over the grey tonality of the wash give the drawing a vigour and relief that are quite extraordinary. The caption is couched in terms of direct address that create a very human emotive bond between the artist and his characters.

C.38(37) [185] p. 263

El Maricon de la tia Gila (Lp) (Auntie Gila's pansy) – c.1803-24 – 205 × 141 – I – No. (I) – No. add. 87 (Lp) – *Paper :* horizontal chain lines – Mounted on pink paper – *Watermark :* C.II – *Hist. :* Javier Goya; Mariano Goya; Román Garreta → Museo de la Trinidad (5.4.1866) – Madrid, Prado (283) – GW 1276

This dubious character is clearly defined by the title inscribed on the drawing. It is unquestionably a man, and not a woman as López-Rey (Bibl. 131, p. 90) believed. In fact, the Spanish word *maricón* is quite explicit and the face, which Goya drew with the utmost care, is undoubtedly a man's. The woman's dress – justified by his habits – is a rudely comical disguise in which the skirt, stressed by the violent light, is an element of the first importance in the

composition. The grinning face, intended to be as provocative as the gesture of the hands that raise the skirt, is one of the most sinister Goya ever drew.

C.39(38) [186] p. 264
Vision burlesca (Lp) (Comic vision) – c.1803-24 – 205 × 141 – I – No. (I) – No. add. 86 (Lp) – *Paper :* horizontal chain lines – Mounted on pink paper – *Watermark :* C.II – *Hist. :* Javier Goya; Mariano Goya; Román Garreta → Museo de la Trinidad (5.4.1866) – Madrid, Prado (264) – GW 1277

This is the first of nine drawings devoted to episodes of the same nightmare. For a commentary on the whole series, see the introduction to this album. The first monster born of the artist's sleep is a woman whose lantern-jawed head is set on a stunted bust supported by over-long legs. Hands on hips, dullard's face thrust out, she is like a music-hall announcer about to present a stage turn.

C.40(39) [187] p. 265
Otra en la misma noche (Lp) (Another [vision] in the same night) – c.1803-24 – 205 × 141 – I – No. (I) – No. add. 85 (Lp) – *Paper :* horizontal chain lines – Mounted on pink paper – *Watermark :* C.II – *Hist. :* Javier Goya; Mariano Goya; Román Garreta → Museo de la Trinidad (5.4.1866) – Madrid, Prado (265) – GW 1278

This second vision settles an important point concerning this series of nine drawings: all are the fruit of a single night, and are the phantoms of sleep, not waking fancies, for the caption of the sixth vision, C.44, specifies "with nightmare". So these are really dreams, like those that gave rise to the *Caprichos*. This one might be described as a "military vision", in view of the soldierly dress of this figure with a feline countenance, which seems to be cutting capers while holding its head between its hands. The sober technique is here remarkably effective: each brushstroke tells, keeping to essentials with a sureness of touch characteristic of Goya at his best. Note the masterly foreshortening of the right leg from the knee down to the foot raised just above the ground. Note, too, how the shading is limited to the needs of the very sober modelling.

C.41(40) [188] p. 266
3.ª en la/misma (Lp) (3rd [vision] in the same [night]) – c.1803-24 – 205 × 141 – I – No. (I) – No. add. 84 (Lp) – *Paper :* horizontal chain lines – Mounted on pink paper – *Watermark :* C.II – *Hist. :* Javier Goya; Mariano Goya; Román Garreta → Museo de la Trinidad (5.4.1866) – Madrid, Prado (266) – GW 1279

This comical figure, merry yet grotesque at the same time, is wearing a strange costume, with ruff and hoop-skirt, which seems to be a reminiscence of Velazquez. The face is more animal than human; it has much in common with one of the caricatural heads in a pen drawing executed presumably in 1798 (GW 657, upper right), and so it still shows the influence of Lavater's theories which had affected Goya at the time he did the *Caprichos*.

C.42 [189] p. 267
4.ª /en la misma (Lp) (4th [vision] in the same [night]) – c.1803-24 – 205 × 141 – I – No. (I) – No. add. 83 (Lp) – *Paper :* horizontal chain lines – Mounted on pink paper – *Watermark :* C.II – *Hist. :* Javier Goya; Mariano Goya; Román Garreta → Museo de la Trinidad (5.4.1866) – Madrid, Prado (267) – GW 1280

After C.40 here is another "military" vision. The grotesque, outsize head recalls the famous *cabezudos* (large-headed dwarfs) which appear together with *gigantes* (giants) in all the popular Spanish fiestas. Details of the uniform have been deliberately left vague, but we have no difficulty in making out the buckskin breeches, the boots and spurs and, in the right hand, a ridiculously small sabre. The tousled hair and the swarthy, whiskered face setting off the whites of the prominent eyes suggest a swashbuckler whose threatening gestures merely invite laughter. This is the third consecutive figure in the series to "appear" to Goya in this skipping attitude which gives them the unreal air of marionettes.
Goya inscribed the number 42 without any crossing out or correcting. This means that, having renumbered the previous drawings up to what is now 41, he then inserted this fourth vision into the already existing series, but did so before adding the captions. The following drawings, up to and including what is now 47, were thus shifted forward by two numbers.

C.43(41) [190] p. 268
5.ª (Lp) (5th [vision]) – c.1803-24 – 205 × 142 – I – No. (I) – No. add. 82 (Lp) – *Paper :* horizontal chain lines – Mounted on pink paper – *Watermark :* C.I – *Hist. :* Javier Goya; Mariano Goya; Román Garreta → Museo de la Trinidad (5.4.1866) – Madrid, Prado (268) – GW 1281

As in the two previous drawings, the grotesqueness of the figure lies in the fact that the head is out of all proportion to the body. The effect of oddity is heightened by the foolish expression of this noble Spaniard in his tie-wig, so pleased with himself at

being able to spell out the words he is reading. This drawing takes up the theme treated before in *Capricho 37, ¿Si sabrá mas el discipulo?,* but without the donkeys, which, moreover, were an iconographical conceit of the 18th century.

C.44(42) [191] p. 269

6.ª/con pesadi/lla (Lp) (6th [vision] with nightmare) – c.1803-24 – 205 × 140 – I – No. (I) – No. add. 81 (Lp) – *Paper:* horizontal chain lines – Mounted on pink paper – *Hist.:* Javier Goya; Mariano Goya; Román Garreta → Museo de la Trinidad (5.4.1866) – Madrid, Prado (269) – GW 1282

This vision, the only one that took the form of a nightmare, is also the only one in which the main figure has nothing grotesque or monstrous. There is, on the contrary, something pathetically human and tragic about this woman bowed down, indeed almost disfigured, by some unexplained grief. Dishevelled, her mouth distorted by a cry, she wrings her (unseen) hands in anguish. Behind her appear the heads of two men and a thickset, hooded silhouette. But the strangest feature of this scene is the broad stream, perhaps of light, pouring down diagonally across the background, swept with long strokes of a very lightly inked brush and flecked with shapeless blobs and patches. The nightmare springs precisely from this irrational assemblage of forms begotten of night and Goya's imagination.

C.45(43) [192] p. 270

7.ª (l.p) (7th [vision]) – c.1803-24 – 205 × 141 – I – No. (I) – No. add. 80 (Lp) – *Paper:* horizontal chain lines – Mounted on pink paper – *Watermark:* C.I – *Hist.:* Javier Goya; Mariano Goya; Román Garreta → Museo de la Trinidad (5.4.1866) – Madrid, Prado (270) – GW 1283

In this seventh vision reappear the same grotesque elements as in the first five: the ape-like face and the strange dress. The gesture made by this gnome, who descends in a direct line from Lavater, is one for which Goya shows a particular predilection from about 1805 on – a gesture appealing in its very pathos and expressing expectation, either pleased (drawing C.115), anguished (Christ on the Mount of Olives, GW 1640) or pathetic in its helplessness, as here and in drawing C.1.

C.46(44) [193] p. 271

8.ª (Lp) (8th [vision]) – 1803-24 – 205 × 141 – I – No. (I) – No. add. 79 (Lp) – *Paper:* horizontal chain lines – Mounted on pink paper – *Hist.:* Javier Goya; Mariano

Goya; Román Garreta → Museo de la Trinidad (5.4.1866) – Madrid, Prado (271) – GW 1284

This female bogey, with her rapacious expression, is one of those gigantic figures which are conjured up periodically in Goya's work, beginning with the *Caprichos,* in particular plate 3, *Que viene el Coco* (Here comes the bogey-man). In addition to the two colossi, one in a painting (GW 946), one in a print (GW 985), we find several characteristic examples in the *Disparates,* notably in plates 2 (*Disparate de miedo*) and 4 (*Disparate de bobo*). Here the bogey is swooping down on two small figures roughly sketched in the lower left corner; with a fiendish leer on her face, she holds in her left hand the large bag which strikes fear into all the children deluded by this absurd belief.

C.47(45) [194] p. 272

9.ª (Lp) (9th [vision]) – 1803-24 – 205 × 140 – I – No. (I) – No. add. 78 (Lp) – *Paper:* horizontal chain lines – Mounted on pink paper – *Watermark:* C.I – *Hist.:* Javier Goya; Mariano Goya; Román Garreta → Museo de la Trinidad (5.4.1866) – Madrid, Prado (276) – GW 1285

Here the vision takes the form of an unmistakable satire of monastic life: three monks are walking in procession with clasped hands and closed eyes, singing a hymn or canticle at the top of their voice, to judge by the gaping mouths of the first two. But the visionary side of the scene appears chiefly in the features of the foremost monk, who has the monstrous profile of a cockatoo. Obviously this caricature has much in common with certain *Caprichos,* notably Nos. 54, 57, 61 and 63, in which similar beaked noses appear; but it also owes something to Lavater's theories which emphasized the frequent parallels between birds and certain human profiles (Bibl. 127, fig. 62, reproducing a plate from Lavater's *Physiognomische Fragmente*).

C.48 [195] p. 273

Religion en la Asia (Lp) (Religion in Asia) – 1803-24 – 205 × 140 – I – No. (I) – No. add. 77 (Lp) – *Paper:* horizontal chain lines – Mounted on pink paper – *Hist.:* Javier Goya; Mariano Goya; Román Garreta → Museo de la Trinidad (5.4.1866) – Madrid, Prado (275) – GW 1286

This sheet was marked 48 from the first, there being no previous number to change; it was inserted at the end of the series of visions when Goya numbered the definitive sequence, and thus stands between the ninth vision, C.47, and the next drawing, C.49(46). In placing it here, Goya presumably wished to relate this figure to those in the ninth vision, with which there

are obvious similarities. The satire on monks is thus continued and at the same time deliberately deflected from its real target by the fanciful caption, which may have been suggested to Goya by accounts of missionary activity in the Far East. The caricatural cast of the face and the skipping step connect this figure closely with the previous visions.

C.49(46) [196] p. 274

la misma (Lp) (The same [night?]) – 1803-24 – 205 × 140 – I – No. (I) – No. add. 76 (Lp) – *Paper :* horizontal chain lines – Mounted on pink paper – *Hist. :* Javier Goya; Mariano Goya; Román Garreta → Museo de la Trinidad (5.4.1866) – Madrid, Prado (45) – GW 1287

In Goya's original sequence this drawing followed C.47, the ninth vision of a single night. So it seems likely that the rather vague caption of this sheet refers to the series of visions and means "The same night", not "The same religion in Asia", as might be inferred from the final sequence of the sheets arrived at after Goya had written in the captions. The admirable foreshortening of the body lying flat on the ground tellingly conveys the agony of this poor man, whose facial features remain indistinct – a common device with Goya when he wishes to evoke wretchedness or suffering.

C.50 [197] p. 275

Pobre en Asia q.ᵉ se enciende/la cabeza hasta q.ᵉ le dan algo (Lp) (Poor man in Asia who sets his head aflame until they give him something) – 1803-24 – 205 × 140 – I – No. (I) – No. add. 75 (Lp) – *Paper :* horizontal chain lines – Mounted on pink paper – *Hist. :* Javier Goya; Mariano Goya; Román Garreta → Museo de la Trinidad (5.4.1866) – Madrid, Prado (273) – GW 1288

Here the caption is justified by the drawing, which clearly represents an Asiatic, unlike C.48, whose caption is quite fanciful. This scene of human distress carried to its extreme limit may have been suggested to Goya by accounts of missionary work, which were often very popular in Spain. The trance-like state of the figure is emphasized by the particularly spirited handling of the ink wash, applied with energetic strokes in the draperies and with an almost dry pen in the streaks marking the shadows.

C.51 [198] p. 276

esto/ya se be (Lp) (One still sees this) – 1814-24 – 205 × 141 – I – No. (I) – No. add. 74 (Lp) – *Paper :* horizontal chain lines – Mounted on pink paper – *Hist. :* Javier Goya; Mariano Goya; Román Garreta → Museo de la Trinidad (5.4.1866) – Madrid, Prado (300) – GW 1289

This scene is one of the most composed and most moving in the whole album, with its contrast between these two figures of equal prominence, one a wretched prisoner, bound hand and foot, fainting with inanition, the other a monk whose pale face is set off by the dark hood, holding a cross in one hand and shaking and exhorting the condemned man who is too exhausted to react. What confession is he trying to force from him? What crime can he have committed for this holy man to come and torment him in the name of Christ? The setting of this terrible scene is the interior of a church or monastery, with a large pillar on the left to which the prisoner is chained and a monumental crucifix towering over the monk on the right. This drawing probably refers to the period after 1814 when the Inquisition played so active a part in the repressive measures taken against Spanish liberals.

C.52 [199] p. 277

este tiene/muchos pa-/rientes y/algunos/racionales (Lp) (This one has lots of relatives and some of them rational) – 1803-24 – 205 × 140 – I – No. (I) – No. add. 72 (Lp) – *Paper :* horizontal chain lines – Mounted on pink paper – *Watermark :* faint – *Hist. :* Javier Goya; Mariano Goya; Román Garreta → Museo de la Trinidad (5.4.1866) – Madrid, Prado (44) – GW 1290

Another monstrous figure, and one that would not be out of place in the series of visions seen in a single night, C.39 to C.47. It differs from them, however, in the brutish realism which Goya has imparted to it to show that it belongs to the great human family. The torso is wrapped in an animal's hide, which the figure hugs tightly with both arms crossed over its breast; the squinting eyes are set in a dull stare; the legs are bare beneath the ragged tunic. Here, Goya seems to say, is one of our brothers. It is a bitter vision of mankind, recalling that of drawing C.2.

C.53 [200] p. 278

no se sabe (Lp) (One doesn't know) – 1803-24 – 205 × 141 – I – No. (I) – No. add. 73 (Lp) – *Paper :* horizontal chain lines – Mounted on pink paper – *Hist. :* Javier Goya; Mariano Goya; Román Garreta → Museo de la Trinidad (5.4.1866) – Madrid, Prado (298) – GW 1291

A wilfully confused composition in which, at most, one can distinguish two figures facing each other in a

mountainous landscape, the rest being an indecipherable tangle of dark lines and masses. López-Rey asserts (Bibl. 131, pp. 62 and 96) that these two men and the one in the next drawing, C.54, are French soldiers, easily recognizable by their tunic. This view seems to me unwarrantable; no such uniform – assuming that word can be used here – was ever worn in the Napoleonic armies. Goya was familiar enough with the French uniforms, as shown by the plates in the *Disasters of War*. This tunic, on the contrary, is of the type often worn by the Spanish peasants represented in Goya's work; see, for example, drawings B.93, E.115, E.i, C.63, F.37, F.39, and also certain figures in the fresco at San Antonio de la Florida. So this scene might very well predate the War of Independence and, like so many others, represent a fight between mountaineers or bandits.

C.54 [201] p. 279

tan poco (Lp) (Nor in this case) – 1803-24 – 205 × 140 – I – No. (I) – No. add. 71 (Lp) – *Paper:* horizontal chain lines – Mounted on pink paper – *Hist.:* Javier Goya; Mariano Goya; Román Garreta → Museo de la Trinidad (5.4.1866) – Madrid, Prado (299) – GW 1292

A connection between the caption of this drawing and the previous one seems clear enough. We find a similar connection between two successive drawings in the *Disasters of War 35* and *36*, entitled respectively *No se puede saber por qué* (One can't tell why) and *Tampoco* (Not in this case either). This scene might well be the sequel to the affray represented in the previous drawing: one of the two figures has finished off his antagonist and seems to be inveighing against him still, emphasizing his words with a sweep of his left arm, while in his right hand he holds a pistol. The upper part of the figure is lightly sketched in with a few rapid strokes and slight indications of shading. The whole lower part of the drawing, however, is treated in dark wash, the indispensable highlights being left in reserve.

C.55 [202] p. 280

menos (Lp) (Still less) – 1803-24 – 204 × 141 – I – No. (I) – No. add. 70 (Lp) – *Paper:* horizontal chain lines – Mounted on pink paper – *Hist.:* Javier Goya; Mariano Goya; Román Garreta → Museo de la Trinidad (5.4.1866) – Madrid, Prado (380) – GW 1293

In 1947 I published this drawing in the same position in album C, although at that time its number was not

visible; I was led to place it here because its caption seemed to form a logical sequence with those of C.54 and C.53. López-Rey, feeling it safer not to commit himself, refrained from publishing this drawing, though he mentioned my suggestions (Bibl. 131, p. 64, note 1). Now that its slip-in mount has been removed, the whole sheet is visible and the number 55 is clearly legible in the upper right corner, thus confirming the assumption I made in 1947. The connection with C.54 seems to be purely formal and to refer only to the confusion of the scene; it must be remembered that, in all likelihood, the captions were added some time after the drawings had been made. So that what Goya meant to convey by the caption is simply the fact that this scene is no more precise in its meaning than the last two. The only distinct figure is the old woman sitting in the foreground, in the light, with her skirt hitched up over her thin shanks. The rest of the composition is a mass of dark shadows teeming with undefinable figures.

C.56 [203] p. 281

Estropiada codiciosa (Lp) (Worn out with greed) – 1803-24 – 210 × 145 – I – No. (?) – *Paper:* horizontal chain lines (28 mm) – Mounted on cardboard – *Hist.:* Javier Goya; Mariano Goya; V. Carderera – Madrid, Biblioteca Nacional (B.1255) – GW 1381

A gap was left in the album at this point when the drawing, mistakenly placed here in my 1970 catalogue (GW 1294), was given its rightful place as C.6 (see in this connection the entry for C.6). But thanks to a closer examination of several drawings in the Biblioteca Nacional in Madrid which have defied classification, and thanks also to information supplied by Señora Elena Páez de Santiago and the availability of new photographs, it has been possible to ascertain that this drawing, published in 1970 as belonging to album D (GW 1381), actually possesses the fundamental characteristics of album C: the paper has horizontal chain lines (not vertical ones, as in album D) and the format is that of the larger sheets already known to us. Conclusive proof is provided by the number 56, which has now been made out in the upper right corner beside the stamp of the Biblioteca Nacional. Furthermore, the style of this drawing, with the wash extending over the whole background, is out of keeping with that of the known drawings of album D, whose background is generally left blank. In the exhibition catalogue of the Royal Academy (Bibl. 22, No. 190), Enriqueta Frankfort already suggested that the drawing should belong in this album.

C.57 [204] p. 282
bayan en ora buena (Lp) (Good luck go with them) – 1803-24
– 205 × 141 – I + S – No. (S) – No. add. 68 (Lp) – *Paper:*
horizontal chain lines – Mounted on pink paper – *Water-mark:* faint, C.I. (?) – *Hist.:* Javier Goya; Mariano Goya;
Román Garreta → Museo de la Trinidad (5.4.1866)
– Madrid, Prado (262) – GW 1295

In the absence of any definite evidence for fitting it
into album C, López-Rey refrained from publishing
this drawing. But in view of the apparently regular
sequence of the subsequent numbers, I proposed in
1970 to assign it to the vacant place of No. 57 (GW 1295
and note 1293-1295). Now that the slip-in mount has
been removed, a 57 written in sepia can be read quite
distinctly in the upper right corner, thus confirming
my hypothesis. This sheet, moreover, marks a turning
point in the sequence of drawings in album C: from
here on, sepia wash is increasingly used in preference
to Indian ink, not only in the composition but also in
the numbers and captions. Here the sepia wash is
applied with particular emphasis to the upper part of
the figures and to the background. These monks with
their belongings setting off for an unknown destination
are saluted by Goya with unmistakable irony, and
with no regrets. This vein of anticlerical satire runs
through the entire album.

C.58 [205] p. 283
Ya dispertará (Lp) (He's going to wake up) – 1803-24
– 205 × 141 – I + S – No. (S) – No. add. 67 (Lp) – *Paper:*
horizontal chain lines – Mounted on pink paper – *Water-mark:* C.II – *Hist.:* Javier Goya; Mariano Goya; Román
Garreta → Museo de la Trinidad (5.4.1866) – Madrid,
Prado (305) – GW 1296

This further drawing of a monk, in the extreme
spareness of its technique, offers a striking contrast
with the previous sheet. The figure is reduced to a
heap of clothes indicated by a few strokes of the
brush, and to two patches of shadow, one at the foot
of the habit, the other in the oval of the face, under the
hood tightly drawn over the head. The face is that of a
man sound asleep, and the coarse features are clearly
marked. The Indian ink wash is very light, but
heightened with a few vigorous strokes of sepia which
emphasize the length of this unseen but bulky body
under the heavy folds of frieze.

C.59 [206] p. 284
Sueño raro (Lp) (Bizarre dream) – 1803-24 – 205 × 142
– S + I – No. (S) – No. add. 66 (Lp) – *Paper:* horizontal
chain lines – Mounted on pink paper – *Watermark:* C.I

– *Hist.:* Javier Goya; Mariano Goya; Román Garreta
→ Museo de la Trinidad (5.4.1866) – Madrid, Prado (306)
– GW 1297

In this drawing the proportions of Indian ink and
sepia are reversed, the latter now definitely predomi-
nating up to and including C.116. This was a wholly
new medium for Goya, who had hitherto employed
Indian ink almost exclusively in all his drawing albums.
The figure shown here is again a sleeping monk, as in
the previous sheet, but now he is floating in the air,
working his arms and legs as if trying to shake off his
habit, whose dark mass in sepia wash strongly contrasts
with the rest of the drawing, laid in with light strokes
of the brush. Goya treated an almost identical subject
in Bordeaux, in the black chalk drawing H.32; this is
but one example among many of the continuity of
certain themes in his graphic work.

C.60 [207] p. 285
P.ª los q.ᵉ/estan en/P.ᵈᵒ Mortal (Lp) (For those in a state of
deadly sin) – 1803-24 – 205 × 141 – S + P – No. (S)
– No. add. 65 (Lp) – *Paper:* horizontal chain lines
– Mounted on pink paper – *Watermark:* C.I – *Hist.:* Javier
Goya; Mariano Goya; Román Garreta → Museo de la
Trinidad (5.4.1866) – Madrid, Prado (290) – GW 1298

This very fine figure, one of the most monumental to
be found in the whole corpus of Goya's drawings, has
the profound appeal of his great equivocal works – the
Colossi, the *Black Paintings,* the *Disparates.* What does
this young woman represent, with her long dark veils,
holding a tray in her hands with an almost ritual
gesture? Her brightly lighted face is full of sweetness,
but also of mystery, with the shadow falling across her
brow. The caption enlightens us, with all the gravity
that emanates from the image itself: it represents
Charity coming to succour the wretched of the earth.
This sheet lacks the stamp of the National Museum of
Painting which was set on the others, apparently at the
time they were acquired in 1866.

C.61 [208] p. 286
Calla/el tiempo mu-/da las oras (Lp) (Be quiet. Time changes
the hours) – 1803-24 – 205 × 142 – S + I + P – No. (S)
– No. add. 64 (Lp) – *Paper:* horizontal chain lines (23 mm)
– Mounted on pink paper – *Watermark:* C.I – *Hist.:* Javier
Goya; Mariano Goya; Román Garreta → Museo de la
Trinidad (5.4.1866) – Madrid, Prado (261) – GW 1299

This drawing, not published by López-Rey, was placed
here in my 1970 catalogue on the evidence of its

secondary number 64. The Prado sheets having now been remounted, Goya's autograph number 61, written in sepia, can be plainly read in the upper right corner, thus confirming the position tentatively assigned to this drawing. The previous figure, with its graceful drapery of veils, is followed here by a woman apparently of riper years, also draped in long dark veils, but seated beside a tomb. The density of the sepia wash makes it an image of mourning and despair. The overshadowed face is cupped in both hands, the latter fully illuminated. Goya's caption is addressed to his figure, to console and soothe its grief.

C.62 [209] p. 287

Puede ser q.ᵉ sea bueno (Lp) (It may be that he's a good man) – 1803-24 – 205 × 141 – S + I – No. (S) – No. add. 63 (Lp) – *Paper*: horizontal chain lines – Mounted on pink paper – *Watermark*: C.I – *Hist.*: Javier Goya; Mariano Goya; Román Garreta → Museo de la Trinidad (5.4.1866) – Madrid, Prado (307) – GW 1300

After the symbolic figures of the last two sheets, images of a tormented and suffering Spain, here again is a monk, apparently a Benedictine, quietly seated at his working table; pen in hand, he is reading or writing in a large volume. Before this studious figure, Goya seems to feel respect or anyhow to be indulgent, as he had been before in drawing C.8. The latter sheet deals with manual work, this one with brain work, but in both cases the religious orders are judged by the same criteria; and, as already pointed out, they are the criteria of Goya's "enlightened" friends. In its technique this drawing shows a harmonious combination of Indian ink and sepia, the latter being used exclusively for the monk's ample habit, which thus acquires unusual prominence.

C.63 [210] p. 288

esto ya se/be q.ᵉ no es/arrancar Nabos (Lp) (One can see that this is not a matter of pulling up turnips) – 1803-24 – 205 × 141 – S + I – No. (S) – No. add. 62 (Lp) – *Paper*: horizontal chain lines – Mounted on pink paper – *Watermark*: C.I – *Hist.*: Javier Goya; Mariano Goya; Román Garreta → Museo de la Trinidad (5.4.1866) – Madrid, Prado (289) – GW 1301

For the first time, we find in this album a drawing done entirely in sepia wash; and this is the case with all the subsequent drawings up to and including C.89, apart from three (C.71, C.73, C.75), which show a few traces of Indian ink. But Goya seems to have hesitated before giving up Indian ink completely, for an initial

sketch in this medium is faintly visible in the background of this drawing. The final composition was worked over again with a wetter brush, thickening the lines and deepening the shadows. The figure represented is a strapping, poorly dressed peasant straining to wrench off a branch or to root up a small tree. An impression of strenuous effort is tellingly conveyed by the two legs planted wide apart and the head turned to one side. The caption is ironical but at the same time full of sympathy for this hard-working peasant.

C.64 [211] p. 289

Ciego ena/morado de/su potra (Lp) (Blind man in love with his hernia) – 1803-24 – 205 × 141 – S – No. (S) – No. add. 61 (Lp) – *Paper*: horizontal chain lines (23 mm) – Mounted on pink paper – *Watermark*: C.I – *Hist.*: Javier Goya; Mariano Goya; Román Garreta → Museo de la Trinidad (5.4.1866) – Madrid, Prado (302) – GW 1302

In this drawing Goya handles the sepia wash with remarkable economy: a series of rapid strokes delineating essentials and two zones of shadow, around the head and on the ground. Featureless except for the patch of light on his nose, this blind man, firmly planted on legs set wide apart, is characterized by a large bald head and, above all, by a monstrous hernia which has become his pride and joy, to the detriment of the rest of his body. Comparing this drawing with the other "monsters" in this album, notably C.21, C.35, C.36 and C.38, one is struck here by a much more direct, almost brutal manner of treating the subject. This was probably the outcome of a stylistic evolution spanning several years.

C.?(65) [212] p. 290

mal señal (Lp) (A bad sign) – 1803-24 – 205 × 142 – S – No. add. 60 (Lp) – *Paper*: mounted on pink paper – *Hist.*: Javier Goya; Mariano Goya; Román Garreta → Museo de la Trinidad (5.4.1866) – Madrid, Prado (263) – GW 1303

No autograph number can be made out on this drawing, the sepia background covering almost the entire surface of the sheet. For this reason López-Rey did not include it in his sequence. But if we go by the evidence of the secondary number subsequently added (which in so many other cases has proved a reliable guide), this is the only place to which this fine drawing can be assigned. It is as darkly shadowed and mysterious as the previous one was spare and clear. The sepia has been applied in such thick washes that it has attacked the paper and eaten through it in several places on the

right of the figure. The play of light on the cape is made all the more intense by the dark wash around it. Something is up: the shadowy figure with its invisible face looms up ominously in the darkness, the gleaming cape betraying its presence through the tangle of leafage.

C.67 [213] p. 291

de esto hay mucho, y no se be (Lp) (There is much of this but one doesn't see it) – 1803-24 – 205 × 142 – S – No. (S) – No. add. 59 (Lp) – *Paper:* horizontal chain lines – Mounted on pink paper – *Hist.:* Javier Goya; Mariano Goya; Román Garreta → Museo de la Trinidad (5.4.1866) – Madrid, Prado (260) – GW 1304

The interpretation of this drawing given by López-Rey (Bibl. 131, p. 100) seems to me far-fetched. Admittedly it is difficult to puzzle out some of Goya's compositions. For that very reason it behoves us to be cautious, and while there is always room for a sensible interpretation of a puzzling theme, we must be careful not to stretch the evidence for it, as we do here if we assume this man to be drunk and the woman a prostitute. The scene appears to be of a more humanitarian character and to represent a woman giving something to drink to a sick or wounded man. A deliberate contrast is drawn between the bright silhouette of the woman and the dark mass of the half-reclining man, whose face and chest alone are illuminated.

C.68 [214] p. 292

esto huele à|cosa d.ᵉ Magia (Lp) (This smacks of magic) – 1808-14 – 205 × 142 – S + P – No. (S) – No. add. 58 (Lp) – *Paper:* horizontal chain lines – Mounted on pink paper – *Hist.:* Javier Goya; Mariano Goya; Román Garreta → Museo de la Trinidad (5.4.1866) – Madrid, Prado (367) – GW 1305

Sánchez Cantón was the first to suggest that this man kneeling in mid-air might be Pope Pius VII, wearing boots and spurs under his soutane and holding in his hands a terrestrial globe. An image, then, of his political ambitions and machinations, but one to which Goya has added a suggestion of magic to ridicule the pope's would-be spiritual authority. The terrestrial globe at which the pope is gazing intently is a parody of the crystal ball of clairvoyants, while the curious graffiti scribbled over his head with a fine pen suggest the cabalistic formulas used by magicians. So scabrous a composition could only have been ventured on at a time of relative religious liberalism in Spain – that is,

most probably, between 1808 and 1814, and those very years correspond to the most troubled period of the pontificate of Pius VII.

C.69 [215] p. 293

estas Brujas lo diran (Lp) (These witches will tell) – 1808-14 – 205 × 142 – S – No. (S) – No. add. 57 (Lp) – *Paper:* horizontal chain lines – Mounted on pink paper – *Hist.:* Javier Goya; Mariano Goya; Román Garreta → Museo de la Trinidad (5.4.1866) – Madrid, Prado (368) – GW 1306

It seems certain that Goya meant this drawing together with the last and the next to form a sort of magic triad, as in fact was already noticed by Sánchez Cantón (Bibl. 173, No. 338), even though he was unaware that the autograph numbers are consecutive. There are reminiscences in these three sheets of certain plates in the *Caprichos,* Nos. 62 and 66 in particular, but now the style is quite different and the forcefulness of the figures is self-contained, without recourse to sky effects or tragic backgrounds. This witch hungrily devouring snakes has the same windblown hair as the pope in the previous drawing. Is one to assume that this witch and the next two have been conjured up by the incantations of Pius VII and that from them will come the reply so long awaited by the faithful? Such, anyhow, is a possible explanation of this strange group of three drawings.

C.70 [216] p. 294

Nada dicen (Lp) (They say nothing) – 1808-14 – 205 × 142 – S – No. (S) – No. add. 56 (Lp) – *Paper:* horizontal chain lines – Mounted on pink paper – *Hist.:* Javier Goya; Mariano Goya; Román Garreta → Museo de la Trinidad (5.4.1866) – Madrid, Prado (369) – GW 1307

The two witches hovering in the air in strangely contorted postures are trying to lift a heavy slab by pulling at a ring fastened to it. The long-awaited reply is the same as that given in the famous plate of the *Disasters of War 69,* the skeleton emerging from its grave: "Nothing". There is nothing, sheer nothingness. It may be conjectured that this group of three drawings, though anterior to the last plates of the *Disasters of War,* is a product of the same mood of anticlericalism and disbelief.

C.71 [217] p. 295

tuti li mundi (Lp) (literally, all the world; meaning "peep-show") – 1803-24 – 207 × 144 – S + I + P – No. (S) – *Paper:* horizontal chain lines – Mounted on pink paper – *Hist.:*

Javier Goya; Mariano Goya; Román Garreta; F. de Madrazo; R. de Madrazo y Garreta; A. M. Huntington (1913) – New York, Hispanic Society of America (A.3314) – GW 1308

This sheet from album C is one of five at present known which do not belong to the Prado collections. It is interesting to note, however, that the two drawings from album C now owned by the Hispanic Society of America (this one and C.128), once belonged to Román Garreta (Bibl. 184, p. 12), as did the one hundred and eighty-six drawings purchased in 1866 by the Museo de la Trinidad. Since these two lack the secondary, added number which figures on those in the Prado, it may be inferred: (1) that this numbering was added not by Javier Goya but by Román Garreta; and (2) that these two drawings were not included in the lot sold in 1866, probably for reasons of propriety. It is possible that other sheets lacking in the Prado were excluded for the same reason. For this scene – imagined or really witnessed by Goya? – has the same coarseness as certain quips of which he was particularly fond in his letters and whose key word designates what has here aroused the young woman's smiling curiosity. It is amusing to find this bumpkin unwittingly providing a free show, whereas he has had to pay to see the imaginary sights in the peep-show. Innocent as it may seem to us, this popular spectacle, known in Spain as *mundonuevo* or *tutilimundi*, was condemned by Jovellanos in his famous *Memoria para el arreglo de la policia de los espectáculos y diversiones públicas* (Memoir for the regulation of spectacles and public entertainments), written in 1790 and read at a public sitting of the Royal Academy of History on July 11, 1796.

C.73 [218] p. 296
No la engañas (Lp) (You don't fool her) – 1803-24 – 205 × 142 – S + I + P – No. (S) – No. add. 55 (Lp) – *Paper:* horizontal chain lines – Mounted on pink paper – *Watermark:* faint – *Hist.:* Javier Goya; Mariano Goya; Román Garreta → Museo de la Trinidad (5.4.1866) – Madrid, Prado (250) – GW 1309

Here again we find the pair of figures already familiar to us from the Madrid album and the *Caprichos*: the prostitute and her *Celestina,* the latter, as always, with a veil over her head and a rosary in her hands. But what a change in her protégée! She has nothing of the provocative elegance of those shapely young *majas* strolling along the *paseo* and fluttering their fans. Stout and common-looking, she saws the air with her hand as she does her best to take in the old bawd. But Goya

knows well enough how it will end and tells her so: "The old woman knows every trick in the book! You won't get the better of her!"

C.74 [219] p. 297
tan vien aqui/hay amores (Lp) (There are amours here too) – 1803-24 – 205 × 142 – S + P – No. (S) – No. add. 54 (Lp) – *Paper:* horizontal chain lines (23 mm) – Mounted on pink paper – *Hist.:* Javier Goya; Mariano Goya; Román Garetta → Museo de la Trinidad (5.4.1866) – Madrid, Prado (304) – GW 1310

As López-Rey has suggested (Bibl. 131, p. 102), it is quite possible that this and the previous drawing were meant to form a kind of diptych on the theme of love. The first leaf may be taken as representing "city love", the second "country love", judging by the caption applied to this group of four peasants, one a young woman, eating a meal on the ground beside a fire over which stands a frying-pan. In both cases Goya takes a disillusioned view of love, in keeping with the satirical mood that had come over him since the *Caprichos*. For this second drawing one can only concur with López-Rey, who thinks it has been clumsily reworked by another hand, particularly in the patches of sepia which distort the outline of the figure in the foreground and in the many additions made with a fine pen around its right leg. Assuming that little Rosario Weiss, the old master's darling pupil, was responsible for these "corrections", then they must date to the period between 1821, when the little girl made her first attempts at drawing at the age of seven, and Goya's departure for France in 1824. (See in this connection López-Rey, Bibl. 130, p. 25 in particular.)

C.75 [220] p. 298
Con la musica à otra parte (Lp) (Away with that rubbish) – 1812-24 – 206 × 142 – S + P + I – No. (S) – No. add. 53 (Lp) – *Paper:* horizontal chain lines – Mounted on pink paper – *Watermark:* traces – *Hist.:* Javier Goya; Mariano Goya; Román Garreta → Museo de la Trinidad (5.4.1866) – Madrid, Prado (370) – GW 1311

Here is further proof, if such were needed, of Goya's anticlericalism. A priest wrapped in a voluminous soutane flies through the air, clinging nervously to a large candlestick still giving off wisps of smoke. His only company in the sky is a flock of sinister night-birds, the largest, set off with Indian ink, being a cross between an owl and a man. This is Goya's usual symbol for the backward forces of that "*España negra*" in which, owing to the ignorance of the masses, the

preponderant role was played by the clergy and the Inquisition. Compare with *Caprichos 43, 45, 68* and *75*, *Disasters of War 72* and *73*, and drawing C.122 in this album.

C.76 [221] p. 299

Que sacrificio (S) (What a sacrifice) – 1812-24 – 205 × 142 – S – No. (P.S) – No. add. 52 (Lp) – *Paper :* horizontal chain lines – Mounted on pink paper – *Hist. :* Javier Goya; Mariano Goya; Román Garreta → Museo de la Trinidad (5.4.1866) – Madrid, Prado (325) – GW 1312

This drawing was not published by López-Rey. In my 1970 catalogue (GW 1312) it was assigned to this place on the evidence of its secondary number 52. Examining the sheet in 1972 when it had been removed from its slip-in mount, I found the number 76 plainly indicated in the upper right corner, thus confirming my previous assumption. The whole left and centre of the composition, where the sepia has been laid on too thickly, is now very difficult to make out. But to the right of this shadowy mass stands out the exquisite figure of a young woman, fully illuminated. Sánchez Cantón suggested that she is being forced into marriage (reminding one of *Capricho 14*, with the same title of *Que sacrificio*) or into prison (Bibl. 173, No. 356). Either interpretation would seem to fit the scene, for on a bed in the shadows on the left lies an Oriental figure in a turban, surrounded by guards also dressed in Oriental costume. Perhaps the young woman has been captured by Barbary pirates and brought now to a sultan's palace to join his harem. Such episodes figure repeatedly in Spanish literature from the 16th century on, beginning with Cervantes both in his comedies and in *Don Quixote*. A change occurs in this drawing in one significant particular: from now on, up to and including C.116, the captions are written in sepia wash instead of pencil.

C.77 [222] p. 300

Comer vien veber mejor y/dormir olgar y pasear (S) (To eat well, drink better and sleep, loaf and stroll about) – 1812-24 – 205 × 141 – S + P – No. (P.S) – No. add. 51 (Lp) – *Paper :* horizontal chain lines (23 mm) – Mounted on pink paper – *Watermark :* C.II – *Hist. :* Javier Goya; Mariano Goya; Román Garreta → Museo de la Trinidad (5.4.1866) – Madrid, Prado (301) – GW 1313

What Goya is denouncing here is not just a toper indulging in his vice, but a whole way of life. Pithily, in five verbs, the caption sums up the "ideal" of this man and his like. The verb "to work" is conspicuously absent – a word which has figured in the caption of so many other drawings, either to condemn "those who avoid work" or to encourage those who, however lowly their employment, apply themselves to it. Some parts of the drawing, as López-Rey has pointed out (Bibl. 131, p. 103), seem to have been reworked by an unskilful hand.

C.78 [223] p. 301

Lastima es q.ᵉ no te ocupes en otra/cosa (S) (It's a pity you don't have something else to do) – 1808-24 – 203 × 140 – S + P – No. (S) – *Paper :* ? – *Hist. :* Koenigs; Ps. Sotheby 20.11.1957; Paris, priv. coll.; Knoedler – New York, priv. coll. – GW 1314

In contrast with the lazy toper of the previous drawing, here is a fine picture of a humble working girl. This water-carrier brings to mind not only the tapestry cartoon of 1791-92, *Las mozas del cántaro* (Women water-carriers) (GW 300), but more particularly a painting certainly much closer in date, *La Aguadora* (The water-carrier) (GW 963) in the Budapest Museum. But the caption of this drawing adds an element of personal appreciation on Goya's behalf – a veritable *piropo* (compliment paid by a man to a woman he admires in the street) which he addresses to his figure, whose grace and beauty seem to him worthy of a better occupation.

C.79 [224] p. 302

estos hacen raya/en la taberna (S) (These outdo themselves at the tavern) – 1812-24 – 205 × 142 – S – No. (S) – No. add. 50 (Lp) – *Paper :* horizontal chain lines – Mounted on pink paper – *Watermark :* C.II – *Hist. :* Javier Goya; Mariano Goya; Román Garreta → Museo de la Trinidad (5.4.1866) – Madrid, Prado (252) – GW 1315

This tavern scene oversteps the bounds of propriety, for Goya does not shrink from representing the most revolting details in order to show what the "ideal" of the figure in drawing C.77 may lead to. But though he satirizes self-indulgence and dissipation, Goya is no scowling moralist, no enemy to the pleasures of life. Everything we know about him bears this out. Over and above the man, however, stands the artist, who cannot help observing his contemporaries and saying outright what he thinks of them, laughingly or chidingly, but always in the name of truth.

The sepia wash has been laid on so thickly that in many places it has attacked the paper. With Indian ink this never happens.

C.80 [225] p. 303

Gran mano para|hurtar sonajas (Por q.ᵉ era tremulo) (S) (A great hand at stealing little bells [because his hand was shaky]) – 1812-24 – 207 × 143 – S – No. (S) – No. add. 110 (Lp) – *Paper:* horizontal chain lines – Mounted on white paper – *Watermark:* C.I – *Hist.:* Javier Goya; Mariano Goya; Román Garreta → Museo de la Trinidad (5.4.1866) – Madrid, Prado (253) – GW 1316

As in the previous sheet, Goya has here recorded a scene which he had either witnessed or heard about: the barber, who has a shaky hand and weak eyes, judging by the thick glasses he is wearing, sticks his nose against his customer's cheek, trying his best not to cut him to pieces with the razor. The victim's face is contorted with fear and he has pulled up his legs, as if about to make a dash for safety. The exertions of the old barber and the well-grounded anxiety of his customer, a neighbour who has come over in slippers for his morning shave – that is the gist of this drawing, a scene taken directly from everyday life.

C.81 [226] p. 304

Ó Sᵗᵉ brague (S) (O Holy Breeches) – 1812-24 – 205 × 142 – S + P – No. (S) – No. add. 49 (Lp) – *Paper:* horizontal chain lines (23 mm) – Mounted on pink paper – *Watermark:* C.I – *Hist.:* Javier Goya; Mariano Goya; Román Garreta → Museo de la Trinidad (5.4.1866) – Madrid, Prado (308) – GW 1317

It would be difficult to find a more pointed piece of sarcasm in the whole corpus of Goya's drawings, and when we remember the trouble he had with the Inquisition because of the *Caprichos,* we can imagine what might have happened had he ventured to publish such a drawing. A monk solemnly holding his breeches in the air like a processional banner – this in itself is scandalous enough. But the caption, neatly turned in macaronic Latin, like the words of a canticle, adds sacrilege to scandal. In the reign of Ferdinand VII, men were sentenced to penal servitude for much less.

C.82 [227] p. 305

Edad con desgracias (S) (The mishaps of old age) – 1812-24 – 205 × 142 – S – No. (S) – No. add. 48 (Lp) – *Paper:* horizontal chain lines (23 mm) – Mounted on pink paper – *Watermark:* C.I – *Hist.:* Javier Goya; Mariano Goya; Román Garreta → Museo de la Trinidad (5.4.1866) – Madrid, Prado (292) – GW 1318

A pathetic scene, but one of an almost brutal realism: an old man has overturned his close-stool and finds himself with his trousers down lying on the floor in the midst of his own excrement. The blank stare of the eyes shows that he is aghast at his mishap, from which, alone, he is probably incapable of extricating himself. The thick patches of sepia staining his lower body and left hand heighten our sense of the afflictions to which old age is exposed. This is the poignant statement of an artist who, after the death of his wife in 1812, was certainly haunted by the thought of a lonely old age.

C.83 [228] p. 306

Desbergonzado, (S) *con todas, todas* (I) (Shameless with all women, all) – 1812-24 – 205 × 143 – S – No. (S) – No. add. 47 (Lp) – *Paper:* horizontal chain lines – Mounted on pink paper – *Hist.:* Javier Goya; Mariano Goya; Román Garreta → Museo de la Trinidad (5.4.1866) – Madrid, Prado (251) – GW 1319

Here again we meet with the group of women sitting in chairs along the *paseo* (see Madrid album B.16, B.18, B.28, B.38, etc.), but times have changed and these are no longer the elegant *majas* of Goya's youth. The deterioration of the military man is even more striking, if we compare him with the smart young men in drawings B.22 and B.39, for example. But now, too, Goya was more concerned with recording what he saw around him of human depravity and baseness. The caption was completed subsequently in Indian ink, the word "*todas*" being added and repeated to emphasize the senile obsession of his grotesque old swaggerer.

C.84 [229] p. 307

Nada nos ynporta (S) (Nothing matters to us) – 1812-24 – 205 × 143 – S – No. (S) – No. add. 46 (Lp) – *Paper:* horizontal chain lines – Mounted on pink paper – *Watermark:* C.I – *Hist.:* Javier Goya; Mariano Goya; Román Garreta → Museo de la Trinidad (5.4.1866) – Madrid, Prado (249) – GW 1320

This is the last sheet in album C before the long series depicting the victims of the Inquisition. Goya has deliberately ended on a note of serenity and love, an intimation of what man's life might be, freed of oppression and fanaticism. The mood of this drawing is one of sweet intimacy and insouciance; its caption, of a type rare in the drawing albums, expresses not the artist's feelings but those of the figures themselves, asserting the protective power of their love against all the vicissitudes of existence. (See drawing C.4 for a caption in the same style.)

C.85 [230] p. 308

P.ʳ haber nacido en|otra parte (S) (For being born somewhere else) – 1814-24 – 205 × 143 – S – No. (S) – No. add. 44 (Lp) – *Paper:* horizontal chain lines – Mounted on pink paper – *Hist.:* Javier Goya; Mariano Goya; Román Garreta → Museo de la Trinidad (5.4.1866) – Madrid, Prado (309) – GW 1321

Here begins the long series of drawings representing prisoners and torture victims of the Inquisition. It comprises twenty-nine sheets at the present time; only one is missing, No. 110. (See the general study devoted to this series in the introduction to this album.) An initial group of eight drawings deals with the public executions and exhibitions of condemned persons, all of them, except in drawing C.91, wearing the *sanbenito* and the *coroza* (paper tunic and tall hat worn by those condemned by the Inquisition). This drawing shows a woman about to be burnt at the stake, thick smoke already filling the background of the composition. The grounds of the indictment were written on the *sanbenito* worn by the victims; in similar fashion, Goya's captions give the charge against them, repeating the stock formula always beginning with *Por . . .* (For . . .). Born "somewhere else", this foreign woman is a suspected heretic. Goya has deliberately simplified the case, striking the imagination by the play of light and shadow rather than keeping to a plain statement of historical fact.

C.86 [231] p. 309

Por traer cañutos|de Diablos de Bayona (S) (For bringing diabolical tales from Bayonne) – 1814-24 – 205 × 144 – S – No. (S) – No. post. 43 (Lp) – *Paper:* horizontal chain lines (23 mm) – Mounted on pink paper – *Hist.:* Javier Goya; Mariano Goya; Román Garreta → Museo de la Trinidad (5.4.1866) – Madrid, Prado (311) – GW 1322

This pathetic composition is undoubtedly an implicit censure of the methods and spirit of the Inquisition. But it is far from certain that the date of the scene and the execution of the drawing coincide. Bayonne was the centre for the distribution of revolutionary propaganda in Spain as early as 1792-93. And there was no lack of volunteers to carry tracts (the *cañutos,* no doubt) and pamphlets against tyranny and intolerance (cf. on this point Bibl. 108, pp. 222-244). After 1814 the same sort of surge against Ferdinand VII's absolutism and repression was countered with the same harsh measures by the Holy Office, whose courts had recently been reinstated. The degrading punishment meted out to this man was followed, as a rule, by exile or incarceration in a convent.

C.87 [232] p. 310

Le pusie|ron mor|daza p.ʳ|q.ᵉ habla|ba |y le di|eron palos|en la|cara||Yo la bi|en Zaragoza à Orosia Moreno|P.ʳ q.ᵉ sabia hacer|Ratones (S) (They put a gag on her because she talked. And hit her about the head. I saw her in Saragossa, Orosia Moreno. Because she knew how to make mice) – 1814-23 – 205 × 144 – S – No. (S) – No. add. 42 (Lp) – *Paper:* horizontal chain lines (23 mm) – Mounted on pink paper – *Hist.:* Javier Goya; Mariano Goya; Román Garreta → Museo de la Trinidad (5.4.1866) – Madrid, Prado (312) – GW 1323

This drawing is very close to the previous one as far as the composition is concerned. The same horrible scene backed by the same crowd of people – they also appear in many sheets of the *Tauromaquía* – gaping at the condemned woman. She is viewed full front, gagged and bound hand and foot. The caption refers to a scene that Goya actually witnessed at Saragossa when he went there for the last time in 1808, summoned by Palafox. The victim was apparently called Orosia Moreno. Another scene of the same kind is mentioned in Moratín's diary for February 19, 1804: "In the street: I saw the mob watching a woman *encorozada* by the Holy Office." The explanation of the sentence indicates that she was tried for witchcraft.

C.88(78) [233] p. 311

P.ʳ linage de ebreos (S) (For being of Jewish ancestry) – 1814-24 – 205 × 142 – S – No. (S) – *Paper:* horizontal chain lines – *Hist.:* bought at Colnaghi's in 1862 – London, British Museum (1862.7.12.187) – GW 1324

This scene is very different from the others of the same group, where the sufferer is always alone. Here we have a very dramatic mass effect. A long procession of condemned men, all wearing the *coroza,* passes through an arched doorway before being exposed to the public gaze. They are flanked by pitiless monks and *alguazils.* The first *encorozado* stands out in the full light against the mass of indistinct figures, his head sunk on his chest in an attitude of deepest shame at the idea of having to face the scorn and insults of the mob. Why was he there? Simply for being a Jew, Goya says. It is worth mentioning that in a previous numeration this drawing was marked 78 and therefore opened the series of convicts.

C.89(79) [234] p. 312

P.ʳ mober la lengua de otro modo (S) (For wagging his tongue in a different way) – 1814-24 – 205 × 143 – S – No. (S) – No. add. 45 (Lp) – *Paper:* horizontal chain lines (23 mm) – Mounted on pink paper – *Hist.:* Javier Goya; Mariano Goya; Román Garreta → Museo de la Trinidad (5.4.1866) – Madrid, Prado (313) – GW 1325

The style of dress worn by this man as he listens to the sentence handed down by the tribunal of the Holy Office shows that the scene took place in the 18th century. There is an obvious parallel with *Capricho 23* (*Aquellos polbos*) and the *Inquisition Scene* in the Academy of San Fernando (GW 966); the latter was very likely executed at the same time as the drawings in this section of album C. The different density of the ink helps to make the condemned man and his shadow stand out against the rest of the composition. If we are to believe the caption, he was sentenced for making heterodox remarks.

C.90(80) [235] p. 313

Por no tener piernas (S) (For having no legs). This title was written over a long inscription, parts of which are hard to decipher: *Yo lo conoci á este baldado, q.ᵉ no tenia pies/|y dicen q.ᵉ le pedia limosna al . . .|cuando salia de Zaragoza|y en la calle de Alcala cuando entraba lo encontraba pidiendole* (S) (I knew this crippled man who had no feet and they say that . . . when he left Saragossa and when one went into the calle de Alcalá one found him there begging) – 1814-24 – 205 × 143 – S + I – No. (S) – No. add. 40 (Lp) – *Paper*: horizontal chain lines – Mounted on pink paper – *Hist.:* Javier Goya; Mariano Goya; Román Garreta → Museo de la Trinidad (5.4.1866) – Madrid, Prado (314) – GW 1326

The strong effect of light and shade in this drawing is apparently due more to chance than to the artist's deliberate intention. The dark area of Indian ink and sepia wash that covers the right-hand half of the sheet served originally to blot out a caption written higher up near the earlier number 80. The last letters of two lines (. . . *tes*/. . . *cia*) can still be discerned to the right of the wash. In any case the artist seems to have hesitated between a horizontal and a vertical background, as in two drawings in the Madrid album, B.34 and B.45. Whatever the purpose of the large areas of wash, the contrasts of light and shade are extremely effective. As for the earlier caption, I totally disagree with López-Rey (Bibl. 131, p. 110) when he says that Goya alluded to some devilish exploit by this cripple between Saragossa and Madrid. Suffice it to recall that, arriving from Saragossa, one enters Madrid through the Alcalá Gate and the street of the same name.

C.91(81) [236] p. 314

Muchos an acabado asi (S) (Many have ended like this) – 1814-24 – 205 × 143 – S + I – No. (S) – No. add. 34 (Lp) – *Paper*: horizontal chain lines – *Hist.:* Javier Goya; Mariano Goya; Román Garreta → Museo de la Trinidad (5.4.1866) – Madrid, Prado (348) – GW 1327

This is a classic image of the atrocious *garrote* to which Goya devoted one of his first etchings about 1778-80 (GW 122). It recurs in two famous plates of the *Disasters of War* 34, *Por una navaja* (Because he had a knife), and 35, *No se puede saber por qué* (Who knows why?). It is worth noting that in the first of the two etchings the scene is composed very much as it is in the drawings C.86, C.87 and C.90 and not very differently from this one. In particular, the treatment of the crowd in relation to the condemned man is the same. There is no doubt that all were executed about 1815. Here, however, the wash is far deeper and there is some confusion concerning the proportions of the three monks. This drawing also differs from the others by its "secular" character. In fact, the victim wears none of the distinguishing marks of the Inquisition.

C.92(82) [237] p. 315

P.ʳ querer á una burra (S) (For loving a she-ass) – 1814-24 – 205 × 145 – S + I – No. (S) – No. add. 35 (Lp) – *Paper*: horizontal chain lines – Mounted on pink paper – *Watermark*: C.I – *Hist.:* Javier Goya; Mariano Goya; Román Garreta → Museo de la Trinidad (5.4.1866) – Madrid, Prado (310) – GW 1328

Of all the drawings of victims of the Inquisition, this last one is the plainest and also perhaps the most moving. The man has already been garroted; executioners, monks and onlookers have dispersed. *Rigor mortis* has already set in and all that is left on the sinister stage is a lifeless puppet that interests nobody. There is very little wash in this drawing, except on the post at which the execution took place and a few patches of shadow on the scaffold floor. But the pure white of the paper is slashed by the chief lines of the design and particularly by the horizontal which cuts the post at right angles and behind which there is nothing but the void. The series is closed by this crime as old as the hills; however horrible, it is infinitely less so than the punishment thought up by the Holy Office.

C.93(83) [238] p. 316

Por casarse con quien quiso (S) (For marrying whom she wanted) – 1814-24 – 205 × 144 – S – No. (S) – No. add. 36 (Lp) – *Paper*: horizontal chain lines – Mounted on pink paper – *Hist.:* Javier Goya; Mariano Goya; Román Garreta → Museo de la Trinidad (5.4.1866) – Madrid, Prado (342) – GW 1329

Like many drawings in album C, this one was given a merely provisional classification in my catalogue of 1970 because the mount made it impossible to read the

autograph number. The place suggested by the number 36 added in another hand is now proved correct by the 93 written over an 83 that is clearly visible in the top right-hand corner. López-Rey, who discussed (Bibl. 131, p. 112, note 1) the hypothesis put forward in my first tentative catalogue of 1947, saw a curious parallel between this dramatic torture scene and C.84. This is interesting because at that time he could not have known that under the number 93 there was the 83 of a first numeration in which the two drawings occupied adjacent positions. The original arrangement gave C.84 a very strong overtone after the torments suffered by a woman who had merely married for love. In this context the words of the two young lovers might be interpreted as "Nothing counts for us but love, even if that is the fate we may expect." The horror of the scene is conveyed by the technical means employed: the violent contrast between the deep shade in which the torturers go about their hideous business and the bright light focused on the young woman's upturned face.

C.94(85) [239] p. 317

Por descubrir el mobimiento/de la tierra (S) (For discovering the motion of the earth) – 1814-24 – 205 × 144 – I + S – No. 94 (S), 85 (I) – No. add. 37 (Lp) – *Paper:* horizontal chain lines – Mounted on pink paper – *Hist.:* Javier Goya; Mariano Goya; Román Garreta → Museo de la Trinidad (5.4.1866) – Madrid, Prado (333) – GW 1330

Goya has not given this prisoner a name, but there is no mistaking the reference to Galileo's tragic story that had been told throughout Europe for close on two centuries. The famous physicist and astronomer had come to be considered the victim *par excellence* of the Holy Office, symbolizing the spirit of science oppressed by religious obscurantism. He was depicted as rotting in a Roman jail, suffering the uttermost refinements of torture and yet crying out the famous words: "*Eppur si muove!*" It was this legend that led Goya to imagine his Galileo, hands and feet literally sealed to the stone of his dungeon, humiliated and reduced to a physical wreck. The real facts were very different, but the artist's long indictment of the Inquisition needed a choice victim, a world-famous hero whose halo as the martyr of Truth would shed its light on the innumerable humble, nameless ones who followed in his wake.

C.95(86) [240] p. 318

No lo saben todos (S) (Not everyone knows it) – 1814-24 – 205 × 143 – I + S – No. (S) – No. add. 38 (Lp) – *Paper:* horizontal chain lines – Mounted on pink paper – *Watermark:* C.I – *Hist.:* Javier Goya; Mariano Goya; Román Garreta → Museo de la Trinidad (5.4.1866) – Madrid, Prado (338) – GW 1331

A prisoner lies fettered in his cell, forgotten by the rest of the world. The deep penumbra round about him is broken only by the bright light that enters through the barred window. It illuminates the upper part of his body and a section of wall in the background behind him. Here Goya, after portraying the most illustrious victim of the Inquisition, shows us the lowliest – the hero without a name.

C.96(87) [241] p. 319

No haver escrito para tontos (S) (Because he didn't write for fools) – 1814-24 – 207 × 144 – S + I – No. (S) – No. add. 14 or 143 (?) – *Paper:* horizontal chain lines – Pasted on white paper – *Hist.:* Javier Goya; Mariano Goya; Román Garreta → Museo de la Trinidad (5.4.1866) – Madrid, Prado (343) – GW 1332

In this drawing the dungeon is depicted as a sombre mass in which we can just barely make out the figure of a young man wrapped from head to foot in a cloak or blanket. Only his face emerges from the shadows, not livid but rendered ashen-pale by a thin Indian ink wash. Through the narrow rectangle of the barred window a pallid ray of light falls on the flagged floor and part of the wall behind the prisoner. A pitcher of water stands on the floor to the right. The caption tells us slyly the crime he was expiating: he had written for people who were not imbeciles. Here Goya denounces not only intolerance but still more the despotic rule of stupidity.

C.97 [242] p. 320

te conforma? (S) (Are you persuaded?) – 1814-24 – 204 × 133 – S + I – No. (S) – No. add. 39 (Lp) – *Paper:* horizontal chain lines – Traces of pink paper – *Watermark:* C.I – The stamp of the National Museum of Painting was not impressed on this drawing in 1866 – *Hist.:* Javier Goya; Mariano Goya; Román Garreta → Museo de la Trinidad (5.4.1866) – Madrid, Prado (344) – GW 1333

Like some other drawings in album C I have already mentioned, this one was not published by López-Rey. As early as 1947 (Bibl. 135), I suggested that it should be given this place. My hypothesis was borne out in 1970 by the discovery of the numbers added later. Now that it has shed its mount, the whole sheet can be seen with the number 97 in the top right-hand corner. This scene of a suspect being tortured during questioning is one of the most dreadful of all. On the right

two monks are pressing her with questions, but her face is quite expressionless and she refuses to say a word. So the brutish-looking executioner on the left is making ready to operate the well rope, one end of which is tied round her body. The brutally concise caption echoes the inquisitor's last question before the torture is applied.

C.98 [243] p. 321
P.r liberal? (S) (For being a liberal?) – 1814-24 – 205 × 142 – S + I – No. (S) – No. add. 33 (Lp) – *Paper:* horizontal chain lines – Mounted on pink paper – *Watermark:* C.II – *Hist.:* Javier Goya; Mariano Goya; Román Garreta → Museo de la Trinidad (5.4.1866) – Madrid, Prado (335) – GW 1334

This drawing, like some of the others dealing with condemned persons, apparently does not represent a scene witnessed by the artist nor even one that took place at the time when the sheets of this album were executed. Once again, what Goya wanted, at a time when violence and oppression had become unbearable, was to denounce by every means at his disposal the excesses that degraded his fellow men. Here he has chosen as an example a woman victimized by her cruel jailers. Her feet are pinioned by a block of wood, her neck is gripped by an iron collar, her hands are tied behind her back. Her face expresses the mortal anguish of a body shackled to a hellish wall of crossed beams. Yet it would seem that the only crime she was accused of was having been a liberal. It is worth noting that the word was first used in its political sense in Spain about 1811-12, when the Cortes, assembled at Cadiz, proclaimed the famous Constitution.

C.99 [244] p. 322
Cayó en la trampa (S) (He fell into the trap) – 1814-24 – 205 × 142 – S + I – No. (S) – No. add. 32 – *Paper:* horizontal chain lines – Mounted on pink paper – *Watermark:* C.II – *Hist.:* Javier Goya; Mariano Goya; Román Garreta → Museo de la Trinidad (5.4.1866) – Madrid, Prado (332) – GW 1335

Here Goya has rendered a different kind of torture with an extraordinarily vigorous handling of light and shade. The man's muscular body is literally wedged into a sort of easel. He is making desperate efforts to free himself but, as the caption says, the trap is solid. A ray of bright light throws his bare chest into strong relief, while his face, its features almost invisible in the deep shade, is turned towards its own shadow cast on

the plank that forms his bed of torture. The effect is proportionate to the barbarous cruelty of the punishment.

C.100 [245] p. 323
No comas celebre Torregiano (S) (Don't eat, great Torrigiano) – 1814-24 – 205 × 142 – S + I – No. (S) – No. add. 31 (Lp) – *Paper:* horizontal chain lines – Mounted on pink paper – *Hist.:* Javier Goya; Mariano Goya; Román Garreta → Museo de la Trinidad (5.4.1866) – Madrid, Prado (339) – GW 1336

This drawing was the subject of a detailed study by López-Rey (Bibl. 120, pp. 165-170), who rightly insisted on Goya's stay at Seville in 1796, where he spent a long time examining Torrigiano's famous statue of St. Jerome with his friend Ceán Bermúdez. Back in Madrid, he drew inspiration from it for his own painting of the saint (GW 716). So he must have learnt from Bermúdez all about how the Italian sculptor had died in prison at Seville, as related by Vasari in his *Vite*. Goya may have retained a clear recollection of that when he did the drawings of this series, but one must not forget that he went back to Seville at the end of 1817 to set up his picture of *Saint Justa and Saint Rufina* (GW 1569) in the sacristy of the cathedral. The idea of including Torrigiano among his victims of the Inquisition may have come to him on that second view of a sculpture he had so greatly admired over twenty years earlier. The caption is a direct allusion to Vasari's story that Torrigiano let himself die of hunger in his prison cell.

C.101 [246] p. 324
No se puede mirar (S) (One can't look) – 1814-24 – 205 × 142 – S + I – No. (S) – No. add. 30 (Lp) – *Paper:* horizontal chain lines – Mounted on pink paper – *Watermark:* C. – *Hist.:* Javier Goya; Mariano Goya; Román Garreta → Museo de la Trinidad (5.4.1866) – Madrid, Prado (336) – GW 1337

The atrocity of the torture is stressed by the intricate tangle of ropes and machines – perhaps a reminiscence of Piranesi, for we know that Goya had a collection of his engravings – to which this old man is shackled. His head bears a curious resemblance to St. Peter's. The diagonal composition, with the man's body stretched out full length, the importance of the hands clasped round a crucifix, and the strong modelling of head and clothing, make this drawing one of the finest in the whole of album C.

C.102 [247] p. 325
Pocas óras te faltan (S) (You've only a few hours left) – 1814-24 – 205 × 142 – S + I + P – No. (S) – No. add 29 (Lp) – *Paper:* horizontal chain lines – Mounted on pink paper – *Watermark:* C.I – *Hist.:* Javier Goya; Mariano Goya; Román Garreta → Museo de la Trinidad (5.4.1866) – Madrid, Prado (352) – GW 1338

This pallid woman who kneels with closed eyes still gripping a paper or pamphlet in her clenched hands does not seem to be chained. The only comfort Goya has to offer her is that death will soon bring release from her torments. The drawing gives an impression of being unfinished: the brushwork lacks firmness and some of the lines are unsteady. One is tempted to hazard the suggestion that they were added by a different hand.

C.103 [248] p. 326
Mejor es morir (S) (It's better to die) – 1814-24 – 205 × 142 – S + I – No. (S) – No. add. 28 (Lp) – *Paper:* horizontal chain lines – Mounted on pink paper – *Watermark:* very weak – *Hist.:* Javier Goya; Mariano Goya; Román Garreta → Museo de la Trinidad (5.4.1866) – Madrid, Prado (341) – GW 1339

This is one of the most powerful evocations of prison Goya ever drew. It should be compared with F.80 in the Metropolitan Museum, New York, which must have been done at about the same time. But here, as in virtually all the drawings of this album, the human figure dominates the scene. Tall, heavily shackled, bent under the superhuman effort enforced by the torture, it occupies the centre of the composition. The cell, with barred window, arched doorway and the deep shadows on the right, is a no less crushing burden than the heavy fetters on the man's feet. The combination of the two media stresses to the utmost the contrast between the dark and light areas (respectively in sepia and Indian ink) of the drawing.

C.104 [249] p. 327
Muchas viudas an llorado como tu (S) (Many widows have wept like you) – 1814-24 – 203 × 141 – S + I – No. (S) – No. add. 27 (Lp) – *Paper:* horizontal chain lines – Mounted on pink paper – *Watermark:* C.I – *Hist.:* Javier Goya; Mariano Goya; Román Garreta → Museo de la Trinidad (5.4.1866) – Madrid, Prado (254) – GW 1340

In this drawing Goya displays a degree of boldness that can only be explained by the fact that the albums were kept secret. There are others that attacked the Inquisition, but indirectly and never by name. Here, instead, he had no scruples about placing the arms of the Holy Office – crossed sword and olive branch – in full view over the doorway in the distance. In the foreground a woman, bowed down by grief, hides her face in her handkerchief, while her little daughter nestles against her, raising an arm towards her in a gesture of tender affection. The caption supplies the logical link between the mother and daughter and the "Santa", as it was called in Spain. The husband died behind those walls, leaving his poor widow alone with their child. But, as in C.91, to console her the artist insists on the host of victims who have been through the same thing. It is worth noting that the arms of the Inquisition were added in sepia at a later date. At present the centre area of the drawing is badly damaged.

C.105 [250] p. 328
Quien lo puede pensar! (S) (Who can think of it!) – 1814-24 – 205 × 142 – S + I – No. (S) – No. add. 26 (Lp) – *Paper:* horizontal chain lines – Mounted on pink paper – *Watermark:* C.I – *Hist.:* Javier Goya; Mariano Goya; Román Garreta → Museo de la Trinidad (5.4.1866) – Madrid, Prado (353) – GW 1341

This drawing is remarkable for its strength and sobriety. The young woman, condemned by her barbarous jailers to crouch bent double on her knees, gives the impression of being riveted to the wall of her cell by the huge chain attached to a ring above her head. Apart from two pools of shadow, on the figure itself and on the floor, the whole drawing is done with the brush tip, leaving the rest of the paper bare. The caption, no less concise than the composition, proclaims Goya's indignation at such horrible treatment.

C.106 [251] p. 329
No habras los ojos (S) (Don't open your eyes) – 1814-24 – 205 × 142 – S + I – No. (S) – No. add. 25 (Lp) – *Paper:* horizontal chain lines – *Hist.:* Javier Goya; Mariano Goya; Román Garreta → Museo de la Trinidad (5.4.1866) – Madrid, Prado (337) – GW 1342

Another young woman imprisoned after being brutalized, as proved by the marks on her face. She lies unconscious, her hands tied behind her back, on the heap of straw on which they dropped her – a white figure of innocence backed by the dark mass of the straw. Here, too, Goya converses with his "creature", and his plain words of comfort are like those a father would use to his child: "Don't open your eyes!"

Better darkness, even perhaps for ever, than the sight of this barbarous world.

C.107 [252] p. 330

el tiempo hablará (S) (Time will tell) – 1814-24 – 204 × 142 – S + I – No. (S) – No. add. 24 (Lp) – *Paper :* horizontal chain lines – Mounted on pink paper – *Watermark :* C.I (weak) – *Hist.:* Javier Goya; Mariano Goya; Román Garreta → Museo de la Trinidad (5.4.1866) – Madrid, Prado (340) – GW 1343

The intense effects of light and shade link this drawing to C.100 and C.103. The sheet is completely covered with a deep sepia wash over a light Indian ink base to render the dank darkness of the dungeon. The iron grating lets one guess at the maze of passageways and vaulted chambers beyond the weighty arched door, where the only sound is the executioners' heavy tread. The window provides the one patch of pallid light to break the darkness, but it is chequered by thick iron bars. In the centre, the towering figure of the prisoner is viewed close-up, violently illuminated by a light that has no source – symbolically stressing her youth and innocence.

C.108 [253] p. 331

Que crueldad (S) (What cruelty!) – 1814-24 – 205 × 142 – S + I – No. (S) – No. add. 23 (Lp) – *Paper :* horizontal chain lines – Mounted on pink paper – *Hist.:* Javier Goya; Mariano Goya; Román Garreta → Museo de la Trinidad (5.4.1866) – Madrid, Prado (334) – GW 1344

One of the most terrible visions Goya ever conjured up: a man tortured with ropes and winches till his body is reduced to a mass of misshapen limbs. By his side, two steps higher up, the Inquisitor's stool is vacant: he has accomplished his task. A big crucifix, like the one in C.51, towers behind the victim as witness to his tormentors' clear conscience – unless that by the dark veil of sepia wash masking it, Goya was hinting that Christ was not perhaps on the side one might think.

C.109 [254] p. 332

Zapata/tu gloria será eterna (S) (*Zapata*. Thy glory will be eternal) – 1814-24 – 204 × 144 – S + I – No. (S) – No. add. 41 (Lp) – *Paper :* horizontal chain lines – Mounted on pink paper – *Hist.:* Javier Goya; Mariano Goya; Román Garreta → Museo de la Trinidad (5.4.1866) – Madrid, Prado (351) – GW 1345

This is the third and last historical victim of the Inquisition (after Galileo and Torrigiano) included by Goya in his long list of those imprisoned or put to death. The caption says he was called Zapata. The name is written slightly higher up than the rest of the phrase. The writing, too, is different and might not be by the artist's own hand, notably because the Z of "Zapata" is entirely different from that of "Zaragoza" on C.87. It really seems as if the name was added later to the inscription, invoking an anonymous hero. Be that as it may, López-Rey (Bibl. 131, pp. 127-128) is probably quite right when he suggests that the Zapata referred to in the adjunct was Don Diego Martín Zapata, an eighteenth-century physician accused and condemned by the Inquisition for being favourable to Judaism. Quite apart from the problem of identifying the character portrayed, the chained figure wrapped in the black folds of his gown breathes a serenity and strength that we may seek in vain in the other drawings of this group.

C.111 [255] p. 333

No te aflijas (S) (Don't grieve) – 1814-24 – 205 × 143 – I + S – No. (S) – No. add. 22 (Lp) – *Paper :* horizontal chain lines – Mounted on pink paper – *Hist.:* Javier Goya; Mariano Goya; Román Garreta → Museo de la Trinidad (5.4.1866) – Madrid, Prado (349) – GW 1346

After the gap left by the missing C.110, here we have a prisoner who has given way to despair. Head in fettered hands, he leans against the squared stones of his dungeon. This latter lacks the sombre aspect of many others; indeed, on the whole it is quite bright but built up of odd structures that hem it in with their menacing bulk. What counts more is the tone of the caption which, like those of the next three drawings, points to a hope of release. Goya seems to have deliberately contrived a steady crescendo culminating in the explosion of joy of C.115, *Divina Libertad*.

C.112 [256] p. 334

Dispierta ynocente (S) (Wake up, innocent) – 1814-24 – 205 × 145 – S + I – No. (S) – No. add. 21 (Lp) – *Paper :* horizontal chain lines – Mounted on pink paper – *Hist.:* Javier Goya; Mariano Goya; Román Garreta → Museo de la Trinidad (5.4.1866) – Madrid, Prado (350) – GW 1347

This prisoner, prostrated or sound asleep on the flagged floor of his cell, forms a dark, barely human heap caught up in the geometric net of wall and floor. The distribution of the two washes is quite remarkable

– Indian ink for all the stone part, sepia for the man's body. What is more, the design is entirely inscribed in the rectangle of wash, giving the impression of a dark window cut in the white sheet of paper. This technique, current in the Madrid album – cf. for example B.81 and B.87 – is exceptional in this one. It is worth noting that the pink paper mount encroaches on the drawing and bears part of the stamp of the National Museum of Painting.

C.113 [257] p. 335

Ya bas á salir de penas (S) (You are going to escape from your sorrows) – 1814-24 – 205 × 142 – S + P – No. (S) – No. add. 20 (Lp) – *Paper:* horizontal chain lines (23 mm) – Mounted on pink paper – *Watermark:* C.I – *Hist.:* Javier Goya; Mariano Goya; Román Garreta → Museo de la Trinidad (5.4.1866) – Madrid, Prado (354) – GW 1348

This drawing was done entirely in sepia wash with a few pen strokes on the folds of the prisoner's dress. Goya has not dwelt on minute details. There are just the few brush strokes needed to define the figure seated on the ground; a quick dash of wash for the hair, under which the face is barely hinted; and particularly the dark smudge of the table against which the young woman leans, with the clearly drawn cross and water jug. This sinister severity is made up for by the good news announced in the caption.

C.114 [258] p. 336

Pronto seras libre (S) (You will soon be free) – 1814-24 – 205 × 144 – S + I – No. (S) – No. add. 19 (Lp) – *Paper:* horizontal chain lines (23 mm) – Mounted on pink paper – *Hist.:* Javier Goya; Mariano Goya; Román Garreta → Museo de la Trinidad (5.4.1866) – Madrid, Prado (355) – GW 1349

In the series of drawings beginning with C.93 we have lived through the long dark night of anguish and humiliation suffered by those who dwelt in the closed world of prison depicted here for the last time. These drawings and the ones that follow are not isolated images but, as I have already pointed out, form a deliberately contrived logical succession. The whole converges towards Liberty and Justice as symbolized by C.115, C.117 and C.118. Already in this drawing the rigour of the previous dungeons has disappeared. It is as if the prisoner, now treated in a more humane fashion, only awaits the last formalities before being released. There are no chains, no iron collar, no other sign of torture and anguish. The woman sits hunched up on a bench, seemingly buried in deepest thought. By her side are a pitcher of water and, a little further back, a spindle. Goya has placed the rustic implement there (cf. C.11) to signify that life has already recommenced and freedom is near at hand. It is also worth noting that the caption to this drawing is the only one in the entire prison series that contains the word *libre* (free), thus announcing the *Divina Libertad* of the next.

C.115 [259] p. 337

Divina Libertad (S) (Divine Liberty) – 1820-24 – 205 × 144 – S + I – No. (S) – No. add. 18 (Lp) – *Paper:* horizontal chain lines – Mounted on pink paper – *Watermark:* weak – *Hist.:* Javier Goya; Mariano Goya; Román Garreta → Museo de la Trinidad (5.4.1866) – Madrid, Prado (346) – GW 1350

Few of Goya's works express such explosive joy as this drawing. The man, dressed like a member of the middle class of about 1820, kneels not to pray but to welcome with a gesture of ecstasy Freedom, symbolized by shafts of sunlight. Flooding and illuminating his face and hands, they embody the divine essence of the Freedom so long awaited. An ink well and a sheet of paper on the ground suggest that the man is a writer for whom freedom of thought and expression is the indispensable condition of human dignity. But before 1824 that condition never existed in Spain except after the revolt captained by Rafael Riego in 1820, which led to the restoration of the liberal Constitution of 1812 and the establishment of the freedom of the press. Though he was seventy-two years old and had gone through an almost fatal illness at the end of 1819, Goya insisted on attending, for the last time, the meeting of the Academy on April 4, 1820, to take the oath to the Constitution. That historic act and the drawing we are discussing leave no doubt as to his opinions and the enthusiasm with which he hailed the new era he thought was dawning for Spain.

C.116 [260] p. 338

Dure la alegria (S) (May their joy last) – 1820-24 – 204 × 142 – S + I – No. (S) – No. add. 17 (Lp) – *Paper:* horizontal chain lines – Mounted on pink paper – *Hist.:* Javier Goya; Mariano Goya; Román Garreta → Museo de la Trinidad (5.4.1866) – Madrid, Prado (356) – GW 1351

This drawing was not published by López-Rey. The place I ascribed to it in my catalogue of 1970 was confirmed by the discovery of the number masked by

the mount. But its interpretation in relation to the adjacent sheets is no easy matter. Goya obviously wanted to give this group of drawings a symbolic value and a logical continuity. So in my view there can be no doubt whatsoever that it represents merely a commonplace drinking bout in a tavern. One should, however, look for a political meaning. I offer two suggestions. First, the gay crowd are drinking to an aristocratic (or middle-class) couple, symbolizing the social reconciliation at the dawn of the new liberal regime. Second, given the extremely dignified bearing of the woman dressed all in white and the entirely different posture of the man huddled on his chair, it represents the common people drinking at the same table as King Ferdinand VII, forced by the pressure of events to swear an oath to the Constitution, in the presence of that Constitution personified by the female figure seated at some distance from him and occupying an important place in the composition. In either case the caption expresses Goya's wish that their joy may last, not unclouded by a touch of scepticism. I would point out that the grinning, grimacing faces in this drawing recall some details of the *Black Paintings,* notably in *The Pilgrimage of San Isidro* (GW, pp. 316-317), executed about the same time.

C.117 [261] p. 339
LUX EX TENEBRIS (Lp) (Light out of the darkness) – 1820-24 – 205 × 143 – I + S – No. (S) – No. add. 16 (Lp) – *Paper:* horizontal chain lines – Mounted on pink paper – *Hist.:* Javier Goya; Mariano Goya; Román Garreta → Museo de la Trinidad (5.4.1866) – Madrid, Prado (347) – GW 1352

In this allegorical drawing of the constitutional period, the beaming young woman Goya was so partial to (cf. *Disasters of War 79, 80* and *81*) symbolizes at once Freedom, Truth, as in those plates of the *Disasters,* and Justice – three ideals indissolubly linked in the artist's eyes. In this case they are apparently united and embodied by the book, representing the Constitution, which she bears like a precious relic in her hands. It will be recalled that Ferdinand VII under the pressure of events had been forced to swear an oath to the Constitution on March 9, 1820, and that Goya had done the same, but with immense joy, at the Academy of San Fernando on April 4. In this composition the dazzling light radiated by the girl and the book rises like a new sun over a Spain just emerging from the night of obscurantism and tyranny. The title in classical Latin is written in capital letters at the bottom of the sheet like an inscription engraved on a monument. It

stresses the solemnity with which Goya wanted to honour that historic event.

C.118 [262] p. 340
1820-24 – 205 × 142 – I + S – No. (S) – No. add. 15 (Lp) – *Paper:* horizontal chain lines – *Hist.:* Javier Goya; Mariano Goya; Román Garreta → Museo de la Trinidad (5.4.1866) – Madrid, Prado (345) – GW 1353

This is the only drawing in this album on which Goya did not write an inscription in his own hand but left the allegory to speak for itself. So in my view it is an abuse to do what Sánchez Cantón (Bibl. 173, No. 381) did, namely invent a caption in Goya's style, no matter how pertinent it may be, just where the artist himself thought well to abstain from doing so. The vision of the scales of Justice in perfect balance through a bright gap in the cloudy sky is another allusion to the new era that was beginning in 1820. As López-Rey (Bibl. 131, p. 133) sensibly observed, the scene is treated like a Last Judgment. "The time has come at last," Goya seems to think. And we see on the left the just rejoicing in their well-deserved share of the light while the wicked on the right flee or draw back in terror. Among the latter, the black figure of a priest stands out in the foreground turning his back on the vision with a gesture of disapproval.

C.119 [263] p. 341
Ya hace mucho tiempo q.e som.s conoci-/-dos (I) (We've been known for a long time) – 1820-24 – 205 × 142 – I + S – No. (I) – No. add. 14 (Lp) – *Paper:* horizontal chain lines – Mounted on pink paper – *Hist.:* Javier Goya; Mariano Goya; Román Garreta → Museo de la Trinidad (5.4.1866) – Madrid, Prado (358) – GW 1354

This drawing is the first of an important sequence devoted to the monastic life viewed from two different angles. Up to and including C.126, the tone is overtly satirical, sometimes violently so; from there on, to the penultimate sheet of the album, C.131, comes a group of monks and nuns discarding their habits. Here several cowled monks approach with their hands deep in their wide sleeves, as if to keep them warm. They are seemingly humble and preoccupied only with God, but Goya ironically observes: "We've been known for a long time."

C.120 [264] p. 342
No sabras/lo q.e llebas a/quest/as (?) (I) (Will you never know what you're carrying on your back?) – 1820-24 – 200 × 142 – I + S – No. (I) – No. add. 2 (Lp) – *Paper:* horizontal

chain lines – Pasted on white paper – *Hist.*: Javier Goya; Mariano Goya; Román Garreta → Museo de la Trinidad (5.4.1866) – Madrid, Prado (361) – GW 1355

López-Rey classified this drawing in the group of monks and nuns discarding their habits (Bibl. 131, p. 136), where it was clearly out of place. Actually, it bears the number 120 (not 128, as one might possibly have surmised before the publication of the Hispanic Society of America's drawing) and finds its logical position among the satirical subjects of the first group. In fact, though the caption is not easy to decipher, Goya obviously aimed a shaft at the glaring disparity between the wealth of the monastic orders and the indigence of the Spanish peasantry. Here a ragged peasant hacks with might and main at the soil into which he is sinking, while a florid-looking friar eats comfortably perched on his back and watches him at work.

C.121 [265] p. 343

Busca un medico (S) (She's looking for a doctor) – 1820-24 – 205 × 143 – I + S – No. (I?) – No. add. 13 (Lp) – *Paper:* horizontal chain lines – Mounted on pink paper – *Hist.:* Javier Goya; Mariano Goya; Román Garreta → Museo de la Trinidad (5.4.1866) – Madrid, Prado (363) – GW 1356

On this sheet, heavily washed with sepia and Indian ink, the monk's face and hand picked out by the strong light before the dark wall contrast with the sombre, anonymous figure of the woman silhouetted against the brightness of an arched doorway or open window. The scene, probably a confession, would be quite commonplace were it not for the caustic caption barely visible in the shadows above the monk's head. It is the typical reflection of a liberal denouncing the credulity of the many people, particularly women, who are ready to entrust not only their soul but also their body to their confessor.

C.122 [266] p. 344

Divina Razon (I)/ *No deges ninguno* (S) (Divine Reason. Don't spare one of them) – 1820-24 – 205 × 143 – I + S – No. (S) – No. add. 12 (Lp) – *Paper:* horizontal chain lines – Mounted on pink paper – *Hist.:* Javier Goya; Mariano Goya; Román Garreta → Museo de la Trinidad (5.4.1866) – Madrid, Prado (409) – GW 1357

This allegorical composition combines Goya's figuration of Truth, a young woman dressed in white and crowned with leaves, with the scales of Justice. The former already appeared, haloed with light, in the

drawing C.117 and the famous *Caprichos enfáticos* (the last three plates of the *Disasters of War 79, 80* and *81*). The latter occurs in the drawing C.118 we have already discussed. Symbolizing Truth and Justice, the young woman brandishes a whip to drive away a flock of black birds, no doubt ravens. As a rule in Goya's *œuvre,* like the flying creatures of the night, they represent the forces of ignorance, intolerance and oppression. Here, however, in the context of the other drawings devoted to monks, it is quite clear that Goya intended to show Truth attacking the monastic orders. The caption, written at two different moments – the words *No deges ninguno* were apparently added later – refers to the suppression of a great many convents at the beginning of the liberal period and voices quite openly its author's thought. On the subject of this drawing see the commentary by López-Rey (Bibl. 131, pp. 133-134), and the important study by E. W. Palm (Bibl. 152, pp. 337-340).

C.123 [267] p. 345

¿Que quiere este fantasmon? (S) (What does this great phantom want?) – 1820-24 – 205 × 143 – S + I – No. (S) – No. add. 11 (Lp) – *Paper:* horizontal chain lines – Mounted on pink paper – *Hist.:* Javier Goya; Mariano Goya; Román Garreta → Museo de la Trinidad (5.4.1866) – Madrid, Prado (357) – GW 1358

The bitter irony that pervades this image makes it at once violent and impressive. The nocturnal vision of a monk with dazzling white habit and ashen face is the phantom of the "Black Spain" fought by the liberals, one of the evil "birds" of the previous drawing that Goya wished to see Truth drive out for ever.

C.124 [268] p. 346

¿Q.ᵉ trabajo es ese? (I) (What sort of work is that?) – 1820-24 – 205 × 143 – S + I – No. (S) – No. add. 10 (Lp) – *Paper:* horizontal chain lines – Mounted on pink paper – *Watermark:* C.I – *Hist.:* Javier Goya; Mariano Goya; Román Garreta → Museo de la Trinidad (5.4.1866) – Madrid, Prado (359) – GW 1359

This monolithic figure standing alone in the middle of the white page is the essential target of Goya's shafts. His head covered with the cowl, his hands thrust deep into his sleeves, an expression of humble foolishness on his shadowy features, this Capuchin is the very image of a certain form of religious life: the form that in the 18th century Goya's enlightened friends and later the liberals – the two were often identical –

always censured with the utmost vigour. And always for the same reason, voiced in the forceful caption: "What sort of work is that?" We have already more than once come across the same *leitmotif* that work is beneficial and restorative for the individual, vital for society: cf. C.1, C.8, C.11, C.22, and others in this album, and most of the drawings in album D. It is worth noting that this sheet and the next have never before been reproduced in their entirety. This led López-Rey to believe, mistakenly, that the artist had aimed at achieving an exceptional effect (Bibl. 131, p. 135).

C.125 [269] p. 347

¿Cuantas baras? (S) (How many yards?) – 1820-24 – 205 × 143 – S + I – No. (S) – No. add. 9 (Lp) – *Paper:* horizontal chain lines – Mounted on pink paper – *Hist.:* Javier Goya; Mariano Goya; Román Garreta → Museo de la Trinidad (5.4.1866) – Madrid, Prado (362) – GW 1360

This is the last drawing directed against the monks. As in the two we have just seen, the caption is a harsh question, shot like an arrow at Goya's favourite quarry. The artist has made a sport of him by multiplying beyond all verisimilitude the folds of the robe in which he is draped. Against a very dark background composed of two coats of wash, sepia and Indian ink, the massive silhouette stands out, violently lit, from the top of the bald pate to the hem of the impressive drapery that sweeps the ground. The excessive opulence of the robe is intended to symbolize the provocative wealth of the religious orders in the poverty-stricken Spain of that day. But I cannot agree with López-Rey (Bibl. 131, p. 135) when he suggests that the caption had a double meaning because the Spanish word *vara* can also designate the lance used by the picador in the bull ring and, by inference, the lance wounds inflicted on the bull.

C.126 [270] p. 348

Sin camisa, son felices (I) (Shirtless and happy) – 1820-24 – 205 × 145 – S + I – No. (I) – No. add. 8 (Lp) – *Paper:* horizontal chain lines – Mounted on pink paper – *Watermark:* C.I – *Hist.:* Javier Goya; Mariano Goya; Román Garreta → Museo de la Trinidad (5.4.1866) – Madrid, Prado (360) – GW 1361

This drawing opens the last series of album C. It, too, is devoted to monks and nuns, but they are now forced by the secularization laws to divest themselves of their habits. The captions have a totally different

tone: most display sympathy, some even a warmer feeling. After his ruthless attacks on the monks' ostentation of useless wealth, Goya now suddenly finds himself face to face with a touching human situation. To close the convents was an easy matter and one of the things that the liberals wanted. But what was to be done afterwards with all those unfrocked men and women? What sort of life could those outcasts expect in a society of which many had no knowledge at all? Here we have a particularly difficult case: Goya good-humouredly remarks that these white-bearded old monks are happy without a shirt. Off they go, pack on back, bent and lost in thought. But what is their destiny, what their destination?

C.127 [271] p. 349

Se desnuda p.ª siempre (Lp) (He gets undressed for good) – 1814-24 (?) – 206 × 144 – I + S – No. (I) – No. add. 7 (Lp) – *Paper:* horizontal chain lines – Mounted on pink paper – *Watermark:* C.I – *Hist.:* Javier Goya; Mariano Goya; Román Garreta → Museo de la Trinidad (5.4.1866) – Madrid, Prado (371) – GW 1362

In this drawing and the next four we are shown the slightly unseemly spectacle of monks and nuns divesting themselves of their habits. The five scenes – up to and including C.131 – were done almost entirely in Indian ink, as were their numbers, and the captions written in pencil. Previously these techniques occurred only in the first half of the album, from C.26 to C.56. But what strikes one most is the stylistic resemblance with some of the last-mentioned drawings, where the figures are considerably smaller relatively to the sheet of paper (see, for example, C.30, C.31 and C.34). A typical feature of this scene is the contrast between the whiteness of the secular clothes the monk is putting on and the dark skin of his face, the only part of his body that had ever seen the sun.

C.128 [272] p. 350

Tiene prisa de ecapar (Lp) (She's in a hurry to escape) – 1810-24 – 202 × 142 – I – No. (I) – No. add. on back 43 – *Paper:* horizontal chain lines – Mounted on pink paper – *Watermark:* C.I – *Hist.:* Javier Goya; Mariano Goya; Román Garreta; Federico de Madrazo; R. de Madrazo y Garreta; A. M. Huntington (1913) – New York, Hispanic Society of America (A.3318) – GW 1363

Goya has deliberately given this young nun a touch of coquetry as, with her pretty face still framed by the coif, she removes her stockings after letting her coarse woollen habit fall to the ground. One might suppose

that she had not taken her vows with any great fervour and was impatient to return to the "world" and its pleasures. In Goya's times a scene of this sort was considered doubly improper because it concerned a woman and, what is more, a nun.

C.129 [273] p. 351

Tambien lo dejan estas (Lp) (These also take it off) – 1810-24 – 205 × 145 – I + S – No. (I) – No. add. 5 (Lp) – *Paper*: horizontal chain lines – Mounted on pink paper – *Watermark*: C.I – *Hist.*: Javier Goya; Mariano Goya; Román Garreta → Museo de la Trinidad (5.4.1866) – Madrid, Prado (374) – GW 1364

Two nuns discard their habits; the one in the foreground is pulling off her heavy robe of coarse wool, whose hood still covers her head. The dark mass of the nun's dress gathered about her shoulders contrasts with the white shift that forms a bright patch in the centre of the composition. Further back the other nun has knelt down to fold with religious care the habit she has just discarded; she would seem to be already dressed to leave the convent.

C.130 [274] p. 352

Lo cuelga ravioso (Lp) (He hangs it up in a rage) – 1810-24 – 205 × 145 – I – No. (I) – No. add. 4 (Lp) – *Paper*: Javier Goya; Mariano Goya; Román Garreta → Museo de la Trinidad (5.4.1866) – Madrid, Prado (372) – GW 1365

Of all the monks and nuns in this group of drawings this lusty friar is the only one to show anger. His frock, no longer of any use to him, hangs on a line looking like some ridiculous scarecrow, while he twists his body this way and that in an effort to put on clothes with which he has lost all familiarity. The dark areas of wash, notably the broad patch of shadow on the ground, contrast with the light that falls on the head and shoulders of the monk, whose ample tonsure provides clear proof of his veritable calling. A first sketch for a head can be seen above the monk's.

C.131 [275] p. 353

Esta lo deja pensativa (Lp) (This one takes it off pensively) – 1810-24 – 206 × 146 – I + S – No. (S?) – No. add. 3 (Lp) – *Paper*: horizontal chain lines – Mounted on pink paper – *Watermark*: C.I – *Hist.*: Javier Goya; Mariano Goya; Román Garreta → Museo de la Trinidad (5.4.1866) – Madrid, Prado (373) – GW 1366

The monks and nuns depicted in the last four drawings in the act of leaving their convent display different feelings. This one is the saddest of them all. As in C.129, Goya's brush has caught the nun at the instant when her dark gown is falling to the ground, revealing the white shift underneath. Neither impatience nor coquetry are expressed by her face and downcast eyes, but only the sadness of a nun at a loss to comprehend a measure that has wrecked her life. One can just make out, in the background, a low chest that occupies the whole width of the sheet and that bears, to the left, a pious picture.

C.133 [276] p. 354

Todo lo desprecia (S) (She despises everything) – 1820-24 – 205 × 146 – I + S – No. (I) – No. add. 1 (Lp) – *Paper*: horizontal chain lines – Mounted on pink paper – *Watermark*: C.II – *Hist.*: Javier Goya; Mariano Goya; Román Garreta → Museo de la Trinidad (5.4.1866) – Madrid, Prado (418) – GW 1367

This last drawing of album C has no connection with any of those that went before. Indeed, it is separated from them by the gap left by the missing No. 132. Incidentally, this composition reverts to the large figures that appear to be a typical feature of the last period of this album (1814-24). The strange scene is very hard to interpret. Did Goya intend to portray a sort of witch averting her face in disgust from the image she sees in the looking-glass? The crown on her head cannot conceal the pair of huge donkey's ears. Her thin, flaccid body, completely naked, is in full light; the glass instead is dim. And two curious animals, resembling hogs or big black tapirs, are apt attendants on such ugliness. An image of vanity and decay to close the album, if indeed this drawing is actually the last.

Sepia Album (F)

Introduction

Unlike album C, which is characterized by the variety of the techniques employed, album F is remarkable for its homogeneity. Without exception, the 88 surviving sheets, out of a probable total of 106 (the highest number known at present), are all executed in brush and sepia wash. The autograph numbers are also written in sepia, usually with a brush, occasionally with a pen: in no case have they been written over or changed. The sheets were numbered consecutively with no afterthoughts or subsequent corrections, such as occur so frequently in album C. And yet this extensive series is by no means made up of disparate or unconnected subjects which Goya could have aligned and numbered from 1 to 106 as he produced them. The existence of internal sequences, as coherent as those in album C, proves on the contrary how concerned he was to develop certain themes, without ever hesitating over the order of the drawings in which he treated them. More will be said presently about these different groups of subjects. Here it need only be noted that, from the outset, their existence heightens the impression of spontaneity produced by this album.

In another, more surprising respect, the unity of this series is striking: except in three specific cases, commented on in the entries, all the drawings are untitled. There is no further trace of that monologue which Goya had kept up in his captions at the bottom of the sheets and whose tone had gradually risen to that of reprimand, inquiry or indignant exclamation. All at once, with this album in sepia wash, his voice falls silent and the pictures alone remain, expressing, purely in terms of line and wash, the complex world of the artist's innermost thoughts. But one may wonder whether Goya really intended his album to be captionless or whether, for some reason unknown to us, he renounced his intention of writing them in, once the drawings had been numbered and ordered, following the procedure which we have described in connection with album C. The question is really one of pure form, for needless to say we have no way of answering it. Yet it seems to me worth raising, because we meet with the same problem in connection with the last album drawn in Bordeaux, and in that case, as we shall see, there are reasons for entertaining serious doubts.

We would once more emphasize the unity of album F as regards the style of the drawings. Numerically, this series is the second in importance of all Goya's albums, always taking into account the highest number known for each series; and yet from the first sheets to the last, numbered 106, there is a great similarity in the execution and composition of the subjects. Throughout the album, the figures playing the leading part in the scene are given about the same proportions, and at no point is it possible to single out any particular sign which, as in album C, would justify us in speaking of a change of style in mid-course. A single detail, but one of technique rather than style, may be noted: the early drawings in the album offer several examples of a sepia so strong that it almost blots out the subject under an opaque area of wash which, in some cases, has eaten into the paper. See in particular F.6, F.8, F.9, F.10 (lower left), F.13, F.18, F.19 and F.20. One has the impression that Goya had not yet mastered the sepia medium; it betrayed him as soon as he attempted to get those powerful chiaroscuro effects of which he was fond. (The same observation holds good for certain drawings in the latter half of album C, like C.60, C.73, C.76, C.79, C.82, C.96, C.97, C.104, etc.) At a later stage, the artist overcame this failing, and in compositions like F.33, F.35, F.40 and F.52 even the heaviest areas of wash are shaded off harmoniously.

Does the homogeneity of album F mean that it was produced in a relatively short period of time? For none of the albums made up between 1800 and 1824 is it possible, we repeat, to fix any precise date-limits; those which we have indicated are only reasonable estimations of the time-span in which this or that album may have taken shape. For this particular album the dating 1812-23 does not mean that Goya worked on it for eleven years. Indeed, I would say that the core of the series may be assigned to about 1815-20, only a few sheets being executed before or after those dates. For we have a certain number of sure points of reference which justify this dating; it was already proposed by H. B. Wehle (Bibl. 186, p. 12) and roughly corresponds to the only exact chronological evidence provided by Carderera for the Fortuny album (Bibl. 84).

First of all, as has often been pointed out, drawing F.12 in the duelling sequence served as a preliminary study for the lithograph *Old style duel* (GW 1644), an impression of which in the Paul Lefort collection bore the autograph inscription "Madrid, Marzo 1819" (Madrid, March 1819). H. B. Wehle (ibid.) has also pointed out the significant connection between F.51 and *The forge* (GW p. 244) in the Frick collection, New York, whose dating oscillates between 1812 and 1818. Other connections, too, can be detected: several drawings in album F recall plates in the *Disasters of War* recording events in the terrible famine winter of 1811-12 (which is not to say that either these drawings or the prints were executed at the time). F.1, for example, is very close to *Disaster 52: No llegan a tiempo* (They do not arrive in time), and the group F.21 to F.23 pictures the poverty and degradation which Spaniards experienced during the War of Independence. As Wehle has pointed out (ibid.), F.45 takes up the allegory, dear to Goya, of the young woman clad in white and emitting rays of light: a symbol of Truth and Justice which appears in the last plates of the *Disasters of War 79, 80* and *82*), dating to 1815-20, and also in drawing C.117, significantly entitled *LUX EX TENEBRIS*. Other subjects suggest further dates: the building site in F.46, which may have some connection with the work begun on the Madrid opera house in 1818; and the wounded man in F.52?, who is apparently clad in the uniform worn during the War of Independence. As regards F.57 and F.83, they represent strange savages who recall the no less strange series of paintings of 1808-14 (GW 922 to 927). Were these various scenes inspired by the same story Goya had heard or the same book he had read? F.83 in particular seems to show a missionary brought before the mitred chief of a tribe; if so, the subject of the two pictures in the Besançon museum (GW 922 and 923) might have to be reconsidered. Finally, I would call attention to the curious drawing F.42 whose circular composition invites comparison with two pictures in the Academy of San Fernando, datable to 1812-19, the *Burial of the sardine* (GW p. 2) and the *Bullfight in a village* (GW p. 240); it has been studied by Xavier de Salas from a new stylistic angle (Bibl. 159, pp. 4-5). Whatever the margin of approximation that must be allowed for in the relations between these works, the period 1815-20 is seen to stand out as the central time-span of this album, a few sheets, as we have seen, having perhaps been executed before or after those dates.

Javier Goya broke up album F and extracted four large lots of drawings from it. The first, sold to Román Garreta, comprised at least twenty-four drawings. Of these, twenty-two were acquired by the Museo de la Trinidad in 1866 and from there entered the Prado in 1872; two others remained in the family until 1913, when Román Garreta's nephew Raimundo de Madrazo sold them to Archer M. Huntington (Hispanic Society of America).

The other three lots were numbered by Javier Goya (see general introduction). The first, composed of twenty-nine sheets, formed part of the Fortuny album sold in 1935 to the Metropolitan Museum in New York; the second and third, comprising thirty-five sheets, were among the 106 drawings (120 with the versos) sold and dispersed in Paris in 1877. But the make-up of these four lots calls for one remark: while the latter three were chosen from throughout the album, the first consisted essentially of twenty-two sheets all taken from the beginning, together with two others sold to Carderera and now in the Biblioteca Nacional in Madrid (F.3 or 5? and F.25?). The highest number in this lot being 28, one may infer that the missing sheets also formed part either of the Garreta or of the Carderera collection. It would appear that Javier Goya considered these drawings to be second-best; he did not take the trouble to number them with a fine pen as he did the other three lots, which do in fact contain some of Goya's finest drawings.

The first systematic catalogue of this album was compiled by H. B. Wehle who, in publishing the drawings of the Fortuny album, did not limit himself to the twenty-nine sheets in the Metropolitan Museum, but drew up a far fuller list (Bibl. 186, pp. 14-16) including sheets from the Prado, the Biblioteca Nacional in Madrid, the Berlin Museum, the Clementi collection in Rome and the Barnes Foundation at Merion, Pa. – forty-nine items in all, one of which (No. 84, p. 15) does not belong to this album (C.84 in the Prado). A few years later I published the twenty-two drawings in the Prado (Bibl. 135), extending the catalogue of this album to sixty

Fragment of F.I *Fragment of F.II* *Fragment of F.III*

items. But, when it came to reconstructing the album, both of us came up against the same difficulty as with the black border album: tracing the sheets dispersed at the 1877 sale. Wehle catalogued only three (F.39, 79 and 91), and a fourth very indefinitely under the title "Huntsman with a dog", which I take to be F.106. All the others were slowly identified piecemeal up to the publication in 1970 (Bibl. 97) of the 88 drawings known at present. Thanks to the catalogue of the 1877 sale (Bibl. 34 and 99), we now know, too, the approximate subjects of ten "phantom sheets", thus accounting for 98 drawings out of an estimated total of 106.

With respect to subject matter, here are the four most homogeneous sequences to be found in this album: F.10 to F.15, old style duelling; F.30 to F.32, the Casa de Campo; F.36 to F.39, riding a mule; F.97 to F.106, hunting. All the rest, the bulk of the album, consists of a great variety of scenes with no very evident connection between them. Beggars, monks, peasants, prisoners, workmen, murderers, dancers, grotesque old men, acrobats, soldiers, savages, young women and children – a whole world of vivid and colourful figures passes before our eyes in no particular order. One is surprised, however, to find no witches or flying figures as in the previous albums. All the subjects here are realistic and profoundly human. None of the figures represented assume the character of "freaks" or "cases", as in the first half of album C, for example. In this album, moreover, Goya much prefers groups of figures to those isolated individuals which account for most of the sheets in C, D and E; to take album C as an instance, two-thirds of the sheets are found to contain a single figure, whereas more than half the sheets in album F represent groups or even crowds of figures, as in those extraordinary drawings F.30, 31, 42, 44 and 46. The novelty extends to the scenes, which give the impression of taking place in the open air, in nature, as in the duels (F.10 to F.15), but above all in F.30, 31, 32, 39, 71, 72 and several hunting scenes at the end (F.98, 102, 103 and 105). One thinks of the parallel style of certain pictures, like the *Burial of the sardine,* the *Bullfight in a village, Making gunpowder in the sierra* and *Making shot in the sierra* (GW 980 and 981), and *Young women with a letter* (GW p. 243), all datable to about 1812-20. Such works perhaps reflect his desire to escape from the city, a desire realized in 1819 when he purchased the Quinta del Sordo close by the Casa de Campo, on the edge of that great wilderness of the *meseta* which stretches into the distance, out to the blue line of the Guadarrama.

Paper: White laid paper, Spanish mark PAULAR. Horizontal chain lines 23 to 25 mm apart.

Watermark: Three types of watermark occur, the first two being the upper and lower half of the same mark:

F.I: leaf-like ornament surmounted by a cross (width 47 mm);

F.II: ornament surrounding an M and ending in a heart (width 47 mm, height 41 mm);

F.III: the name PAVLAR in full or curtailed (width 65 mm, height of the letters 10 mm).

These watermarks are sometimes plainly visible, even in reproductions, as for example F.I on F.56, F.II on F.102 and F.III on F.27.

Maximum sheet size: 209 × 149 mm.

Drawing: Recto only.

Technique: Executed entirely in sepia wash, with a few touches of Indian ink and occasional pen strokes.

Captions: Nearly all the drawings are devoid of captions, which occur in only three cases: F.16, F.38 and F.86, where they are written at the top of the sheet, the two latter being fairly long.

Goya's numbers: Usually in brush and sepia wash. A few drawings have autograph numbers written with a pen (F.15, F.16, F.65, F.81, F.82 and F.92). The highest number is 106; the number of sheets catalogued is 88.

Additional numbers:

1. *Javier Goya's numbering:* numbers carefully written with a fine pen.

Fortuny album: in the upper right corner, usually followed by a full stop.

Album I sold in Paris in 1877: in the upper right corner, underscored with a curving stroke of the pen and usually followed by a full stop (16 drawings identified, 14 bearing numbers written with a fine pen).

Album II sold in Paris in 1877: at the top centre of the sheet, usually followed by a full stop, as in the Fortuny album (9 sheets identified, 8 bearing numbers written with a fine pen). Total of the drawings from album F sold in 1877: 25 identified plus 10 "phantom sheets".

2. *Román Garreta's numbering:* numbers in lead pencil in the lower right corner on the 22 drawings in the Prado.

BIBLIOGRAPHY

Exhibitions: 2, 4, 7, 8, 10, 12, 13, 14, 19, 20, 22, 23, 26, 27.

Public sales: 34, 36, 42, 47, 48, 49, 53, 55, 61, 68.

Authors: 77, 84, 93, 97, 99, 113, 132, 135, 136, 145, 159, 169, 173, 184, 186.

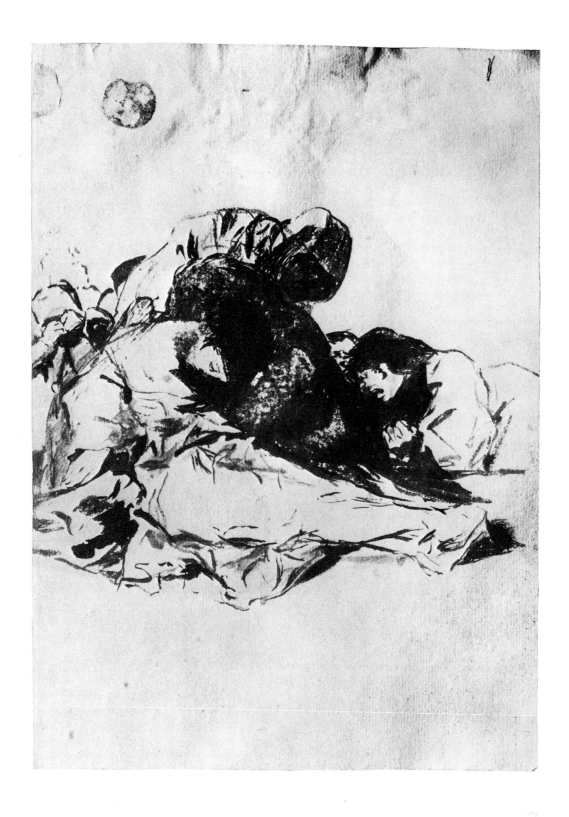

7

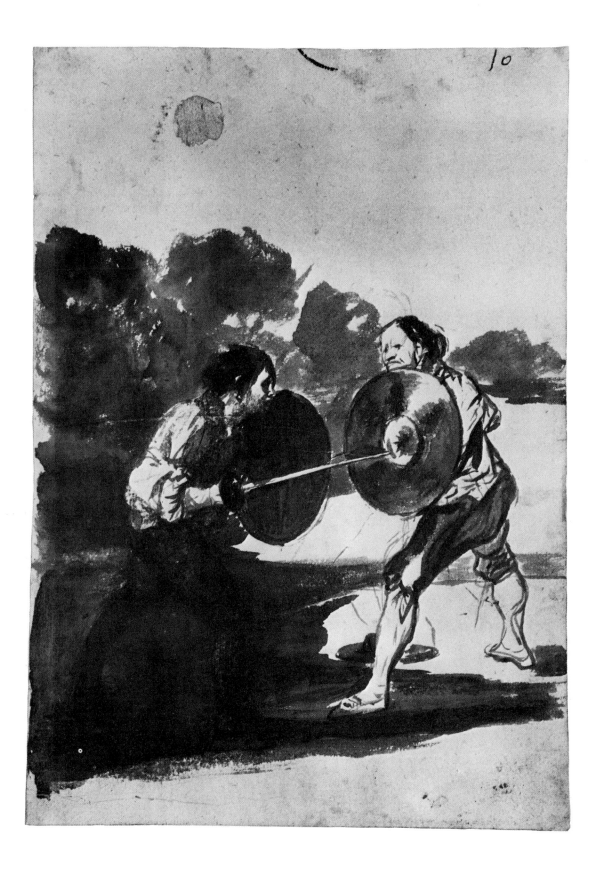

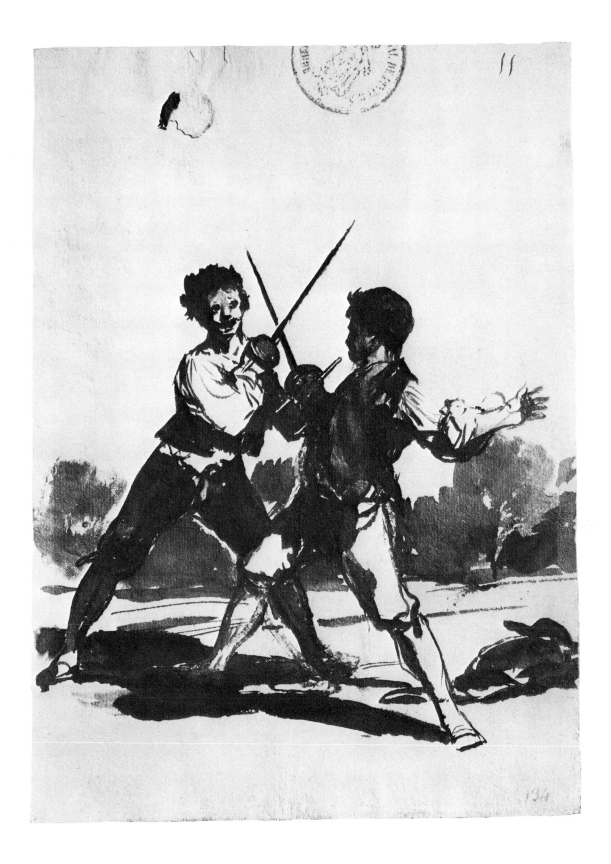

12

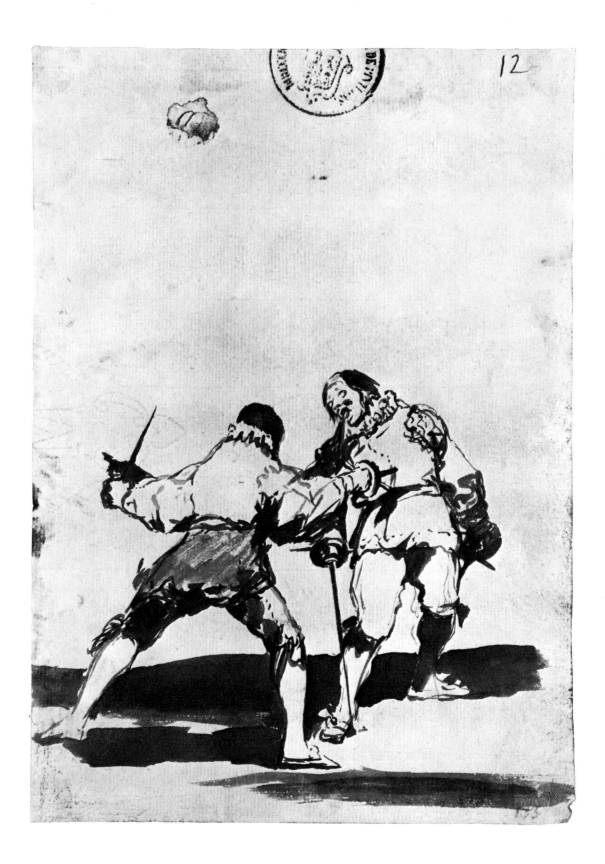

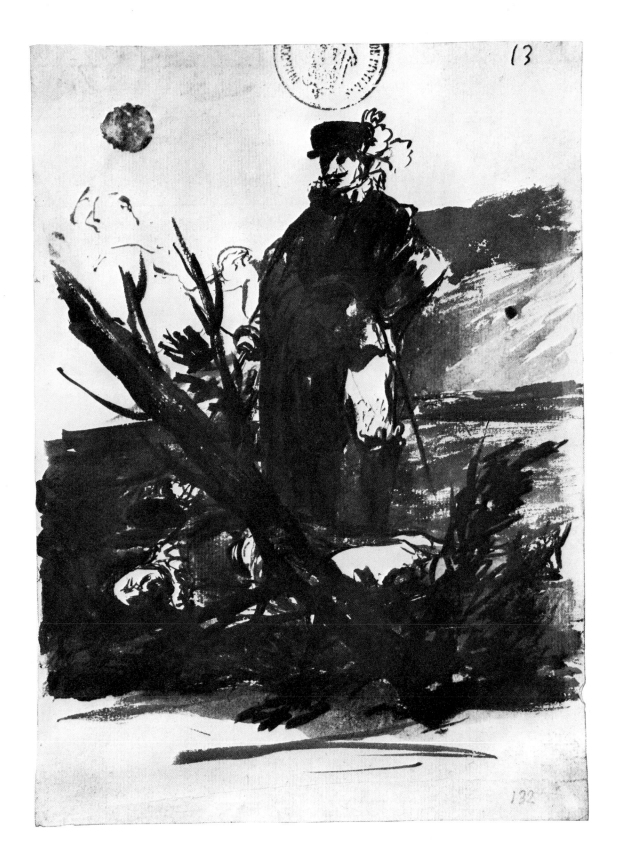

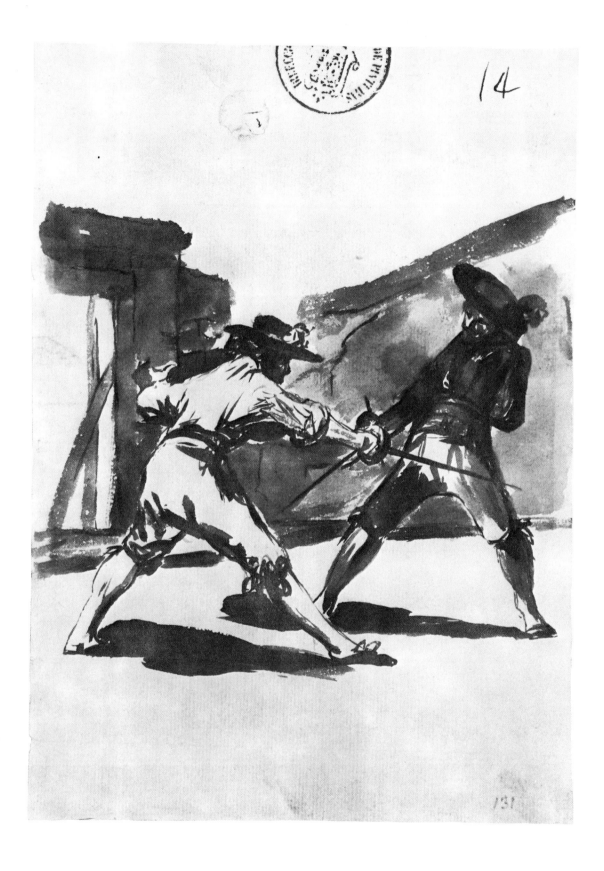

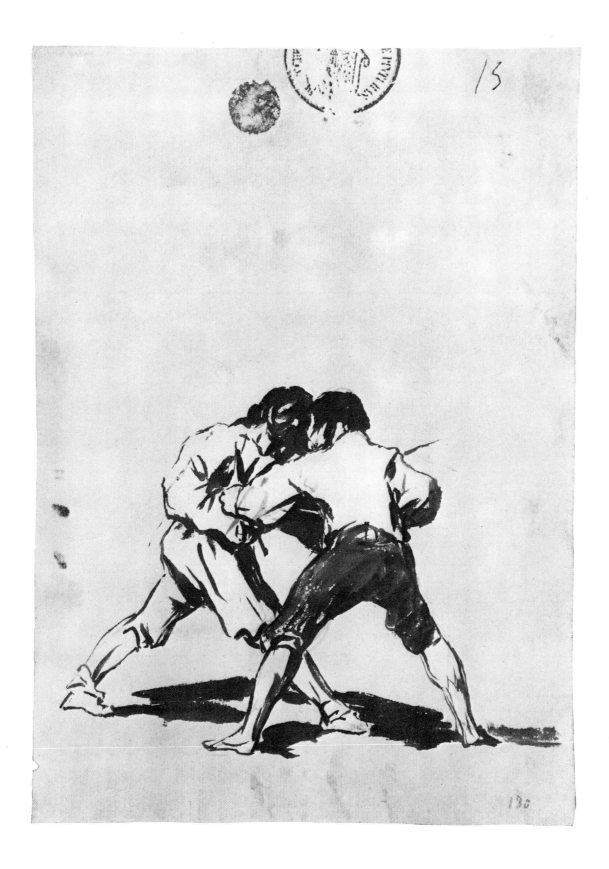

122

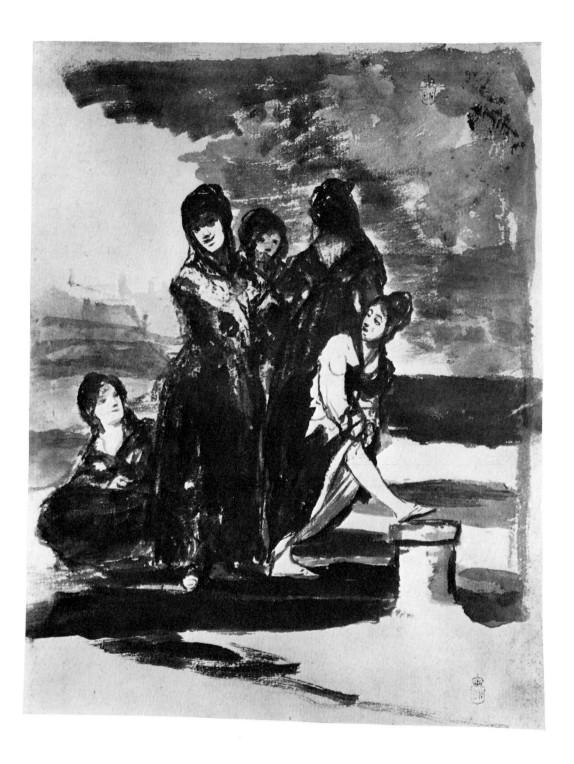

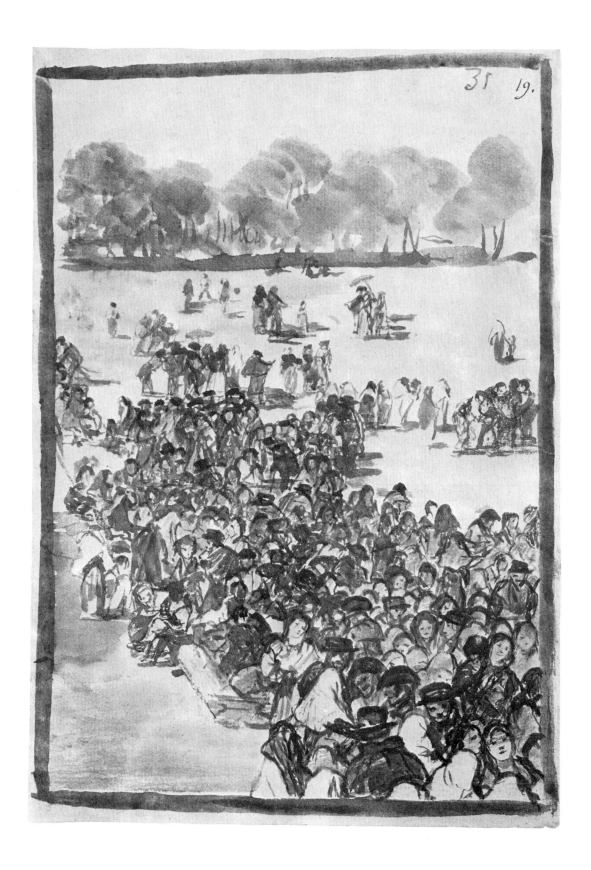

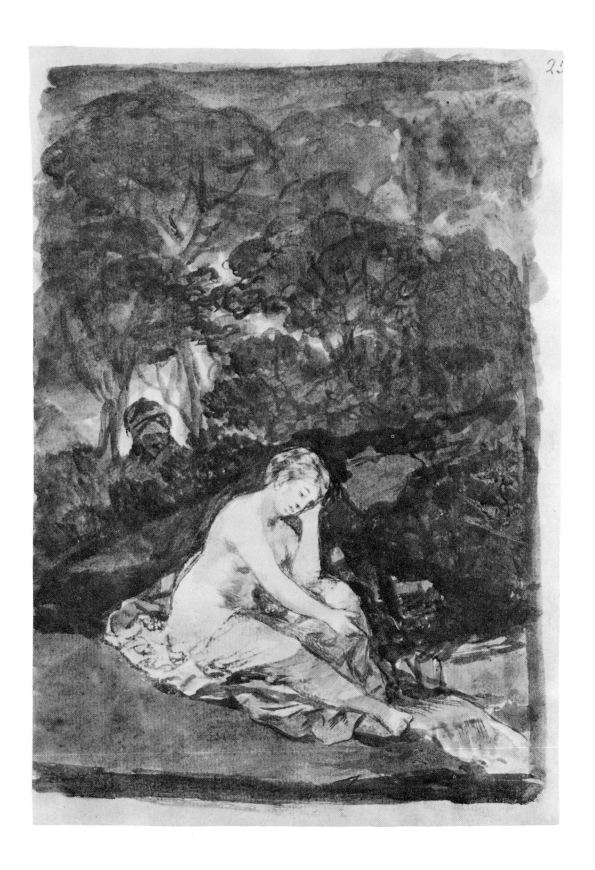

33 20

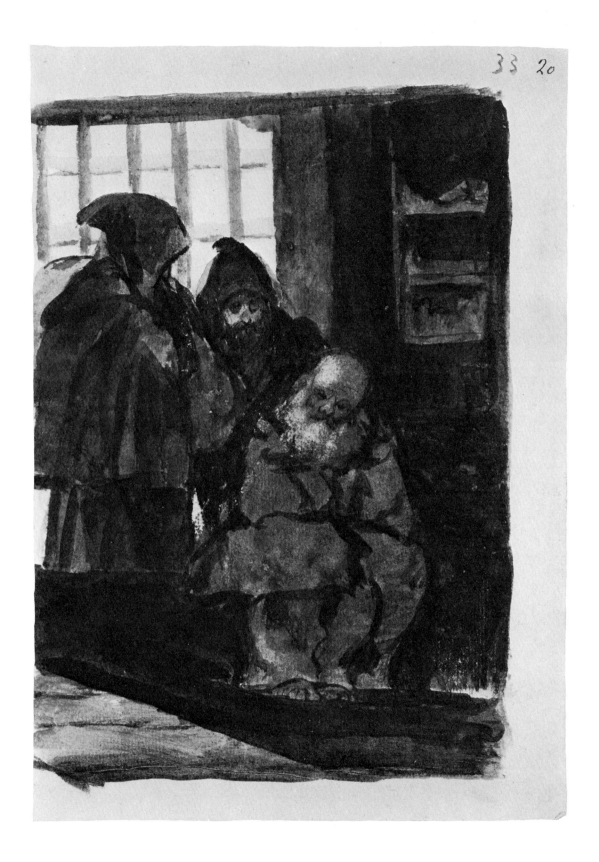

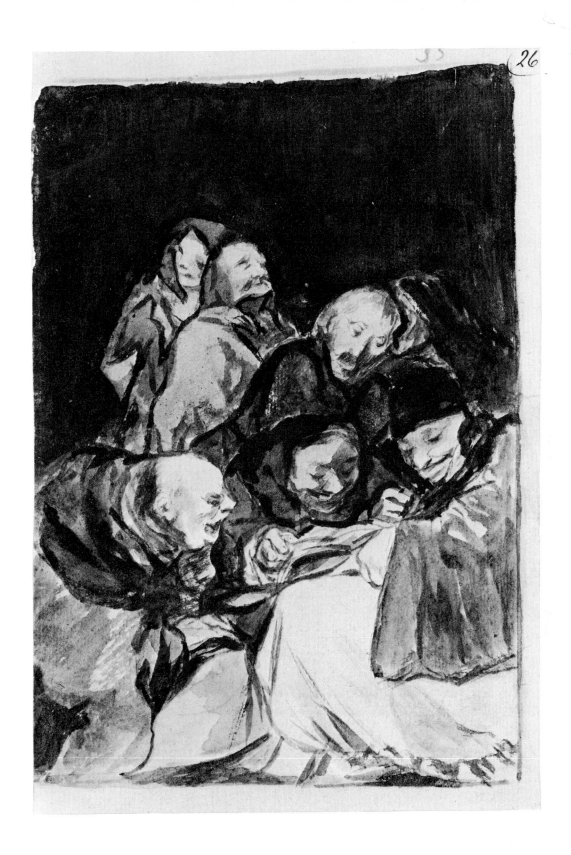

27.

41 28.

42

29.

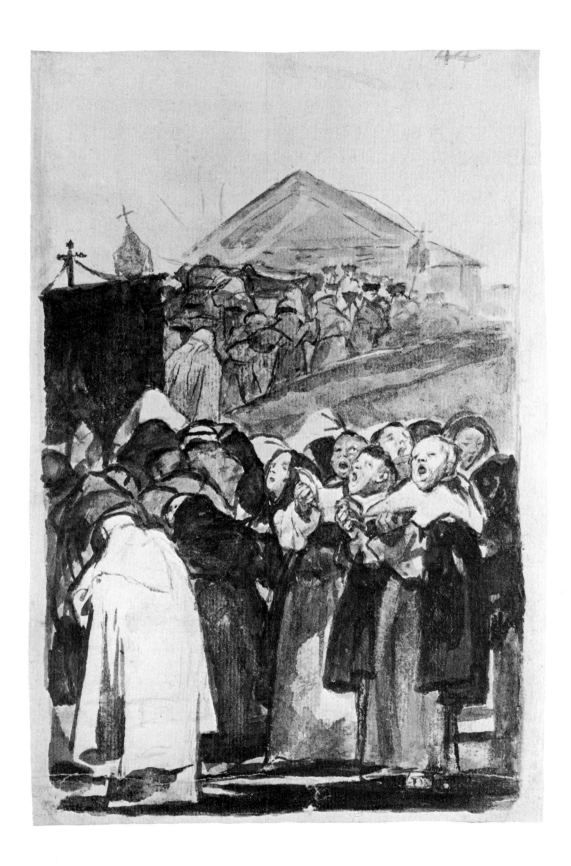

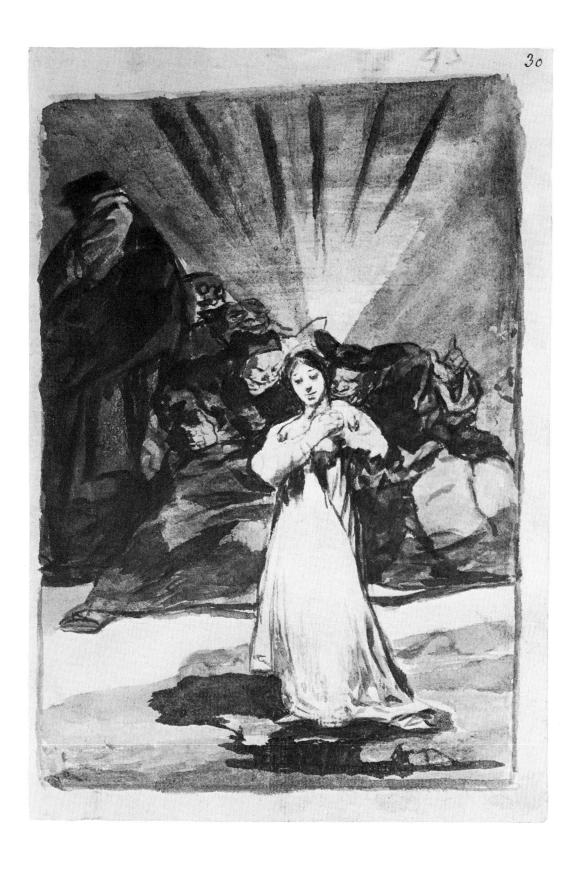

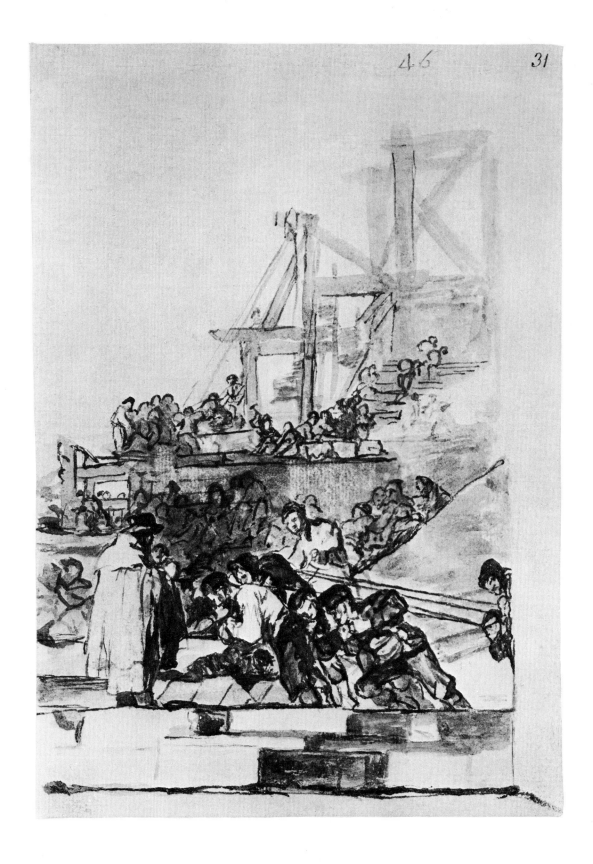

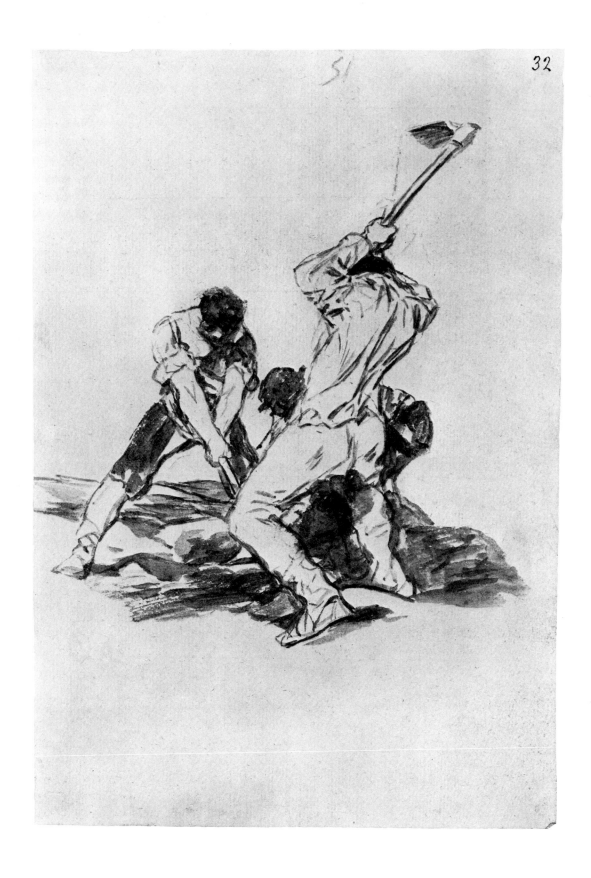

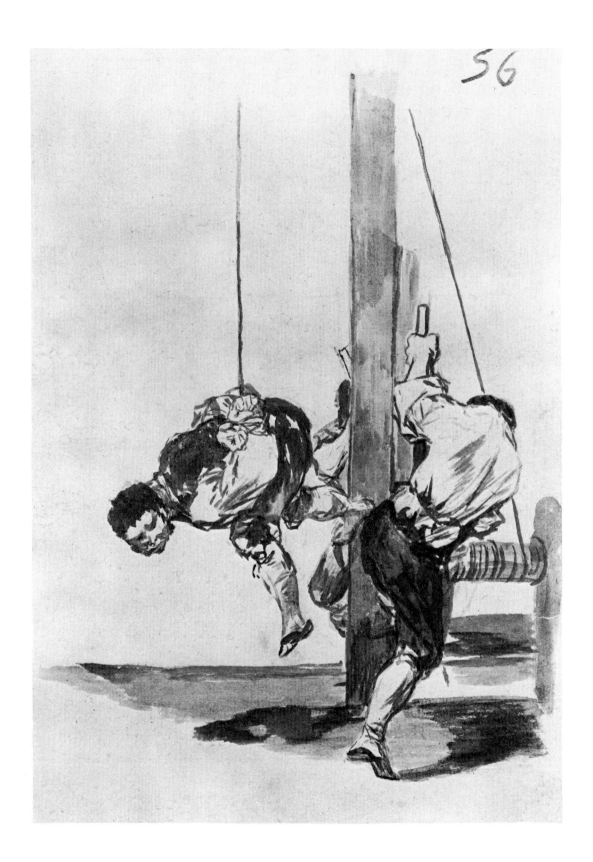

14.

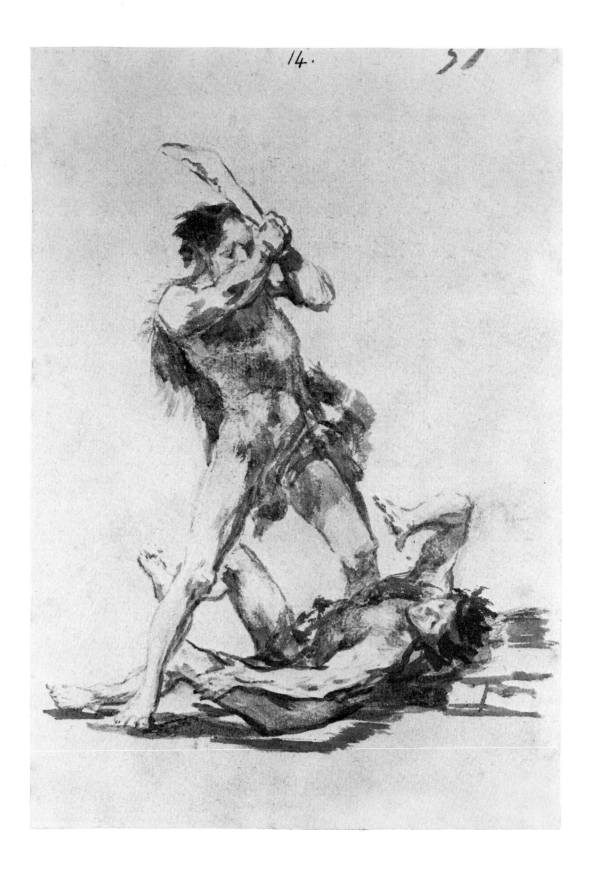

31

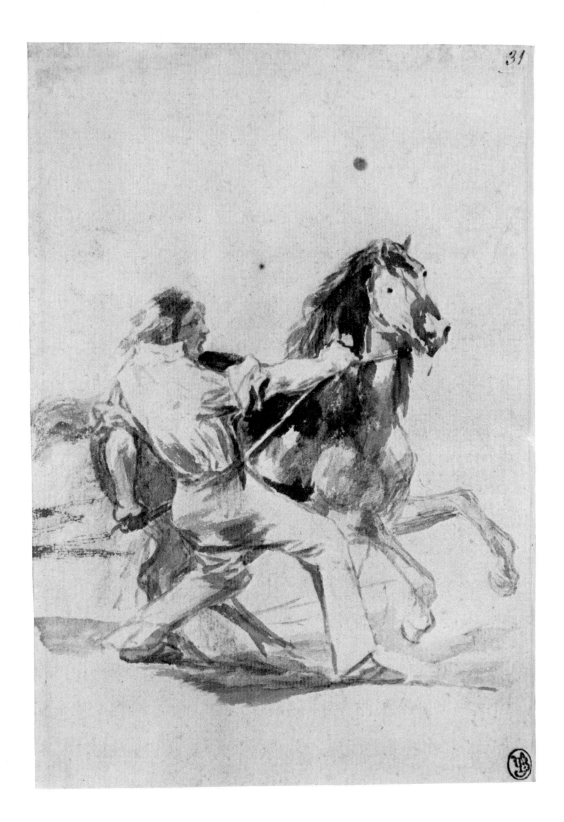

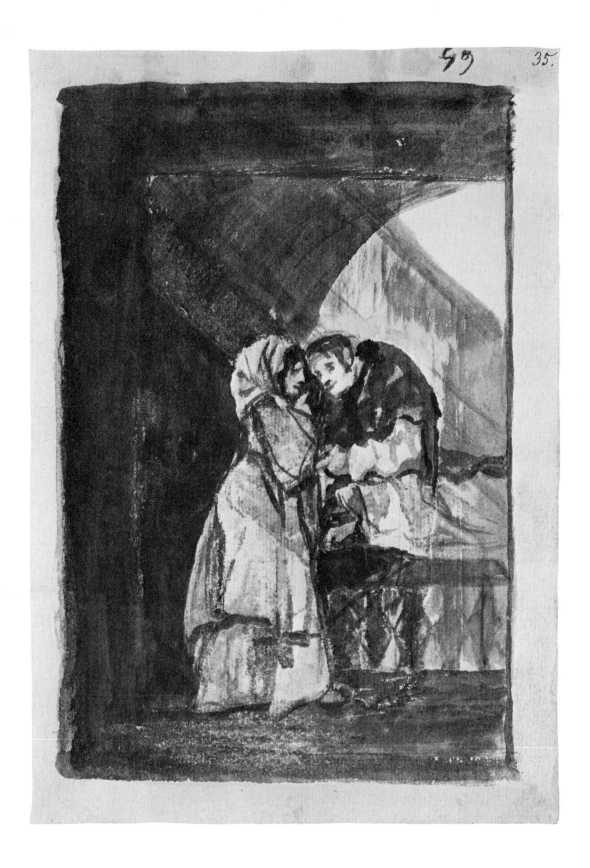

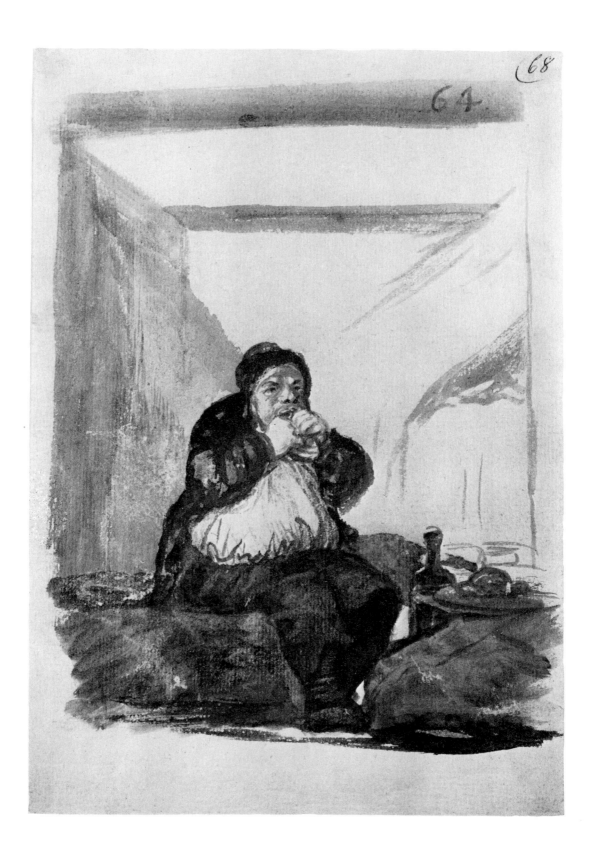

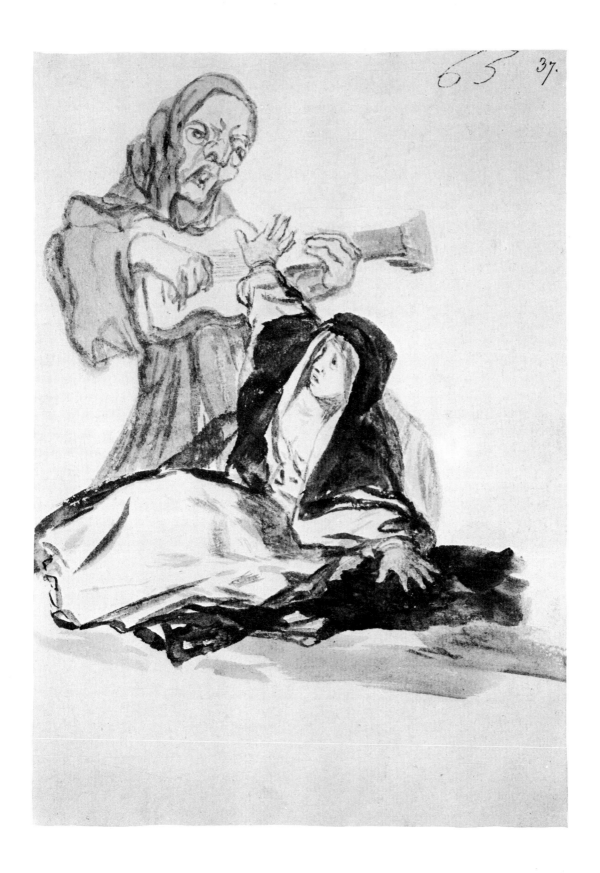

67 38.

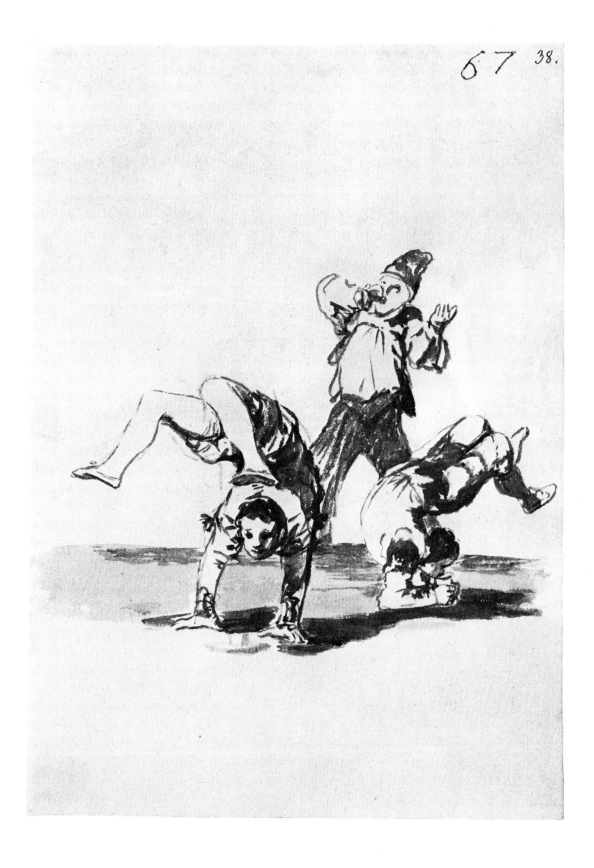

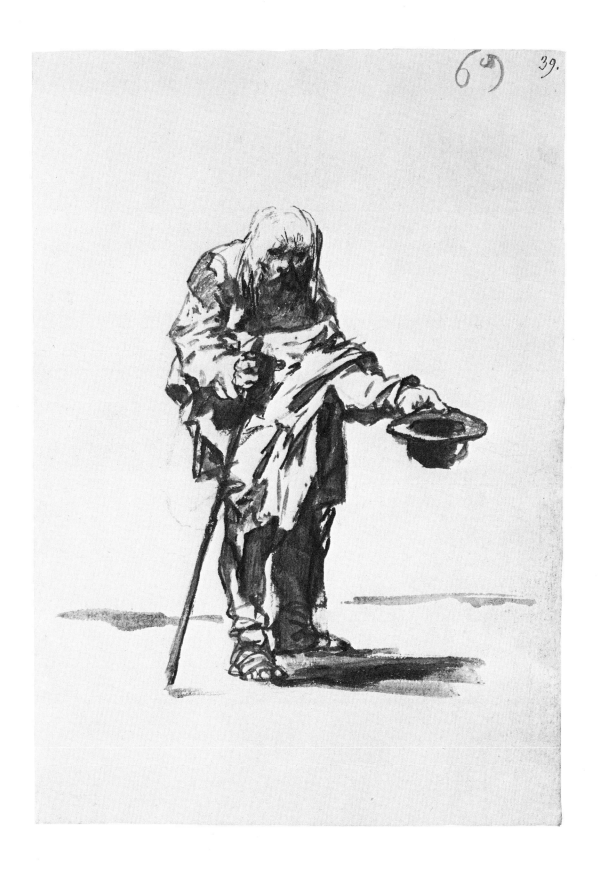

70

40.

16.

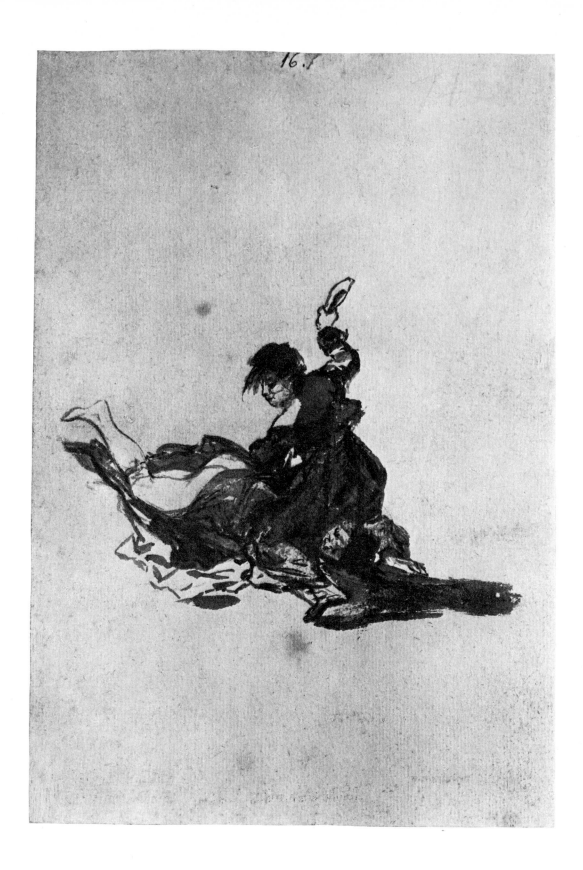

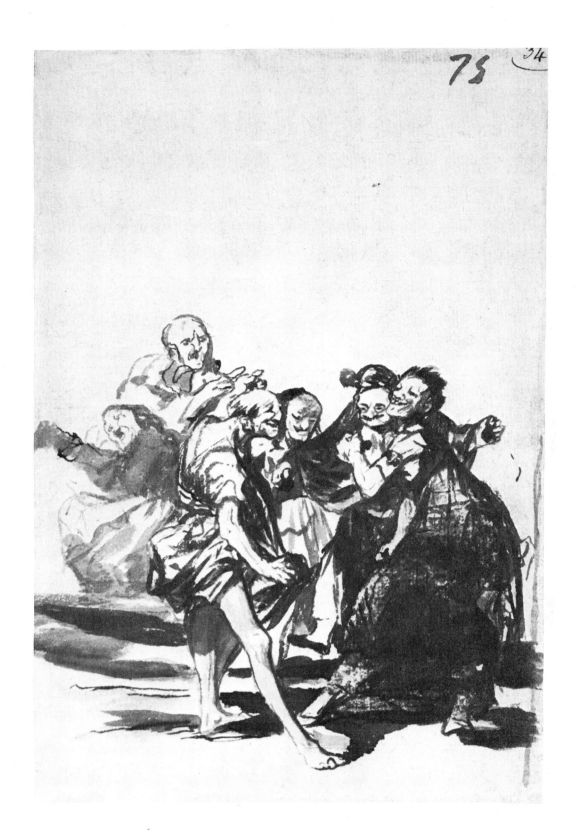

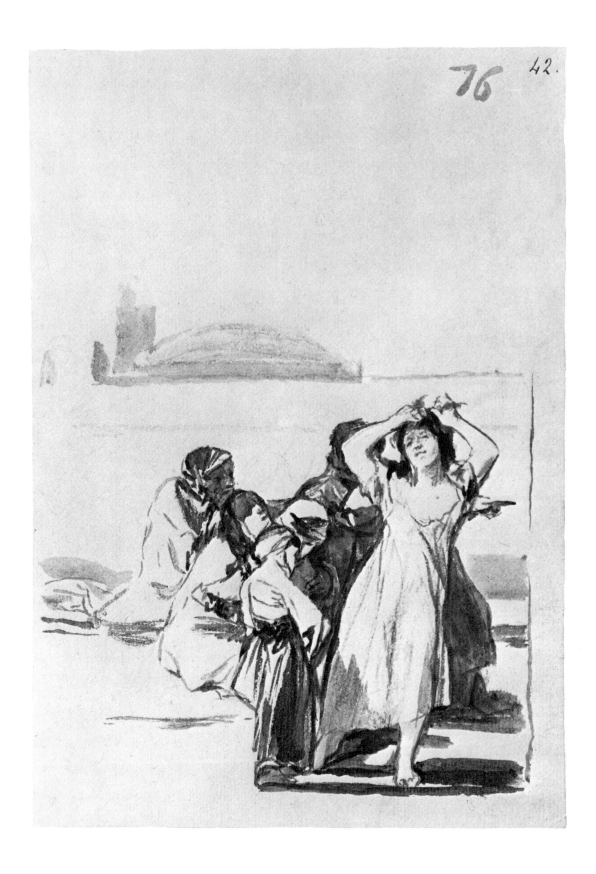

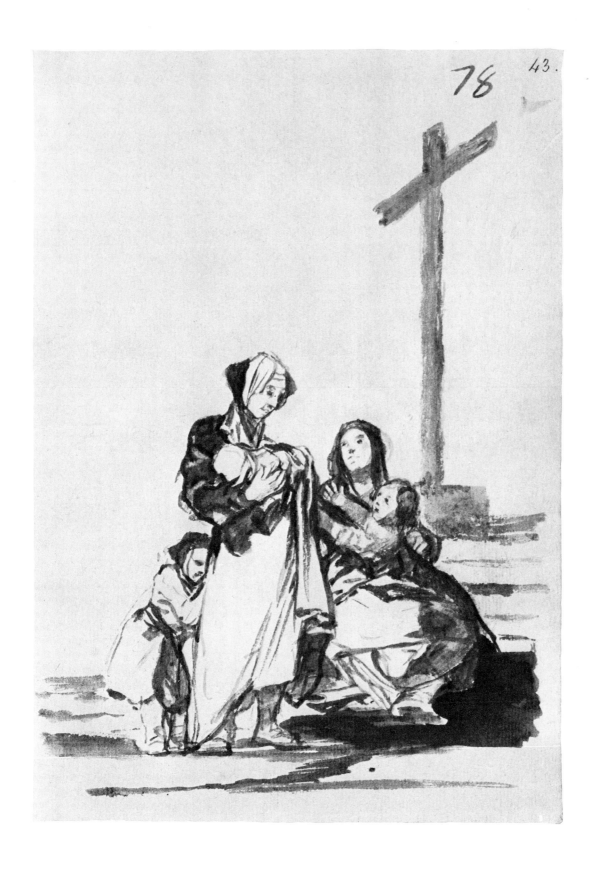

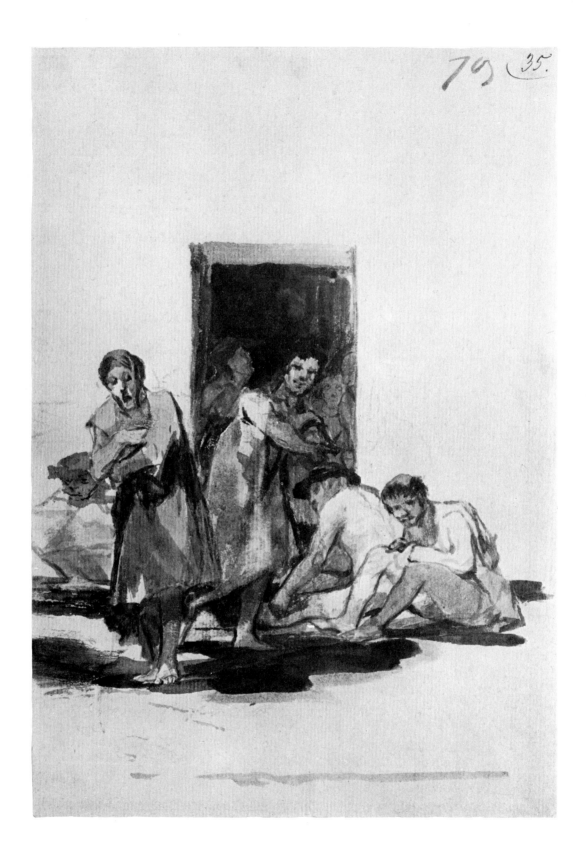

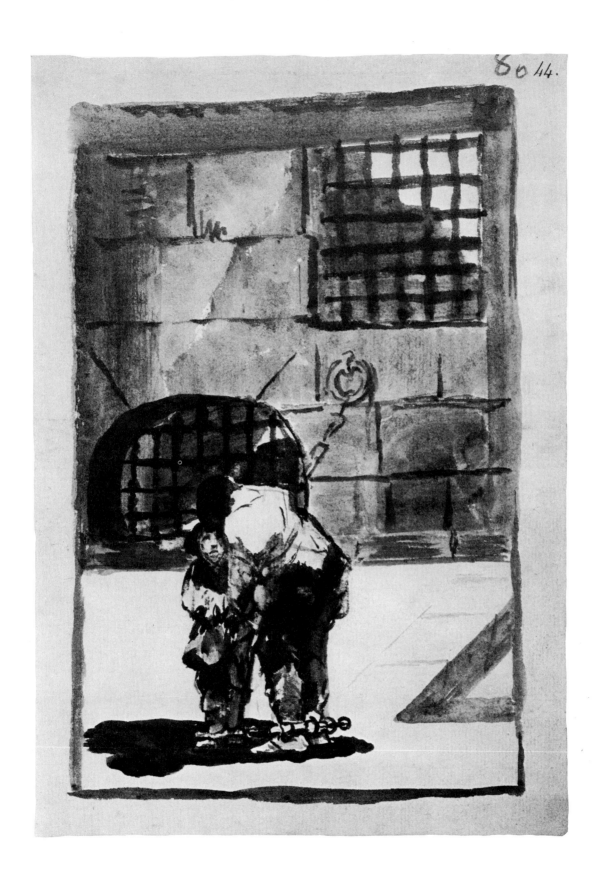

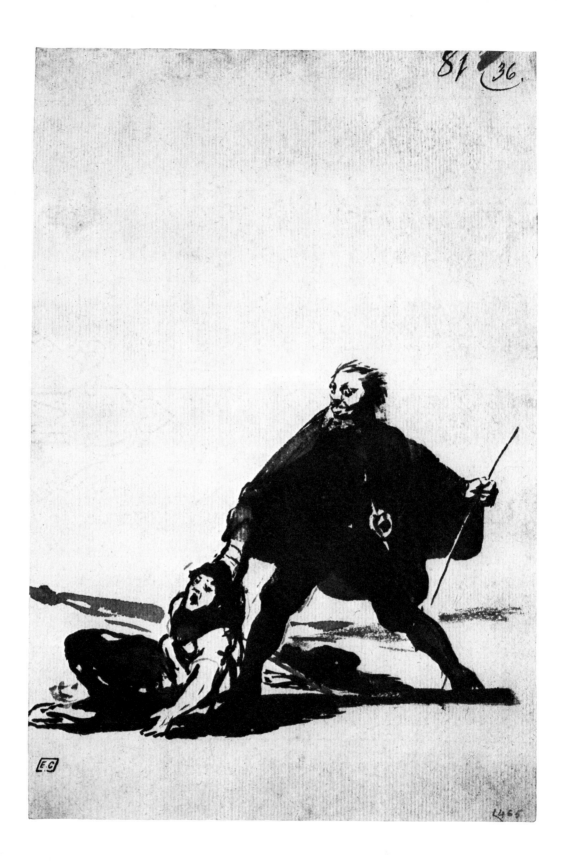

82 45.

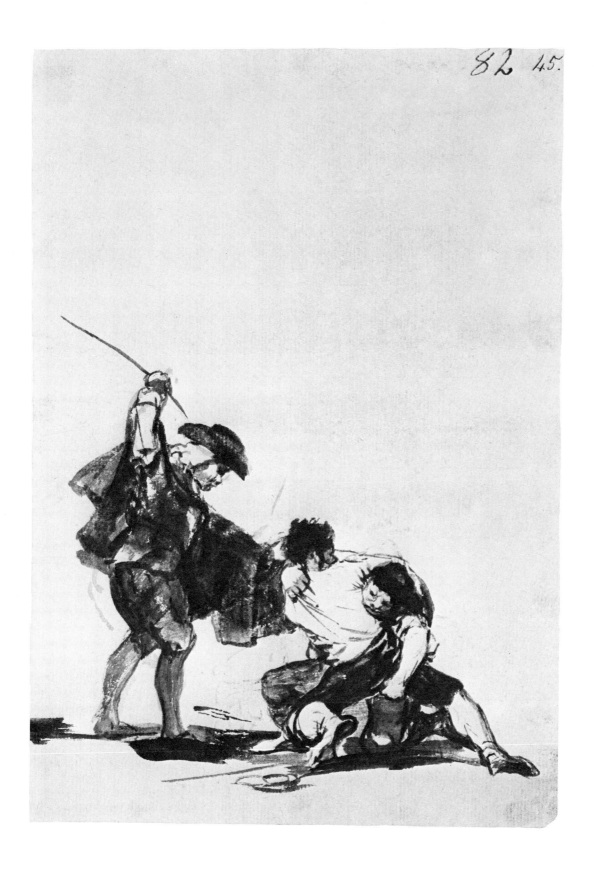

49.

Muerte del Alguacil Lampiño, por per
seguidor de estudiantes, y mugeres de fortuna,
las q.e le hecharon una labatiba con cal viva

87 46.

89 47.

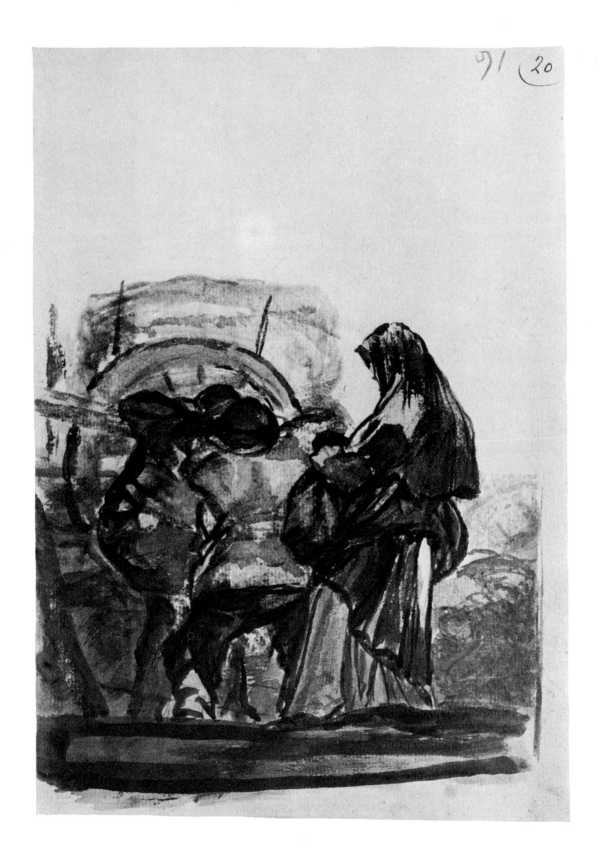

Le portefaix

94 69

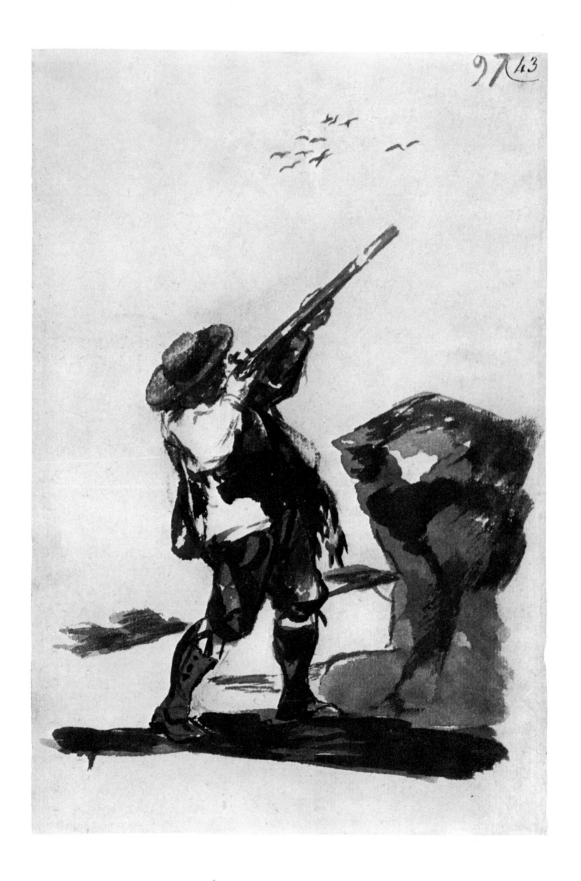

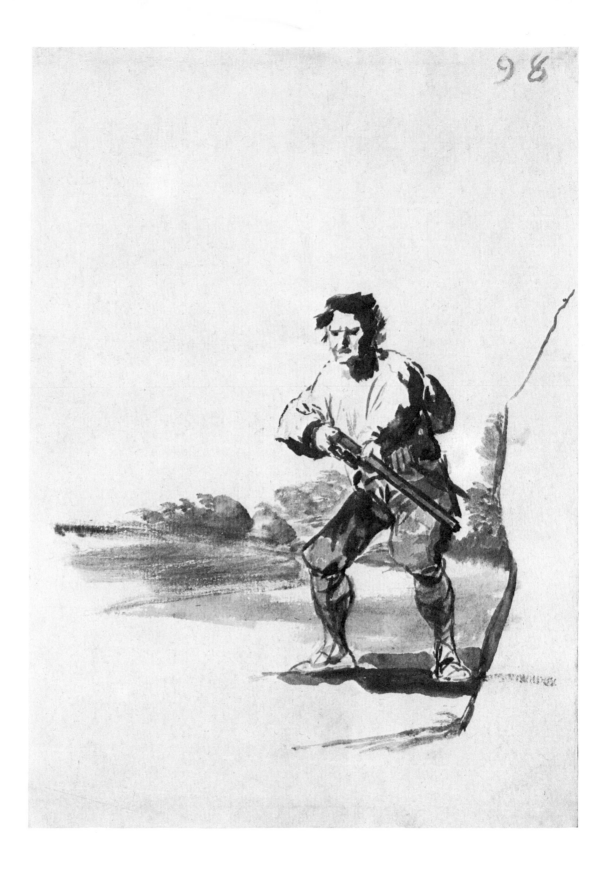

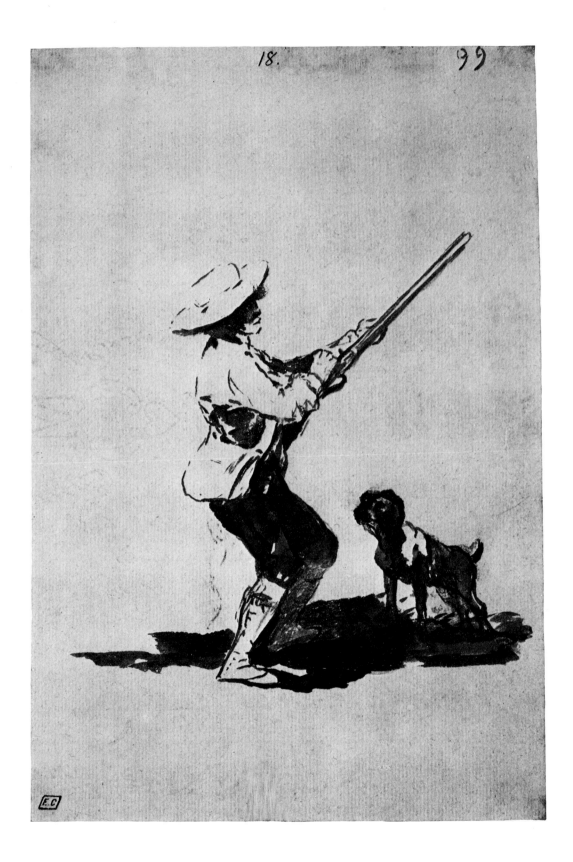

100

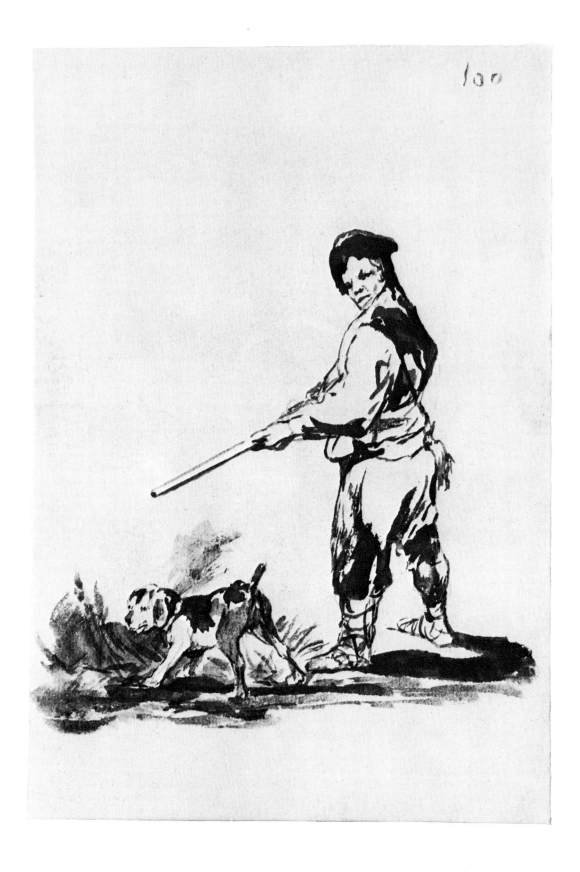

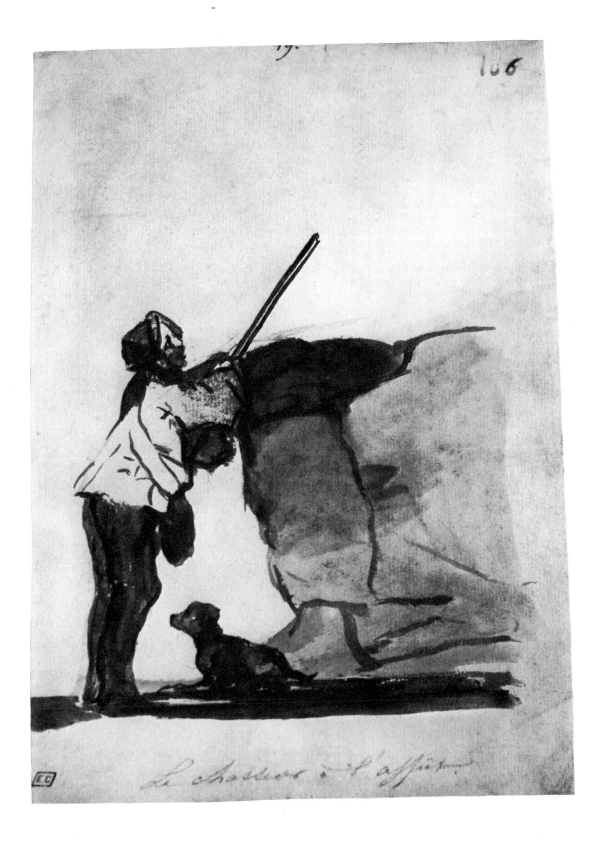

Le chasseur à l'affût

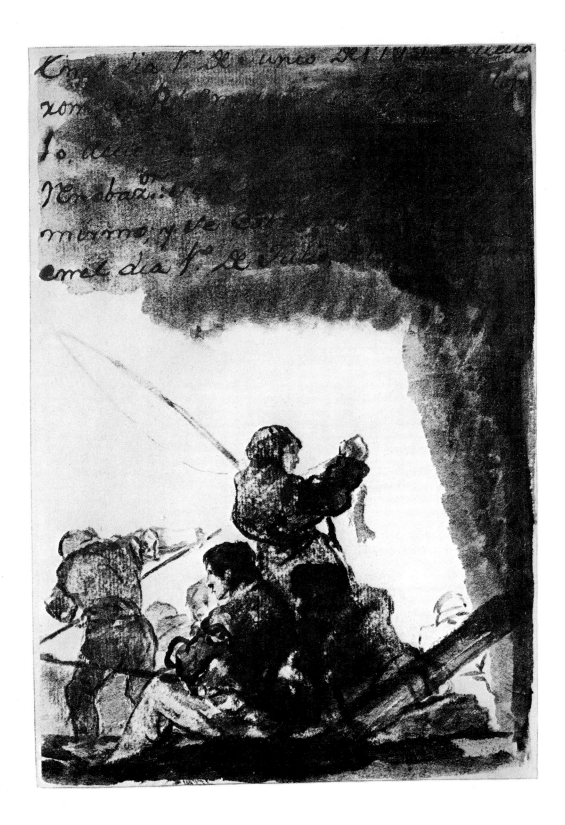

Sepia Album (F)

Captions and Commentaries

F.1 [277] p. 389
'Dead from hunger" – 1812-23 – 192 × 140 – S – No. (S) – *Paper*: horizontal chain lines – Mounted on pink paper – Two traces of sealing wafers at upper left corner – *Hist.*: Javier Goya; Mariano Goya; Román Garreta → Museo de la Trinidad (5.4.1866) – Madrid, Prado (303) – GW 1431

This first drawing of album F should be compared with the scenes of famine and distress that form a close-knit group among the *Disasters of War* and relate to the dreadful winter of 1811-12. The characters that press round the dying girl, particularly the veiled figure bent over her, are very reminiscent of *51, 52* and *59* of that set of prints. The drawing might even be given the same title as *52,* "They have come too late". The very dark patch of sepia wash in the middle of the sheet burnt the paper.

F.2 [278] p. 390
'In Turkey?" – 1815-20 – 206 × 144 – S – No. (S) – No. add. 139 (Lp) – *Paper*: horizontal chain lines – Mounted on pink paper – Trace of sealing wafer – *Hist.*: Javier Goya; Mariano Goya; Román Garreta → Museo de la Trinidad (5.4.1866) – Madrid, Prado (293) – GW 1432

This is one of the "Turkish" scenes one comes across now and then in Goya's *œuvre*. Some, as for instance E.9, are directly related to the French occupation and Napoleon's Mamelukes. But as a rule they were probably the product of literary reminiscences or an oral tradition derived from well-known plays or Cervantes's *Don Quixote* – cf. in this connection the note to C.76. This scene of Oriental cruelty strikes one by the resemblance of the composition to *The Last Communion of Saint Joseph of Calasanz* (GW p. 306). In both there is one figure kneeling in front of one standing with, behind them on a lower level, the massed heads of the onlookers; in both sunbeams illuminate the scene from the left. The painting is dated 1819, which tallies with the results of all the studies on the dates of the drawings in this album (Bibl. 186, p. 12).

F.3 or 5? [279] p. 391
"Women at prayer" – 1812-23 – 178 × 146 – S – Stamp of Carderera collection (1867) – *Paper*: horizontal chain lines – Pasted on cardboard – The sealing wafer has been removed, leaving a white moon in the upper left corner – *Hist.*: Javier Goya; Mariano Goya; V. Carderera → B.N. de Madrid (1867) – Madrid, Biblioteca Nacional (B.1259) – GW 1434

The contrasts of light and shade in this scene, probably set in the open air, are so violent that they were long attributed to the moonlight because of the small round white form that pierces the darkness at the top of the drawing. It has recently been discovered that a sealing wafer had been stuck on that spot of Goya's sheet of paper. When it was removed later by some unknown person, the bare paper gave rise to a white circle that the artist had certainly not intended. What is certain, however, is that this nocturnal scene calls to mind the violent lighting of some of the *Disasters of War,* for example *50* and *62*. Lastly, though the drawing is not numbered, I suggest it should be either F.3 or F.5, the only vacancies among the first nineteen sheets of this album, all of which show traces of a sealing wafer.

F.6 [280] p. 392
"Death of a saint (?)" – 1812-23 – 209 × 145 – S – No. (S) – No. add. 138 (Lp) – *Paper:* horizontal chain lines – Mounted on pink paper – *Watermark:* faint – Trace of sealing wafer – *Hist.:* Javier Goya; Mariano Goya; Román Garreta → Museo de la Trinidad (5.4.1866) – Madrid, Prado (324) – GW 1433

It is virtually impossible to decipher this scene because the paper has been so severely damaged where the sepia wash was especially thick. It is almost pitch dark under the massive vault but one can just make out on the left the brightly lit figure of a woman leaning towards a human shape lying on the ground. The impression of mystery is still very strong despite the burns caused by the sepia. This drawing was wrongly classified in my catalogue of 1970. An examination of the whole sheet revealed a 6 in the top right-hand corner.

F.7 [281] p. 393
"Street performers" – 1812-23 – 206 × 145 – S – No. (S) – No. add. 137 (Lp) – *Paper:* horizontal chain lines – Mounted on pink paper – Trace of sealing wafer – *Hist.:* Javier Goya; Mariano Goya; Román Garreta → Museo de la Trinidad (5.4.1866) – Madrid, Prado (294) – GW 1435

This is the first of Goya's works, previous to the series of black-chalk drawings done at Bordeaux (cf. album H), in which a scene of mountebanks occurs. Here the show is on a very small scale: two wandering players have paused in a village under the shadow of a large building. One plays the guitar while the other dances with a monkey on his back. A few idlers have gathered round them and make no attempt to hide their glee. In the foreground, two bottles, a half-empty glass and a plate may perhaps represent the spectators' payment in kind.

F.8 [282] p. 394
"People sheltering in a cave" – 1812-23 – 205 × 146 – S – No. (S) – No. add. 136 (Lp) – *Paper:* horizontal chain lines – Mounted on pink paper – Trace of sealing wafer – *Hist.:* Javier Goya; Mariano Goya; Román Garreta → Museo de la Trinidad (5.4.1866) – Madrid, Prado (326) – GW 1436

Of all the drawings in the Prado none has suffered as much as this one. In the spate of inspiration, the artist employed his sepia wash at too high a concentration, so that today the paper is entirely burnt through. What is more, in course of time the sepia reacted to the light, producing a sort of white mould that makes it quite impossible to decipher the essential details of the scene. As far as one can judge, considering the present state of the sheet, it represents a group of people gathered in a cave after the fashion of some paintings in the collection of the marquises de la Romana (cf. in particular GW 918 and 920), executed a few years prior to 1812.

F.9 [283] p. 395
"Two figures beside a rock" – 1812-23 – 205 × 145 – S – No. (S) – No. add. 135 (Lp) – *Paper:* horizontal chain lines – Mounted on pink paper – *Watermark:* very faint – Trace of sealing wafer – *Hist.:* Javier Goya; Mariano Goya; Román Garreta → Museo de la Trinidad (5.4.1866) – Madrid, Prado (327) – GW 1437

Here, too, Goya was misled in his excessive use of sepia. The entire left side of the composition is very confused. One can just make out a half-reclining figure with open mouth, a dying man it would seem, hidden behind an oddly shaped rock. A second figure, on the right, whose face is brightly lit, looks like a fierce guerrilla. This drawing is noteworthy for the exceptional proportions of the figures.

F.10 [284] p. 396
"Duel with shields" – 1815-19 – 206 × 149 – S – No. (S) – *Paper:* horizontal chain lines – Mounted on pink paper – Trace of sealing wafer – *Hist.:* Javier Goya; Mariano Goya; Román Garreta → Museo de la Trinidad (5.4.1866) – Madrid, Prado (284) – GW 1438

The first of a group of six drawings devoted to old-style duels, judging by the costumes worn by the different figures. Duelling, moreover, already belonged to the past and was no longer practised in early nineteenth-century Spain. Even in the latter half of the previous century it had been condemned by enlightened minds as a barbarous custom, unworthy of a civilized people. A date limit can be fixed for these duelling scenes in view of the fact that a lithograph based on one of them, F.12, is dated "Marzo 1819" on an early impression. So these drawings are an evocation of Spain's past, a sort of document recording the senseless cruelty and harshness of earlier times. This scene is set in a wooded landscape with sharp contrasts between the dense shadows on the left and the light bathing the rest of the landscape. Several alterations are visible in the duellist on the right, the position of his legs having been completely changed.

F.11 [285] p. 397
"En garde!" – 1815-20 – 205 × 149 – S – No. (S) – No. add. 134 (Lp) – *Paper:* horizontal chain lines – Mounted on pink paper – *Watermark:* F.III – Trace of sealing wafer – *Hist.:* Javier Goya; Mariano Goya; Román Garreta → Museo de la Trinidad (5.4.1866) – Madrid, Prado (285) – GW 1439

In a landscape similar to that of the previous drawing, two men, both in their shirt sleeves, cross swords. Their coats and hats lie on the ground to the right. Noteworthy is the remarkable design of this scene, the slanting rapiers and legs forming a strict pattern of parallel lines. A sense of relief and volume is conveyed by the cast shadows falling over the duellists and over the ground in broad areas of sepia wash.

F.12 [286] p. 398
"Sword-thrust" – 1815-20 – 205 × 145 – S – No. (S) – No. add. 133 (Lp) – *Paper:* horizontal chain lines (24 mm) – Mounted on pink paper – *Watermark:* F.II – Trace of sealing wafer – *Hist.:* Javier Goya; Mariano Goya; Román Garreta → Museo de la Trinidad (5.4.1866) – Madrid, Prado (286) – GW 1440

The costume worn by the two men is a reminiscence of the 16th and the early 17th century, when gentlemen wore the pleated ruff shown here. The dramatic outcome of this duel, fought now with a rapier in both hands, is represented by Goya with compelling realism: the man run through the chest staggers back, blood pouring from his mouth, while his antagonist, with his legs firmly planted wide apart, drives home the death blow. Goya made a lithograph of this scene (GW 1644), and one impression bears the autograph inscription "*Madrid. Marzo 1819*".

F.13 [287] p. 399
"Victory without witnesses" – 1815-20 – 206 × 148 – S – No. (S) – No. add. 132 (Lp) – *Paper:* horizontal chain lines – Mounted on pink paper – Trace of sealing wafer – *Hist.:* Javier Goya; Mariano Goya; Román Garreta → Museo de la Trinidad (5.4.1866) – Madrid, Prado (295) – GW 1441

This scene looks like the sequel to the previous one: the man run through the chest is now lying on the ground behind some bushes, while his antagonist, erect and alive, sword in hand, has put on his plumed hat and is about to leave this deserted spot, having avenged himself in an affair of honour. The last rays of the setting sun cast a glow over this tragic scene and the surrounding landscape; the whole left side of the composition has already sunk into the shadows of oncoming night. In the foreground the oblique mass of the tree-trunk falls sharply across the corpse of this ill-fated man.

F.14 [288] p. 400
"Gentlemen duelling in hats" – 1815-20 – 205 × 147 – S – No. (S) – No. add. 131 (Lp) – *Paper:* horizontal chain lines – Mounted on pink paper – *Watermark:* F.II – Trace of sealing wafer – *Hist.:* Javier Goya; Mariano Goya; Román Garreta → Museo de la Trinidad (5.4.1866) – Madrid, Prado (287) – GW 1442

The two gentlemen here are fighting it out, not in the open country, as in the previous drawings, but beside a ruined house; behind and on the left are a door smashed open, a crumbling wall and some fallen beams. The man on the left has just made a thrust at his antagonist, but the latter has parried it; the fight is not yet over but one can already guess the outcome. Lights and shadows are beautifully patterned over the duellists, in alternating strokes and patches of sepia, without any excessive emphasis on wash areas.

F.15 [289] p. 401
"Duelling with knives" – 1815-20 – 205 × 146 – S – No. (S + P?) – No. add. 130 (Lp) – *Paper:* horizontal chain lines (23 mm) – Mounted on pink paper – Trace of sealing wafer – *Hist.:* Javier Goya; Mariano Goya; Román Garreta → Museo de la Trinidad (5.4.1866) – Madrid, Prado (288) – GW 1443

This is the last of this group of duelling scenes; the two men are fighting with knives, almost hand to hand. The man with his back to us stands with his legs in almost exactly the same position as the victorious swordsman in F.12. The composition is remarkable for the pattern of parallel lines formed by the two pairs of legs, as in F.11 and F.14. The dense shadows on the ground set off this geometry, which stands out here against the whiteness of the blank sheet.

F.16 [290] p. 402
El pelado/de Ybides (P) (The native of Ybides stripped) – 1812-23 – 205 × 148 – S – No. (S.P) – No. add. 129 (Lp) – *Paper:* horizontal chain lines – Mounted on pink paper – Trace of sealing wafer – *Hist.:* Javier Goya; Mariano Goya; Román Garreta → Museo de la Trinidad (5.4.1866) – Madrid, Prado (296) – GW 1444

Several such scenes of brigandage appear in Goya's work, both in paintings and drawings. As we have already pointed out, these subjects are not necessarily connected with the War of Independence, for brigandage had long been endemic in the mountainous regions of Spain. See also in this connection drawing E.41. Beside a tree almost bare of leafage, a burly outlaw seen against the light stands in front of a poor peasant whom he has forced to his knees, having bound his hands. He grips him by the throat and levels his musket at him. Terror is written in the man's face and no help is forthcoming in this deserted spot. It is not certain that the caption is written in Goya's hand. Sánchez Cantón has pointed out that there is a village in Aragon named Ibides (Bibl. 173, No. 279).

F.17 [291] p. 403

"To market?" – 1812-23 – 203 × 143 – S – No. (S) – No. add. 128 (Lp) – *Paper:* horizontal chain lines – Traces of pink paper – *Watermark:* F.I – Trace of sealing wafer – *Hist.:* Javier Goya; Mariano Goya; Román Garreta → Museo de la Trinidad (5.4.1866) – Madrid, Prado (291) – GW 1445

A peasant family is walking through open country: the father and mother, bowing under heavy loads, are accompanied by a little girl, who looks up at her father, and a little dog trotting out in front of them. Light impinges on them from the left, illuminating in particular the bags they are carrying. All the rest of the figure group is in shadow, pierced only by a few shafts of light focused on the faces of mother and child. A few brushstrokes indicate cast shadows in the foreground and the horizon line in the distance.

F.18 [292] p. 404

"Conjugal row" – 1812-23 – 208 × 146 – S – No. (S) – No. add. 122 (Lp) – *Paper:* horizontal chain lines – Traces of pink paper – Piece of paper added at the top of the sheet – *Hist.:* Javier Goya; Mariano Goya; Román Garreta → Museo de la Trinidad (5.4.1866) – Madrid, Prado (255) – GW 1446

The problems of married life inspired several works by Goya, in different moods and mediums, beginning with the tapestry cartoon *La Boda* (The wedding) (GW 302) and including in particular drawing B.58, *Capricho 92*, the small picture of the *Wedding of the ill-assorted couple* recently acquired by the Louvre (Bibl. 77, No. 28), drawings C.19, C.93, G.13, G.15, and others. But none of these shows so violent a quarrel: on the edge of a disordered bed, the husband has seized his wife by the hair and is about to drag her to the floor. The commotion of the linework conveys the commotion of the couple, standing out in full light against a background of dark curtains. The added piece of paper (on which a clenched hand has been drawn) probably went to mend the paper at the point where the sealing wafer had been applied.

F.19 [293] p. 405

"A fine pair!" – 1812-23 – 205 × 144 – S – No. (S) – No. add. 127 (Lp) – *Paper:* horizontal chain lines (24 mm) – Mounted on pink paper – *Watermark:* F.III (?) – Trace of sealing wafer – *Hist.:* Javier Goya; Mariano Goya; Román Garreta → Museo de la Trinidad (5.4.1866) – Madrid, Prado (256) – GW 1447

This drawing, unfortunately damaged like several others by sepia burns, is one of the finest in this album, both for its composition and for the strangeness of these figures seen from behind. The shadowy masses in wash of the two figures are perfectly balanced between the dense ground shadow and the vault (apparently) whose dark curve arches over the scene. Tall and slender, with only her upper body illuminated, the woman faces the grotesque onlookers and points to a dwarf whose bulky silhouette is leaning on a stick. The light in the background is dazzling and throws the couple into arresting relief. Possibly they represent a fortune-teller with her confederate.

F.20 [294] p. 406

"In the choir" – 1812-23 – 185 × 144 – S – No. (Lp) in another hand, recopied from the autograph number which was trimmed off when the sheet was recut – No. add. 126 (Lp)? – The number added by Garreta was also trimmed off, but another hand recopied it in white crayon in the lower left corner – *Paper:* horizontal chain lines – Traces of pink paper – *Hist.:* Javier Goya; Mariano Goya; Román Garreta → Museo de la Trinidad (5.4.1866) – Madrid, Prado (317) – GW 1448

A monastic scene, whose composition is very similar to that of the previous drawing: the same dark vault overhead and the identical light effect between the two foreground figures seen against the light and the roughly sketched monks standing in the brightly lit background. The title given by Sánchez Cantón (Bibl. 173, No. 314) fits the subject perfectly: a monk standing in the choir in front of a lectern on which lies a psalter surmounted by a statue of the Virgin. A

number of similar compositions figure in this album, among others F.28, F.33, F.59 and F.62 (?). It is noteworthy that this sheet shows no trace of the stamp of the National Museum of Painting; it may have been trimmed off when the drawing was recut.

F.21 [295] p. 407
"Protection" – 1812-23 – 205 × 144 – S – No. (S) – No. add. 125 (Lp) – *Paper:* horizontal chain lines – Mounted on pink paper – *Hist.:* Javier Goya; Mariano Goya; Román Garreta → Museo de la Trinidad (5.4.1866) – Madrid, Prado (257) – GW 1449

Again we find this dark vault overarching the scene, weighting it with a sense of mystery and fate. Three figures have taken shelter there, but the woman half reclining on the ground appears to have succumbed (the inertness of her limbs is admirably rendered by Goya); one of her companions takes her by the waist to carry her away, while an old man standing on the right, gazing at the body of the woman who is perhaps his daughter, makes a gesture of surprise and despair. The warmth of the sepia gives this drawing an unusual emotional intensity. Compare with the plates in the *Disasters of War* picturing the famine winter in Madrid (1811-12), above all plate No. 57 in which a similar type of vaulting appears.

F.22 [296] p. 408
"Poverty" – 1812-23 – 205 × 142 – S – No. (S) thrice repeated at the top of the sheet – No. add. 124 (Lp) – *Paper:* horizontal chain lines – *Hist.:* Javier Goya; Mariano Goya; Román Garreta → Museo de la Trinidad (5.4.1866) – Madrid, Prado (258) – GW 1450

Another drawing reminiscent of the famine scenes of the winter of 1811-12 which inspired plates 48 to 64 of the *Disasters of War*. A sense of decay and destitution pervades this composition, from the dilapidated window on the right to the two figures occupying this bare room. The half-naked man wearing a large hat carefully examines his clothes, no doubt picking out the lice and fleas; the woman in the background, seen from behind, is sketched in with a lighter wash, which has the effect of giving greater depth to the scene.

F.23 [297] p. 409
"Help" – 1812-23 – 206 × 145 – S – No. (S) – No. add. 123 (Lp) – *Paper:* horizontal chain lines (24 mm) – Mounted on pink paper – *Watermark:* F.II – *Hist.:* Javier Goya; Mariano Goya; Román Garreta → Museo de la Trinidad (5.4.1866) – Madrid, Prado (259) – GW 1451

A final scene of poverty and trouble forming with the last two a homogeneous group close to certain plates in the *Disasters of War* (see entries for F.21 and F.22). Although there are no explicit clues to what is happening here, we feel that these three women have been brought together by the spirit of charity, two of them taking compassion on the third who is sitting on the ground. They bend over to help her; the woman on the left is brightly illuminated and the graceful silhouette of her body expresses all the tenderness that has prompted her to act. Behind her, as a counterpattern, Goya has raised the stark geometry of a dark fence standing out forbiddingly against the empty sky.

F.25? [298] p. 410
"Group of women" – 1812-23 – 179 × 138 – S – No. (S) – *Paper:* horizontal chain lines (28 mm)? – *Hist.:* The acquisition stamp of the Carderera collection does not figure on this drawing, but it seems safe to say, following Mayer's view, that it did belong to that collection – Madrid, Biblioteca Nacional (B.1258) – GW 1452

The autograph number of this drawing, in the upper right corner, is practically illegible under the sepia wash. This group of five women of the town is shown out-of-doors, waiting for passers-by on the public way. One, resting her foot on a boundary-stone, is fastening her garter with the same gesture as the *maja* in *Capricho 17, Bien tirada esta* (It is well pulled up). The chiaroscuro of the scene is emphasized by the wash with which Goya has partially covered the sky with irregular brushstrokes, leaving the foreground bathed in light.

F.27 [299] p. 411
"Scene of exorcism" – 1812-23 – 205 × 147 – S + I – No. (S) – No. add. 121 (Lp) – *Paper:* horizontal chain lines (24 mm) – Mounted on pink paper – *Watermark:* F.III – *Hist.:* Javier Goya; Mariano Goya; Román Garreta → Museo de la Trinidad (5.4.1866) – Madrid, Prado (316) – GW 1453

The scene takes place in a monastery where a mother has brought her daughter to be exorcised; she and a monk are holding up the child, who seems to be unconscious, while another monk, gazing heavenwards with his arms outspread, implores divine inter-

cession. In the right background stands an altar towards which the mother and the exorcising monk turn their eyes. Here, expressed as in drawing C.121 and the next sheet, F.28, we find poor women showing the same credulity in their search for a "healer" of souls and bodies. We have seen what Goya's views were concerning these practices.

F.28? [300] p. 412

"The visit to the hermit" – 1812-23 – 182 × 135 – S – No. (Lp) in another hand, presumably copying the autograph number which was trimmed off when the sheet was cut down by over two centimetres – No. add. 120 (Lp) – *Paper:* horizontal chain lines – Traces of pink paper – *Hist.:* Javier Goya; Mariano Goya; Román Garreta → Museo de la Trinidad (5.4.1866) – Madrid, Prado (315) – GW 1454

Here again is the characteristic composition – already encountered in this album – of a vault overarching the figures and the contrasting light effect between the dark foreground and the brightly lit background (see drawings F.19, F.20, F.21 and, further on, F.59 and F.62). The connection between this subject and the previous one is obvious, with this difference, however, that here it is a young mother bringing an infant to a hermit, no doubt in the hope of a cure. In the foreground looms the dark, bulky figure of the holy man, whose face is not visible.

F.30 [301] p. 413

"The skaters" – 1812-23 – 205 × 143 – S – No. (S) – No. add. 47 (fine P), top centre – *Paper:* horizontal chain lines – Mark E.C. (Lugt 837) – *Hist.:* Paris, Paul Lebas; APs. Paris, H.D. 3.4.1877, No. 29 "Les Patineurs" → de Beurnonville (100 fr.); Ps. de Beurnonville, Paris, H.D. 16-19.2.1885, lot 49 → E. Calando (320 fr. for 11 drawings from this lot) – Boston, Museum of Fine Arts, Otis Norcross Fund and Gift of Mrs. Thomas B. Card (61.166) – GW 1456

An open-air scene remarkable for its perspective and realism, but surprising in Spain where a sheet of water rarely freezes so hard as to allow ice-skating. The sight can, however, be seen occasionally in a severe winter, and its very unusualness is precisely what struck Goya. As for the landscape represented, the only possible one would seem to be the Casa de Campo on the outskirts of Madrid, beyond the Manzanares. Since the 17th century, Madrilenians have been fond of resorting to this magnificent property laid out and kept up by the kings of Spain. It includes, among

other picturesque sites, a large pond from which the Sierra de Guadarrama can be seen in the distance. Goya has thus faithfully represented this fine landscape, which he must have admired many times in the course of his life; it already formed the background of his tapestry cartoon *Blind man's buff* (GW p. 69), which shows roughly the same view. But he was chiefly familiar with it after 1819, when he bought the Quinta del Sordo which stands close by. He did another drawing of skaters in Bordeaux (GW 1837) and also drew a *Lay brother on skates* (H.28).

F.31 [302] p. 414

"Crowd in a park" – 1812-23 – 206 × 143 – S – No. (S) – No. add. 19 (fine P), upper r. corner – *Paper:* horizontal chain lines – Mounted on pink paper – *Hist.:* Javier Goya; Mariano Goya; V. Carderera; F. de Madrazo; Venice, Mariano Fortuny y Madrazo (Fortuny album) → 1935 – New York, Metropolitan Museum of Art, Harris Brisbane Dick Fund, 1935 (35.103.19) – GW 1457

This bird's-eye view of a crowd of strollers in a vast landscape is unique in Goya's work. Only the *Meadow of San Isidro* (GW pp. 66-67) might be compared to it, despite a profound difference of style and conception in the treatment of the crowd; in the painting it is laid out on planes, according to a standard technique, whereas in the drawing it is a human mass, a cluster of individuals such as we find in the background of several works of the years 1812-19: *Burial of the sardine* (GW p. 2), *Bullfight in a village* (GW p. 240), *Inquisition scene* (GW 966), *Procession of flagellants* (GW 967) and several plates in the *Tauromaquia*. This type of crowd reappears later in this album in sheets F.42, F.44 and F.46. Finally, there is a close connection between this drawing and the last. The setting of both, in my opinion, is the Casa de Campo in Madrid, here on a fine spring day (one notes that, despite the sun, several figures are wearing capes or coats) when Madrilenians love to go there for a stroll or a chat on the benches.

F.32? [303] p. 415

"Nude woman seated beside a brook" – 1812-23 – 206 × 143 – S – No. (S) – No. add. 25 (fine P), upper r. corner – *Paper:* horizontal chain lines – Mounted on pink paper – *Hist.:* Javier Goya; Mariano Goya; V. Carderera; F. de Madrazo; Venice, Mariano Fortuny y Madrazo (Fortuny album) → 1935 – New York, Metropolitan Museum of Art, Harris Brisbane Dick Fund, 1935 (35.103.25) – GW 1458

In this drawing, and several others in this album, the landscape is given unusual prominence. We need only mention the two drawings preceding this one, in which nature and the open air play a preponderant part. It is common knowledge how rare such subjects are in Goya's work; his interest was in man. Here the thick leafage and the play of light through the trees are treated with the same freedom as in the two small paintings, *Making gunpowder in the sierra* (GW 980) and *Making shot in the Sierra de Tardienta* (GW p. 213), which are generally dated to the last years of the war (1810-14). But what is this naked woman by a brook doing in these woods, her head pensively resting on her left hand, while a man lurks behind a thicket, observing her on the sly? Actually the scene takes on its full meaning when we note beside her the dark silhouette of another man whose cast shadow is clearly visible on the ground to the left. Perhaps we are still in the woods of the Casa de Campo, whose pleasures were not reserved for sober-minded Sunday strollers alone.

F.33 [304] p. 416
"Monks in an interior" – 1812-23 – 205 × 143 – S – No. (S) – No. add. 20 (fine P), upper r. corner – *Paper:* horizontal chain lines – Mounted on pink paper – *Hist.:* Javier Goya; Mariano Goya; V. Carderera; F. de Madrazo; Venice, Mariano Fortuny y Madrazo (Fortuny album) → 1935 – New York, Metropolitan Museum of Art, Harris Brisbane Dick Fund, 1935 (35.103.20) – GW 1459

Two Capuchins have come to pay a visit to an old friar sitting in the half-light of an interior. The scene is illuminated by a large window at the back of the room, the two visitors standing out against the light, while the old man bathes in a soft light that plays over his bald head and bushy white beard. The dense shadow on the floor is balanced by the bright area of the floor tiles in the lower left corner. The attitude of the three figures seems to indicate hostility on the part of the two Capuchins and obstinacy in their interlocutor who, with hunched shoulders, is perhaps refusing to follow or answer them.

F.35 [305] p. 417
"Monks reading" – 1812-23 – 202 × 141 – S – No. (S) – No. add. 26 (fine P), upper r. corner – *Paper:* horizontal chain lines – *Hist.:* Paris, Paul Lebas; APs. Paris, H.D. 3.4.1877, No. 43 "Une lecture intéressante" (29 fr.); A. Strolin → 1910 – Dresden, Kupferstichkabinett (C.1910.56) – GW 1460

In my 1970 catalogue this drawing was tentatively assigned the number 34. Careful examination of a photograph of the whole sheet has revealed the lower half of the figure 35 on the upper right. The scene is an outright caricature, the animal-like features of the three monks grouped in the foreground being lit up with coarse laughter; probably it is not a devotional book that they are reading. A wash background so completely opaque is very rare in Goya's drawing albums. It recurs only in four sheets of album C, three of them, significantly enough, being caricatures of monks: C.120, C.123 and C.125.

F.36 [306] p. 418
"Man and woman on a mule" – 1812-23 – 205 × 143 – S – No. (S) – No. add. 21 (fine P), upper r. corner – *Paper:* horizontal chain lines – Mounted on pink paper – *Watermark:* F.I – *Hist.:* Javier Goya; Mariano Goya; V. Carderera; F. de Madrazo; Venice, Mariano Fortuny y Madrazo (Fortuny album) → 1935 – New York, Metropolitan Museum of Art, Harris Brisbane Dick Fund, 1935 (35.103.21) – GW 1461

This drawing is the first of a group of four representing various figures mounted on mules, the animal being simply the common denominator of four anecdotes which Goya remembered or had heard about. This one is a quiet, touching scene: a man is taking away his young wife, or bride perhaps, who is seated athwart his mule; a bright, frail silhouette seen only from behind, she is nevertheless the focal point of the scene. The background has been dabbed with dark wash to make the mule and the couple stand out more vigorously.

F.37 [307] p. 419
"Monk on a mule beaten by a man" – 1812-23 – S – No. (S) – No. add. 12 (fine P), upper centre – "En voyage" (Lp) in another hand – *Paper:* horizontal chain lines – *Hist.:* Paris, Paul Lebas; APs. Paris, H.D. 3.4.1877, No. 31 "En voyage" → Fiantana (or Fiantance?) (30 fr.); Madrid, Duchess of Montpensier; Marquess of Valdeterrazo – Madrid, Valdeterrazo heirs – GW 1462

The idyllic calm of the previous scene is followed by a livelier episode: the mule carrying this monk is not moving fast enough to suit him and the muleteer is about to whip the animal's hindquarters. But in both sheets Goya treats the setting in the same way: a formless wash provides the background in the upper right part of the sheet, and, in addition to the shadows

cast by the figures and mule, a few lines and patches go to indicate a slight dip in the ground. The inscription in another hand was added by a French collector (Paul Lebas?) at some time previous to the 1877 sale, for the drawing was there catalogued under the title inscribed on the sheet.

F.38 [308] p. 420

Este caso sucedió en Aragón sien/do yo muchacho, y el religioso quedo muy/maltratado del caballo y la Borrica (S) (This incident occurred in Aragon when I was a boy, and the monk was very ill-treated by the horse and so was the donkey) – 1812-23 – 215×140 – S – No. (S) – No. add. 19 (fine P), upper r. corner – *Paper:* horizontal chain lines – Mark E.C. (Lugt 837) – Spurious signature, lower left corner – *Hist.:* Paris, Paul Lebas; APs. Paris, H.D. 3.4.1877, No. 40 " Le Cheval et l'Ane" → E. Calando (40 fr.); Ps. Calando, Paris, H.D. 11-12.12.1899, No. 74 (240 fr.); Ps. G. Bourgarel, Paris, H.D. 13-15.11.1922, No. 90 → Hamcoin (5,000 fr.) – New York, priv. coll. – GW 1463

The long autograph caption is of special interest because it shows that memories of the past were running in Goya's mind at the time he made these drawings. The scene obviously struck him by its very extravagance and he recorded it as a monstrous cluster of animals and man, with the muleteer running up to them and raising his stick, trying to calm the excited horse.

F.39 [309] p. 421

" Dogs chasing a cat perched on the head of a man riding a donkey" – 1812-23 – 200×140 – S – No. (S) – No. add. 27 (fine P), upper r. corner – *Paper:* horizontal chain lines – *Watermark:* F.II – *Hist.:* Paris, Paul Lebas; APs. Paris, H.D. 3.4.1877, No. 44 "Cavalier attaqué par des chiens" → Pascal (46 fr.); Ps. H. Rouart, Paris, Manzi-Joyant, 16-18.12.1912, No. 157, 2º/ → Levesque (1,850 fr. with 1º/) – Merion Station, Pa., Copyright 1973 by the Barnes Foundation – GW 1464

This final scene from the group of " mule drawings" (F.36 to F.39) is almost nightmarish, so keen are the sufferings of this poor man as the cat, pursued by a pack of hounds, digs its claws into his head. Frightened by the dogs, the rearing donkey is not making matters any easier. A slanting line of trees in the distance creates a rising perspective for the whole of this open space bathed in light, where two men can be seen waving their arms and running up amidst the rest of the hounds. An exceptionally dynamic drawing with its rich combination of varied movements.

F.40 [310] p. 422

"Hunting lice" – 1812-23 – 205×146 – S – No. (S) – No. add. 27 (fine P), upper r. corner – *Paper:* horizontal chain lines (24 mm) – Mounted on pink paper – *Watermark:* F.II – *Hist.:* Javier Goya; Mariano Goya; V. Carderera; F. de Madrazo; Venice, Mariano Fortuny y Madrazo (Fortuny album) → 1935 – New York, Metropolitan Museum of Art, Harris Brisbane Dick Fund, 1935 (35.103.27) – GW 1465

An interior wholly characteristic of Goya's style in the years 1815-20, when he achieved total mastery in the rendering of human forms and the varied combinations of light and shade. One need only compare this drawing and F.33, for example, with some of his early wash drawings in the Madrid album, like B.71 and B.84, to see how far he had moved in the direction of a singularly modern expressionism.

F.41 [311] p. 423

" Interior of a church" – 1812-23 – 205×143 – S – No. (S) – No. add. 28 (fine P), upper r. corner – *Paper:* horizontal chain lines – Mounted on pink paper – *Watermark:* F.II – *Hist.:* Javier Goya; Mariano Goya; V. Carderera; F. de Madrazo; Venice, Mariano Fortuny y Madrazo (Fortuny album) → 1935 – New York, Metropolitan Museum of Art, Harris Brisbane Dick Fund, 1935 (35.103.28) – GW 1466

In the closed world of this interior, vigorously delimited by a stroke of sepia wash, Goya succeeds in conveying a powerful impression of depth by varying the play of lights and shadows over the four figures standing before an altar of the Virgin, under the lofty vaulting of a church. Three of them are set out along a diagonal running from the monk (or nun) in gleaming white, in the foreground, towards the dark mass of the old woman communing in the right background, by way of the officiating priest clad in his chasuble, under which appears the brighter patch of the alb. The monk kneeling on the left, in the shadows, turns his head towards the main group, drawn by the hushed solemnity of the ceremony.

F.42 [312] p. 424

"Crowd in a circle" – 1812-23 – 206×143 – S – No. (S) – No. add. 29 (fine P), upper r. corner – *Paper:* horizontal chain lines (24 mm) – Mounted on pink paper – *Watermark:* F.II – *Hist.:* Javier Goya; Mariano Goya; V. Carderera; F. de Madrazo; Venice, Mariano Fortuny y Madrazo (Fortuny album) → 1935 – New York, Metropolitan Museum of Art, Harris Brisbane Dick Fund, 1935 (35.103.29) – GW 1467

This circular composition has been likened by Xavier de Salas (Bibl. 159, pp. 4-5) to that of the *Burial of the sardine* (GW p. 2) and the *Bullfight in a village* (GW p. 240), whose dating corresponds to that of this album. Here the effect is particularly remarkable on account of the unusual empty space left in the centre of the circle and the shading off of light values from the foreground group to the back rows of the crowd (this latter feature also characterizes the two paintings). An overcast sky and a tall building on the right close off the composition, which is also surrounded by a wash outline. There is an air of expectancy about the crowd, which may be waiting for some acrobats or wrestlers to appear – perhaps the figures outside the circle to whom a woman is giving something to drink.

F.43 [313] p. 425

"Three people round a dying man" – 1812-23 – 205 × 143 – S – No. (S) – Inscription on the back of the mount: "Given me by Sig.ʳ R. de Madrazo, 1895, J.P.H.", with red seal J.P.H. – *Paper*: horizontal chain lines – Mounted on pink paper – *Watermark*: faint – *Marks*: J.P.H. and G. – *Hist.*: R. de Madrazo; J. P. Heseltine (1895); Ps. Heseltine, London, May 1935, No. 115 – Paris, priv. coll. – GW 1468

In a room as dilapidated as those in sheets F.22 and F.40, an old man is dying on a mean bed. A woman in the foreground hides her head in her arms, overcome with grief, while on the other side of the bed another woman holds up the dying man. The group of four figures is illuminated by light streaming in from the window on the right, devoid of panes or fittings. Outside can be seen some roofless beams, a further sign of the ruinous state of the building. Note the inscription by the English collector J. P. Heseltine, where we learn that this one was a gift from Raimundo de Madrazo, who on the death of his father Federico de Madrazo, in 1894, had inherited a number of Goya drawings, among them those now belonging to the Hispanic Society in New York. See the identical inscription on B.81/82.

F.44 [314] p. 426

"Procession of monks" – 1812-23 – 204 × 138 – S – No. (S) – *Paper*: horizontal chain lines – *Hist.*: F. de Madrazo – Berlin-Dahlem, Kupferstichkabinett (4292) – GW 1469

Thanks to the winding path taken by this procession as it moves away from us towards some kind of temple in the background, Goya obtains a dual effect of spatial recession and passing time. The monks intone their chants, and the banners sway to the rhythm of the slow forward march of this rapt crowd. But the object of this ceremony is up at the head of the procession, and largely escapes our notice. One can make out an imposing litter, the outline of a head and above all some rays of light emanating from it. These may be the venerated remains of a saint. Or possibly, in view of the next drawing and other compositions in which the same radiant figure appears (see C.117), Goya means us to assist at the burial of Truth before its coming resurrection (F.45).

F.45 [315] p. 427

"Truth beset by dark spirits" – 1820-23 – 205 × 143 – S – No. (S) – No. add. 30 (fine P), upper r. corner – *Paper*: horizontal chain lines – Mounted on pink paper – *Watermark*: F.III – *Hist.*: Javier Goya; Mariano Goya; V. Carderera; F. de Madrazo; Venice, Mariano Fortuny y Madrazo (Fortuny album) → 1935 – New York, Metropolitan Museum of Art, Harris Brisbane Dick Fund, 1935 (35.103.30) – GW 1470

This subject is obviously connected with drawing C.117 and plates *79, 80* and *82* of the *Disasters of War*: in all of them the white-clad woman emitting rays of light symbolizes Truth, as opposed to the dark forces of ignorance and oppression. Among the latter Goya does not scruple to include monks, priests and even a bishop (*Disasters of War 79*). Here, behind Truth, are two churchmen making threatening gestures, while on the left a figure of imposing stature, clad in a religious habit, turns away from the apparition and plunges back into darkness.

F.46 [316] p. 428

"Construction in progress" – 1812-23 – 205 × 143 – S – No. (S) – No. add. 31 (fine P), upper r. corner – *Paper*: horizontal chain lines (24 mm) – Mounted on pink paper – *Watermark*: F.III – *Hist.*: Javier Goya; Mariano Goya; V. Carderera; F. de Madrazo; Venice, Mariano Fortuny y Madrazo (Fortuny album) → 1935 – New York, Metropolitan Museum of Art, Harris Brisbane Dick Fund, 1935 (35.103.31) – GW 1471

Mighty structures or those with an air of unreality about them seem to have had a certain fascination for Goya throughout his life. We already find them in the tapestry cartoons (*La novillada*, GW p. 43, *The game of pelota*, GW 130, *Summer*, GW p. 70, *The wedding*,

GW 302), and in a work of similar inspiration (*Transporting a stone*, GW 252), in which construction is in progress. More fanciful are the drawings of the *Pyramid* (GW 754) and the *Commemorative monument* (GW 758), and frankly dreamlike is the picture of a *City on a rock* (GW 955) in the Metropolitan Museum. This drawing represents a large building site with a busy concourse of workmen, laid out on several levels in ascending perspective, following the orders of a foreman or master builder in a cape on the left. This scene may have been suggested to Goya by the building of the Madrid opera-house, which began in 1818.

F.51 [317] p. 429

"Three men digging" – 1812-20 – 206 × 143 – S – No. (S) – No. add. 32 (fine P), upper r. corner – *Paper :* horizontal chain lines (24 mm) – Mounted on pink paper – *Hist. :* Javier Goya; Mariano Goya; V. Carderera; F. de Madrazo; Venice, Mariano Fortuny y Madrazo (Fortuny album) → 1935 – New York, Metropolitan Museum of Art, Harris Brisbane Dick Fund, 1935 (35.103.32) – GW 1472

This drawing has always been regarded as the starting point of the famous picture in the Frick collection, *The forge* (GW p. 244), which is certainly subsequent to 1812 but cannot be later than 1819. The position of the three men is practically identical and, although the work is different, the powerful build of the two diggers matches that of the blacksmiths. Apart from the figures, Goya did no more than sketch in the bit of ground on which they are working; the rest of the sheet is blank.

F.52? [318] p. 430

"Three men carrying a wounded man" – 1812-23 – 205 × 145 – S – No. (?) – *Paper :* horizontal chain lines (24 mm) – *Watermark :* F.III – *Hist. :* Paris, Paul Lebas; APs., Paris, H.D. 3.4.1877, No. 32 "Transport d'un blessé" → E. Calando (21 fr.); Ps. Calando, Paris, H.D. 11-12.12.1899, No. 69 (170 fr.); Paul Meurice; heirs of P. Meurice; APs. Paris, Gal. Charpentier, 9.4.1957, No. 61; Clarence Buckingham → 1960 – Chicago, Art Institute (1960.313) – GW 1473

This might well be a scene from the War of Independence, for it would seem that at least the wounded man and the man standing on the right are wearing uniforms of this period. The setting of the episode is a desolate landscape dominated at the back by a rocky crest or hill. There are other works by Goya showing figures carrying a wounded man or a corpse: *The wounded mason* (GW 266), *Capricho 8* (They carried her

off!), a drawing after Flaxman (GW 763) and *Disasters of War 21, 50* and *56*.

F.53 [319] p. 431

"The stabbing" – 1812-23 – 205 × 143 – S – No. (S) – No. add. 33 (fine P), upper r. corner – *Paper :* horizontal chain lines – Mounted on pink paper – *Hist. :* Javier Goya; Mariano Goya; V. Carderera; F. de Madrazo; Venice, Mariano Fortuny y Madrazo (Fortuny album) → 1935 – New York, Metropolitan Museum of Art, Harris Brisbane Dick Fund, 1935 (35.103.33) – GW 1474

Album F contains two equally savage murder scenes, this one and F.87. Here, below the hump of a hill, in a lonely spot near a wood roughly indicated at the back, the murderer is shown at the very moment of plunging his dagger into the breast of his victim, who lies prostrate. Blood flows over the ground beside the crouching brute whose face wears an expression of bestial savagery. This scene of violence contrasts with the gentleness of the surrounding landscape.

F.54 [320] p. 432

"Don Quixote" – 1812-23 – 207 × 144 – S + P – No. (S) – Inscription "D.Quijote Goya" (Lp) in another hand – *Paper :* horizontal chain lines (24-25 mm) – *Watermark :* F.I – *Hist. :* Colnaghi's → 1862 – London, British Museum (1862.7.12.188) – GW 1475

This drawing has been studied by López-Rey (Bibl. 132), who questions its authenticity. He regards it as a copy of an etching by Félix Bracquemond; the etching was published in the *Gazette des Beaux-Arts* in 1860 to illustrate the famous article by Carderera (Bibl. 84). It is important to note that López-Rey's lengthy argumentation rests entirely on stylistic considerations. But from the technical evidence of the paper – whose characteristics have been checked by John Gere of the British Museum, who was kind enough to examine the sheet personally – there can be no doubt that this drawing belongs to album F. How, moreover, could anyone make a copy after Bracquemond's etching between 1860 and 1862 (when this drawing entered the British Museum) and inscribe on it the number 54, which does not figure on the etching and which happened to be one of the few vacant numbers in the album – something that no one at the time could have known? Finally, comparing the figures 5 and 4 of this number with those on so many other drawings by Goya, one cannot avoid the conclusion that this number is written in Goya's hand. For further details, see GW note 1475.

F.55 [321] p. 433
"Woman kneeling before an old man" – 1812-23 – 205 × 143 – S – No. (S) – No. add. 34 (fine P), upper r. corner – *Paper:* horizontal chain lines (25 mm) – Mounted on pink paper – *Watermark:* F.I – *Hist.:* Javier Goya; Mariano Goya; V. Carderera; F. de Madrazo; Venice, Mariano Fortuny y Madrazo (Fortuny album) → 1935 – New York, Metropolitan Museum of Art, Harris Brisbane Dick Fund, 1935 (35.103.34) – GW 1476

The chiaroscuro qualities that we found in F.33, F.40 and F.41 reappear in this interior. Light coming in from a tall window on the left plays over the two figures in the foreground, who thus stand out sharply against the dark background. The young woman is kneeling in the same attitude as the *Christ on the Mount of Olives* (GW 1640), dated 1819. But the old man to whom she bows so devotedly is not a monk. In the shadows at the back we can make out two figures leaning their elbows on a wall set on a higher level than the foreground. Like others in this album, the drawing is outlined with a thick stroke of sepia.

F.56 [322] p. 434
"Torture of a man" – 1812-23 – 205 × 143 – S – No. (S) – No. add. 56 (verso) and 5 (on the mount) – *Paper:* horizontal chain lines – Mounted on pink paper – *Watermark:* F.I – *Hist.:* Javier Goya; Mariano Goya; Román Garreta; F. de Madrazo; R. de Madrazo y Garreta → A. M. Huntington (1913) – New York, Hispanic Society of America (A.3312) – GW 1477

The only picture of torture in album F, this representation of the strappado (called *garrucha* in Spain) is a masterpiece of dynamic realism; first the exertions of the two torturers, one on each side of the winch, pulling strenuously at the handles; then the contorted body of the wretched victim, whose sufferings have only begun. The comparison made by Elizabeth du Gué Trapier (Bibl. 184, p. 18) with drawing F.51 in this album is wholly convincing; however, I do not think that this torture has any direct connection with the revival of the Inquisition in 1814, for the strappado was no longer in use at that time. Also, though the analogous scenes painted by Magnasco (Bibl. 184, note 14) reveal a parallel inspiration, they were probably unknown to Goya. One must, however, insist on the importance of Callot's prints, which had been diffused throughout Europe, in particular the series of the *Grandes Misères de la Guerre,* in which one plate represents the strappado, which also figures in the *Siege of Breda* and the *Tortures.* Sánchez Cantón, moreover, had already put forward the name of Jacques Callot in connection with the "fifteen prints" listed as anonymous in the 1812 inventory of Goya's belongings (Bibl. 169, pp. 19 and 34).

F.57 [323] p. 435
"Naked savage about to cudgel another" – 1805-12? – 207 × 141 – S – No. (S) – No. add 14 (fine P), upper centre – *Paper:* horizontal chain lines (25 mm) – *Watermark:* F.I – *Hist.:* Paris, Paul Lebas; APs. Paris, H.D. 3.4.1877, No. 33 "Samson" → Féral (50 fr.); London, Colnaghi's (1951); P. M. Turner; F. F. Madan → 1962 – Oxford, Ashmolean Mus. – GW 1478

Some have read a biblical meaning into this composition and called it *Cain slaying Abel,* and then *Samson slaying a Philistine* (Bibl. 22, No. 183, p. 92). But both the *Report* of the Ashmolean Museum (1962, p. 42) and Enriqueta Frankfort have accepted the new interpretation proposed by myself: a fight to the death between two savages, such as also figure in several small paintings dated 1808-14 (GW 922 to 927). The title given in the catalogue of the 1877 sale (Bibl. 99, pp. 113 and 117, note q) probably accounts for this biblical tradition; curiously enough, it has been taken up again, if but tentatively, in the catalogue of the Royal Academy (Bibl. 22). A point of some importance should be noted: the style of this drawing and the next (F.58) differs markedly from the rest of this album and comes much closer to certain compositions in album E, particularly as regards the shorter brush-stroke and the reworking of outlines and hair in dark wash (see E.19 and E.20). Are we to infer that these are drawings executed before 1812 and subsequently included in this album?

F.58 [324] p. 436
"Man holding back a horse" – 1805-12? – 197 × 133 (vis.) – S – No. (S) – No. add. 31 (fine P), upper r. corner – *Paper:* horizontal chain lines – Mark A.B. (A. Beurdeley) – *Hist.:* Paris, Paul Lebas; APs. Paris, H.D. 3.4.1877, No. 47 "Le Cheval qui se cabre" → de Beurnonville (38 fr.); Ps. de Beurnonville, Paris, H.D. 16-19.2.1885, lot 49; Ps. Beurdeley, Paris, G. Petit, 2-4.6.1920, No. 175 → Le Garrec (3100 fr.); Worcester, Mass., F. Charming Smith, Jr.; Bradford, Pa., T. E. Hanley – New York, John D. Herring coll. – GW 1479

Here we have a composition whose dynamism is comparable to that of drawings F.51, F.56 and F.57, these last two immediately preceding it. The style, however, seems unusual for this album (on this point see the entry for F.57). The two opposing movements of the

horse, rearing and pulling away, and the man, pulling it back, give power to this drawing; the man's strenuous effort is particularly noticeable in the arm muscles and the position of the left leg bearing the whole weight of the body.

F.59 [325] p. 437

"Woman whispering to a priest" – 1812-23 – 205 × 143 – S – No. (S) – No. add. 35 (fine P), upper r. corner – *Paper:* horizontal chain lines (24 mm) – Mounted on pink paper – *Watermark:* F.II – *Hist.:* Javier Goya; Mariano Goya; V. Carderera; F. de Madrazo; Venice, Mariano Fortuny y Madrazo (Fortuny album) → 1935 – New York, Metropolitan Museum of Art, Harris Brisbane Dick Fund, 1935 (35.103.35) – GW 1480

In the Fortuny album, which was actually put together by Javier Goya (see general introduction), this drawing and F.55 (whose added numbers are 35 and 34 respectively) were placed side by side; and no wonder, the two scenes being so close in subject matter and chiaroscuro technique. The only difference is that here the light comes from an opening at the back, giving on a court or cloister. It is amusing to note the almost greedy expression on the priest's face as he listens to the young woman's secrets.

F.60 [326] p. 438

"Two men with bundles" – 1812-23 – 210 × 150 – S – No. (S) – No. add. 15 (fine P), upper centre – Inscription at the bottom of the sheet in another hand: "Les Portefaix" (Lp) – *Paper:* horizontal chain lines – *Watermark:* F.II – Mark E.C. (Lugt 837) – *Hist.:* Paris, Paul Lebas; APs. Paris, H.D. 3.4.1877, No. 34 "Les Portefaix" → de Beurnonville (15 fr.); Ps. de Beurnonville, Paris, H.D. 16-19.2.1885, lot 49 → E. Calando (320 fr. for 11 of the 18 drawings in the lot); Ps. Calando, Paris, H.D. 11-12.12.1899, No. 71; purchased by the present owner about 1947 in the South of France – France, priv. coll. – GW 1481

The theme of men carrying bundles appears twice in this album, here and in F.92; and the provenance of the latter is the same. The theme provides an apt illustration of physical exertion, for the legs of the man in the foreground, judging by their position, seem to be giving way under the weight of his load; in view of its small size, one can only suppose that it consists of very heavy objects, perhaps ore extracted from some workings in this mountain landscape through which the men are making their way. Its relief and movement make this very spare drawing

one of the finest in the album. The French title must have been inscribed on it before the 1877 sale, when it was repeated in the catalogue, like the titles of F.37, F.60, F.92 and F.106.

F.61 [327] p. 439

"Cavalier helping a woman to climb some steps" – 1812-23 – 208 × 142 – S – No. (S) – No. add. 32 (fine P), upper r. corner – *Paper:* horizontal chain lines – *Watermark:* F.II – *Hist.:* Paris, Paul Lebas (?); APs. Paris, H.D. 3.4.1877, No. 48 "L'invitation" → Féral (50 fr.) – France, priv. coll. – GW 1482

Several features of this drawing are odd, beginning with the man's dress, which is obviously not a Spanish costume of this period. The embroidery, the dolman, the breeches fitting the legs tightly from top to bottom, the sabre and the low, plumed hat make up an unusual costume which is more like the fancy dress of some stage performance. The young woman is dressed in normal fashion, with a generous *décolleté* and a small capote on her head. The gentleman politely offers his arm to help her up some broad steps arching over an empty space. Several figures in the middle distance look on with curiosity. It seems safe to say that this drawing corresponds to No. 48 of the 1877 catalogue, entitled *Une invitation,* in view of the parallelism that exists between the numbering of Javier Goya and that of the sale catalogue.

F.62? [328] p. 440

"Recumbent old man welcoming two visitors" – 1812-23 – *Hist.:* Javier Goya; F. de Madrazo; Saragossa, B. Montañés; Madrid, A. de Beruete; Berlin, Gerstenberg – Destroyed (1945) in Berlin, formerly Gerstenberg coll. – GW 1483

Of this drawing, destroyed in the fall of Berlin in 1945, all that remains is a photograph in the Moreno archives in Madrid. As regards the meagre information given by Lafond in 1907 (Bibl. 113), this refers vaguely to a single drawing in pen and Indian ink, whereas this is obviously a wash drawing with all the stylistic characteristics of album F (compare in particular with drawings F.19, F.20 and F.28). A lengthy pen inscription was blotted out by the thick wash applied at the top of the sheet; one can, however, make out a number 62 in the upper right corner. As for the subject, we once thought that it could be identified with the bloody tunic brought to Jacob (GW note 1483), but a better print of the Moreno photograph shows that the

two figures in the foreground are not bringing the old man anything in the way of a tunic, but rather separate objects hanging on a stick. The back-lighting is so strong that it is impossible to identify the objects. So it seems more prudent to regard these as anonymous figures; such, moreover, are more in keeping with Goya's usual choice of subject matter.

F.63　[329]　p. 441
'Man drinking from a wineskin" – 1812-23 – 205 × 143 – S – No. (S) – No. add. 36 (fine P), upper r. corner – *Paper:* horizontal chain lines – Mounted on pink paper – *Watermark:* F.II – *Hist.:* Javier Goya; Mariano Goya; V. Carderera; F. de Madrazo; Venice, Mariano Fortuny y Madrazo (Fortuny album) → 1935 – New York, Metropolitan Museum of Art, Harris Brisbane Dick Fund, 1935 (35.103.36) – GW 1484

This scene again takes up the theme of the wine-drinker of drawing E.24 in the Metropolitan Museum, but with important differences. Here the man is alone, kneeling on the floor, surrounded by what may be a crumpled blanket. There is no one to nag at him and remind him of the harmful results to which his addiction may lead. The drinker's gesture is identical in both drawings. Visible on the left are traces of an initial sketch in scumbles of sepia.

F.64　[330]　p. 442
"Glutton eating by himself" – 1812-23 – 203 × 141 – S – No. (S) – No. add. 68 (fine P), upper r. corner – *Paper:* horizontal chain lines – *Watermark:* F.III – *Hist.:* Paris, Paul Lebas; APs. Paris, H.D. 3.4.1877, No. 61 "Un Glouton" → de Beurnonville (9 fr.); Ps. de Beurnonville, Paris, H.D. 16-19.2.1885, lot 49; Mme Teynac; London, Mrs M. H. Drey (1964); Paris, P. Prouté – Williamstown, Mass., Sterling and Francine Clark A.I. (64.01) – GW 1485

After the excessive drinking, apparently harmless enough, of the peasant in the previous drawing, here is a picture of inveterate gluttony. In an interior sketchily indicated with a few light brushstrokes, possibly an inn, the man has settled himself in front of a platter and a large bottle. His dark coat is unbuttoned and drawn back on either side of a swelling paunch thrown into prominence by the white shirt. The rest of his body is of a piece with it: chubby face, plump hands and, so far as one can judge, fat legs. Note the pattern of tiny shirt folds just above the belt, neatly conveying the characteristic obesity of the glutton.

F.65　[331]　p. 443
"Nun frightened by a ghost" – 1812-23 – 205 × 145 – S – No. (P.S.) – No. add. 37 (fine P), upper r. corner – *Paper:* horizontal chain lines (24 mm) – Mounted on pink paper – *Watermark:* F.III – *Hist.:* Javier Goya; Mariano Goya; V. Carderera; F. de Madrazo; Venice, Mariano Fortuny y Madrazo (Fortuny album) → 1935 – New York, Metropolitan Museum of Art, Harris Brisbane Dick Fund, 1935 (35.103.37) – GW 1486

Remarkable use is made of the wash whose variations of intensity, in other words of concentration, bring out the contrast between the reality of the nun's figure and the eeriness of the apparition. The fright of the nun, as she starts up, is expressed both in her face and in the gesture of her right hand, a forcible equivalent of "Vade retro, Satana". But Goya adds the burlesque touch of an enormous, repulsively ugly ghost in the shape of a monk strumming a guitar – evidently a symbol of the forbidden pleasures that haunt the poor nun in her dreams.

F.67　[332]　p. 444
"Acrobats" – 1812-23 – 205 × 146 – S – No. (S) – No. add. 38 (fine P), upper r. corner – *Paper:* horizontal chain lines (25 mm) – Mounted on pink paper – *Watermark:* F.III – *Hist.:* Javier Goya; Mariano Goya; V. Carderera; F. de Madrazo; Venice, Mariano Fortuny y Madrazo (Fortuny album) → 1935 – New York, Metropolitan Museum of Art, Harris Brisbane Dick Fund, 1935 (35.103.38) – GW 1487

This is the second sheet in this album to represent acrobats (see F.7). Later, in Bordeaux, during his walks through the city, Goya took pleasure in watching these street performers, who figure frequently in one of the last two albums (H.40, H.41, H.45, etc.).

F.69　[333]　p. 445
"Beggar holding a stick in his right hand" – 1812-23 – 205 × 143 – S – No. (S) – No. add. 39 (fine P), upper r. corner – *Paper:* horizontal chain lines – Mounted on pink paper – *Hist.:* Javier Goya; Mariano Goya; V. Carderera; F. de Madrazo; Venice, Mariano Fortuny y Madrazo (Fortuny album) → 1935 – New York, Metropolitan Museum of Art, Harris Brisbane Dick Fund, 1935 (35.103.39) – GW 1488

We met in album C with several drawings of beggars, to which the captions imparted a social and political significance still closely related to the great ideals of the 18th century (C.1, C.5, C.17, C.22, etc.). All of

them figure in the first half of the album and probably date to the years 1803-12. Here we find in succession (F.69 and F.70) two types of beggar, each of whom may be considered the quintessence of his kind, independent of any ideological context: they are human beings pure and simple, as Goya was increasingly intent on representing them. The command of line and chiaroscuro in these two sheets is such that one is inevitably reminded of the artist whom Goya regarded as one of his masters: Rembrandt.

F.70 [334] p. 446

"Beggar holding a stick in his left hand" – 1812-23 – 205 × 143 – S – No. (S) – No. add. 40 (fine P), upper r. corner – *Paper:* horizontal chain lines – Mounted on pink paper – *Hist.:* Javier Goya; Mariano Goya; V. Carderera; F. de Madrazo; Venice, Mariano Fortuny y Madrazo (Fortuny album) → 1935 – New York, Metropolitan Museum of Art, Harris Brisbane Dick Fund, 1935 (35.103.40) – GW 1489

See entry for previous drawing.

F.71 [335] p. 447

"Waking from sleep in the open air" – 1812-23 – 205 × 146 – S – No. (S) – No. add. 41 (fine P), upper r. corner – *Paper:* horizontal chain lines – Mounted on pink paper – *Hist.:* Javier Goya; Mariano Goya; V. Carderera; F. de Madrazo; Venice, Mariano Fortuny y Madrazo (Fortuny album) → 1935 – New York, Metropolitan Museum of Art, Harris Brisbane Dick Fund, 1935 (35.103.41) – GW 1490

Although, in keeping with the rule we set ourselves, we have retained the title given to this drawing by H. B. Wehle (Bibl. 186, pl. XXXIX), we cannot altogether subscribe to his interpretation of this scene. In this wooded landscape – reminiscent of the one in F.32 – are three figures: a standing man combing his hair impassively; a woman sitting behind him with her knees drawn up, as if asleep; and lastly, forming a prominent oblique axis in the composition, the figure of another woman lying athwart the foreground, her skirts pulled up to the top of her thighs, so that all we can see of her is a pair of gleaming white legs pressed tightly together. I conclude that the only appropriate title would be: "After making love in the open air". Note the remarkable transparency of the sepia wash which, in this second half of the album, Goya has fully mastered.

490

F.72 [336] p. 448

"Peasant carrying a woman" – 1812-23 – 205 × 143 – S – No. (S) – No. add. 72 (on the verso) and 6 (on the mount) – *Paper:* horizontal chain lines (25 mm) – Mounted on pink paper – *Hist.:* Javier Goya; Mariano Goya; Román Garreta; F. de Madrazo; R. de Madrazo y Garreta → A. M. Huntington (1913) – New York, Hispanic Society of America (A.3315) – GW 1491

As Elizabeth du Gué Trapier has aptly pointed out (Bibl. 184, p. 18), this drawing owes much of its charm to the landscape setting. Following the scene of love-making in the open air (F.71), it shows a sturdy peasant lifting a woman across a watercourse, in such a way that one can hardly believe that it is only to keep her from getting wet. It looks more like an abduction, and this interpretation would seem to be borne out by the expression on the woman's face. The scumbling in the foreground, in vertical strokes, does not appear to be by Goya's hand, for these subsequent brushstrokes have only served to blot out a pen inscription faintly distinguishable underneath.

F.73 [337] p. 449

"Two men fighting" – 1812-23 – S – No. (S) – *Paper:* horizontal chain lines – *Hist.:* Javier Goya; V. Carderera; F. de Madrazo; R. de Madrazo y Garreta (?); Rome, Clementi Vannutelli (c.1875) – USA, priv. coll. – GW 1492

This drawing invites comparison with E.32, *Son coléricos* (They are angry), showing an equally furious tussle between two men. These two, scantily clad, seize each other violently: all the light impinges on the man seen from behind; the other, with his legs set wide apart, scowls at his antagonist. Deep shadows are cast on the ground beneath and behind them.

F.74 [338] p. 450

"Woman spanking another with a shoe" – 1812-23 – 205 × 141 – S – No. (S) – No. add. 16 (fine P) upper centre – Mark F.K. (Lugt 1023a) – *Paper:* horizontal chain lines (25 mm) – *Hist.:* Paris, Paul Lebas; APs. Paris, H.D. 3.4.1877, No. 35 "La Correction" → de Beurnonville (60 fr.); Ps. de Beurnonville, Paris, H.D. 16-19.2.1885, lot 49; Beaudoin; A. Strolin → L. Böhler (1908); F. Koenigs → 1927 – Rotterdam, Boymans-van Beuningen Mus. (S.17) – GW 1493

Here is another drawing forming a pair with the sheet that precedes it, but with a touch of humour fairly bold for the period. After a fight between two men, Goya shows a scuffle between two women: two totally

different styles of fighting. The men grapple with each other, the women resort to spanking. And here it is lustily administered with a shoe by this amazon of an unexpected type. Clothes and shadows are executed in dark wash so as to set off the white legs and buttocks of the victim. Legible at the bottom of the sheet is a pencilled inscription in French, "La correction", which must predate the 1877 sale, since it is reproduced in the catalogue.

F.75 [339] p. 451

"Old people singing and dancing" – 1812-23 – 200 × 140 – S + P – No. (S) – No. add. 34 (fine P), upper r. corner – *Paper*: horizontal chain lines – *Watermark*: F.I – *Hist.*: Paris, Paul Lebas; APs. Paris, H.D. 3.4.1877, No. 50 "Joyeuse compagnie" → Pascal (43 fr.); Ps. H. Rouart, Paris, Manzi-Joyant, 16-18.12.1912, No. 157 1º/ → Levesque (1850 fr. with 2º/) – Merion Station, Pa., Copyright 1973 by the Barnes Foundation – GW 1494

The most caricatural scene in the album, with F.35. This Andalusian fiesta forty years on is being enacted by four old people who seem to be having the time of their lives. The two old women on the right have broken into a dance, mimicking the classic steps of the fandango, clicking their castanets. In the background a guitarist and his companion, clapping his hands, set the rhythm of this grotesque ballet. In several parts of the drawing, but particularly in the two background figures, additions have been made with a pen by another hand.

F.76 [340] p. 452

"Group with a dishevelled woman" – 1812-23 – 206 × 145 – S – No. (S) – No. add. 42 (fine P), upper r. corner – *Paper*: horizontal chain lines (25 mm) – Mounted on pink paper – *Watermark*: F.I – *Hist.*: Javier Goya; Mariano Goya; V. Carderera; F. de Madrazo; Venice, Mariano Fortuny y Madrazo (Fortuny album) → 1935 – New York, Metropolitan Museum of Art, Harris Brisbane Dick Fund, 1935 (35.103.42) – GW 1495

A group of figures, consisting of women, children and an old man, has gathered in the open country round a young woman, in a plain white camisole, who is tearing her hair in despair; behind her, on the right, a pointing finger seems to indicate the cause of her emotion. But the strangest feature of this composition is the vast structure with a low dome flanked by a tower which can be seen lightly sketched in on the horizon. Its shape gives the scene a pronounced Oriental character, borne out, it would seem, by the costumes of the child in the foreground and the old man.

F.78 [341] p. 453

"Women and children by a wayside cross" – 1812-23 – 205 × 143 – S – No. (S) – No. post. 43 (fine P), upper r. corner – *Paper*: horizontal chain lines (24 mm) – Mounted on pink paper – *Watermark*: F.I – *Hist.*: Javier Goya; Mariano Goya; V. Carderera; F. de Madrazo; Venice, Mariano Fortuny y Madrazo (Fortuny album) → 1935 – New York, Metropolitan Museum of Art, Harris Brisbane Dick Fund, 1935 (35.103.43) – GW 1496

On the right stands a cross, probably in the vicinity of a town or village; and two women, out for a walk with their children, have stopped beside it. Each figure in this quiet scene has an attitude corresponding to the feelings of the moment: the seated woman is moved at the sight of the young mother coming up with her baby in her arms; the child on the right holds out its arms towards this unexpected "plaything", while the other little girl holds back timidly, clutching her mother's skirts. The perspective imparted to the whole composition by the arms of the cross gives a reverential aspect to this scene which, in itself, is commonplace enough.

F.79 [342] p. 454

"At the door of the baths" – 1812-23 – 204 × 141 – S – No. (S) – No. add. 35 (fine P), upper r. corner – *Paper*: horizontal chain lines – *Watermark*: F.II – *Hist.*: Paris, Paul Lebas; APs. Paris, H.D. 3.4.1877, No. 51 "Des Baigneurs" → de Beurnonville (80 fr.) Ps. de Beurnonville, Paris, H.D. 16-19.2.1885, lot 49; A. Strolin → 1907 – Berlin-Dahlem, Kupferstichkabinett (4397) – GW 1497

A thorough study of the 1877 sale catalogue (Bibl. 99) and the albums made up by Javier Goya leads me now to propose a new interpretation for this drawing. For the title given in the 1877 catalogue, "Some bathers", probably stems from an earlier tradition going back to Javier Goya himself; such is the case for other sheets figuring in that sale. Furthermore, the parallelism between the added numbers and the catalogue numbers of the sale justifies the identification (see in this connection the general introduction). Finally, looking closely at the figures coming out of this narrow door in a gleaming white wall, one sees that some of them are rubbing their arms or legs as if to dry themselves, while the man in the left foreground hugs himself as if for warmth. There is a sharp contrast between the

broad daylight outside, casting deep shadows on the ground, and the darkness inside the bathing house, where the men are packed together.

F.80 [343] p. 455

"Two prisoners in irons" – 1820-23 – 206 × 143 – S – No. (S) – No. add. 44 (fine P), upper r. corner – *Paper :* horizontal chain lines (24 mm) – Mounted on pink paper – *Watermark :* F.II – *Hist. :* Javier Goya; Mariano Goya; V. Carderera; F. de Madrazo; Venice, Mariano Fortuny y Madrazo (Fortuny album) → 1935 – New York, Metropolitan Museum of Art, Harris Brisbane Dick Fund, 1935 (35.103.44) – GW 1498

This drawing is probably the most accomplished of all those devoted by Goya to the victims of arbitrary rule. Comparing it with the sheets in album C dealing with similar scenes (e.g. C.100, C.103 and C.107), one is struck here by the perfect balance of the composition and above all by the different scale of the figures which gives the cell an unusual breadth. Equally remarkable are the quality of the wash and its variations in terms of the lighting in the different parts of the cell.

F.81 [344] p. 456

"Constable dragging a woman by the arm" – 1812-23 – 205 × 140 – S – No. (P.S) – No. add. 36 (fine P), upper r. corner – Mark E.C. (Lugt 837) – *Paper :* horizontal chain lines – *Watermark :* F.II – *Hist. :* Paris, Paul Lebas; APs. Paris, H.D. 3.4.1877, No. 52 " Une correction " → Barasgue (25 fr.); E. Calando – France, priv. coll. – GW 1499

As so often in this album, we meet here with two successive drawings that form a pair, with a theme in common: that of the intervention of a constable. The *alguazil* (constable) shown here seizes by the arm a woman who has fallen down, and is presumably a prostitute. In his fury, plainly written in his face, he has lost his hat which can be seen lying on the ground; but he has kept hold of his staff, the insignia of his office. For the identification of this sheet in the 1877 sale, see Bibl. 99, pp. 117-118, note r).

F.82 [345] p. 457

"Man interfering in a street fight" – 1812-23 – 205 × 143 – S – No. (P.S) – No. add. 45 (fine P), upper r. corner – *Paper :* horizontal chain lines (24 mm) – Mounted on pink paper – *Watermark :* F.II – *Hist. :* Javier Goya; Mariano Goya; V. Carderera; F. de Madrazo; Venice, Mariano Fortuny y Madrazo (Fortuny album) → 1935 – New York, Metropolitan Museum of Art, Harris Brisbane Dick Fund, 1935 (35.103.45) – GW 1500

The second street scene in which a constable intervenes. Here he wears a wig under his hat and we recognize a type of figure already met with in *Capricho 24,* the preparatory drawing for *Capricho 21* (GW 495) and drawing C.88. Raising his stick, he is about to strike two men who are savagely fighting together. For such fights, see sheet F.73 in this album. One can make out a few light brushstrokes belonging to an initial sketch of the scene. This drawing and the previous one forming a pair, both carry an autograph number written with a pen, not a brush, as was the case with the other drawings in this part of the album.

F.83 [346] p. 458

"Savages in a cave" – 1812-23 – 205 × 140 – S – No. (S) – No. add. 67/37 (fine P), upper r. corner – Mark E.C. (Lugt 837) – *Paper :* horizontal chain lines – *Hist. :* Paris, Paul Lebas; APs. Paris, H.D. 3.4.1877, No. 60 " Sauvages dans une grotte " → de Beurnonville (40 fr.); Ps. de Beurnonville, Paris, H.D. 16-19.2.1885, lot 49 → E. Calando (320 fr. for 11 drawings from this lot); Ps. E. Calando, Paris, H.D. 11-12.12.1899, lot 71; Paris, priv. coll.; Anon. Ps. London, Christie's 20.3.1973, No. 157 – GB, priv. coll. – GW 1501

This scene with savages may be compared with those in the paintings GW 922 to 927, already cited in connection with drawing F.57 in this album. The setting is roughly the same: the mouth of a cave, with strong chiaroscuro effects. Here an unruly pack of savages brings a man in a long white garment (perhaps a missionary?) into the cave to the leader of the tribe, draped in an ample robe and wearing a mitre on his head. Are these the relics of a bishop who has already been massacred? If this were so, then the subject of the paintings referred to above would have to be reconsidered. (See in this connection Bibl. 22, No. 103 and Bibl. 77, Nos. 23 and 24.)

F.86 (cut down) [347] p. 459

Muerte del Alguacil Lampiños, por per/seguidor de estudiantes, y mugeres de fortuna,/las q.ᵉ le hecharon una labatiba con cal viva (P.S) (Death of Constable Lampiños because he persecuted students and women of the town who gave him a douche of quicklime) – 1812-23 – 205 × 145 – S – No. (S) – No. add. 49/23 (fine P), upper r. corner – *Paper :* horizontal chain lines (24 mm) – Mounted on pink paper – *Watermark :* F.III – *Hist. :* Javier Goya; Mariano Goya; V. Carderera; F. de Madrazo; Venice, Mariano Fortuny y Madrazo (Fortuny album) → 1935 – New York, Metropolitan Museum of Art, Harris Brisbane Dick Fund, 1935 (35.103.49) – GW 1502

Several drawings in this album, like this one, bear (or bore, before it was rubbed out) a caption, often quite lengthy, written at the top of the sheet: F.16, F.38, F.62 and F.a. Though unusual in this album, these inscriptions seem indeed to be in Goya's hand, but they must have been added some time after the execution of the drawing. This Constable Lampiños might well be the same man as in sheets 81 and 82; judging by his actions there, he does not seem to have been particularly tender-hearted. But the anecdotal importance of this personage is, I find, confirmed by a reference in the 1877 catalogue to a drawing, now lost, which bore an autograph caption relating to him: "Constable Lampiños sewn up in the hide of a dead horse" (Bibl. 99, p. 113 and p. 118, note v). The latter scene probably occupied a position in album F close to this sheet, being perhaps 84 or 85; and, if my cross-checkings are correct, it bore the added number 25 in the upper right corner.

F.87 [348] p. 460

"Woman murdering a sleeping man" – 1812-23 – 205 × 143 – S – No. (S) – No. add. 46 (fine P), upper r. corner – *Paper*: horizontal chain lines (24 mm) – Mounted on pink paper – *Watermark*: F.III – *Hist.*: Javier Goya; Mariano Goya; V. Carderera; F. de Madrazo; Venice, Mariano Fortuny y Madrazo (Fortuny album) → 1935 – New York, Metropolitan Museum of Art, Harris Brisbane Dick Fund, 1935 (35.103.46) – GW 1503

This is the second murder scene in this album. The first (F.53) was the tragic outcome of a clash between two men, whereas this one is particularly odious, the victim lying asleep and the aggressor being a woman. All the details recorded by Goya go to show the milieu and circumstances in which the crime is taking place: the man is a woodcutter, sleeping peacefully with his head on a faggot; tree-trunks lying in the foreground show that he has paused for a rest in the midst of his work, leaving his basket and particularly his axe beside him unsuspectingly. In an instant the woman will bring the axe crashing down upon him and all will be over.

F.88 [349] p. 461

"The tambourine player" – 1812-23 – 205 × 141 – S – No. (S) – No. add. 17 (fine P), upper centre – Mark E.C. (Lugt 837) – *Paper*: horizontal chain lines (24 mm) – *Watermark*: F.I – *Hist.*: ? Paris, Paul Lebas; APs. Paris, H.D. 3.4.1877, No. 38 (?) "Le Rendez-vous" → de Beurnonville (50 fr.); Ps. de Beurnonville, Paris, H.D. 16-19.2.1885,

lot 49 → E. Calando (320 fr. for 11 of the 18 drawings in this lot); Ps. Calando, Paris, H.D. 11-12.12.1899, No. 70 "Le crieur" (245 fr. for lot of 4 drawings); purchased by the present owner about 1947 in the South of France – France, priv. coll. – GW 1504

In the catalogue of the Calando sale this drawing is called "The crier" and indicated as coming from the 1877 sale; but no title in the latter catalogue seems to fit this subject. On the evidence of the added number, however, one might tentatively identify it with No. 38 *The rendezvous*, a title answering to the role of the town-crier who calls the citizens together to announce news of local interest. But one cannot dismiss the possibility that it represents a regional dance, perhaps of the Basque country. In this case the drawing would form a pair with the next one, which obviously represents a provincial dance.

F.89 [350] p. 462

"Provincial dance" – 1812-23 – 206 × 143 – S – No. (S) – No. add. 47 (fine P), upper r. corner – *Paper*: horizontal chain lines – Mounted on pink paper – *Hist.*: Javier Goya; Mariano Goya; V. Carderera; F. de Madrazo; Venice, Mariano Fortuny y Madrazo (Fortuny album) → 1935 – New York, Metropolitan Museum of Art, Harris Brisbane Dick Fund, 1935 (35.103.47) – GW 1505

This lively dance is not an impromptu: a guitarist in the right background is singing and accompanying the pair of dancers who have put on their finest clothes. Both are young, and they are probably engaged; he has a smiling, happy face, she has her eyes modestly downcast. One is struck by the difference in their attitudes: the girl seems to dance reluctantly, resignedly, while he is moving with springy steps, not without a certain awkwardness, but with an air of self-satisfaction. Between the couple, in the background, appear two smiling onlookers. There are faint traces of an initial sketch of the male dancer, with his head erect and his left foot touching the ground. See the previous entry for a possible connection between the two subjects.

F.91 [351] p. 463

"Woman and two men with a cart" – 1812-23 – 204 × 142 – S – No. (S) – No. add. 20 (fine P), upper r. corner – *Paper*: horizontal chain lines – *Hist.*: ? Paris, Paul Lebas; APs. Paris, H.D. 3.4.1877, No. 41 "Villageois en voyage" → de Beurnonville (28 fr.); Ps. de Beurnonville, Paris, H.D. 16-19.2.1885, lot 49; A. Strolin → 1907 – Berlin-Dahlem, Kupferstichkabinett (4398) – GW 1506

The peculiarity of this village scene is that, of the three figures represented, not a single face is visible. The two men, in back view, bustle about their cart, one wheel of which can be seen. The woman stands in the foreground, in side view, but wrapped in her travelling clothes, with a shawl completely hiding her head; she holds in front of her a large bundle which seems to be quite heavy. It must be admitted that this composition lacks the qualities of balance and vigour to which one is accustomed in this album.

F.92 [352] p. 464

"Man with an enormous bundle" – 1812-23 – 205 × 140 – S – No. (P.S) – No. add. trimmed off, 66? (fine P), upper r. corner – "Le portefaix" (Lp) in another hand – Mark E.C. (Lugt 837) – *Paper:* horizontal chain lines (24 mm) – *Hist.:* Paris, Paul Lebas; APs. Paris, H.D. 3.4.1877, No. 59 "Un Portefaix" → de Beurnonville (25 fr.); Ps. de Beurnonville, Paris, H.D. 16-19.2.1885, lot 49 → E. Calando (320 fr. for 11 drawings out of 18 in this lot); Ps. E. Calando, Paris, H.D. 11-12.12.1899, lot 70 (245 fr. for lot of 4 drawings) – France, priv. coll. – GW 1507

For the second time in this album Goya depicts a porter with his load – an image of the hardest, most primitive kind of work there is. The first (F.60) showed two men in back view carrying heavy bundles; they were like two anonymous beasts of burden. This one shows a single porter, but one so much weighed down by his huge load that his faceless body is reduced to a pair of hands and legs supporting his monstrous burden. The size of the patch of shadow is in keeping with that of this fabulous mushroom. The French title "Le portefaix" has been written on the sheet in pencil; similar inscriptions figure on other drawings in this album (F.37, F.60, F.74 and F.106).

F.93 [353] p. 465

"Woman handing a mug to an old man" – 1812-23 – 206 × 143 – S – No. (S) – No. add. 48 (fine P), upper r. corner – *Paper:* horizontal chain lines (24 mm) – Mounted on pink paper – *Watermark:* F.I – *Hist.:* Javier Goya; Mariano Goya; V. Carderera; F. de Madrazo; Venice, Mariano Fortuny y Madrazo (Fortuny album) → 1935 – New York, Metropolitan Museum of Art, Harris Brisbane Dick Fund, 1935 (35.103.48) – GW 1508

An admirable scene of charity, its vigorous modelling recalling that of F.40 and 55. The pathetic face of the emaciated old man is raised towards the woman, who is handing him something to drink, with the anguished avidity of the dying; this scene, which Goya has charged with compassionate tenderness, is watched from a distance by a figure (or two figures?) roughly sketched in on the right. The vault or arch at the top of the composition recalls those which we have already seen in this album in F.19, F.20 and F.28. But the shaded area just over the woman's head appears to have been added later to conceal an inscription still faintly distinguishable in places. Only the darker patch to the right belonged, presumably, to the original drawing. F.62 and F.a show, even more distinctly, a similar patch of sepia laid in over an inscription which Goya (or someone else?) wished to obliterate.

F.94 [354] p. 466

"The widow" – 1812-23 – 205 × 145 – S – No. (S) – No. add. 69 (fine P), upper r. corner – Mark E.C. (Lugt 837) – *Paper:* horizontal chain lines – *Watermark:* F.I – *Hist.:* ? Paris, Paul Lebas; APs. Paris, H.D. 3.4.1877, No. 62 "Une jeune femme" → de Beurnonville (30 fr.); Ps. de Beurnonville, Paris, H.D. 16-19.2.1885, lot 49 → E. Calando (320 fr. for 11 out of 18 drawings in this lot); Ps. E. Calando, Paris, H.D. 11-12.12.1899, lot 71 (245 fr. for lot of 4 drawings) – France, priv. coll. – GW 1509

This drawing affords a most interesting comparison with a sheet in the Madrid album which, several years earlier, dealt with the same subject (see B.50): a young woman in tears wringing her hand with grief, while a little dog tugs at the hem of her skirt. One notes first of all the great advance made by Goya's art in the interval between these two works. There is a lack of elasticity in the first woman, standing stiffly upright in her unyielding dress, while the supple forms of the second convey a real impression of overwhelming suffering. But there is something more: in the first drawing the body of a man lying on the ground behind some shrubbery justified the young woman's grief; in the second the cause has completely disappeared. Now even the dog can scarcely be distinguished in the dark patches of sepia wash, above which a few branches still appear, devoid of support. From this, I think we may conclude that the composition has been sweepingly modified by an unskilled hand. If these formless masses of shadow are closely examined, they are seen to be coarsely executed in order to blot out the original background of the drawing which undoubtedly, as in B.50, provided an explanation of the scene. How is this daubing to be accounted for? We shall probably never know.

F.97 [355] p. 467
"Hunter shooting birds" – 1812-23 – 207 × 146 – S
– No. (S) – No. add. 43 (fine P), upper r. corner – Mark
F.K. (Lugt 1023a) – *Paper:* horizontal chain lines (25 mm)
– *Watermark:* F.I – *Hist.:* Paris, Paul Lebas; APs. Paris,
H.D. 3.4.1877, No. 56 "Chasseur visant un oiseau"
→ Pacat d'Yenne (16 fr.); Baudouin; A. Strolin
→ F. Koenigs (1908) – Rotterdam, Boymans-van Beuning-
en Museum (S.16) – GW 1510

The last nine drawings in this album form a homogen-
eous group devoted to hunting. This one corresponds
unmistakably to No. 56, "Hunter taking aim at a
bird", in the catalogue of the 1877 sale. After a lapse
of some forty years, it harks back to one of the first
tapestry cartoons, *The quail shoot* (GW p. 44), in which
the hunter on the left levels his gun very much like
this man. But it is particularly interesting to compare
the preparatory drawing of 1775 (GW 65) with this
one; it is scarcely surprising that some of these early
studies by Goya should have been attributed to his
brother-in-law Bayeu.

F.98 [356] p. 468
"Hunter raising his gun" – 1812-23 – 207 × 146 – S
– No. (S) – *Paper:* horizontal chain lines (24 mm) – *Water-
mark:* F.II – *Hist.:* Paris, Paul Lebas; APs. Paris, H.D.
3.4.1877, No. 57 (?) "Autre chasseur" → de Beurnonville
(14 fr.); Ps. de Beurnonville, Paris, H.D. 16-19.2.1885,
lot 49; Boston, Boris Mirski; Philip Hofer → 1954
– Cambridge, Mass., Harvard University, Fogg Art
Museum (1954.30), Gift of Mr. and Mrs. Philip Hofer
– GW 1511

Hard by a wood, sketched in on the horizon, the
hunter has taken up a position behind a boulder and,
tensed and alert, he keeps a sharp eye on the game,
ready to level his gun. With a few rapid strokes of the
brush Goya has laid in this figure, whose accoutrement
is familiar to him: cartridge pouch, knapsack and
leggings. One also notes the flexibility of his technique:
fine lines drawn with the tip of the brush (the hunter's
coat and the top of the boulder); broadly applied
washes for more or less intense shading (hair, trousers,
leggings); and scumbling with an almost dry brush
(field or meadow on the left).

F.99 [357] p. 469
"Hunter loading his gun" – 1812-23 – 205 × 142 – S
– No. (S) – No. add. 18 (fine P), upper centre – Mark E.C.
(Lugt 837) – *Paper:* horizontal chain lines – *Watermark:*
F.II – *Hist.:* Paris, Paul Lebas; APs. Paris, H.D. 3.4.1877,
No. 36 (?) "Le chasseur" → de Beurnonville (30 fr.);

Ps. de Beurnonville, Paris, H.D. 16-19.2.1885, lot 49
→ E. Calando (320 fr. for 11 drawings out of 18 in the lot);
Ps. E. Calando, Paris, H.D. 11-12.12.1899, lot 70 (245 fr.
for lot of 4 drawings) – France, priv. coll. – GW 1512

One notes that this hunter, like others in this final
group of drawings in album F, receives a shaft of
bright light on the upper part of his body, while his
legs remain in shadow (see F.97, F.98 and F.102). This
play of light and shade imparts a vigorous modelling
to the figures; at the same time it conveys a sharp
sense of the open air and sunlight. The dog watches its
master load his gun, expectantly waiting for the game
which, apparently, is not yet in sight. To the left of the
legs are faint traces of an initial sketch.

F.100 [358] p. 470
"Hunter and his dog on the alert" – 1812-23 – 205 × 147
– S – No. (S) – *Paper:* horizontal chain lines (25 mm)
– Mounted on pink paper (335 × 246) – *Watermark:* F.II
– *Hist.:* Javier Goya; Mariano Goya; V. Carderera; F. de
Madrazo; Venice, Mariano Fortuny y Madrazo; Señora
Fortuny – Italy, priv. coll. – GW 1513

Among the drawings of hunters at the end of this
album, this one and F.104 are the only two which
never formed part of Javier Goya's albums. One can-
not help noticing that its execution does not achieve
the extraordinary harmony of, for example, F.97
and F.99. This may be why it was eliminated from
Javier's albums. One is struck, however, by the sturdy
figure and rugged features of this peasant; on the
right, a woodcock can be seen hanging from his
belt.

F.101 or 102? [359] p. 471
"Hunter with his dog running" – 1812-23 – 205 × 142 – S
– *Paper:* horizontal chain lines – *Watermark:* F.II – *Hist.:*
Paris, Paul Lebas; APs. Paris, H.D. 3.4.1877, No. 58
"Chasseur au marais et son chien" → E. Féral (15 fr.);
Lucerne, Ps. Wendland; L. Böhler – France, priv. coll.
– GW 1514

The ground over which the hunter and his dog are
moving is drawn with sufficient care for us to see
clearly that it is marshland, into which the feet sink
amidst the long marsh grass. The bearing of the
figure, seen full face, is particularly fine, and the eyes,
shadowed over by the hat, seem to be scanning the
horizon in search of game. The long streaks of wash in
the background, of the same intensity as those in the
foreground, probably indicate the boundaries of the
marsh.

F.103 [360] p. 472
" Rabbit hunter with retriever " – 1812-23 – 206 × 146 – S – No. (S) – No. add. 22 (fine P), upper r. corner – *Paper:* horizontal chain lines – Mounted on pink paper – *Hist.:* Javier Goya; Mariano Goya; V. Carderera; F. de Madrazo; Venice, Mariano Fortuny y Madrazo (Fortuny album) → 1935 – New York, Metropolitan Museum of Art, Harris Brisbane Dick Fund, 1935 (35.103.22) – GW 1515

This is the most fully developed landscape to be found in these drawings of hunters. Thick foliage goes to form a substantial background which, beginning on a nearer plane to the left, extends to the horizon on the right, thus giving depth and sweep to the setting. This impression is heightened by the knoll on which the hunter and his dog are standing: the latter, coming to a halt on the higher level of ground, has retrieved a rabbit, and its master, on the lower level, is leaning down and seems to be urging the dog to drop its prey.

F.104 [361] p. 473
" Hunter loading his gun " – 1812-23 – S – No. (S) – *Paper:* horizontal chain lines – *Hist.:* Javier Goya; V. Carderera; F. de Madrazo; R. de Madrazo y Garreta (?) → Clementi Vannutelli (c. 1875) – USA, priv. coll. – GW 1516

The main figure, shown full face, is loading his gun with a ramrod. He is carrying a knapsack. Shading is indicated with rapid, spirited brushstrokes, heightened with a few lines in darker wash. His two companions, sitting on the ground behind him, are taking refreshment: the man on the right, in side view, is drinking from a bottle; the other seems to be eating something. There is a sharp contrast between the shading on the hunter's trousers and the two brightly illuminated figures behind him. No definite information about this drawing has been obtainable since it left Italy.

F.105 [362] p. 474
" Bird hunters with decoy " – 1812-23 – 205 × 143 – S – No. (S) – No. add. 23/49 (fine P), upper r. corner – *Paper:* horizontal chain lines (25 mm) – Mounted on pink paper – *Watermark:* F.III – *Hist.:* Javier Goya; Mariano Goya; V. Carderera; F. de Madrazo; Venice, Mariano Fortuny y Madrazo (Fortuny album) → 1935 – New York, Metropolitan Museum of Art, Harris Brisbane Dick Fund, 1935 (35.103.23) – GW 1517

This is the only scene with two hunters; hiding behind some bushes, they are manœuvring a decoy to attract winged game, possibly larks. A flight of birds is wheeling in the sky overhead. The amazing lifelikeness of the attitudes devised by Goya is beyond praise: working at home from memory, he recreated all these scenes as if they had been taken from life.

F.106 [363] p. 475
" Le chasseur à l'affût " (Lp) in another hand (Hunter in ambush) – 1812-23 – 200 × 143 – S – No. (S) – No. add. 19 (fine P), upper centre – Mark E.C. (Lugt 837) – *Paper:* horizontal chain lines – *Hist.:* Paris, Paul Lebas; APs. Paris H.D. 3.4.1877, No. 37 " Le Chasseur à l'affût " → de Beurnonville (20 fr.); Ps. de Beurnonville, Paris, H.D. 16-19.2.1885, lot 49 → E. Calando (320 fr. for 11 out of 18 drawings in the lot); Ps. E. Calando, Paris, H.D. 11-12.12.1899, lot 70 (245 fr. for lot of 4 drawings); Paul Brame; New York, Paul Rosenberg and Co. – New York, E. V. Thaw coll. – GW 1518

Here is the last in this group of hunting scenes, anyhow in the present state of the album. Hiding behind a boulder, his gun pointing to the sky, the hunter lies in wait with his dog at his feet. The lights and shadows in this composition are distributed with a certain disconnectedness; there seems no reason, for example, why the trousers should be so darkly shadowed over and the jacket so gleamingly white. The boulder is sketchily drawn. In short, the finer graphic qualities of the rest of the album are lacking here.

F.a [364] p. 476
" Anglers " – 1812-23 – 195 × 135 – S – Long, partly illegible inscription in another hand at the top of the sheet, under the large patch of sepia wash; it consists of six lines written with a pen, only the opening words of the lines being legible: " En el dia 1.º de Junio de 1799 . . ./10 acciones . . ./renobaz.on . . ./mismo; y se cobraron . . ./en el dia 1.º de Julio del mismo año . . ." (On the 1st of June 1799 . . ./10 shares . . ./renewal . . ./same; and paid over . . ./on the 1st of July of the same year . . .) – *Paper:* horizontal chain lines – *Watermark:* F.I – *Hist.:* Fairfax Murray; Ps. Oppenheimer, London, Christie's, 10.7.1936, lot 449 – New York, Frick coll. (A.412) – GW 1455

The composition of this drawing, with an extensive background wash occupying one side and the whole upper part of the sheet, recurs in several other drawings in this album: F.19, F.20, F.21, F.28, F.36, F.37, F.59, F.62, F.83 and F.93. This ominous shadow often takes the form of a vault or arch, as here, but on this sheet we also find a long inscription, apparently not by Goya, covered over with several successive coats of wash. Dated 1799, it refers to financial transactions, perhaps to some shares in the bank of San Carlos

which Goya owned. Similar inscriptions can be divined under the wash at the top of drawings F.62 and F.93; presumably Goya made these drawings on sheets of paper which had already been used for other purposes. Here the arch of the bridge fits in perfectly with this picture of anglers which, we may note, links up with the group of hunters in this album just as these two themes were linked up in one of Goya's earliest tapestry cartoons in 1775 (GW 66).

Lost drawings

F.b "Submission" – *Hist.*: Paris, Paul Lebas; Ps. Paris, H.D. 3.4.1877, No. 30 → E. Calando (31 fr.)

F.c "Repentance" – *Hist.*: Paris, Paul Lebas; Ps. Paris, H.D. 3.4.1877, No. 39 → bought back for 21 fr.

F.d "Constable Lampiños sewn into the hide of a dead horse" – *Hist.*: Paris, Paul Lebas; Ps. Paris, H.D. 3.4.1877, No. 42 → bought back for 27 fr.

For further reference to this lost drawing, see the entry for F.86.

F.e "A wounded man" – *Hist.*: Paris, Paul Lebas; Ps. Paris, H.D. 3.4.1877, No. 45 → E. Féral (20 fr.)

I mistakenly believed that this drawing could be identified with F.43 (Bibl. 99, p. 113), since the title given in the catalogue of the 1877 sale corresponds to the scene represented. But an inscription on the back of this drawing records that it was given by Raimundo de Madrazo himself, in 1895, to the collector J. P. Heseltine, thus ruling out its presence in the 1877 sale.

F.f "A reproof" – *Hist.*: Paris, Paul Lebas; Ps. Paris, H.D. 3.4.1877, No. 46 → E. Féral (30 fr.)

For this drawing and others with a similar title, see Bibl. 99, pp. 117-118, note r.

F.g "A critical situation" – *Hist.*: Paris, Paul Lebas; Ps. Paris, H.D. 3.4.1877, No. 49 → E. Féral (30 fr.)

F.h "Eagle hunter" – *Hist.*: Paris, Paul Lebas; Ps. Paris, H.D. 3.4.1877, No. 53 → E. Calando (11 fr.)

F.i "A sculptor" – *Hist.*: Paris, Paul Lebas; Ps. Paris, H.D. 3.4.1877, No. 54 → de Beurnonville (26 fr.); Ps. de Beurnonville, Paris, H.D. 16-19.2.1885, lot No. 49. This drawing may have been purchased either by E. Calando, with 10 others (320 fr.), or by Maurice de Beurnonville, with 5 others (180 fr.)

F.j "Hunter and his dog" – *Hist.*: Paris, Paul Lebas; Ps. Paris, H.D. 3.4.1877, No. 55 → de Beurnonville (15 fr.); Ps. de Beurnonville, Paris, H.D. 16-19.2.1885, lot No. 49. This drawing may have been purchased either by E. Calando, with 10 others (320 fr.), or by Maurice de Beurnonville, with 5 others (180 fr.)

F.k "Procession with a Madonna" – *Hist.*: Paris, Paul Lebas; Ps. Paris, H.D. 3.4.1877, not catalogued, but figures in the sales records under the number 106, untitled, sold to de Beurnonville for 22 fr.; Ps. E. Calando, Paris, H.D. 11-12.12.1899, lot 71 (245 fr. for lot of 4 drawings).

The catalogue of the E. Calando sale records the fact that the eighteen drawings forming lots 67 to 75 inclusive came "from the sale of the Album of 106 drawings by Goya" (1877 sale). From this information and further cross-checking, I have been able to prove that this drawing alone, from lot 71, "Procession with a Madonna", could correspond to No. 106 of the 1877 sale. The same deductions lead me to believe that this drawing bore the autograph number 84 of album F.

Bordeaux Albums (G and H)

Introduction

With albums G and H, this cycle of Goya drawings comes to an end in a curiously symmetrical fashion, as it had begun thirty years before with the Sanlúcar and Madrid albums: two albums closely related to each other, being alike in the medium employed, in their paper and format (this, however, was not the case with the first two), and in the fact that they fall within a well-defined period of time and were produced with a view to a series of etchings or lithographs. But while the first two and the last two albums also balance each other numerically, there being about one hundred and twenty drawings in each set, they are very different in technique and style. The difference is all the more striking because some of the early subjects reappear in these Bordeaux albums, and we find now so thorough a transmutation of the means of expression that we might almost imagine ourselves in the presence of two distinct artists working in a completely different spirit at two completely different periods. Just as in the Sanlúcar album Goya had inaugurated the highly original procedure (see introduction to album A) of working in Indian ink wash alone, so in albums G and H for the first time he employed black chalk in conjunction with the lithographic crayon. Though he had brought the brush and wash technique to a rare degree of perfection, both in Indian ink and in sepia, and it would have been easy for him to carry on in these media in which he had made himself so proficient, yet, at the age of nearly eighty, he chose to try his hand at a wholly new medium which he mastered at once.

There would appear, however, to be a definite reason for this drastic change of technique, and to my mind it may be summed up in one word: lithography. At the same time, we shall see that the reason behind this change also goes to confirm the now unanimously accepted dating of these two albums to the Bordeaux period (1824-28). For it is important to remember certain circumstances connected with Goya's journey to France and to Paris in particular. Of course there were political and emotional reasons for his departure from Spain; but, leaving these aside, it has always seemed a matter for surprise that he should have left so hastily for Paris only three days after his arrival in Bordeaux, when the official purpose of his journey to France was of a medical nature and his poor health – natural enough at the age of seventy-eight – undoubtedly called for rest and medical care. So the question arises: why did Goya hurry off to Paris? True, there was the attraction of "that great Court", as he called it in a letter to his friend Ferrer, and his eagerness to see the monuments and works of art which he must often have heard about from so many French and Spanish friends; perhaps, too, the nostalgic desire to look up old acquaintances of the past, like the jurist González Arnao, a friend of Moratín as early as the time of the *Caprichos,* later Prefect of Madrid under Joseph Bonaparte and now occupying an important position in Paris where his *salon* was much frequented; the Countess of Chinchón, of whom he had made two dazzling portraits (GW p. 19 and p. 59); the Marchioness of Pontejos, whom he had portrayed in all the glory of her youthful beauty (GW p. 62); the Duke of San Carlos (GW 1542 to 1544); the Duchess of Híjar; and Joaquín Ferrer and his wife, whose portraits he was now to paint in Paris (GW 1659 and 1660). But the name that gives the key to his hasty journey to Paris is that of José María Cardano, "friend Cardano", as he calls him in his letters. Director of the first lithographic printing works opened in Madrid in 1819, Cardano had initiated Goya into this new technique, which he had learned himself in Paris the previous year from men who were already experienced lithographers, such as Carle and Horace Vernet. But Goya's first attempts in this new medium,

printed by Cardano, were rather crude, the only process employed in Madrid at that time being transfer lithography, the drawing being done with brush or pen on paper and then transferred to the stone. In 1823, after the re-establishment of Ferdinand VII, Cardano left Spain and settled in Paris. It has been pertinently assumed (Bibl. 92, pp. 327-332), on the strength, moreover, of information given by Matheron (Bibl. 137, p. 89), that one of the purposes of Goya's journey to Paris was to meet Carle and above all Horace Vernet, whom Cardano had told him about and whom his Spanish friend could have introduced him to at this time (July-August 1824). From the French artists he learned the technical process which enabled him to carry lithography to its highest point of perfection: drawing directly on the stone with the greasy crayon known as a lithographic crayon. Unlike transfer lithography, in which fine gradations of tone and line are lost, this process gave the line a vigour and spontaneity perfectly suited to Goya's temperament. It was the only process he was to use in Bordeaux, notably in the famous plates of the *Bulls of Bordeaux* (GW p. 347) and the extraordinary portrait of Gaulon (GW p. 345) (cf. Bibl. 97, pp. 345-349). It is significant, moreover, that the 1824 Salon in Paris, where Goya could have seen Delacroix's *Massacre of Chios* and some canvases by Constable, was the first in which an independent section was devoted to lithography.

On his return to Bordeaux, where he settled for good with Leocadia Weiss and two of her children, he made the acquaintance of Gaulon, a printer who had opened a lithographic printing plant there in 1818 and who was therefore well versed in all the technical requirements of such work. With Gaulon's help, he began practising the technique of the greasy crayon which he had discovered in Paris, and it was Gaulon who printed his lithographs, in particular the *Bulls of Bordeaux*. No wonder, then, that at the same time he began drawing on paper with the same crayons he used on his lithographic stones: lithography now played roughly the same part that aquatint had played in 1797 at the time of the *Caprichos*. Passionate by nature as he was – passionate and headstrong, as the Aragonese are said to be – he could now conceive of no other possible means of expression than the one to which all his energies were directed. Hence his complete abandonment of wash drawing in favour of black chalk and litho crayons. And even though none of the one hundred and twenty or so drawings in the two Bordeaux albums resulted in a lithograph – but, for three of them (H.22, H.32 and H.58), in mediocre etchings – the similarity of technique between these drawings and his lithographs is such that in executing the former he must have had the latter continually in mind.

To Carderera, once again, we owe the first reference to certain sheets in these two series. After referring to the Fortuny album, and in particular to the sepia drawings, which he dated to 1819, he added: "The ones that follow must have been done in Bordeaux. Twenty-four are in black chalk on small quarto sheets. One notes among them two French ladies at Mass; a condemned man walking to the guillotine accompanied by a priest, with this epigraph, *French penalty,* and another drawing, also with these manuscript words, *Mad woman who sells delights: she is French.*" It is interesting to note that Carderera refers to a lot of twenty-four drawings, three of them described with precision (H.62, G.49 and G.45), which later formed part of the Beruete-Gerstenberg collection, now destroyed. This collection, which actually included more than twenty-four drawings, was then in the possession of Federico de Madrazo, at whose house Carderera could have seen them, without recalling the exact number of sheets comprised in the collection.

The most important later publication – though issued in a very limited edition – for our knowledge of these Bordeaux drawings is that of Paul Lafond in 1907 (Bibl. 113), to which the author gave the title *Nouveaux Caprices de Goya*. It contained high-quality reproductions of all the drawings in the Beruete collection, i.e. thirty-one sheets from albums G and H. As for Lafond's introductory text, its only interest lies in the particulars it gives concerning the provenance of this lot. For the rest, it is only a confused medley of information, with, by way of conclusion, one of the most astonishing misconceptions to which Goya's art has ever given rise: "Virtually unresponsive to new sensations and things, he takes his stand solely on the past." It is noteworthy that Lafond, like so many other authors after him, published these drawings pell-mell, without realizing that they belonged to two distinct series.

Mayer was the first to suspect the existence of these two albums, and he was honest enough to admit to his doubts and difficulties when it came to dividing the drawings between the two series (Bibl. 144). He thought for a time that there might even be three series; but finally the existence of two sets of numbers convinced him that there were certainly two. He tried hard to sort out the main themes but in the end proposed no particular order for them. The great merit of his study lay in making known an extensive lot of black chalk drawings which were then in a private collection in Lausanne and came from the Hyadès-Boilly album, which will be dealt with presently.

When in 1947 I published the Prado drawings, I came up against the same problem as Mayer: according to what criterion should the drawings be classified and in how many distinct series? With the experience of the previous albums behind me (Sanlúcar and Madrid, then C and F), where the presence of captions was an important distinctive sign, I envisaged the existence of one album without captions and another with captions. The Prado drawings and those of the Gerstenberg collection (formerly Beruete, published by Lafond) permitted fairly stable lists to be drawn up, but in places those lists were inexact because the number of missing sheets was still quite large. Certain repeated numbers in particular, in the album with captions, brought an element of confusion into these series which, until then, it had seemed possible to reconstruct without the least distortion. It became evident that the two Bordeaux albums did not have the same homogeneity as the others and that a larger number of drawings would be required before a definitive classification could be attempted.

WATERMARKS

Fragment of GH.I *Fragment of GH.II* *Fragment of GH.III*

This was done in 1958 by Enrico Crispolti (Bibl. 86, pp. 129-132) who, though he did not reproduce them, succeeded in drawing up two much more substantial lists, thanks to the discoveries made in recent years (Boston exhibition in 1955, drawings from the Berlin museum, the National Gallery of Canada and the Fitzwilliam Museum in Cambridge). Finally, the two almost complete albums were reproduced in my 1970 catalogue (Bibl. 97), in a new order which eliminated the repeated numbers but required five drawings with captions to be inserted in the uncaptioned series. It is worth noting that four of these five drawings represent circus scenes, and one of them (H.45) gives us the date 1826. Here, for the first time, all these drawings are reproduced full-size, with the single exception of G.50, of which it proved impossible to obtain a photograph for the 1970 catalogue, in spite of all the efforts made at that time by Juliet Wilson and myself. A large proportion of the drawings has thus been assembled, large at least with respect to the highest number known for each album: 54 out of 60 for the series with captions and 58 out of 63 for the uncaptioned series. I would add that three further drawings are known to exist in the United States but are being reserved for a future publication: G.27 with a caption beginning *De secreto . . .* (?); H.26 which represents a witch sitting on the ground and writing on a tablet; and H.39 with the caption *Feria en Bordeaux*.

It is comparatively easy to fix the chronological limits of these two black chalk albums. The extreme limit is of course the date of Goya's death, April 1828, and this terminal date can doubtless be moved back to 1827, for in the last three months of his life his creative activity can hardly have been very great. Furthermore, his last visit to Madrid, when he painted his dear Mariano for the last time (GW p. 353), occupied the whole summer of 1827. So we have a time-span extending from his return to Bordeaux from Paris (September 1824) to the end of 1827, a fairly long period, but one broken up by several intervals in which he was unable to work: a serious illness in the spring of 1825, a journey to Madrid in the spring of 1826, and his last visit to Madrid in the summer of 1827. A letter written to his friend Ferrer on 20 December 1825 probably alludes to the drawings and

the possibility of commercializing them in the form of prints, in particular of lithographs. Its terms are well known but they deserve to be weighed once again. Replying to Ferrer's suggestion that he should reissue or copy the *Caprichos,* he explained that the plates were now inaccessible and added: "... and I would not copy them, because today I have better ideas for things that would sell to greater effect." Although further on he refers to the forty miniatures on ivory executed in the previous winter, that of 1824-25, I think that by these "ideas" he meant the "new caprices", as Paul Lafond was later to call these album drawings. For on his return from Paris he certainly began drawing again, if only to teach the rudiments of the craft to the little Rosario, the daughter of Leocadia Weiss (and perhaps of Goya himself). In a letter written from Bordeaux on 30 November 1824 to the Duchess of San Fernando, younger sister of the Countess of Chinchón (Bibl. 160), he refers to a study – probably a drawing – which he is sending her, representing three dwarfs which he had seen at the fair of Bordeaux "two months before", i.e. in September, the time at which this fair is known to have been held. This makes it quite clear that he had begun to take an interest in those amusing scenes which figure here and there in album G: G.2, the peepshow; G.7, the pair of grotesque dancers; and G.20, the performing donkey. He also recorded memories of Paris: the shoulder chairs (G.24, 26 and 28) and the old woman in a cart drawn by her dog (G.31). Other scenes are set in France, like the two terrible evocations of the guillotine (G.48 and 49), the woman selling delights (G.45) (cf. the entry for this drawing), and the beggar in his little cart (G.29).

In the other, probably later album, we find several drawings relating to the fair of Bordeaux in 1826: H.40, 41, 45 and 54 (not counting H.39, here uncatalogued). Carderera refers to H.62 and specifically tells us that it represents "two French ladies at Mass". So it seems certain that both albums contain figures and scenes that had caught his eye in France, either in Paris or Bordeaux. This did not prevent Goya from interspersing them with memories of Spain, as in G.14 (which reverts to a theme treated in the Madrid album, B.60?), G.16, G.53, G.57, H.3, H.13, etc.: these may be taken as evidence of homesickness but, as with the *Bulls of Bordeaux,* they also represent a choice of themes calculated to appeal to a French public, in case the drawings were lithographed and sold in Paris.

In our study of the albums, we have seen how Javier Goya pasted nearly all the drawings inherited from his father into three large books made up of sheets of rather ordinary pink paper. Apparently intended to safeguard the drawings, this operation had the effect of disrupting the sequences which Goya had carefully preserved in the order of the serial numbers, as Eleanor Sayre has materially demonstrated by pointing out that two sheets in the National Gallery of Canada (H.19 and H.53) bear on the verso the imprint of the next sheet (H.20 and H.54) (Bibl. 25, No. 41, p. 207). I have established the subsequent existence of three lots of drawings selected and numbered by Javier: the Fortuny album and the two lots sold in Paris in 1877. Now these, as we have seen, do not contain a single sheet from the Bordeaux albums, from which it may be inferred either that Javier had already parted with them or that he did not see fit to include any black chalk drawings in these sets of wash drawings. However this may be, the two Bordeaux albums were mixed together at an early date, and all the more easily because, as already noted, their technique, paper and format are identical. In my opinion, we have to go back as far as Leocadia Weiss in order to reconstruct their history. It may not be amiss to record here once more the information given by Matheron, who was himself a native of Bordeaux and had been well informed by Goya's friend, the young painter Antonio Brugada. Referring to the "several hands" in which Goya's drawings were then to be found (Bibl. 137, catalogue of drawings), Matheron says: "Madame W... has a collection of them, whose principal pieces have been certified by Monsieur Madrazo." Beyond any doubt, he meant Leocadia Weiss, to whom he had already referred by the same initial in the text of his book. For after Goya's death she retained in her possession a certain number of his works, and among them – besides the *Milkmaid of Bordeaux* (GW p. 25) – were some drawings which must have comprised the ones executed by her daughter Rosario under Goya's guidance as well as original drawings, those "principal pieces" mentioned by Matheron and certified by Madrazo. I have suggested that these drawings, separated from the black chalk albums, later went to form the Hyadès-Boilly album (see general introduction). What is known for certain about this lot comes on the one hand from the Jules Boilly sale of 1869 (Bibl. 29, No. 48), where it was thus described: "Scenes of Spanish manners and caprices. An album containing twenty drawings in Indian ink and black chalk, plus the portrait of Goya, etched after Lopez"; and, on the other, from the collector who had the whole album in his possession. According to the latter, it was a small album of red lustrine, with the price marked on it (1 fr. 95) and the hand-written words: "Hyadès, inspecteur d'armée". But what proves that the Hyadès album and that of the Boilly sale were one and the same is the fact that the portrait etching of Goya after López is still in the possession of the same collector. The etching (220 × 140 mm) was done by Jules Boilly himself, whose signature it bears and

apparently a date, "52" (i.e. 1852), together with an engraved inscription: "GOYA/d'après Lopez/musée de Madrid". The famous portrait painted by Vicente López in Madrid in 1826 was rather freely transposed; Goya is made to look much younger and Boilly peopled the background with figures taken from the *Caprichos* and the *Tauromaquía,* and on the lower right, on the painter's palette, he represented the whole central scene of the *Second of May,* with the epigraph *2 Mayo* beneath it. All this proves that the engraver was thoroughly familiar with Goya's works and greatly admired him. But, since nothing is known about this army inspector named Hyadès, one question remains: was the album made up by him or by Boilly? It is quite possible that the French painter bought this lot of drawings in Madrid, where he could have seen the *Second of May*; that he bound up the twenty sheets and added the frontispiece engraved by himself; and that after his death in 1869 the purchaser whose name we know, one Leurceau, may have sold it subsequently to Hyadès, who then inscribed his name on the album. It may be noted in passing that Leocadia Weiss left Bordeaux in 1833 and returned to Madrid, where she died in 1856 (Bibl. 150, p. 265, and 162, p. 110, doc. 24).

If I have been able to reconstruct the contents of this album, it is thanks to the obliging cooperation and inexhaustible patience of its present owner. It comprised fifteen drawings from the Bordeaux albums (G.10, 17, 28, 29, 32, 33, 40, 42, 43, 44, 53 and H. 25, 29, 36 and 51), plus two sheets from the Sanlúcar album (A.m/A.n and A.o/A.p), purchased perhaps from Carderera, and three copies, including GW 767 and 1838, the latter apparently a copy made by Rosario Weiss after drawings G.56 and H.31. On the back of the portrait etching after López, the father of the present owner wrote, after making the purchase: "18 drawings by Goya, ex collection Hyadès, army inspector in Bordeaux". The number eighteen is accounted for by the fact that, out of the three copies, only GW 767 was considered by this collector to be an original by Goya. One point in particular seems to prove that these drawings never formed part of Javier Goya's collection: none of them, to my knowledge, shows any trace of pink paper.

As regards the rest of the Bordeaux albums, two large lots must be distinguished, whose fate has been very different. The first was purchased by Román Garreta, either from Javier Goya or his son Mariano. It included the forty black chalk drawings in the Prado (eleven from album G, twenty-nine from album H), plus two others sold by Garreta's nephew Raimundo de Madrazo to Archer M. Huntington in 1913 (now in the collection of the Hispanic Society of America). The second was purchased from Javier by Federico de Madrazo: it consisted of thirty-one drawings (sixteen from album G, fifteen from H) which were subsequently given to Bernardino Montañés, director of the School of Fine Arts in Saragossa, and at his death came into the possession of Aureliano de Beruete, who sold them, after 1907 (the date of their publication by Lafond, Bibl. 113), to the German collector Gerstenberg. This lot, with the exception of three drawings, was apparently destroyed in the Battle of Berlin in 1945. Federico de Madrazo also owned three further drawings from these albums (G.1, G.39 and H.22), which he gave to the French collector Charles Gasc on 26 December 1859, as certified by Gasc's inscription on the back of each of them.

Apart from these lots, there remain a certain number of sheets from the Bordeaux albums whose complete history it has not been possible to trace. It is interesting to note that early copies exist of the three Gasc drawings, apparently made by the same hand as the copy of H.11 in the British Museum; since the latter was acquired in 1876, all these copies may be dated to 1859-76.

As regards the subjects treated by Goya in these albums, four homogeneous sequences can be distinguished:

G.24 to G.32 (except G.30): unusual means of transport;
G.33 to G.45: lunatics;
G.47 to G.49: punishments;
H.39 (not catalogued here) to H.41: fair scenes.

The group of lunatics in album G is by far the largest and most impressive ever pictured by Goya. Did some event occur during his stay in Bordeaux which would explain his new interest in these wretches? Or was it only a return to the past, the revival of a theme already treated in 1793-94 in some of the small pictures presented to the Academy (GW p. 111) and in 1812-19 in *The madhouse* in the Academy of San Fernando (GW 968)? Either explanation is possible, the latter in particular being well in keeping with the creative process observable in other drawings in these albums.

Apart from these sequences, a great variety of subjects is treated and they seem like a final recapitulation of Goya's principal obsessions: gigantic figures or animals (G.3 and 4); flying creatures (G.5, 53, H.19, 32, 52, 59); eroticism (G.8 and 46); dreams (G.12); marriage and women (G.13, 15, 19, H.57); violence and cruelty (G.16,

56, H.14, 18, 30, 34, 36, 38, 53); monks and religion (G.1, 57, H.4, 10, 12, 13, 28, 32, 37, 44, 48, 56); witches (G.59, H.15, 27); children (H.2, 43, 49) and old men (G.54, H.10, 17, 33, 58, 60). But one also notes the appearance in these two albums of a wholly new physical type: a figure, generally a man, with a large head, a broad grin lighting up its face, with legs set wide apart and forming an arch (G.4, 30, 39, 55, H.6, 38, 42, 51, 61, 63). In the entries I have pointed out the many connections between these drawings and the figures in the *Bulls of Bordeaux* lithographs and in the miniatures of 1824-25 (for example GW 1677, 1686 and 1687), which often deal with closely related subjects.

Finally, it is important to emphasize the fine workmanship of these two series of drawings. Some students have alluded to Goya's declining powers and unsteady hand in the last works executed in Bordeaux. A careful scrutiny of the two drawing albums fails to show any such shortcomings. On the contrary, his line seems to have gained in vigour and tellingly conveys, without any hesitation, the idea he wishes to express. Most of the time, rather in the manner of his wash drawings, he develops his subject in two or three stages, first sketching it out in black chalk, in a mellow grey, through which show the wire-marks of the paper; then with a fairly sharp-pointed greasy crayon he emphasized certain lines of force and outlined the essential volumes; finally, with the same crayon, he added those zigzags or small serrated accents (doubtless taken by some as evidence of an unsteady hand) with which he punctuated his composition, doing so with unfailing restraint and moderation, never going so far as to overstress or unbalance the fundamental masses of shadow and light. This technique is brought to perfection in album H, which for this reason, among others, must be later than G. Particularly fine examples are drawings H.4, H.5, H.19, H.21 and H.47.

It is worth emphasizing, too, the astonishing variety shown by Goya in his manner of working. The execution is never monotonous. It ranges from the tragic sobriety of G.16, devoid of chiaroscuro effects, to the powerful impact of G.34 and G.40, fraught with shadows and anguish; from the monastic spareness of H.32 and H.37 to the complex design of H.13 and H.25. Sometimes the figures stand before us upright and steady (G.15, 20, 23, 34, 37, 38, 45, H.10, 22, 31, 40, etc.), sometimes the body is drawn out along the diagonal of the sheet, breaking up the page layout with a surging baroque rhythm (G.5, 22, 32, 46, H.18, 19, 20, 25, 28, 30, 36, 47). Often the background simply consists of the blank sheet of paper (G.29, 31, 43, H.10, 19, 28, 37, 58); elsewhere it is darkened with the most opaque and absolute blacks in order to set off the whiteness of the main figure (G.34, 38, 40, 54, H.48, 49, 60, 61). Finally, on a still deeper level which can only be grasped when the albums are seen as an organic whole in their natural order, we find Goya characteristically ranging from reality to dream through ambiguous combinations of them – from the guillotine and means of transport to the " Bad dream" of G.12 or the phantom of H.61, by way of the enigmatic figures and animals of G.4, G.5, G.9, G.46, G.51, H.15, H.18, H.57 and H.60

TECHNICAL FEATURES

Paper : Greenish-grey tinted laid paper, Dutch-made (?). Horizontal chain lines, 25 to 28 mm apart.
Watermark : Three types of watermark occur, the first two being the upper and lower half of the same mark:
 GH.I: a large heart surmounted by a trefoil;
 GH.II: a St Andrew's cross between two confronted lions;
 GH.III: the letters R J cut off by the edge of the paper.
Maximum sheet size : 194 × 158 mm, the most nearly square of all the formats employed by Goya in his drawing albums.
Drawings : Recto only.
Technique : Black chalk and greasy crayon (lithographic crayon).
Captions : They figure on all the drawings of album G, written exclusively in black chalk or greasy crayon.
Goya's numbers : Written in black chalk or greasy crayon. In album G, the highest number is 60 and the number of sheets catalogued is 54.
Additional numbers : Only the drawings belonging to the Prado were numbered by Román Garreta in lead pencil in the lower right corner. No sheets from these albums figured in the 1877 sale in Paris; on none of them, therefore, do we find the numbers added by Javier Goya with a fine pen.

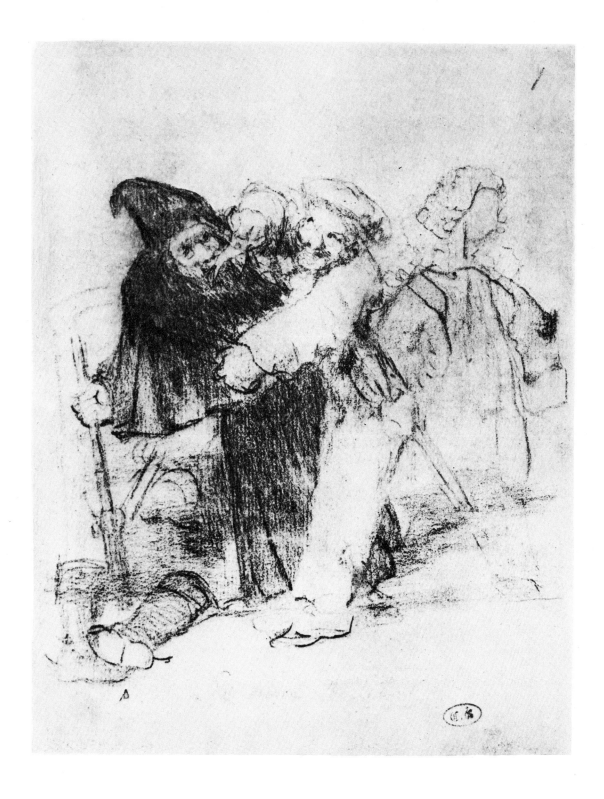

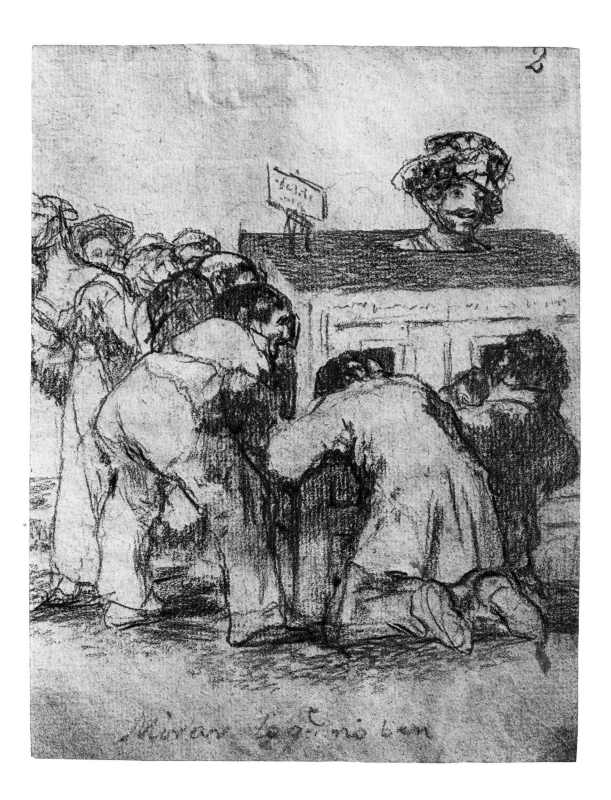

Mirar lo que no ven

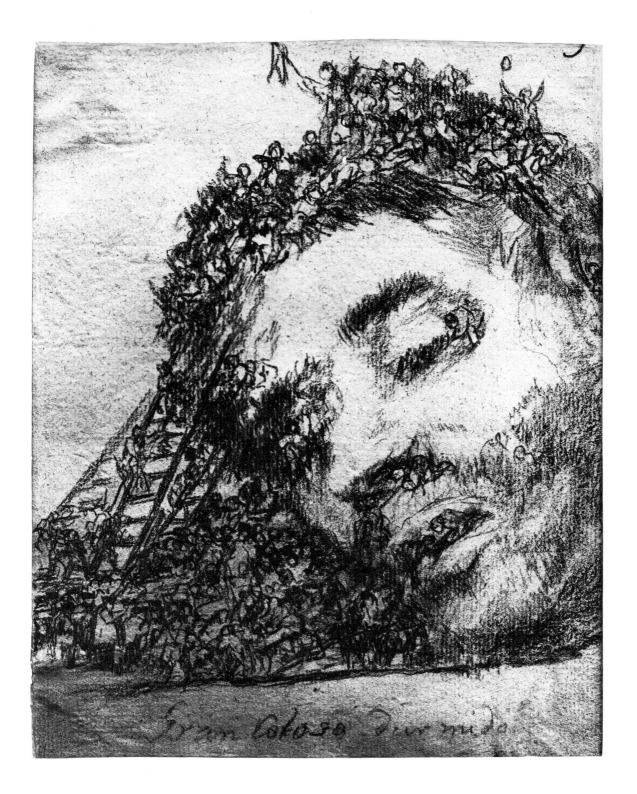

Gran Coloso dormido

Animal de letras

El perro volante

Ni por esas

Gran disparate

Andar ventado à pie y a cavallo

Mal Marido.

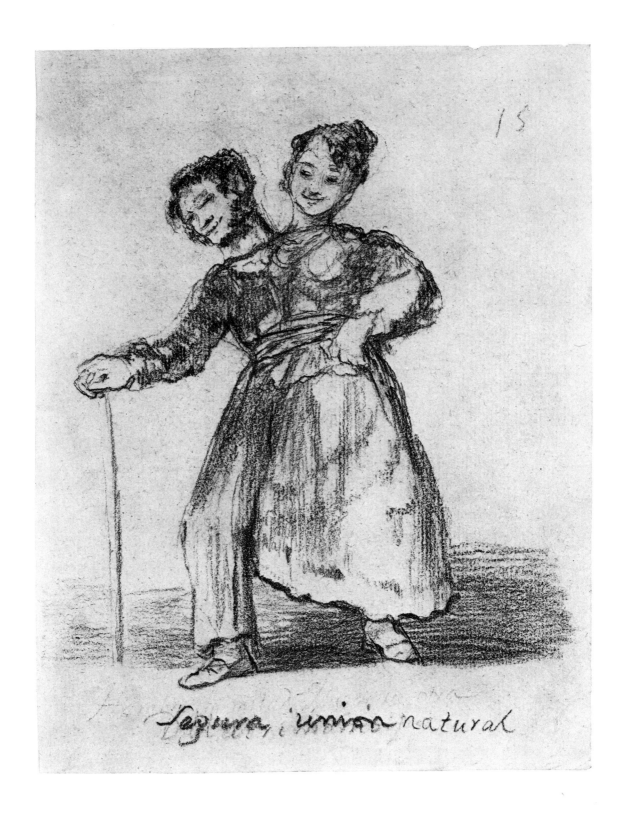

Segura, i union natural

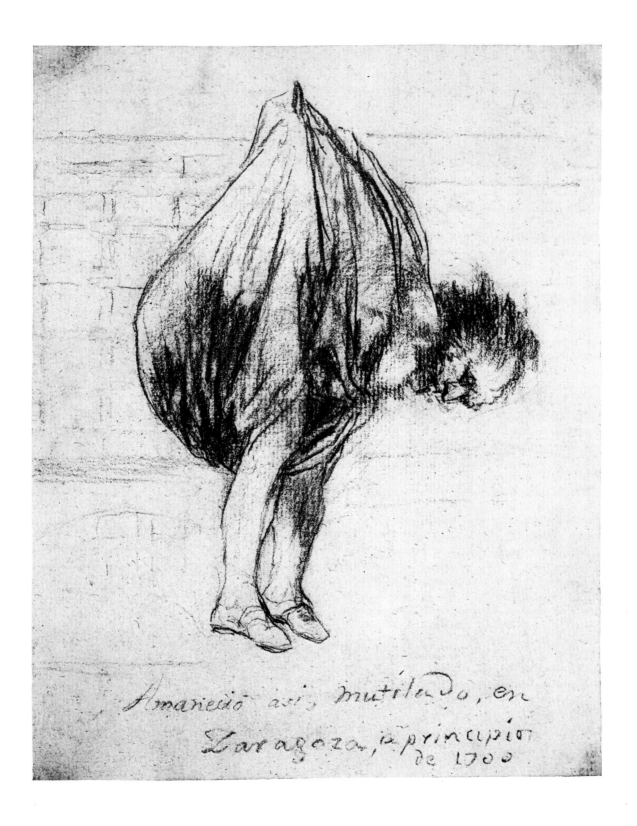

Amanecio asi mutilado, en
Zaragoza, à principio
de 1700

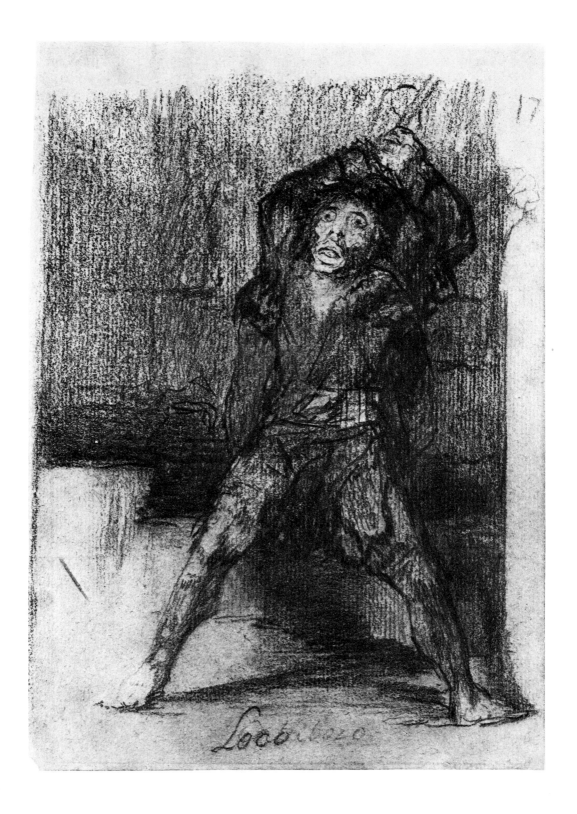

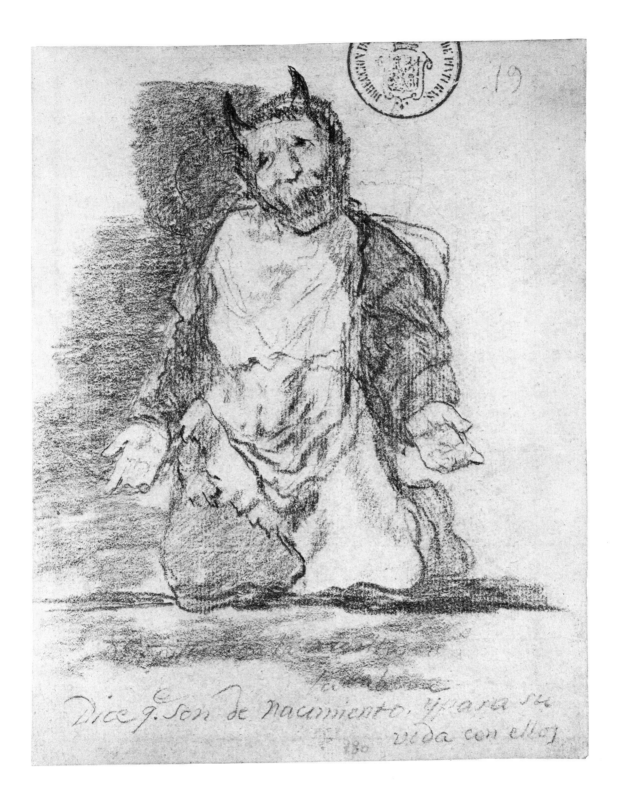

Dice q.e son de nacimiento, ypara su
vida con ellos

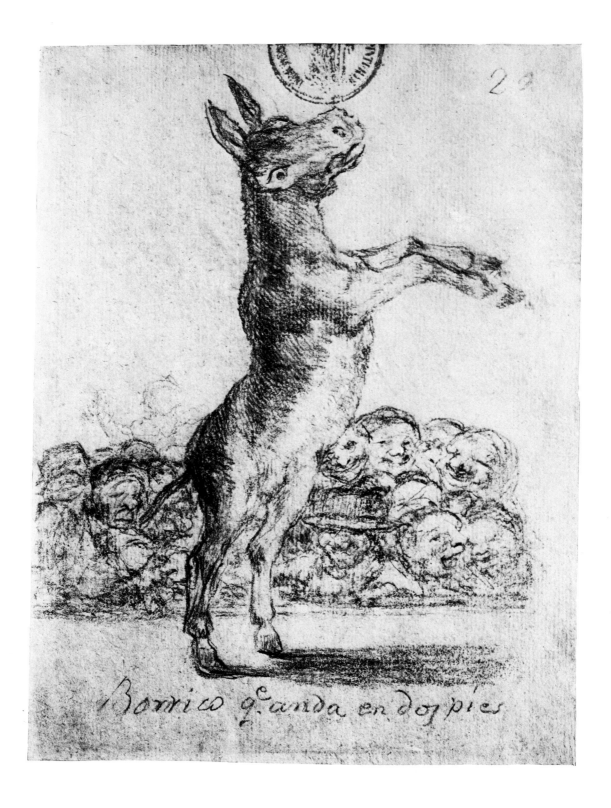

Borrico q.^e anda en dos pies

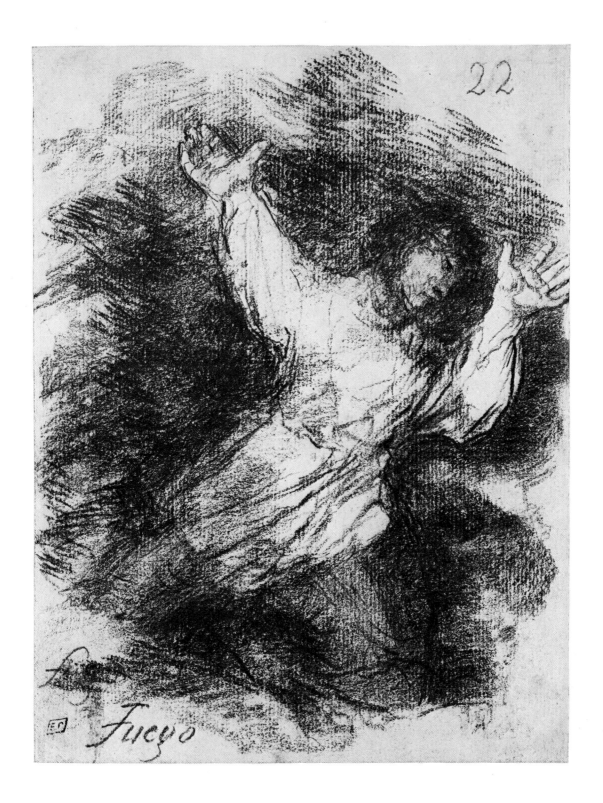

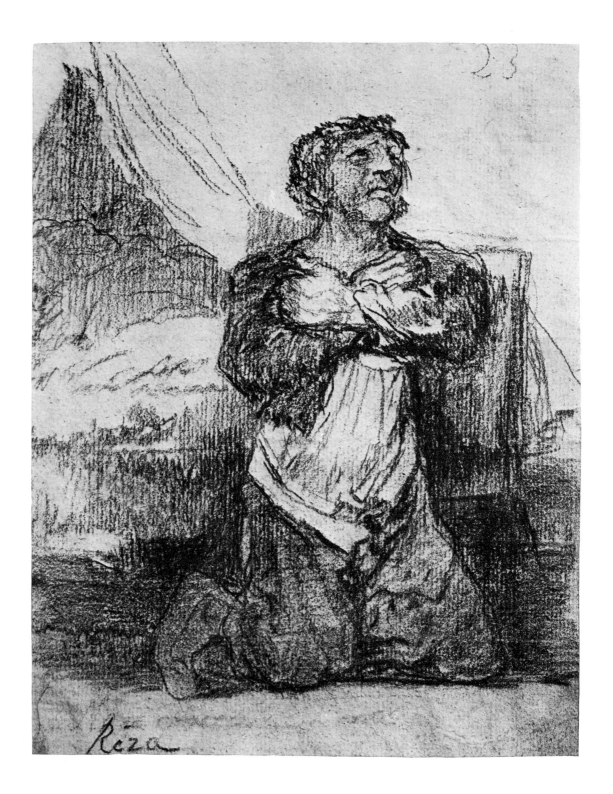

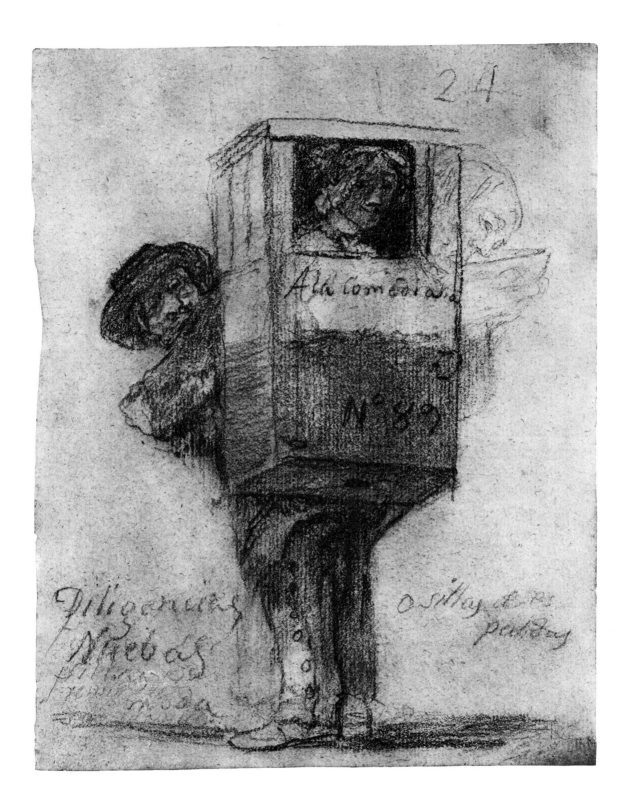

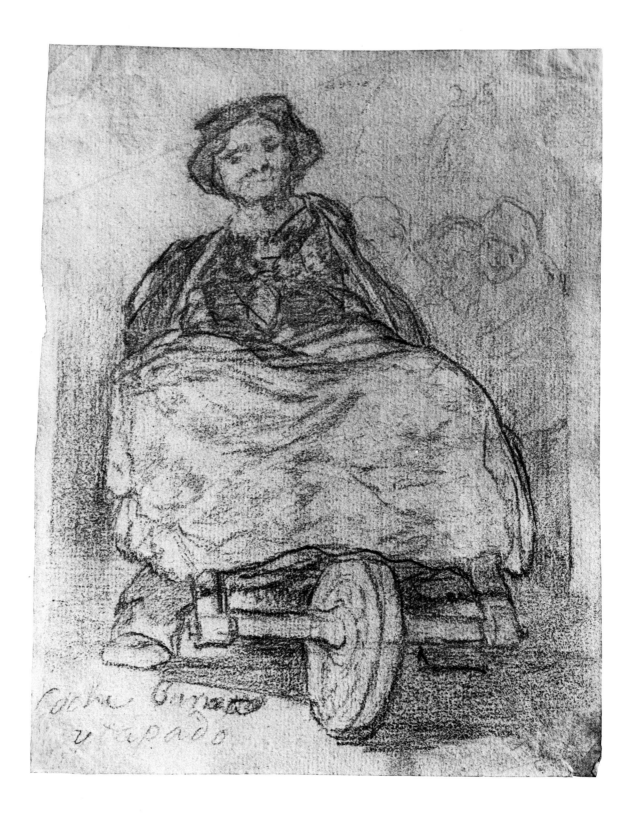

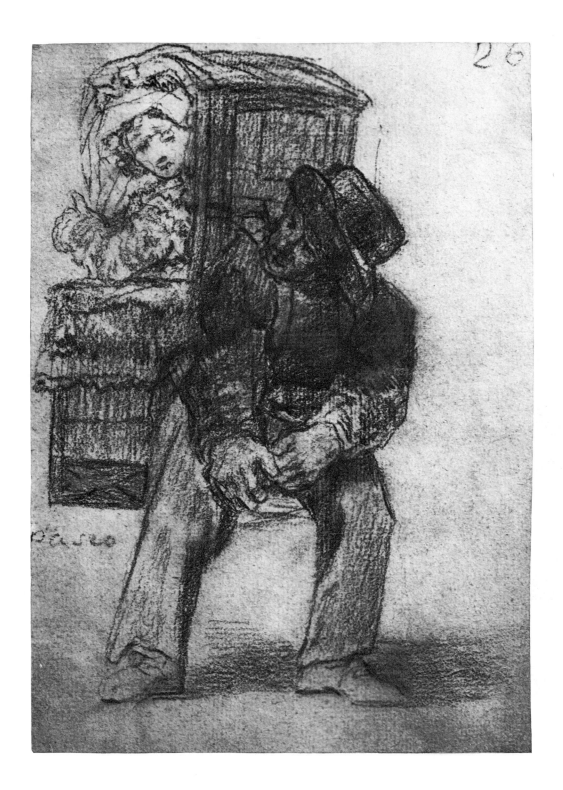

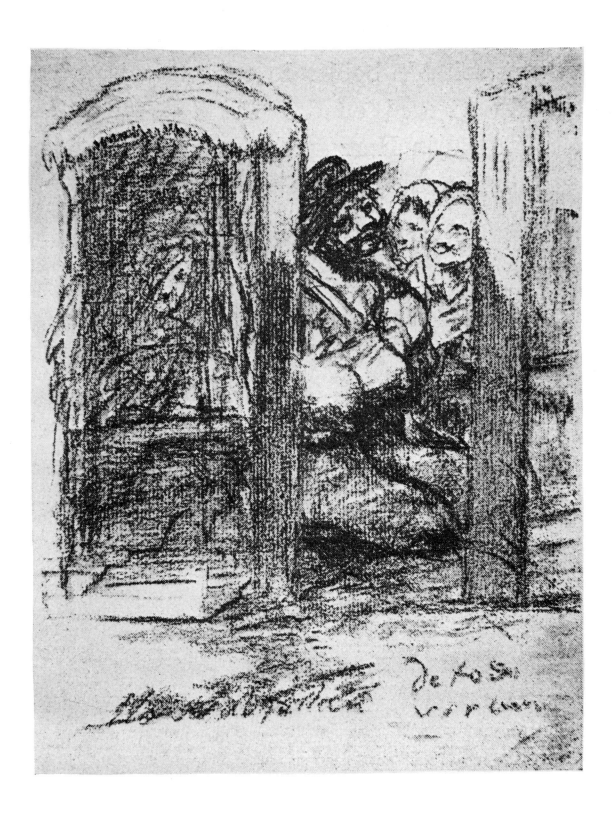

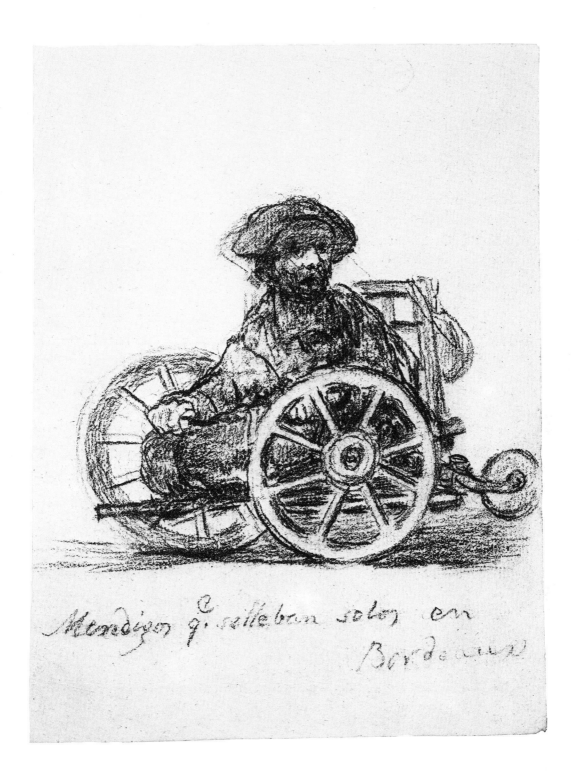

Mendigos q.^e selleban solos en
Bordeaux

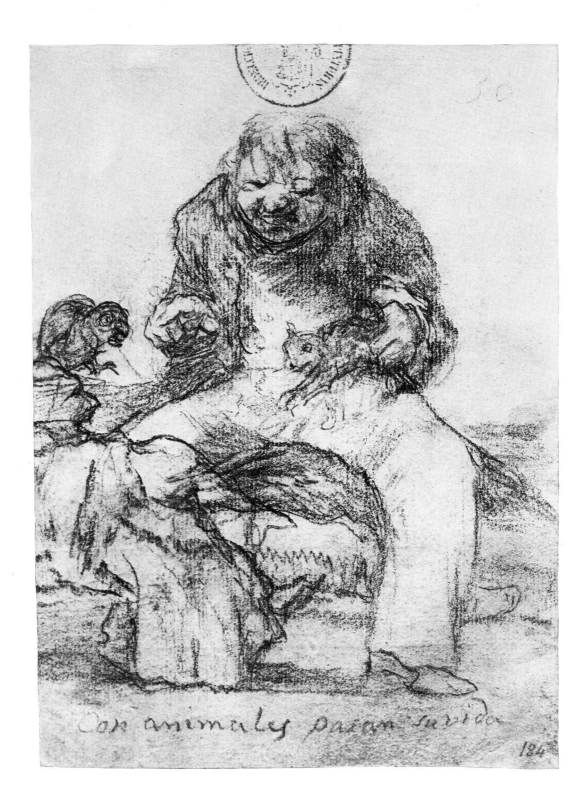

Con animales pasan su vida

184

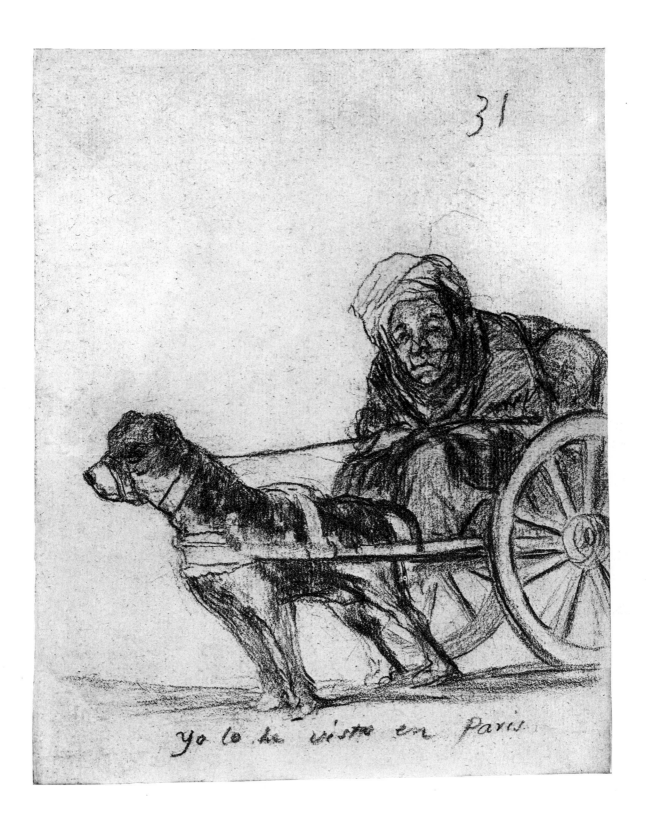

31

yo lo he visto en Paris

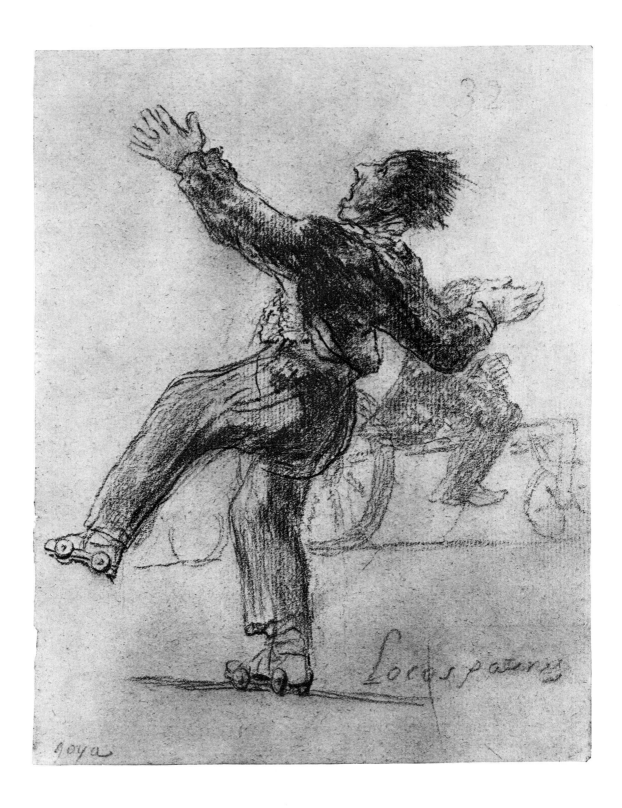

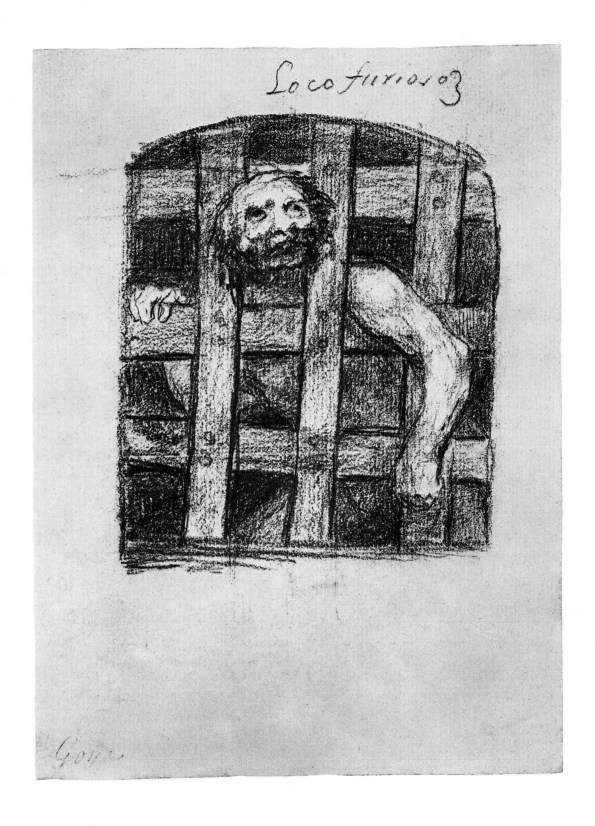

Loco furioso

Goya

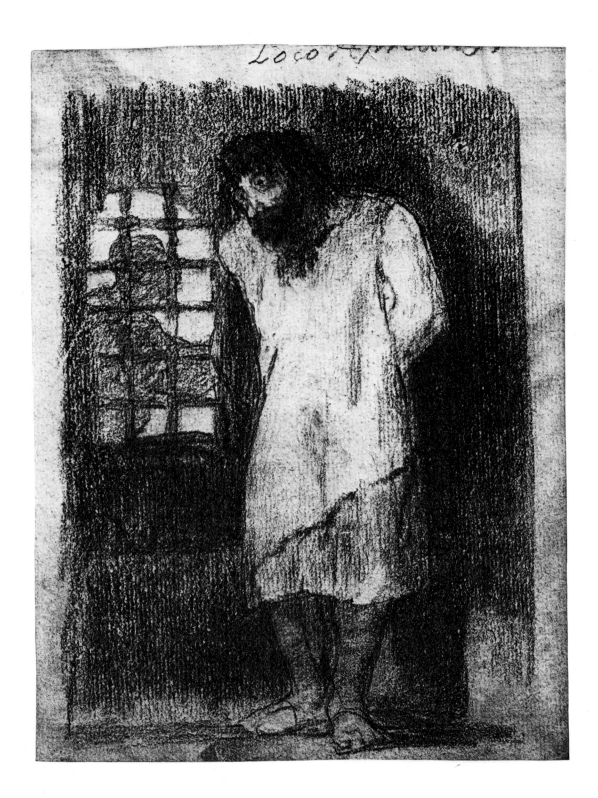

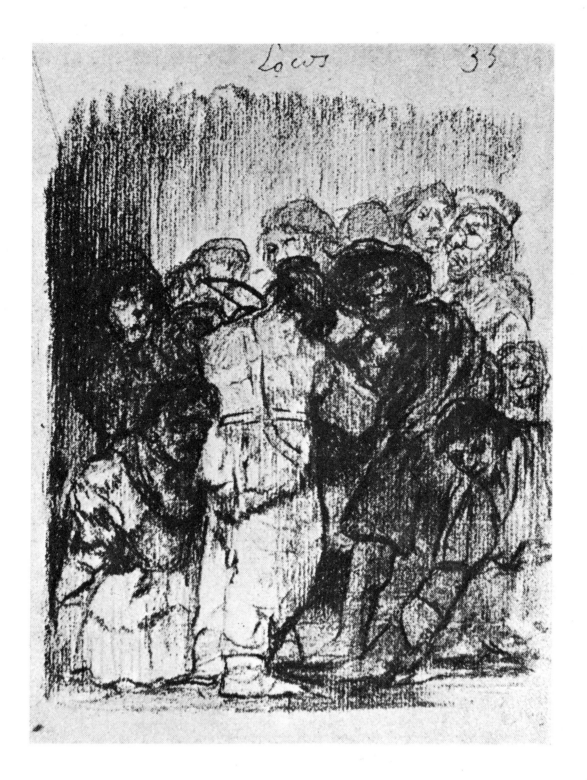

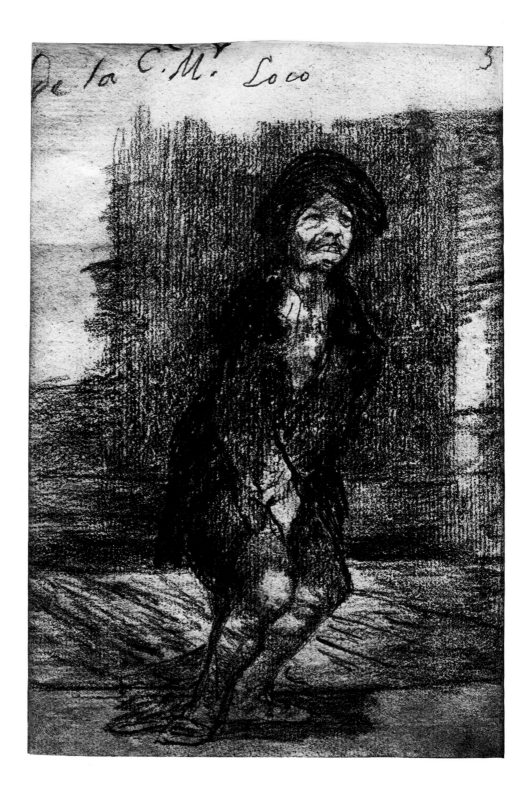

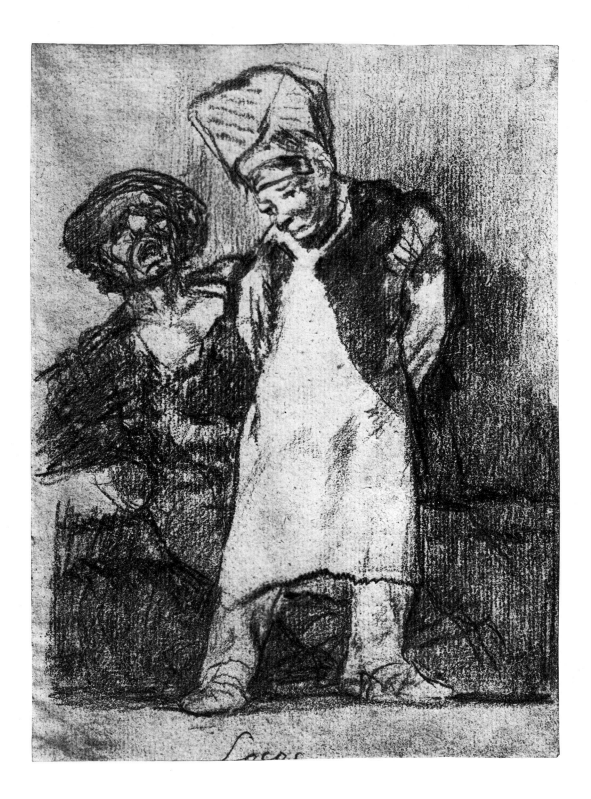

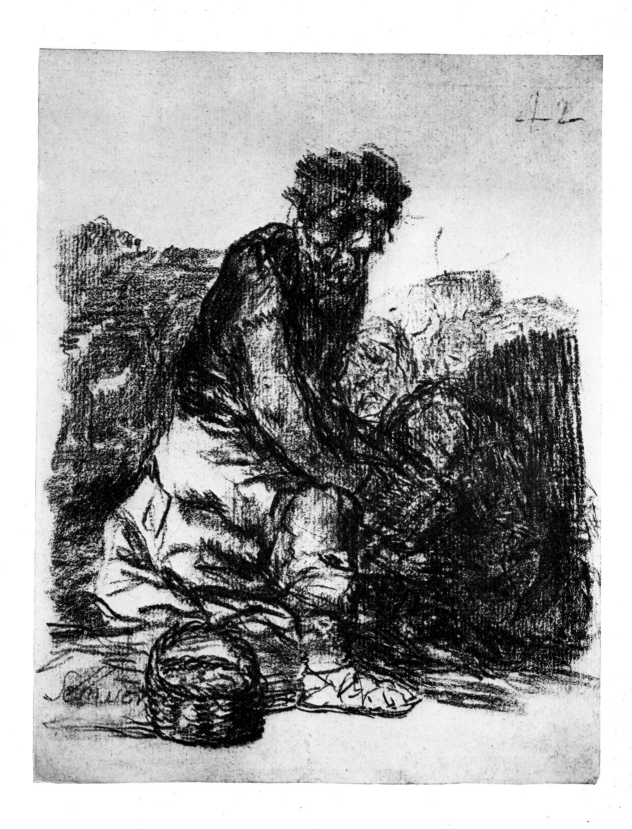

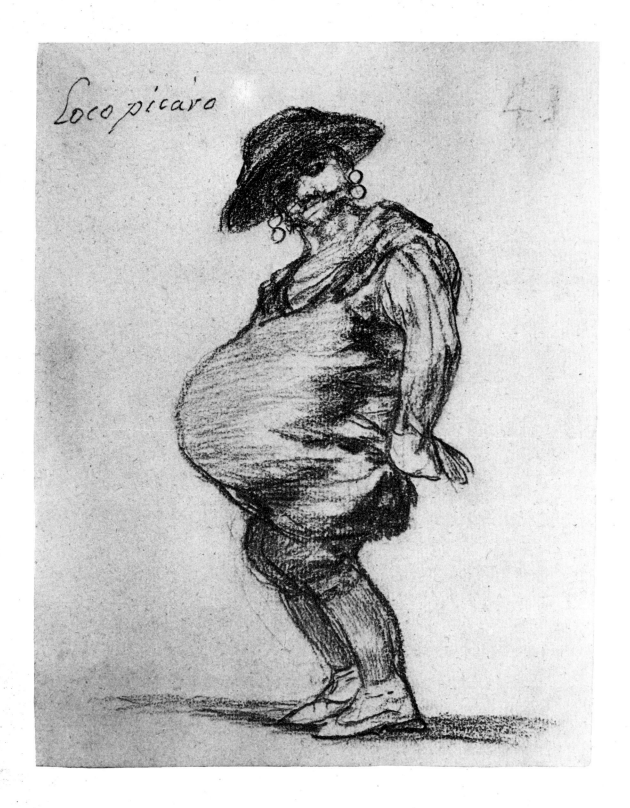

Loco picaro

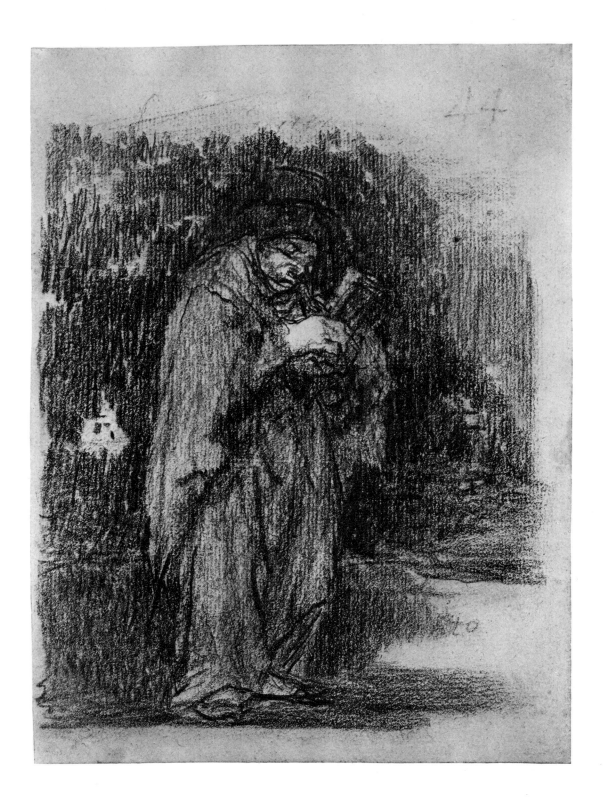

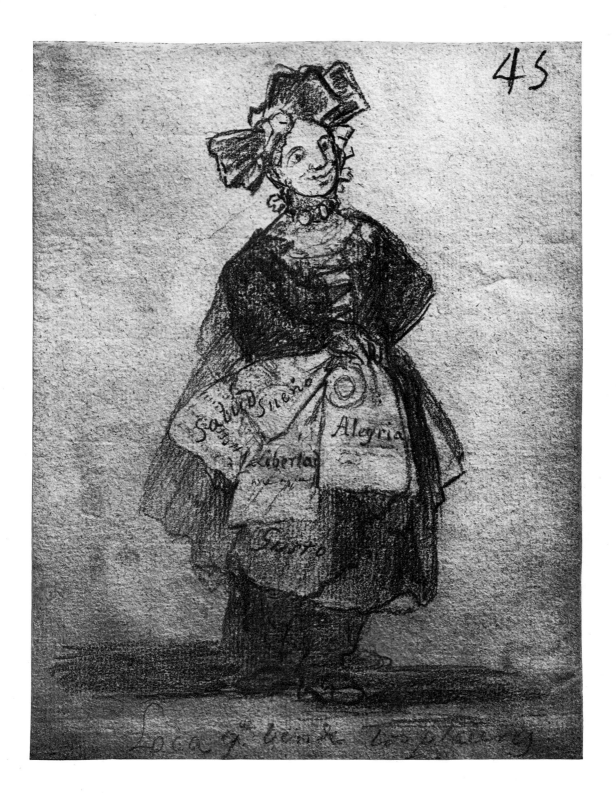

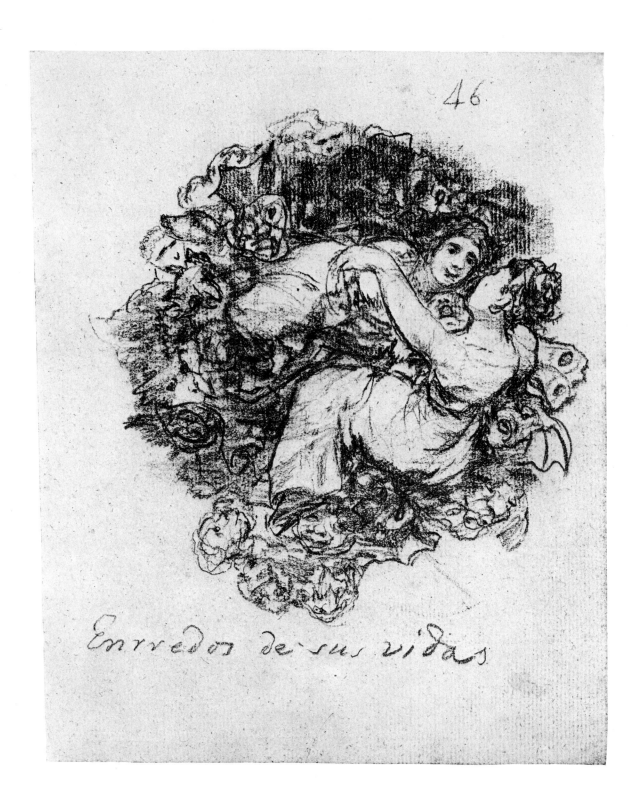

Enrredos de sus vidas

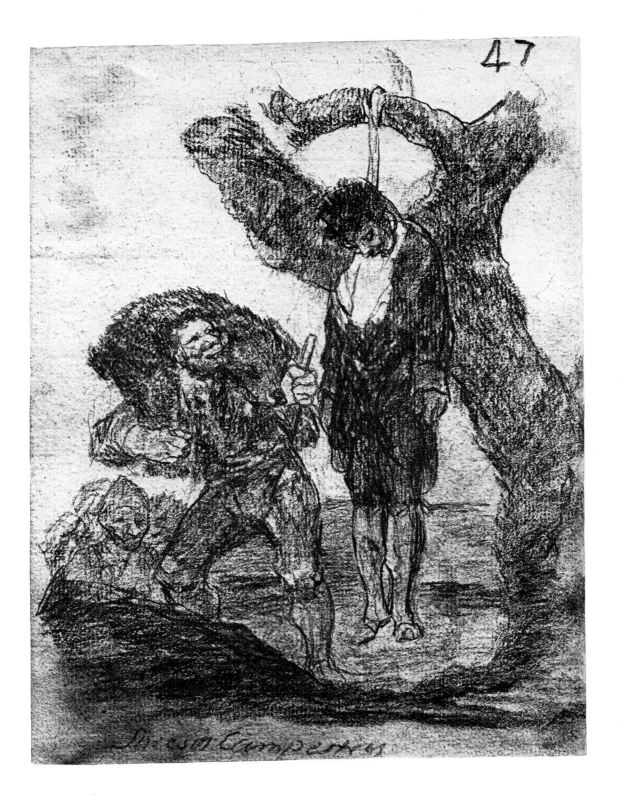

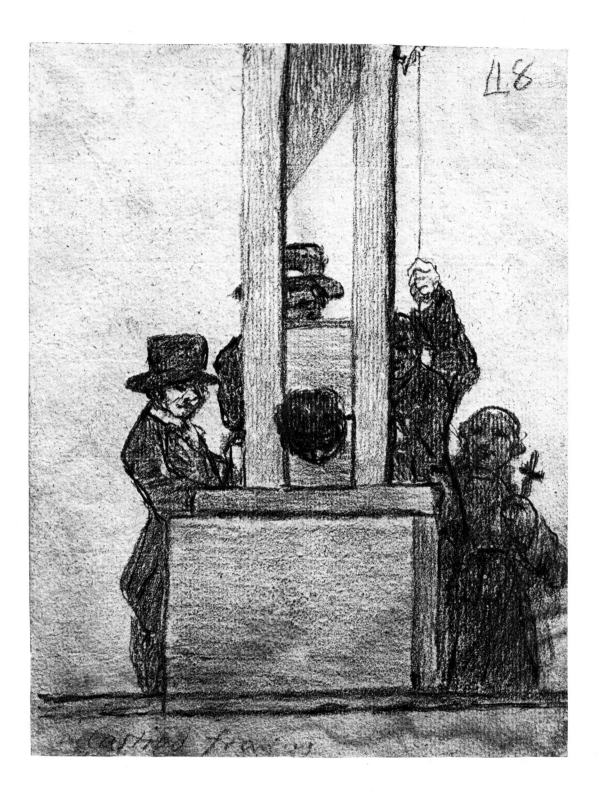

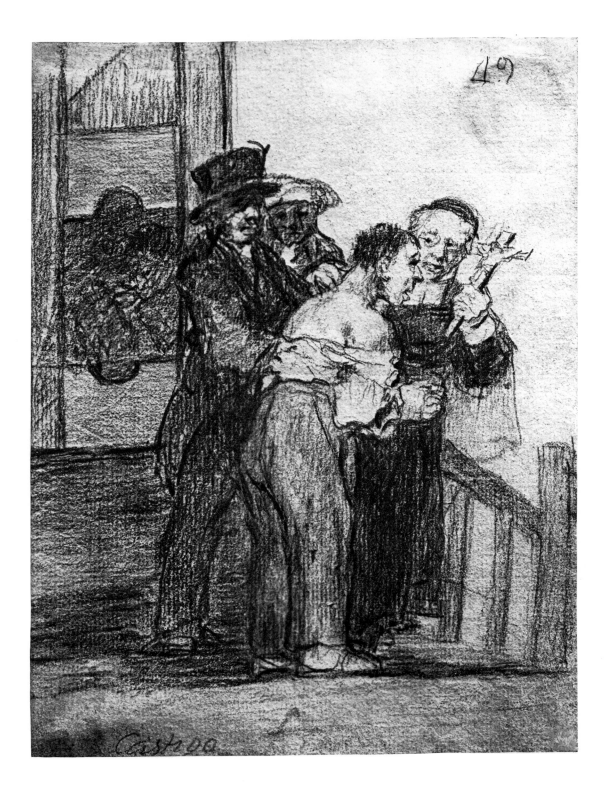

Castigo

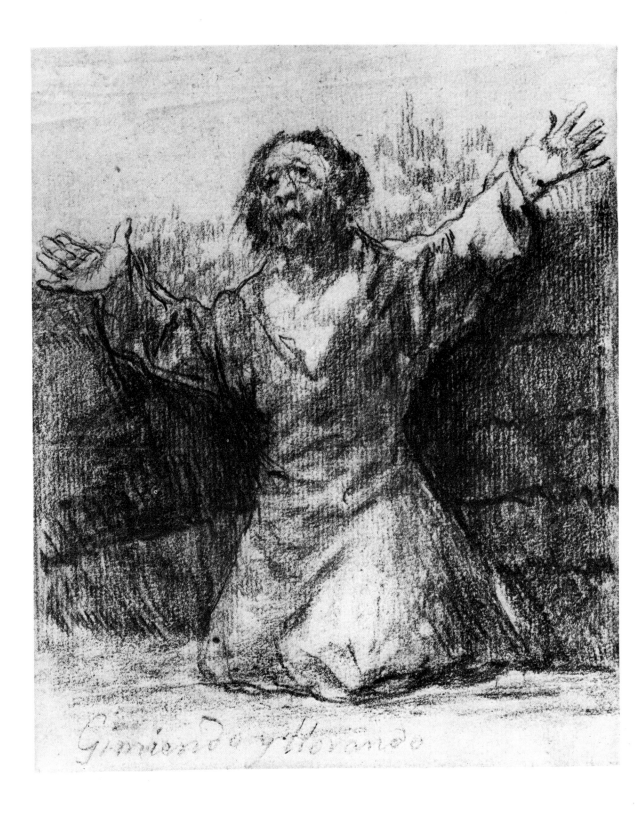

Gimiendo y llorando

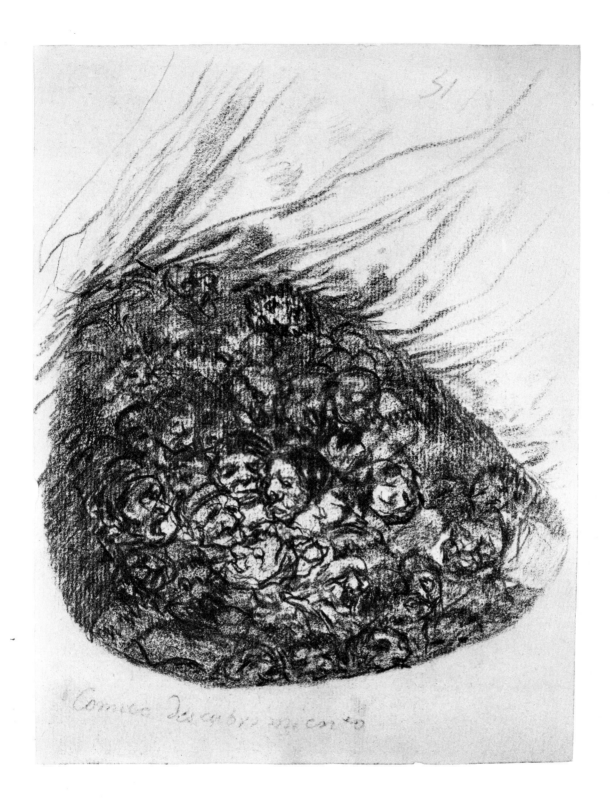

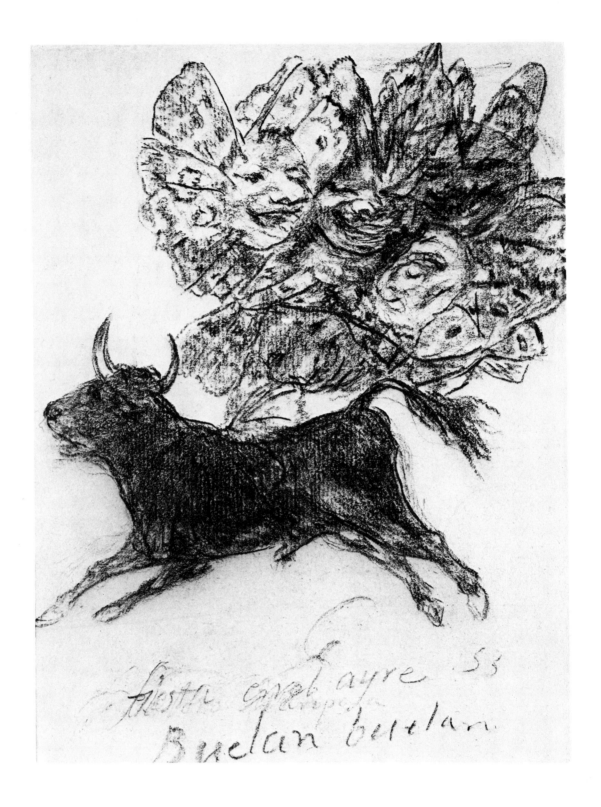

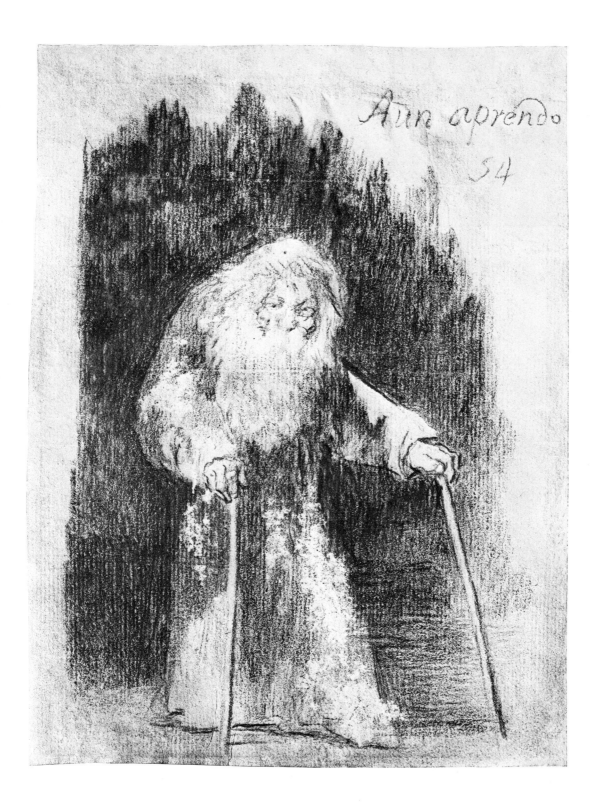

Semana S.
En tiempo pasado
en España

Quien Lencera?

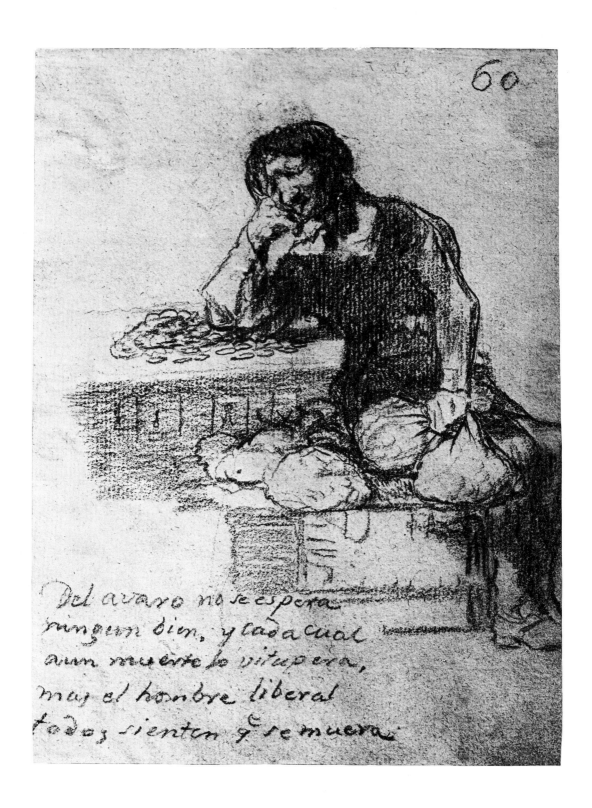

Del avaro no se espera
ningun bien, y cada cual
aun muerto lo vitupera,
mas el hombre liberal
todos sienten q.^e se muera.

Mala Sueño

Bordeaux Album (G)

Captions and Commentaries

G.1 [365] p. 505

Se hace militar (Bc) (He's turning into a soldier) – 1824-28 – 190 × 155 – Bc – No. (Bc) – Stamped C.G. in red (Lugt 542) – *Paper:* horizontal chain lines – Inscription on verso: "Goya y Lucientes (François) né à Fuendetodos Aragon en 1746; mort à Bordeaux en 1832 – 0,191 L. = 0,155. Ce dessin m'a été donné le 26 décembre 1859 à Madrid par Mr. Madrazo, peintre de la Reine d'Espagne. – Collection Goya fils. – Collection Madrazo. – C. Gasc (signature). – Goya – Collection Madrazo – Madrid 1859 – Num. 60" (Goya y Lucientes (Francis) born at Fuendetodos Aragon in 1746; died at Bordeaux in 1832 – 0,191 L = 0,155. This drawing was given me on December 26th, 1859 at Madrid by Mr. Madrazo, painter to the Queen of Spain. – Collection Goya's son. – Collection Madrazo. – C. Gasc (signature). – Goya – Collection Madrazo – Madrid 1859 – No. 60) – *Hist.:* Javier Goya; F. de Madrazo; C. Gasc – Madrid, Marqués de Castromonte coll. – GW 1711

A burlesque scene of a sort of recruiting sergeant determined to enrol an old bearded Capuchin friar willy-nilly. Gripping the cowl with his left hand, he is busy cutting off his beard with an enormous pair of scissors. The monk, though seemingly terrified, offers no resistance; the soldier wears an expression of sadistic glee. The monk holds a gun in his right hand; on the ground at his feet lie a pair of spurred boots. The wig and suit of clothes on a lay figure beside the sergeant probably belonged to a previous victim. The long inscription on the back of the sheet is extremely interesting because it tells us that Federico de Madrazo got the drawing directly from Javier Goya; that must have been before 1854, the year when the latter died. There is an identical inscription on the verso of G.39. Copies of the two drawings are in the Print Room, Berlin-Dahlem, numbered 4,390 and 4,392 respectively.

G.2 [366] p. 506

Mirar lo q.ᵉ no ben (Bc) (Looking at what they cannot see) – 1824-28 – Bc – No. (Bc) – *Paper:* horizontal chain lines (26 mm) – *Hist.:* Javier Goya; F. de Madrazo; Saragossa, B. Montañés; Madrid, A. de Beruete; Berlin, Gerstenberg (after 1907) – Destroyed (1945) Berlin, formerly Gerstenberg coll. – GW 1712

The scene is comical enough, and Goya was the first to be amused by it, as he had already been by a similar subject in the drawing C.71. Here too we have a peep-show – what the Spaniards called "*mundonuevo*" and Jovellanos had condemned (cf. note to C.71) – but the model is different. The showman is enclosed in his magic box and the spectators jostle each other to get a look at what goes on inside through the holes supplied for the purpose. What can they see? One could imagine all sorts of things, but the caption is reassuring. It is simply a trick: you look inside but do not see a thing. Among the customers on the left is a monk, his eyes glued to the hole while a woman waits her turn behind him. Several details of the drawing are done in hatched and jagged strokes – a feature of the technique Goya employed at Bordeaux.

G.3 [367] p. 507

Gran coloso durmido (Bc) (Great colossus asleep) – 1824-28 – Bc – No. (Bc) – *Paper:* horizontal chain lines (26 mm) – *Watermark:* traces visible on the reproduction along the left edge – *Hist.:* Javier Goya; F. de Madrazo; Saragossa, B. Montañés; Madrid, A. de Beruete; Berlin; Gerstenberg (after 1907) – Destroyed (1945) in Berlin, formerly Gerstenberg coll. – GW 1713

Goya represented a colossus in two other enigmatic works. One is a painting (GW p. 215) in which the real

subject is the terror-stricken crowd panicking at the awesome sight. The second, a mezzotint engraving (GW 985), shows a colossus at rest dominating a vast, tranquil horizon. In this drawing there is only the monster's head, giving a still more striking impression of colossal size because of the seething mass of tiny figures that explore it with the help of ladders as if it was a natural phenomenon. The image of the sleeper seems to have been inspired by *Gulliver's Travels* (Part I, Chapter 1); several Spanish translations of Swift's work did, in fact, appear in the 18th century. Whether Goya read the famous novel himself or had been told its most salient episodes, the drawing almost certainly sprang from a literary source. Note the multitude of Lilliputians on the huge head, one of them waving a flag to signal the successful outcome of the adventurous climb. Cf. the drawing for a *Disparate* that was never transferred to the copper plate (GW 1611).

G.4 [368] p. 508

Animal de letras (Bc) (Literate animal) – 1824-28 – 191 × 150 – Bc – No. (Bc) – No. add. 173 (Lp) – *Paper:* horizontal chain lines (25/26 mm) – Mounted on pink paper – *Hist.:* Javier Goya; Mariano Goya; Román Garreta → Museo de la Trinidad (5.4.1866) – Madrid, Prado (398) – GW 1714

After the recollection of Gulliver in Lilliput, here we have a gigantic animal – apparently a huge member of the cat family, with pointed ears and an almost human muzzle. It holds a book in its paws but is not reading. The animal's expression is extremely serious, almost grave. Behind its back a man armed with a broom looks at it and laughs. This is probably a satire on men of letters who assume an air of gravity to make themselves look important but keep a library only for show. The animal's coat is rendered most skilfully by a mass of brief, criss-crossed pencil strokes. The shadows at the throat are obtained with jagged strokes of a crayon.

G.5 [369] p. 509

El perro volante (Bc) (The flying dog) – 1824-28 – 190 × 150 – Bc – No. (Bc) – No. add. 172 (Lp) – *Paper:* horizontal chain lines – Mounted on pink paper – *Hist.:* Javier Goya; Mariano Goya; Román Garreta → Museo de la Trinidad (5.4.1866) – Madrid, Prado (394) – GW 1715

The artist may have got the first idea for this extraordinary vision and its allegorical content from a tale he had read or heard. What strikes one most is the refinement and precision of the details, which demon-

strate how far in Goya the imaginary was always true and, as Baudelaire cleverly put it, the monstrous was plausible. The wings of the fabulous dog are attached to its body by straps, so it is merely a sort of canine Icarus – cf. drawing H.52. However, the tips of its paws are webbed and its eyes are almost human. The animal is not really flying – it is diving, rather, with bared teeth at the minute houses of a village nestling in a little valley. The supernatural menace gives this vision an agonizing quality. Note the important *pentimento* on the left hind paw.

G.7 [370] p. 510

(El cojo y) Jorobado Bailarin (Bc) (The lame and hunchbacked dancer) – 1824-28 – 191 × 151 – Bc – No. (Bc) – No. add. 174 (Lp) – *Paper:* horizontal chain lines – Mounted on pink paper – *Hist.:* Javier Goya; Mariano Goya; Román Garreta → Museo de la Trinidad (5.4.1866) – Madrid, Prado (415) – GW 1716

This is a burlesque parody of the Andalusian ballet, an example of which we have already seen in a drawing in Album F (F.75). There the two dancers were ridiculous only for their age; here instead it is their physical deformities that make their show really comical. The man started out a hunchback, as the original caption says; then Goya added insult to injury by making him bandy-legged too. But there is no stopping the old fool. Making a leg with all the airs and graces of a juvenile lead, he casts irresistible amorous glances at his partner. She is hardly more attractive than he and takes advantage of a dance step to make the horn gesture behind his back as she plays the castanets. Note the refinement of the pencil work on the costumes: it has not the slightest touch of preciosity. The stroke is sharp, often jagged for greater vigour – not, as some scholars have believed, because the artist's hand shook owing to his great age.

G.8 [371] p. 511

Ni por esas (Que tiranía) (Bc) (Nothing doing! What tyranny!) – 1824-28 – 191 × 152 – Bc – No. (Bc) – No. add. 175 (Lp) – *Paper:* horizontal chain lines (26 mm) – Mounted on pink paper – *Hist.:* Javier Goya; Mariano Goya; Román Garreta → Museo de la Trinidad (5.4.1866) – Madrid, Prado (405) – GW 1717

The theme of the woman imprisoned in a sort of cuirass with a latch or padlock that a man attempts to open with a bunch of keys had already attracted Goya at the time of the *Caprichos* (cf. drawing GW 656). It is

a quite obvious sex symbol well known to psycho-analysts. Here the bearing of the two characters gives it a comical twist. The man, entirely in the dark except for his hand holding the keys, seemingly wears an *alguazil's* uniform with short cloak. He can hardly wait to open the padlock and attain the object of his desire. Shining with a bright light that may betoken purity, the young woman bends her head sadly towards him and clasps her hands to indicate that he is wasting his time.

G.9 [372] p. 512

Gran disparate (Bc) (Great folly) – 1824-28 – 192 × 152 – Bc – No. (Bc) – No. add. 176 (Lp) – *Paper :* horizontal chain lines – Mounted on pink paper – *Hist. :* Javier Goya; Mariano Goya; Román Garreta → Museo de la Trinidad (5.4.1866) – Madrid, Prado (382) – GW 1718

This drawing is undoubtedly a reminder of the *Disparates* engraved in Madrid between 1815 and 1824. The mood is the same but one misses the metaphysical anxiety that was a typical feature of the prints and also of the *Black Paintings,* some of which were done at that time. The ludicrous funnel might tempt one to relate the drawing to the fancies of Hieronymus Bosch. In fact, F. D. Klingender did so (Bibl. 111, pp. 168-169). He compared it very pertinently with the famous *Extraction of the Stone of Folly* in the Prado, that Goya may have been familiar with, since in 1794 it was kept in the Duque del Arco's *quinta.* The secondary figure on the left recalls some witches in the *Black Paintings,* while its extraordinarily free handling foreshadows some of Daumier's work.

G.10 [373] p. 513

Andar sentado a pie y a cavallo (Bc) (To go along seated, on foot and on horseback) – 1824-28 – 192 × 150 – Bc – No. (Bc) – *Paper :* horizontal chain lines – *Hist. :* Bordeaux, Hyadès; Paris, J. Boilly; Ps. J. Boilly, Paris, H.D., 19-20.3.1869, No. 48 → Leurceau (450 fr. for the album of twenty drawings); A. Strolin – USA, priv. coll. – GW 1719

In France Goya discovered several ingenious vehicles, many of them rather bizarre. This one is a sort of three-wheeled draisine fashioned like a horse, and seems to have amused him greatly. The machine is running downhill and its hatless rider, with an expression of terror at the uncontrollable speed on his face, clings desperately to the handlebar, lifting his feet as high off the ground as he possibly can. The old

painter's astonishment is reflected in the caption, which details the three main features of the extraordinary invention.

G.13 [374] p. 514

Mal marido (Bc) (Bad husband) – 1824-28 – 192 × 151 – Bc – No. (Bc) – No. add. 177 (Lp) – *Paper :* horizontal chain lines – Mounted on pink paper – *Watermark :* G.H.I – *Hist. :* Javier Goya; Mariano Goya; Román Garreta → Museo de la Trinidad (5.4.1866) – Madrid, Prado (414) – GW 1721

We have already seen a telling instance of a domestic quarrel in the drawing F.18. In that context, I pointed out that Goya was interested in – and amused by – everything connected with marriage and its consequences, whether agreeable or the contrary. What we have here is not a scene between two spouses but a comical situation symbolizing the husband's tyranny over his wife. Cracking his whip, he forces her to carry him on her back like a pack animal. His spiteful looks match the role. She, instead, her eyes cast down in resignation, clasps both hands round the feet of her lord and master. It is worth noting that in C.120 the artist employed a rather similar composition to show the peasantry overwhelmed by the wealth of the religious orders.

G.14 [375] p. 515

Mitad de cuaresma (Partir la vieja) (Bc) (Mid-Lent. Cutting the old woman in two) – 1824-28 – Bc – No. (Bc) – *Paper :* horizontal chain lines – *Hist. :* Javier Goya; F. de Madrazo; Saragossa, B. Montañés; Madrid, A. de Beruete; Berlin, Gerstenberg (after 1907) – Destroyed (1945) in Berlin, formerly Gerstenberg coll. – GW 1722

The resemblance of this seemingly barbarous drawing and B.60 (?) in the Madrid album has already been studied in detail (Bibl. 122, pp. 141-143, and 94, pp. 34-36). In fact, as I pointed out in the note to B.60 (?), both are symbolic representations of Mid-Lent. This is now confirmed by the definitive caption to this one. Goya found it amusing to revert to the theme over a quarter of a century later. What is entirely new is the realistic impression given by the handling and the composition. The old woman is set on a carpenter's bench with drawers on the front, and the symbolic operation is being performed by a stalwart, brawny-armed sawyer under the eager eyes of two characters – priests, it would seem – in the background.

561

G.15 [376] p. 516

Segura union natural (Hombre la mitad Muger la otra Dulce union) (Bc) (Sure and natural union. Man one half, Woman the other. Sweet union) – 1824-28 – 192 × 150 – Bc – No. (Bc) – *Paper:* horizontal chain lines – *Watermark:* G.H.I – Stamp J. Peoli on the reverse (Lugt 2020) – *Hist.:* Ps. J. Peoli, New York, 8.5.1894; Ch. Ricketts & Ch. Shannon (1937) – Cambridge, Fitzwilliam Mus. (2067) – GW 1723

Goya treated marriage problems a great many times in his *œuvre,* particularly in the drawings – cf. note to F.18. This amusing composition proposes an original solution, indeed the only feasible way to achieve a harmonious balance between the two parties. The spouses, joined together in the narrowest sense of the term, show by their beaming smiles that their union is a happy one, in sharp contrast to the situation described in G.13. The definitive title is written over two others that are still just barely legible. They prove what great care Goya devoted not only to the drawings themselves – note the *pentimenti* by the two heads – but also to the style of the captions; he was satisfied only by the most forceful wording. This drawing should be compared with *Disparate 7,* in which a similar kind of union is viewed in a tragic light.

G.16 [377] p. 517

Amaneció asi, mutilado, en/Zaragoza, a principios/de 1700 (Bc) (He appeared like this, mutilated, in Saragossa, early in 1700) – 1824-28 – 194 × 148 – Bc – No. (Bc) – *Paper:* horizontal chain lines – *Hist.:* Bordeaux, Hyadès; Paris, J. Boilly; Ps. J. Boilly, Paris, H.D., 19-20.3.1869, No. 51 → Leurceau (50 fr.); A. Strolin – France, priv. coll. – GW 1724

There are a great many scenes of physical suffering and torture in Goya's drawings and prints, yet few as horrific as this. The huge bag of human limbs slung before a wall from a hook does not, however, at first sight reveal any sign of spectacular violence. The legs hang limp and the head, projecting from the mouth of the sack, seems lifeless too. The unusually explicit caption tells us exactly what it is all about. The man was atrociously mutilated (hands or arms amputated) and that was how they found him at Saragossa one fine morning in the year 1700. The lower part of the sack is soaked with the victim's blood – the only sign of the butchery that took place the night before. Two hypotheses may be put forward: either Goya had heard the story at Saragossa in his youth and was still haunted by it during the last years of his life; or he got it from one of the many Aragonese exiles he associated with at Bordeaux.

G.17 [378] p. 518

Loco (Calabozo) (Bc) (Madman [Cell]) – 1824-29 – 193 × 147 – Bc – No. (Bc) – *Paper:* horizontal chain lines (28 mm) – *Hist.:* Bordeaux, Hyadès; Paris, J. Boilly; Ps. J. Boilly, Paris, H.D., 19-20.3.1869, No. 48 → Leurceau (450 fr. for the album of twenty drawings); A. Strolin; Munich, A. S. Drey (1939) – Buenos Aires, Z. Bruck coll. – GW 1725

A little further on in this album an important group of drawings is devoted to lunatics (G.33 to G.40), so one might be surprised to find this isolated case all by itself long before the others and surrounded by subjects of a totally different kind. As a matter of fact, the apparent anomaly is explained by the original title "*Calabozo*" (cell), which gives the scene a certain vagueness that would not warrant its inclusion in that group. Goya must have written the definitive title later, when the layout of the whole album had been settled, but did not change the numeration as he had done more than once in album C. Be that as it may, there is a striking resemblance between this composition and G.34 and G.36. In all three, the cell is treated in the same way: a very dark area of black chalk against which the human figure stands out more or less brightly lighted. Here the accent is on the face of the man, whose gesture and staring eyes reveal his madness.

G.19 [379] p. 519

Dice q.ᵉ son de nacimiento, y pasa su/vida con ellos (Bc) (He says he was born with them and keeps them on all his life). Half-erased caption below the figure's knees: "... *con la ... en/la cabeza*" (... with the ... on his head) – 1824-28 – 191 × 150 – Bc – No. (Bc) – No. add. 180 (Lp) – *Paper:* horizontal chain lines (25/26 mm) – Mounted on pink paper – *Hist.:* Javier Goya; Mariano Goya; Román Garreta → Museo de la Trinidad (5.4.1866) – Madrid, Prado (397) – GW 1726

Every detail of this strange figure excites our pity. As he kneels with head bent to one side, his imploring gaze and outstretched palms seem to plead for sympathy. The pair of horns he wears suffice to explain his life-long tragedy. But in the caption Goya repeats the excuse invented by the poor fellow: a congenital deformity has horned him for life. A first inscription probably supplied a different commentary on the drawing; unfortunately its essentials cannot be deciphered. The handling is remarkable for combining the very soft effects obtained with black chalk and touches of crayon to bring out certain important details, notably of the head. Traces of a discarded first sketch are clear to see by the shoulder, on the right, while some few *pentimenti* to the left of the head were seemingly covered by the rubbed background.

G.20 [380] p. 520

Borrico q.ᵉ anda en dos pies (Bc) (A donkey on two legs). A different word, now illegible, was written under "*Borrico*" – 1824-28 – 191 × 147 – Bc – No. (Bc) – No. add. 33 (or 53?) (Lp) – *Paper:* horizontal chain lines – Mounted on pink paper – *Hist.:* Javier Goya; Mariano Goya; Román Garreta → Museo de la Trinidad (5.4.1866) – Madrid, Prado (376) – GW 1727

This is the first circus or fairground scene to appear in the Bordeaux drawings. We shall find others later in this album and in album H (cf. in this connection the introduction to albums G and H). The trained ass, erect on its hind feet, is both funny and grotesque, but that is all there is to it. Instead, the crowd of idlers or spectators treated as a mass of heads showing a wide range of expressions is very interesting indeed. Arranged in a horizontal strip behind the ass, they recall the onlookers at the executions of the victims of the Inquisition – cf. in particular C.86, C.87 and C.90. But here the faces are treated in far greater detail and each is given a distinctive character.

G.22 [381] p. 521

Fuego (Fuego) (Bc) (Fire! Fire!) – 1824-28 – 190 × 150 – Bc – No. (Bc) – Stamp E.C. (Lugt 837) – *Paper:* horizontal chain lines (25/26 mm) – *Hist.:* Paris, E. Calando; bought by the present owner in the South of France about 1947 – France, priv. coll. – GW 1728

This drawing owes its exceptional quality to the strong contrast of light and shade that makes the bright figure of the man stand out in bold relief against the dark background of the fire, from which he is fleeing, dressed only in a shirt that hangs down outside his trousers. The figure with its gesture of panic is rendered with a few rapid strokes overlaid here and there with light smudges due to the fire. The background, instead, is worked up with a heavy hatching of crayon – very obvious at the top and on the right – over a first uniform grey preparation. This produces a striking effect of thick smoke and leaping flames, from which the man is making a desperate effort to escape.

G.23 [382] p. 522

Reza (Bc) (He's saying his prayers) – Autograph inscription almost entirely effaced above *Reza* – 1824-28 – Bc – No. (Bc) – *Paper:* horizontal chain lines (26 mm) – *Hist.:* Javier Goya; F. de Madrazo; Saragossa, B. Montañés; Madrid, A. de Beruete; Berlin, Gerstenberg (after 1907) – Destroyed (1945) in Berlin, formerly Gerstenberg coll. – GW 1729

The subject in itself has nothing unusual: a man kneeling at the foot of his bed, saying his prayers. But several elements in the scene strike a note of oddity that one feels without being able to define it. First, the look of this man with his uncouth face, imbued with intense fervour: his arms crossed over his chest, suggesting sincere repentance; and the disarray of his clothes, his trousers unfastened and slipping down. Presumably the initial caption, all but obliterated and quite illegible, provided a commentary on the scene and explained it better than the single word *Reza*. Highlights in the hair and on the arms were added with a crayon in short, zigzagging lines. The final caption was also written with the crayon.

G.24 [383] p. 523

Diligencias|nuebas|o sillas de es|paldas||A la comedia|No. 89 (Sillas de|moda) (Bc) (New stage-coaches or shoulder chairs. To the theatre No. 89. Fashionable chairs) – Under *Diligencias nuebas* is another, illegible inscription – 1824-28 – Bc – No. (Bc) – *Paper:* horizontal chain lines – *Hist.:* Paris, X coll.; Ps. Paris, c.1934-35; A. Strolin → 1953 – Boston, Museum of Fine Arts, Arthur T. Cabot Fund, (53.2376) – GW 1730

This album includes a homogeneous group of drawings representing means of transport whose novelty must have struck Goya when he saw them in Paris and Bordeaux. We have already met with an isolated example in drawing G.10, while here begins a set of seven scenes devoted to this theme (with the exception of G. 30). Three of them represent shoulder chairs (G.24, G.26, G.28), and the different inscriptions, here written on the subject itself, show how much Goya's curiosity was aroused by this picturesque means of individual transport; they also enable us to situate this scene in the neighbourhood of the Rue Marivaux, where the artist lived during his two-month stay in Paris. Just across the way is the Opéra-Comique (at that time the Théâtre des Italiens); this accounts for the words *A la comedia* written on the chair. The present subject was executed over an earlier drawing, a remnant of which can be seen on the right: the outline of an old woman drinking from a large bowl which she holds in both hands.

G.25 [384] p. 524

Coche barato|y tapado (Bc) (An economical covered carriage) – 1824-28 – 192 × 151 – Bc – No. (Bc) – *Paper:* horizontal chain lines (25 mm) – *Watermark:* GH.I – *Hist.:* Madrid, Marquess of Cerralbo – Madrid, Museo Cerralbo – GW 1731

A wheelbarrow can hardly be considered as a means of transport of any great novelty. If Goya included it in this group of drawings, he must have been struck by some unusual detail. Nothing of the kind is revealed in the drawing as we now have it. But in view of the gross distortion of the man's right shoulder, one cannot help wondering if the drawing is not unfinished at this point. Moreover, the three vague silhouettes distinguishable on the right seem to be amused by the scene, but there is nothing in this wheelbarrow and its covered load to account for their laughter.

G.26 [385] p. 525
Paseo (Bc) (Promenade) – 1824-28 – Bc – No. (Bc) – *Paper:* horizontal chain lines – *Hist.:* Javier Goya; F. de Madrazo; Saragossa, B. Montañés; Madrid, A. de Beruete; Berlin, Gerstenberg (after 1907). Destroyed (1945) in Berlin, formerly Gerstenberg coll. – GW 1732

Another view of the shoulder chair, but one now of a different type. While the one in drawing G.24 was a sort of individual "taxi", this one apparently has a "hood" that can be opened when the weather is fine. The woman sitting inside has called to the porter and is pointing out the direction in which she wishes to go. Wearing a large hat as in the other drawings, the man stands with his legs set widely apart and attends to her words, before setting out again on the way.

G.28 [386] p. 526
De todo/sirven. (No se alquilan) (Bc) (Can be used for anything. Not for hire) – 1824-28 – 192×147 – Bc – No. (Bc) – *Paper:* horizontal chain lines – *Hist.:* Bordeaux, Hyadès; Paris, Jules Boilly; Ps. J. Boilly, Paris, H.D. 19-20.3.1869, No. 48 → Leurceau (450 fr. for album of 20 drawings); A. Strolin – USA, priv. coll. – GW 1733

A lady has just engaged the shoulder chair on the left and taken her place in it; two others stand at the back waiting for the chair on the right to be available. Here again an initial caption has been cancelled out with a few crayon strokes, but without making it illegible as in other cases. No further information about this drawing has been obtainable since it entered an American collection.

G.29 [387] p. 527
Mendigos q.ᵉ se lleban solos en/Bordeaux (Bc) (Beggars who get about on their own in Bordeaux) – 1824-28 – 184×142

– Bc – No. (Bc) – *Paper:* horizontal chain lines – *Hist.:* Bordeaux, Hyadès; Paris, Jules Boilly; Ps. J. Boilly, Paris, H.D. 19-20.3.1869, No. 48 → Leurceau (450 fr. for album of 20 drawings); A. Strolin – France, priv. coll. – GW 1734

Comparing this beggar with the one in drawing C.35, we can see how surprised Goya must have been to find the French beggar equipped with a vehicle that seemed almost luxurious by Spanish standards. Two large driving wheels and one small back wheel, to make steering easier, represent a considerable advance over the bare plank with four solid wheels used, even then, only by the luckiest cripples in Madrid. This man sits bolt upright, supported by a back-piece on which he has hung his bag, and though the upper part of his face is slightly overshadowed, there is nothing woeful in his gaze. From his improved vehicle, Goya got the impression that this beggar, far from being an outcast, had regained his independence and social dignity.

G.30 [388] p. 528
Con animales pasan su vida (Bc) (They spend their life with animals) – 1824-28 – 192×148 – Bc – No. (Bc) – No. add. 184 (Lp) – *Paper:* horizontal chain lines (25-26 mm) – Mounted on pink paper – *Hist.:* Javier Goya; Mariano Goya; Román Garreta → Museo de la Trinidad (5.4.1866) – Madrid, Prado (400) – GW 1735

This scene shows two figures, one full face filling most of the sheet, while the other, less obvious, is half reclining athwart the drawing, his legs passing under the arch formed by those of his companion. They are amusing themselves with a small animal which the latter holds back to prevent it from leaping on a strange winged creature standing on the left. The main figure represents a new morphological type in Goya's work, one apparently peculiar to the Bordeaux period. He is characterized by a stout build and a large round head, like the figures in drawings G.39, H.6, H.38, H.60 and also certain miniatures executed in the winter of 1824-25 (notably GW 1677, GW 1686 and GW 1687). The position of the legs forming an arch recurs in the first three drawings referred to above, in H.51 and in the lithograph from the *Bulls of Bordeaux* entitled *Spanish entertainment* (GW p. 347) (the man in the foreground on the far right). All these figures give an impression of vulgar, thickset sturdiness.

G.31 [389] p. 529
Yo lo he visto en Paris (Bc) (I saw it in Paris) – 1824-28 – 194×148 – Bc – No. (Bc) – *Paper:* horizontal chain lines

Hist.: Ps. Paris, c.1934-35; A. Strolin – France, priv. coll. – GW 1736

Coming back to means of locomotion, we find here the only one of Goya's drawings with an explicit reference to Paris written in his own hand. By such a scene, both unexpected and profoundly human, he was much more struck than by the sights and monuments of the French capital. As in the majority of his more personal works, Goya is not concerned with the landscape or the setting for its own sake, but solely with man and the objects touching him closely. If we consider the drawings that have come down to us, we can say that, for Goya, Paris was summed up in this old woman trundled along by her dog in a little cart – a glimpse of street life which for him expressed something essential and which, by the magic of his art, he made eternal.

G.32 [390] p. 530
Locos patines (Bc) (Mad skates) – "Goya" (Lp) in another hand, lower left corner – 1824-28 – 192 × 151 – Bc – No. (Bc) – *Paper*: horizontal chain lines (25-26 mm) – *Hist.*: Bordeaux, Hyadès; Paris, Jules Boilly; Ps. J. Boilly, Paris, H.D. 19-20.3.1869, No. 48 → Leurceau (450 fr. for album of 20 drawings); A. Strolin → 1953 – Boston, Museum of Fine Arts, Arthur Gordon Cabot Fund, (53.2377) – GW 1737

Despite the word *locos* with which the caption begins, this drawing belongs to the group dealing with new means of locomotion (cf. entry for G.24) and not to the series which immediately follows portraying lunatics. Moreover, Goya made a point of including in the background the early type of velocipede known as a hobby, which had been in fashion in France since 1818. The figure in the foreground is not a lunatic, but a man who has rashly ventured on rolling skates for the first time and they have got out of control; he is falling over backwards and, giving a shriek, his hair streaming in the wind (like the man in G.10), he flings out his arms, vainly trying to regain his balance. Plainly distinguishable here are the crayon strokes giving added vigour to certain outlines (e.g. the underside of the arm on the right, the lower part of the back and the inner contour of the left leg).

G.3(3)? [391] p. 531
Loco furioso (Bc) (Raging lunatic) – "Goya" (Lp) in another hand, lower left corner – 1824-28 – 193 × 145 – Bc

– No. (Bc) – *Paper*: horizontal chain lines (25-26 mm) – *Hist.*: Bordeaux, Hyadès; Paris, Jules Boilly; Ps. J. Boilly, Paris, H.D. 19-20.3.1869, No. 48 → Leurceau (450 fr. for album of 20 drawings); A. Strolin; priv. coll. → 1972 – New York, Ian Woodner coll. – GW 1738

Although the second figure of the autograph number has been half scratched away, it hardly seems possible to place this drawing anywhere else, its subject making it one of the key works of this series devoted to lunatics. What a vision of madness this is, seen from the outside, from the world of health and light, through thick bars riveted fast together! From this black hole grimly set in the whiteness of the wall, a wild-eyed man tries in vain to break out. He has passed his head and an arm through the bars, impelled not by hope but by an obscure instinct for freedom.

G.34 [392] p. 532
Loco Africano (Bc) (African lunatic) – 1824-28 – Bc – No. (Bc) – *Paper*: horizontal chain lines – *Hist.*: Javier Goya; F. de Madrazo; Saragossa, B. Montañés; Madrid, A. de Beruete; Berlin, Gerstenberg (after 1907) – Destroyed (1945) in Berlin, formerly Gerstenberg coll. – GW 1739

The first madman in this series (G.3[3]) was seen from the outside. Now we find ourselves on the other side of the walls and bars, introduced into the cells of the asylum. Here reigns the darkness of clouded minds, an atmosphere even more tragic than that of the Inquisition prisons (e.g. C.103 or C.107), for here there is no hope of freedom. Against the thick shadows on the walls stands out the white figure of this African lunatic, shaggy, bearded, staring dully at the floor. An undefined silhouette appears outside the barred window, a guard or relative whose presence brings no reaction from this poor wretch.

G.35 [393] p. 533
Locos (Bc) (Lunatics) – 1824-28 – 186 × 147 – Bc – No. (Bc) – *Paper*: horizontal chain lines – *Hist.*: Paris, Maurice Marignane coll.; A. Strolin (c. 1928) → 1955 – Boston, Museum of Fine Arts (55.662) – GW 1740

This drawing is the only one in the group of lunatics which shows a crowd of figures huddled together. One can distinguish two men standing in the foreground: one in back view, strongly illuminated, the other in front view, in the shadows, wearing a large hat and looking wildly about him. On the left is a woman in three-quarter view with a shawl over her

head and a skirt with large flounces. The other lunatics stand behind them, roughly sketched in with black chalk alone, all with strange and disturbing faces. The background laid in with broad parallel strokes of chalk indicates that the scene is set in the ward of an asylum. It has unfortunately proved impossible to obtain a good photograph of this exceptionally fine drawing.

G.3(6)? [394] p. 534
de la C.ᵉ M.ʳ (?) Loco (Bc) (Lunatic from the Calle Mayor?) – 1824-28 – Bc – No. (Bc) – *Paper :* horizontal chain lines – *Hist. :* Javier Goya; F. de Madrazo; Saragossa, B. Montañés; Madrid, A. de Beruete; Berlin, Gerstenberg (after 1907) – Destroyed (1945) in Berlin, formerly Gerstenberg coll. – GW 1741

This scene appears to be set out-of-doors, perhaps in a street, if the first part of the caption is considered to be autograph and the interpretation of it seems acceptable. The figure is dressed for outdoors and wears a normal hat, but the bizarre attitude and wild eyes betray an unsound mind. The background is divided into two distinct planes, an upright wall and a pavement, by a differing use of the pencil, whose more or less serried hatchings go to suggest both light and space.

G.37 [395] p. 535
Locos (Bc) (Lunatics) – 1824-28 – (Bc) – No. (Bc) – *Paper :* horizontal chain lines (25-26 mm) – *Hist. :* Javier Goya; F. de Madrazo; Saragossa, B. Montañés; Madrid, A. de Beruete; Berlin, Gerstenberg (after 1907) – Destroyed (1945) in Berlin, formerly Gerstenberg coll. – GW 1742

These two lunatics are contrasted both in facial expression and in lighting. The one a little behind on the left, leaning back on a bench, remains in the shadows marked by an accumulation of spirited strokes, except for a luminous zone on his throat; his raised head and open mouth sufficiently express his wretched condition. In contrast, the foreground figure standing in the light lowers his head sadly, overcome by some demented dream of grandeur; like the wretches whom Goya had shown crowned in *The madhouse* (GW 968) in the Academy of San Fernando in Madrid, he is wearing a kind of large shako made of paper, which seems to weigh him down with its imaginary glory.

G.38 [396] p. 536
El hombre feliz (Bc) (The happy man) – The same caption was written at the bottom of the sheet, then struck out

with the crayon – 1824-28 – Bc – No. (Bc) – *Paper :* horizontal chain lines – *Hist. :* Javier Goya; F. de Madrazo; Saragossa, B. Montañés; Madrid, A. de Beruete; Berlin, Gerstenberg (after 1907) – Destroyed (1945) in Berlin, formerly Gerstenberg coll. – GW 1743

This human apparition but faintly modelled by light against a very dark ground expresses the terrible affliction of madness, as if the last glimmerings of reason were fading into these thick shadows. The gesture of the arms with open hands and the head bowed on the chest convey the bewilderment of the mind at the darkness closing in from all sides. The face is already overshadowed. But in his caption Goya seems to suggest that this may be the perfect bliss, on the threshold of the nothingness announced in a famous plate of the *Disasters of War 69, Nada. Ello dirá* (Nothing. The event will tell).

G.39 [397] p. 537
Locos (Bc) (Lunatics) – 1824-28 – 190 × 145 – Bc – No. (Bc) – Red mark C.G. (Lugt 542) – Inscription on verso: " Goya y Lucientes (François) né à Fuentedetodos Aragon en 1746; mort à Bordeaux en 1832. – 0,191 L. = 0,155. Ce dessin m'a été donné le 26 décembre 1859 à Madrid par Mr. Madrazo, peintre de la Reine d'Espagne. Collection Goya fils – Collection Madrazo – C. Gasc (signature) – Goya – Collection Madrazo – Madrid 1859 Num. 60 " – *Paper :* horizontal chain lines (25-26 mm) – *Hist. :* Javier Goya; F. de Madrazo; C. Gasc (1859) – Madrid, Marqués de Castromonte coll. – GW 1744

Here we have the mirthful type of lunatic, in contradistinction to the specimens of tragic madness depicted in the rest of the series. Again we have a stout, thickset figure, with a plump, almost puffy face, like the one noted previously (G.30). Between his legs, set wide apart and forming an arch, can be seen two other figures, also mad no doubt (since the caption is in the plural), on which the fat man is about to sit; hence the broad grin lighting up his foolish face. On the back of the sheet is the same inscription in the hand of the collector C. Gasc which we have already met with on the back of G.1.

G.40 [398] p. 538
Loco furioso (Bc) (Raging lunatic) – 1824-28 – 190 × 144 – Bc – No. (Bc) – *Paper :* horizontal chain lines (25 mm) – *Hist. :* Bordeaux, Hyadès; Paris, Jules Boilly; Ps. J. Boilly, Paris, H.D. 19-20.3.1869, No. 48 → Leurceau (450 fr. for album of 20 drawings); A. Strolin – France, priv. coll. – GW 1745

This is the second "raging lunatic" in the series, now a human beast, half undressed, wild-eyed, with brutish features. His hands appear to be tied behind his back (as in G.34 and G.37) and – a frequent device with Goya – he stands out fully illuminated against a dark background produced by repeated scumblings with the crayon. In the upper right corner is a pattern of thick bars, like those in G.3(3)?, and, more to the left, two huge hands are clutching them. One has the impression that under the dark background an initial subject was sketched out, then covered over to make way for the final drawing. One notes here, as in other drawings of this album, the unerring sureness with which long crayon lines are laid in to stress a form or define a contour; for example, along the body on the left and along the edge of the white garment, from top to bottom.

G.41 [399] p. 539

Loco p.ʳ escrupulos (Bc) (Mad through scruples) – 1824-28 – 185 × 140 – Bc – No. (Bc) – Mark E.C. (Lugt 837) – *Paper:* horizontal chain lines (26 mm) – *Hist.:* Paris, E. Calando; purchased by the present owner in the South of France about 1947 – France, priv. coll. – GW 1746

This drawing represents a man jumping over a balcony in a fit of madness. He holds a paper in his hand, probably a letter, which accounts for this gesture of despair and which the caption refers to: rather than scruples, it was no doubt remorse that seized him on reading the letter. Goya tells us nothing more definite, and in fact there would be little point in doing so. What mattered for him was the sudden onset of madness that sent this man to his death. Curiously enough, when I first saw this drawing about 1955, it was framed upside down, the *passe-partout* concealing the caption, and was supposed to represent a man throwing up his arms as if calling for help.

G.42 [400] p. 540

Se mueren . . . (Bc) (They are dying . . .) – 1824-28 – 194 × 148 – Bc – No. (Bc) – *Paper:* horizontal chain lines (26 mm) – *Hist.:* Bordeaux, Hyadès; Paris, Jules Boilly; Ps. J. Boilly, Paris, H.D. 19-20.3.1869, No. 48 → Leurceau (450 fr. for album of 20 drawings); A. Strolin – France, priv. coll. – GW 1747

Apart from the old man sitting in the foreground, it is difficult to make out the details in the rest of the composition. Another figure seems to be half reclining in the shadows on the right, but one divines rather than sees his head resting against his companion's left arm. Madness here would seem to be ruled out; poverty, rather, is the subject. The old man's face, though reduced to a few patches of shadow and light, expresses heavy affliction. But if we perceive it from the intense pathos with which Goya contrives to imbue the very texture of his drawing, we do not quite understand it, for the caption seems to have been deliberately cut short by the artist, the last words having been blotted out by the second basket drawn in the foreground; the full meaning thus escapes us. Presumably Goya was dissatisfied with his caption and covered it up with an additional element (cf. G.8, G.14, G.15, G.19, etc.), but did not have time to write in another one.

G.43 [401] p. 541

Loco picaro (Bc) (Crafty lunatic) – 1824-28 – 192 × 150 – Bc – No. (Bc) – *Paper:* horizontal chain lines (26 mm) – *Watermark:* GH.II – *Hist.:* Bordeaux, Hyadès; Paris, Jules Boilly; Ps. J. Boilly, Paris, H.D. 19-20.3.1869, No. 48 → Leurceau (450 fr. for album of 20 drawings); A. Strolin; priv. coll.; London, Calmann → 1968 – Stockholm, Nationalmuseum (274.1968) – GW 1748

This might also be called the "disguised lunatic", but the gaze and the exaggerated pose well express all the craftiness with which Goya meant to endow his figure. With hat, ear-rings and fine shoes, he has disguised himself as a woman; then to make himself more interesting, he has imitated a well-advanced pregnancy by stuffing a thick cushion under his shirt, whose tail ends he holds behind his back, and even bending his knees so as to make his enormous belly as prominent as possible. Despite his madness, to which Goya attributes this rather heavy piece of humour, one is struck by his sidelong glance which, in this self-assured figure, seems to denote a real turn for play-acting. Noteworthy is the perfect orientation of the line according to the form represented, particularly on the make-believe belly and the legs.

G.44 [402] p. 542

Loco p.ʳ errar (Bc) (Mad by error?) – 1824-28 – 191 × 146 – Bc – No. (Bc) – Another inscription has been covered over to the right of the figure's legs; only the final letters . . . *nto* are still visible – *Paper:* horizontal chain lines (26 mm) – *Hist.:* Bordeaux, Hyadès; Paris, Jules Boilly; Ps. J. Boilly, Paris, H.D. 19-20.3.1869, No. 48 → Leurceau (450 fr. for album of 20 drawings); A. Strolin; priv. coll. → 1953 – Boston, Museum of Fine Arts, Arthur Tracy Cabot Fund (53.2378) – GW 1749

Here the figure treated in half-tones stands out only faintly from the dark background of superimposed hatchings. Wearing an ample cloak and a large hat with turned-up brim, he is poring over a book, rather like a priest reading his breviary as he walks along. As in other drawings of this album, an initial caption has been obliterated by Goya himself. López-Rey thought he could still read the word *santo* (Bibl. 133, p. 366); actually, only the letters . . . *nto* are visible. As regards the final caption written at the top of the sheet, López-Rey has proposed to interpret it as *loco por herrar* (crazy enough for branding), but this seems to me unconvincing; such a phrase is out of keeping with the colloquial language used by Goya. If we keep the spelling *errar,* the most acceptable meaning would perhaps be "mad through erring". But admittedly the caption is obscure and difficult to construe. Such minor problems, however, in no way detract from the expressive power of this drawing, one of the finest in the series of lunatics.

G.45 [403] p. 543

Loca q.ᵉ bende los placeres (Bc) (Mad woman who sells delights). Inscriptions on the skirt: *Salud/Sueño/Libertad/Gusto/Alegria* (Health Sleep Liberty Pleasure Joy) – 1824-28 – Bc – No. (Bc) – Another inscription was scribbled out to the right of the figure's feet; it was probably the phrase *Es francesa* (She is French) recorded by Carderera (Bibl. 84, p. 227), a few letters of which can still be divined – *Paper :* horizontal chain lines (26 mm) – *Hist. :* Javier Goya; F. de Madrazo; Saragossa, B. Montañés; Madrid, A. de Beruete; Berlin, Gerstenberg (after 1907) – Destroyed (1945) in Berlin, formerly Gerstenberg coll. – GW 1750

Examining this figure closely, one has the impression that there was an initial drawing beneath it to which the caption recorded by Carderera, "She is French", must have referred. Still visible behind the feet of this "mad woman" are other feet differently disposed on a more distant plane; and her dress has been modified, particularly on the left, where its full sweep is ill adjusted to the much darker bodice. To begin with, then, there was probably a typically French female figure – as indicated by Carderera's caption – who must have caught Goya's eye in the streets of Bordeaux and whom he subsequently changed into a sort of allegorical figure. The final caption seems to provide the key to the enigma: this "mad woman who sells delights" is simply a street vendor of those cornet-shaped wafers known in France as *plaisirs* or *oublies,* which she proposed to passers-by after a drawing of lots. At about the same period Châteaubriand speaks of "*vendeuses de plaisirs*" hawking their "*oublies*". So I suppose that Goya, playing on the word *plaisirs,* which he translated literally as *placeres* (whereas these wafers are called *barquillos* in Spain), amused himself by turning this humble street vendor seen in France into an allegorical figure offering men a symbolic selection of boons – "health, sleep, liberty, pleasure and joy".

G.46 [404] p. 544

Enrredos de sus vidas (Bc) (Their lives' entanglements) – 1824-28 – 191 × 153 – Bc – No. (Bc) – *Paper :* horizontal chain lines (26 mm) – *Hist. :* bought in Madrid between 1858 and 1860 by the 1st Baron Savile of Rufford; Rufford Abbey, John Savile, 2nd Baron Savile of Rufford; London, Colnaghi's → 1923 – Ottawa, National Gallery (2997) – GW 1751

At first sight this drawing appears to show a bouquet of flowers, with two young women dressed in white emerging from it – an unearthly apparition whose originality is unparalleled in Goya's work. But, as often happens with these very elaborate drawings, it is only when we come to examine the minutest details that it is possible to get at the underlying meaning or anyhow to propose a plausible interpretation of it. Here one realizes that this "bouquet of flowers" actually consists of a multitude of half-human, half-animal heads, most of them with leering faces – a stock iconographical element in Goya's work, appearing as early as 1788 in the background of the painting of *St Francis Borgia at the death-bed of an impenitent* (GW 243) and even more clearly in the sketch (GW p. 57). It reappears later in the first preparatory drawing for *Capricho 43, El sueño de la Razon* . . . (The dream of Reason) (GW 538), in which the sleeping artist himself is beset by the monsters. In the Bordeaux albums we find these monstrous heads in H.11, again grouped round the main figure. For Goya they symbolize the temptations of the flesh, the sexual licence which he had already denounced in the *Caprichos.* Have we here, as E. Sayre suggests (Bibl. 25, p. 51, No. 39), a case of homosexuality? For my part, I would only point out that there are some significant differences between these two women. The one below, with butterfly-wings and some kind of crown on her head, seems to be drawing or luring away the uppermost woman, who is distinctly younger and whose face, alone of the two, is visible. It is significant, too, that the original caption was *Enrredos de su vida,* the last two words having been changed to the plural at some later moment with a finer pencil. So that the original reference was to the love life of the younger woman alone, the other perhaps personifying a "temptress".

As regards the bouquet design, it appears again in this same album in drawing G.57, also with monstrous heads, but now with laughing faces.

G.47 [405] p. 545

Sucesos campestres (Bc) (Rural events) – 1824-28 – Bc – No. (Bc) – *Paper :* horizontal chain lines (26 mm) – *Hist. :* Javier Goya; F. de Madrazo; Saragossa, B. Montañés; Madrid, A. de Beruete; Berlin, Gerstenberg (after 1907) – Destroyed (1945) in Berlin, formerly Gerstenberg coll. – GW 1752

This macabre scene appears to be a settling of accounts between peasants or hunters; it has some analogy with drawing F.16. Here one of the antagonists has been hanged, and the other, gloating over his victory, puts out his tongue at him as he prepares to go his way; slung over his shoulders is a piece of big game (apparently a bear), which was presumably the subject of dispute. In the left background, a third, sinister-looking figure appears on a lower level. The foreground planes are heightened with crayon strokes, thus taking on a vigour which emphasizes the tragic sense of this "rural event". This technique is particularly evident in all parts of the tree and in the fur of the animal carried by the hunter.

G.48 [406] p. 546

Castigo francés (Bc) (The French penalty) – 1824-28 – Bc – No. (Bc) – *Paper :* horizontal chain lines (26 mm) – *Hist. :* Javier Goya; F. de Madrazo; Saragossa, B. Montañés; Madrid, A. de Beruete; Berlin, Gerstenberg (after 1907) – Destroyed (1945) in Berlin, formerly Gerstenberg coll. – GW 1753

Here, in two consecutive drawings, is the most direct and terrible record we have of the guillotine. Since the famous etching of *The garrotted man* (GW 122) of nearly fifty years previously, Goya had never hesitated to denounce by every means at his disposal the horrors of torture and capital punishment – witness the plates in the *Disasters of War,* the *Shootings of May Third* and many drawings in album C. But in none of these works, except for the *Shootings,* do we feel as here the imminent presence of death as organized and as it were sanctified by the social order. Goya records the instant, one might almost say the split second, just before the blade comes down and cuts off a human life. That life is reduced in the drawing to a ridiculous ball imprisoned in the infernal machine. Everything here is deathly black: the condemned man's head, the executioners in their formal hats, the assistant about to pull the rope

and, lower down, the priest with a cross as dark as his soutane. In contrast, the implacable geometry of the scaffold stands out in light grey against a perfectly clear sky. After the garrotte, the guillotine: Goya must have felt that nothing had changed and that men were being dispatched with as good a conscience on one side of the Pyrenees as on the other.

G.49 [407] p. 547

Castigo [*francés*] (Bc) The [French] penalty) – 1824-28 – Bc – No. (Bc) – *Paper :* horizontal chain lines (26 mm) – *Hist. :* Javier Goya; F. de Madrazo; Saragossa, B. Montañés; Madrid, A. de Beruete; Berlin, Gerstenberg (after 1907) – Destroyed (1945) in Berlin, formerly Gerstenberg coll. – GW 1754

Drawing mentioned by Carderera in 1860 (Bibl. 84, p. 227): "A condemned man walking to the guillotine accompanied by a priest with the epigraph 'French torture'." In his book (Bibl. 185, p. 142) the Count of La Viñaza also referred to the forty drawings owned by Don Bernardino Montañés, director of the School of Fine Arts at Saragossa, and recorded the fact that two of them "represent the guillotine" with the caption *castigo francés.* For this drawing only the word *castigo* has remained clearly visible. But now, thanks to a better developed negative, one can make out the word *francés* on the right, partially obliterated in the half-tone of the ground-level. By rights, the scene should be the first of the two; the fact it is not proves, incidentally, that Goya's numbering does not necessarily follow a chronological order. The scene is divided up by light and shadow: on the right, the last moments of life in front of the cross are still illuminated; on the left, the work of death is being prepared in the shadows. And there are two distinct movements: on one side, the inclined figures of priest and condemned man, running parallel to the cross, towards the open sky; on the other, the strict verticality of guillotine and executioner, the latter already laying hold of his victim to place him in the open lunette.

G.50 [408] p. 548

Gimiendo y llorando (Bc) (Weeping and wailing) – 1824-28 – 192 × 155 – Bc – No. (Bc) – *Paper :* horizontal chain lines (26 mm) – *Hist. :* London, Sir Robert Mond coll.; heirs of Sir Robert Mond – Calcutta, Mrs Joy Sen Gupta coll. – GW 1755

In 1969, I and my collaborator Mrs Juliet Wilson had tried to track down this drawing, whose existence was known. Our initial efforts to obtain a photograph

came to nothing and so it was impossible to reproduce it in my 1970 catalogue of the drawings. Here at last is this moving figure, whose pathos could hitherto only be guessed at from the caption. This imploring old man, leaning against a wall made of large hewn stones, is a cross between the central figure in the *Shootings of May Third* (GW p. 20) and *Christ on the Mount of Olives* (GW p. 305): he is neither defiant nor submissive, but a grief-stricken supplicant.

G.51 [409] p. 549

Comico descubrimiento (Bc) (Comical discovery) – 1824-28 – 192 × 149 – Bc – No. (Bc) – On the verso: mark of J. Peoli (Lugt 2020) – *Paper:* horizontal chain lines (26 mm) – *Watermark:* GH.II – *Hist.:* Ps. J. Peoli, New York, 8.5.1894; Charles Ricketts and Charles Shannon → 1937 – Cambridge, Fitzwilliam Museum (2066) – GW 1756

This drawing has been studied and commented on, from very different points of view, by Van Hasselt and E. Sayre (Bibl. 103, pp. 87-89, and Bibl. 22, No. 198). One thing is certain: from about 1795 on, Goya was obsessed by these groups of heads, usually caricatural. They already occur in the *Caprichos* (notably plates Nos. 23, 24, 58 and 64), but above all in two drawings in the Prado for unexecuted plates (Bibl. 173, Nos. 201 and 206), the first entitled *A modern Judith* by Mayer, the second *The appeal* by Sánchez Cantón. Whatever the foreground figure is meant to represent, both drawings show a serried mass of heads surrounded by large draperies, looking in the first drawing like a tent. Here we find these same elements, but with heads unmistakably caricatured, which invite comparison with contemporary works like drawing G.20 (in which similarly grotesque faces appear, let us note, in the crowd watching a side-show at a fair or circus), and with certain miniatures (GW 1677, 1685 and 1686). Finally, there is the caption, which lays stress on the comic side of the scene. So one wonders if this may not be a caricatural evocation of a crowd, possibly seen under a circus tent at Bordeaux in 1826 – any crowd being easily transformed, in the eyes of a rationalist, into an infernal vision. See, for example, the *Black Paintings* and, more in line with my interpretation here, the crowd watching a "circus queen" in the *Disparate Puntual* (GW 1602).

G.53 [410] p. 550

Buelan buelan (Fiesta en el ayre – El toro mariposa) (Bc) (They fly, they fly. Fiesta in the air. The butterfly bull) – 1824-28

– 190 × 150 – Bc – No. (Bc) – *Paper:* horizontal chain lines (25 mm) – *Watermark:* GH.III – *Hist.:* Bordeaux, Hyadès; Paris, Jules Boilly; Ps. J. Boilly, Paris, H.D. 19-20.3,1869, No. 48 → Leurceau (450 fr. for album of 20 drawings); A. Strolin; Paris, priv. coll. – London, priv. coll. – GW 1757

This drawing was thoroughly studied by López-Rey when it was exhibited at the Royal Academy in London in 1963-64 (Bibl. 133, pp. 367-368). The most important point in his commentary is the reference to the print made in 1784 by Isidro Carnicero and to the Talavera plate representing the same scene, but with an exact date: 15 May, 1784, the day of San Isidro, patron saint of Madrid, where it is celebrated with bullfights. These antecedents provide further evidence of the important part played by memories in the creative process of Goya's art. Even in the case of works apparently of pure fancy, it is often possible to trace their starting point to something he had actually seen, perhaps years before, but carefully noted and stored away in his mind. The idea illustrated by Carnicero, of holding a bullfight in the air by means of balloons, was one of those follies (*disparates*) engendered by the search for novelty in the practice of bullfighting. It is curious to note that in this drawing appears the symbol of butterfly wings, already used in the *Caprichos* (plate 61 and single proof of the *Dream of lying and inconstancy*): the bull is winged, but floating in the air above it are enormous heads blown up like balloons and adorned with butterfly wings. These mirthful heads belong, moreover, to the morphological type already noted in G.30. With the butterfly bull they form a new *Disparate* obviously related to the print *Disparate de tontos* (GW p. 311), the *tontos* (fools) being represented here by five specimens of the family of "big heads". One is also reminded of the flying bull in drawing E.20.

G.54 [411] p. 551

Aun aprendo (Bc) (I am still learning) – 1824-28 – 191 × 145 – Bc – No. (Bc) – No. add. 171 (Lp) – *Paper:* horizontal chain lines (25 mm) – Mounted on pink paper – This drawing lacks the stamp of the Museo Nacional – *Hist.:* Javier Goya; Mariano Goya; Román Garreta → Museo de la Trinidad (5.4.1866) – Madrid, Prado (416) – GW 1758

This figure of a hoary old man, bent by age but still young in spirit, is commonly assumed to be an ideal image of Goya at the end of his life. Treated in light-hued masses against a background of dark chalk, it has the evocative power of those allegorical figures of Truth and Justice of which he was so fond (see draw-

ings C.117 and F.45). Fine though it is, this composition would be merely anecdotal were it not for its caption. As luminously terse as the figure to which it applies, that caption is the very soul of the drawing. To grow old and keep learning, keep pressing forward, such was the ideal of this artist who, though ill and far from home, wondered, in a letter written to his son Javier shortly before his death, whether he might not live to the age of ninety-nine, like Titian. There is an admirable vigour here in the details of hands and face. One only regrets that the drawing should have suffered so much, whole areas of it now having disappeared (left arm and lower part of the garment).

G.56 [412] p. 552

Aqui algo/ha de aber (Bc) (Here something is bound to happen) – 1824-28 – Bc – No. (Bc) – *Paper:* horizontal chain lines (26-27 mm) – *Hist.:* Javier Goya; F. de Madrazo; Saragossa, B. Montañés; Madrid, A. de Beruete; Berlin, Gerstenberg (after 1907) – Destroyed (1945) in Berlin, formerly Gerstenberg coll. – GW 1760

This mysterious scene carries us back over the years to the period of *majas* and *embozados* (men wrapped in their cape up to the eyes); see in particular the tapestry cartoon *El paseo de Andalucia* (GW 78), executed in 1777. These reminiscences also occur now in two drawings in album H (H.22 and H.31) and in an etching made from the latter drawing (GW 1828), the main figure in these last two works being, as here, an *embozado* whose gun is concealed under the cape. The two dark figures in the background, a woman and a man – the latter also armed – give notice that a fight is about to break out. The chiaroscuro effect on the *embozado* and the cast shadows on the ground give a strong suggestion of depth to the scene.

G.57 [413] p. 553

Semana S.^{ta}/en tiempo pasado/en España (Bc) (Holy week in Spain in times past) – 1824-28 – 192 × 147 – Bc – No. (Bc) – *Paper:* horizontal chain lines (26 mm) – *Watermark:* GH.II and III – *Hist.:* purchased in Madrid between 1858 and 1860 by the 1st Baron Savile of Rufford; Rufford Abbey, John Savile, 2nd Baron Savile of Rufford; London, Colnaghi → 1923 – Ottawa, National Gallery (2999) – GW 1761

Here we have an opportunity of comparing two drawings on the same subject, but separated by an interval of thirty years. For we have already met with a procession of flagellants in the Madrid album (B.80), with the caption "Masquerades of Holy Week in the year '94". In contrast with the schematic figures and chiaroscuro of the early drawing, we find here a supple line and delicate modelling which really give this scene that "surrounding magic" which Goya himself spoke of as the supreme aim. It is enough to observe the flagellant's arm in both drawings to measure not only the progress but the prodigious leap forward which the Spanish master had made. Finally, we may note this profound difference: the drawing in the Madrid album is an indictment, by a man of the enlightenment, of barbarous practices still current in his country; this drawing is an almost nostalgic evocation of "times past", of his younger days, by an old man in exile who must have felt that, all things considered, flagellants and garrottes were no worse than the French guillotine. In the interval between the two drawings, he had painted the famous picture in the Academy of San Fernando, *Procession of flagellants* (GW 967), which is closely related to this drawing.

G.58 [414] p. 554

Quien vencera? (Bc) (Who will win?) – 1824-28 – Bc – No. (Bc) – *Paper:* horizontal chain lines (26-27 mm) – *Hist.:* Javier Goya; F. de Madrazo; Saragossa, B. Montañés; Madrid, A. de Beruete; Berlin, Gerstenberg (after 1907) – Destroyed (1945) in Berlin, formerly Gerstenberg coll. – GW 1762

Here is a much more modern and expeditious type of duel than the ones represented by Goya in album F (F.10 to F.15) and in the lithograph *The duel* (GW p. 348); the latter may be dated to 1824-25 and so belongs to the same period as this drawing. The fight is taking place with rifles at pointblank range, and from the attitude of the two men, perfectly balanced in the blacks and whites of their clothes, one senses the hatred driving them on. The man in front view, especially, is admirable in the foreshortening of his gesture, the position of the legs and the single eye prolonged by the barrel aimed straight at his antagonist's chest. Dark shadows on the ground and a curtain of trees behind provide a particularly sinister setting for this death scene. In the distance on the right two silhouettes can be vaguely divined, perhaps two women involved in this affair of honour.

G.59 [415] p. 555

Se quieren mucho (Bc) (They love each other very much) – 1824-28 – 192 × 150 – Bc – No. (Bc) – No. add. 179 (Lp) – *Paper:* horizontal chain lines (26 mm) – Mounted on

pink paper – *Watermark:* a trace on the left – *Hist.:* Javier Goya; Mariano Goya; Román Garreta → Museo de la Trinidad (5.4.1866) – Madrid, Prado (392) – GW 1768

These figures rising into the air recall, at first sight, certain plates in the *Caprichos,* notably No. 48, *Soplones* (Squealers), and No. 66, *Allá va eso* (There it goes). But I am not at all sure that we have here a witchcraft scene of the same type. On the left is a woman with a horribly withered body, being carried off by an old winged sorcerer with a concupiscent leer; ecstasy can be read in the bestial features of the woman and justifies Goya's ironic caption. This is probably a satire on the sensual passions of certain old men, which neither physical ugliness nor fear of ridicule can check.

G.60 [416] p. 556

Del avaro no se espera|ningun bien, y cada cual|aun muerto lo vitupera,|mas el hombre liberal|todos sienten q.e se muera (Bc) (One can expect no good from a miser and even after his death everyone speaks ill of him, whereas everyone regrets the death of a generous man) – 1824-28 – Bc – No. (Bc) – *Paper:* horizontal chain lines – *Hist.:* Javier Goya; F. de Madrazo; Saragossa, B. Montañés; Madrid, A. de Beruete; Berlin, Gerstenberg (after 1907) – Destroyed (1945) in Berlin, formerly Gerstenberg coll. – GW 1764

To oppose avarice to generosity, Goya contented himself with representing a miser, leaving it to his caption to point the antithesis between the two human types. But this rather commonplace contrast between a vice and its contrary had provided the subject of one of the drawings in the Madrid album (B.76) entitled *Largueza contra Abaricia* (Generosity versus Greed), done at a time when he shared the moralizing tendencies of his "enlightened" friends. Here, on the other hand, it is the man alone and his infinite sadness that concern him: the face seems to be consumed from within by his vice, and even the sight of his gold fails to raise his spirits, for he knows that he is already despised by all. The unusually long caption is oddly arranged, in the form of a stanza and in fact with rhyming lines. Possibly it is a reminiscence of some popular maxim thrown into poetic form; the careful handwriting and the neat ordering of the lines make this seem likely.

G.a [417] p. 557

Mal sueño (Bc) (Bad dream). An initial caption stands under the word *sueño,* beginning with *A...,* but the rest is indecipherable. The word *Mal* was added subsequently by Goya. – 1824-28 – 191 × 151 – Bc – No. (Bc) – No. add. 178 (Lp) – *Paper:* horizontal chain lines – Mounted on pink paper – *Hist.:* Javier Goya; Mariano Goya; Román Garreta → Museo de la Trinidad (5.4.1866) – Madrid, Prado (396) – GW 1720

Careful examination of the sheet has failed to reveal an autograph number; and the number added subsequently by Garreta is of no help in placing the drawing in the album. So we set it apart here, pending further information. The great subject of dreams reappears now in unusual but strikingly modern form. To convey more tellingly the nightmare of this man, who is still aghast at it, Goya represents the man as he is in reality and beside him the dream he remembers: in a sort of aureole, indicating what is going on in his mind (rather like the bubble-captions in strip cartoons), his head alone can be seen, a prey to black birds who are pecking at it. And, ironically enough, his two cats sit unconcernedly beside their master, who is still haunted by his encounter with their dearest victims.

G.b [418] p. 558

Comer mucho (Bc) (Eat a lot) – Another, much longer caption has been obliterated at the bottom of the sheet; it extended from the far left, where a *C...* can be divined, to the added number on the right – 1824-28 – 191 × 148 – Bc – No. (Bc) – No. add. 183 (Lp) – *Paper:* horizontal chain lines (26 mm) – Mounted on pink paper – *Hist.:* Javier Goya; Mariano Goya; Román Garreta → Museo de la Trinidad (5.4.1866) – Madrid, Prado (384) – GW 1759

This interior again shows two fleshy figures with large heads (see entry for G.30). The Rabelaisian subject hardly calls for explanation. Goya made a point of fully illuminating the main figure, his backside in particular, which plays the key part in the composition. The grinning face of the figure in the background (man or woman?) shows that the results of the operation are satisfactory; its grin contrasts with the anxious, questioning look of the person concerned. The initial, longer caption was obliterated; it may have given too realistic a commentary. All that remains is *Comer mucho* which, for anyone familiar with Spanish popular speech, suggests the rest: *...y c... mejor* (.. and sh... the more). The caption is fittingly inscribed on the side of the close-stool.

Bordeaux Album (H)

TECHNICAL FEATURES

Paper : Greenish-grey tinted laid paper, Dutch-made (?). Horizontal chain lines, 25 to 28 mm apart.

Watermark : Three types of watermark occur, the first two being the upper and lower half of the same mark :

 GH.I: a large heart surmounted by a trefoil;

 GH.II: a St Andrew's cross between two confronted lions;

 GH.III: the letters R J cut off by the edge of the paper.

Maximum sheet size : 194 × 158 mm, the most nearly square of all the formats employed by Goya in his drawing albums.

Drawings : Recto only.

Technique : Black chalk and greasy crayon (lithographic crayon).

Captions : No captions, except on five drawings (H.40, 41, 45, 53 and 54).

Signature : 34 drawings in this album bear the signature "Goya" in black chalk, usually at the foot of the subject. These 34 signed drawings all occur before No. 40. The signatures, both in the handwriting and in their position with respect to the subject, are identical with those which appear at the same period on several lithographs: see in particular the *Bulls of Bordeaux, Modern duel* and *El vito* (GW pp. 347 and 348). Though Goya signed none of the drawings in the other albums, he often signed his prints (see the *Caprichos, Disasters of War* and *Tauromaquía*). One may therefore infer that these signed drawings in album H were in fact preparatory studies for a set of lithographs.

Goya's numbers : Written in black chalk or greasy crayon. The highest number is 63; the number of drawings catalogued is 58.

Additional numbers : Only the drawings belonging to the Prado were numbered by Román Garreta in lead pencil in the lower right corner. No sheets from this album figured in the 1877 sale in Paris; on none of them, therefore, do we find the numbers added by Javier Goya with a fine pen.

BIBLIOGRAPHY

Exhibitions : 1, 2, 4, 10, 11, 12, 13, 18, 19, 20, 22, 25, 26.

Public sales : 29, 32a, 38.

Authors : 84, 86, 92, 94, 97, 103, 111, 113, 117, 122, 133, 135, 137, 142, 144, 145, 150, 160, 162, 173, 184, 185.

2.

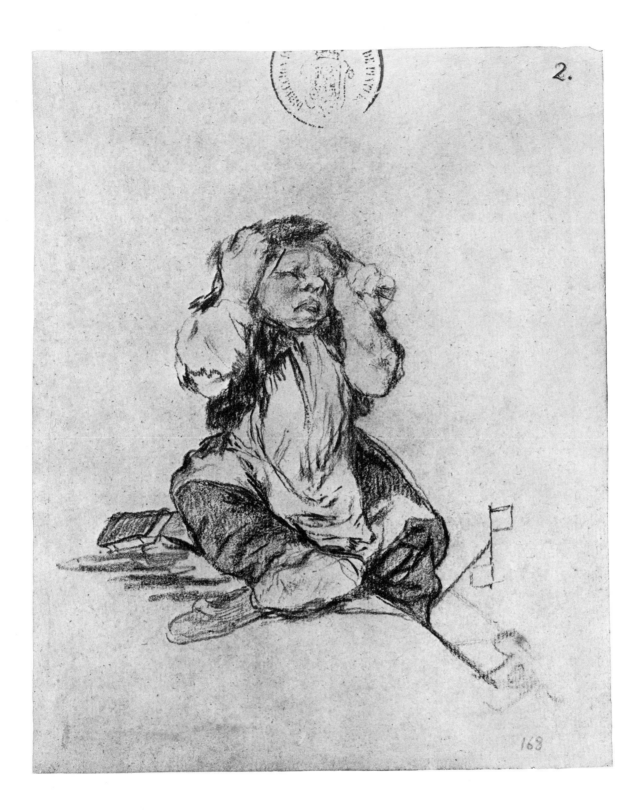

168

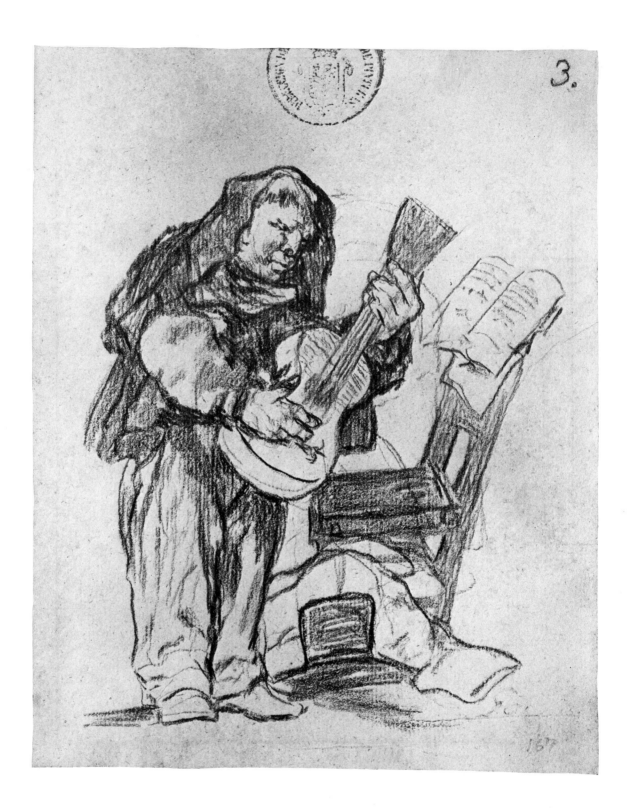

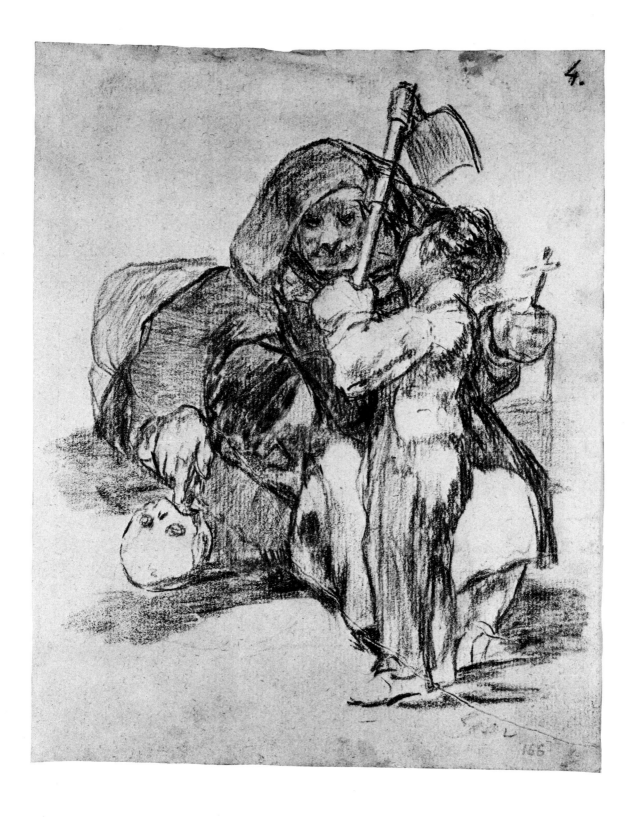

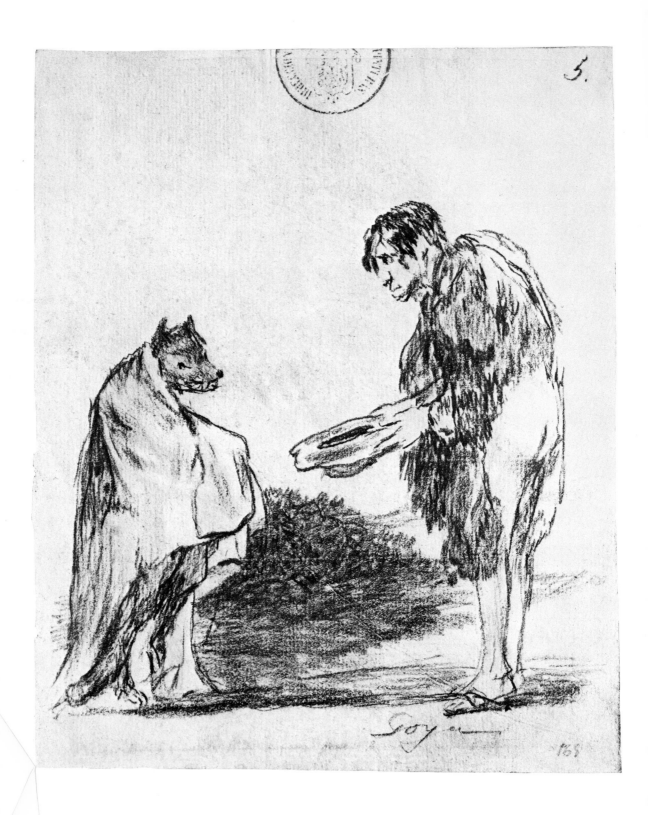

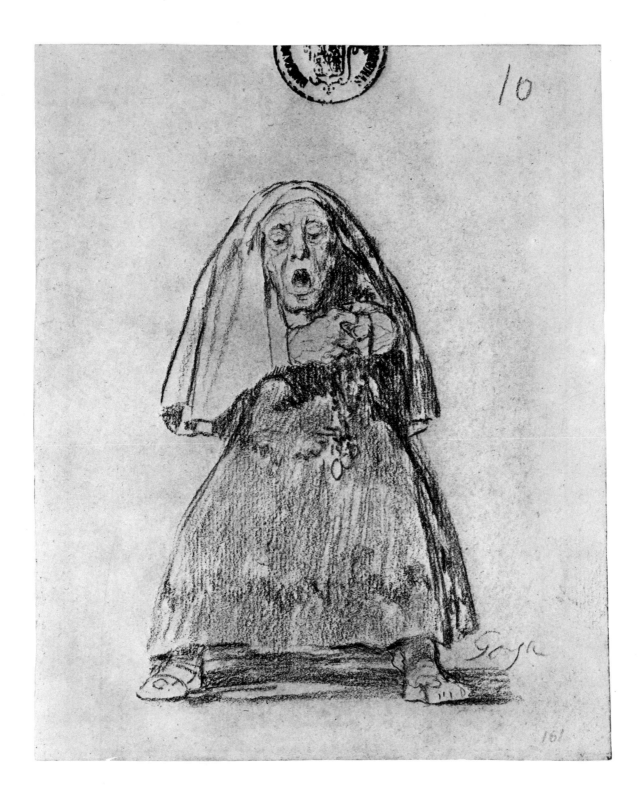

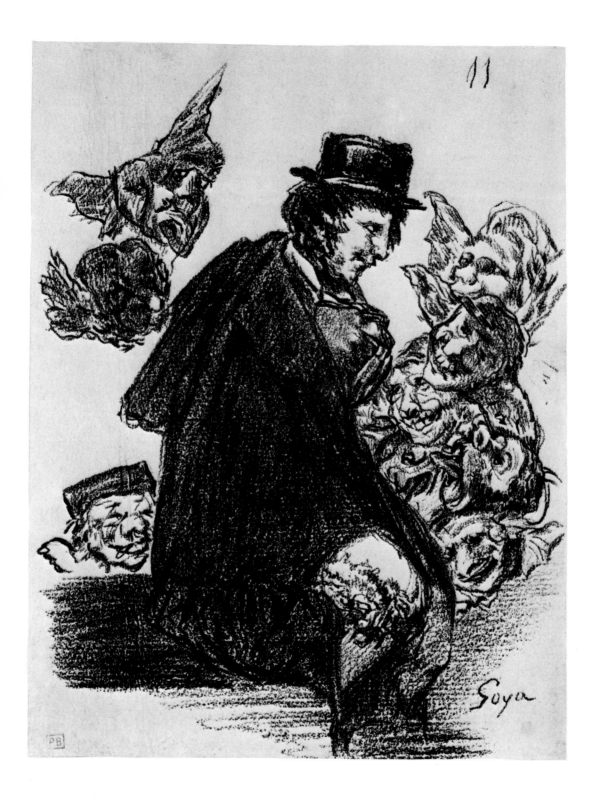

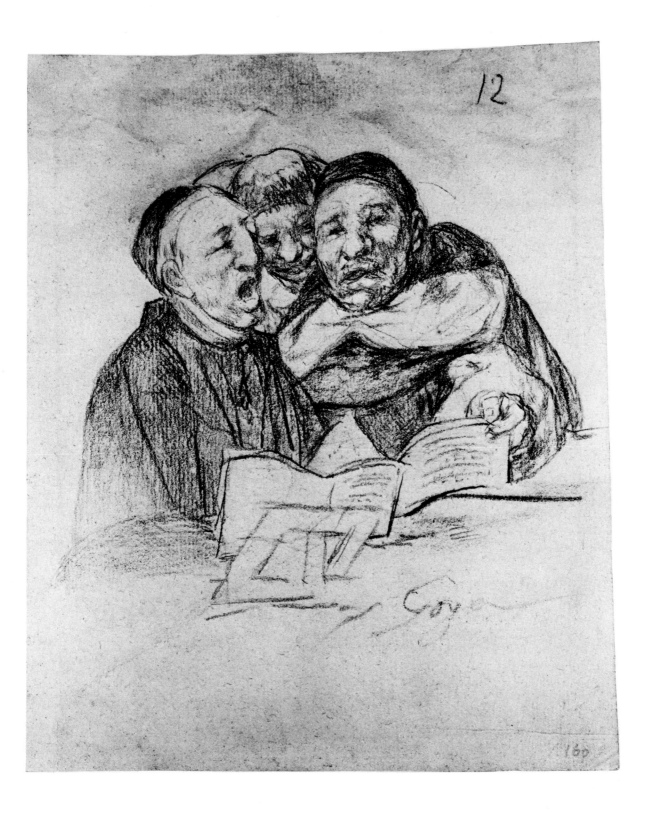

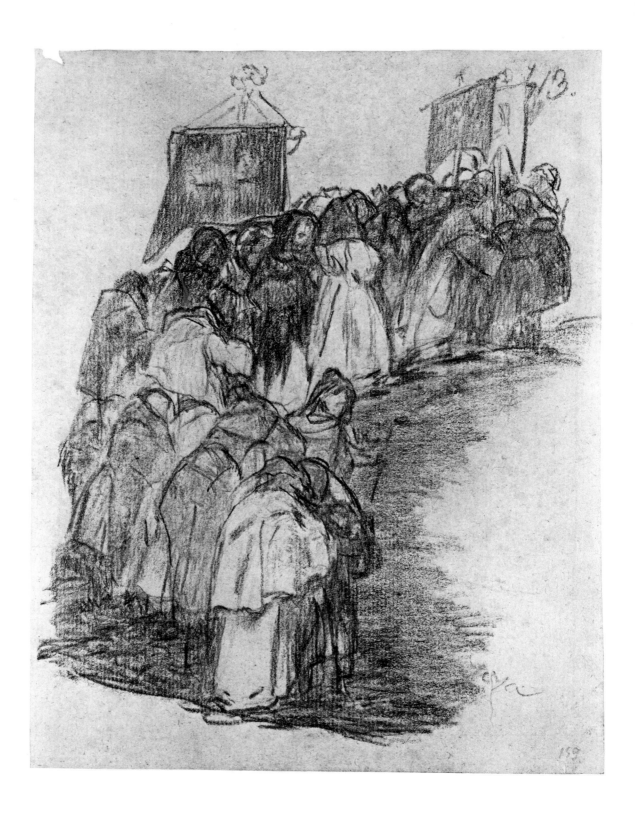

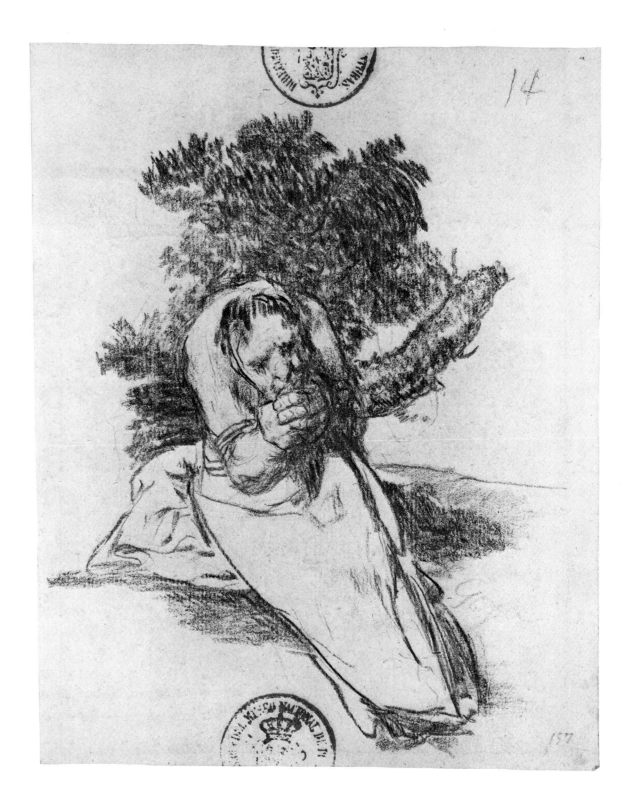

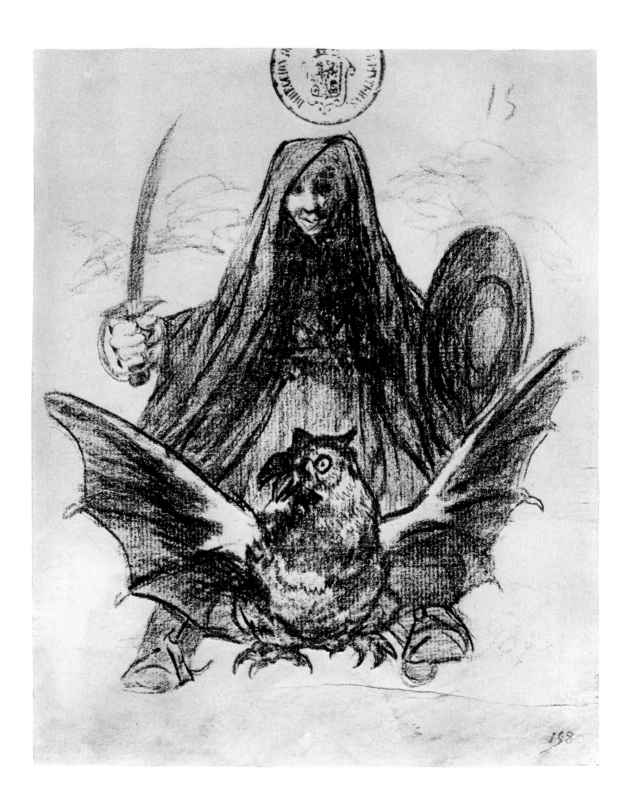

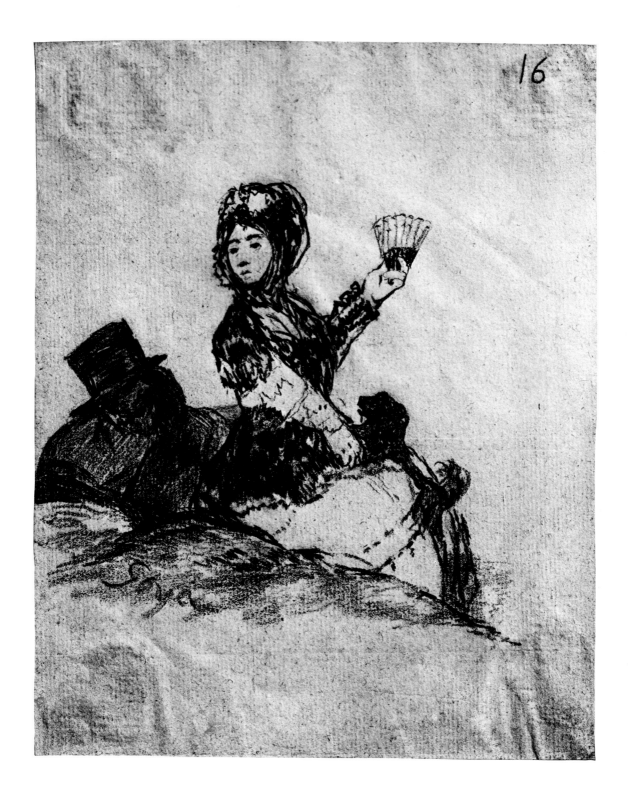

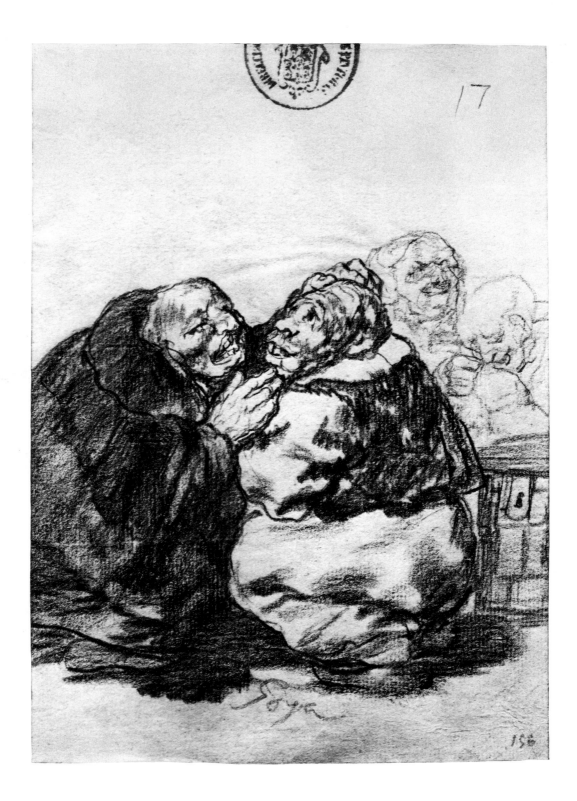

17

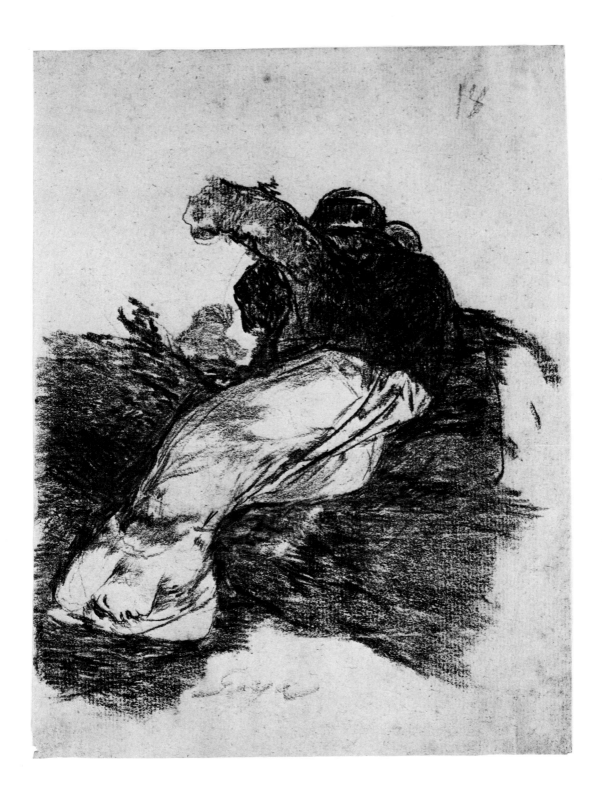

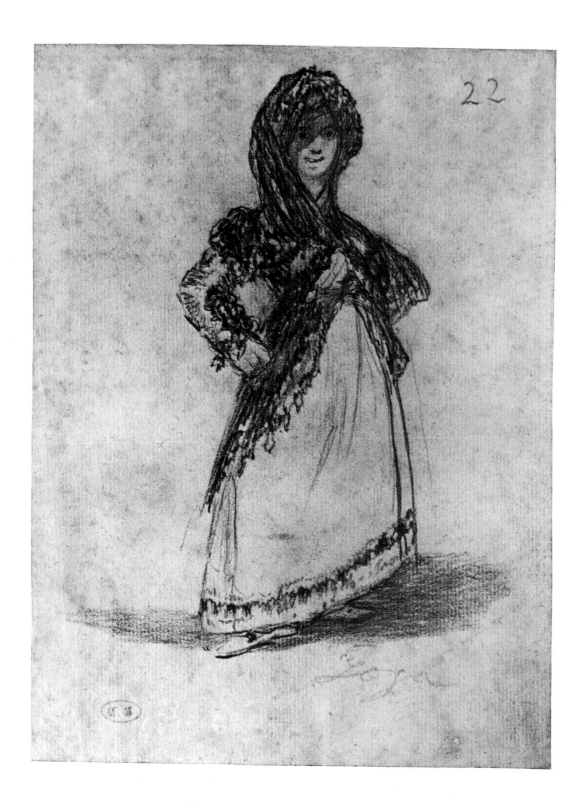

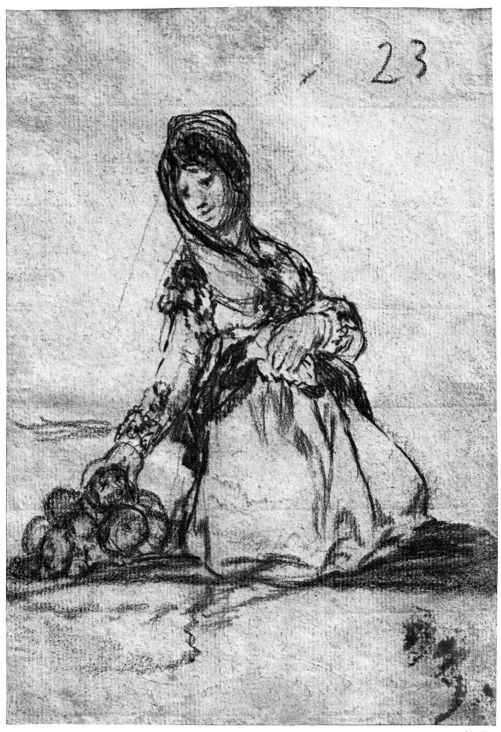

23

H.23.

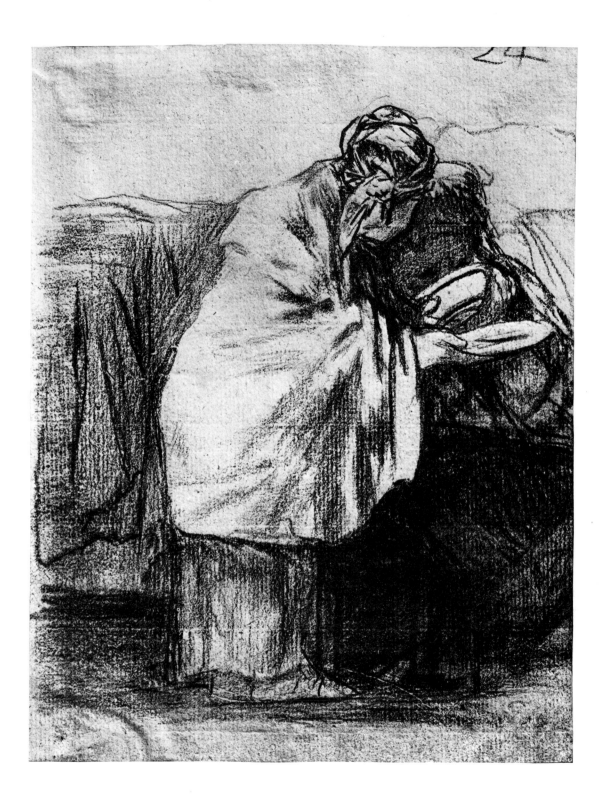

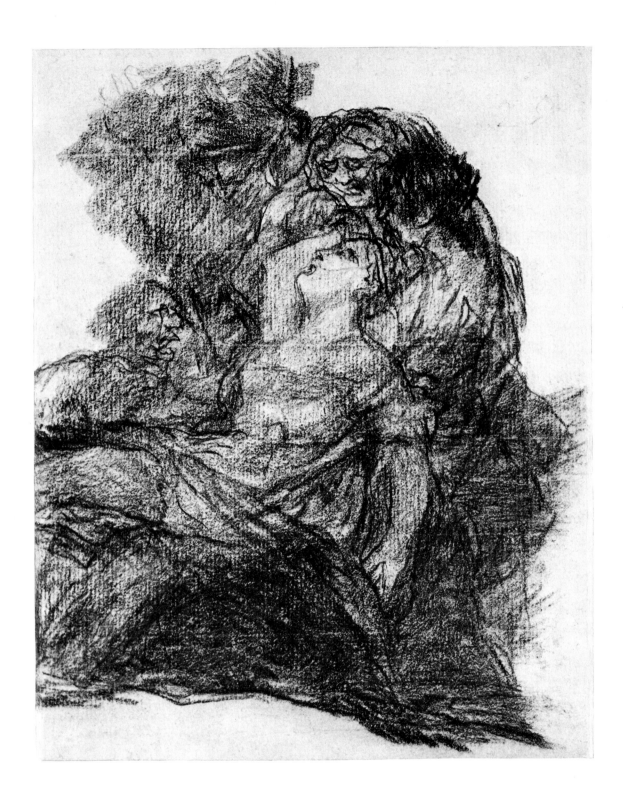

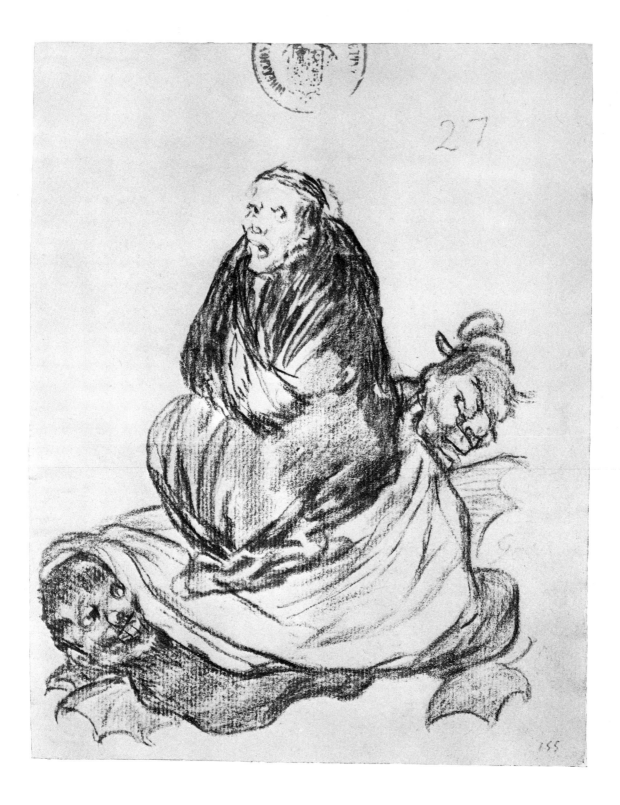

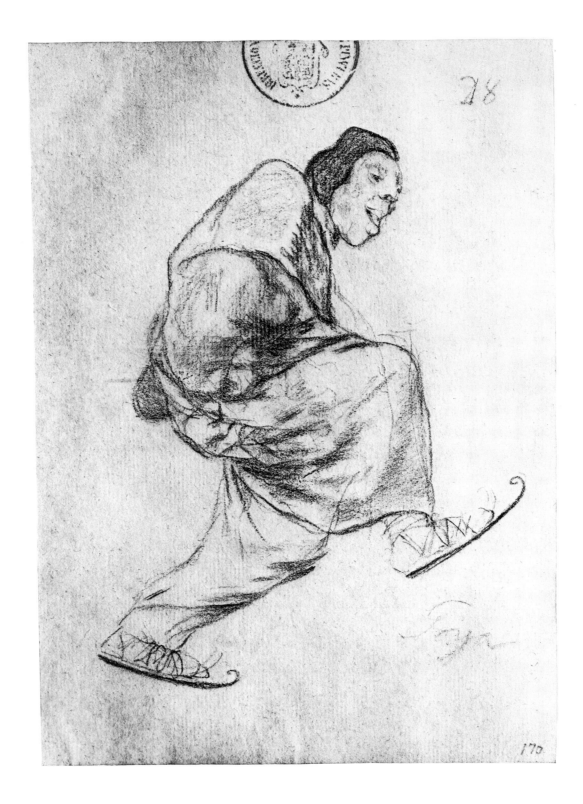

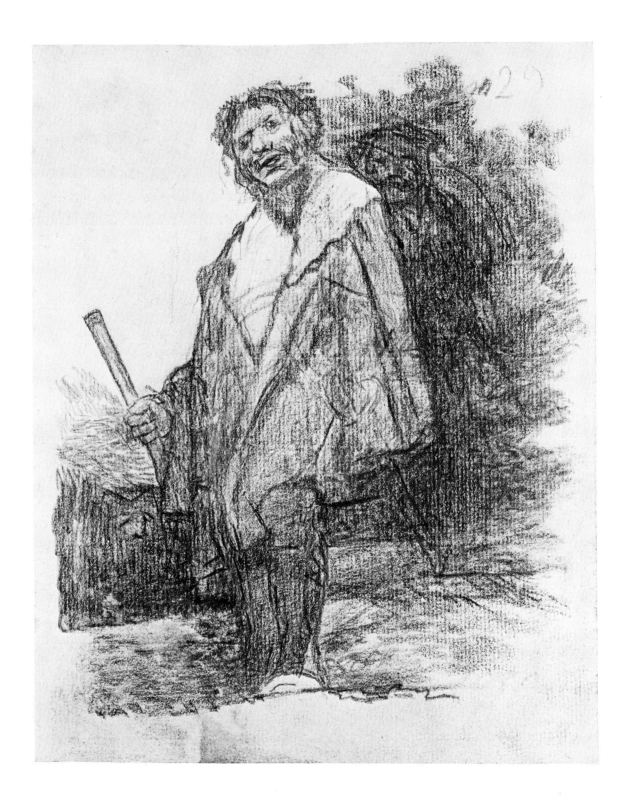

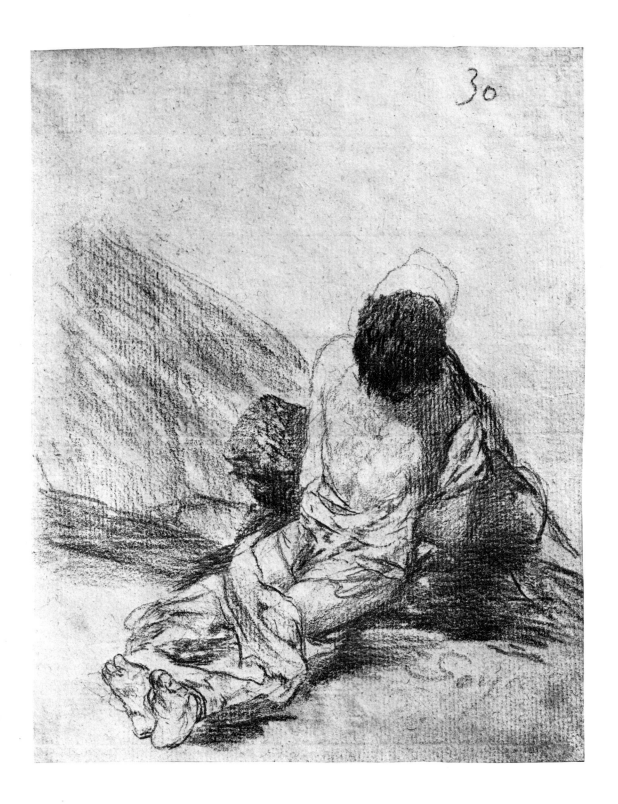

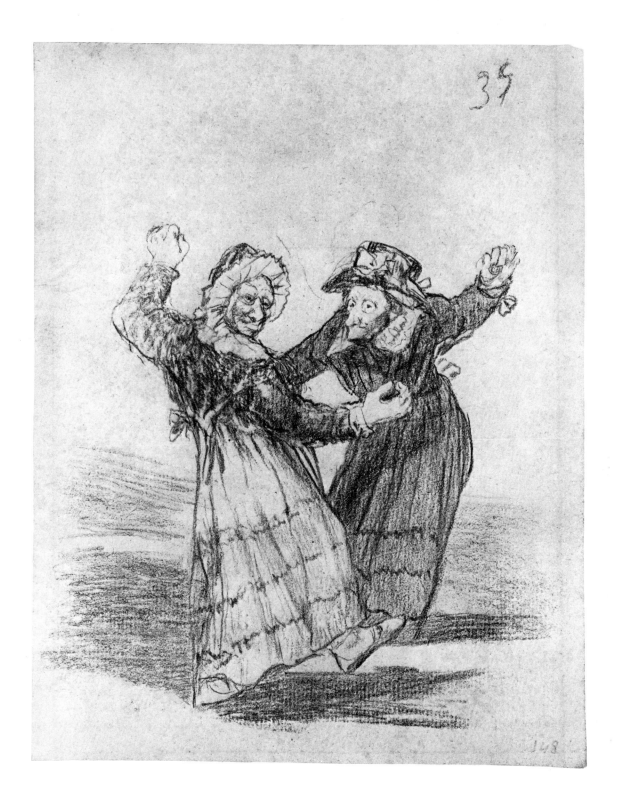

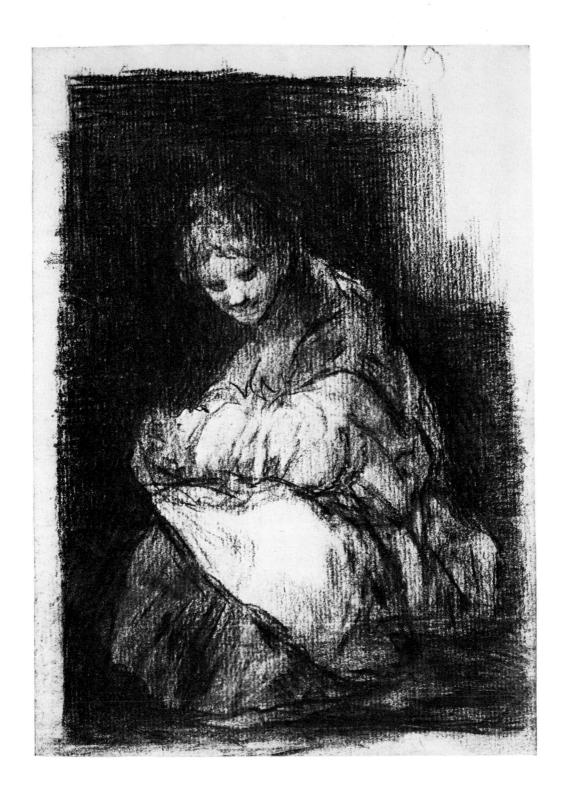

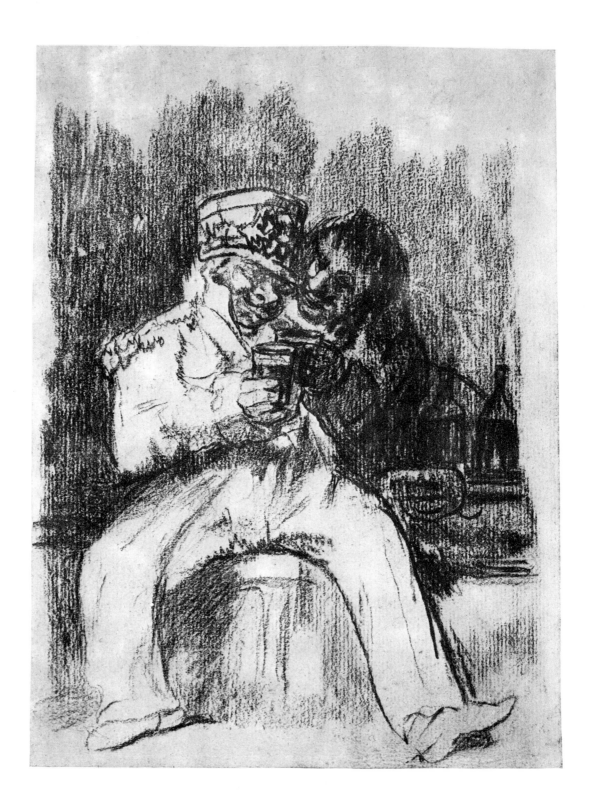

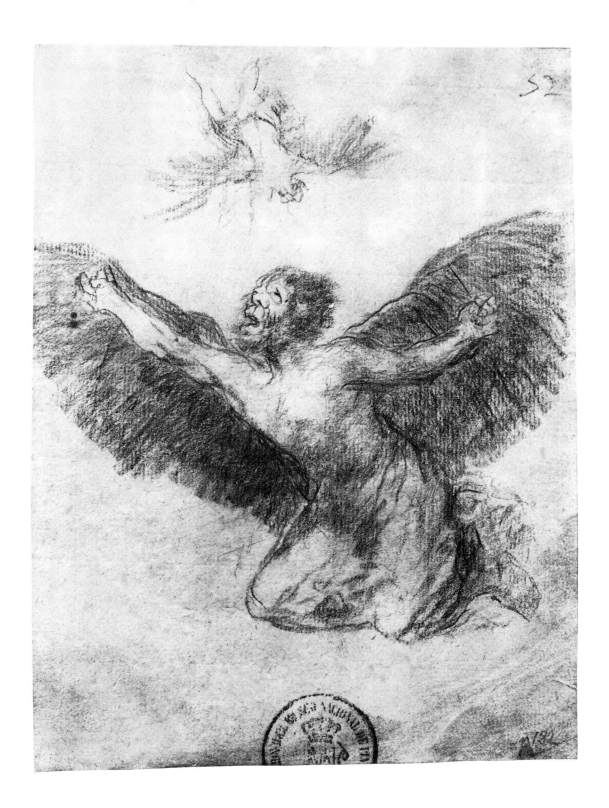

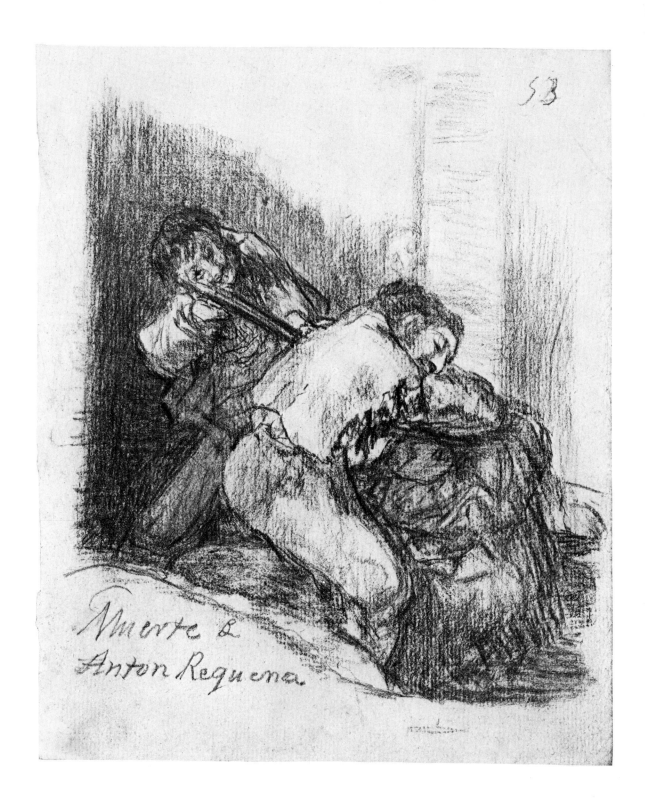

Muerte &
Anton Reguena

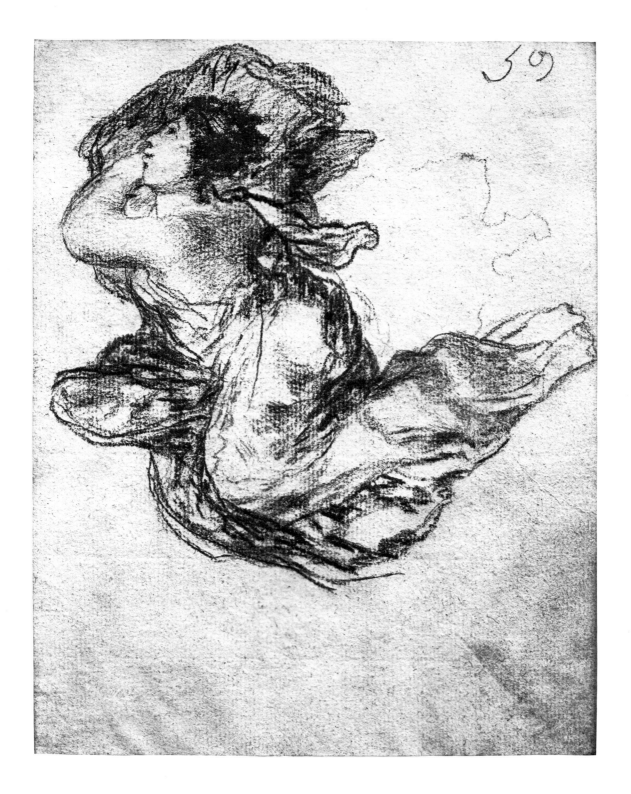

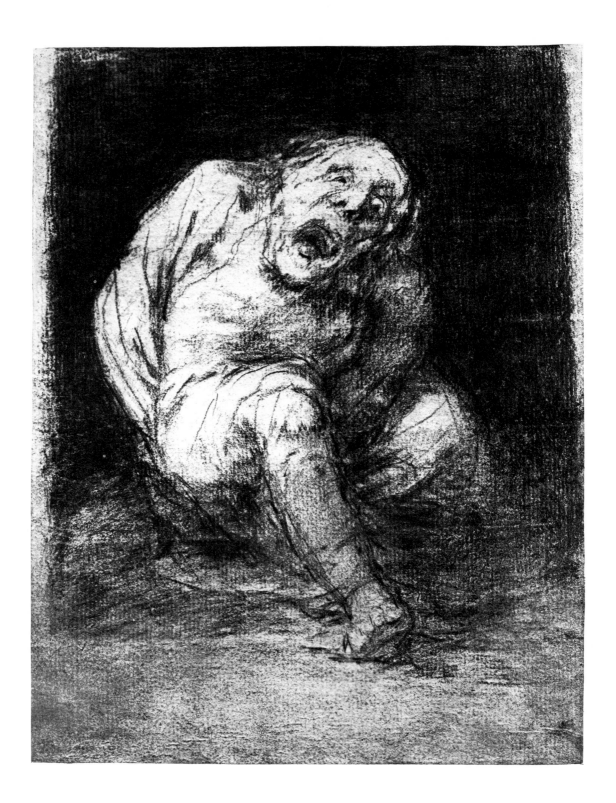

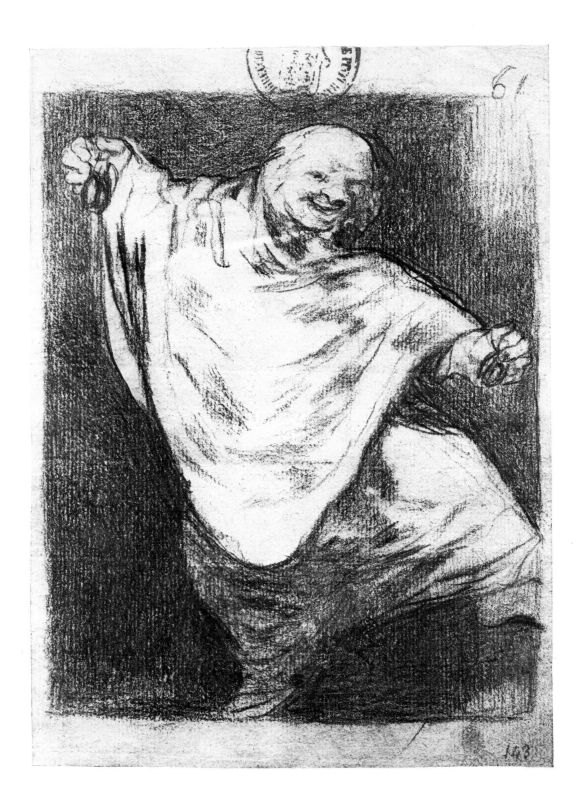

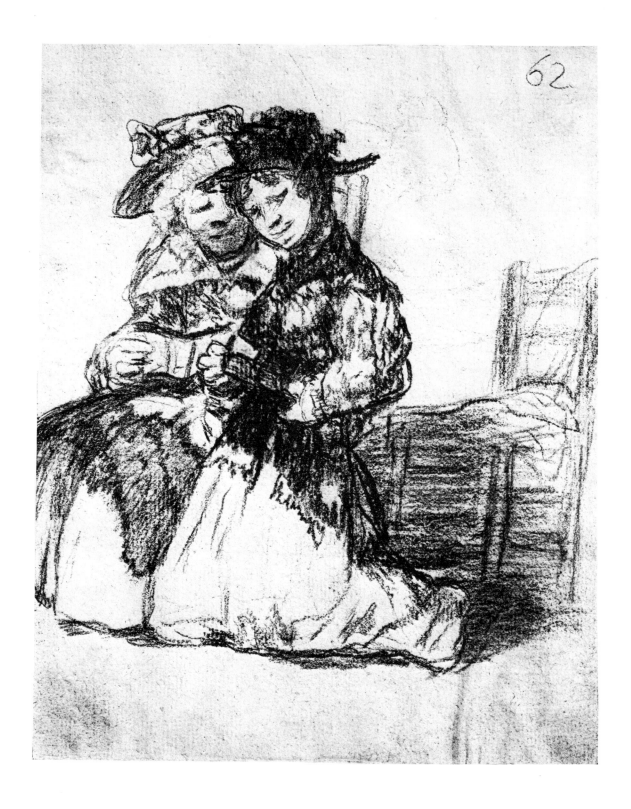

Bordeaux Album (H)

Captions and Commentaries

H.2 [419] p. 575
"Childish rage" – 1824-28 – 191 × 156 – s. "Goya" (Bc)
– Bc – No. (Bc) – No. add. 168 (Lp) – *Paper:* horizontal
chain lines – Mounted on pink paper – *Watermark:* GH.II
– *Hist.:* Javier Goya; Mariano Goya; Román Garreta
→ Museo de la Trinidad (5.4.1866) – Madrid, Prado (318)
– GW 1765

Album H in its present state opens with the only
portrait of a child that figures in the drawing albums.
Goya several times shows children in the company of
grown-ups, usually to illustrate problems of upbring-
ing (C.9, C.13, E.13, F.78, etc.). But this is the only
drawing entirely devoted to a child, and instead of
lingering over the graces or innocence of childhood,
as he had done so often in admirable painted portraits
(GW 210, 233, 293, 786, 884, 885, 895, etc.), he shows
the child in a tantrum, shaking with anger, pulling its
hair, its face bloated with tears, its toys lying scattered
round it – in short, a child at its most provoking.
Presumably this ruthless drawing was the exasperated
old artist's revenge on some howling brat he had met
with. From the very beginning of this album, one
notes an even more refined handling of the black-
chalk medium than in album G.

H.3 [420] p. 576
"Guitar-playing monk" – 1824-28 – 191 × 151 – s. "Goya"
(Bc) – Bc – No. (Bc) – No. add. 167 (Lp) – *Paper:*
horizontal chain lines – Mounted on pink paper – *Hist.:*
Javier Goya; Mariano Goya; Román Garreta → Museo de
la Trinidad (5.4.1866) – Madrid, Prado (364) – GW 1766

This guitar-player intent on picking out the notes on
the score fastened to the back of a chair is undoubtedly
a monk, as pointed out by Sánchez Cantón (Bibl. 173,

No. 401). Although his head is covered with his hood,
the front of his tonsure is plainly indicated. His face
expresses his absorption, a frown showing that he has
come up against a difficult passage; he has in fact lifted
his right hand from the strings until he can read the
music. But the detail that radically changes the mean-
ing of this scene is the heap of lay clothes and tall hat
lying beside the chair. Is this monk, too, going to give
up the frock, like those in album C (C.126 to C.131)?
Or is this lay dress a remnant of some previous com-
position, a few outlines of which can be seen at the
back between the chair and the monk? However we
interpret this figure of a man, it is a masterly piece of
drawing. The upper part of the body is treated in a
succession of highlights; even finer is the handling of
the trousers, whose lines, slightly broken here and
there, admirably render the creases in the thick material
of which they are made.

H.4 [421] p. 577
"Good counsel" – 1824-28 – 190 × 153 – s. "Goya" (Bc)
– Bc – No. (Bc) – No. add. 166 (Lp) – *Paper:* horizontal
chain lines (26 mm) – Mounted on pink paper – Seal of the
Museo Nacional lacking on this sheet – *Hist.:* Javier
Goya; Mariano Goya; Román Garreta → Museo de la
Trinidad (5.4.1866) – Madrid, Prado (402) – GW 1767

The curious thing about this scene is the deliberate
antithesis between the seated monk, holding a cross in
one hand and pointing with the other to a human skull
lying on the ground, and the boy standing in front of
him and lifting over his head a hoe, whose handle runs
exactly parallel to the monk's cross. The latter, with
his sober countenance, evokes the vanity of human
concerns in the face of eternal life, while the peasant

lad, armed with the only working instrument he knows, personifies daily labour unmindful of metaphysical preoccupations. With his uplifted hoe is he mocking the monk or possibly even provoking him? By not showing us the boy's face, Goya has left it to us to guess what is happening. The least one can say is that the monk is not looking at him with the mildness one would expect towards a child. The combination of different crayon techniques is quite visible here: grey surfaces by means of parallel hatchings carefully oriented to render the contrast of textures (monk's habit, iron hoe, boy's trousers), highlights with a fine crayon (hair, lines delimiting the monk's habit) and a few serrated accents (head and shirt of the peasant boy).

H.5 [422] p. 578

"The wolf's revenge" – 1824-28 – 191 × 158 – s. "Goya" (Bc) – Bc – No. (Bc) – No. add. 165 (Lp) – *Paper*: horizontal chain lines (26 mm) – Mounted on pink paper – *Hist.*: Javier Goya; Mariano Goya; Román Garreta → Museo de la Trinidad (5.4.1866) – Madrid, Prado (375) – GW 1768

In entitling this drawing "The performing wolf" in my 1970 catalogue (GW 1768), I was following up an idea implicitly put forward by Sánchez Cantón (Bibl. 173, No. 424) who regarded this as a fair scene similar to those which do in fact occur later in this album (H.40, H.41, H.45, H.54). Today I read this scene quite differently. Though the setting is but roughly sketched in, the bush on the left indicates that this strange encounter is taking place in the country. Furthermore one would hardly expect the exhibitor of a performing animal to appear half-naked, like the man shown here. For all he has on is an animal's hide, rendered by compact, serrated crayon strokes, covering only the upper part of his body; while the wolf is wearing a long cape which leaves only his head, paws and tail visible. It is as if the two figures had exchanged their station in life: the man has become an animal and the wolf, a noble lord; and the man respectfully presents his hat to his new master, either to give it to him or to crave alms of him.

H.6 [423] p. 579

"The hidden treasure" – 1824-28 – 191 × 157 – s. "Goya" (Bc) – Bc – No. (Bc) – No. add. 164 (Lp) – *Paper*: horizontal chain lines – Mounted on pink paper – *Hist.*: Javier Goya; Mariano Goya; Román Garreta → Museo de la Trinidad (5.4.1866) – Madrid, Prado (406) – GW 1769

The lust for gold inspired three other drawings in these albums, B.76, C.56 and G.60, not to mention *Capricho 30: Porque esconderlos?* (Why hide them?) in which appeared the figure of an old miser clutching his money bags. The present scene may be interpreted in two different ways: either he is hiding a treasure or he is unearthing one. The latter interpretation seems more likely in view of the expression on his face, which conveys exultation and covetous awe at the sight of the money bags. On the floor, moreover, among the coins, lies a sword of ancient make, which must form part of the hoard. The shovel with which he dug it up rests against a wall faintly indicated in the right background. Here again we find a stalwart type of figure with a large head and legs forming an arch firmly planted on the ground (see G.30). The sturdiness of the body is neatly rendered by the pattern of broken lines marking the contours.

H.7 [424] p. 580

"The pen is mightier than the sword" – 1824-28 – 192 × 156 – Bc – No. (Bc) – On the verso: mark of J. Peoli (Lugt 2020) – *Paper*: horizontal chain lines – *Watermark*: GH.II – *Hist.*: Ps. J. Peoli, New York, 8.5.1894; London, Charles Ricketts and Charles Shannon → 1937 – Cambridge, Fitzwilliam Museum (2068) – GW 1770

Drawing published and studied by F. D. Klingender (Bibl. 111, p. 197), and C. van Hasselt (Bibl. 103, pp. 87-89), whose views differ concerning the figure represented here. For van Hasselt, it is a monk; for Klingender, an allegorical combination of Truth and Justice. The latter view seems to me more likely, considering what is the essential element of the drawing: the scales held in the figure's left hand. They obviously evoke the scales of Justice, as in drawings C.118 and C.122, with this difference, however, that here the pans are occupied by a sword on the left and a goose quill on the right, symbolizing force and mind respectively; the latter tips the scales, but, one notes, only slightly. Finally, from the old man's brightly illuminated brow emanate rays of light – a certain indication, in Goya's iconography, that the figure personifies some such virtue as Truth or Justice. Never, moreover, has Goya represented a monk with anything like an aureole. So all the evidence goes to suggest an allegorical figure symbolizing the triumph of the Spirit over Violence. E. Sayre has drawn attention to the imprint, on the back of this sheet, of the next drawing, No. 8 (see in this connection the introduction to this album).

H.8 [425] p. 581

"Pensive shepherdess" – 1824-28 – 191 × 150 – s. "Goya" (Bc) – Bc – No. (Bc) – No. add. 163 (Lp) – *Paper:* horizontal chain lines – Mounted on pink paper – *Hist.:* Javier Goya; Mariano Goya; Román Garreta → Museo de la Trinidad (5.4.1866) – Madrid, Prado (320) – GW 1771

We have already met with a very similar subject in album C (C.25): there the mountain landscape with its successive planes gave a broad, open sweep to the composition. Here attention is focused on the figure, which is of much more imposing proportions, and the dog. The latter lies at its mistress's feet and refrains from disturbing her silent musings. Short serrated strokes are used to remarkable effect in the garments of the shepherdess.

H.9 [426] p. 582

"Man attacked by a bear" – 1824-28 – 190 × 156 – s. "Goya" (Bc) – Bc – No. (Bc) – No. add. 162 (Lp) – *Paper:* horizontal chain lines – Mounted on pink paper – *Hist.:* Javier Goya; Mariano Goya; Román Garreta → Museo de la Trinidad (5.4.1866) – Madrid, Prado (404) – GW 1772

Sánchez Cantón proposed to read this drawing as a nightmare (Bibl. 173, No. 414) and this interpretation was provisionally accepted in my 1970 catalogue. Further consideration of the subject leads me now to believe that it is not a nightmare but an actual scene. Though the setting is vague, it seems to be taking place beside a thicket. Sitting with crossed legs on the edge of an embankment, the man has been attacked from behind by a young bear. Despite the alarming claws which it displays, the bear seems to be chiefly interested in sniffing the man's face; the latter cries out in fright and makes a desperate gesture with his outstretched hand. To the left of his head, an initial sketch of a hand is still visible.

H.10 [427] p. 583

"Devout woman" – 1824-28 – 191 × 155 – s. "Goya" (Bc) – Bc – No. (Bc) – No. add. 161 (Lp) – *Paper:* horizontal chain lines – Mounted on pink paper – *Hist.:* Javier Goya; Mariano Goya; Román Garreta → Museo de la Trinidad (5.4.1866) – Madrid, Prado (322) – GW 1773

The image of the devout old woman telling her beads appears in Goya's graphic work at various periods. In the Madrid album and the *Caprichos* she plays her part in the social satire with which Goya was concerned at that time: she is *Celestina,* the old bawd inseparable

from the *maja* whom she protects and guides through the convolutions of her love affairs (see in particular B.4). Later she becomes a human type in herself: bent by age and prayer (drawing D.e), she is a touching incarnation of poverty and simple-minded faith. Here the accent is laid on the robust stupidity of the old woman: standing with her legs firmly planted on the floor, she recites the rosary with more ostentation than devoutness, curiously recalling the chanting monk in drawing D.7. The crayon technique is handled with remarkable freedom, enabling us to observe the interplay of black chalk and greasy crayon, the latter heightening the composition with darker accents which, however, are always delicately merged into the mass of greys. Note, for example, the treatment of the face, the hands with the rosary and, at the bottom of the skirt, the light embroidering of the material.

Copy H.11 [428] p. 584

"Man beset by monsters" – 1824-28 – 189 × 150 – s. "Goya" (Bc) – Bc – No. (Bc) – Mark P.B. (Lugt 2071) – *Paper:* the *horizontal* wire-marks of the paper are plainly visible in the black mass of the cloak, whereas all the drawings in this album are executed on paper with *vertical* wire-marks (and horizontal chain lines) – *Hist.:* Philippe Burty; Ps. P. Burty, London, Sotheby, 1.5.1876, No. 719 – London, British Museum (1876.5.10.376) – GW 1774

This is undoubtedly an early and faithful copy of Goya's original drawing, which is now lost. As indicated above, the paper differs from that used everywhere else in the album, and one easily detects a hesitant hand in the signature, particularly in the capital G, which Goya always writes with a perfectly clean-cut stroke of the crayon. This composition reverts to a favourite theme of Goya's: a figure assailed by monstrous creatures, the first and most famous example being plate 43 of the *Caprichos,* "*The dream of Reason...*". From the Bordeaux period we have drawing G.46, in which two women are surrounded by grimacing faces fitted with bats' wings as here – probably a symbol of obsessive memories and dreams connected with their love life.

H.12 [429] p. 585

"Monks and priest singing" – 1824-28 – 190 × 158 – s. "Goya" (Bc) – Bc – No. (Bc) – No. add. 160 (Lp) – *Paper:* horizontal chain lines – Mounted on pink paper – *Hist.:* Javier Goya; Mariano Goya; Román Garreta → Museo de la Trinidad (5.4.1866) – Madrid, Prado (381) – GW 1775

As pointed out by Sánchez Cantón (Bibl. 173, No. 427), this drawing is so direct and realistic that it seems to have been done from life, as if the three figures had posed for the artist. This is quite possible, but we know, too, what intensity of life Goya was capable of imparting to a gesture or face. In any case, this scene is not meant as a caricature and the sober perfection of the drawing commands attention for its own sake: minute facial details in which black chalk and greasy crayon are combined; faint lights and shadows barely grazing the forms; firm strokes of the crayon, notably in the monk's hand, gnarled and strong like the rest of his person. Presumably the priest on the left is playing the harmonium, on which the score is placed and the right-hand monk is leaning.

H.13 [430] p. 586

"Procession of monks" – 1824-28 – 191 × 155 – s. "Goya" (Bc) – Bc – No. (Bc) – No. add. 159 (Lp) – *Paper:* horizontal chain lines (26 mm) – Mounted on pink paper – *Hist.:* Javier Goya; Mariano Goya; Román Garreta → Museo de la Trinidad (5.4.1866) – Madrid, Prado (380) – GW 1776

Goya was fond of representing such processions, slowly moving to the rhythm of the chants, with banners held aloft or *pasos* (statues representing Passion scenes, carried in procession, especially during Holy Week) glittering with gold and colours borne on the men's backs. Such is the contradiction of the Spanish mind: a man may be anticlerical and liberal like Goya, and yet respond to the deep religious fervour of the people celebrating the great traditional feastdays, like those of Holy Week, Corpus Christi and, in Madrid, San Isidro, patron saint of the city. In its composition this procession is very close to that of drawing F.44, but it is handled much more freely as regards the figures, which here merge into an anonymous mass patterned only by unemphatic lights and shadows.

H.14 [431] p. 587

"Sufferer by the roadside" – 1824-28 – 191 × 154 – s. "Goya" (Bc) – Bc – No. (Bc) – No. add. 157 (Lp) – *Paper:* horizontal chain lines (25 mm) – Mounted on pink paper – *Hist.:* Javier Goya; Mariano Goya; Román Garreta → Museo de la Trinidad (5.4.1866) – Madrid, Prado (321) – GW 1777

There can be no doubt that the hands and feet of this unfortunate man are bound fast by cords which are plainly visible on the left, above the elbow. Rather

than a prisoner, he would seem to be the victim of some revenge or simply of highwaymen (cf. C.32 and, in this album, H.30). Stripped of his clothes, which lie on the ground behind him, he is clad only in a queer sort of long skirt which even conceals his feet. Are we to infer that he is a monk? This would seem to be borne out by the thin hair straggling over his brow in the manner of a tonsure. Huddled up in pain or misery, this sufferer with closed eyes is the very image of helpless distress. With an extraordinary touch of refinement, Goya has placed him in front of a young tree whose dark, vigorous leafage sets off his white figure.

H.15 [432] p. 588

Allegorical figure; War (?) – 1824-28 – 190 × 155 – s. "Goya" (Bc) – Bc – No. (Bc) – No. add. 158 (Lp) – *Paper:* horizontal chain lines (26 mm) – Mounted on pink paper – *Hist.:* Javier Goya; Mariano Goya; Román Garreta → Museo de la Trinidad (5.4.1866) – Madrid, Prado (391) – GW 1778

This drawing combines several themes often used by Goya in his graphic work: the witch flying through the air, the diabolical animal on which she rides, and the monstrous bird which always evokes evil (see in particular *Caprichos 43, 66, 75, Disasters of War 72, 76* and *Disparate 5*). Here the allegorical figure has all the attributes of war: sword in one hand, shield in the other, and spurs and stirrups on its feet. Its mount is a fanciful bird of prey, also well armed, with its large beak, its formidable talons and, on the edge of its wings, a row of sharp spurs. All these elements together justify the interpretation of Sánchez-Cantón (Bibl. 173, No. 432), who saw here an allegory of War. One might add that this woman enveloped in long dark veils, with her triangular face and all but empty eye sockets, aptly evokes the mourning and death that she leaves in her wake. It seems likely that Goya borrowed all or part of this composition from iconographical sources which remain to be discovered.

H.16 [433] p. 589

"*Maja* and cloaked *majo*" – 1824-28 – s. "Goya" (Bc) – Bc – No. (Bc) – *Paper:* horizontal chain lines (26 mm) – *Hist.:* Javier Goya; F. de Madrazo; Saragossa, B. Montañés; Madrid, A. de Beruete; Berlin, Gerstenberg (after 1907) – Destroyed (1945) in Berlin, formerly Gerstenberg coll. – GW 1779

This young woman in the costume of a *maja* is not the only evocation in this album of the Spain of the past, now doubly dear to the exiled artist. A little further on

we find a very similar female figure in sheets H.22 and H.23, accompanied in the latter by some puppies. There can be no doubt that these themes and others betray the homesickness from which Goya and all his Spanish friends suffered in Bordeaux. Two figures are sitting on the farther side of a hillock in the country, the man a dark, indefinite shape on a lower level than the young woman, who looks back at him, one would say, not very graciously. In her left hand she holds up her fan (the dry, impatient snap of it is almost audible), but with the other she fondles the little black dog curled up on her lap. Extensive use of the greasy crayon gives an exceptional vigour to this drawing, whose triangular composition, slightly off-centre, recalls that of several drawings in the Madrid album, notably B.8, whose subject is similar.

H.17 [434] p. 590

"Medical examination" – 1824-28 – 191 × 151 – s. "Goya" (Bc) – Bc – No. (Bc) – No. add. 156 (Lp) – *Paper:* horizontal chain lines (26 mm) – Mounted on pink paper – *Hist.:* Javier Goya; Mariano Goya; Román Garreta → Museo de la Trinidad (5.4.1866) – Madrid, Prado (401) – GW 1780

The import of this scene is obscure, assuming Goya intended it to have a definite meaning. For the caricatural power of the two figures in the foreground prevails over all other considerations and defies the logic of ordinary human relationships. Both crouching down, equally bulky and repulsive, they nevertheless differ in dress and role. The man on the left is wearing a voluminous dark cloak, which suggests that he has come in from outside to examine the second man, who is allowing his face, or perhaps more precisely his eye, to be examined. At the back, behind a kind of chest with a lock, two old men are roughly sketched in, the one on the right with his hands held close to his face, as if engaged in a piece of work demanding careful attention to detail. Noteworthy in this drawing is the forceful linework, both in the parts shaded with hatchings and in the outlines of certain volumes, particularly the hand of the "consulting physician".

H.18 [435] p. 591

"Woman in white lying on the ground" – 1824-28 – 188 × 150 – s. "Goya" (Bc) – Bc – No. (Bc) – *Paper:* horizontal chain lines (26 mm) – *Hist.:* purchased in Geneva about 1940 – France, priv. coll. – GW 1781

The strikingly beautiful plastic effect of this composition is achieved through the strong contrasts of black and white, the former being confined to the landscape and the mysterious figure lurking in it after having committed his crime, the latter to the innocent victim of this dark plot. The massive or hostile black forms are set off by the long slender figure of this white Ophelia, perhaps already dead, who has been brutally thrown into a ditch. The enigma of the scene adds to its emotive power. What has happened? Foul play, vengeance, rape? We do not know, neither does it greatly matter. For the banality of facts Goya has substituted the tantalizing ambiguity of his art.

H.19 [436] p. 592

"Young woman flying on a rope" – 1824-28 – 191 × 155 – s. "Goya" (Bc) – Bc – No. (Bc) – On the verso: imprint of the next drawing, H.20 [437] – *Paper:* horizontal chain lines (26 mm) – *Watermark:* GH.II – *Hist.:* bought in Madrid between 1858 and 1860 by the 1st Baron Savile of Rufford; Rufford Abbey, John Savile, 2nd Baron Savile of Rufford; London, Colnaghi → 1923 – Ottawa, National Gallery (2996) – GW 1782

Long assumed to represent a girl skipping, this enigmatic figure is thought by E. Sayre to show a young witch swinging (Bibl. 25, No. 41, p. 87). It is certain that several details clearly indicated by Goya are puzzling: first the tiny wings on her slippers (which, it seems to me, are difficult to identify with bats' wings); then the absence of any ground-level, as in H.58; and finally the fact that the rope is floating in space, held by the two uplifted hands, which is certainly not the right position for skipping. So the young woman does indeed appear to be flying through the air, with her skirt blown out behind her, and swinging on her rope. But I see no reason to regard her as a witch; the wings on her feet do not make her one, for they occur in none of the witches drawn or etched by Goya. One detail, furthermore, remains unexplained: the headband running across her brow, which almost covers her eyes and is not the attribute of a witch. The meaning, I think, must be looked for in a different quarter. It may be an allegorical figure or, more simply, it may symbolize the fickleness and levity of young women with reference to the fickleness of fortune. Noteworthy here is the masterly handling of the greasy crayon, with which, in the upper part of the garment, Goya obtains the small, serrated highlights so characteristic of him.

H.20 [437] p. 593

"Man pulling on a rope" – 1824-28 – s. "Goya" (Bc) – Bc

– No. (Bc) – *Paper:* horizontal chain lines – *Hist.:* Javier Goya; F. de Madrazo; Saragossa, B. Montañés; Madrid, A. de Beruete; Berlin, Gerstenberg (after 1907) – Destroyed (1945) in Berlin, formerly Gerstenberg coll. – GW 1783

Few of the drawings are as immediately striking as this one, for two reasons: first the extraordinary dynamism emanating from this uncouth figure tugging at a rope; then the proportions of the figure in relation to the small background landscape and to the sheet of paper itself. And, further heightening the monumentality of this scene, forms are outlined with strokes of rare vigour and unfailing accuracy: arm, hand, legs and, above all, the hat are thus set off by Goya's crayon against the white ground and acquire an intensity and relief in keeping with the strenuous exertions of this peasant. Goya deliberately conceals the nature of his work, but it is clear, at the top of the sheet, that the rope is about to snap. The scene thus illustrates the proverb: "The rope is pulled so often that at last it snaps." For the dynamism and proportions of the figure, compare with drawing C.63.

H.21. [438] p. 594

"Old man kneeling, with hands bound" – 1824-28 – 191 × 148 – s. "Goya" (Bc) – Bc – No. (Bc) – No. add. 169 (Lp) – *Paper:* marked greenish colour, horizontal chain lines – Mounted on pink paper – *Hist.:* Javier Goya; Mariano Goya; Román Garreta → Museo de la Trinidad (5.4.1866) – Madrid, Prado (323) – GW 1784

Here we have another wretched old man with his hands bound, as in H.14, but in this case kneeling against a completely white background. With his head turned to one side, he gazes helplessly into space. One notes the magnificent handling of the greasy crayon in details of the head and particularly in the beard and hair, made of serrated lines laid in over the black chalk. The strictly parallel vertical lines visible among his rags, above and below the arms, are the wiremarks of the paper showing through as a result of being rubbed with the black chalk.

H.22 [439] p. 595

"*Maja*" – 1824-28 – 191 × 146 – s. "Goya" (Bc) – Bc – No. (Bc) – Red mark C.G. (Lugt 542) – *Paper:* horizontal chain lines – On the verso: "Ce dessin m'a été donné à Madrid le 26 Décembre 1859 par M. Madrazo, peintre de la Reine d'Espagne". Signed C. Gasc – *Hist.:* Javier Goya; F. de Madrazo; C. Gasc (1859) – Buenos Aires, A. Santamarina coll. – GW 1785

This drawing was one of those given to the French collector Charles Gasc by Federico de Madrazo in Madrid on December 26, 1859. Two others have already been noted: G.1 and G.39. But it is quite possible that there were still more, now either lost or known only through early copies (see, for example, the entry for the copy H.11, p. 584). There exists, moreover, a copy of this *maja* made by the same hand as H.11 and purchased by the British Museum at the same time, at the Philippe Burty sale in 1876 (Brit. Mus. No. 1876. 5.10.375, Bibl. 32, No. 718). From this drawing an etching was made (GW 1824), with the *maja* reversed as usual. In this young woman with her provocative pose, there are obvious reminiscences of the 1797 portrait of the Duchess of Alba (GW p. 115).

H.23 [440] p. 596

"Woman with puppies" – 1824-28 – (?) s. "Goya" (Bc) below the puppies? – Bc – No. (Bc) – *Paper:* horizontal chain lines (26 mm) – *Hist.:* Javier Goya; F. de Madrazo; Saragossa, B. Montañés; Madrid, A. de Beruete; Berlin, Gerstenberg (after 1907) – Destroyed (1945) in Berlin, formerly Gerstenberg coll. – GW 1786

This young woman dressed in the traditional Spanish manner is clearly related to the *maja* in the previous drawing and the one in H.16; all have the same physical type and wear national costumes. This kneeling woman looks round with a graceful turning movement at the puppies huddled together beside her. Her melancholy expression and the handkerchief she holds against her with her left hand suggest a heavy heart, for which she is seeking consolation with her puppies. Just beneath them, one divines the half-obliterated signature of Goya disposed horizontally. Copies exist of this drawing, as of others in the Bordeaux albums (G.1, G.39, H.11, H.22, H.30 and possibly H.56): an earlier one in black chalk, like the original (Paris, priv. coll.), and a later one in ink wash, like the copy of H.30, with a fanciful title in pencil and a simulated autograph number (sold at Sotheby's, London, 10.5.1961, lot 73).

H.24 [441] p. 597

"Woman helping a sick person to drink" (?) – 1824-28 – s. "Goya" (Bc) – Bc – No. (Bc) – *Paper:* horizontal chain lines (26 mm) – *Hist.:* Javier Goya; F. de Madrazo; Saragossa, B. Montañés; Madrid, A. de Beruete; Berlin, Gerstenberg (after 1907) – Destroyed (1945) in Berlin, formerly Gerstenberg coll. – GW 1787

The two figures in this composition are reduced to faceless silhouettes, one modelled in the light, in the centre of the sheet, the other, barely distinct, in the shadows on the right. What mattered for Goya were attitudes, gestures and, above all, the interplay of variously illuminated volumes. As often with him, there is a sharp contrast between the woman who brings help, in glowing white, and the woman helped, who sinks into the shadows symbolizing illness or poverty. In the middle distance are some draperies which may belong to a bed on which the sick person is lying; the woman standing seems to have got up and hurriedly thrown a large shawl about her, and knotted a scarf round her hair, in order to bring the invalid a large bowl of broth on a plate. One is surprised at the size of the sick person's head; it does not, however, appear to be a giant, but rather one of those figures with curiously bloated forms (see entry for drawing G.30).

H.25 [442] p. 598
"Young woman fainting, surrounded by witches" – 1824-28 – 189 × 150 – Bc – No. (Bc) – *Paper:* horizontal chain lines (26 mm) – *Hist.:* Bordeaux, Hyadès; Paris, Jules Boilly; Ps. J. Boilly, Paris, H.D. 19-20.3.1869, No. 48 → Leurceau (450 fr. for album of 20 drawings); A. Strolin – France, priv. coll. – GW 1788

This drawing shows how magisterially free and varied Goya's technique had become: sometimes he produces a composition dominated by the vigorous outlines enclosing volumes (see in particular H.20 and the two drawings after this one); sometimes, the same crayons being employed, the drawing merges into a mass of shadow and light in which the essential forms are highlighted with a greasy crayon. Such is the case with this scene in which the bright figure of the fainting girl seems to sink into a welter of more or less dark lines and patches, peopled with diabolical heads. Over her leans the bulky figure of a witch, and on the right a younger woman with dark hair stands beside her. The fainting woman here resembles the young woman in drawing H.18 and the one in a lithograph of the same period entitled *Sleep* (GW 1700).

H.27 [443] p. 599
"Travelling witch" – 1824-28 – 191 × 151 – s. "Goya" (Bc) – Bc – No. (Bc) – No. add. 155 (Lp) – *Paper:* horizontal chain lines (26 mm) – Mounted on pink paper – *Hist.:* Javier Goya; Mariano Goya; Román Garreta → Museo de la Trinidad (5.4.1866) – Madrid, Prado (390) – GW 1789

Drawing H.25 is logically connected with this one by way of an intermediate drawing, H.26, representing (according to E. Sayre) a "Witch sitting on the ground writing on a tablet". It has proved impossible to obtain any information about this intermediate sheet, now in a private collection in Boston. But E. Sayre's description of the subject shows clearly enough that the three drawings form a series of witchcraft scenes inserted in this album. This scene is of the "flying" type, many examples of which occur in Goya's work, particularly in the *Caprichos* (see plate No. 61, *Volaverunt*). The two fiends carrying the witch have bats' wings; they look up at their "passenger" with grimacing faces reminiscent of some of the heads surrounding the two women in G.46.

H.28(18) [444] p. 600
"Lay brother on skates" – 1824-28 – 192 × 147 – s. "Goya" (Bc) – Bc – No. (Bc) – No. add. 170 (Lp) – *Paper:* horizontal chain lines – Mounted on pink paper – *Watermark:* GH.I – *Hist.:* Javier Goya; Mariano Goya; Román Garreta → Museo de la Trinidad (5.4.1866) – Madrid, Prado (379) – GW 1790

The oddity of this drawing lies in the fact that this lay brother shod with large ice-skates seems to be dancing in the air rather than actually skating, for the surface of the ice under his feet is not indicated. Whether it is a dream or reality hardly signifies. His foolish face expresses the satisfaction he takes in thus hopping about, despite the encumbrance of his heavy clothes, which even conceal his arms. Two other drawings of skaters occur in Goya's work: the earlier one, F.30, represents skaters in (as I have conjectured) the Casa de Campo in Madrid; the other (GW 1837), a pen drawing executed during his stay in Bordeaux, disappeared with the Gerstenberg collection in the fall of Berlin in 1945.

H.29 [445] p. 601
"Man holding a musket" – 1824-28 – 191 × 152 – s. "Goya" (Bc), all but obliterated in the lower right corner of the subject – Bc – No. (Bc) – *Paper:* horizontal chain lines (25 mm) – *Hist.:* Bordeaux, Hyadès; Paris, Jules Boilly; Ps. J. Boilly, Paris, H.D. 19-20.3.1869, No. 48 → Leurceau (450 fr. for album of 20 drawings); A. Strolin → 1931 – Berlin-Dahlem, Kupferstichkabinett (14.716) – GW 1791

This drawing is not one of Goya's best. It reverts to the theme of the armed man – here with a musket in

his right hand, a long sword under his cloak and a cutlass in his belt – who roams the countryside, ready for anything. Whether a bandit or a tough mountaineer he has no qualms about dispatching anybody who gets in his way: see, among others, C.65, F.16, F.53, G.56, and G.58. In a thicket behind him looms the shadowy figure of another man who seems to be carrying a load on his shoulder; perhaps there is some smuggling afoot. This drawing has lost something of its firmness as a result of excessive rubbing, which has blurred certain parts of it; even the signature on the lower right has been almost obliterated.

H.30 [446] p. 602

" Bound and half-naked man on the ground " – 1824-28 – s. " Goya " (Bc) – Bc – No. (Bc) – *Paper:* horizontal chain lines (26/27 mm) – *Hist.:* Javier Goya; F. de Madrazo; Saragossa, B. Montañés; Madrid, A. de Beruete; Berlin, Gerstenberg (after 1907) – Destroyed (1945) in Berlin, formerly Gerstenberg coll. – GW 1792

While the previous drawing was lacking in firmness, this one possesses all the qualities of vigour and spiritedness which, on the whole, characterize this album. This faceless man, as nameless as the dire wrong which he has suffered, is no more than a limp, cadaverous body abandoned by the wayside, against a rock. His feet have been bound and probably his hands as well; he has been stripped of his clothes, which lie in tatters about his waist and legs. After hesitating over the position of the head, an initial outline of which can still be seen, Goya finally chose the most moving solution, bending it down completely over the bare chest. What outrage has the wretched man suffered in this wild, mountainous setting? We have no way of knowing, the only clue being a few stains, which might be blood, on the torn remnants of his clothes. Anyhow it is not the anecdote that matters, but rather the man himself and the sufferings he has undergone. A copy of this drawing, executed in Indian ink wash, exists in a Parisian collection (226 × 156), with a fanciful caption in pencil, " *Miseria* ", written at the bottom of the sheet; simulated autograph numbers have been inscribed at the top (on the right 41, beside an 18 crossed out; in the centre 41, effaced then repeated). Certain proof that this ink wash drawing is a fake lies in the fact that the paper has *vertical* chain lines; which suggests that the forger was trying to contrive a drawing in the style of album D, whose paper corresponds to that of this copy. Sold on December 5, 1961 at the Palais Galliéra in Paris, this copy shows a certain similarity with another copy based on album H and

sold, curiously enough, that same year in London (see entry for H.23).

H.31 [447] p. 603

" *Embozado* (cloaked man) with a gun " – 1824-28 – 191 × 152 – s. " Goya " (Bc) – Bc – No. (Bc) – No. add. 142 (Lp) – *Paper:* horizontal chain lines – Mounted on pink paper – *Hist.:* Javier Goya; Mariano Goya; Román Garreta → Museo de la Trinidad (5.4.1866) – Madrid, Prado (319) – GW 1793

This reminiscence of Andalusia during his stay at Bordeaux is one more proof that Goya, like any other exile, was homesick for his native land. The figure very closely resembles the *embozado* on the cartoon for the tapestry *El paseo de Andalucia* (GW 78) dated 1777. This drawing was the first sketch for two small etchings executed at Bordeaux (GW 1827 and 1828), the second of which has a bull behind the *embozado*.

H.32 [448] p. 604

" Monk floating in the air " – 1824-28 – s. " Goya " (Bc) – Bc – No. (Bc) – *Paper:* horizontal chain lines – *Hist.:* Javier Goya; F. de Madrazo; Saragossa, B. Montañés; Madrid, A. de Beruete; Berlin, Gerstenberg (after 1907); Miss Gerstenberg → 1943 – Berlin, priv. coll. – GW 1794

From the stylistic viewpoint, the characteristic trait of this drawing is the predominance of the linework over the light effects, which are reduced to the few needed to model the volumes. The extremely simplified composition lacks even the accents in crayon that Goya used so felicitously in the Bordeaux albums. Instead, he used crayon to draw the outlines of the figure, giving it the appearance of being graven in the pure white paper. The flying monk is probably dreaming, like the one in C.59, to whom he is closely related. His eyes are shut and his mouth expresses woe. But what is the meaning of the gesture of the arms and the rod in the right hand? This drawing – together with two others not included in the albums – were saved from the destruction of the Gerstenberg collection because Miss Gerstenberg gave them to friends of hers in Madrid before the end of the War.

H.33 [449] p. 605

" Old woman with a mirror " – 1824-28 – 191 × 148 – s. " Goya " (Bc) – Bc – No. (Bc) – No. add. 154 (Lp) – *Paper:* horizontal chain lines – Mounted on pink paper

– *Hist.:* Javier Goya; Mariano Goya; Román Garreta
→ Museo de la Trinidad (5.4.1866) – Madrid, Prado (412)
– GW 1795

In this drawing Goya reverted to a subject he had
already treated but now at Bordeaux he did so in an
obviously different key. Times had changed since
Capricho 55, Hasta la muerte (Unto death), but the
coquetry and obsessions of old age are eternal. This
respectable old middle-class woman, her back bent by
age, is far removed from the repulsive old coquette
Goya had engraved half a century earlier. Alone in a
rather poor-looking room, she examines her face in
the mirror through a magnifying glass with all the
curiosity of an entomologist. There is nothing gro-
tesque in this scene, merely the pitiable spectacle of
physical decay, with which Goya certainly sympa-
thized. In fact, we must not forget Matheron's invalu-
able testimony (Bibl. 137, p. 96): "Perhaps you will
laugh when I tell you that Goya did all his lithographs
with a magnifying glass. That was not to achieve great
fineness but merely because his eyes were getting
weak." This drawing differs from the previous one in
that it reverts to the use of crayon accents. Note in
particular the jagged line at the hem of the skirt and
the handling of the big black shawl.

H.34(36) [450] p. 606
"Man killing a monk" – 1824-28 – 191 × 153 – s. "Goya"
(Bc) – Bc – No. (Bc) – No. add. 153 (Lp) – *Paper:*
horizontal chain lines – Mounted on pink paper – *Hist.:*
Javier Goya; Mariano Goya; Román Garreta → Museo de
la Trinidad (5.4.1866) – Madrid, Prado (403) – GW 1796

Here crime is inseparable from the madness which
explains but does not excuse it. That is clear to see in
the murderer's wild eyes. As for the victim, all one can
be sure of is that he or she was very old and a member
of a religious order. But whether monk or nun – the
two interpretations are equally plausible – makes not a
jot of difference to the horror of the scene, due pre-
cisely to the fatal concurrence of the three elements
– madness, age and religion. Observe once again the
contrast so dear to the artist between the dark figure
(evil) and the bright figure (innocence). This schematic
treatment of the subject produced a splendidly intense
plastic effect but, all unknown to Goya, it derived
from an aesthetic that was typically romantic. What
we have here is already the antithesis between light
(= good) and dark (= evil) which was the keynote of
Victor Hugo's *œuvre* and philosophy. The two

blotches to the right on the monk's frock are due to
mildew.

H.35(37) [451] p. 607
"Two old crones dancing" – 1824-28 – 190 × 148 – Bc
– No. (Bc) – No. add. 148 (Lp) – *Paper:* horizontal chain
lines – Mounted on pink paper – *Watermark:* GH.II – *Hist.:*
Javier Goya; Mariano Goya; Román Garreta → Museo de
la Trinidad (4.5.1866) – Madrid, Prado (417) – GW 1797

Sánchez Cantón (Bibl. 173, No. 423) entitled this
drawing *Máscaras bailando* (Dancing masks) on account
of the resemblance of the old women dancing to the
sound of castanets and the centre group in *Burial
of the sardine* (GW p. 2). Taking into account the way
the two figures are turned out and particularly their
extravagant headdresses, one might indeed be tempted
to view them as masqueraders. In fact, one can make
out on each side of the two faces a dark line that might
well be the contour of a mask. So perhaps the hypo-
thesis should not be rejected out of hand, especially as
it refers us back to the important mask theme that first
appeared in the Madrid album – B.55 – of half a
century previously. It is worth noting that this draw-
ing, unlike most of the others in this album, bears no
signature.

H.36(38) [452] p. 608
"Wounded soldier leaning on a tree-trunk" – 1824-28
– 194 × 154 – s. "Goya" (Bc) – Bc – No. (Bc) – *Paper:*
horizontal chain lines (26 mm) – *Hist.:* Bordeaux, Hyadès;
Paris, Jules Boilly; Ps. J. Boilly, Paris, H.D. 19/20.3.1869,
No. 48 → Leurceau (450 fr. the album of 20 drawings);
A. Strolin – France, priv. coll. – GW 1798

This is another of those faceless human figures to
which Goya succeeded so well in giving a pathetic
expression all the more intense for being anonymous.
But, like the great artist he was, he did so exclusively
by employing such original plastic procedures that
they give each drawing a unique quality. Here it is the
diagonal composition that sets the key. The tree slants
at such a steep angle that it seems on the point of
falling, and the soldier who leans against it – a bright
form silhouetted against a dark one – may, like it, be
wounded and perhaps mortally. A few twigs at his feet
and a bunch of leaves above his shoulder provide the
essential setting for a drama as commonplace as he is
himself. The same slanting arrangement of the figure
and the same contrast of light and shade occur in other
drawings – all of them tragic – done at Bordeaux:
G.22, G.40, H.14, H.18, H.25 and H.30.

H.37(39) [453] p. 609

"Monk drawing with a compass" – 1824-28 – 191 × 147 – s. "Goya" (Bc) – Bc – No. (Bc) – No. add. 152 (Lp) – *Paper:* horizontal chain lines – Mounted on pink paper – *Watermark:* traces on the left – *Hist.:* Javier Goya; Mariano Goya; Román Garreta → Museo de la Trinidad (5.4.1866) – Madrid, Prado (378) – GW 1799

This drawing has already been compared to H.32 in this album for both the subject matter and the very simple handling (Bibl. 173, No. 419). Apart from the habit, whose material is rendered with a truly classical purity, all we can see of the monk is his open-mouthed profile and one hand. The first denotes the rather childish concentration of the tyro; the second confirms that impression by the awkward way it holds the compass. Note the fineness of the long crayon strokes that model the volumes.

H.38(40) [454] p. 610

"Easy victory" – 1824-28 – 190 × 154 – s. "Goya" (Bc) – Bc – No. (Bc) – No. add. 151 (Lp) – *Paper:* horizontal chain lines (26 mm) – Mounted on pink paper – *Hist.:* Javier Goya; Mariano Goya; Román Garreta → Museo de la Trinidad (5.4.1866) – Madrid, Prado (399) – GW 1800

The type of man with a big head and ample frame I have already called attention to in the note to G.30 as characteristic of the Bordeaux period seems, so to say, doubled in this drawing. The killer and his victim are identical, as if the former is murdering his twin brother. Straddling him with legs wide apart, he has the same thick nose and broad grin as the figures in G.30 and G.39. But one is struck by the curious fact that the man he grips so violently by the hair and threatens with his dagger is exactly like him even in his facial features, which wear an expression of pain rather than glee. Even if we admit, as Sánchez Cantón suggested (Bibl. 173, No. 409), that they are two madmen, the explanation fails entirely to cover their strange mimesis or the crime apparently on the point of being committed. Is this a modern version of Cain and Abel? Or simply a vision of man destroying his fellow? Or a new *disparate* (folly) imagined gratuitously by Goya? These are not the only hypotheses that might be formulated. It is worth noting that the number 38 was written over a 40, not a 48.

H.40 [455] p. 611

Serpiente de/4 bar.⁸/en Bordeaux (Bc) (Serpent 4 yards long in Bordeaux) – 1826-28 – Bc – No. (Bc) – *Paper:* horizontal chain lines (27 mm) – *Hist.:* Javier Goya; F. de Madrazo;

Saragossa, B. Montañés; Madrid, A. de Beruete; Berlin, Gerstenberg (after 1907) – Destroyed (1945) in Berlin, formerly Gerstenberg coll. – GW 1801

A drawing bearing the number 39 actually exists and, according to E. Sayre, is entitled *Feria en Bordeaux* (Fair in Bordeaux), but no information is forthcoming as to the identity of its present American owner. The autograph caption suffices, however, to place it just before this one, at the head of the fairground scenes that Goya did at Bordeaux in 1826. What struck him most there were the many exotic animals, such as this snake, apparently a boa, 4 *baras* (about 4 yards) long. This drawing is meticulously exact right down to the details of the reptile's skin, and its dominant note is the extraordinary arabesque that the showman, probably an American Negro, displays on his bare head and hands.

H.41 [456] p. 612

Crocodilo/en Bordeaux (Bc) (Crocodile in Bordeaux) – 1826-28 – Bc – No. (Bc) – *Paper:* horizontal chain lines (27 mm) – *Hist.:* Javier Goya; F. de Madrazo; Saragossa, B. Montañés; Madrid, A. de Beruete; Berlin, Gerstenberg (after 1907) – Destroyed (1945) in Berlin, formerly Gerstenberg coll. – GW 1802

Another scene jotted down by Goya at the Bordeaux Fair of 1826. The crocodile tamer is a pendant to the snake showman in the previous drawing. He displays the animal on his gloved right hand and makes it do its act with a little stick held in the other hand. The briefly sketched background tells us that the scene unfolds before a wall or low fence like those which enclose circus rings. The man wears an exotic costume complete with turban; in this he differs from the boa tamer, who is dressed like Monsieur Loyal (a character in Molière's *Tartuffe*).

H.42 [457] p. 613

"The enema" – 1824-28 – 190 × 155 – Bc – No. (Bc) – No. add. 150 (Lp) – *Paper:* horizontal chain lines – Mounted on pink paper – *Hist.:* Javier Goya; Mariano Goya; Román Garreta → Museo de la Trinidad (5.4.1866) – Madrid, Prado (383) – GW 1803

This drawing shows how widely and surprisingly Goya's subject matter ranges in this album. Here four characters rendered to the life play their parts, which their faces and gestures enable us to grasp without any difficulty. On the right a maidservant brandishes a syringe with a knowing smile, while the wife gently endeavours to persuade her husband to let her do her

job. He, with his shirt hanging outside his trousers and a grimace of apprehension on his face, seems far from convinced. But the picturesque note of the scene is provided by the fourth character: a little girl we can just spy between her father's legs, lurking all unnoticed by the others in order not to miss a single detail of the operation. The artist roguishly added this grain of salt in precisely the right place in the family picture; nor has he forgotten the close-stool further back on the left.

H.43 [458] p. 614
"Woman with two children" – 1824-28 – 191 × 146 – Bc – No. (Bc) – On the verso: "33" – On the mount: "11" – *Paper:* horizontal chain lines (26 mm) – Mounted on pink paper – *Hist.:* Javier Goya; Román Garreta; F. de Madrazo; R. de Madrazo y Garreta; New York, A. M. Huntington (1913) – New York, Hispanic Society of America (A.3311) – GW 1804

E. du Gué Trapier (Bibl. 184, pp. 18-19) has already called attention to the oddly Oriental appearance of the young woman busy playing with two small children. It is due first of all to her very ample gown and the turban she wears to keep her hair tidy. But it is enhanced by the fact that she is sitting on the floor, her back propped up by the big cushions of a sort of sofa; also by her wide cheekbones and broad, fleshy mouth, which call to mind some of the angels in San Antonio de la Florida. Holding one child tightly clasped in her arms, she smiles tenderly at the other, who sits on the floor with its head twisted in an amazing perspective. The comparison drawn by E. du Gué Trapier between this drawing and H.49 is valid only as far as the subject matter is concerned. From the stylistic viewpoint they seem to me to represent two very different conceptions, which I have already pinpointed in the note to H.25. Here the linework dominates with only a few very light shadows, whereas H.49 is a magnificent example of chiaroscuro with blended lights and shadows. Note the *pentimento* below the child on the floor: two legs later covered by the rubbed black chalk. This drawing was shown in the New Gallery, London, in 1895-96, when it belonged to Raimundo de Madrazo, together with H.58 (Bibl. 1, p. 105).

H.44 [459] p. 615
"He's helping him to die well" – 1824-28 – 191 × 155 – Bc – No. (Bc) – No. add. 147 (Lp) – *Paper:* horizontal chain lines (26 mm) – Mounted on pink paper – *Hist.:* Javier Goya; Mariano Goya; Román Garreta → Museo de la Trinidad (5.4.1866) – Madrid, Prado (365) – GW 1805

An aged, bearded Capuchin offers the comfort of religion to a convict before his execution. The scene is apparently set in a chapel, at the foot of an altar surmounted on the right by a huge crucifix. The two figures are seated on the altar steps; they lean towards each other as the prisoner reads what is perhaps a last prayer and the monk shows him a small black cross. We can just make out, grey against the grey background, a third figure behind the other two. It is interesting to compare this drawing with C.51, which is very close to it for the figures and the setting, but differs entirely in the feelings they express: the violence of the monk (probably a Dominican) and the prisoner's refusal to be convinced. We might also take a look at the scene of the guillotine in the first Bordeaux album – G.49 – where a priest on the scaffold presents the cross to a condemned man being dragged away by the executioner. In the wash drawing, religion was the handmaiden of force; in the two chalk drawings it is all charity.

H.45 [460] p. 616
Claudio Ambrosio Surat/Llamado el Esquelete vibiente/en Bordeaux año 1826 (Bc) (Claudio Ambrosio Surat known as the living skeleton in Bordeaux the year 1826) – 1826-28 – Bc – No. (Bc) – *Paper:* horizontal chain lines – (26 mm) – *Hist.:* Javier Goya; F. de Madrazo; Saragossa, B. Montañés; Madrid, A. de Beruete; Berlin, Gerstenberg (after 1907) – Destroyed (1945) in Berlin, formerly Gerstenberg coll. – GW 1806

The living skeleton has always been a classic fairground attraction like the snake-woman and the woman with a beard. This one must have made a sensation in Bordeaux in 1826, for we know that a local artist, Louis Burgade – sometimes confused with Antonio Brugada, one of Goya's closest friends in Bordeaux – published in that year a lithograph entitled *L'homme squelette vivant* (Bibl. 150, p. 250). This proves, incidentally, that Goya's caption is the literal translation of the name of the attraction, which must have been the talk of the town. We may also presume that the picture he has left us is a faithful rendering of the original. The dark ground behind the figure and the pencil strokes on the upper part of the sheet might present a fair booth or circus tent.

H.47 [461] p. 617
"Man brandishing a knife" – 1824-28 – 191 × 150 – Bc – No. (Bc) – Stamp: F.K. (Lugt 1023a) – *Paper:* horizontal chain lines (25 mm) – *Hist.:* L. Böhler; Amsterdam, F. Koenige → 1929 – Rotterdam, Boymans-van Beuningen Museum (S.15) – GW 1807

This figure of a peasant is not as simple as it might at first glance appear. How, in fact, are we to reconcile the pathetic expression of the face and arms with the cutlass brandished in the right hand? And, more important still, what is the character's actual position? Since the legs are visible only from the knees up, one might assume that he is kneeling; but if that were so, given the posture of the right thigh, we should see it continued by the lower leg along the ground. You will notice that the ground presents a sort of fold or hollow at each side of the knee. This leads me to suggest that the man is bogged down, like the two fantastic figures in the famous *Black Painting* entitled *Duelo a garrotazos* (Duel with cudgels) (GW p. 320). The anguish written on his face and the desperate gesture of his arms are perfectly in keeping with the tragedy of the situation. Some details display the well-known technique involving heightening with jagged crayon strokes, notably on the right under the arm.

H.48 [462] p. 618
"Penitent monk" – 1824-28 – Bc – No. (Bc) – *Paper*: horizontal chain lines (26 mm) – *Hist.*: Javier Goya; F. de Madrazo; Saragossa, B. Montañés; Madrid, A. de Beruete; Berlin, Gerstenberg (after 1907) – Destroyed (1945) in Berlin, formerly Gerstenberg coll. – GW 1808

If we compare this startling drawing with H.44, where the Capuchin's role seems quite different from what Goya had accustomed us to in many earlier compositions, we cannot help asking ourselves if the artist's attitude towards some forms of religion did not undergo a change towards the end of his life. Here, whether the scene is one of penance or contemplation, the figure of the monk humbly prostrated to the ground gives an uncommonly intense impression of fervent faith. In this drawing, as in H.49 and H.60, the effect of light and shade is stronger than anywhere else in this album. It renders perfectly the material of the habit, which glows with a bright light, in contrast to the very dark background and the face that can just barely be distinguished under the cowl. Without insisting on the drawings from C.119 to C.126, which display an uninhibited disrespect for the monastic life, we might recall C.18 and C.58 in the same album, which offer a striking contrast with this monk, who has nothing to envy the ascetics portrayed by El Greco or Ribera.

H.49 [463] p. 619
"Woman with a child on her lap" – 1824-28 – Bc – No. (Bc)

– *Paper*: horizontal chain lines (26/27 mm) – *Hist.*: Javier Goya; F. de Madrazo; Saragossa, B. Montañés; Madrid, A. de Beruete; Berlin, Gerstenberg (after 1907) – Destroyed (1945) in Berlin, formerly Gerstenberg coll. – GW 1809

Like H.60 and H.61 in this album, this drawing is remarkable for the extremely dark background that covers virtually the entire surface of the paper; the monumental figure stands out against it like a nocturnal apparition in the centre of the page. If we examine the deep black ground we can see that it is built up of a close network of horizontal and vertical crayon strokes carefully drawn around the young woman. Some of these strokes even encroach on the figure, forming a sort of web of shadow which originates in that black ground – in the hair, for instance, and the left-hand side of the gown. This gives the group of the mother and child an exceptional softness which foreshadows some lithographs by Eugène Carrière executed at the end of the 19th century.

H.51 [464] p. 620
"Soldier with a drinking companion" – 1824-28 – 191 × 147 – Bc – No. (Bc) – *Paper*: horizontal chain lines (26 mm) – *Watermark*: GH.I and II – *Hist.*: Bordeaux, Hyadès; Paris, Jules Boilly; Ps. J. Boilly, Paris, H.D. 19-20.3.1869, No. 48 → Leurceau (450 fr. for the album of 20 drawings); A. Strolin – France, priv. coll. – GW 1810

This amusing scene is merely a pretext for a very fine composition in which we find the contrast of light and shade frequently encountered in these drawings – cf. in this context the note to H.34 – and also the figure of a man with broadly arched legs typical of the artist's Bordeaux period, as I observed in the note to G.30. The silly expression of the soldier who takes pride in his handsome uniform contrasts with the rather satanic face of the dark man obviously intent on making him drunk. Proof of this is offered by the big, well-filled glasses they are quaffing and the two bottles waiting ready on the right. Here, too, Goya has used short, nervous, jagged strokes to stress the details of the uniform and the seams of the trousers.

H.52 [465] p. 621
"Daedalus seeing Icarus fall" (?) – 1824-28 – 191 × 148 – Bc – No. (Bc) – No. add. 182 (Lp) – *Paper*: horizontal chain lines (26 mm) – Mounted on pink paper – *Hist.*: Javier Goya; Mariano Goya; Román Garreta → Museo de la Trinidad (5.4.1866) – Madrid, Prado (395) – GW 1811

Sánchez Cantón entitled this drawing "*Demon imploring*" (Bibl. 173, No. 435), but actually the winged man is not on his knees. Indeed, like so many other figures created by Goya in these albums – cf. in particular H.19 and H.59 – he is flying through the air. This is borne out by a detail observed in other drawings: his hair floats in the wind, giving the impression of a figure in motion – cf. G.10 and G.32. The suggestion that the drawing represents a demon or a falling angel, though clever, does not strike me as convincing because we can see that the man grips his wings with the help of handles and therefore has nothing in common with the real demons Goya portrayed in other works (*Caprichos* 48 and 66 and drawings G.59 and H.57), which either had wings independent of their arms or had no arms at all. So what we have here is a man who has fastened wings to his back and works them with his arms in order to fly. This obviously calls to mind the famous myth of Daedalus and his son Icarus, though Goya had little taste for mythological subjects. Or it might be simply a dream vision, like *Disparate 13, Way to fly,* engraved in Madrid between 1815 and 1820.

H.53(52) [466] p. 622

Muerte de/Anton Requena (Bc) (The death of Anton Requena) – 1824-28 – 191 × 156 – Bc – No. (Bc) – *Paper:* horizontal chain lines (26 mm) – *Hist.:* bought at Madrid by the 1st Baron Savile of Rufford between 1858 and 1860; Rufford Abbey, John Savile, 2nd Baron Savile of Rufford; London, Colnaghi → 1923 – Ottawa, National Gallery (2998) – GW 1812

We know nothing whatever about this Anton Requena, whose unusual death must have been the talk of the town in Goya's day or else was told him later at Bordeaux. A mad-looking individual is shooting pointblank at a man apparently asleep in a curious position – standing with his head cradled in his arms, which rest on what looks like a big sculptured rock. A vague silhouette in the background observes the scene. Although the composition is very good, the linework in the details lacks the nervous strength generally found in the Bordeaux albums. E. Sayre has pointed out that on the reverse there is the imprint of the following drawing, *Telegrafo,* H.54.

H.54 [467] p. 623

Tele-/grafo (Bc) (Telegraph) – 1824-28 – 191 × 152 – Bc – No. (Bc) – No. add. 146 (Lp) – *Paper:* horizontal chain lines (26 mm) – Mounted on pink paper – *Hist.:* Javier Goya; Mariano Goya; Román Garreta → Museo de la Trinidad (5.4.1866) – Madrid, Prado (377) – GW 1813

This professional acrobat – observe the specially designed trousers fixed round the ankles – is not doing his act in public but appears to be practising on a trestle table. In the background to the left a woman with a shawl on her head sits with what looks to me like a hen on her knees; one can make out its beak and feathers drawn with jagged strokes. The curious title alludes to the motion of the acrobat's legs, which imitates or attempts to imitate the signals made with a semaphore.

H.56(55) [468] p. 624

"Group of monks beneath an arch" – 1824-28 – 186 × 134 – Bc – No. (Bc) – *Paper:* horizontal chain lines 26/27 mm) – *Hist.:* F. de Madrazo (?) – Berlin-Dahlem, Kupferstichkabinett (4293) – GW 1814

At first glance this drawing seems to have been treated with a sketchiness poles apart from the refined technique of the black-chalk compositions of the Bordeaux period. For this reason it has been viewed as a copy, like those already called attention to in this album (cf. the note to H.11). But, for one thing, the known imitations are almost too well executed and never show negligence. That is not the case here. Moreover, the paper used for the copy H.11 and the others is not the one Goya usually employed, whereas that used for this drawing is identical with the old paper of albums G and H. For these reasons I believe that this sketch, whether unfinished or unsuccessful, must be viewed as certainly by Goya's own hand.

H.57(56) [469] p. 625

"United by the devil" – 1824-28 – 191 × 150 – Bc – No. (Bc) – No. add. 146 (Lp) – *Paper:* horizontal chain lines (26/27 mm) – Mounted on pink paper – *Hist.:* Javier Goya; Mariano Goya; Román Garreta → Museo de la Trinidad (5.4.1866) – Madrid, Prado (393) – GW 1815)

This union of a half-naked old man and a much younger woman who pinions both his arms behind his back is truly diabolical. He makes a grimace of pain of exasperation; she smiles with an air of victory. This is not a squabble between husband and wife, like the one we saw in F.18, but a demonstration of a young woman's tyranny over an old man – the tyranny of the

flesh, which the horrid devil behind them consecrates in the name of the lust he symbolizes. In this drawing the distribution of light and shade is also worth noting; it has no connection with the lighting of the scene, for there is none, but is linked with the part played by each of the characters. The old man, who is the victim of the union, is very bright; the devil, who is the cause of all his misfortune, is dark. This dualism has already been called attention to in other drawings of the Bordeaux period – cf. the note to H.34.

H.58(57) [470] p. 626

"Old man on a swing" – 1824-28 – 190 × 151 – Bc – No. (Bc) – On the verso: "35" – On the mount: "12" – *Paper*: horizontal chain lines – Mounted on pink paper – *Watermark*: GH.I – *Hist.*: Javier Goya; Mariano Goya; Román Garreta; F. de Madrazo; R. de Madrazo y Garreta; New York, A. M. Huntington (1913) – New York, Hispanic Society of America (A.3313) – GW 1816

This drawing was revealed in 1963 in an important study by E. du Gué Trapier (Bibl. 184, pp. 11-20). It is certainly one of the strangest in the Bordeaux albums although the subject itself is extremely commonplace. Forty years after tapestry cartoon *El Columpio* (The Swing) of 1779 (GW 131), the decorative panel painted in 1786-87 for the Marqués de Osuna's study (GW 249), and thirty after the drawing B.21 in the Madrid album, Goya's interest in the age-old theme of the swing was suddenly roused anew in Bordeaux. Not only this drawing but two etchings (GW 1825 and GW 1826) found their inspiration in the same source. But what a difference! The charming *majas* of the distant past have been replaced by a barefooted old man in rags with a broad grin on his face, and, instead of the pleasant setting of the *fête galante,* there is a total void. The ropes are attached to nothing and there is nothing beneath the swaying old man; it is as if he was suspended in a vacuum that has neither beginning nor end. His big head makes him akin to the characters I have already called attention to (cf. the note to G.30), and still more to those we saw in the crowd, above and to the right, in G.20. There we found the same puffy faces grinning from ear to ear. I must insist, once again, on the magnificent, jagged crayon strokes that heighten some details of the man's clothes. The very fine, vermiculated lines on the face are also in keeping with the style of the period and are not by any means due to an unsteady hand. See the head to the left in the background of G.4 and G.14; the figures to the right in the background of G.17; and, especially, the gleeful face of the protagonist in H.38.

H.59 [471] p. 627

"Young woman floating in the air" – 1824-28 – Bc – No. (Bc) – *Paper*: horizontal chain lines (26 mm) – *Hist.*: Javier Goya; F. de Madrazo; Saragossa, B. Montañés; Madrid, A. de Beruete; Berlin, Gerstenberg (after 1907) – Destroyed (1945) in Berlin, formerly Gerstenberg coll. – GW 1817

Another flying figure draped in long, flowing veils that form a sort of irregular rose around the half-naked torso. The hair, too, waves in the breeze, as in drawings G.10, G.32 and H.52. Nonetheless, I do not think this young woman is a witch. A more plausible theory would be a dream, as in E.20, but with neither anxiety nor nightmare – indeed, quite the contrary. It is also interesting to observe the kinship between this graceful figure and some of the angels in San Antonio de la Florida. Cf. in this context Bibl. 117, p. 91.

H.60 [472] p. 628

"The idiot" – 1824-28 – Bc – No. (Bc) – *Paper*: horizontal chain lines (27 mm) – *Hist.*: Javier Goya; F. de Madrazo; Saragossa, B. Montañés; Madrid, A. de Beruete; Berlin, Gerstenberg (after 1907) – Destroyed (1945) in Berlin, formerly Gerstenberg coll. – GW 1822

Goya has seldom rendered human decadence so forcefully. We have already seen two extremely tragic cases (G.33 and G.40) in the series of lunatics in album G, both entitled *Loco furioso* (Raving madman), but neither attained the degree of horror we find here. First of all there is the black ground out of which the monstrous figure emerges; then the enormous face that approaches us with wide-open mouth and staring eyes. Compared to the drawings I have just mentioned, this one strikes us by the gigantic size of the figure, which puts us in mind of Goya's obsession with colossi. All human proportions are lost and our anxiety springs also from the darkness that might well be peopled by other monsters of the same kind. This matchless work, unfortunately destroyed, ushered in the adventure of expressionism. An improved printing of the block revealed the autograph number 60 in the dark background at the upper right.

H.61 [473] p. 629

"Phantom dancing with castanets" – 1824-28 – 191 × 150 – Bc – No. (Bc) – No. add. 143 (Lp) – *Paper*: horizontal chain lines (26 mm) – Mounted on pink paper – *Hist.*: Javier Goya; Mariano Goya; Román Garreta → Museo de la Trinidad (5.4.1866) – Madrid, Prado (385) – GW 1818

This is the third drawing in this album, after H.49 and H.60, with a totally black ground. The relief effect is weaker than in the previous drawing, H.60, but the jeering figure of a phantom dancing to the sound of castanets is no less forceful than the visions of monks in album C – cf. C.123 and C.125 – though lacking the satirical intention typical of the liberal period (1820-23). The caption to C.123 dwelt ironically on the phantom-like aspect of the sinister-looking monk. Here instead we have a gay phantom, whose obese figure and hydropic head recall once again the characters encountered so many times in the Bordeaux albums (cf. G.30, G.39, G.55, H.6, H.38, and others). The face, with the big pug nose, two tiny eyes and wide mouth grinning from ear to ear, has several counterparts in these black-chalk drawings, e.g. G.39, H.38 and H.58, not forgetting those framed by butter-fly wings in G.53. The phantom's fantastic dance has been compared with *Disparate 4,* often entitled *Bobalicón* (The great boob), but it is more like that of the old woman in the drawing E.2. This is not surprising for the posture is typical of a Spanish dance step.

H.62 [474] p. 630

"Two women in church" – 1824-28 – Bc – No. (Bc) – *Paper:* horizontal chain lines – *Hist.:* Javier Goya; F. de Madrazo; Saragossa, B. Montañés; Madrid, A. de Beruete; Berlin, Gerstenberg (after 1907) – Destroyed (1945) in Berlin, formerly Gerstenberg coll. – GW 1819

"We observe two French ladies at Mass", is what Carderera says of this drawing in an article published in the *Gazette des Beaux-Arts* in 1860 (Bibl. 84, p. 227). He had probably seen it either at Federico de Madrazo's before it was given to Bernardino Montañés or, earlier still, at Javier Goya's, before the latter's death in 1854. The description is exact and the drawing shows a scene Goya had actually witnessed in Bordeaux or, as is always possible in his works, he had heard of. The two women seem to be mother and daughter. The first sits with a big prayer-book open in her hands; the second kneels beside her giving all her attention to a little note handed her by a gallant, towards whom she casts a sly glance under the shadow of her large hat. In the background, to the right, we can just distinguish the vague outline of a woman's bowed head.

H.63 [475] p. 631

"Monk guzzling from a large bowl" – 1824-28 – 190 × 151 – Bc – No. (Bc) – No. add. 141 (Lp) – *Paper:* horizontal chain lines (25 mm) – Mounted on pink paper – *Hist.:* Javier Goya; Mariano Goya; Román Garreta → Museo de la Trinidad (5.4.1866) – Madrid, Prado (366) – GW 1820

Here the satire has two objects: first, gluttony, which attains a truly Pantagruelian dimension in this draw-ing; secondly, the monk (here apparently a priest) cheerfully committing one of the seven deadly sins. The same subject was treated in F.64, but during the Bordeaux period it was amplified to a sort of gigantism which I have already called attention to. We find this trait in absolutely fantastic figures – cf. G.3 and G.4 – and, more frequently, in powerfully built individuals who, in spite of their big head and almost superhuman stature, are not monsters. But what is really new in many of the Bordeaux drawings is the layout, which tends to expand the figure till it occupies the entire sheet. Note the corrections Goya made on the chair-back, and perhaps in the number 63, where the second digit is not quite clear.

H.(a) [476] p. 632

"The broken pot" – 1824-28 – s. "Goya" (Bc) – Bc – The autograph number seems to have been erased upper right – *Paper:* horizontal chain lines – *Hist.:* Javier Goya; F. de Madrazo; Saragossa, B. Montañés; Madrid, A. de Beruete; Berlin, Gerstenberg (after 1907) – Destroyed (1945) in Berlin, formerly Gerstenberg coll. – GW 1821

Here Goya has portrayed a little peasant girl in tears beside her broken jug backed by a landscape like that of H.14. (Incidentally, there are very few landscape backgrounds in the Bordeaux albums.) Illuminated from the front, her dress with hardly a trace of model-ling, she stands out against a lopped, almost leafless tree and the dark shadow cast on the ground. The freshness of the girl's young face is veiled by a touch of rubbed crayon to enhance her sad expression. One cannot help recalling La Fontaine's scatterbrained Perrette, Greuze's famous painting and the old proverb about crying over spilt milk. In this reproduction the signature is clearly visible at the lower right, which would lead to the inference that the drawing might have its place at the beginning of the album before H.40 (cf. the introduction to album H).

Bibliography

I Exhibition Catalogues

1	1895-96	Exhibition of Spanish Art, New Gallery, London.
2	1922	Exposición de dibujos 1750-1860, Sociedad Española de Amigos del Arte, Madrid.
3	1934	Exposición de dibujos de antiguos maestros españoles, Madrid.
4	1935	Exposition de l'Œuvre gravé, de Peintures, de Tapisseries et de Cent-dix Dessins du Musée du Prado, Bibliothèque Nationale, Paris.
5	1936	Goya, his Paintings, Drawings and Prints, The Metropolitan Museum of Art, New York.
6	1937	Exhibition of Paintings, Drawings and Prints by Francisco Goya, California Palace of the Legion of Honor, San Francisco.
7	1941	The Art of Goya. Paintings, Drawings and Prints, Art Institute, Chicago.
8	1946	Grabados y dibujos de Goya, Biblioteca Nacional, Madrid.
9	1950	A loan exhibition of Goya, Wildenstein, New York.
10	1951	Goya, 1746-1828, Bordeaux.
11	1953	Goya. Gemälde, Zeichnungen, Graphik, Tapisserien, Kunsthalle, Basle.
12	1954	Goya. Drawings, Etchings and Lithographs, Arts Council, London.
13	1955	Goya. Drawings and Prints from the Museo del Prado and Museo Lázaro Galdiano, Madrid, and the Rosenwald Collection, National Gallery of Art, Washington, D.C., circulated by the Smithsonian Institute.
14	1955	Goya. Drawings and Prints, Catalogue supplement. Paintings, drawings and prints added to the exhibition for the showing at Metropolitan Museum of Art from May 4 through May 30, 1955.
15	1955	El Greco to Goya, Winnipeg Art Gallery.
16	1956	De Tiepolo à Goya, Bordeaux.
17	1957	Exposition de la Collection Lehman de New-York, Musée de l'Orangerie, Paris
18	1958	The Goya Collection of Dr. Z. Bruck, Museo de Bellas Artes, Buenos Aires.
19	1959-60	Stora Spanska Mästare, Nationalmuseum, Stockholm.
20	1961-62	Goya, Musée Jacquemart-André, Paris.
21	1962	The Nineteenth Century: one hundred and twenty-five master drawings, Minneapolis and New York.
22	1963-64	Goya and His Times, Royal Academy of Arts, London.
23	1966	Goya. Zeichnungen, Radierungen, Lithographien, Ingelheim am Rhein.
24	1966	Spanische Zeichnungen von el Greco bis Goya, Kunsthalle, Hamburg.
25	1959	From Dürer to Picasso, Exhibition of Drawings from the National Gallery of Canada, Florence, London and Paris.
26	1970	Goya. Dessins, gravures, lithographies, Galerie Huguette Bérès, Paris.
27	1972	Francisco Goya: Portraits in paintings, prints and drawings, Virginia Museum, Richmond, Va.

II Catalogues of Public Sales

(All the sales in Paris at the Hôtel Drouot, unless otherwise stated)

28	1869 (28.1)	Paul Lefort, Paris.
29	1869 (19/20.3)	Jules Boilly, Paris.
30	1872 (8.2)	Etienne Arago, Paris.
31	1872 (15.3)	Barroilhet, Paris.

32	1873 (20/22.1)	Jean G[igoux], Paris.
32a	1876 (1.5)	Philippe-Burty, Sotheby, London.
33	1876 (2.2)	Anonymous, Paris.
34	1877 (3.4)	Anonymous, Paris.
35	1882 (20.3)	J. G[igoux], Paris.
36	1885 (16/19.2)	Baron de Bernonville, Paris.
37	1890 (5.2)	Anonymous, Paris.
38	1894 (8.5)	John J. Peoli, New York.
39	1898 (28/29.3)	A. Marmontel, Paris.
40	1898 (26.12)	Charles Yriarte, Paris.
41	1899 (4/5.5)	Comte A. Doria, Galerie Georges Petit, Paris.
42	1899 (11/12.12)	E. Calando, Paris.
43	1903 (27/29.1)	H. Lacroix, Paris.
44	1906 (26.3)	Anonymous, Paris.
45	1906 (25.5)	Paul Meurice, Paris.
46	1906 (19.6)	G. Poelet, Paris.
47	1912 (9/18.12)	Henri Rouart, Galerie Manzi-Joyant, Paris.
48	1920 (2/4.6)	Alfred Beurdeley, Galerie Georges Petit, Paris.
49	1922 (15/16.6)	Georges Bourgarel, Paris.
50	1923 (11.5)	J. Homberg, Galerie Georges Petit, Paris.
51	1929 (11.12)	Anonymous, Paris.
52	1930 (12.5)	Boerner und Graupe, Berlin.
53	1935 (Mai)	J. P. Heseltine, London,
54	1936 (14.5)	Anonymous, Paris.
55	1936 (10.7)	Oppenheimer, Christie's, London.
56	1938 (28.6)	Anonymous, Paris.
57	1939 (30.6)	Jacquin, Paris.
58	1943 (12/13.2)	Heidsieck, Parke-Bernet, New York.
59	1950 (21.6)	Anonymous, Sotheby, London.
60	1952 (8.11)	Anonymous, Parke-Bernet, New York.
61	1957 (9.4)	Anonymous, Galerie Charpentier, Paris.
62	1957 (20.11)	Koenigs, Sotheby, London.
63	1957 (3.12)	Tony Mayer, Paris.
64	1958 (21.3)	Anonymous, Galerie Charpentier, Paris.
65	1960 (29.6)	Anonymous, Sotheby, London.
65a	1961 (10.5)	Anonymous, Sotheby, London.
66	1966 (1.12)	Anonymous, Sotheby, London.
67	1972 (26.5)	Anonymous, Paris.
68	1973 (20.3)	Anonymous, Christie's, London.

III Alphabetical List of Authors

A

69 Acchiardi, Pierre d'. Les dessins de Francisco Goya au Musée du Prado, Roma, 1908.
 Adhémar, Jean, v. Bibl. 4.

70 Anonymous, Colección de cuatrocientas cuarenta y nueve reproducciones de cuadros, dibujos y aguafuertes de Don Francisco de Goya, Madrid, 1924.

71 Anonymous. *Bulletin of the Fogg Art Museum,* 1940.

72 Anonymous. *Boston Museum Bulletin*, Dec. 1954.

73 Anonymous. *Boston Museum Bulletin*, LIII, 1955, pp. 43-67.

73 Anonymous. Description of the Sale at Galerie Charpentier on 9.4.1957. Bibl. 61, *Archivo Español de Arte*, Oct. 1957, nº 30.

75 Anonymous. *Boston Museum Bulletin*, "Centennial acquisitions", LXVIII, 1970, p. 87.

B

76 Barcia, Angel M. de. Catálogo de la colección de dibujos originales de la Biblioteca Nacional, Madrid, 1906.
77 Baticle, Jeannine. Catalogue de l'Exposition Goya, Orangerie des Tuileries, Paris, 1970.
78 Baticle, Jeannine. "L'activité de Goya entre 1796 et 1806 vue à travers le *Diario* de Moratín", *Revue de l'Art*, 1971, nº 13, pp. 111-113.
79 Blanco White, José Maria. Letters from Spain, London, 1822. (Spanish translation, referred to here: Cartas de España, Madrid, 1972.)
80 Boix, Félix. Los dibujos de Goya, Madrid, 1922.
81 Boix, Félix and F. J. Sánchez Cantón. Museo del Prado. Goya. I. Cien Dibujos inéditos, Madrid, 1928.
Boix, Félix, v. Bibl. 2.

C

82 Calvert, Albert F. Goya, London, 1908.
83 Camón Aznar, José. "Dibujos de Goya del Museo Lázaro", *Goya*, Jul.-Aug. 1954, pp. 9-14.
84 Carderera, Valentín. "François Goya - Sa vie, ses Dessins et ses Eaux-Fortes", *Gazette des Beaux-Arts*, VI, 1860, pp. 215-227.
85 Caro Baroja, Julio. Las brujas y su mundo, Madrid, 1961.
86 Crispolti, Enrico. "Disegni inediti di Goya", *Commentari*, IX, 1958, pp. 124-132.
87 Crispolti, Enrico. "Otto nuove pagine del taccuino 'di Madrid' di Goya ed alcuni problemi ad esso relativi", *Commentari*, IX, 1958, pp. 181-205.

D

88 Desparmet-Fitzgerald, X. L'œuvre peint de Goya, Paris, 1928-50.
89 Desparmet-Fitzgerald, X. "Deux dessins inédits de Francisco Goya", *Panthéon*, XXIII, 1965, pp. 111-115.
90 Di San Lazzaro, G. "Parigi. Disegni di Goya e di Victor Hugo", *Emporium*, nº 6, 1935.
Doblado, Leucadio (pseudonym of Blanco White, José Maria), v. Bibl. 79.

E

91 Ezquerra del Bayo, Joaquín. La Duquesa de Alba y Goya, Madrid, 1928. (Reprinted in 1959; references are to this reprint.)

F

92 Florisoone, Michel. "La raison du voyage de Goya à Paris", *Gazette des Beaux-Arts,* LXVIII, 1966, pp. 327-332.

G

93 Gassier, Pierre, v. Bibl. 135.
93 — "De Goya-Tekeningen in het Museum Boymans", *Bulletin Museum Boymans,* Rotterdam, IV, 1, 1953, pp. 12-24.
94 — "Les dessins de Goya au Musée du Louvre", *La Revue des Arts*, 1, 1954, pp. 31-41.
95 — Goya, Geneva, 1955.
96 — "Les premiers signes du fantastique dans l'œuvre de Goya", *Cahiers de Bordeaux*, 4e année, 1957, pp. 94-97.
97 — Vie et œuvre de Francisco Goya (en collaboration avec Juliet Wilson), Fribourg, 1970. English translation: Goya: his life and work. With a catalogue raisonné, London, 1971, published in the USA as: The life and complete work of Francisco Goya, New York, 1971.
98 — "Goya à Paris", *Goya*, nº 100, Jan.-Feb. 1971.
99 — "Une source inédite de dessins de Goya en France au XIXe siècle", *Gazette des Beaux-Arts*, Jul.-Aug. 1972, pp. 109-120.

651

100 Gómez-Moreno, María Elena. "Un cuaderno de dibujos inéditos de Goya" *Archivo Español de Arte*, XIV, 1941, pp. 155-163.

101 Gudiol Ricart, José. Goya, Barcelona, 1970.

H

102 Harris, Tomás. Goya. Engravings and lithographs, Oxford, 1964.

103 Hasselt, Carlos van. "Three Drawings by Francisco Goya (1746-1828) in the Fitzwilliam Museum, Cambridge", *Apollo*, LXV, 1957, pp. 87-89.

104 Held, Jutta. "Francisco de Goya. Graphik und Zeichnungen", *Zeitschrift für Kunstgeschichte*, vol. 27, 1964, fasc. 1, pp. 60-74.

105 Helman, Edith.

105 — "The Younger Moratín and Goya: on duendes and brujas", *Hispanic Review*, XXVII, 1959, pp. 103-122.

106 — Transmundo de Goya, Madrid, 1963.

107 — "Fray Juan Fernández de Rojas y Goya", Homenaje a Rodríguez Moñino, Madrid, 1966, 1, p. 241-252.

108 Herr, Richard. The Eighteenth-Century Revolution in Spain, Princeton University, N.J., 1958.

109 Hofer, Philip. Fogg Art Museum Annual Report, 1953-54.

J

110 Jovellanos, Gaspar Melchor de. Informe sobre los juegos, espectáculos y diversiones públicas, Gijón, 1790.

K

111 Klingender, F. D. Goya in the Democratic Tradition, London, 1948.

L

112 Lafond, Paul. Goya, Paris, 1902.

113 — Nouveaux Caprices de Goya, suite de trente-huit dessins inédits, Paris, 1907.

114 — "Les dernières années de Goya en France", *Gazette des Beaux-Arts*, XXXVII, 1907, pp. 114-131, 241-257.

115 Lafuente Ferrari, Enrique.

115 — Antecedentes, coincidencias e influencias del arte de Goya, Madrid, 1947.

116 — Los Desastres de la Guerra de Goya y sus dibujos preparatorios, Barcelona, 1952.

117 — Les Fresques de San Antonio de la Florida à Madrid, Geneva, 1955.

118 Loga, Valerian von.

118 — Francisco de Goya, Berlin, 1903.

119 — "Goyas Zeichnungen", *Die Graphischen Künste*, XXXI, Wien, 1908.

120 López-Rey, José.

120 — "Goya's drawing of Pietro Torrigiano", *Gazette des Beaux-Arts*, March 1945, pp. 165-170.

121 — "The unfrocking drawings of Francisco de Goya", *Gazette des Beaux-Arts*, May 1945, pp. 287-296.

122 — "Goya's vision of Mid-Lent merriment", *The Art Quarterly,* Detroit Institute of Art, 1946, vol. IX, nº 2, pp. 141-143.

123 — Goya y el mundo a su alrededor, Buenos Aires, 1947.

124 — "A XXth century forger of Goya's works", *Gazette des Beaux-Arts*, XXXIV, 1948, pp. 107-113.

125 — "Four visions of woman's behaviour in Goya's graphic work", *Gazette des Beaux-Arts*, November 1948, pp. 355-364.

126 — "Two sheets from Goya's Madrid sketchbook", *Gazette des Beaux-Arts,* May-June 1952, p. 341.

127 — Goya's Caprichos. Beauty, Reason and Caricature, Princeton, 1953.

128 — "Hidden meanings in Goya's drawings", *Art News*, April 1955, pp. 19-23.

129 — "Las cárceles de Piranesi, los prisioneros de Goya", Scritti di storia dell'arte in onore di Lionello Venturi, Rome, 1956, vol. 2, pp. 111-116.

130 — "Goya and his pupil: María del Rosario Weiss", *Gazette des Beaux-Arts*, May-June 1956, p. 1-34.

131 — A cycle of Goya's drawings, London, 1956.

132 — "Una cospirazione del gusto: un falso Goya", *Critica d'Arte*, 1957, March-April, nº 20, pp. 143-159.

133 — "Goya at the London Royal Academy", *Gazette des Beaux-Arts*, May-June 1964, pp. 359-369.

M

134 Mackenzie, Helen F. "The art of Goya", *Bulletin of the Art Institute of Chicago*, vol. XXXV (1941), nº 2, pp. 18-22.

135 Malraux, André. Dessins de Goya au Musée du Prado, Geneva, 1947. (With a tentative catalogue by Pierre Gassier.)

136 Mariani, Valerio. "Primo centenario della morte di Francesco Goya. Disegni inediti", *l'Arte*, XXI, 3, 1928, pp. 97-108.

137 Matheron, Laurent. Goya, Paris, 1858.

138 Maule, Nicolás de la Cruz y Bahamonde, Conde de. Viaje de España, Francia y Italia, Cádiz, 1813.

139 Mayer, August L.

139 — Handzeichnungen Spanischer Meister, Leipzig and New York, 1920.

140 — Francisco de Goya, Munich, 1923; London, 1924; Barcelona, 1925.

141 — Francisco Goya. Ausgewählte Handzeichnungen, Berlin [1924].

142 — "A Goya drawing", *Burlington Magazine*, March 1930, pp. 272-278.

143 — "Echte und falsche Goya-Zeichnungen", *Belvedere*, 1930, 1, pp. 215-217.

144 — "Dibujos desconocidos de Goya", *Revista Española de Arte*, XI, 1933, pp. 376-384.

145 — "Some unknown drawings by Francisco Goya", *Old Master Drawings,* IX, 1934-35, pp. 20-21.

146 — "Goya drawings in the Louvre", *Old Master Drawings*, XII, September 1938, p. 22.

147 Moratín, Leandro Fernández de. Diario, edición anotada por René y Mireille Andioc, Madrid, 1968.

148 Morel-Fatio, Alfred. La satire de Jovellanos contre la mauvaise éducation de la noblesse, 1898.

N

149 Nordström, Folke. Goya, Saturn and Melancholy, Stockholm, 1962.

150 Núñez de Arenas, M. "Manojo de noticias – La suerte de Goya en Francia", *Bulletin Hispanique*, 3, Bordeaux, 1950.

O

151 Ortega y Gasset, José. Papeles sobre Velázquez y Goya, Madrid, 1950. (Reprinted with numerous additions in: Goya, Madrid, 1958. References are to this reprint.)

P

152 Palm, E. W. "Goya et Jean-Baptiste Boudard", *Gazette des Beaux-Arts*, May 1971, pp. 337-340.

153 — "Zu Goyas Capricho 56", *Aachener Kunstblätter,* vol. 41, 1971.

154 Pérez Sánchez, Alfonso E. Catálogo de la colección de dibujos del Instituto Jovellanos de Gijón, Madrid, 1969.

R

155 Rothe, Hans. Francisco Goya, Handzeichnungen, Munich, 1943.

S

156 Salas, Xavier de.

156 — "El segundo texto de Matheron", *Archivo Español de Arte*, XXXVI, 1963, pp. 297-305.

157 — "Sobre un autorretrato de Goya y dos cartas inéditas sobre el pintor", *Archivo Español de Arte*, XXXVII, 1964, pp. 317-320.

158 — "Portraits of Spanish artists by Goya", *Burlington Magazine*, CVI, 1964, pp. 14-19.

159 — "Precisiones sobre pinturas de Goya: el Entierro de la Sardina, la serie de obras de gabinete de 1793-94 y otras notas", *Archivo Español de Arte,* XXXVIII, 1965, pp. 207-227.

160 — "Una carta de Goya y varios comentarios a la misma", *Arte Español*, XXVI, fasc. 1, 1968-69, pp. 27-28.

161 — "Sur cinq dessins du Musée du Prado", *Gazette des Beaux-Arts*, LXXV, 1970, pp. 29-42.

— V. Bibl. 12.

162 Saltillo, Marqués del. Miscelánea Madrileña, histórica y artística. Primera serie: Goya en Madrid: su familia y allegados (1746-1856), Madrid, 1952.

163 Sambricio, Valentín de. Tapices de Goya, Madrid, 1946.
 Sánchez Cantón, F. J.
164 — Los dibujos del viaje a Sanlúcar, Madrid, 1928.
165 — Sala de los dibujos de Goya. (Guías del Museo del Prado II). Madrid, 1928.
166 — "Goya en la Academia", *Real Academia de Bellas Artes de San Fernando. Primer Centenario de Goya, Discursos...*,
 Madrid 1928, pp. 11-23.
167 — "Crítica de *Fifty Drawings by Goya* de H. B. Wehle", *Archivo Español de Arte*, July-August 1940, pp. 45-46.
168 — Museo del Prado. Goya. II. Dibujos inéditos y no coleccionados, Madrid, 1941.
169 — "Como vivía Goya", *Archivo Español de Arte*, XIX, 1946, pp. 73-109.
170 — Los Caprichos de Goya y sus dibujos preparatorios, Barcelona, 1949.
171 — Vida y obras de Goya, Madrid, 1951.
172 — "Goya refugiado", *Goya*, 3, 1954, pp. 130-135.
173 — Museo del Prado. Los dibujos de Goya, Madrid, 1954.
174 — "Una docena de dibujos goyescos", *Archivo Español de Arte*, XXVII, 1954, p. 288.
175 Sarrailh, Jean. L'Espagne éclairée de la seconde moitié du XVIIIe siècle, Paris, 1954.
176 Sayre, Eleanor A.
176 — "An old man writing. – A study of Goya's albums", *Boston Museum Bulletin*, LVI, 1958, pp. 116-136.
177 — "Eight books of drawings by Goya. – I.", *Burlington Magazine*, CVI, 1964, pp. 19-30.
178 — "Goya's Bordeaux miniatures", *Boston Museum Bulletin*, LXIV, 1966, pp. 84-123.
179 Solis, Ramón. El Cádiz de las Cortes, Madrid, 1958.
180 Starkweather, William E. B. Paintings and Drawings by Francisco Goya in the Collection of the Hispanic
 Society of America, New York, 1916.
181 Stoll, Robert Th. Francisco Goya: Pinselzeichnungen, Wiesbaden, 1953.
182 Symmons, Sarah. " John Flaxman and Francisco Goya: Infernos transcribed", *Burlington Magazine*, CXIII, 1971,
 pp. 508-512.

T

183 Trapier, Elizabeth du Gué.
183 — Goya. A Study of his Portraits, 1797-99, New York, 1955.
184 — "Unpublished drawings by Goya in the Hispanic Society of America", *Master Drawings*, I, 1963, pp. 11-20.

V

185 Viñaza, C. Muñoz y Manzano, Conde de la. Goya: su tiempo, su vida, sus obras, Madrid, 1887.

W

186 Wehle, Harry B. "Fifty Drawings by Francisco Goya", *The Metropolitan Museum of Art. Papers*, no. 7, New York,
 1938.
187 Weissberger, Herbert. "Goya and his Handwriting", *Gazette des Beaux-Arts*, XXVIII, 1945, pp. 181-192.
 Wilson, Juliet, v. Bibl. 97.

Y

188 Yebes, Condesa de. La Condesa-Duquesa de Benavente. Una vida en unas cartas, Madrid, 1955.
189 Yriarte, Charles. Goya. Sa biographie, les fresques, les toiles, les tapisseries, les eaux-fortes et le catalogue de
 l'œuvre, Paris, 1867.

Z

190 Zapater y Gómez, Francisco. Goya. Noticias biográficas, Zaragoza, 1868. (Reprinted in Bibl. 70.)

Glossary of Spanish Terms

Aficionado	Amateur, enthusiast, usually referring to a bullfight fan
Cantaor	Flamenco singer
Celestina	Procuress, bawd (a stock character in Spanish literature going back to *La Celestina* by Fernando de Rojas, a novel in dramatic form first published in 1499).
Coroza	High, pointed paper cap worn by the victims of the Inquisition
Embozado	Man wrapped in his cloak up to the eyes
Encorozado	Figure wearing the *coroza*
Majo, maja	Young man and young woman of the people, chiefly in the 18th century
Paseo	Public walk, promenade
Paso	Float, sometimes of considerable size, figuring in the Holy Week processions and displaying highly realistic painted statues, usually representing Passion scenes
Petimetre	Fop, beau, from the eighteenth-century French term *petit maître*
Piropo	Compliment or flattering remark elicited from a man as he passes a pretty woman in the street
Posada	Inn
Sanbenito	Kind of paper tunic worn by the victims of the Inquisition, on which was often written the reason for their condemnation
Tertulia	Club or circle meeting in a café or some other place of public resort

ACKNOWLEDGMENTS

We would like to extend our thanks to the museums and private collectors throughout the world who lent us their material, and to the following photographers and institutions:

Barbaix, Gent: pp. 113, 114
Calman, London: pp. 101, 102
Crispolti, Roma: pp. 31, 32, 85, 86, 115, 449, 473
Freeman, London: p. 537
Hinz, Basel: pp. 33, 34, 35, 36, 87, 88, 111, 112, 195, 425, 438, 439, 456, 458, 464, 466, 469, 471, 517, 521, 527, 529, 531, 538, 539, 540, 591, 598, 608, 620
Joubert, Paris: pp. 89, 90, 196
Kleinhempel, Hamburg: pp. 49, 50, 77, 78
Knoedler, New York: p. 193
Lindsey, Occidental (Cal.): pp. 109, 110
Moreno, Madrid: pp. 440, 506, 515, 522, 525, 532, 534, 535, 536, 543, 545, 546, 547, 552, 554, 556, 589, 593, 596, 597, 602, 604, 611, 612, 616, 618, 619, 627, 628, 630, 632
Nahmias, Paris: p. 201
Photo Etienne, Bayonne: pp. 206, 207
Photo Rousset, Paris: p. 461
Service de documentation photographique des Musées nationaux, Versailles: pp. 91, 92, 93, 94, 143, 150, 155, 182
Sotheby, London: pp. 119, 120, 159, 181
Stears & Sons, Cambridge: pp. 516, 649, 580
Steinkopf, Berlin: pp. 174, 178, 191
Studio Gérondal, Lomme-Lille: pp. 97, 98
Studio Lourmel 77, Paris: p. 190

This book was printed in July 1973 by Roto-Sadag S.A., Geneva.
The photolitho work was carried out by Atesa S.A., Geneva.
The binding was executed by Roger Veihl S.A., Geneva.
Watermarks were drawn by Bruno Baeriswyl. Editorial: Giles
Allen and Marie-José Treichler. Production: Franz Stadelmann.

Printed in Switzerland